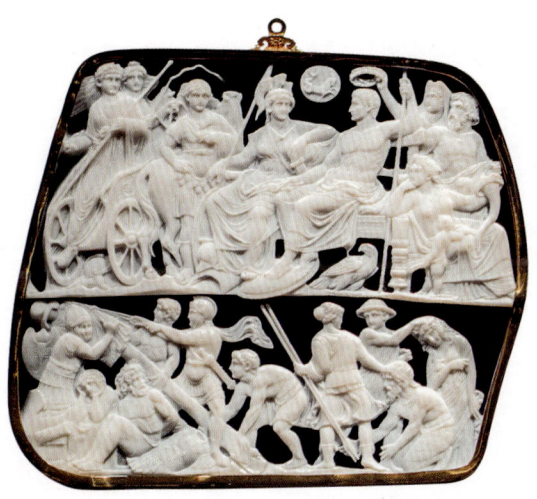

**Roman
Art &
Archaeology**

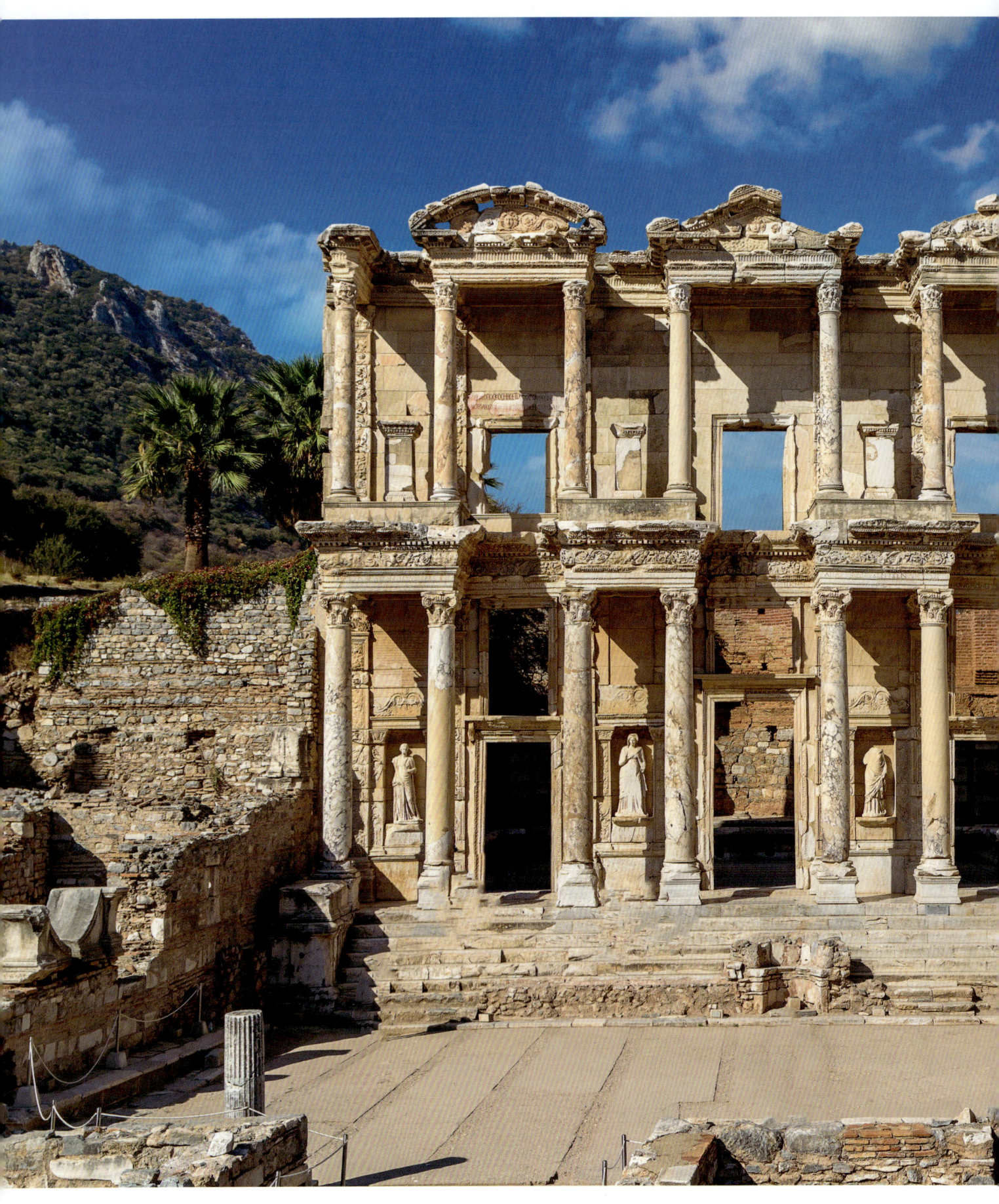

Mark D. Fullerton

Roman Art & Archaeology
753 BCE to 337 CE

490 illustrations

To Monica, for her unreserved love
and support for everything I do.

Front cover: Bust of Emperor Caracalla, 3rd century CE.
akg-images/De Agostini Picture Library/G. Dagli Orti

Half-title: Gemma Augustea, 1st century CE. See 6.9.

Title page: Library of Celsus, Ephesus, Turkey, 2nd century CE.
See 11.17.

Roman Art & Archaeology © 2019 Thames & Hudson Ltd, London

Text © 2019 Mark D. Fullerton

All Rights Reserved. No part of this publication may be reproduced or transmitted in any form or by any means, electronic or mechanical, including photocopy, recording or any other information storage and retrieval system, without prior permission in writing from the publisher.

First published in 2019 in the United States of America by Thames & Hudson Inc., 500 Fifth Avenue, New York, New York 10110

www.thamesandhudsonusa.com

Library of Congress Control Number 2019942538

ISBN 978-0-500-294079

Printed and bound in China by Everbest Printing Co. Ltd

Brief Contents

9 Preface
11 Introduction: What Is Roman about Roman Art?

18 **Part I: ROME AND ITALY BEFORE THE EMPIRE** (c. 800–27 BCE)
20 1. **Etruscan and Early Roman Art**
48 2. **Republican Rome and the Hellenistic World: Triumph, Commemoration, and Public Art**
74 3. **Republican Rome and the Hellenistic World: Art of the Roman Household**
100 4. **From Republic to Empire: Art in the Age of Civil War**

126 **Part II: THE FORMATION OF THE ROMAN EMPIRE** (27 BCE–96 CE)
128 5. **Augustus, the Principate, and Art**
152 6. **Imperial Portraiture and Commemoration in the Early Empire**
178 7. **Palaces and Public Works in the Early Empire**
204 8. **Provincial and Private Art in the Early Empire**

232 **Part III: THE HIGH EMPIRE** (96–192 CE)
234 9. **Art in the Reign of Trajan**
260 10. **The Art of Hadrian and the Antonines**
286 11. **Provincial Art in the High Empire**

314 **Part IV: COLLAPSE AND RECOVERY: ART ACROSS THE LATER ROMAN EMPIRE** (193–337 CE)
316 12. **Art in the Age of the Severans**
342 13. **The Art of the Soldier Emperors and the Tetrarchy**
366 14. **Constantine and the Legacies of Roman Art**

388 Glossary
392 Further Reading
395 Sources of Quotations
396 Sources of Illustrations
398 Index

Contents

Preface 9
Introduction: What Is Roman about Roman Art? 11
 Architectural Orders in Rome and the Empire 17

Part I
Rome and Italy before the Empire
(c. 800–27 BCE) 18

1. Etruscan and Early Roman Art 20
Beginnings of Rome 22
The Villanovans 23
Etruscans in the Wider World 25
 ETRUSCAN TOMBS 28
 TOMB PAINTING 30
 ETRUSCAN SCULPTURE 36
 ETRUSCAN BRONZES 40
 ETRUSCAN AND EARLY ROMAN TEMPLE ARCHITECTURE AND STATUARY 44
The Legacy of Etruscan Art 47
 Romulus's Rome 22
 The Aristonothos Krater 27
 The Capitoline Wolf: A Case for Caution 43
 MATERIALS AND TECHNIQUES: *Terracotta Sculpture* 46

2. Republican Rome and the Hellenistic World: Triumph, Commemoration, and Public Art 48
The Empire of Alexander and the Rise of Rome 50
Conquest and Culture 51
Roman "Museums" of Greek Art 53
The Triumph and Republican Temple Architecture 55
 LARGO ARGENTINA 56
 TEMPLES BY THE TIBER 57
 TEMPLES AT TIVOLI 60
 SANCTUARY OF FORTUNA AT PRAENESTE 60
 TRIUMPHAL PAINTING 63
Sculpture 65
 MUNICH MARINE *THIASOS* AND PARIS CENSUS RELIEFS 65
 AEMILIUS PAULLUS MONUMENT 67
 LAGINA, TEMPLE OF HECATE FRIEZE 68
 VIA SAN GREGORIO PEDIMENT 69

Portraiture 70
 IMAGINES AND REPUBLICAN PORTRAITS 71
 VERISM 72
 The Reception of Greek Art in Rome 51
 Roman Histories of Greek Art 54
 MATERIALS AND TECHNIQUES: *Concrete* 62
 Polybius on Imagines *and the Roman Republican Funeral* 71

3. Republican Rome and the Hellenistic World: Art of the Roman Household 74
Evidence from Delos and Vesuvius 76
The Atrium House 76
 MOSAICS 79
 MURAL PAINTING 82
Domestic Sculpture 90
 "NEO-ATTIC" SCULPTURE AND THE ART MARKET 90
Roman and Hellenistic Art 98
 MATERIALS AND TECHNIQUES: *Linear and Atmospheric Perspective* 86
 The Mahdia and Antikythera Wrecks 93
 Cicero as Collector 95
 Herculaneum: The Villa of the Papyri 99

4. From Republic to Empire: Art in the Age of Civil War 100
The First Triumvirate and Civil War 102
 PORTRAITS OF POMPEY AND CAESAR 103
 THEATER OF POMPEY 105
 FORUM OF CAESAR 105
The Second Triumvirate and Civil War 109
 PORTRAITS OF ANTONIUS AND OCTAVIAN 110
Transforming Rome 111
 HOUSE ON THE PALATINE 112
 TEMPLE OF CAESAR IN THE REPUBLICAN FORUM 117
 BASILICA AEMILIA 119
 COMPLETING CAESAR'S BUILDINGS IN THE CAMPUS MARTIUS 121
 Greek and Roman Theaters 106
 MATERIALS AND TECHNIQUES: *Marble* 112
 Restorations of Republican Temples 115

Part II
The Formation of the Roman Empire
(27 BCE–96 CE) 126

5. Augustus, the Principate, and Art 128
Augustus in Concept and Image 130
- PORTRAITS OF AUGUSTUS 132
- PORTRAITURE, THE FAMILY OF AUGUSTUS, AND SUCCESSION 134

The Building Program of Augustus 138
- MAUSOLEUM OF AUGUSTUS 138
- HOROLOGIUM 139
- ARA PACIS 140
- FORUM OF AUGUSTUS 144

Later Second Style Wall Painting 147
Third Style Wall Painting 150
Augustus's Legacy 151
- *Augustus and the Honors of 27 BCE* 130
- MATERIALS AND TECHNIQUES: *Roman Coins* 131
- *Identity and Individuality in Roman Portraits of Women* 137
- *Vitruvius on Wall Painting* 149

6. Imperial Portraiture and Commemoration in the Early Empire 152
The Julio-Claudians 154
- PORTRAITURE OF TIBERIUS AND CALIGULA 154
- PORTRAITURE OF CLAUDIUS AND NERO 156
- JULIO-CLAUDIAN CAMEOS 160
- JULIO-CLAUDIAN COMMEMORATIVE SCULPTURE 165

The Flavians 168
- FLAVIAN PORTRAITURE 169
- FEMALE PORTRAITURE: JULIO-CLAUDIAN VS. FLAVIAN 170
- FLAVIAN COMMEMORATIVE SCULPTURE 173
- *The Julio-Claudian Dynasty and Imperial Succession* 156
- MATERIALS AND TECHNIQUES: *Cameos* 161
- *The Cult of Roma and Augustus* 164
- *Imperial Women* 171
- *The Flavian Portraits from Misenum* 172

7. Palaces and Public Works in the Early Empire 178
Imperial Palaces 181
- DOMUS AUREA 181
- DOMUS FLAVIA 183
- INTERIORS: FOURTH STYLE WALL PAINTING 186
- INTERIORS: STATUARY 189

Public Works 193
- TEMPLUM PACIS 195
- FORUM OF DOMITIAN/NERVA 196
- AQUEDUCTS 197
- BATHS 198
- THE FLAVIAN AMPHITHEATER AND PUBLIC SPECTACLE 199
- *New Light on Early Imperial Palaces* 180
- *The Domus Aurea—Tacitus and Suetonius* 183
- MATERIALS AND TECHNIQUES: *Damnatio Memoriae* 185
- *Sperlonga and Statuary* 192

8. Provincial and Private Art in the Early Empire 204
Private Funerary Art 206
- AMITERNUM RELIEFS 206
- TOMB OF EURYSACES 208
- TOMB OF THE HATERII 210

Art and Architecture in the Provinces 213
- TEMPLES IN THE PROVINCES 213
- COMMEMORATION IN THE PROVINCES 222
- THEATERS AND AMPHITHEATERS IN THE PROVINCES 227
- *Liberti in the Early Empire* 207
- *Corinth* 218
- *Temple of Dendur* 220
- *The Stadium at Aphrodisias* 228

Part III
The High Empire (96–192 CE) 232

9. Art in the Reign of Trajan 234
Nerva's Successor 236
- IMPERIAL PORTRAITS 237

Trajan's Buildings in Rome 239
- BATHS 239
- MARKETS 241
- FORUM OF TRAJAN 242
- TRAJANIC FRIEZE ON THE ARCH OF CONSTANTINE 250

Trajan's Buildings outside Rome 251
- ARCH AT BENEVENTUM 251
- *TROPAEUM TRAIANI* AT ADAMKLISSI 253
- OSTIA 254

From Trajan to Hadrian 257
- *ANAGLYPHA HADRIANI* (FORMERLY *TRAIANI*) 257
- *Adoption in Rome* 236
- *Seneca and Life in a Roman Bath* 240
- *Where Was the Temple of Divus Traianus?* 244
- MATERIALS AND TECHNIQUES: *Colored Marbles and Exotic Stones* 246

10. The Art of Hadrian and the Antonines 260

Hadrian 262
- HADRIAN'S PORTRAITURE 262
- RELIEF SCULPTURE 263
- HADRIANIC BUILDING IN ROME 266

The Antonines 274
- SUCCESSION 274
- PORTRAITURE 275
- COMMEMORATIVE RELIEF SCULPTURE 276
- ANTONINE BUILDING IN ROME 283
- MATERIALS AND TECHNIQUES: *Roman Brick Stamps and the Dating of the Pantheon* 268
- *Hadrian and Apollodorus* 270
- *Excavations at the Athenaeum* 273
- *Bronze Sculpture and the Equestrian Portrait of Marcus Aurelius* 280

11. Provincial Art in the High Empire 286

The Provinces 288
- URBAN DEVELOPMENT 290
- COLONNADED STREETS 296
- COLONNADED FACADES/STATUARY DISPLAY 297
- THE BATH-GYMNASIUM 300
- STAGE BUILDINGS 300
- HADRIAN'S VILLA AT TIVOLI 301
- SCULPTURE IN THE PROVINCES 306

Funerary Art and Sarcophagi 310
- *Herodes Atticus and Euergetism* 288
- *Hadrian's Wall and the Limits of the Empire* 304
- *Antinous and the Travels of Hadrian* 308

Part IV
Collapse and Recovery: Art across the Later Roman Empire (193–337 CE) 314

12. Art in the Age of the Severans 316

Severan Portraiture 318
- PORTRAITS OF SEPTIMIUS SEVERUS 318
- THE IMPERIAL FAMILY 320
- LATER SEVERAN PORTRAITURE 323

Building in Rome 324
- RESTORATIONS 324
- PALATINE 325
- BATHS OF CARACALLA AND ITS DECORATIVE PROGRAM 326
- ARCH OF THE *ARGENTARII* 328
- PARTHIAN ARCH IN THE ROMAN FORUM 330
- LEPTIS MAGNA 332

Private Art after the Antonines 337
- BACCHIC AND SEASONS SARCOPHAGI 337
- ANTIOCH MOSAICS 338
- *Mummy Portraits* 322
- *Forma Urbis Romae* 325
- *Leptis Magna and the Severans* 336
- MATERIALS AND TECHNIQUES: *Roman Mosaics* 340

13. The Art of the Soldier Emperors and the Tetrarchy 342

Soldier Emperors 344
- PORTRAITURE 344
- BIOGRAPHICAL SARCOPHAGI 349

The Tetrarchy 351
- PORTRAITURE 353
- COMMEMORATIVE SCULPTURE 355
- PALATIAL ARCHITECTURE ACROSS THE EMPIRE 360
- MATERIALS AND TECHNIQUES: *Roman Pottery across the Empire* 345
- *The Tetrarchy: Tradition and Innovation* 352

14. Constantine and the Legacies of Roman Art 366

Constantine the Emperor 368
- CONSTANTINE'S PORTRAITURE 369
- CONSTANTINE'S BUILDING PROGRAM IN ROME 370
- LATE ANTIQUE STYLE 373
- CHRISTIAN ROME 374
- THE "NEW" ROME OF CONSTANTINE 377

Epilogue: Rome's Lasting Legacy 382
- ROMAN EMPIRES RETAINED AND REVIVED 382
- ROMAN MODELS IN MODERN TIMES 383
- *Basilica of Maxentius* 368
- *Catacombs in Rome* 378
- MATERIALS AND TECHNIQUES: *Ancient Statuary in Constantinople* 380
- *Otto III and Rome* 384

Glossary 388
Further Reading 392
Sources of Quotations 395
Sources of Illustrations 396
Index 398

Preface

The history of Roman art is long and complex; many versions of it exist, each with its own perspective and system of organization. Mine is inevitably forged by my careers as student, researcher, and teacher. My first serious research topic was an excavated group of Archaic Etruscan terracottas, which led me to reflect on interactions among three distinct but interrelated cultures (in this case Italic, Greek, and Near Eastern). In the forty years since, I have always found that the core issue of that first study—unraveling the strands of cultural interaction revealed in the styles and subjects of an artwork to understand why it was made—can only be achieved by a full consideration of its historical context. Yet, when appraising a Roman artwork, not all books remember to ask: What was going on in Rome at the time of the artwork's creation? Who commissioned the piece, and why? Who was meant to see it? What was it meant to say to its viewers? Without answers to these questions, an analysis of Roman art can never be complete, nor will it make sense to a modern viewer.

In this book, I have placed the story of Roman art in the overarching social and political narrative of Rome and its empire, which is necessary in order for us to grasp the full extent of what each artwork tries to convey, both through its subject matter and the artistic styles used. Roman art was the product of multiple traditions, and Roman artists could employ diverse styles in different works, and sometimes in the same work. The choice of styles became a visual language based on people's associations of certain stylistic features with specific cultures, values, classes, subjects, and contexts—various combinations could suggest various meanings depending on where one was in the empire.

Indeed, as Roman rule spread throughout the Mediterranean, additional cultural traditions expanded this language, which turned out to be uniquely suited to an audience that became ever-more diverse. Given how often art from outside the city of Rome is overlooked by authors, I have striven to give the Roman provinces their due in two dedicated chapters; that numerous emperors were not born in the city of Rome and new rulers used art to underline their right to rule in all corners of the empire meant that artworks made there took on greater significance, and therefore deserve closer examination.

Plan of the Book

The fourteen chapters, which correspond to the conventional number of weeks in a college semester, are arranged in four parts, running chronologically from the eighth century BCE to 337 CE. With helpful visuals and reconstructions showing how Romans might have viewed, interacted with, and interpreted their art, each presents a distinct stage in the development of Roman art and culture, building on themes in which phenomena of encounter, change, and continuity are central. In order to provide the reader with the broadest historical context for the discussion of the artworks in this book, each Part opens with a brief overview of the period to be examined, as well as a timeline to help orient the reader within the long history of Roman art. Chapter-opening pages build on this with either a map of Rome that, as the book progresses, shows the development of the city or a map of a region relevant to the chapter, and a chronological overview of key works discussed in the chapter. The text throughout is intended to reflect developments in art and culture empire-wide and across social classes, but two chapters (Chapter 8, Provincial and Private Art in the Early Empire, and Chapter 11, Provincial Art in the High Empire) are aimed at providing the most comprehensive coverage of this material.

Using the art of the first Romans, Part I traces Rome from its foundations, through its conquest

of the Mediterranean, the consequent civil wars among Roman aspirants to power, and finishes with the emergence of Octavian from civil wars as victor and sole ruler of the armies.

While Part I presents the formation of the Roman empire as a geographic entity still ruled by Republican institutions, Part II considers that empire as the principate. This was formulated by Octavian, now titled Augustus, and institutionalized by his wholesale use of art to legitimize his rule, cement his position and plan for his successors, the Julio-Claudians. That dynasty's collapse resulted in the rule of the Flavians. Given that these new emperors originated from outside the elite that had been in power since the origins of the city, we conclude this section with an account of the art of the middle classes and of the provinces.

These provinces come even more to the fore in Part III, which examines the High Empire (96–192 CE). The peace and prosperity of that era allowed for massive building programs everywhere in the empire. This resulted in a similarity in urban structures and public spaces across an empire in which each region still retained a certain local flavor. Part IV explores forces that brought about an end to the empire. For our purposes, this comes with Constantine, whose promotion of Christianity as a social and political force introduces a new era. With it arose a "late antique" style that would come to play a central role in the arts of the next millennium.

Much of the book is concerned with why Roman art was made, yet it is also important to understand how. The book features numerous "Materials and Techniques" segments, which examine the fabrics and processes of Roman art and showcase specific artistic developments, allowing readers to appreciate the Romans' contribution to the wider history of art.

Finally, each chapter includes two types of box feature. The first highlights points of particular interest, through accounts of prominent individuals, archaeological finds, or art-related historical or social phenomena. The second contains relevant extracts from ancient literary sources, showing the Romans' attitudes to their art in their own words, providing further context by allowing readers to get that much closer to the works themselves.

Instructor Resources

The following materials are available to qualified instructors in North America. Contact your local representative for more information.

Images as PowerPoint slides and JPEGs: all images from the textbook can be downloaded digitally for use in the classroom.

The textbook is available as an **ePDF** and **ePub**.

For all of these resources, please navigate to: digital.wwnorton.com/roman

Readers outside North America should email education@thameshudson.co.uk for further information.

Acknowledgments

I cannot begin to thank sufficiently the contributions made to this work by my commissioning, project, and copy-editors at Thames & Hudson. They took a rough, and rather overlong, manuscript and helped me make innumerable improvements from beginning to end.

I should also like to thank most warmly the scholars who read and commented on my text, offering suggestions for improvements and pointing out potential errors in fact, or infelicities of expression. These are: Arleen Arzigian, Berklee College of Music; Rozmeri Basic, the University of Oklahoma; Alexandra Carpino, Northern Arizona University; Laura Gawlinski, Loyola University Chicago; Glenn Gunhouse, Georgia State University, Atlanta; Sarah Harvey, Kent State University; Sean O'Neill, Hanover College; Alexander Rich, Florida Southern College; Alden Smith, Baylor University.

Finally, I want to thank my wonderful wife of over thirty-six years, Monica Barran Fullerton, who has been with me for the entire journey that led, with many twists and turns, to this book. In countless Classical sites she encouraged and advised me, and in Columbus, where all of the writing took place, she read my text, answered questions, helped me find answers, and indulged me in the many hours given over to this project.

Introduction

What Is Roman about Roman Art?

Roman art conjures distinct images: massive public works, such as aqueducts, amphitheaters, markets, and meeting halls; vivid landscape paintings in the houses of nobles; and imposing portraits of generals and statesmen, whose accomplishments are depicted in detail by sculptured reliefs on towering arches and columns. Yet defining Roman art is no easy task. It is more than simply art produced in the ancient city of Rome, as for half a millennium the Romans held sway over much of Europe and the Mediterranean, building cities and erecting monuments in every corner. Similarly, it is not only (or even mainly) art created by a Roman hand, since most of what we call Roman was the work of non-Roman artisans. We might be closer to the truth by speaking of art made for Romans, although much imperial art was commissioned and paid for by provincial **patrons**, whose own sense of "Roman-ness" (*romanitas*) varied greatly. What might be considered most Roman about Roman art is the role it played in supporting Roman aims and values, especially, although not exclusively, in politics and warfare. It is therefore preferable to describe the parameters of Roman art, rather than propose constrictive definitions, so that our objects and objectives might emerge more clearly.

When, Where, and Why was Roman Art Made and Used?

The Romans believed that their city was founded in 753 BCE, which agrees with the earliest physical evidence. Rome was thought to have been ruled by monarchs until 509 BCE, when King Tarquinius Superbus (r. 535–509 BCE) was expelled and a representative government was established. This Roman Republic was governed by two annually elected chief civic and military leaders (**consuls**), together with an array of lower-ranked magistrates (**praetors**, **quaestors**, **tribunes**, and **aediles**), each with a specific sphere of authority and activity. The primary governing body was the senate, made up of Rome's male aristocrats, mostly current and former magistrates. Membership in the senate was guarded by respected elders (**censors**), chosen solely for this purpose. The society that formed and was formed by this system was highly competitive; traditionally wealthy and powerful families dominated, and accomplishments in the political, economic, and military realms were closely related.

For about five hundred years, until the early third century BCE, Roman interaction and influence was principally limited to the city itself, the fellow Latin peoples of western central Italy, and the Etruscans to the north [0.1]. By around

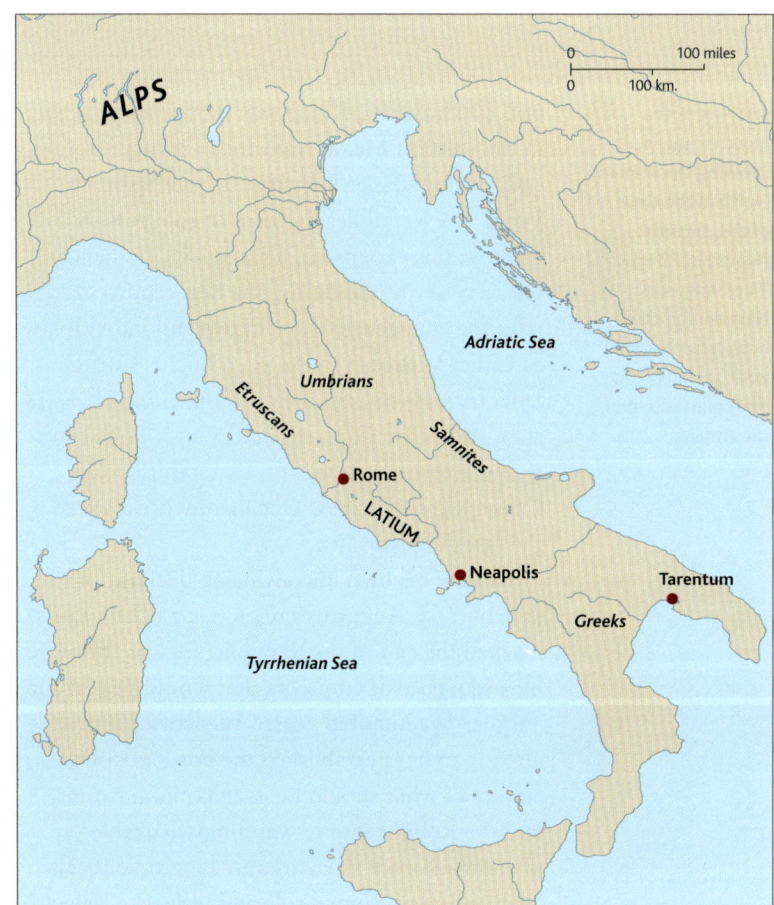

0.1 Map of Italy, showing Rome's Latin, Etruscan, and Greek neighbors. Both myth and archaeology suggest that Rome interacted closely with nearby Italic peoples from early times.

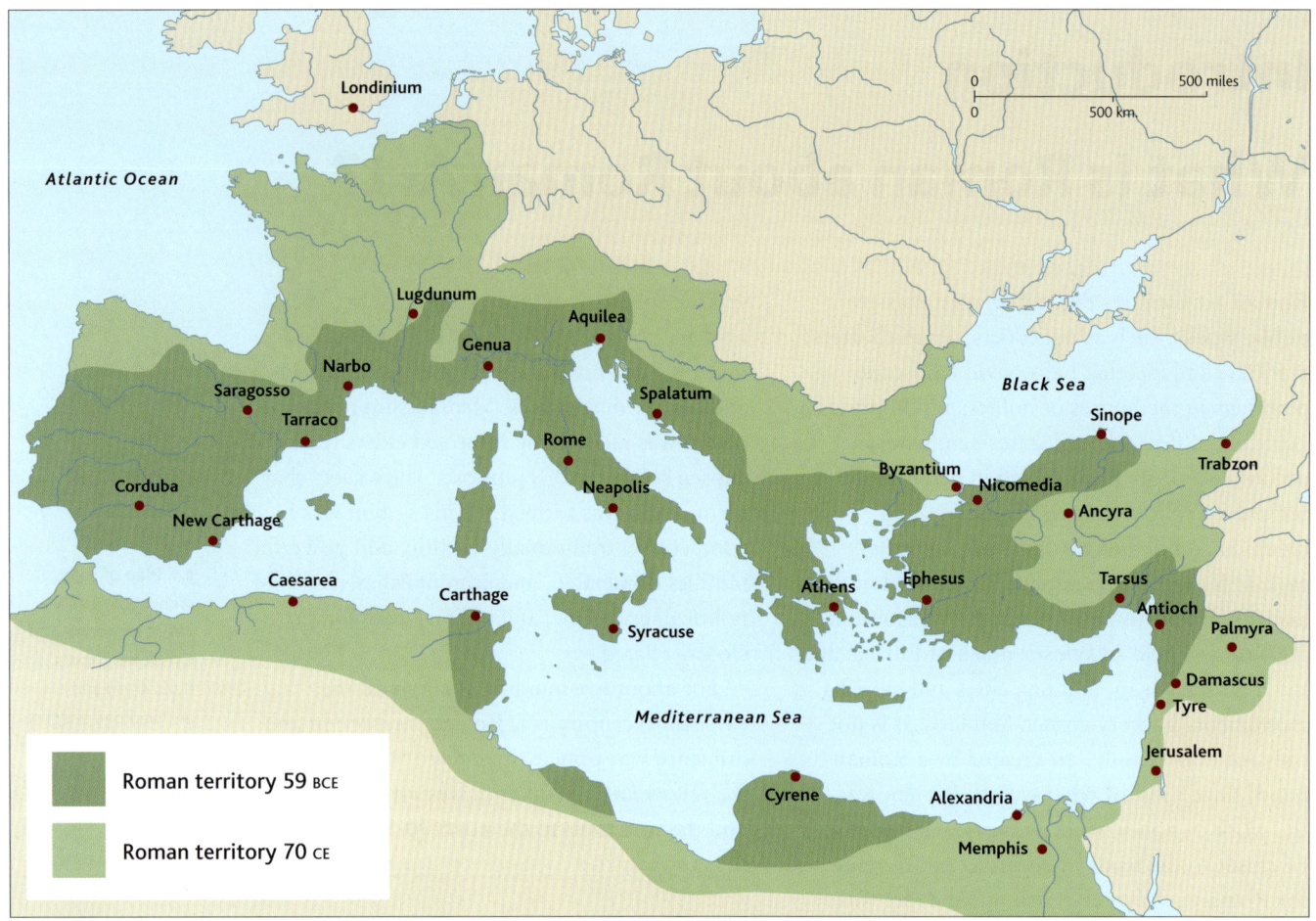

0.2 Map of the Mediterranean, showing the Roman world in the time of the emperor Augustus, 27 BCE–14 CE. Augustus claimed that these boundaries denoted what should be the maximum extent of the empire.

200 BCE, however, Rome was the foremost power in the western Mediterranean; a century later still, its dominance had spread from Spain to Syria. The Republican system of rule persisted through this expansion, although its resilience was severely tested during the first century BCE, with the emergence of such powerful individuals as Gaius Marius (157–86 BCE), Lucius Cornelius Sulla (c. 138–78 BCE), Pompey the Great (106–48 BCE), and Julius Caesar (100–44 BCE). Following civil wars, sole rule was firmly established by Caesar's great-nephew Octavian, who adopted the title **Augustus** in 27 BCE.

Despite his own unconvincing declarations to the contrary, Augustus's reign (r. 27 BCE to 14 CE) marked the end of the Republic; he was followed by a sequence of emperors that would persist for another five hundred years. Augustus claimed already to have established the borders of the empire at what should be its maximum extent, and the Roman empire was a mostly stable phenomenon for a remarkably long time [0.2]. This sphere of Roman rule and influence reflects the geographical range of Roman art—from the city itself in early times, to what was, from the Augustan era onward, the majority of the world that was known to them.

Given its enormous geographical and chronological range, the great variety of the art of this empire is no great surprise. In **medium** (for example, sculpture, painting, or architecture), material, subject matter, function, context, and style, the existing works of Roman art and architecture are far more diverse than those of any other ancient civilization. Egyptian art, for example, is known primarily from burials, and Classical Greek works resulted principally from public building programs and sacred dedications. Roman art, however, adorned not only temples and tombs but also houses, palaces, theaters, baths, **gymnasia**, and vast public spaces [0.3]. It comprises sculpture in both stone and metal; paintings and mosaic; vessels in ceramic, glass, silver, and gold; and gems of every sort. The styles displayed by these works are as varied as the cultures brought together by this vast empire.

12 INTRODUCTION: WHAT IS ROMAN ABOUT ROMAN ART?

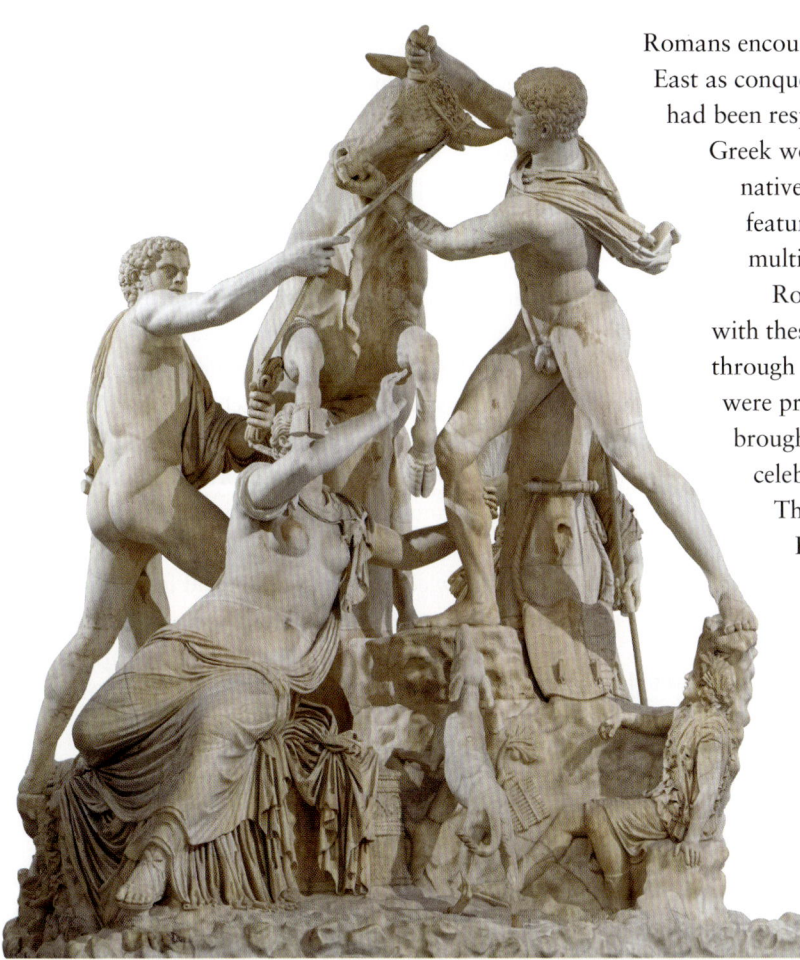

Romans encountered the Greek-speaking East as conquerors, their artistic customs had been responding to stimuli from the Greek world, absorbing them into native elements and Etruscan features to form a varied and multi-layered cultural tradition.

Rome first made direct contact with these Greek cities mainly through warfare; works of art were prominent among the spoils brought home for triumphal celebration and public display. These wars also created in Roman Italy a class of people who could afford to display such luxuries, and for whom they were a mark of status, on which political power depended. During the last centuries of the Roman Republic, Classical Greek art was revered and imitated, and became a symbol of cultured learning and sophistication.

Buildings and monuments made in the materials and styles of the vanquished were sponsored by Roman generals in commemoration of their victories. Following successes in Greece, these monuments were sometimes built in Greek marble, according to Greek plans, and following one or more of the Greek architectural **orders** (**Ionic**, **Doric**, or **Corinthian**); one such structure still stands in Rome today (see 2.10, p. 59). Sculptures and paintings in a variety of Greek styles were also displayed in the homes of Romans who had achieved, or aspired to, elevated social status (see Mural Painting, p. 82 and Domestic Sculpture, p. 90).

Already in the time of Augustus there was a sophisticated appreciation of the multiple artistic sources available: Greek **Archaic** (*c.* 600–480 BCE), **Classical** (480–323 BCE) and **Hellenistic** (323–*c.*100 BCE), as well as Etruscan, Roman Republican, and even more exotic visual forms, such as those of Egypt and the Near East. Each set of stylistic features and figural types had its own associations and traditions, and the Romans

0.3 Farnese bull from the baths of Caracalla, Rome, Italy, 3rd century CE. Roman copy of a Hellenistic original. Marble. H. approx. 4 m (13 ft 1½ in.); W. approx. 3.3 m (10 ft 10 in.). This sculpture is a fine example of the decoration used in public buildings.

Yet this kaleidoscopic variety does not result simply from medium, geography, and context. The Romans could have easily imposed a uniform, inflexible stamp on art and architecture across their empire, unvarying from one border to another. That they did not, and only rarely even tried to do so, has primarily to do with those features that make Roman art uniquely Roman and that are built into and result from its origins, its development, and its functions.

Where Did Roman Art Come From?

It should come as no surprise, therefore, that the beginnings of Roman art are complex. We know little of the earliest centuries, but the picture becomes clearer during the period of the Etruscan kings in the sixth century BCE. Although this monarchy was expelled, Roman art and architecture continued to look Etruscan for centuries. Etruscan art was, in turn, heavily influenced by Greece, through imports, immigrant craftsmen, and direct contact with Greek culture in southern Italy. Consequently, long before the

were especially adept at employing them in the service of Roman rule.

As such, modern scholars have often defined Roman art in terms of how it differed from these sources of inspiration, leading to a view that Roman art was of lesser quality than its models. Additionally, because much of it was mass-produced for domestic and public display, it was dismissed as unoriginal. Finally, since its subjects were often living people and contemporary events, it was criticized for its lack of **idealism** compared to these other sources. Such judgments are unhelpful, however, since they rely on artistic criteria—creative genius, technical perfection, and humanistic idealism—that reflect values of the critics themselves, not standards to which actual Romans adhered.

Does Roman Art Change over Time—and How?

It is no surprise, then, that the development of Roman art has mostly been evaluated using Classical Greece as the norm. The expectation that artistic styles naturally evolve over time is rooted in Greek art itself and reinforced by ancient accounts of it. Already in the Hellenistic period, Greek art was appreciated for its progression from a stage of abstract purity to a stage that perfectly balances idealism and naturalism, afterward lapsing into a decadent period of visual realism, imitation, and melodramatic exaggeration. This organic sequence of "bloom" and "decay" was taken from the ancient sources by the eighteenth-century scholar Johann Joachim Winckelmann (1717–1768), the "father of ancient art history." His *History of Ancient Art* presents, in detail, a now canonical sequence of primitive, grand, beautiful, and imitative stages in style based on his knowledge of ancient art and literature, and backed up by the similar sequence in the art of medieval, Renaissance, and baroque Europe.

Despite the fact that Greek art is the only ancient art that displays this type of organic development, scholars have repeatedly struggled to arrange Roman art in a similar manner; it has proved to be impossible. When a distinctly

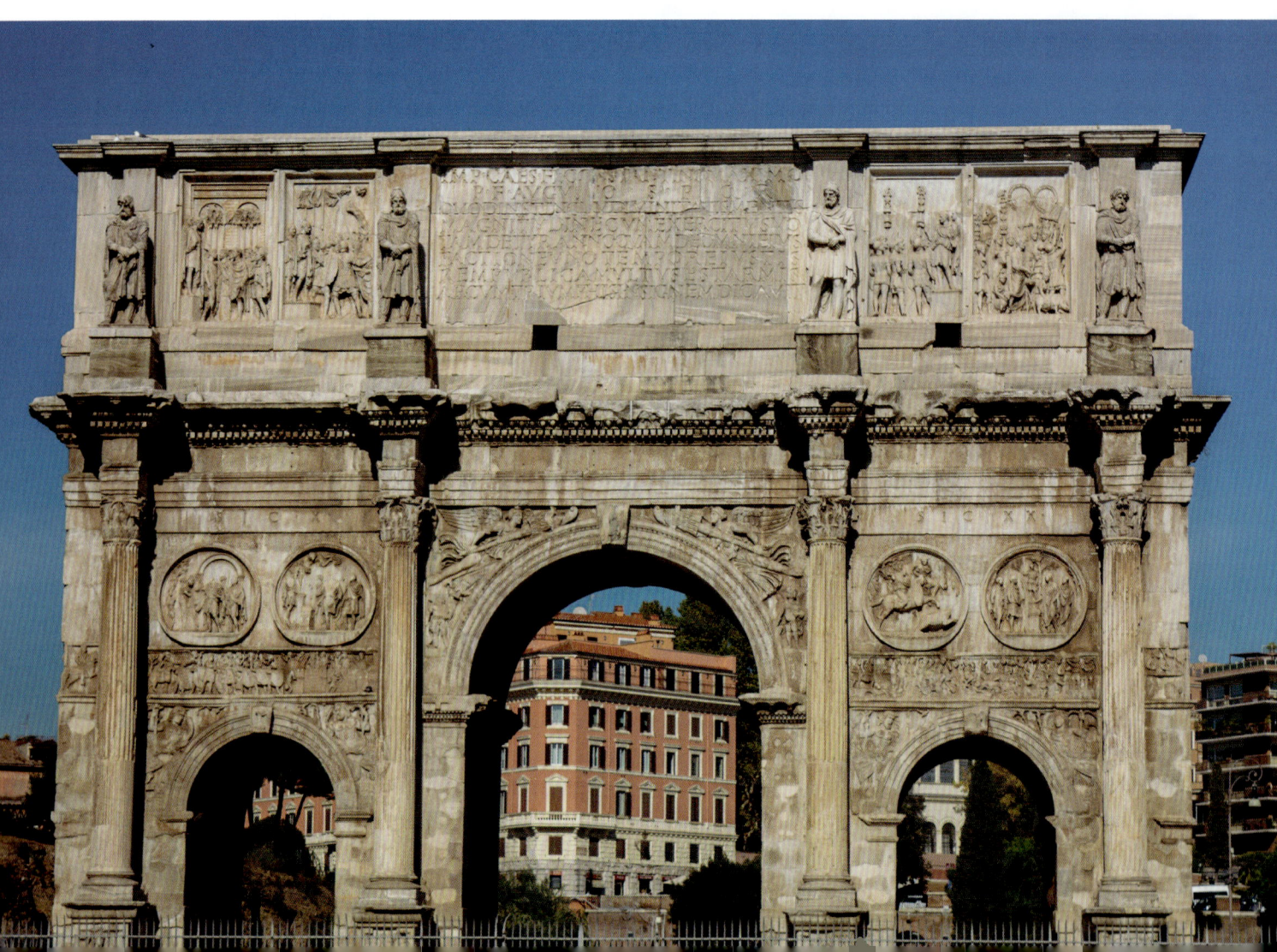

0.4 The Arch of Constantine, Rome, Italy, dedicated 315 CE. Marble and porphyry. H. 21 × W. 26 × D. 7 m (69 × 85 × 23 ft). This monumental triumphal arch is notable for its mix of styles, all from different periods.

Roman brand of art first began to develop, the entire range of stylistic possibilities developed by Greek (and Italic) art was fully available and fully exploited, each style or figural type chosen for its appropriateness to a particular subject or its effectiveness in the conveyance of meaning. This approach continued unchanged through the empire. While it is sometimes possible to identify characteristic features of art and architecture from a given era, these changes, from emperor to emperor, were motivated by immediate needs or personal taste, and not by a self-perpetuating model of development unconcerned with events of the time. Writers on Roman art, for example, frequently note the Classicism of art during the reign of Augustus or Hadrian, or the "baroque" tendencies of the Flavian and Severan eras. Yet even when such observations are accurate, stylistic characterizations of a particular reign or dynasty are never all-encompassing. In all Roman periods, works of every style were created, with consideration to tradition, function, and context.

Nonetheless, while an organic model of development cannot be applied, change did occur over time. The abstract, sometimes even rough, forms of late imperial art are very different from the more refined and Classical-looking styles of earlier times. The Arch of Constantine (see also 14.4 and 14.5, p. 371) serves as a perfect illustration since it displays, side by side, sculptures from different eras [0.4]. The older reliefs display a style that is drawn directly from the repertoire of Classical Greece: the figures flex and shift in reaction to their imagined weight; the drapery of the figures describes the underlying three-dimensional forms; and facial features—although many are portraits of real people—approximate the ideal beauty of Classical gods. Sculptures from the later empire of Constantine are in what might be termed an anti-Classical style. Figures are flat, **frontal**, and weightless, their proportions stumpy and their heads overly large; forms are outlined through deeply cut, linear, almost geometric patterns, and the spatial relationships between figures are distinctively unrealistic.

Since Greek art evolved gradually from a more abstract to a more perceptually convincing style, it is tempting to detect in Roman art a reversal of this process, but such temptation is to be avoided at all costs. The process by which this **late antique** style appeared was far more complex, being neither consistent in its pace nor universal across the Roman world. As spelled out in the later chapters of this book, its sources were various and its motivations are only partially clear. Though we characterize the phenomenon of stylistic change in Roman art, it is distinctly different from and more historically dependent than the more straightforward chronological sequencing of styles that we have come to accept for Greek art.

What Were the Functions of Roman Art?

Sculpture and monumental architecture in early Greece served a very narrow set of mostly public and religious uses. Mural and panel painting was limited to public buildings, at least through Classical times. Less expensive objects, such as terracotta figurines and painted clay vessels, were personal possessions, but these, too, were often used primarily for funerary or ritual activities. Macedonian nobles had long used physical symbols of wealth (especially monumental tombs filled with vessels, armor, and personal adornments in precious metals) to signify their power. After Alexander the Great's death in 323 BCE, these same Macedonian lords and generals founded Hellenistic kingdoms, so the necessities and opportunities for the development of a more individualistically focused art grew exponentially. Meanwhile, the monumental public-building traditions of the Classical Greek *polis* (city-state) continued and expanded, with the construction of huge and elaborate new temples, city centers, meeting halls, and gymnasia. Images of the Olympian deities were produced in the new Hellenistic kingdoms at a rate equal to or even greater than that of Classical Greece. New monarchic systems of government, as well as influences from the non-Greek East, encouraged the construction of palaces, regal tombs, victory monuments, and the development of dynastic portraiture, expanding not only the size and number of artworks but also the functions of public art.

When the Romans, through long expansion of their territory, became heirs to this artistic legacy during the second century BCE, their own artistic traditions were fully compatible with it (indeed,

0.5 Togatus Barberini, Rome, Italy, first century CE. Marble. H. 1.65 m (5 ft 5 in.). The sculpture depicts a toga-wearing patrician with busts of his ancestors.

as noted above, they already had extensive experience of the artistic forms they inherited). The Roman Republic's aristocratic, partly representative social and political structures encouraged the advertisement of personal and familial status and accomplishment. Young Roman magistrates positioned themselves for ever higher office through public generosity, often building civic structures at personal expense. Victorious generals applied their family names to public monuments that became permanent reminders of their achievements to present and future voters. The funeral, and particularly funerary portraiture, also played a role in this process, a custom called to mind by the elaborate pastiche known as the Togatus Barberini, which shows a Roman aristocrat bearing the portraits of his ancestors [0.5]. These ancestral images were displayed publicly at spectacular funerals, otherwise remaining within the home. Yet Roman residences were far from being private spaces, as they hosted, almost daily, public interaction with both peers and dependent citizens (*clientes*).

The financial impact of the Mediterranean conquest of Greek cities by Roman armies through the third and second centuries BCE had accelerated this process of advertising status. As the battlefields had moved further beyond Latium, spoils of war became more valuable and the stakes of victory higher; fortunes were made in the wake of spreading Roman rule. Armies needed to be equipped for multi-year campaigns, and taxes were to be collected from the vanquished. An influx of less costly slave labor encouraged the establishment of vast agricultural estates (made possible by the land conquered by Rome), and so the Roman aristocracy became richer than ever, as did the slave traders themselves. Competition for high-level magistracies (and the accompanying military commands) consequently intensified, and the wealthy were both more able and more motivated to promote themselves through private and public display. In the houses of Roman nobles, complex decorative schemes of sculpture, painting, and mosaic complemented other trappings of prosperity, such as gold and silver plate, gems, **cameos**, and glass. Eminent figures of the late Republic embarked on significant public building programs to commemorate and perpetuate their accomplishments and influence.

With the onset of Augustus's **principate** in 31 BCE, a major project became the building of cities. Administering an empire was greatly aided by urbanization, since a concentration of the population in sizeable settlements increased dependence on central authority and so facilitated control. Roman cities offered an immense variety of buildings designed to meet civic, commercial, and religious needs, and an equally diverse array of structures was designed for health and entertainment purposes, all equipped with sculptures, painted and **stuccoed** walls and vaults, and mosaic floors. While this resulted in a recognizably Roman atmosphere in these cities as one moved across the empire, artistic influences did not come solely from the capital; buildings were locally sponsored, and local traditions of material, style, and workmanship frequently left their distinctive mark on the finished products. Roman imperial art was a creation of the Roman empire as a whole, not something conceived entirely in the city of Rome.

That Roman art was therefore overwhelming in its quantity, ubiquitous in its distribution, and dazzling in its variety affects our interpretation of it in two important ways. First, since the use of art was more widespread throughout Roman culture than was the case for other ancient civilizations, the study of art can give us a more thorough insight into that culture, ranging from the concerns of the emperor to those of the foot soldier or shopkeeper. Second, much Roman art was mass-produced; it was meant to impress by its sheer scale, and to convey

meaning as a whole rather than as individual works. Modern art-historical prejudices based on standard ideas of connoisseurship, uniqueness, originality, and technical skill can obscure rather than reveal its true genius. Roman art cannot be attributed with the same values of an earlier or subsequent civilization, nor can it be made to fit within models or patterns that apply elsewhere in the ancient world. It is to be approached on its own terms and read in its own cultural language. Indeed, it is by recognizing only what is truly Roman about Roman art that we can begin to understand and appreciate its special contribution.

Architectural Orders in Rome and the Empire

As part of its legacy from Hellenistic culture, Rome adopted the three Greek architectural orders. The architect Vitruvius (first century BCE), in *De Architectura*, considers these orders to have formal human characteristics. The Doric order, invented for a temple to Apollo, is male as it embodies "the proportions, strength and beauty of a man." The Ionic order, created for temple to Diana, displays the "delicacy, adornment, and proportions characteristic of women." The third, Corinthian order "is an imitation of the slenderness of a maiden." It seems he was correct that the Doric and the Ionic arose early in mainland and eastern Greece, respectively, and the Corinthian somewhat later, perhaps invented by the Classical Athenian sculptor Callimachus. The oft-repeated idea that the Doric order was used for temples to gods and the Ionic for goddesses is, though, unsupportable.

The features that define these three orders are well known. The fluted but otherwise unadorned Doric column stands directly on the floor surface; its top supports a **capital**, consisting of two undecorated elements: a circular **echinus** and square **abacus**. Atop this capital rests the **entablature**, which is made up of a plain **architrave** and a **frieze** adorned by panels called **metopes** separated by sets of three carved vertical lines called **triglyphs**. As Vitruvius suggests, the overall decorative effect is restrained and the proportions are powerful.

The Ionic order is different in most respects. These **fluted** columns rest on molded bases. The capital is adorned with **volutes**, **palmettes**, and sculptured carving. The architrave is divided into multiple parallel surfaces (*fasciae*), and the frieze above, if present, often bears uninterrupted figural sculpture. The proportions, as Vitruvius points out, are slenderer than in the Doric, and the overall appearance is lighter and more decorative.

The Corinthian order resembles the Ionic, but employs a basket-shaped capital adorned with a radial pattern of acanthus leaves and tendrils, making the column more three-dimensional than the Ionic, which suggests that it was invented for a freestanding column or as an alternative to the awkward Ionic corner capital.

Of the three orders, the Romans preferred the Corinthian, but did also use the Ionic; architects even developed their own hybrid—the **Composite**, which replaces the corner tendrils with Ionic volutes [0.6]. The Doric is extremely rare in Roman-era buildings, replaced by another Roman hybrid, the **Tuscan**, which, as its name suggests, derives from the local Italic form used in Vitruvius's "Tuscan" temples (see 1.38, p. 44). This retains the unfluted columns, bases, and smooth-sided capitals of Etruscan columns, but its proportions are often slenderer, sometimes nearing those of the Ionic and Corinthian. The style is often used for the ground level of multistory facades, reprising the strength implicit in its Etruscan and Doric predecessors.

As did sculptors and painters, Roman architects also developed a visual palette that drew on a history of architecture, choosing from imported forms and blending them with local traditions to create something unique to the tastes and purposes of their patrons.

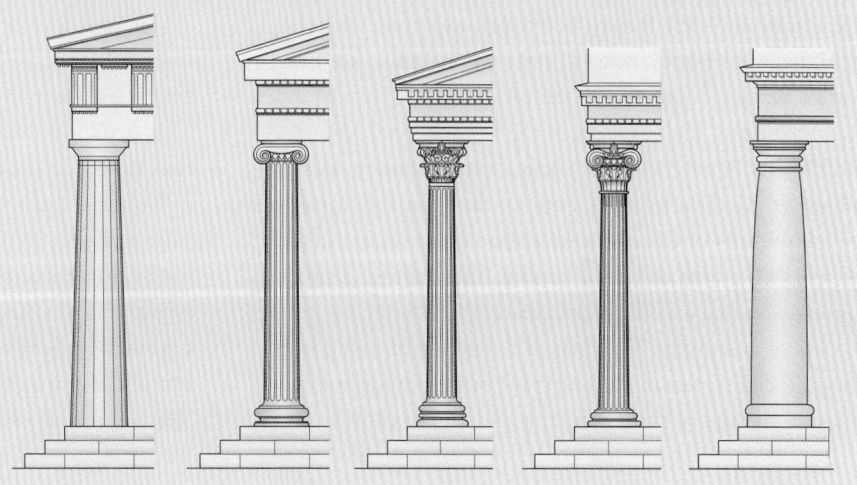

0.6 The five orders of architecture. These are (l–r) the Doric, Ionic, Corinthian, Composite, and Tuscan.

Part I
Rome and Italy before the Empire (c. 800–27 BCE)

When Augustus, the first emperor of Rome, was putting in place the customs, titles, and policies that transformed the Roman Republic into a monarchic principate, one piece of rhetoric that he used to support his measures was centered around the "re-foundation" of Rome. Perhaps for this reason, the art and literature of his reign (27 BCE–14 CE) were more than usually concerned with the very earliest history of the city. Virgil's *Aeneid*, an epic poem written during the time of Augustus, presents the story of Aeneas's travels from Troy to Italy, and his establishment there of the family line who would later build Rome. His contemporary, the historian Livy, writes in his *Annales* a history of Rome from its beginning (traditionally dated to 753 BCE) down to his own time. Roman art drew on these stories.

There is much legend mixed with history within the Romans' own accounts of their most remote past, but it is possible to compare their versions with Greek historical sources and the archaeological record to get a sense of what actually happened. In general terms, the Romans seem to have got their version right. What are presented as the mythological wanderings of Aeneas reflect a very real situation on the Italian peninsula, at a time when the indigenous populations of Italy were coming into ever-increasing contact with peoples from the eastern Mediterranean, including from the Levant, Asia Minor, and Greece. A newly visible society was emerging, in part influenced by these visitors. Among these Italic cultures were the inhabitants of Etruria—the region of west central Italy immediately north of Latium and Rome—whose distinct cultural identity was the most clearly transformed by this process of encounter. Similarly, the remains of habitation sites and cemeteries in Rome corroborate the traditional foundation date of the city to the mid-eighth century BCE.

About a century and a half later (traditionally 614 BCE), the kingship founded by Romulus was taken on by Tarquinius Priscus, who, as his name suggests, came from Tarquinia in Etruria. He initiated an extensive program of urbanization through the building of public structures, especially temples in service of state cults, which drew heavily on Etruscan building forms. His imprint on Roman art and architecture persists to the very end of Roman times, but the monarchy itself did not last beyond the sixth century. The last king of Rome, the notorious Tarquinius Superbus ("the haughty"), was expelled in 509 BCE. There followed a more representative form of government—representative, that is, of the wealthiest Romans, whose offspring would trace their ancestry back to this era of liberty for another millennium. This institution was called *res publica*, or "public matter," as the affairs of state were now ideally the concern and the responsibility of all. That the contrast between this form of government and the preceding monarchy (*regnum*) was a profound one became a defining principal of Roman Republican culture. As we shall see, it also greatly influenced the means employed to re-create sole dynastic rule by the first Roman "emperor" half a millennium later.

There is less in the way of archaeological and artistic material from the early Republic of the fifth and fourth centuries BCE than remains from the monarchy of the sixth. This need not mean that works were not undertaken at that time, but may reflect somewhat reduced circumstances in Rome, or, just as likely, indicate how little survived the sack of Rome by Gauls in 390 BCE. Somewhat after this long-remembered disaster, however, the Roman world began to grow. During the fourth century, Rome remained within a Hellenized (Greek-influenced) Etrusco-Italic sphere, but in the third, its political and military influence spread. War against the Hellenistic king Pyrrhus of Epirus, driving

him from the Italian peninsula, brought Rome in closer contact with the Greek cities of southern Italy, and at the end of the first war against the Carthaginians, Sicily came under Roman control. During the second of these "Punic" Wars, that area was organized as a province under control of the Roman senate, setting a precedent for imperial administration that would serve for centuries. At the end of this war, with the defeat of Hannibal in battle in 202 BCE, Roman hegemony had extended beyond Italy throughout the entire western Mediterranean.

Barely a generation later, by the 160s BCE, armies from Rome had bested those of the Hellenistic kings of Asia, Macedonia, and Greece, and the entire Mediterranean was brought under its direct or indirect control, although the organization of this territory into provinces of Rome would take another century. During this era of conquest, there was a major and continual influx of art and literature from the now subject states into Rome itself, first from South Italy and Sicily and eventually from the Hellenistic centers Asia, Greece, and Egypt. The ancient sources recount how triumphant military generals brought back thousands of works—as well as the people who made them—as symbols of their conquest and pacification. These accounts appear, like the others, to have been fundamentally accurate.

As it turns out, the expansion of Roman power, which was the greatest achievement of the Republic, is precisely what brought it down. An unwieldy quasi-representative aristocracy, together with a tradition of citizen-soldiers and seasonal campaigns, proved inadequate to the demands of world dominion and administration. Powerful leaders with professional armies emerged in the first century BCE and for decades vied with one another for sole control. Gaius Marius, Lucius Sulla, Pompey the Great, Julius Caesar, Marcus Antonius—all larger-than-life figures memorialized by ancient and modern biographers alike and emulated by generations of ambitious men. In the end, it was an opportunistic and clever youth named Octavian who entered the fray and, a decade or so later, emerged triumphant, his rivals eventually extinguished. As the first emperor (Augustus), he effected the transformation from the Republic to a new form of dynastic rule by a single man, although he carefully avoided the term *regnum* (kingdom). On the contrary, he actually claimed to have restored the Republic, which consequently persisted in the minds of Romans not only as an idyllic past but also, at least for a while, as a present fiction.

Timeline

DATE	EVENT
900–700 BCE	Villanovan period
753 BCE	Conventional date for the founding of Rome by Romulus
700–325 BCE	Period of the Etruscan civilization
575 BCE	Temple at the site of Sant'Omobono
509 BCE	Foundation of the Roman Republic
499 BCE	Roman defeat of the Latin League at the Battle of Lake Regillus
400 BCE	Wall painting: First Style appears in Greece
396 BCE	Capture of Veii
264–241 BCE	First Carthaginian (Punic) War
218–201 BCE	Second Carthaginian (Punic) War
215–205 BCE	First Macedonian War
201 BCE	Carthage surrenders to Rome
200–197 BCE	Second Macedonian War
149–146 BCE	Third Carthaginian (Punic) War
82 BCE	Sulla named dictator
80 BCE	Wall painting: Second Style appears, Italy
78 BCE	Death of Sulla
60 BCE	Formation of the First Triumvirate: Pompey, Crassus, and Julius Caesar
49 BCE	Julius Caesar marches on Rome
46 BCE	Dedication of the Forum of Caesar
44 BCE	Julius Caesar assassinated
43 BCE	Formation of the Second Triumvirate: Marcus Antonius, Lepidus, and Octavian
38 BCE	Marriage of Octavian and Livia
36 BCE	Lepidus stripped of power and retires to Campania
31 BCE	Battle of Actium
30 BCE	Deaths of Antonius and Cleopatra

EARLY ROME: 900–700 BCE to 509 BCE
THE REPUBLIC: 499 BCE to 44 BCE
CIVIL WAR: 43 BCE to 30 BCE

1 Etruscan and Early Roman Art

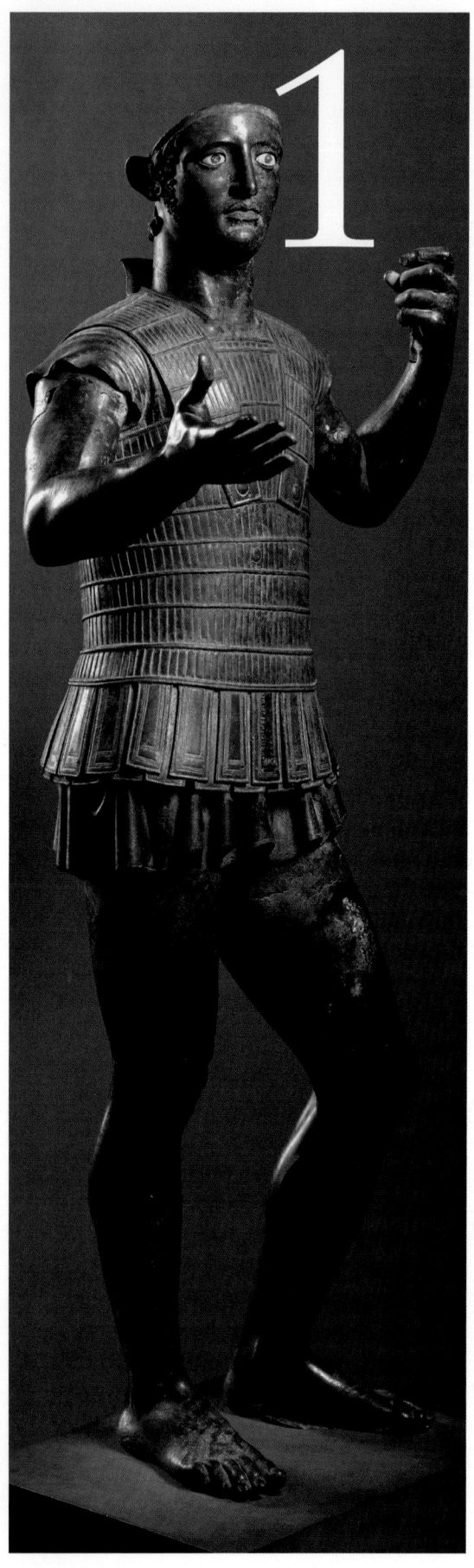

22	**Beginnings of Rome**
22	Box: Romulus's Rome
23	**The Villanovans**
25	**Etruscans in the Wider World**
27	Box: The Aristonothos Krater
28	ETRUSCAN TOMBS
30	TOMB PAINTING
36	ETRUSCAN SCULPTURE
40	ETRUSCAN BRONZES
43	Box: The Capitoline Wolf: A Case for Caution
44	**ETRUSCAN AND EARLY ROMAN TEMPLE ARCHITECTURE AND STATUARY**
46	Materials and Techniques: Terracotta Sculpture
47	**The Legacy of Etruscan Art**

Chronological Overview

DATE	EVENT
900–700 BCE	Villanovan period
753 BCE	Conventional date for the founding of Rome by Romulus
700–325 BCE	Period of the Etruscan civilization
c. 650 BCE	Regolini-Galassi Tomb, Cerveteri
575 BCE	Temple at the site of Sant'Omobono
509 BCE	Foundation of the Roman Republic
c. 500 BCE	Portonaccio Temple, Veii
396 BCE	Capture of Veii
390 BCE	Sack of Rome by Gauls
c. 350 BCE	Ficoroni Cista
c. 300 BCE	François Tomb, Vulci

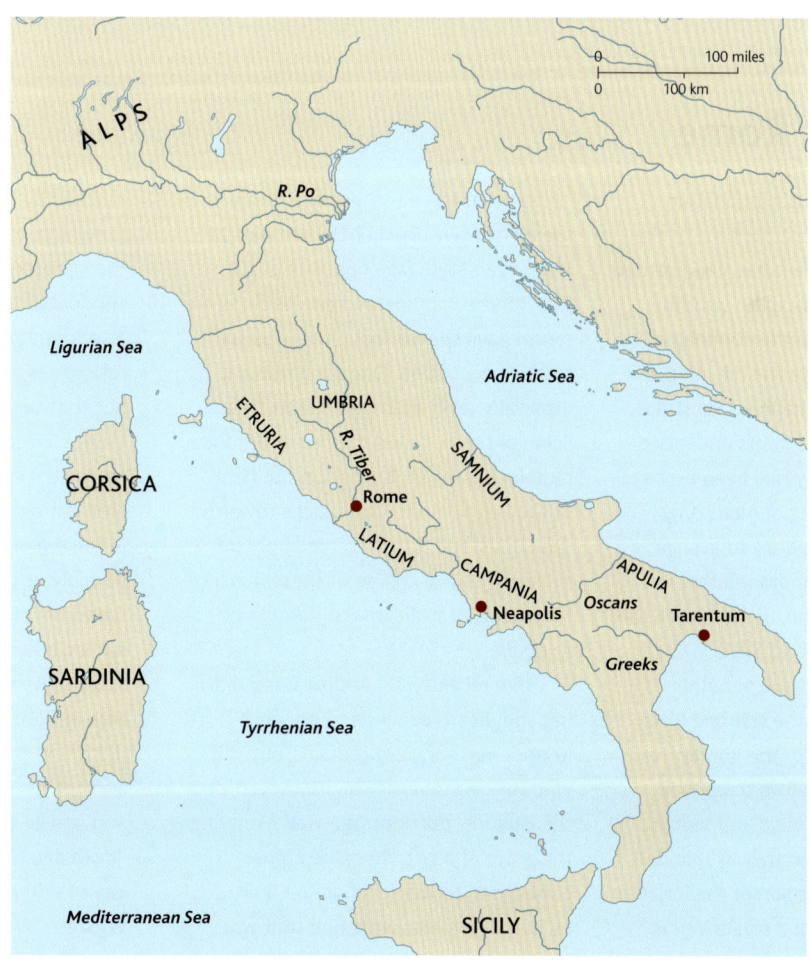

Right: Map of Italy showing Rome and the surrounding regions.

CHAPTER 1: ETRUSCAN AND EARLY ROMAN ART 21

Beginnings of Rome

Roman art begins with the Etruscans. Previously a scattering of hill villages, Rome became a city only under the Tarquin monarchs (616–509 BCE), who are credited with introducing many architectural, artistic, and cultural forms from their homeland Etruria, in central Italy. At the height of its power, Etruria had a considerable presence across the Italian peninsula and dominated Rome for more than a century.

Etruria developed during the seventh century as a result of its increased interaction with civilizations from the east, especially with Greece. Greek artisans were quick to create works for the new Italic market, and no small number of them moved west to take better advantage of these new opportunities. Through the development of Etruscan workshops and the influence of Etruscan patronage, a truly local production soon became established, which retained both its Greek and its Etruscan identities for centuries. This greatly influenced the artistic traditions of early Rome, and prepared the city for the influx of **Hellenism** that would result from Rome's conquest of the Mediterranean in the later Republic.

Some two centuries before the Tarquin monarchs, and around the time of Romulus (see box: Romulus's Rome), traders seeking new markets had arrived in the seas west of Italy. The earliest merchants hailed from Carthage in North Africa (near modern Tunis), a **Phoenician** settlement that was initially an outpost but eventually became the wealthiest city in the western Mediterranean. Soon after (*c.* 750 BCE), Greeks, primarily from the island of Euboea, arrived and found mineral wealth in the northern part of central Italy: copper in the Apennine foothills and iron on the island of Elba. In addition, they encountered an established culture, expert in the mining and manipulation of these metals and further enriched by the considerable agricultural resources of its homeland, bounded by the River Tiber to the south and east, the River Arno to the north, and the sea to the west. The Greeks called these people (and their sea)

Romulus's Rome

The details of Romulus's foundation of Rome were hazy before the time of the empire, by which time it had been settled that on April 21, 753 BCE, the youthful twins Romulus and Remus founded a settlement on the Palatine hill, on the slopes of which the shepherd Faustulus had rescued them as infants and raised them as his own. They had been exposed there by Numitor, king of Alba Longa, who feared they would try to avenge his usurpation of their grandfather's throne. As a precaution, he had made the old king's daughter, Rhea Silvia, a virgin priestess of Vesta, but she nonetheless became pregnant by the war god Mars. Romans, and especially the Roman emperors, could therefore trace their lineage back to both Mars and Venus, since the Alban monarchy was founded by Ascanius/Iulus, the son of the Trojan prince Aeneas, himself a son of Venus.

So, what trace is there of a Rome in the eighth century BCE? The remains of Villanovan-style (see opposite page) huts on the Palatine and graves along the forum have shown that there was some sort of occupation. One such hut was especially revered in much later times. "One of these, called the hut of Romulus, remained even to my day on the flank of the Palatine hill which faces towards the Circus, and it is preserved holy by those who have charge of these matters" (Dionysius of Halicarnassus, *Roman Antiquities* 1.79.11).

More recently, Dr. Andrea Carandini has sought to recover and preserve Rome's most ancient remains, and not without controversy. He discovered, on the Palatine, portions of a wall overlying the grave of a girl. These, he argues, correspond to the fortification built by Romulus—the same one that was mocked by his twin Remus, an offense for which Romulus killed him. The grave, then, preserves a ceremonial sacrifice conducted to consecrate the wall. He also found remains in the forum of regal residences and a cult to Vesta, including a hut that served as the house of the Vestal Virgins. Decades ago, archaeologists revealed a similar complex in the same area dating to the sixth century—late in the era of the Etruscan kings or possibly at the beginning of the Republic. Carandini places his finds two centuries earlier, however, concluding that the story of Romulus as we have it is literally true in both date and in details. Romulus did found Rome at that time, he believes, and not as a basic gathering of huts and graves, but as a complex city-state "from day one"—not simply the first day of Rome, but the beginning of Western civilization.

Tyrrhenian, after a legendary hero from Lydia (in Asia Minor, modern-day western Turkey). The Romans would refer to them as *Tusci* or *Etrusci* and to their land as Etruria; the designation persists still today in the name of the Italian region of Tuscany.

The Villanovans

When traders from Greece and Carthage first arrived on the Italian peninsula [1.1], they found an Etruscan culture in its early stage—one that archaeologists have termed "Villanovan." The name comes from a site near Bologna, which is actually to the north of Etruria proper, but the customs it describes extended south as far as Latium (a region of central west Italy that includes Rome). These people are known from their graves: simple "*pozzo*" burials that look similar to wells, in which the cremated remains of the deceased were interred in characteristic **cinerary urns** and accompanied by other possessions, such as vases, jewelry, and weapons [1.2].

The container of choice was the **biconical** urn—a handmade (as opposed to wheel-thrown) pot that approximates, in shape, two cones attached at their wider ends [1.3]. The material from which the urn is made is called *impasto*, a thick grayish-to-black clay; the decoration is limited to incised marks (scratched into the surface before firing), mostly abstract motifs. Another kind of ash-container was modeled in

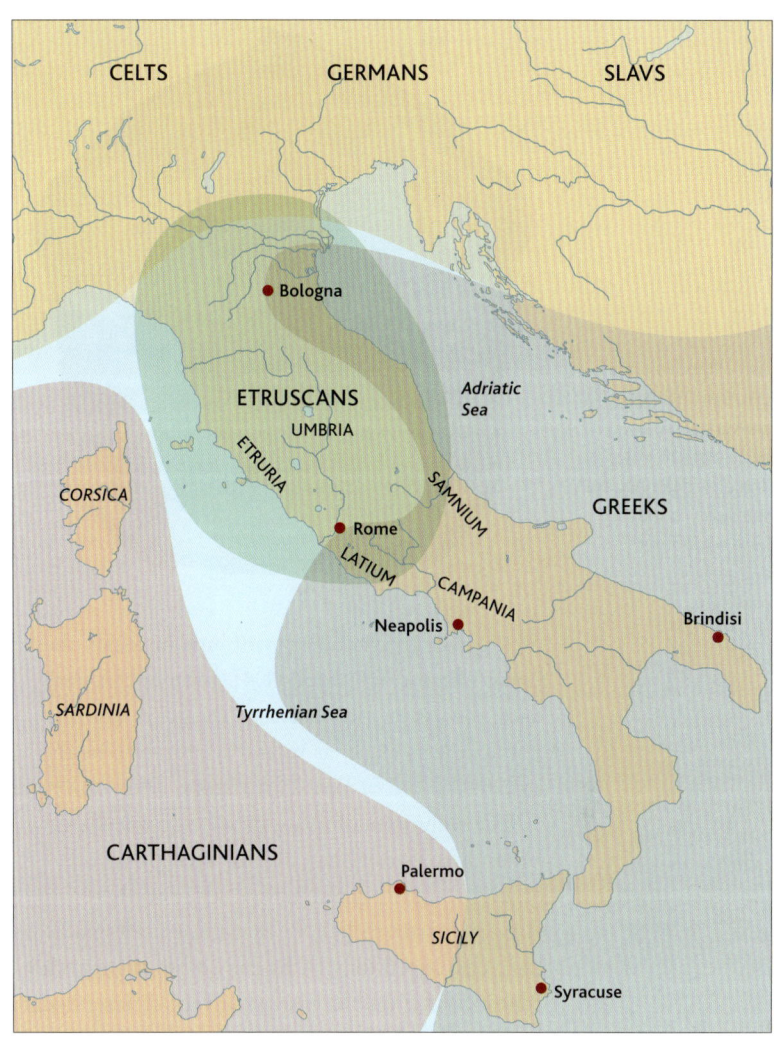

1.1 Map of Italy. This shows spheres of Punic (Carthaginian), Greek, and Etruscan influence during the Etruscan period.

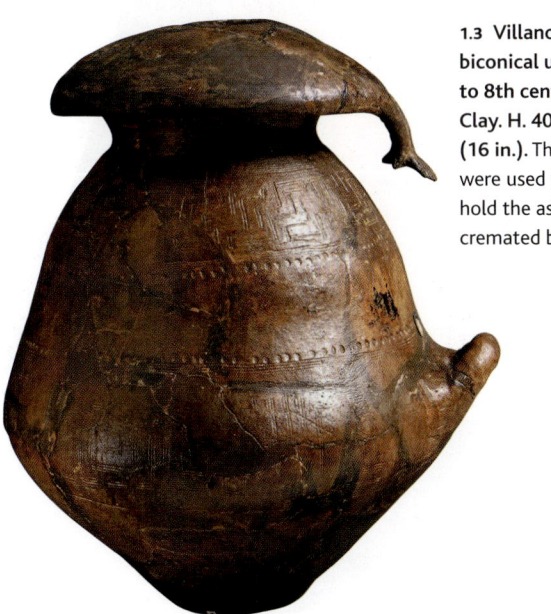

1.3 Villanovan biconical urn, 9th to 8th century BCE. Clay. H. 40.6 cm (16 in.). The urns were used to hold the ashes of cremated bodies.

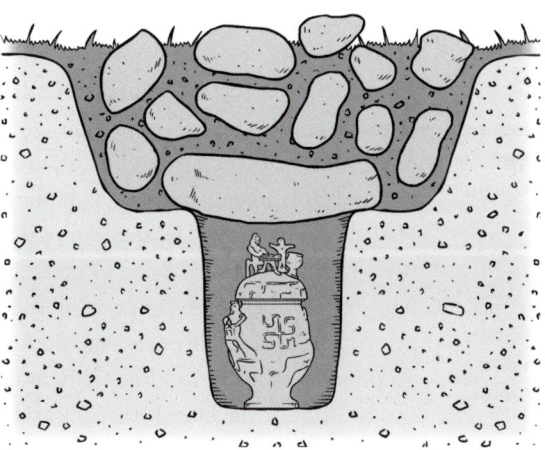

1.2 Villanovan *pozzo* burial, 9th century BCE. Biconical urns were buried in graves that were similar in appearance to wells.

CHAPTER 1: ETRUSCAN AND EARLY ROMAN ART 23

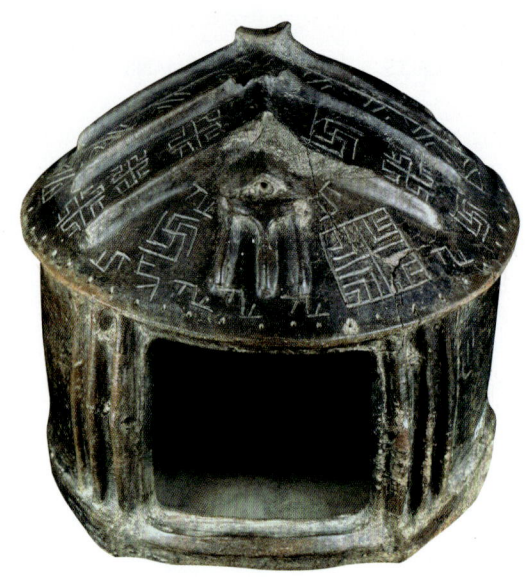

1.4 Villanovan hut urn, 9th to 8th century BCE. Clay. H. 27 cm (11 in.). The urns demonstrate the close connection between homes and graves.

1.5 Painted biconical urn, Copenhagen, Denmark, 8th century BCE. Clay. The patterning is reminiscent of Greek funerary vases, which indicates that the Villanovans considered other styles when creating urns.

the form of the thatched-roof huts in which these "proto-Etruscans" lived [**1.4**]. Even at this early date, the association between the grave and the domicile was close, as would continue to be the case to the end of Etruscan history.

The technique of using incision to decorate Villanovan pottery can also be seen on metal objects found in the same burials, and there is every reason to believe that these crafts had been developed locally. By the end of the eighth century BCE, though, vases of a very different sort began to be made here. These were thrown on a potter's wheel, rather than built up by hand, and were decorated with painted, rather than incised, ornament. Although made of local clay, and surely of local manufacture, these vases are strongly reminiscent of the famous monumental funerary vases that served as grave markers in the cemeteries of eighth-century BCE Greece. Yet such Greek vases were not easily, or often, exported. Therefore, and given the difficulty of this ceramic technique and the expertise it demanded, it is highly probable that the Italic vases were the work of immigrant Greek potters established at Etruscan centers. Occasionally, vases of Villanovan shape were rendered in this Hellenic technique [**1.5**], suggesting that this early Italic culture was open to outside influences, while at the same time prone to modifying foreign prototypes to suit native stylistic preferences and accommodate local traditions. Much the same can be said for the later Etruscans and Romans as well.

The impact of the foreign traders who arrived in Italy during the eighth century BCE was substantial. Carthage would spread its mercantile activity along the shores of the Tyrrhenian Sea, off the west coast of Italy. Greek culture was more pervasive still. Although, as far as can be discerned, the earliest visitors were primarily seeking to trade goods, by the end of the eighth century BCE dozens of Greek colonies had been established in southern Italy and Sicily. Within another century, the entire Italian coast from the Bay of Naples to Apulia, and all but the westernmost point of coastal Sicily, were entirely populated by Greek colonists. Through this expansion of trading routes, the Greeks came into ever-greater contact with people and goods arriving from the Levant, in the eastern Mediterranean. The influence of this contact would soon become evident in the subjects and motifs that characterize Etruscan art and traditions.

There are two fundamental differences between the seventh-century BCE Etruscans and their Villanovan forebears. The first is that the Etruscans were considerably wealthier, and the second is that the Etruscans lived in a culturally broader and more diverse world. The simple

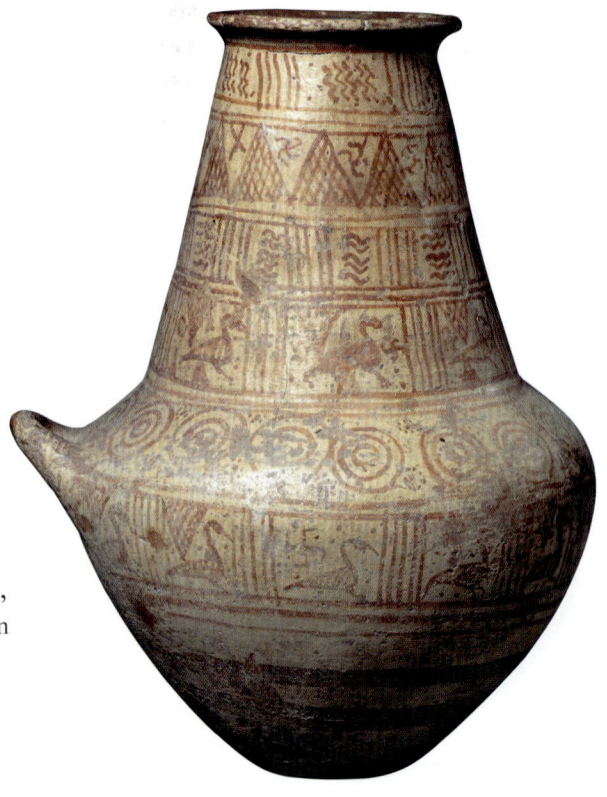

PART I: ROME AND ITALY BEFORE THE EMPIRE

pozzo graves of the Villanovans gave way to elaborate, usually multi-chambered, tombs that were hollowed into the earth where the bedrock would permit, or built above ground where it would not. The majority of our knowledge of the Etruscans comes from the objects found in their tombs. Surviving Etruscan texts consist entirely of short inscriptions—no literature was later transmitted by Roman or medieval scribes—and so the range of written information is extremely limited. A reconstruction of Etruscan religious, economic, and social history can be gleaned from the descriptions that writers in other cultures, especially Greeks and Romans, saw fit to mention, but most of what we know about the Etruscans comes from archaeology.

Etruscans in the Wider World

Similar to the ancient Greeks, the Etruscans lived in independent city-states that periodically developed loose federations for religious and political purposes. Some, at least, of these polities were controlled by kings as well as by a class of nobles that is well documented by surviving tombs. The Etruscans worshiped a pantheon not unlike that of Greece and Rome; most Etruscan deities had Greek equivalents, and religion, like many aspects of Etruscan life, took on an increasingly Hellenic appearance over time.

The question of Etruscan origins has long dominated Etruscan studies, and was being asked as far back as the time of ancient Greece and Rome. Herodotus, a Greek historian who wrote in the fifth century BCE, preserves the Greek belief that the Etruscans migrated to Italy from Lydia. Dionysius of Halicarnassus (*c.* 60–after 7 BCE), a Hellenistic Greek who was writing in Rome at the time of Augustus, asserted to the contrary and that the Etruscans were indigenous to Italy.

Today there is a belief that the Etruscans were native to Italy—insofar as any people in the ancient Mediterranean were native to their region—given the movements of populations and cross-cultural influences that characterize ancient cultures. In recent times, DNA testing has been applied to the Etruscan question. Samples of human remains of ancient Etruscans as well as modern DNA taken from their living Tuscan descendants (and their cattle), have been compared with samples taken from other regions of Italy and from the eastern Mediterranean, in particular Turkey. Reports that these tests proved Herodotus right gained prominence in the popular press, but the results seem on the whole ambiguous, with variations among regions within Etruria, and distinctly different results from ancient and modern DNA samples. So the question remains.

While the emergence of Etruscan culture in the seventh century BCE was partly a product of interaction with merchants from Carthage and the East, traders and colonists from Greece arrived nearly as early, and through their many settlements established a more widespread and permanent presence. Local Etruscan versions of Greek painted ceramics were appearing by the end of the eighth century BCE and continued to be manufactured for centuries. Especially popular in the seventh and early sixth centuries BCE was an uneven imitation of the pottery styles from Corinth that dominated the Mediterranean market at that time [**1.6**].

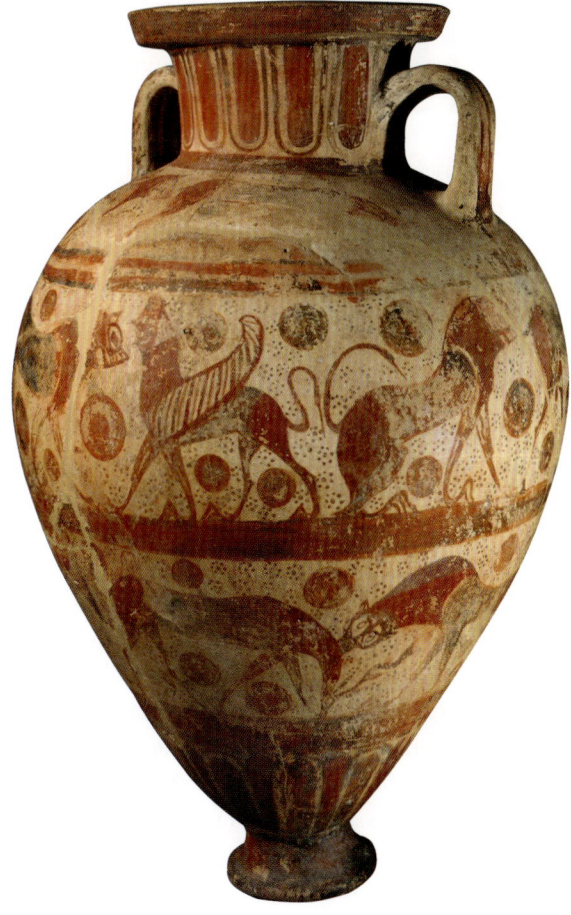

1.6 Amphora by the Bearded Sphinx Painter, Vulci, Italy, 610–600 BCE. Clay. H. 82 cm (2 ft 8⅓ in.). The pottery design reflects Corinthian styles, indicating the influence from across the Mediterranean.

CHAPTER 1: ETRUSCAN AND EARLY ROMAN ART 25

1.7 Detail of a Pontic amphora by the Paris Painter, Vulci, Italy, 540–530 BCE. Clay. H. 36 cm (1 ft 2¼ in.). These vases were produced in Etruria, but include Greek styles and themes, such as the Judgment of Paris.

spoken in ancient Italy. Moreover, the Etruscans were a consumer culture, and what they consumed more than anything else was Greek painted pottery. From the mid-sixth century BCE, the preferred vases were Athenian; there were even workshops in Athens that devoted themselves entirely to producing pots for the Etruscan market. Additionally, potters working in Etruria continued to produce vases that imitated the painting styles of the Greek imports. These vases are often called "Pontic" **amphorae**, named after Pontus, a region along the southern coast of the Black Sea. The amphorae were locally made but incorporate Greek subjects, eastern Greek styles, and follow, in shape and decorative arrangement, the model of Athenian vases [**1.7**]. Etruscan vase painting developed, in turn, a black-figure and red-figure style inspired by the similar contemporaneous development in Greek pottery. For this reason, the chronology conventionally used for Etruscan art approximates that used for Greek: Archaic (c. 600–480 BCE), Classical (480–323 BCE), and Hellenistic (323–c. 100 BCE).

This Etrusco-Corinthian ware reminds us that the **orientalizing** process in Etruria was not so straightforward as it might otherwise seem, since Greek pottery of the time was also heavily influenced by Near Eastern sources similar to those that inspired Etruscan craftsmen. The practice of writing was learned by the Etruscans from Greeks, who had adapted their alphabet from that of the Phoenicians. The expanding world of the Etruscans was pan-Mediterranean, and they drew from all these available sources, so distinguishing the various traditions represented in a given work is not always easy (see box: The Aristonothos Krater, opposite).

The Etruscan civilization that emerged by 600 BCE from this mixture of local Villanovan tradition with Greek and Near Eastern influences was distinct both from that of its Italian neighbors and those of its foreign trading partners. The Etruscan language is linguistically unrelated to Greek, Latin, or any other language

In other media, such as architecture, sculpture, or wall painting, the dependency on Greek sources is less close than in painted pottery. This may be explained by the absence of original prototypes, since statuary, buildings, and murals are not easily transported. In these realms, the Etruscans developed their own traditions: not without drawing on the stylistic and iconographic sources offered by imported goods, and, no doubt, employing some familiarity with the monuments from Greek colonies in southern Italy and Sicily, but with a significant admixture of characteristically Italic forms.

26 PART I: ROME AND ITALY BEFORE THE EMPIRE

The Aristonothos Krater

This large mixing bowl, found in a tomb at Cerveteri (ancient Caere) in southern Etruria, and dating from the mid-seventh century BCE, is remarkable in a number of ways [1.8 and 1.9]. First, it is the earliest known Greek vase to bear the signature of its maker—ARISTONOTHOS EPOIESEN (Aristonothos made [me])—squeezed almost apologetically between a handle and the upper right corner of a painted scene. This inscription is painted in Euboean script, which is not unexpected as Euboea, a large, long island north of Athens, was one of the first regions where Greeks settled, and their script served as a model for that of the previous non-literate Etruscans. One might then conclude that this is a Euboean work, yet the figure style most resembles the outline painting style of mid-seventh century **Attica** (the mainland region surrounding and including Athens) and Aegina (an island east of Athens), and the shape is best paralleled in Italy. Most believe it was created in Italy by an immigrant potter/painter or local pupil (with a Greek name).

On one side of the bowl (right), two ships face off in what is clearly not just a meeting but a battle. The ship at left, with its battering-ram prow and bank of rowers, is clearly Greek. Its opponent, with its far bulkier form, appears to be a merchant vessel, but both ships support a row of armed marines ready to engage in warfare. The distinctive form of the second ship is identified variously as Etruscan/Italic or Phoenician/Punic but, whatever the case, the primary point is that it is not Greek; here, the theme of encounter is key, and the viewer is introduced to it in an emphatic manner.

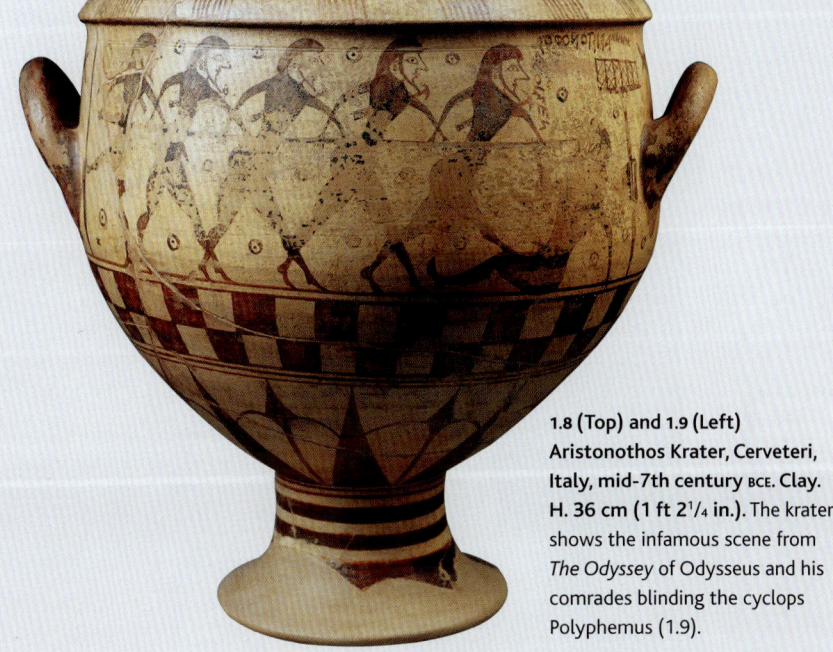

1.8 (Top) and 1.9 (Left) Aristonothos Krater, Cerveteri, Italy, mid-7th century BCE. Clay. H. 36 cm (1 ft 2¼ in.). The krater shows the infamous scene from *The Odyssey* of Odysseus and his comrades blinding the cyclops Polyphemus (1.9).

The other side (bottom left) depicts Odysseus and his companions skewering the one eye of Polyphemus the Cyclops in order to escape from his cave and the promise of almost certain death. The story of Odysseus's exploits, as related in Homer's *Odyssey* and other ancient works both lost and surviving, are often thought to be generally reflective of the Homeric era (the eighth and seventh centuries BCE), a time of Greek exploration and colonization stretching from the shores of the Black Sea to the Straits of Gibraltar. Odysseus's encounters with strange lands and exotic inhabitants, both benevolent and malevolent, mirror, on a mythical plane, the real-life experiences of Greek merchants and settlers. That this vase was acquired and apparently treasured by an Etruscan, who must have understood its Greek subject matter, suggests that the impact of such interaction was reciprocal.

Whether the ships engage in warfare or piracy, whether the subject was myth, legend, or historical, and whether the vase itself is Etruscan or Greek, no extant work better captures the tone of the times in early Archaic Italy.

ETRUSCAN TOMBS

The archaeological picture of the Etruscans is one based principally on the study of tombs and their contents. Fortunately, the Etruscans must have believed both that the funeral was an opportunity to make a strong statement about status, and that the deceased needed to be well supplied for existence beyond this life. Chamber tombs built by the Etruscans have preserved intact thousands of objects that were placed in them, together with the inhumed (buried), or cremated, remains of the deceased. During the seventh century BCE, these grave goods became increasingly lavish and elaborate. Favored decorative motifs, as well as the exotic materials used—gold, silver, and ivory—were Asiatic and North African in origin. These orientalizing luxury objects, however, were mostly of local manufacture: not rare imported curiosities, but rather reflective of an industry established in Italy in order to satisfy the increasingly expensive tastes of the emerging Etruscan nobility.

One tomb at Cerveteri illustrates perfectly the transition toward identifiably Etruscan traditions. Dating to around the mid-seventh century BCE, the Regolini-Galassi tomb is simple in form, consisting of two long tandem burial chambers flanked by two smaller, rough-hewn openings [1.10]. As is characteristic of the tombs at Cerveteri and many other Etruscan sites, the Regolini-Galassi tomb was covered by a *tumulus*, a rounded, circular mound of earth built up on a stone platform [1.11 and top right of 1.10]. The grave goods from this tomb are preserved thanks to the later building of an additional *tumulus* over and around the original. Tomb robbers

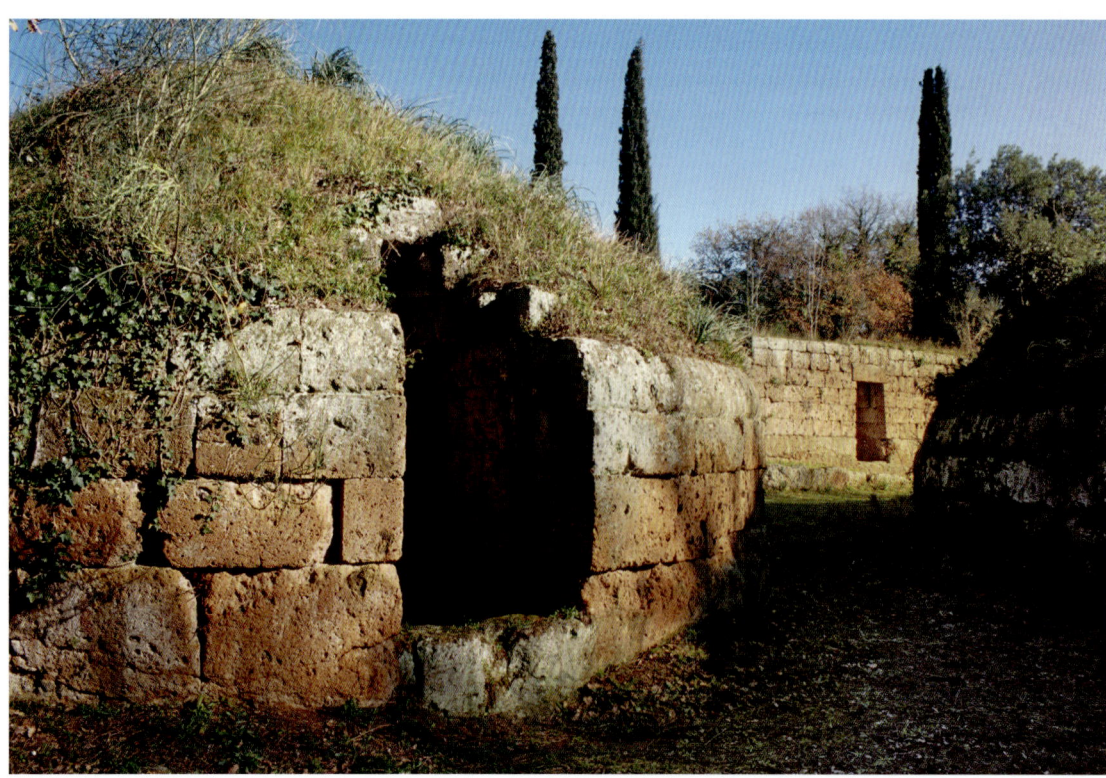

1.10 (Above) Regolini-Galassi tomb, Cerveteri, Italy, 650–600 BCE. The finds from the tomb make it one of the richest surviving in Etruria.

1.11 Necropolis of Banditaccia, Cerveteri, Italy, 7th century BCE. The site comprises circular earth-and-stone buildings, or *tumuli*.

28 PART I: ROME AND ITALY BEFORE THE EMPIRE

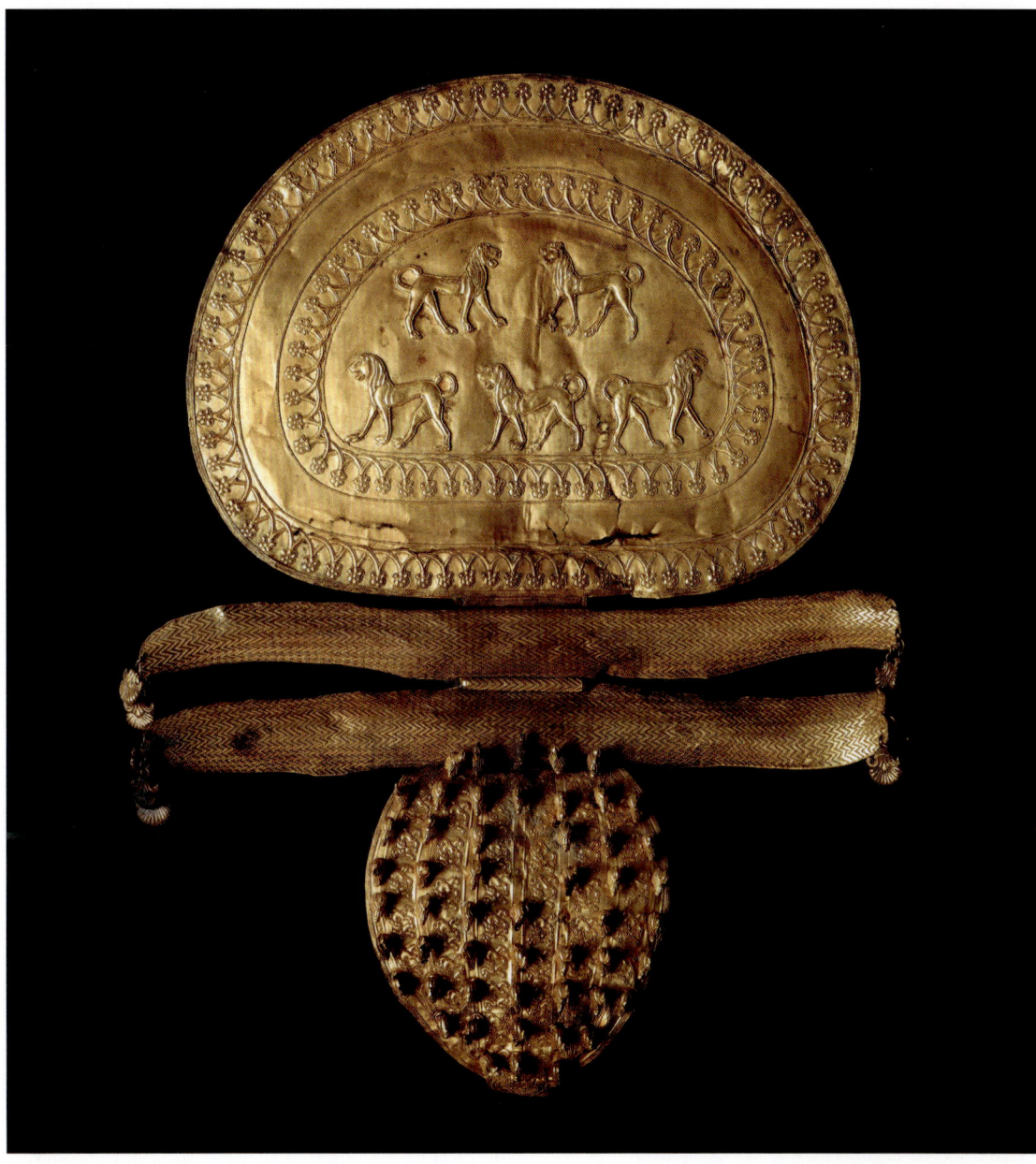

1.12 Gold fibula from the Regolini-Galassi tomb at the Necropolis of Banditaccia, Italy, 7th century BCE. Gold. L. 31.8 cm (12½ in.). The material and technique, as well as the decorative motifs, suggest a Near Eastern influence.

(nearly all Etruscan tombs were robbed, either in antiquity or later times) who cleaned out the bigger *tumulus* missed the treasures from the smaller, earlier *tumulus*, which now fill a large room in the Vatican Museums. Three burials were found in the tomb. In one of the side chambers was discovered a Villanovan cremation burial with a biconical urn and elaborate bronze grave furnishings, especially weapons. The burials found in each of the two main chambers were inhumations that contained perhaps the most lavish and engaging objects ever found in Etruria.

The most stunning piece is a gold **fibula** (fastening pin) a foot in length [1.12] that displays some of the most skillful goldsmithing seen from the ancient world. While the form is native Italic, the scale and richness of the object are unprecedented. Material, technique, and subject are Near Eastern. The **repoussé** (hammered relief) lions and rosette chain on the huge catch plate derive from Levantine sources. At the opposite end of the *fibula*, lines of figures in relief alternate with rows of tiny gold creatures worked **in the round**. The fantastical menagerie includes winged lions, sphinxes, and chimeras: hallmarks of Near Eastern work. Details are picked out with patterns of tiny beads of gold (**granulation**), a technique long known in the

CHAPTER 1: ETRUSCAN AND EARLY ROMAN ART

eastern Mediterranean. While this is an especially spectacular example, luxury goods in exotic materials are quite common in seventh century BCE Etruscan tombs, an indication that the ruling classes throughout the region were suddenly enriched, both materially and culturally, by contact with travelers from the East.

Objects made from other materials reflect similar cross-cultural exchanges. A footed cup [1.13] from the same tomb includes small supporting plaques in the form of standing female figures (**caryatids**). The long, curled locks of hair that flank the face derive from representations of Hathor, the Egyptian cow goddess. Other aspects of this handmade cup, however, have local roots. The fabric itself is called ***bucchero***, developed by the Etruscans from the *impasto* technique of the Villanovan urns (see pp. 23–24). The incised geometric decoration on the cup's foot and the radiating dots on the lip also draw from Villanovan urns. Not only, then, did the Etruscans of the seventh century BCE import goods from the east, but they also adopted elements from these imported crafts and craftsmen, adapting them to local traditions. The interaction between Etruria and the wider Mediterranean was also not a one-way street; *bucchero* pottery was exported across the Mediterranean.

Tombs were monumental, often intricately decorated, from about 600 BCE onward, and, as we have seen, provided with furnishings to an extent that must have taxed the resources of even the wealthiest families. While this practice has resulted in the preservation of an enormous quantity of intact material, it creates serious problems for archaeologists in need of contexts (information relating to where the object was found, and its association with other objects around it). Tomb robbing, of course, has destroyed an enormous quantity of evidence, but even properly excavated tombs present challenges. Tombs are furnished with treasured objects, perhaps heirlooms, and so their co-location in no way indicates contemporaneity; the dating of Etruscan objects and the establishment of a chronological scheme for them is therefore fraught with difficulty. Moreover, reconstructing a civilization known primarily from its tombs relies heavily on subjectivity and deduction. Were the objects placed in the tomb made for this purpose, or were they used in everyday life? Are the painted scenes on tombs specifically funerary, or do they also reflect the preferred pastimes of the living?

TOMB PAINTING

The Etruscan tradition of painting tombs is generally held to have begun in the mid-sixth century BCE, with the Tomb of the Bulls at Tarquinia. The hollow space of the tomb is divided and organized by brightly painted representations of architectural features, such as a frieze, pitched roof, doorframe, and **pediment**, and with a combination of interior and exterior views [1.14]. Such a scheme provides a framework within which figural scenes are arranged, such as the bulls for which the tomb is named.

Squeezed into the painted pediment are a sphinx, a winged lion, a nude male on horseback, and a bull; other animals, real and imaginary, are painted on several surfaces in the main and subsidiary chambers. In addition to the bulls (one with a human face) in the frieze area between the two horizontal bands of color, two scenes of sexual activity are depicted. Below

1.13 Caryatid chalice from the Regolini-Galassi tomb, Cerveteri, Italy, 650–600 BCE. H. 16 cm (6³/₈ in.). The fabric of the cup is the signature Etruscan earthenware pottery known as *bucchero*.

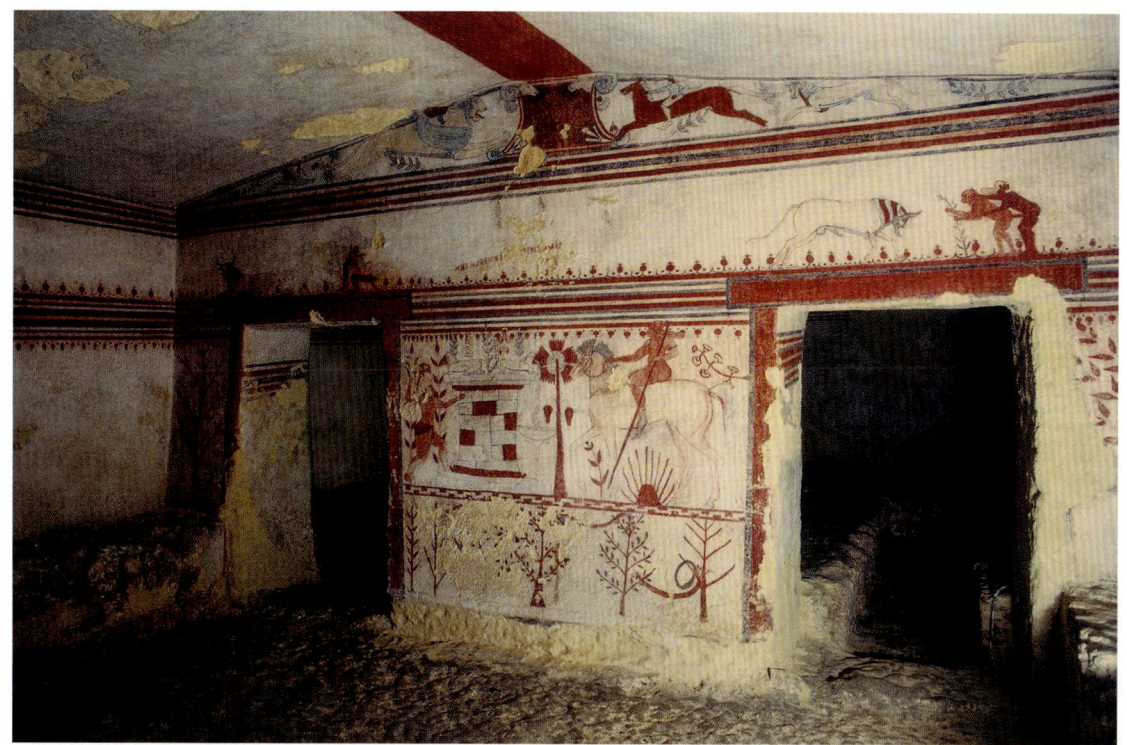

1.14 (Left) Back wall of the Tomb of the Bulls, Necropolis of Monterozzi, Tarquinia, Italy, 540–520 BCE. In composition and subject matter, there are many similarities to vase painting.

1.15 (Below) Detail of back wall of the Tomb of the Bulls, Necropolis of Monterozzi, Tarquinia, Italy, 540–520 BCE. This illustrates the ambush of Troilus by Achilles during the Trojan War.

this, and between the doors, in the focal panel of the complex, is painted the only known scene of Greek myth in an Archaic (*c.* 600–480 BCE) Etruscan tomb painting: the ambush by Achilles of the youthful Trojan prince Troilus [1.15], whose death had been foretold as a precondition of Greek victory in the Trojan War.

As was typical in Archaic Etruria, there is much here that points to the Hellenic world. Both mythological and "pornographic" scenes were commonly depicted on the Greek pottery found in Etruria, as were animals and monsters. The pomegranate chain that runs along the bottom of the frieze area in 1.14 is a motif found commonly on Greek vases. The breaking up of the wall surface into smaller areas of decoration, sometimes unevenly shaped, also recalls Greek vase-painting techniques, and the figures (especially the two horse/rider groups) seem somewhat forced into the space allotted. There is little here that makes an unequivocally funerary statement, and much that seems derived from the decorative repertoire of imported and domestic pottery. Scholars have detected a stylistic similarity with the Pontic vases discussed on p. 26 (see 1.7), which is especially evident in facial profiles; some even feel that the painters of tombs must themselves have been vase painters.

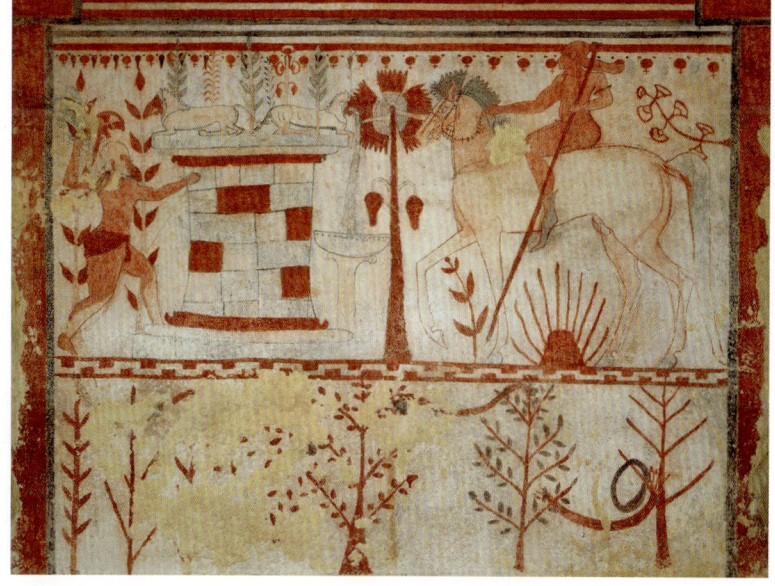

One feature of these tombs that is rarely found in vase painting is the landscape. Stylized trees and bushes appear everywhere, either as a backdrop for the activities depicted or, in some cases, as the sole subject. From the outset, the painters of Etruscan tombs seem eager to move away from the constraints of small-scale painting to the more spacious depictions that befit mural decoration, reflecting an interest in depicting physical settings that are far more extensive than any documented in contemporaneous Greek art.

The Tomb of Hunting and Fishing at Tarquinia

The Tomb of Hunting and Fishing consists of two large, roughly square rooms one behind the other. Both are fully painted. The front room displays an arrangement of dancers among trees and, in the pediment over the inner door, a departure for the hunt [1.16]. The pediment in the second room bears a banqueting scene—reminiscent in subject and style of the **symposia** frequently depicted at this time on Greek vessels, but quite different in detail [1.17]. The man here reclines with his wife, to judge from her dignified attire, and not, as one would expect at a symposium, a courtesan; the smaller figures flanking the couple are more likely to be children than servants. The atmosphere of domesticity here differs sharply from that of the Attic symposium scenes.

The **tableau** painted across the three walls below the banqueting scene exploits the spatial possibilities of mural painting more completely than has been achieved in any extant Archaic work, Greek or Etruscan. Four male figures are fishing from boats, while one hunts birds from the shore. These activities are spread out over two entire walls, while the third wall has no human figures at all. The figures vary in scale (as do the seven crowded into the pedimental banquet) but each is small compared to the pictorial space, as appropriate to the subject. This uniquely convincing portrayal of humans and animals operating in nature is enhanced through the quality of the painting itself. Simple forms and bold colors vividly capture the appearance of leaping dolphins, birds in flight and alighting, and fish taking the bait.

The banquet, which must have formed part of a funerary ritual and had already become a standard subject in burial contexts, seems shifted to the margins here, making way for the innovative pictorial experiment dominating the walls of

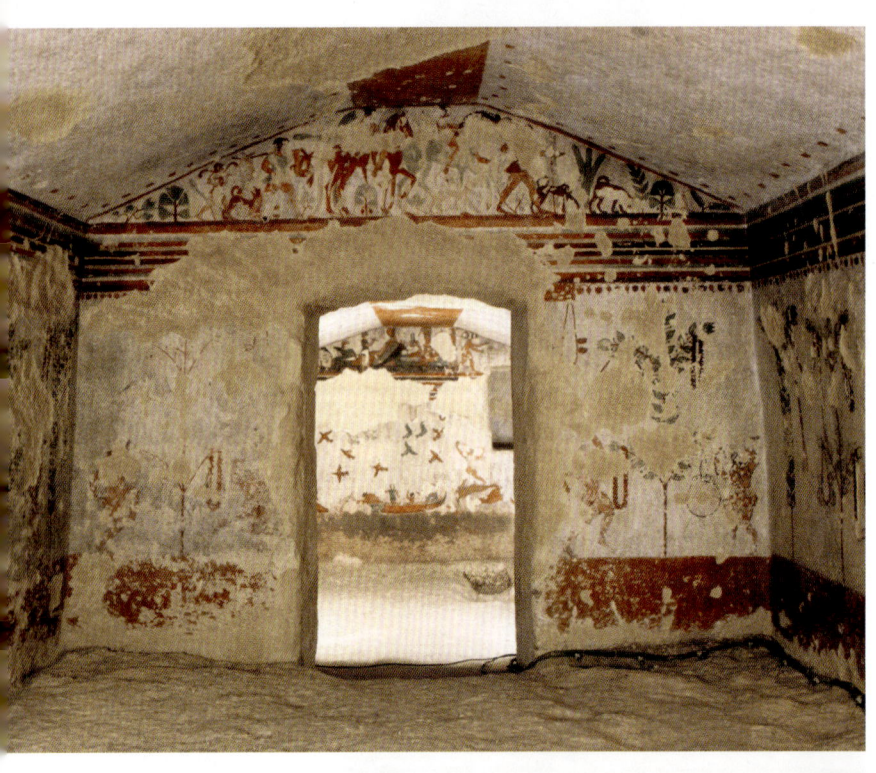

1.16 Front, outer room of the Tomb of Hunting and Fishing, Necropolis of Monterozzi, Tarquinia, Italy, 530–510 BCE. This shows dancers frolicking among a grove of trees, and the start of a hunt.

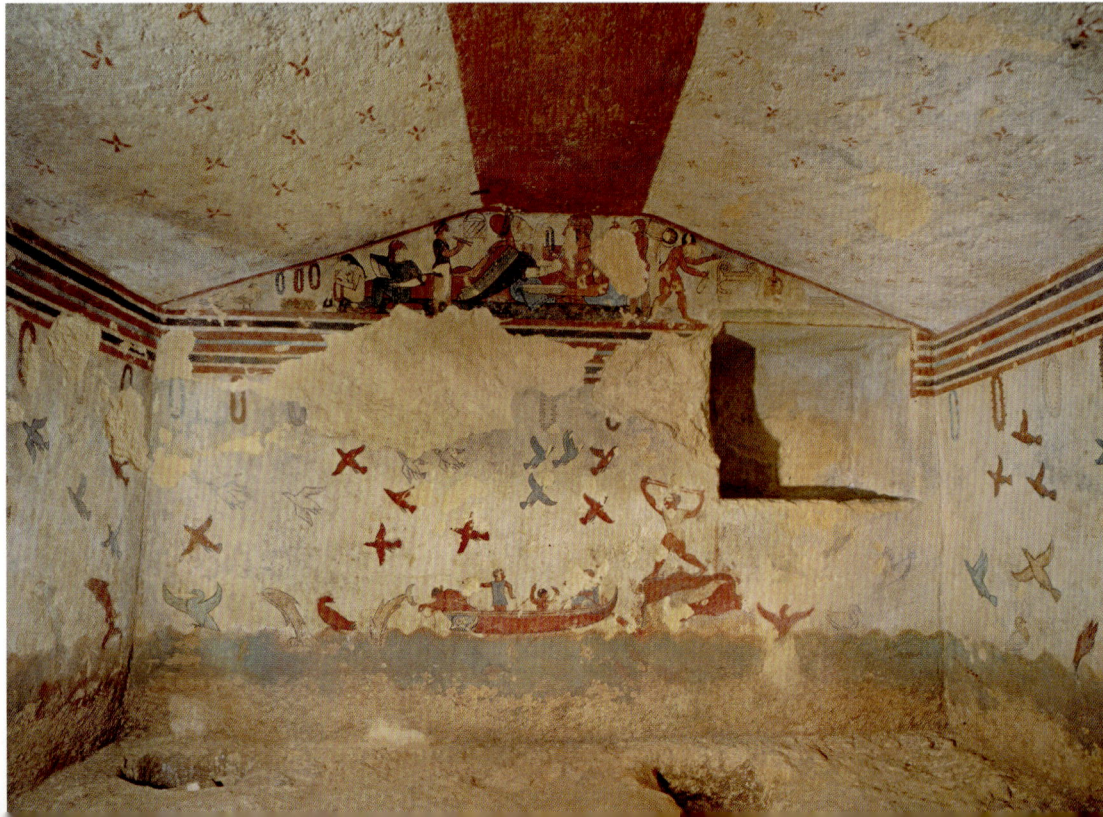

1.17 (Right) Inner room of the Tomb of Hunting and Fishing, Necropolis of Monterozzi, Tarquinia, Italy, 530–510 BCE. This room displays a scene of domesticity and the famous figures fishing in their boats and stretching from the shore to try to bring down birds.

the chamber. What this subject signifies in a funerary context is not at all clear (perhaps a hope for continuing pleasant pastimes in the afterlife, as the banquet can also suggest), but such interest in the depiction of landscape, nature, and human beings within their environment will resurface in much later Roman art.

In the subsequent development of tomb painting, some dominant themes and features emerge. The articulation of the interiors to mimic built structures continues, and in some cases becomes even more pronounced; the concept is traceable from the eighth century hut-urns. Banqueting, with accompanying music and dancing in a lively landscape (in this way transported outside the tomb proper), becomes the standard subject, and decorative schemes become more coherent and integrated, as in the Tomb of the Leopards at Tarquinia, which illustrates, as well, the increasingly Greek-looking figure style [1.18]. The profiles of these musicians and banqueters recall, more strongly than before, the works of Attic red-figure vase painters, although the usage and context are still quite clearly Etruscan.

The François Tomb at Vulci

Mythological scenes disappear from Etruscan tombs after the Tomb of the Bulls (see pp. 30–31), but recur a century or more later when tombs were painted with scenes of the underworld. An especially rich development of this theme is found in the François Tomb at Vulci. Seven burial chambers are arranged around a central room [1.19] in a scheme often compared to the Roman **atrium house** (see p. 76 onward). The dates of the inhumations and grave goods that filled these spaces range over much of the Classical and Hellenistic eras, but the tomb paintings are dated, on the basis of style, to the late fourth or early third centuries BCE.

The ornamental framework here includes a complex Greek **meander frieze** with three-dimensional effects and animal scenes similar to those found on Greek crafts, mosaics, and tomb paintings from the era of Alexander the Great (r. 336–323 BCE) (see 1.20 and 1.21, p. 34). It is, however, the array of large, figured scenes in the T-shaped central area that is most striking. These scenes include smaller, single or two-figured compositions on the narrow wall segments between radiating chambers, and two lengthier panels on either side of the longer central room at the back. Scenes from Greek mythology emphasize funerary aspects. Two themes dominate. One is that of infernal punishment: Sisyphus, whose eternal sentence was to push a stone up a great hill, only for it to fall back down just before reaching the summit, and Amphiaraus, who was swallowed up by the earth as he fled a battle. The other is that of death in battle: Eteocles and Polynices, the sons of Oedipus,

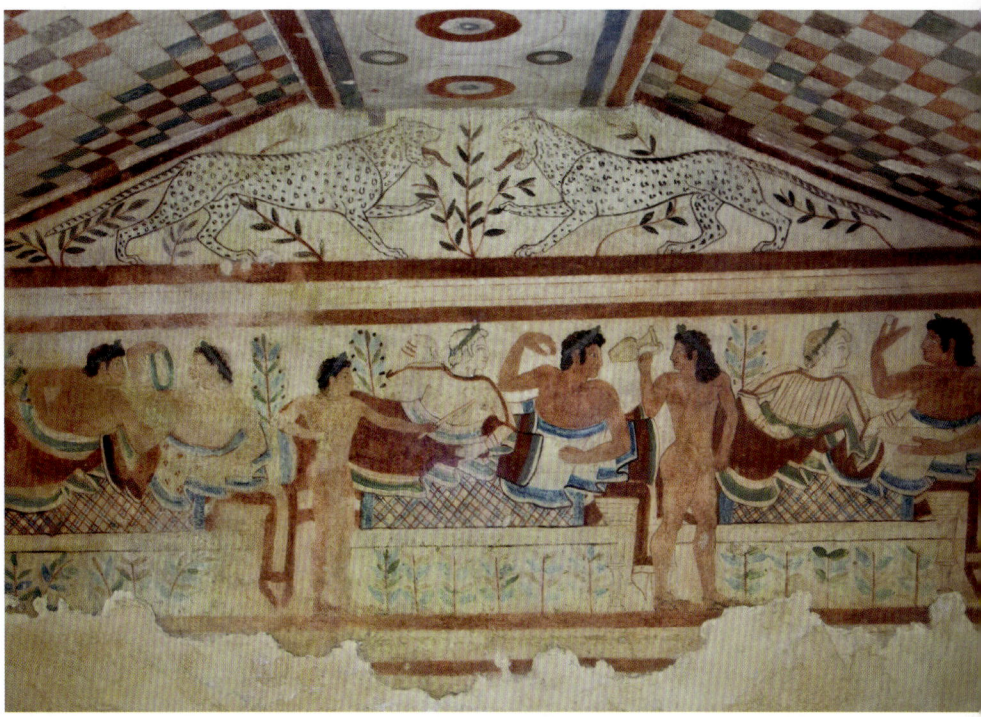

1.18 Tomb of the Leopards, Necropolis of Monterozzi, Tarquinia, Italy, 480–450 BCE. The tomb is named after the two large leopards confronting each other. The style is reminiscent of red-figure vase painting.

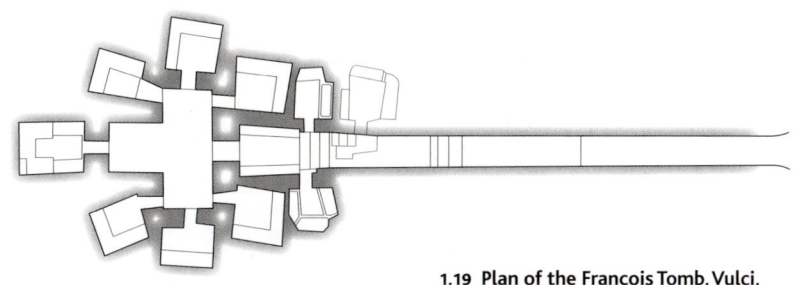

1.19 Plan of the François Tomb, Vulci, Italy, end of 4th century BCE. The tomb belongs to the Etruscan family of the Seties. Vel Seties appears in one of the tomb's paintings (see 1.22, p. 35).

CHAPTER 1: ETRUSCAN AND EARLY ROMAN ART

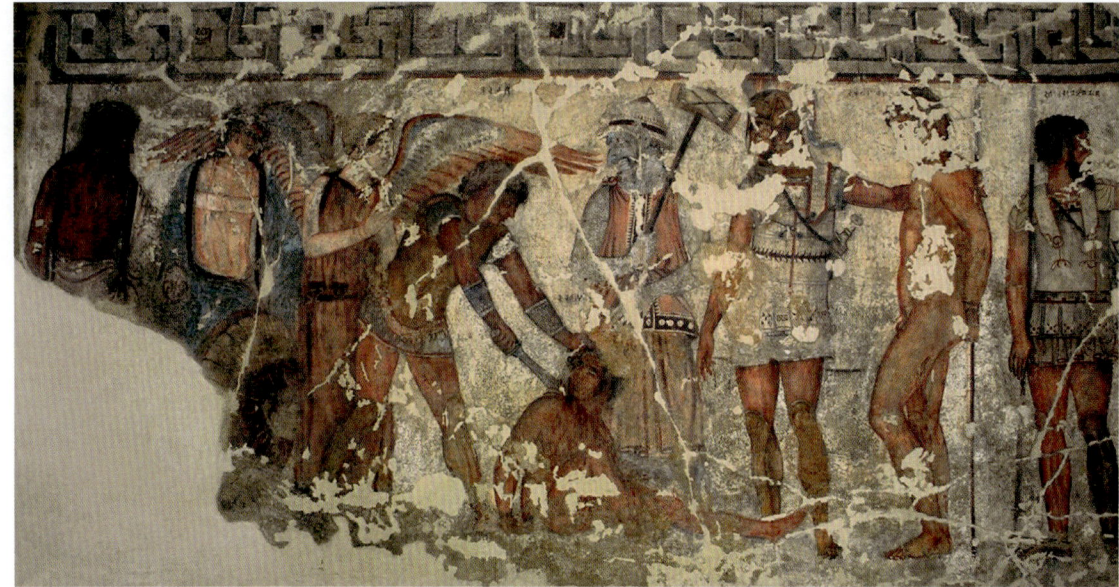

1.20 François Tomb, Vulci, Italy, end of 4th century BCE. This scene shows the sacrifice of a Trojan captive, under the gaze of Etruscan deities Charun and Vanth.

who fought and killed each other to rule Thebes, the slaughter of the helpless Ajax and Cassandra, and the sacrifice of Trojan prisoners [1.20].

As is typical of Etruscan art, a Greek subject is portrayed in a strongly Hellenizing figural style, while given an Etruscan identity by the inclusion of specifically Etruscan figures. In the François Tomb these figures are Charun and Vanth, both Etruscan deities associated with the underworld. The second concept of the tomb is more local: the portrayal of an array of individual battles between figures whose Etruscan names are provided [1.21]. The figures seem to stand for conflicts among Etruscan cities and between the Etruscans and Rome, especially during the era of the Tarquin monarchy. There is at least a modicum of history within the myth.

Two panels that fall in neither category displayed portraits of the tomb owner. The pictorial tour de force here is the depiction of the aristocrat Vel Seties with the dwarf Arnza [1.22]. We know their names from labels made above the figures. Appropriate to his rank, Vel Seties wears a wreath, and a colorful and ornate wrapped mantle that cannot but make one think of the "painted toga" (*toga picta*) reserved for a Roman general. Seties' face is lined, revealing his age and experience, with none of the idealization

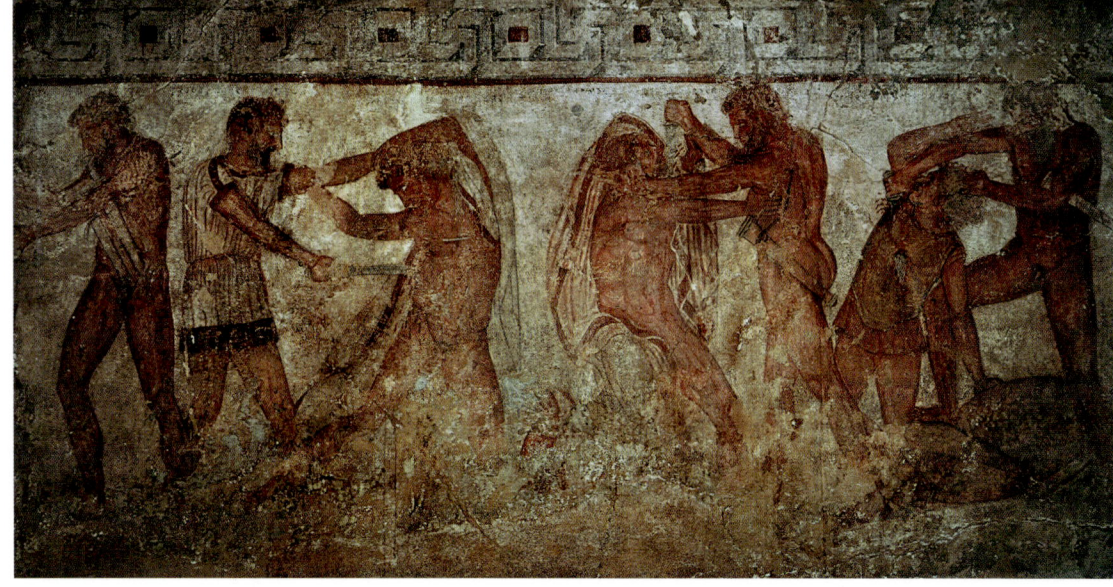

1.21 François Tomb, Vulci, Italy, end of 4th century BCE. The scene shows a battle between figures who are labeled with Etruscan names.

34 PART I: ROME AND ITALY BEFORE THE EMPIRE

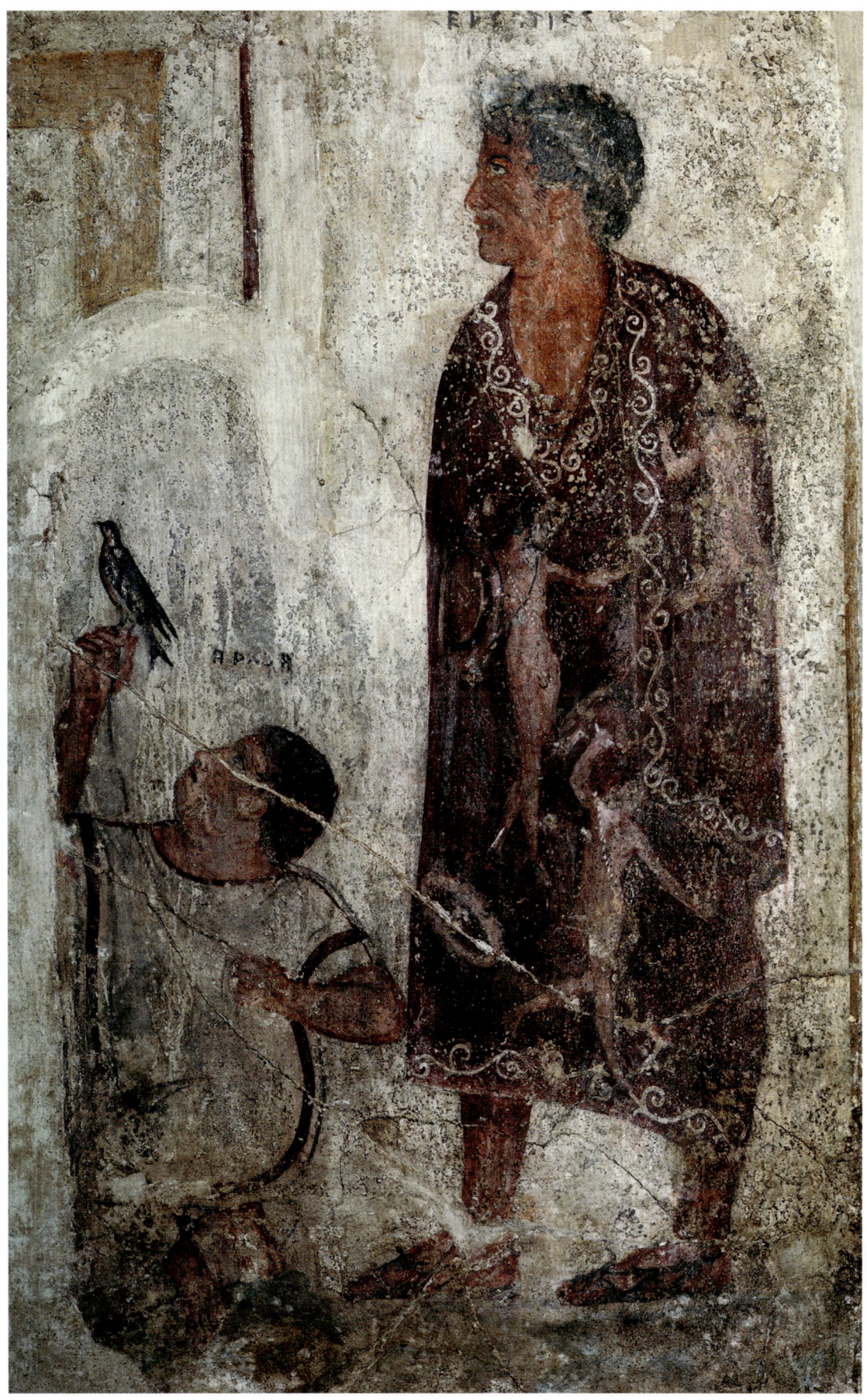

1.22 François Tomb, Vulci, Italy, end of 4th century BCE. This painting shows the owner of the tomb, Vel Seties, wearing a decorated "painted toga."

CHAPTER 1: ETRUSCAN AND EARLY ROMAN ART 35

of the mythological-historical figures. Even more strongly characterized is his servant, with his outsized head and very heavy neck. It is tempting to see here a foreshadowing of the so-called "**veristic**" (or hyper-realistic) portraits of the later Roman Republic (see p. 72), and indeed there probably is a connection, but it is also necessary to acknowledge that Hellenistic art in the East at this same time displayed an equally strong interest in visual characterization.

What is strikingly similar to later Roman practice is the fact that this tomb uses painting to embody the values and status of the deceased, and how it does this. While the portraits function in a very straightforward manner, the mythological and historical images must signify meaning through suggestion and allusion. As outward signs of Hellenization, they are typical enough of both Etruscan and Roman art. The Greek scenes also form a counterpoint, and perhaps a model, for the Italic stories, which are themselves closer—temporally, spatially, and culturally—to the time of Vel Seties himself. Our knowledge is not sufficient to unravel the complex network of references, but the visual interplay of images at work here resembles that which becomes commonplace in the later villas of the Roman elite.

ETRUSCAN SCULPTURE

By the time Seties' portrait was painted in his tomb at Vulci (at the end of the fourth century BCE), the association between an image of the deceased and his or her remains was a well-established tradition in Etruria. The very earliest Etruscan figural sculptures, however—approximately contemporary with the earliest Greek stone statues of the late seventh century BCE—were found in the Pietrera Tomb at Vetulonia [**1.23**].

Several of the sandstone statues preserved in fragments in this tomb are of male subjects, but the female figures are far better preserved. These display a strongly frontal aspect: the bodies are flat at the back, with only the heads carved fully in the round. The women are elaborately coiffed and jeweled, and the belts binding their tunics bear orientalizing reliefs. The effect would have been more opulent still when the original painted decoration was intact. These figures are strongly reminiscent of the caryatids on the *bucchero* chalice (see 1.13, p. 30), and it is almost certain that these life-size statues in the Pietrera Tomb reflect a translation of forms from the smaller-scale sculpture and ceramics. Nonetheless, the crossed arms and elaborate adornment together with the context suggest a funerary aspect, so these first Etruscan sculptures were probably intended as representations of the deceased, although it is not impossible that they were protective deities. Similar in general form to the contemporary statuary of Greece, the Vetulonia pieces differ by being placed in a tomb; even the funerary examples in Greece were displayed openly in the **necropolis**.

Over the course of the sixth century BCE, sculptures placed in Etruscan tombs at Vulci, Cerveteri, and Chiusi continued the tradition of the Pietrera sculptures. Excavations at Chiusi have produced dozens of so-called **canopic urns** that retained the function, and in some cases the form, of Villanovan cinerary containers. The helmets that had been used as covers for some of the Villanovan

1.23 Female figure from the Pietrera tomb, Vetulonia, Italy, late 7th century BCE. Limestone. H. of head 27.9 cm (11 in.); H. of torso 68.1 cm (2 ft 3 in.). One of the earliest Etruscan sculptures discovered.

36 PART I: ROME AND ITALY BEFORE THE EMPIRE

1.24 Canopic urn from Chiusi, Italy, late 6th century BCE. Clay. H. 50 cm (1 ft 7 2/3 in.). The sculpted human head is likely to represent the deceased, whose remains the urn contains.

painted in the Tomb of Hunting and Fishing at Tarquinia (with which this piece is approximately contemporary). The type might well have been inspired by the increasingly popular banqueting scenes painted in Etruscan tombs, and expertise in the medium surely resulted from the long tradition of architectural sculptures. The figures on the Cerveteri sarcophagus are elegantly modeled; their idealized features, with a strong nose and receding forehead, recall the style of eastern Greek Archaic artistry—a style that became increasingly prominent in late sixth-century Etruria. While recalling Greek Archaic work, both figures reflect an emphatic attention to the upper body and head, in contrast to a barely articulated lower body, a lack of harmony that would be surprising if found in Greece. Whereas the structural integrity of the body is a dominant feature of Archaic sculpture, in Etruria, a head alone can stand for its subject.

During Classical and Hellenistic times, stone sarcophagi and ash urns became increasingly common. Sarcophagi are generally found in urns gave way to lids in the form of human heads, some of which are strikingly lifelike [**1.24**]. The intimate physical connection between these images and the remains of the deceased (held within the vessels) makes all but certain their function as likenesses of the deceased. Indeed, several scholars have seen in the Chiusine canopics the beginning of portraiture in Italy.

Similar in function, but more complex in their decoration, are **sarcophagi** (stone coffins) and ash urns, which were often adorned with sculpted representations of the deceased on the lid, usually alone but sometimes in a pair. Perhaps the most famous example is the large terracotta sarcophagus from Cerveteri, modeled in the form of a banqueting couch atop which a formally attired male and female couple recline [**1.25**]. The arrangement of the figures is strikingly similar to that found

1.25 Terracotta sarcophagus, Cerveteri, Italy, late 6th century BCE. Terracotta. H. 1.16 m (3 ft 9 5/8 in.), L. 1.61 m (5 ft 3 3/8 in.). The couple have idealized expressions that are reminiscent of Greek Archaic style, but the posture and shape of the bodies are specifically Etruscan.

CHAPTER 1: ETRUSCAN AND EARLY ROMAN ART 37

1.26 (Left) Lid of sarcophagus with husband and wife, Vulci, Italy, 350–300 BCE. Limestone. L. 2.14 m (7 ft). The carved couple appear heavily influenced by Classical sculpture, with lower-body proportions comparable to the Cerveteri sarcophagus.

1.27 (Below) Low-relief of sarcophagus with husband and wife, Vulci, Italy, 350–300 BCE. Limestone. L. 2.14 m (7 ft). The relief depicts the battle between the Greeks and the Amazons.

southern Etruria and ash urns in the north of the region, preserving their different burial customs. The two types differ only in size; both consist of a rectangular box, usually bearing **relief sculpture**, capped by a lid adorned with an image of the deceased. The designs of stone sarcophagi were not consistent in southern Etruria. A pair of nearly contemporary stone caskets found in the same tomb at Vulci are distinctly different. The two were the property of a single family, and could be no more than a generation apart in date (*c.* third century BCE), yet the sculptures on both the box and lid of each are distinctive. The couple on one of these sarcophagi [**1.26** and **1.27**] closely resembles Greek works from the fourth century BCE, especially those on Athenian grave reliefs, although the scheme of figures reclining on a sarcophagus is characteristically Etruscan. The de-emphasis of the bodies is also an Etruscan feature, as seen on the Archaic sarcophagus from Cerveteri (1.25, p. 37), but the drapery, hairstyles, and idealized facial features are drawn from Greek tradition. Similarly, the **low-relief** frieze on the box depicts an **Amazonomachy**—a Greek subject of a battle between the Greeks and Amazons—and reprises stock figural types from the numerous Greek fourth-century treatments of the theme (1.27).

In contrast, the other sarcophagus, carved in the local soft **nenfro** stone (as opposed to the hard limestone of the more Hellenizing piece), portrays its occupants in a much less idealized manner, with stocky heads and plump faces [**1.28**]. The reliefs are drawn not from Greek mythology, but from the experiences of the deceased [**1.29**]. A procession is shown, and the central scene of a man clasping a woman by the wrist probably refers to the institution of marriage, although the depiction of the death demon (Vanth) on one short side of the coffin suggests that what is being represented here is more likely to be a projected reunion in the afterlife than a literal depiction of the couple's wedding ceremony. It is not uncommon for significant events from the lifetime of the deceased to be depicted on Etruscan sarcophagi—a practice that recurs in the elaborate marble sarcophagi of the Roman empire. At the same time, scenes from Greek mythology are at least equally common on late Etruscan urns and Roman sarcophagi. The two Vulci sarcophagi are highly unusual in some ways; such paired reclining figures are unknown on other Classical or Hellenistic works, for example. The artisan who carved the one piece was surely aware of the other, although it is far from clear which sarcophagus is older. This contrast between artistic traditions is not unusual in Etruscan art, and is a clear feature in the

1.28 (Left) Lid of sarcophagus, Vulci, Italy, early 3rd century BCE. Nenfro. L. 2.11 m (6 ft 11⅞ in.). Sculpted from local stone, the couple shown here are heavier-set and less idealized than the figures depicted on the sarcophagus in 1.26.

1.29 (Below) Relief on side of sarcophagus, Vulci, Italy, early 3rd century BCE. Nenfro. L. 2.11 m (6 ft 11⅞ in.). The procession probably depicts the institution of marriage, with the couple reunited after death.

following Roman art traditions, where styles exist in parallel, related but distinct.

One last sarcophagus is of special interest in our search for the roots of Roman artistic practices. The nenfro sarcophagus of Lars Pulena, from his family tomb at Tarquinia [1.30], preserves a local tradition. Its relief decoration, below the main sculpture, is unapologetically funerary; a central male figure—no doubt the deceased—is shown clearly in the underworld, in the presence of paired Vanths and Charuns. As is typical of Hellenistic examples, the male figure atop the lid no longer reclines in perpetual slumber, but sits up alertly as though living on, at least symbolically. His facial features show no signs of idealization; his mouth is set firmly and his brow bears a slight frown, as befits a person of substance and experience. The diadem on his head and what may be a wreath around his neck must be signs of status, but this was not a man who would wholly entrust his message to symbolic communication. He is shown unrolling a scroll on which is written, in painstaking detail, his public offices and accomplishments: what the Romans would later call a *cursus honorum*.

Lars Pulena's sarcophagus stands at the end of a long Etruscan tradition of funerary monuments that make public statements about individual and family status—a tradition traceable to the orientalizing treasures of the seventh century BCE, and even beyond to Villanovan times. As we will see in Chapter 2, simultaneously it also stands at the head of a Roman tradition of enlisting funerary rites and portraiture to elevate family prestige and achieve explicit political goals.

1.30 Sarcophagus of Lars Pulena, Tarquinia, Italy, early 2nd century BCE. Nenfro. L. 1.98 m (6 ft 6 in.). Using traditional relief styles from the area, this depicts a male figure in the presence of Etruscan deities Vanth and Charun.

CHAPTER 1: ETRUSCAN AND EARLY ROMAN ART

ETRUSCAN BRONZES

The sculptures discussed so far are in clay or stone, yet the Etruscans were equally famed for their skill as bronzeworkers, amply documented by chariots, vessels, tripods, censers (for burning incense), and candelabra. They worked using a variety of techniques, including incision, repoussé relief, and **lost-wax casting** (both hollow and solid). Among the most characteristic objects are the incised mirrors, *cistae*, and bronze free-standing sculptures that all show a melding and reimagining of the Greek influences that went on to form the roots of Roman art traditions.

1.31 Bronze mirror, Rome, Italy, 4th century BCE. L. 22 cm (8³⁄₄ in.). The mirror shows the Judgment of Paris.

Mirrors

The earliest mirrors were made in the Archaic period (c. 600–480 BCE), but the greatest number were created in late Classical and Hellenistic times. In each period, the themes most commonly found on the mirror's engraved surface are derived from Greek myths, especially those that had to do with love and lust among gods, goddesses, and heroes; an example depicting the Judgment of Paris, a beauty contest among three powerful goddesses, is typical [1.31].

The Greek *dramatis personae* in this myth are identified by their Etruscan names, incised as: Turan for Aphrodite (Venus), Uni for Hera (Juno), Menrva for Athena (Minerva), and so on. The figural styles and drapery patterns are authentically Greek, although we are aware that this is not likely to be a creation after a Greek prototype. The craftsmen of such objects were very familiar with the Hellenic visual repertoire but could also produce representations based on a story rather than a pre-existing model. Similarly the consumers of such objects were, by this time, so used to Greek ideas that they would not have seen this myth as a translation into Etruscan ideas, but rather as fully a part of the Etruscan mythological body that had made Greek myth its own.

Cistae

Cistae are covered cylindrical containers for tools of personal adornment, such as mirrors and makeup spoons, used secondarily as cinerary urns. Offering a more expansive field than mirrors for complex figural composition, these are most often adorned with two or more separate scenes. As *cistae* functioned together with mirrors, the similarity in subject and style is not unexpected. More rarely, a single scene continues around the entire vessel. Since the field of decoration, before bending into cylindrical form, is a broad rectangle similar in shape to an interior wall, it is tempting to seek in such works some reflection of mural compositions.

Most *cistae* come from Praeneste, in Latium, south of Etruria, but they still belong within the Etruscan cultural sphere. The concentration of finds in this region suggests that the *cista* industry

was Praenestine, that is, local, but the story may not be so simple. The Ficoroni *cista* [1.32] includes an inscription that states it was made by a Roman (Novius Plautius) in Rome for a Praenestine patron (Dindia Malconia). Its frieze presents an episode from the Argonauts' journey to the Black Sea [1.33]. Ashore in search of water, the heroes are denied what they need by the local king Amycus unless one of them can best him in a boxing match. Pollux, one of the Argonauts, obliges by defeating the impudent king and then binds him to a tree as punishment for his inhospitable behavior. The Argonauts, after replenishing their water supply, sail on. The composition here shows at least three episodes reading from right to left: 1) the sailors fill up their storage amphorae at a spring; 2) Pollux warms up on a punching bag; 3) he ties up the king in the company of deities that are Greek (Athena and Nike) and probably Etruscan (the winged demon to the far right, but behind Pollux in the composition). The boxing match itself is not shown.

The narrative here reflects a Greek, especially Classical, tradition of implying an event—often, as here, the climactic event of the story—by depicting episodes preceding and/or following it. The figural types are clearly derived from a Greek late Classical stock; the extensive landscape and **continuous narrative** (separate episodes involving the same protagonist(s) set against a unified background) are not often found in Classical Greek art, but are common in later Roman painting. So whether this piece was taken from a Greek or Italic prototype, we know that these particular artistic devices were known in Rome at a relatively early date.

1.32 (Above) Ficoroni *cista*, Praeneste, Italy, 350–330 BCE. Bronze. H. 77 cm (2 ft 6⅓ in.). *Cistae* usually held bathroom articles, but were also used as burial urns.

1.33 (Below) Artist's rendition of detail of frieze on the Ficoroni *cista*. This depicts part of the story of the Argonauts.

CHAPTER 1: ETRUSCAN AND EARLY ROMAN ART

1.34 (Below) "Mars," Todi, Italy, early 4th century BCE. Bronze. H. 1.41 m (4 ft 7 ½ in.). The statue is a variation on a shift in weight similar to that found in early Classical Greek art, for example in the *Doryphoros* of Polycleitus.

Bronze Sculptures

The Etruscans also mastered the craft of casting substantial hollow bronze statues as early as the regal period (sixth century BCE), if our sources correctly assess their date. These were usually portraits, and were very popular: they are said to have so thronged the Roman Forum by the period of the mid-Republic as to require a purge. As is the case for Greek statuary, knowledge of early Roman and Etruscan bronzes is hampered by an extremely low survival rate. The shortage of evidence is in fact more problematic given the lack of corresponding marble sculptures, and the fact that the later Romans, who eagerly and extensively produced marble replicas of Greek statuary, seem not to have copied their own. Yet the few preserved bronzes do allow a fragmentary glimpse of what once existed.

As noted in our examination of other media, these bronzes reflect a familiarity with contemporaneous Greek works but maintain a distinct Italic identity. The hollow-cast warrior, called "Mars," from Todi (in the upper Tiber valley), displays a weight-shift pose reminiscent of such fifth-century BCE Greek works as the *Doryphoros* of Polycleitus, which was itself created around 440 BCE as a model for other Greek sculptors [1.34]. But the similarity is superficial. The flat-footed pose of Mars makes the bent left leg longer than the right. Neither legs nor arms are well integrated into the body. The overall impression is restless and momentary, lacking the stability that defines Polycleitan ***contrapposto***. In a more obvious deviation from the heroic Greek figure—most often nude, or nearly so—this figure is fully dressed in a tunic and breastplate.

1.35 Head of "Brutus," Rome, Italy, mid- to late Republic. Bronze. H. 69 cm (2 ft 3¼ in.). The portrait shows the idea that Republican men had favored wearing beards.

Its identity, however, is no clearer for the inclusion of this clue. Whether it depicts a deity (as its nickname suggests) or a particular warrior is not at all certain. The face is conceived in Classical Greek terms, but that does not establish a divine identity, since, as we have already seen, Etruscan artists were simultaneously capable of realistic and idealized renderings. Above all, the deviations from Greek practice should not be seen as a criticism of an extremely well-designed and artfully executed statue. This is an Italic work, created with a specific subject and function in mind by an artist who was well aware of the Greek artistic tradition.

Similarly indeterminate in origin is the bearded male head commonly called "Brutus" [1.35]. Its nickname derives from its supposed resemblance to depictions of Lucius Junius Brutus, one of the consuls from the first year of the Roman Republic (509 BCE), on Roman coins of 54 BCE [1.36]. This characterization reflects the belief that Romans of the early Republic had typically worn beards, which may itself have been suggested by the Hellenization that can be observed in early Etruscan and Roman art. Mature Greek males, both mortal and divine, are invariably shown

42 PART I: ROME AND ITALY BEFORE THE EMPIRE

bearded as a mark of differentiation from youths. The Etruscan images that mostly appear to be portrait-like (on sarcophagi and ash urns) are generally clean-shaven. It is therefore unclear if the beard on this figure is a sign of era or of cultural affiliation, and it does not help with assigning a date to the sculpture. The style of rendering recalls early Greek attempts at portraits that visually describe the character of their subject through his or her facial features. For that reason the "Brutus" is often placed in the late fourth or early third century BCE, but any date down to the last century BCE is entirely possible. Despite the uncertainty about its date, it does represent for us the Etruscan/Roman propensity for displaying virtue through indications of age, experience, and seriousness of purpose (see Portraits of Pompey and Caesar, pp. 103–4). Moreover, it also preserves a rare example of those Republican bronze portraits that crowded the city of Rome, of which we hear so much and can see so little.

1.36 *Denarius* of Marcus Junius Brutus, 54 BCE. Silver. Shown with a portrait of his ancestor, Lucius Junius Brutus.

The Capitoline Wolf: A Case for Caution

In most accounts of early Roman art, the Brutus head is paired with another work in the collections of the Capitoline Museums in Rome: a standing female wolf of unknown origin to which was added, in the Renaissance, bronze images of infants [1.37]. These children represent Romulus and Remus, twin sons of Mars and future founders of Rome, who, according to tradition, were suckled by a wolf before being found and rescued by the shepherd Faustulus. This iconic work has repeatedly been referenced and replicated as an emblem of the greatness and antiquity of Rome, including being adopted as the logo for AS Roma, one of the city's professional football clubs, as well as the 1960 Rome Olympics. It has also been used to represent the peculiarity of Etruscan art, both in its affiliation with, and deviation from, the stylistic characteristics of contemporary Greek works.

The highly stylized treatment of the wolf's locks of fur and the simplified patterns of its anatomy connect it with the Archaic style. Yet there is something very direct and realistic in its appearance. The arched brow gives the animal an unmistakable ferocity. Its skin adheres to its ribcage and haunches, adding to the lean and hungry look fit for a wild animal. This degree of realism is not generally associated with Archaic art, so explanation was sought in the Etruscan practice of following imported prototypes incompletely, inserting features that are thought to be distinctly Italic, as illustrated, for example, by the Todi Mars and Capitoline Brutus.

Another possibility, of course, is that the work is not ancient at all, and several scholars have suggested that a medieval date would also be consistent with this mix of formalism and realism. Fixed attitudes are resistant to change, and this proposal attracted few followers. In 2006, when the piece was being restored, it was noted that the work had been hollow cast whole, rather than using the conventional ancient technique of **piece-casting**, and that certain toolmarks on its surface also seemed inconsistent with ancient workmanship. Scientific tests, including thermoluminescence dating on the metal and **radiocarbon** (C^{14}) dating of organic inclusions, indicate a date in the early medieval period (eleventh to twelfth centuries), which is consistent with the casting technique. The case of the Capitoline she-wolf shows, especially in the case of Etruscan and Roman art objects, that style is, at best, an imperfect indicator of date, and therefore how cautious one must be when evaluating works without context.

1.37 Capitoline Wolf, Rome, 11th to 12th centuries CE. Bronze. H. 85.1 cm (2 ft 9½ in.). The sculpture is an iconic image for the founding of Rome in its representation of the wolf that suckled Romulus and Remus. The dating of some of its material points to its creation in the early medieval period.

ETRUSCAN AND EARLY ROMAN TEMPLE ARCHITECTURE AND STATUARY

From at least the late seventh century BCE onward, Greek city-states built their temples, wherever possible, from stone. Local sources, whether marble or limestone, were generally preferred, and not simply because of convenience and economy. For this reason, despite extensive quarrying of building material from pagan sanctuaries after they went out of use, a few Greek temples survived plunderings and stand sufficiently complete to allow an understanding of their original impact; many more have been re-erected in part, at least, from their original blocks of stone. Such structures were common in the Greek cities of Sicily and southern Italy, and certainly the Etruscans and Romans were aware of them. Nevertheless, the Etruscan architectural tradition remained, to the end, rooted in the use of more impermanent materials. Stone was reserved for foundations and the facing of temple platforms. Columns and roofing structures were made of wood, walls were in mud brick, and various parts of the buildings were sheathed and adorned with terracotta reliefs and statues. Consequently, there are no Etruscan or early Roman temples with surviving superstructures. If one is fortunate enough to excavate the remains of such a building at all, the preserved parts consist of foundations and terracottas; these sometimes permit reconstruction of the original plan and elevation, but it is impossible to experience such a building as we might, for example, the Parthenon in Athens.

Our understanding of Etruscan and early Roman temple plans depends heavily on the treatise written by the architect Vitruvius in the Augustan era (27 BCE to 14 CE). In his overview of temple types, one called "Tuscan" (see 0.6, p. 17) is consistent enough with remains that do exist as to show that it derives from the Etruscan temple tradition [1.38]. The temple proper stands atop a high podium with stairs only in front; it has columns at the front and sometimes along the sides, but never at the back. In Vitruvius's scheme, the **cella** (inner room for the cult image) is tripled, although single- and double-cella arrangements are documented in actual building remains; if multiple, the rooms are always side by side, not tandem as in Greek examples. The Vitruvian Tuscan plan differs most strikingly from the typical Greek temple in its unambiguous orientation—which way it faces—owing to the location of the columnar facade and the point of access in front. This tendency to emphasize the space in front of itself, while denying the space behind, becomes a distinguishing feature of Roman religious architecture.

1.38 Artist's impression of plan and elements of a Tuscan temple. This was based on the writings of Vitruvius, the Roman architect from the first century BCE.

Capitolium

In Rome itself, the most conspicuous example of this tradition must have been the Temple of Jupiter Optimus Maximus ("Best and Greatest") on the Capitoline hill [1.39]. This was an enormous structure—half again broader than the Parthenon and significantly taller—that was originally built by the last Etruscan king, Tarquinius Superbus, no doubt as a response to the competitive flurry of colossal public building being sponsored by sixth-century BCE **tyrants** in

1.39 Reconstruction of the elevation of the Temple of Jupiter Optimus Maximus, Capitoline hill, Rome, dedicated in 509 BCE. It was originally built by Tarquinius Superbus.

an Archaic temple site excavated not far away under the church of Sant'Omobono (near the later Forum Boarium) do, however, include terracotta statuary. These are connected with the second phase of an Archaic temple destroyed around the end of the sixth century, and soon after replaced with two new temples arranged side by side; they should therefore be roughly contemporary with the Capitolium. The **akroterial** group (an ornament placed on a flat base and mounted on the pinnacle of the pediment of a building) of Athena with Herakles (Minerva and Hercules) [1.40] reconfirms the now familiar appropriation of Greek myth by the

1.40 (Below) Remains of the Athena and Herakles akroterion from the Archaic temple underneath Sant'Omobono, Rome, Italy, late 6th century BCE. Terracotta. H. 1.35 m (4 ft 5¼ in.). The sculpture would have topped a temple and shows clear similarities to Greek Archaic sculpture.

Greek *poleis* (city-states) from Asia Minor to Italy. The temple was but one part of an extensive public building program undertaken by the Etruscan kings of Rome, including: the draining of the forum area, which was to be a key and enduring feature of Rome; the establishment of important state-cult centers; and even the first circus for chariot races. Rome may have been founded by Romulus, but it became a city only in the time of the Tarquin kings.

Perhaps to diminish the regal contribution, Roman tradition held that the Capitoline temple was dedicated by the first consuls of the new Republic in 509 BCE. The temple thereby came to stand not for the monarchy, but for the origin of the Roman Republic itself. Destroyed and rebuilt several times over its nearly millennium-long history, it was without question the most significant religious structure in Rome: as the seat of Jupiter, the king of Roman gods; as one of the earliest Roman temples; and equally for its looming presence over the city center. Its plan is an expanded version of the Vitruvian Tuscan scheme (see 1.38), with an extra row of columns in front, and columns along each side. Equipped with three cellas to house the so-called Capitoline triad (Jupiter, Juno, and Minerva), it served as a model for dozens of other "Capitolia" built to dominate the fora of Roman towns and cities across the empire.

The Archaic Jupiter temple was, we know, fully equipped with terracotta sculptures, but little has been preserved, aside from the name of the sculptor who made them (see box: Terracotta Sculpture, p. 46). The remains of

CHAPTER 1: ETRUSCAN AND EARLY ROMAN ART

1.41 Reconstruction of the roof of the Portonaccio Temple, Veii, Italy, c. 500 BCE. In Etruscan style, the temple's roof displayed akroteria.

Etrusco-Italic cultures of central Italy. The theme is strikingly reminiscent of certain Greek Archaic (especially Attic) works that employ the hero as a metaphor for superhuman accomplishment and divine approval, particularly apt at a time when many Greek city-states were ruled by powerful individuals (tyrants) who sponsored much building. On the other hand, the employment of these themes is a conventional strategy for maintaining authority, whether autocratic or aristocratic, so it is suitable for monarchy and republic alike.

The style of these sculptures recalls work from Veii, the Etruscan city nearest (and so most hostile to) Rome, where the manufacture of Archaic architectural terracottas is especially well documented. The Portonaccio Temple there originally bore a full complement of terracotta statuary, arranged, as at Sant'Omobono, along the ridge of its roof as akroteria, a practice unknown on Greek temples but documented in Etruria as early as the seventh century BCE [**1.41**]. The best-known figure here is the famous Apollo, which, similarly to the bronze Mars from Todi, strikes the viewer both with its resemblance to, and dissimilarity from, contemporary Greek work [**1.42**]. The broad Archaic smile, formalized drapery, and stiff conventional pose compare with the features of Greek statuary. Yet there is a vigor

MATERIALS AND TECHNIQUES
Terracotta Sculpture

Pliny the Elder (23–79 CE), writing in the first century CE, discusses at some length the beginnings of terracotta production in Italy (*Natural History* 35.5). According to his account, a man named Demaratus was exiled from the Greek city of Corinth, bringing with him artisans who introduced to Tarquinia the craft of modeling in clay. His son became the first Etruscan king of Rome, Tarquinius Priscus (r. 616–579 BCE), so Demaratus's migration must have occurred around the middle of the seventh century, when mercantile and artistic interaction between Etruria and Corinth was nearing its peak. Later in the same passage (*NH* 35.45), Pliny discusses the sculptor Vulca (Volcanius) from Veii, who made, in terracotta, both the akroteria and the cult image for the Archaic Capitolium at Rome, built by its last Etruscan king at the end of the sixth century BCE. The alignment of the story with the material evidence is striking. Tiled roofs and related architectural terracottas do seem to have been invented in Corinth during the early seventh century BCE, and their manufacture develops especially in Corinthian-controlled or influenced sites stretching from Isthmia to Thermon in northwest Greece, to the Corinthian colony of Syracuse in Sicily. From here the practices may have spread to Rome and Etruria, where they begin in the later seventh century BCE.

The earliest known extensive programs of Etruscan architectural terracottas, at Acquarossa and especially Poggio Civitate, also date to the later seventh century BCE, corresponding to the activity of Demaratus and his workmen at Tarquinia. The closest parallel for late Archaic pieces from Rome is to be found at Veii, an ancient Etruscan city. While Pliny believed the artist Vulca to have been the sculptor of the Capitolium sculptures, whether or not we can attribute the works from Sant'Omobono (or even Portonaccio) to the Vulca workshop is speculative.

Pliny goes on to say in this same passage (*NH* 35.45) that the use of terracotta for temple sculptures was long established in Rome and that they were still well regarded in his own day. "Statues of this kind are still to be found...even at Rome and in the municipal towns there are many pediments of temples, remarkable for their carving and artistic merit and intrinsic durability, more deserving of respect than gold." Ever the moralizer, Pliny displays an admiration for long-lived traditions, the *mos maiorum* (ancestral custom) that was retained by the Roman aristocracy well into the empire. The first emperor Augustus, in fact, is said to have used such old-fashioned roof adornments on newly built temples.

PART I: ROME AND ITALY BEFORE THE EMPIRE

1.42 Apollo akroterion, Portonaccio Temple, Veii, Italy, 510 BCE. Terracotta. H. 1.75 m (5 ft 9 in.). The smile reflects the Greek Archaic style, yet the position of the body is Etruscan.

The facial features, strongly characterized, are similar to those found on the Hellenistic Etruscan urns and sarcophagi. His name, Aulus Metellus, is Roman, but the inscription gives it in the Etruscan form and also provides the names of his Etruscan parents. It seems likely that we are dealing here with a man of Etruscan birth who made his career in Rome, and was honored by this statue in his homeland. The monument represents a stage in the erosion of Etruscan cultural identity exceptionally well, eradicated by the relentless forces of Romanization. But erosion is a slow process, and well into the Roman empire aristocrats delighted in drawing attention to their Etruscan roots—no doubt to distinguish themselves from an increasingly diverse and non-Italic peer group.

In material culture as well, the Etruscan legacy remained strong. As the world of Rome expanded, it came to include new materials and forms in its art and architecture; but in those objects most deeply rooted in ancient customs, the Etruscan imprint persisted. Temples built in the Greek orders with marble surfaces remained frontally oriented, and elevated on platforms in the Tuscan tradition. Images of the deceased, sometimes startlingly lifelike, continued to be associated with tombs and funerary practices. Centuries later, when Romans would revive the custom of inhumation, sarcophagi were carved with a range of themes, both biographical and mythological, similar to those found on much earlier Etruscan counterparts. Yet Etruria's most impactful legacy was the manner in which it embraced, adopted, and adapted from the artistic traditions of its neighbors and trading partners, both near and far away. Indeed, it was through Rome's Etruscan traditions as well as its continuing contact with the Greek world that it was so well prepared (more so than the Romans themselves admitted) to react to the enormous new influx of Hellenism that would result from the Roman conquest of the Mediterranean.

1.43 (Below) Statue of Aulus Metellus, Cortona, Italy, early 1st century BCE. Bronze. H. 1.8 m (5 ft 11⅞ in.). The statue is dressed in an early style of toga. It shows the influence of Romanization on Etruscan culture.

and power visible in both face and pose that seem to derive from the Etruscan artist's propensity for introducing original observations into inherited or borrowed schemes.

The Legacy of Etruscan Art

In 90 BCE, in an attempt to put an end to a rebellion of Italic allied states, Rome extended its citizenship throughout the peninsula, eliminating the already blurred distinction between "Etruscan" and "Roman." Around this time, a life-size bronze portrait was erected, perhaps at the Etruscan sanctuary site of Volsinii, near which it was found [1.43]. Its subject is dressed in Roman clothing (an early form of the toga and the boots of a Roman aristocrat) in the gesture of an orator/statesman; the portrait's Italian nickname is *L'Arringatore*—"he who harangues."

2

Republican Rome and the Hellenistic World: Triumph, Commemoration, and Public Art

50	**The Empire of Alexander and the Rise of Rome**
51	**Conquest and Culture**
51	Box: The Reception of Greek Art in Rome
53	**Roman "Museums" of Greek Art**
54	Box: Roman Histories of Greek Art
55	**The Triumph and Republican Temple Architecture**
56	LARGO ARGENTINA
57	TEMPLES BY THE TIBER
60	TEMPLES AT TIVOLI
60	SANCTUARY OF FORTUNA AT PRAENESTE
62	Materials and Techniques: Concrete
63	TRIUMPHAL PAINTING
65	**Sculpture**
65	MUNICH MARINE *THIASOS* AND PARIS CENSUS RELIEFS
67	AEMILIUS PAULLUS MONUMENT
68	LAGINA, TEMPLE OF HECATE FRIEZE
69	VIA SAN GREGORIO PEDIMENT
70	**Portraiture**
71	*IMAGINES* AND REPUBLICAN PORTRAITS
71	Box: Polybius on *Imagines* and the Roman Republican Funeral
72	VERISM

48 PART I: ROME AND ITALY BEFORE THE EMPIRE

Chronological Overview

DATE	EVENT
280 BCE	Pyrrhus invades Italy
3rd century BCE	"Triumphal" painting from tomb on Esquiline
264–241 BCE	First Carthaginian (Punic) War
218–201 BCE	Second Carthaginian War; Carthage surrenders to Rome (201)
200–197 BCE	Second Macedonian War
168 BCE	Perseus of Macedon defeated by Aemilius Paullus at Pydna
167 BCE	Aemilius Paullus monument at Delphi
2nd century BCE	Via San Gregorio pediment
149–146 BCE	Third Carthaginian War; Carthage sacked (146) and made the Roman colony of Africa
148–146 BCE	Macedonia and Achaea made Roman colonies; Corinth sacked (146)
c. 146 BCE	Portico of Metellus
c. 120 BCE	Sanctuary of Fortuna Primigeneia at Praeneste
107–100 BCE	Marius's African and Gallic wars; Paris and Munich reliefs (c. 100)

The Development of Rome

Right: Map of Rome showing the key buildings in existence in Rome in this chapter.

CHAPTER 2: REPUBLICAN ROME AND THE HELLENISTIC WORLD: TRIUMPH, COMMEMORATION, AND PUBLIC ART

The Empire of Alexander and the Rise of Rome

In Chapter 1, we used the term "Hellenistic" as a purely chronological indicator: the last of a scheme (following "Archaic" and "Classical") that has been adopted from the study of ancient Greece. "Hellenistic," however, is both a more descriptive and more evaluative term than either "Archaic" or "Classical." It implies a fundamental distinction that is based on the assumption that the exploits of Alexander the Great constitute a watershed in Western history.

Alexander was the Macedonian king who, in about half a decade, conquered the Persian king Darius III and brought together an empire comprising, in addition to Macedon and Greece, the regions of Asia Minor, the Levant, Egypt, Mesopotamia, and Persia itself [2.1]. He led an expedition as far as India, and, had he not died young, in 323 BCE, might have extended his rule to span all the way from south Asia to the most western point of the Mediterranean. But so much is speculation. What did happen, following Alexander's death, was the division of these conquests among a few of his generals, who themselves eventually founded dynastic lines: the Ptolemies in Egypt, Seleucids in the Near East, and the Antigonids in Macedon were primary among them. Although Greek cities and colonies peppered much of the Mediterranean, most of the area conquered by Alexander was neither in Greece nor, in any real way, was it Greek. Yet via the establishment of Macedonian-style monarchies throughout this area, all the lands known to them east of mainland Greece became Hellenized, at least at the level of the ruling classes. The kingdoms themselves, and the era they ushered in, are for that reason called "Hellenistic."

The question is, what has all this to do with Rome? The Etruscans and Romans were exposed very early to influences from the Greek world. Although cultural and commercial contacts between Greek southern Italy and Rome had been fruitful and long-standing, it was from 280 BCE, when the Greek general Pyrrhus invaded southern Italy and Sicily, that the Romans became more directly involved, militarily and politically, with their neighbors to the south. Roman expansion southward also notably brought Rome into conflict with Phoenician Carthage in North Africa. Two protracted "Punic" wars between Carthage and Rome in the third century BCE left

2.1 Map of Alexander the Great's conquests. This shows how his empire spanned from the Mediterranean to the borders of India.

the latter, in 201 BCE, pre-eminent in the west, and primed for making further conquests.

This brought Rome into contact with the Hellenistic kingdoms, over which victory came with incredible speed. By 189 BCE, both Philip V of Macedon and the Seleucid king Antiochus III had been defeated. By the time Philip's son and successor, Perseus, was crushed at the Battle of Pydna in Macedon by the Roman general Lucius Aemelius Paullus (168 BCE), it was already standard procedure for the Roman senate to intervene and resolve disputes among Hellenistic kings. It was clear enough where the real power lay. After this, there were frequent revolts against Rome's increasing dominance, and no shortage of chances for Roman generals to enjoy victory; in fact, the final piece of the Roman empire would not be in place until the annexation of Egypt after the death of Cleopatra in 30 BCE (see The Second Triumvirate and Civil War, p. 109). Nevertheless, the fact that the Mediterranean was under Roman control for most of the last two centuries of the first millennium BCE was never seriously in question.

Conquest and Culture

In response to the early exposure to influences from the Greek world, as we have seen, the Etruscans and Romans enthusiastically adopted many trappings of Hellenic culture, including art. They were, therefore, Hellenized long before Alexander ever picked up a lance, but the events of the Hellenistic period raise new questions regarding Rome's changing relationship with the rest of the Mediterranean world. Was Rome, as conqueror, exposed to art in different ways than it had been previously as consumer? Did Romans come to use sculpture, painting, and architecture differently? Are these developments reflected in the monuments and objects themselves?

The answer to the first question is a resounding affirmative, if one accepts the Romans' own comments on the matter (see box: The Reception of Greek Art in Rome). The **triumph** was a Roman custom whereby a victorious general would parade through the city of Rome with

The Reception of Greek Art in Rome

The writer Plutarch (45–127 CE) draws the following comparison between triumphs celebrating the defeat of two Greek cities that sided with the Carthaginian general Hannibal during his extended campaign in Italy. The generals in question are Marcus Claudius Marcellus (c. 268–208 BCE), who sacked Syracuse in 211 BCE, and Quintus Fabius Maximus (c. 280–203 BCE), a victor over Tarentum, in 209 BCE:

> When the Romans recalled Marcellus to the war with which they were faced at home, he returned bringing with him many of the most beautiful public monuments in Syracuse, realizing that they would both make a visual impression of his triumph and also be an ornament for the city. Prior to this Rome neither had nor even knew of these exquisite and refined things, nor was there in the city any love of what was charming and elegant; rather it was full of barbaric weapons and bloody spoils...For this reason Marcellus was even more respected by the populace—he had decorated the city with sights that both provided pleasure and possessed Hellenic charm and persuasiveness—while Fabius Maximus was more respected by the older Romans. For Fabius neither disturbed nor carried any such things from Tarentum when he took it, but rather, although he carried off the money and other valuables of the city, he allowed the statues to remain, adding this widely remembered remark: "Let us leave," he said, "these aggravated gods to the Tarentines."
> (Plutarch, *Life of Marcellus* 21, tr. J. Pollitt)

Plutarch goes on to explain how the older Romans blamed Marcellus for bringing to the Roman people a "taste for leisure and idle talk," while Marcellus himself boasted to have taught the Romans to "respect and marvel at the beautiful and wondrous works of Greece."

The polarities in Plutarch's passage (between Marcellus and Fabius, refinement and rudeness, Hellenism and *romanitas*, new ways and old) were commonplace by his own time (c. 100 CE) and are traceable to the political rhetoric of the late Republic. At stake in this debate was the conflict between change and resistance to change in a Rome that was at the same time profoundly conservative and yet radically transformed by the extension of its hegemony across the Mediterranean world.

his troops, captive enemies, and spoils of war. Passages from ancient sources that describe early triumphs follow a recognizable pattern. Regarding the celebration of victory over Pyrrhus and the Greek city of Tarentum in southern Italy in 275 BCE, the historian Florus, writing about five hundred years later in the second century CE, claimed nothing like it had been witnessed before:

> Prior to this you would have seen nothing but the cattle of the Volsci, the flocks of the Samnites, the wagons of the Gauls, and the shattered armor of the Sabines, but on this day…you would have seen richly adorned statues of gold and charming Tarentine panels.
> (Florus, *Epitomae* I.12.26–7)

By the end of the century, these displays became commonplace, indeed expected, and Romans were already debating their impact and appropriateness.

2.2 Alexander the Great battling on horseback, Naples, 1st century BCE. Bronze. H. 49 cm (1 ft 7⅓ in.). Scholars have used this statuette and others in its group to seek correlations with Metellus's larger group at Dion.

Roman "Museums" of Greek Art

The triumph was unsurpassed as a spectacle, but for the Roman viewer its content, including the artworks, was but a passing parade. There were opportunities for greater scrutiny during the permanent public display of these spoils in buildings funded by the victories that brought them to Rome. For example, Quintus Metellus Macedonicus (c. 210–115 BCE), who celebrated his triumph over Macedonia in 148 BCE, surrounded a pair of temples (to Jupiter Stator and Juno Regina) with a colonnaded enclosure (**portico**) that teemed with Greek sculpture from his vast triumphal booty. This display included statuary by two of the most famous masters of Classical Greece—Phidias from the fifth century BCE and Praxiteles, from the fourth—and others from the succeeding Hellenistic period, complementing cult statues by Greek artists from the time of Metellus himself in the temples.

The artistic centerpiece of the complex was the group representing Alexander and twenty-five of his "companions," cast in bronze by Lysippus (the most eminent sculptor of Alexander's era) and set up in the sanctuary to Zeus at Dion (near Mount Olympus) to commemorate the death of these twenty-five loyal Macedonians at the Battle of the River Granicus. No trace of the sculpture remains, and we do not even know if the heroized were depicted in battle or as a group of more static equestrian statues, but many scholars have sought reflections of the group in small Roman bronzes [2.2]. The symbolism of Metellus's choice is obvious. By elevating the Macedonians of Alexander's time he glorifies his own conquest of their successors by implication, who were in reality, in Metellus's day, hardly able to resist any Roman army. In this way he follows the lead of Hellenistic kings; for example, Attalus I of Pergamon, who in the later third century BCE commissioned heroizing statues of the Gauls who he had defeated, similarly embellishing the significance of his victories [2.3].

Beyond the commemorative function of the portico that Metellus had built, one cannot miss its impact as a museum. Greek art had been imported to Italy for centuries, but it had been mainly limited to pottery and other portable objects. There had never been anything in Rome coming close to this gathering of Greek bronze and marble masterpieces, by the most famous of Greek artists, representing four centuries of development from the time of Pericles (c. 495–429 BCE) to that of Metellus, and made available to view all at once rather than over many generations. How the average Roman viewer may have made sense of this visual assortment we can only guess, but later writers, such as Marcus Tullius Cicero (106–43 BCE), Pliny the Elder, and Quintilian (c. 35–100 CE), provide some insight.

2.3 **The Ludovisi Gaul, Rome, 1st or 2nd century CE. Marble. H. 2.11 m (6 ft 11⅛ in.).** This Roman group of a Gaul killing himself while supporting the figure of a dying woman is thought by some to copy an original at Pergamon.

CHAPTER 2: REPUBLICAN ROME AND THE HELLENISTIC WORLD: TRIUMPH, COMMEMORATION, AND PUBLIC ART

Roman Histories of Greek Art

While we can discover much about Etruscan and Roman attitudes toward Greek art from close observations of the ways in which they incorporated Greek features into their own works, there is much also to learn from what Roman writers have to say on the topic. For sheer quantity of information, no source approaches Pliny the Elder, a Roman scholar and aristocrat who perished in the eruption of Vesuvius in 79 CE. His *Natural History* provides an extensive list of sources, including histories of art written by Greeks (artists themselves); the most famous were the sculptors Antigonus, Xenocrates of Sicyon (both third century BCE), and Pasiteles (first century BCE). From consulting these works, Pliny became aware of two different traditions concerning the development of Greek art, and the stage that should be considered the "peak" of achievement. Both Antigonus and Xenocrates pointed to the late fourth century BCE, or the period immediately preceding their own; Pasiteles, however, who was much later, most admired the earlier works of the mid-fifth century BCE. In keeping with the inclusive nature of his scholarship, Pliny draws from both traditions. "No better work than the Phidian Zeus was ever made," he notes of the giant fifth-century sculpture at Olympia, in Greece; and Polycleitus "is deemed to have perfected this science of statuary just as Phidias is considered to have revealed it."

Yet his treatments of third-century BCE artists Lysippus and Praxiteles are equally laudatory, and after their participation in the hundred-and-twenty-first Olympiad (295–292 BCE), he notes, "*cessavit deinde ars*" ("then art disappeared"). Art history begins, it seems, when art ends.

Rhetoricians, such as Dionysius of Halicarnassus, Cicero, and Quintilian, focus more on matters of style in their analyses of Greek sculpture. These "rhetorical analogists" use visual art's ability to immediately engage a viewer to discuss the artist's communication style and the persuasiveness of the works considered. Dionysius is especially emphatic in his assertion that the styles of individual craftsmen, whether they are painters, sculptors, or orators, are distinctive and distinguishable to the connoisseur, who is presumed to be a practitioner of the same art. A more straightforward art history occurs in the work of the other two authors, each of whom clearly notes a sequence from "harder" to "softer" forms as one moves from the early fifth century BCE to its middle years. Later artists are praised for delicacy and grace (end of the fifth century BCE) or realism (fourth century BCE). For both Cicero and Quintilian, the era of bloom occurred in the mid-fifth century BCE, characterized by the works of Polycleitus and Phidias. The fact that their view is shared by Plutarch, whose affinity with the Classicism of the **Second Sophistic** (a term used to describe Greek rhetoricians writing from the first to the third centuries CE) is clear, suggests that it was rooted in a shared appreciation of the persuasive power not only of the orators of High Classical Greece, but also of its sculptors.

How, then, does this help us assess the importance of Greek features in Roman art? First of all, educated Romans were well versed in the development of Greek art, the names of masters, and the masterpieces attributed to them. Second, they were exposed to different views of when an actual "floruit" (the historical period during which something or someone flourished) had taken place within this arc of development, which partially explains why artists at that time drew inspiration from styles of all periods. Third, and most important, is the contribution of rhetorical analogists, such as Cicero and Quintilian, who teach that style in art, like style in rhetoric, was about supporting the ideas that the work of art is meant to convey. The style or styles that can be made out in a sculpture or painting therefore have more to do with its intended meaning than with the tastes or preferences of its era, or any other factor. This is the primary reason why a history of Roman art framed around a pattern of strict stylistic development (as we can construct for Greece) is impossible to write.

The Triumph and Republican Temple Architecture

Many temples in Republican Rome commemorated victory, and their sites lay on the triumphal route. The Porticus Metelli complex [2.4] is a typical example, located as it is in the southern part of Rome's Campus Martius, named "Field of Mars" for its dedication to the god of war, Mars, and its early usage as a training ground for troops. Just outside the official, and sacred, boundary of Rome (*pomerium*), this was where triumphal processions first assembled, before entering the city through the gate known as the Porta Triumphalis, somewhere between the Capitoline hill and the Tiber. Since the Campus Martius enjoyed high public visibility, it became an area of intense building activity, as a series of generals vied for political status and public support.

The Porticus Metelli, and the temples it contained, are termed **manubial**, from the Latin *ex manubiis* ("from the spoils"), which refers to a building pledged by a general before battle, and then paid for from his share of the spoils of victory. Such structures stem from a broad tradition of private citizens commissioning public building that was deeply rooted in the political practice of a Roman Republican government. Power lay in the hands of the senate and a handful of annually elected officials. The achievement of certain offices carried with it admission to the senate, membership in which was a privilege jealously guarded by a small number of powerful families. Achievement of political prestige, which was the primary life goal of the Roman nobility, depended on both birth and reputation, both of which were, in turn, connected with military record. The path to public eminence (*cursus honorum*) was clear: first came service as a military **legatus** (junior officer); then election to lower office, such as quaestor or treasury magistrate (therefore securing senate membership); thereafter successful candidates would occupy a series of offices and have other opportunities to display military prowess. The ultimate goal was to be elected consul, or at least praetor, with a military command (*imperium*) during the year of office and/or immediately following—the surest path to power and prestige.

Critical to the entire process, not only in securing one's own career, but also to smooth the way for one's children, was public generosity, which took a wide variety of forms, as appropriate to the office occupied. For instance, an aedile might fund a temple or gladiatorial games, or other forms of entertainment that had a quasi-religious association. Other magistrates sponsored such public works as roads and aqueducts, as well as great public buildings, such as basilicas. During the empire there was a particular emphasis on structures that were designed to contribute directly to the enjoyment of the people: theaters, amphitheaters, markets, libraries, and baths, for example. Previously, during the Republic, there seemed to have been some nervousness about this practice being exploited for self-promotion, so the manubial buildings most often constructed were temples. Such a temple would function both as a location for religious activities, and as a public victory monument, all the more so since it would usually bear a large inscription naming the benefactor and the occasion of his triumph, an enduring billboard visible to every worshiper who approached the building.

2.4 **Plan of the Porticus Metelli, Rome, Italy.** A classic example of a temple set up to commemorate a victory.

CHAPTER 2: REPUBLICAN ROME AND THE HELLENISTIC WORLD: TRIUMPH, COMMEMORATION, AND PUBLIC ART

2.5 Remains of the Largo di Torre Argentina, Rome, Italy, from the 3rd to the 1st centuries BCE. The square contains four Republican manubial temples and the Theater of Pompey.

LARGO ARGENTINA

A short distance to the northwest of the Porticus Metelli, the best-preserved complex of Republican manubial temples in Rome is still visible in the Largo di Torre Argentina (or Largo Argentina) [2.5 and 2.6]. Four temples can be seen, designated A-D. The superstructures of all four temples were rebuilt in imperial times, but study of the paving levels and excavated remains has allowed archaeologists to assign a relative sequence. Temples C, and, slightly later, A, are the earliest, probably from the third century BCE.

Both represent a typical single-cella temple of Tuscan type, with a high podium, deep colonnaded porch, lateral columns, and strictly frontal orientation. Between the two was inserted, as late as around 100 BCE, Temple B. Later than the Porticus Metelli temples, this round, **peripteral** (with a single row of pillars on all sides) temple displays a heavy influence from the increasingly popular Greek architectural forms of the late Republic, although it is placed on a high podium with a front porch, in keeping with Italic tradition. The visible podium of Temple D—the largest of the four, incompletely excavated, and the least well understood—dates to around the same time as Temple B, but its platform incorporates the remains of a much earlier predecessor, at least as old as Temples A and C. The conservative design of Temple D was perhaps chosen to preserve some of the features of its predecessor.

All four temples were aligned along a route probably taken by the triumphal procession as it approached the city entrance. There is no agreement as to who these temples were dedicated to, but literary sources mention many

2.6 Plan of the Largo di Torre Argentina, from the 3rd to the 1st century BCE. (Right to left) Temple A was possibly a temple of Juturna; Temple B is a circular *tholos* temple; Temple C is the oldest; Temple D, the largest, may have been vowed by a praetor, Lucius Aemilius Regilius, and dedicated by Marcus Aemilius Lepidus when he was censor.

PART I: ROME AND ITALY BEFORE THE EMPIRE

such dedications, and scholars have proposed various identifications. Most widely accepted is the association of Temple B with the Temple of Fortuna, erected by Quintus Lutatius Catulus (149–87 BCE) to commemorate his victory over the Cimbri tribe at Vercellae in northern Italy in 101 BCE. In actual fact, the credit for the victory was awarded not to Catulus but to his colleague Gaius Marius (157–86 BCE), but Catulus built the temple anyway, illustrating both how these powerful individuals were jockeying for position at the turn of the first century BCE, and how they were using architectural commissions to achieve their aims.

TEMPLES BY THE TIBER

The route of the Roman triumph is a point of scholarly dispute, but it likely started on the Campus Martius and passed the temples in Largo Argentina (opposite) and the Porticus Metelli (later of Octavia), a structure that is explicitly named in ancient accounts of the parade. From there it should have continued, on its way to the Circus Maximus, through the area between the Capitoline and Palatine slopes and the left bank of the Tiber, just where legend has it that Romulus and Remus were rescued as infants. This area comprised several busy places of commerce, including the cattle market, vegetable market, and probably a banking facility as well [2.7]. It was also home to a cluster of Republican temples, conspicuous to both the periodic audiences of the triumphal route and the daily crowds of shoppers.

The mid-Republican successors to the Archaic temple at Sant'Omobono (see pp. 45–46), dedicated to the goddesses Fortuna and Mater Matuta, looked over this area from the lower slope of the Capitoline. At its northern end lay the vegetable market (Forum Holitorium), where sources record four more manubial temples, also dating to the middle of the Republic. Substantial

2.7 Plan of the Campus Martius and the surrounding area during the Republic, 2nd to 1st centuries BCE. This shows some key buildings on the route of the triumphal procession, as well as the Forum Boarium, or cattle market, and the Forum Holitorium, the vegetable market.

2.8 (Right) San Nicola in Carcere, Rome, Italy, 2nd to 1st century BCE. The church includes the remains of three Republican manubial buildings.

2.9 (Below) Temple of Portunus, Rome, Italy, 80–70 BCE. Tuff, travertine, and stucco. A Republican manubial building near the Forum Boarium. Its deep porch, with freestanding columns, references Tuscan styles while the columns themselves are in the Ionic order.

remains of three of these are clearly visible today, incorporated into the church of San Nicola in Carcere [2.8]. Far better preserved, indeed the best-preserved examples of Republican triumphal building in the city, are two structures that stand further south in the cattle market (Forum Boarium). Both were transformed into churches in the Middle Ages, preserving their material sufficiently to allow us to visualize their early appearance after the removal of later additions.

The southern of the two [2.9], dating to the early first century BCE, was probably dedicated to Portunus, a god of the port, or perhaps ferry crossing, as suits its location next to the river. Built of local stone in the Ionic order, the temple proper stands on a high podium, approachable only by a staircase at the front. In front of the cella are six freestanding columns, four on the facade and two flanking the porch, while the remainder of the exterior columns are **engaged** (embedded in the wall) and purely decorative. The podium and frontal orientation, accentuated by the deep porch with its freestanding columns, are features taken from the "Tuscan" temple tradition, while the Ionic order, stone construction, and "pseudo-peristyle" effect are in accord with Greek architectural styles. This blending of traditions, seen already in Temple B in Largo Argentina, is particularly striking here.

A second temple in the cattle market represents a somewhat different architectural tradition [2.10]. It is a round temple, in the Corinthian order, built in the later second century

2.10 Temple of Hercules Victor, Rome, Italy, c. 140 BCE. Pentelic marble. The temple was rebuilt in the early empire and, in contrast to those of its neighbors, its plan is purely Greek.

BCE from Greek Pentelic marble from Attica. The structure is placed on a low platform, and stepped for access all the way round, according to a general plan known in Greece at least as early as the later Classical period, when round temples and sacred **tholoi** (a *tholos* is a round building, not necessarily, or even commonly after the Bronze age, a tomb) were built in a number of sanctuaries. Circular temples were far from unknown in Rome, however. The temple dedicated to Vesta in the Republican forum, one of the oldest cult areas in the city, had been round in shape since it was originally built, whether in the eighth or sixth century. These Italic round temples, such as Temple B in Largo Argentina, stood on high podia and were approachable only from the front, in the same way as their rectangular counterparts, even when they had been "adapted" to incorporate a Greek architectural order. The Hercules temple by the Tiber is, however, an entirely Greek structure—in material, plan, and elevation—set up in the city of Rome.

Once believed to be a temple to Hercules Olivarius (the Olive Merchant), it is now thought more likely to be the temple to Hercules Victor, built by Lucius Mummius Achaicus from the gains of his triumph over the city of Corinth in 146 BCE. Mummius was not of aristocratic birth, and was notorious for a lack of sophistication:

> When he was arranging for the transportation to Italy of paintings and statues, which were masterpieces by the hands of the greatest artists, he warned those in charge of the transportation that if they destroyed any of the statues and paintings, they would have to replace them with new ones.
> (Velleius Paterculus, *Short History* I.13.4)

The Greek plan, Greek marble, and even Greek masonry style of this temple seem not simply vague references to current fashion, but rather a direct allusion to Greece, and to particular structures found there; for example, a direct comparison in masonry style to the Hieron at Samothrace has been made by one scholar. This enhances its effectiveness as a triumphal monument both by referencing the object of his victory and compensating for his lower-class background. Mummius is often mocked for his comment, but perhaps he understood well the abilities of late Hellenistic artists and architects to re-create the forms and styles of the Hellenic past.

2.11 Temples at Tivoli, Italy, early 1st century BCE. The temples sit above the gorge of the River Aniene.

TEMPLES AT TIVOLI

Temples of this sort were not limited to the city of Rome itself, but were erected throughout the area brought under Roman control during the Republic. A comparable pair of round and rectangular temples are preserved at Tivoli (ancient Tibur), perched dramatically above the gorge of the River Aniene (Anio), an important water source for Rome after the construction of an acqueduct (Acqua Anio Vetus) following the victory over Pyrrhus [2.11]. It is not known to which deity the better-preserved round temple was dedicated; its popular name today is the "Temple of Vesta." A certain Lucius Gellius is named on the temple's inscribed architrave as being responsible for its construction (or reconstruction). It is roughly contemporary with the two temples in the Forum Boarium, yet its differences from the Hercules temple are significant [2.12]. While its Corinthian **peristyle** in pure white marble gives it something of a similar effect, it employs the Italic high podium and frontal orientation. The frieze of the Tivoli temple is carved with garlands strung from ox heads, a variation of a vaguely cultic decorative motif used extensively in Hellenistic and, especially, Roman architecture, sculpture, mosaic, and painting. Most striking of all, however, is the construction of the cella walls, using neither masonry nor stucco but concrete. Concrete is a material that was invented and developed by the Romans, and this innovation permitted them to bring about what was no less than an architectural revolution.

2.12 The Temple of Vesta, Tivoli, Italy, early 1st century BCE. The cella of this temple is constructed from concrete.

SANCTUARY OF FORTUNA AT PRAENESTE

Perhaps the most ambitious use of concrete in religious architecture of the Roman Republic is to be found in the so-called theater temples erected in a number of Latin towns, including at Tivoli. Yet by far the most elaborate is the sanctuary dedicated to Fortuna Primigeneia (first-born goddess of fortune) in the hill town of Praeneste (modern Palestrina), about twenty-three miles from Rome. This was a town of major prominence in early Latium, the site of spectacular orientalizing tombs, and the source of many Classical and Hellenistic engraved bronzes, including the Ficoroni *Cista* (see 1.32, p. 41). Still wealthy in the first century, Praeneste had—despite the sanctuary—the bad fortune of siding with Gaius Marius during the civil war of 83 BCE, which ended in his defeat by Lucius Cornelius Sulla (c. 138–78 BCE), a rival for power (see p. 102). Once victorious, Sulla sacked the town but then proceeded to restore the sanctuary, since he was especially devoted to the cult of Fortuna (his cognomen was *Felix*: the fortunate). For the most part, however, the plan of the complex is believed to predate Sulla, going back to the second century BCE.

The sanctuary [2.13] was built over in the Renaissance, but most of its remains were exposed following bombing of the modern town

in World War II. This revealed that the sanctuary was terraced up the hillside, according to a rigidly symmetrical and strictly frontal organizational scheme. At the very top was the small, round temple to Fortuna, behind a semicircular portico; immediately below it was a small theatrical seating area, *cavea*, providing space for performances connected with the cult, and giving this building type its name. This level is carried on a **barrel-vaulted** platform in front of which extends a colonnaded court on another vaulted platform, an arrangement that continues in a sequence of vaulted terraces down to the base of the hill. The concrete vaulting here provides the most extensive and impressive remaining example from pre-imperial times; the facings made with *opus incertum* (see box: Concrete, p. 62) are particularly well preserved [2.14].

One would approach these upper terraces through covered ramps, rising from each side to a small central platform about halfway up, where the visitor suddenly emerges from the darkness, and pivots ninety degrees to face a long narrow staircase, slicing through the center of the sanctuary to the *cavea* and temple looming above. This use of architecture to evoke an emotional response is purely Hellenistic; visitors pass through a dark corridor into a vast unroofed interior. The arrangement of a sanctuary on several colonnaded terraces, as in the Temple of Apollo at Didyma, was also a Hellenistic commonplace, as we see, for example, at Kos or Pergamon, but in these Eastern examples the elements are more organically integrated into the natural terrain. The architect of the sanctuary at Praeneste worked in the Italic style, favoring height, bilateral symmetry, and **frontality**, and aggressively imposed the temple plan on the terrain, just as Rome imposed Roman rule on the Mediterranean.

2.13 Reconstruction of the Sanctuary of Fortuna at Praeneste, Italy, 120 BCE. At the top of the complex was the temple to Fortuna, below which was a *cavea*, which provided room for performances related to the cult.

2.14 Concrete vaulting of the Sanctuary of Fortuna, Praeneste, Italy, c. 120 BCE. This is the most striking existing example of this building method from before the empire.

CHAPTER 2: REPUBLICAN ROME AND THE HELLENISTIC WORLD: TRIUMPH, COMMEMORATION, AND PUBLIC ART

MATERIALS AND TECHNIQUES
Concrete

Complexes in such a style as the one at Praeneste were made possible by the Romans' mastery of vaulted roofing systems and concrete construction. A vault takes the form of a continuous curve from support to support, distributing its own weight, and any weight it bears, from itself to its supports on the sides, thus reducing the natural weakness at its center. Use of these vaults allowed architects to roof far larger uninterrupted interior spaces than could be done with traditional **post-and-lintel** construction. Early Roman and Etruscan (and occasionally Greek) masons constructed arches using *voussoirs* (stones cut into a trapezoidal shape), laid in tightly fitting courses around a temporary support. Once completed, the thrust of each stone against the other held everything in place, and the centering structure could be removed. The types of vaults that the Romans developed are the barrel vault (linear extension of an arch), **cross vault** or groin vault (intersecting barrel vaults), and *dome* (extension of an arch around its vertical axis) [**2.15**]. Variations and combinations of these forms constituted the most characteristic development of Roman architecture from the Republic into, and throughout, the empire.

The Romans were able to exploit the potential of vaulted forms far more fully than any previous culture because of their expertise in the use of concrete. Roman concrete was not poured, like its modern counterpart, but laid similarly to stone masonry, in courses. These were not of blocks, however, but of roughly hewn (or unhewn) material of various substances (aggregate), bound together with a mortar comprised of sand and burnt lime [**2.16**]. To protect and beautify this rough material, a layer of wall facing was applied together with the aggregate and mortar, within a structure of wooden panels (form) that held the material together until it set, at which point the concrete became structurally one large mass. Concrete was therefore a far more fluid and flexible medium than quarried stone, and so its use allowed Roman architects and builders to introduce curves into their building—in walls, ceilings, and roofs—more extensively than ever before, and as a result to define large and highly complex interior spaces. Concrete also had the advantage of being highly practical. The materials used to make it occurred in relatively small pieces, so transport costs were a fraction of those for a marble temple, which required huge blocks of stone. Much of the aggregate, and some facing materials, could even be salvaged from the ruins of earlier buildings, keeping expenses down further. Only the fine volcanic sand (pozzolana)—enabling the mortar to harden firmly underwater—needed to be quarried and transported to the building site, from Puteoli (modern-day Pozzuoli) on the Bay of Naples.

Different types of facings were developed over time, and these can help in assigning dates to buildings. The earliest facings were made of stones flattened at one end and laid in one of two styles: in *opus incertum*, whereby the stones are arranged more or less haphazardly as the shape of each allowed; or in *opus reticulatum*, in which the facing stones are cut into roughly regular squares at the facing end and laid in a diamond pattern resembling a net. During the early empire, broken roof tiles (**testae**) began to be used as wall facing (*opus testaceum*) and, not long after, bricks were manufactured for the purpose. The exterior surface of a concrete construction, however, is generally not very attractive. The bricks themselves were, at times, arranged into a form of architectural decoration, but for the most part concrete facing was covered up. As we will see in subsequent chapters, the possibilities for doing this—using painted plaster, modeled stucco, colored marbles, or mosaic—were practically endless.

2.16 Concrete allowed architects to introduce curves into their buildings. Roman concrete was comprised of aggregate, a mortar of sand and burnt lime, and was finished with a wall facing.

2.15 Artist's impression of Roman concrete vaults. (Clockwise, from left) The barrel vault is a single curve joined on each side. A cross or groin vault involves the intersection of two or more barrel vaults. A dome is an arch, extended and rotated around its vertical axis.

TRIUMPHAL PAINTING

While a temple financed from the spoils of war can recall the military action that produced those funds, nothing engages the viewer more directly than an explicit depiction of the event commemorated, or of ceremonies held in celebration of it. Greek gathering places had many buildings and monuments financed by war booty, but only in a very few instances would one find actual battles represented on them. This practice changed somewhat during the time of Alexander and his followers, as seen in the Granicus monument (see p. 53). At the same time (305 BCE), commemorative wall paintings were displayed, ostensibly for the first time, in the Temple of Salus, built *ex manubiis* (from spoils) by Gaius Junius Bubulcus. It is not clear what these paintings, by the artist Fabius Pictor, depicted, although judging from later practice, they likely contributed to the temple's purpose in memorializing Bubulcus's success in the Samnite wars in central and southern Italy.

As Roman power extended first throughout Italy and then across the Mediterranean, commemorative paintings became more common. Triumphal processions included a display of painted images that depicted the victory being celebrated. These found their way to public exhibition, often in a manubial temple dedicated by the victor but sometimes in the senate house or elsewhere in the forum. Pliny the Elder mentions (*NH* 35.23) a certain Lucius Hostilius Mancinus, who advertised his role in Rome's defeat of Carthage in 146 BCE by "displaying in the Forum a picture of the plan of the city (i.e. Carthage) and of the attacks upon it and by being present himself and describing to onlookers the details of the scene; in this way he secured success in the next consular election." In addition to the paintings presented in the triumphal procession, commemorative mural and panel paintings were also commissioned. The subject matter of these images was not limited to battle scenes. Depictions of the triumph itself have been mentioned, appearing at least as early as the first scenes of military victory. In either case, paintings of this sort re-emphasized the self-promotion that was intrinsic to the manubial buildings in which they were exhibited.

Although sources have much to say about these early paintings, there is very little physical evidence for what they looked like. The François Tomb, discussed on pp. 33–36, includes the depiction of a man in triumphal garb, as well as labeled paintings of historical battles; these latter, however, do not show the wars fought by the occupant of the tomb but, more probably, those of his illustrious ancestors. Closer parallels might be found in a few Roman tomb paintings from as early as the third century BCE, which depict scenes of battle and triumph, as well as funerary processions. Primary among these is a fragment of painting from a Roman tomb on the Esquiline hill in Rome [2.17]. The preserved section of the composition consists of four superimposed figural

2.17 Fragment of fresco from a tomb on the Esquiline hill, Rome, Italy, 3rd century BCE. H. 88 cm (2 ft 10³/₄ in.). The fresco depicts a battle taking place in front of a fortified town.

CHAPTER 2: REPUBLICAN ROME AND THE HELLENISTIC WORLD: TRIUMPH, COMMEMORATION, AND PUBLIC ART

friezes, each approximately a foot in height. The two central bands are best preserved, and each features a two-figured grouping of a warrior and a **togate** (toga-wearing) magistrate, filling the full height of the space. The action in the upper of these two compositions takes place in front of a fortified town, with figures looking down over the tops of a crenellated (featuring battlements) wall. The preserved section of the bottom register shows a group of soldiers in the act of defending their fortified position. The scenes are all consistent with the theme of warfare, showing battles, sieges, and, most probably, the conclusion of treaties between the combatants. Painted inscriptions identify the central protagonists in both treaty scenes as Fabius and Fannius. The date of the painting, however, depends on identifying the exact wars depicted. Studies of the weaponry and clothing have led some to identify scenes from the Samnite wars of the late fourth and early third centuries BCE, in which, it is known, members of the Fabius family were involved; others have favored a second-century date, but both theories correspond to the time period of the triumphal paintings mentioned in the literary sources.

Despite the poor preservation, it is still possible to detect in the painting a high level of artistic skill. Some treatments of space and scale are artificial and conventional, for example the figures in the upper main band, which are at the same height as the adjacent city walls. But in the band below, the smaller figures to left and right are quite possibly shown in correct **perspectival diminution**, and appear further away; the audience members at right are arranged in the form of a **receding orthogonal**. There are also points of resemblance with Greek art. The main figures are shown with proper Classical weight shift in their bodies, and the composition and figural types in the lowest register recall those shown on the shield of the Athena Parthenos (cult statue of the Parthenon in Athens), a monument that no longer exists, but was much quoted and copied in Hellenistic and Roman times. Lucius Aemilius Paullus, who celebrated his triumph over Perseus of Macedonia in 167 BCE, brought the Athenian philosopher and painter Metrodoros to Rome in order to create his triumphal paintings and tutor his children, so some works were probably the effort of Greek artists. Yet, as we have seen, Roman culture was quite strongly Hellenized by this time, so it is not necessary to assume that these were immigrant craftsmen.

If it is reasonable to conjecture that the composition and figure style of the Esquiline fresco reflects features of some triumphal paintings, these may therefore have been divided into registers made up of larger figures, and juxtaposed with scenes of smaller individuals. These scenes in the fresco may even reproduce the actual triumphal paintings of a noble victor, interred in this tomb. Literary sources suggest that some triumphal paintings had a more panoramic aspect, resembling maps of the conquered lands, and

2.18 The Praeneste Mosaic, Fortuna Sanctuary at Praeneste, Italy, 1st century BCE. H. 4.3 m (14 ft 1 in.). W. 5.85 m (19 ft 3 in.). The floor mosaic is of the Nile and its passage into the Mediterranean. The mosaic shows the Roman fascination with the eastern Mediterranean in the first century BCE.

detailing them with individual vignettes of towns, battles, and sieges. This type of composition, called topographic or chorographic, was developed in the Hellenistic East, especially in Ptolemaic Alexandria. The best-preserved example is a floor mosaic [2.18], found in the Fortuna sanctuary at Praeneste. The subject here is clearly Egyptian; it most probably shows a compressed view of the River Nile, with Upper Egypt (to the south) above, and the delta region of Lower Egypt below. As one's eye reads the mosaic, the scenes begin with the highly populated urban areas, with palaces, temples, and pavilions, which then give way to rocky and mountainous terrain, where figures characterized as sub-Saharan Africans hunt wild and exotic beasts, all labeled in Greek. While the viewer has the sense of looking down, with a bird's-eye view, on the vast expanse of Egypt spreading out before him or her, the individual features of the image are rendered in a fairly consistent lateral viewpoint. It is very probable that a similar style of composition would have been used for some, at least, of the triumphal paintings, in order to capture the sense of geographical scale and topographical range. This particular mosaic is a spectacular artistic achievment, and is another testimony to the fascination the exotic lands of the eastern Mediterranean held for Romans, and those who commissioned artworks—an interest that does not diminish throughout the period of the Roman empire.

Sculpture

While triumphal paintings were being created in Rome, commemoration of Roman victory was taking place in different forms in other parts of the Mediterranean. The tradition of commemorating events by pictorial depiction had a long history in Republican Rome, but the use of sculptured relief for this purpose was very rare before the empire, probably because of the challenges of sourcing the required stone. Indeed, stone sculpture of any form was quite scarce in Italy until full-scale operation of the Luna marble quarries in Carrara, Tuscany (northwestern central Italy) began in the mid-first century BCE. Similarly to the marble portraits and statues already discussed above, the few works in relief that are known from the period in question were carved from imported stone.

MUNICH MARINE *THIASOS* AND PARIS CENSUS RELIEFS

Some of the most important sculptures known from this period of the Republic were found in the seventeenth century in the Campus Martius, near the Circus Flaminius, in the heart of that part of Rome once adorned with manubial monuments. These relief slabs were later dispersed: one set of reliefs is currently in Munich and the other is in Paris. Although the two sets of reliefs were carved from two different types of Greek marble, the correspondence in size, place of origin, and framing elements has led most scholars to consider them as belonging to a single monument, most likely as the base for a commemorative statue or statue group. The Munich reliefs, comprising three sides of the original monument, depict a scene from Greek mythology: the marine *thiasos* (procession) of Poseidon (Neptune) and his bride Amphitrite (Salacia), accompanied by deities and divine beings [2.19]. The style of these figures is highly

2.19 The Munich reliefs, originally from manubial buildings on the Campus Martius, Rome, Italy, late 2nd to early 1st century BCE. Marble. H. 81.3 cm (2 ft 8 in.). One of three panels depicting the procession of Poseidon (Neptune) and his bride Amphitrite (Salacia). The style of the carvings reflects Hellenistic Gigantomachy scenes, for example those at Pergamon.

2.20 The Paris reliefs, originally from manubial buildings on the Campus Martius, Rome, Italy, late 2nd to early 1st century BCE. Marble. H. 81.3 cm (2 ft 8 in.). These originally accompanied the Munich reliefs. They depict a scene of a sacrifice, or *suovetaurilia*, offered to Mars, who is shown as the largest figure, left of the altar.

reminiscent of the dramatic manner of such Hellenistic works as the **Gigantomachy** of the Pergamon altar (see 2.24, p. 69); moreover, the scene itself is paralleled on other Hellenistic works as early as 200 BCE, and forms a part of the **Neo-Attic** repertoire of decorative reliefs (see "Neo-Attic" Sculpture and the Art Market, p. 90).

The Paris section, now in the Louvre Museum, is quite different [2.20]. Much of it is taken up with a scene of sacrifice. Here, the particular sacrifice is of a bull, a ram, and a boar (called the ***suovetaurilia***), which was the appropriate offering to Mars. The god is shown, as on the via San Gregorio pediment (see pp. 69–70), larger than all surrounding figures, standing fully armed next to his altar, just left of center in 2.20. Here, however, there are no other divine figures. A togate figure, shorter only than Mars himself, is shown next to the altar and opposite the god. He appears to be conducting the sacrifice (his head is draped, as in the style of a priest), and so depicts the person who commissioned the monument, and whose acts are being commemorated. Numerous other figures are involved, including the sacrificial beasts with *victimarii* (attendants charged with leading victims to sacrifice), musicians, and various attendants, in addition to the two groups of armed soldiers, who frame the sacrifice at either end.

More specific information as to the nature of this ceremonial sacrifice (called a ***lustratio***) is offered at the far left of the Paris sculpture, where four figures are enacting a scene of testimony and record-making that is almost certainly a reference to the institution of the **census**. The Roman census was undertaken sporadically, and involved the assessment of personal property and the drawing up of rolls of the senate and citizenry, using these lists to assign people to their property classes and voting tribes. The census had clear martial associations, as the voting tribes were also military units, and so it was concluded with a sacrifice of thanks and purification to Mars, the god of war. It is just such a ceremony that is illustrated here. The performance of the census was of paramount importance to Republican governance, and it was entrusted to two censors, who were highly respected statesmen and already experienced in the highest magistracies. To serve as censor meant that one had arrived at the highest level of public office, or *cursus honorum*, so it is no surprise that a monument might be set up to commemorate this position. Since we are told by the ancient sources that no Republican census was conducted after 70 BCE, we can be fairly certain that the reliefs in question depict an event that occurred no later than that.

It is commonplace to cite the Paris-Munich reliefs, as they are now commonly known, as reflecting the collision of two cultures. These reliefs strike the modern eye as displaying a juxtaposition of impossibly dissimilar traditions: one Greek and one Roman. Yet a closer look at the census relief will reveal that it includes many figures in Classical poses. The two scenes are compositionally distinct; the complex intertwining of piscine (fish-like) and serpentine (snake-like) forms of the *thiasos* of the Munich sculpture contrasts with the orderly quality of the census, where each figure is given its own distinct space, lined up, as it were, like ducks in a row. But there is, in the census scene, depth, overlap, and variety of pose. The distinction between the two friezes is to be found far more in subject matter than in style; the compositional principles, as well as the figural types, are drawn from a repertoire that is governed by appropriateness (referred to by Vitruvius as

decor) of image to idea. Here, as we have seen consistently in Roman art of the pre-imperial epoch, style is not nearly so much wide-ranging as it is multilingual, as were the Roman nobles who set up these works in their increasingly sophisticated attempts to align themselves with the values of the Republic.

AEMILIUS PAULLUS MONUMENT

In eastern Greece, in the second century BCE, Perseus (*c*. 212–166 BCE), Philip V's son and successor as Macedonian king, who began to bristle under the restrictions of Roman authority, led incursions into Greece proper, and became, in Roman eyes, unendurably rebellious. After several predecessors had failed to bring Perseus under control, the Roman consul, Lucius Aemilius Paullus, finally defeated him at Pydna in Macedonia (168 BCE). Following this victory, Aemilius Paullus toured Greece in a public reaffirmation of Greek liberty that was, in fact, nothing but a fiction under Roman rule. His travels brought him to Delphi, where, as the story goes, he saw two monuments being erected to Perseus, which he commanded be rededicated to honor himself. One of these monuments can be reconstructed on the basis of existing remains [2.21]; it consisted of a stepped base, tall rectangular **pilaster**, and an Ionic entablature with a sculptured frieze and **dentil cornice**. The whole structure functioned as a support for a bronze equestrian statue. We are not told how close to completion the monument was when it was appropriated and rededicated, so it is not clear how far Aemilius Paullus had it changed from Perseus's original design, and therefore how "Roman" it really was. It is also unknown whether a statue of Perseus ever stood on the pilaster, although one was surely planned. It does, however, seem to have been complete enough to have been, or about to have been, dedicated to Perseus, since the Latin dedication replaces an earlier erased, and now illegible, Greek inscription.

The matter of to what degree the monument was Roman is critical to our reading of its sculptured frieze [2.22], since it is possible to detect here two frequent features of Roman art: historical depiction and sequential narrative. If Perseus had already dedicated the monument, then it should have been complete, and therefore Paullus's contribution would have been limited to adding his own portrait and recutting the inscription. Does the appearance of historical depiction and an implied sequential narrative, however, suggest that Paullus made substantial alterations and/or additions?

2.21 Reconstruction of the Aemilius Paullus monument, Sanctuary of Apollo, Delphi, Greece, 167 BCE. Marble. H. 9 m (29 ft 6 in.). The monument celebrates the victory against Macedon at the Battle of Pydna.

2.22 Aemilius Paullus frieze, Delphi, Greece, *c*. 167 BCE. Marble. H. 31 cm (12¼ in.). The frieze demonstrates Roman styles in showing a historical scene and a sequential narrative, although the figures have Classical, Hellenistic, and Macedonian elements.

Historical depiction is a typical feature of later Roman art, and some art historians believe Aemilius Paullus's monument to be an early Roman precursor to this. On its frieze, the central, riderless horse that flees the fray recalls the literary accounts of the Battle of Pydna, which tell of a conflict begun by a localized fight over a runaway pack animal. The armor and equipment borne by the soldiers is identifiable as Macedonian and Roman, lending a flavor of realism. The battle scenes, however, are, in terms of composition and figural type, highly generic, employing many stock features from earlier Classical and Hellenistic examples. The frieze suggests a narrative, which would imply a development through time. The presence of the riderless horse, and the fact that the dead are shown on one side only, may suggest that some sense of progression was intended. Nevertheless, this reading is ambiguous because, in this frieze, depictions of an individual are not repeated within a single view, meaning there is no "continuous narrative" present, strictly speaking.

Moreover, while a Macedonian shield covers one of the corpses, the picture as a whole does not indicate very clearly which side was to be victorious. Indeed, Perseus himself had enjoyed considerable success against the Romans before his demise at Pydna, and he might just have been bold enough to advertise that fact on his monument. The answer to our questions may remain forever within the realm of opinion and speculation, but the fact that uncertainty exists is instructive, as it demonstrates how the monument dedicated by Aemilius Paullus, a Roman, exists within a strongly Hellenistic pictorial and narrative tradition.

LAGINA, TEMPLE OF HECATE FRIEZE

Another monument that reflects the advent of Rome in the Hellenistic world is the sculptured frieze of the Temple of Hecate at Lagina in Caria (western Turkey). Dating to around 120–80 BCE, this small Corinthian peristyle temple stood within a porticoed precinct, in what had, by that time, become a common arrangement in both Rome and the Hellenistic East. The subject of the frieze from the west side of the temple is a highly traditional and conventional battle between gods and giants; many stylistic features, and even entire figural types, were adopted and adapted from earlier monuments. For example, the figure of Apollo at the center of **2.23** follows very closely its counterpart on the right-hand side of the Pergamon Altar Gigantomachy frieze [**2.24**], where he is labeled "Apollon," as does the torch-bearing goddess standing, as we look at Apollo, to his left, and the snake-legged giants he battles. The other subjects of this frieze are somewhat less clear. Some are interpreted as scenes of myth: the birth of Zeus on the east frieze, for example, or, as one scholar has recently argued, episodes from the *Theogony* of the poet Hesiod.

Several scenes throughout the frieze consist of figures of gods and/or personifications, but they are not clearly participating in the conventional and identifiable activities found on Greek temple sculptures. These scenes are thought to reference contemporary historical events. The north frieze may allude to the treaty between Rome and Caria, concluded in 81 BCE [**2.25**]. A focus here is the **cuirassed** soldier shaking hands with a helmeted female. The latter should

2.23 Lagina, Temple of Hecate frieze, Turkey, 120–80 BCE. Marble. H. 93 cm (3 ft 5/8 in.). The frieze is from a small Corinthian peristyle temple.

stand for Rome herself (Thea Roma), and the former for Caria. The cult of the goddess Roma originated in late Hellenistic Asia Minor around this time, replacing the by now irrelevant or ineffectual cults of Hellenistic monarchs, so her presence here is not surprising. Other allegorical and divine figures in the scene are thought to personify concepts related to the historical circumstances of the alliance being referenced. In mixing the Gigantomachy—the subject most commonly depicted in Greek temple sculpture—with unprecedented topics that directly reflect contemporary events, the Lagina temple blurs the boundaries between myth, allegory, and history. It is Greek and, at the same time, Roman: transitional between two cultures and as a result reflective of its times.

2.24 (Above) Frieze from the Pergamon Altar, Turkey, 180–159 BCE. Marble. H. 2.29 m (7 ft 6 in.). There is significant stylistic crossover between the figure of Apollo, here standing on the right, and that shown on the Lagina frieze.

2.25 (Above) Treaty scene from the Lagina, Temple of Hecate frieze, Turkey, 120–80 BCE. Marble. H. 93 cm (3 ft 5/8 in.). This may allude to a treaty between Rome and Caria in Turkey, concluded in 81 BCE.

VIA SAN GREGORIO PEDIMENT

Meanwhile, in Rome itself, the temples that served in the public celebration of military victory bear sculptured references, too, in addition to any triumphal painting. The best-preserved example comprises a group of terracotta pedimental figures discovered near the via San Gregorio on

2.26 Pediment from via San Gregorio. Found between the Palatine and the Caelian hills, Rome, Italy, mid-2nd century BCE. Terracotta. Mars H. c. 1.25 m (4 ft 1 in.) if restored. The pediment depicts a scene of sacrifice to Mars and two female deities.

the Caelian hill [2.26]. These surely adorned a Roman temple, although it is not certain where this temple stood, to which deity it was dedicated, or when it was erected. The main figures include one togate Roman, three apparent deities, and at least two attendants. The scene seems to depict a sacrifice (fragments of victims survive) performed by a Roman magistrate before the figure of Mars and two goddesses, probably Venus and Victoria. As on the Paris census relief (2.20), the sacrifice itself was probably a purification ritual (*lustratio*), a practice known to have taken place after the conclusion of a military action; the presence of Mars here strongly suggests a triumphal temple. A distinct variation in scale (*victimarii* are smallest, the priest is somewhat larger, and divine figures larger still) both reflects the status of the subjects depicted and allows the composition to fit comfortably within the triangular field of the pediment. The subject seems markedly Roman, given the depiction of sacrifice and other religious rituals, with a similar mixture of human and divine figures, frequently found on many commemorative monuments of the Roman imperial era. Yet while the specific rite portrayed unquestionably follows Roman practice, sculptured representation of worshipers sacrificing before gods, with scale used to signify status, had a long Greek history on not only Hellenistic but also Classical, and even Archaic, **votive** reliefs. Moreover, the style of these figures, including the goddesses' delicate idealized facial features and flowing, high-bound garments, as well as the *contrapposto* poses of the male figures and the powerful torsos of the sacrificial attendants, display a marked similarity to idealized ("Classicized") works of Hellenistic sculpture. This is less probably an indicator of Hellenistic "influence" than of Rome's involvement as a full partner in Hellenistic culture at the time of the building itself, probably before 100 BCE.

Portraiture

In the Greek-speaking East, public portraits of significant individuals were erected as early as the fifth century BCE and became common by the end of the fourth; the images of Hellenistic monarchs were circulated widely by means of statuary, coinage, and other media. This practice was known, as well, in Republican Rome, but

material evidence from this period is scant. As already noted, literary sources describe important public areas of the city thronging with honorific portraits; by the mid-second century BCE, the crowding was such that the senate voted to remove all but those decreed by the state. Most or all were rendered in bronze, so few, if any, survive, as most were melted down for metal in post-antiquity. The only extant examples of individual bronze portraits are the Etrusco-Roman Brutus and *L'Arringatore*, both discussed in Chapter 1, and both of which display an interest in realistic depiction/characterization similar to that seen in Etruscan funerary sculptures, or, for that matter, Hellenistic works. It is reasonable, and useful, to surmise that the legions of lost Roman commemorative portraits were stylistically related to these monuments, but it is impossible to recreate the variety that they may have represented. Other examples of Roman portraiture come much later, in the late Republic, through coins, *imagines*, and marble sculptures.

IMAGINES AND REPUBLICAN PORTRAITS

An *imago* (plural *imagines*) was a wax effigy of an ancestor displayed in a wooden cupboard within the **atrium** or other public area of a noble house. Only ancestors who had achieved a minimum level of public service (apparently the office of aedile) could be depicted in this way. Each *imago* was accompanied by inscriptions (**tituli**), providing the subject's name, and listing the offices, honors, and accomplishments that that individual had achieved. The primary function of these images was to add distinction to the **domus** (in both the sense of house and of family). Membership of the ruling class was very much a hereditary matter, and the more illustrious one's forebears, the better situated one was to succeed in the intensely competitive struggle for prestigious magistracies. The *imagines* were prominently displayed in the very area of a Roman noble's home where clients and colleagues were received; they functioned as a conspicuous reminder of the elevated status that the house's own structure and decoration were designed to underscore (see discussion from p. 76 onward).

Being made of wax, no *imagines* survive; they are known only from mentions in literary sources, especially Polybius (c. 200–118 BCE), who considered them highly realistic. It is possible that some of the monuments we have already considered—Etruscan sarcophagi, *L'Arringatore*, Roman coins—reflect the style.

Polybius on *Imagines* and the Roman Republican Funeral

Polybius, a Greek historian of the second century BCE, informs us that the *imagines* were displayed at the funerals of the descendants of the relation depicted, and worn as masks by individuals who enjoyed a similar physical stature to that of the ancestor. Each "actor" was dressed in the garment appropriate to the magistracy held by that forebear, carried the relevant symbols of office, and was followed by lictors, or whatever accompaniment was given to the rank in question. Each aristocratic funeral was, then, nothing short of a public spectacle, advertising not only the exploits of the deceased but also the antiquity and eminence of the entire family, a glory that was intended to reflect upon its living members. The family, in turn, would be called to take its place in this glorious progression:

> There could not easily be a more inspiring sight than this for a young man of noble ambitions and virtuous aspirations. For can we conceive any one to be unmoved at the sight of all the likenesses collected together of the men who have earned glory, all as if they were living and breathing? Or what could be a more glorious spectacle?
> (Polybius, *Histories* 6.53)

The custom illustrated here reflects the most fundamental values of a *domus*-centered Roman society, and one that will manifest itself in significant ways throughout our consideration of Roman art in the coming pages.

As Polybius is not Roman, his account is particularly valuable because it offers us a different frame of reference from that of the Romans themselves. We especially value his brief comment concerning the style of each of these Roman masks as "wrought with the utmost attention being paid to preserving a likeness in regard to both its shape and its contour."

2.28 Bust of a man, 1st century BCE. Marble. H. 36.5 cm (1 ft 2³⁄₈ in.). This displays a good example of heightened realism, with deep-set eyes, a furrowed brow, sagging cheeks, and a downturned mouth.

2.29 Head of a woman, c. 40–20 BCE. Marble. H. 19.7 cm (7⁷⁄₈ in.). The face shows aspects of the veristic style. The sculpture can be dated by its hairstyle, which was popular from the late Republic up until the Augustan period that followed.

2.27 (Above) Portrait of a patrician, Palazzo Torlonia, Rome, Italy, c. 75–50 BCE. Marble. H. of head and neck 35.5 cm (1 ft 2 in.). The Torlonia portrait is a good example of verism: the lined face probably expresses the virtues of an individual who had served in public office.

VERISM

In addition to the few bronze sculptures and writings of wax *imagines*, there also exist a number of early marble sculptures and marble heads [2.27, 2.28, 2.29] that exhibit a specific Roman style called **verism**. The style tends to emphasize every contour of a face ravaged by time and the unpredictability of life. On the island of Delos, Italian patrons who had settled there had already set up such portraits as the famous "Pseudo-Athlete" [2.30], which places the head of a man—clearly in early middle age, unapologetically balding, and jug-eared—on a nude body of a type often used for the Hellenistic depiction of gods and heroes. A similar example comes from Tivoli [2.31] of a general, who is more modestly depicted with the addition of a draped mantle. His stance is calmly Classical; his powerful torso constitutes a Hellenistic interpretation of Classical musculature. The head, however, is fully veristic, with a furrowed brow, deep creases framing the mouth, and eyes wrinkled with age.

How should we read Roman verism? First, the term itself is to be used with caution. It is useful for describing a style of portrait that does not shrink from depicting features that are eliminated or downplayed in art produced by cultures that value a more idealized portrayal. Yet the word's origin could suggest that the intention was "true" depiction, an interpretation that is not so much false as it is incomplete. Cultural values are paramount: Romans chose to be depicted in this way because an expression of qualities that the Romans held in high esteem was inherent to the style. As we have seen, the *imago* was to represent not only the individual but, as re-emphasized by the *tituli*, that individual's entire public career. The wax mask, therefore, was rendered in a style that reflected both the age and experience of the figure depicted, the facial wrinkles forming, as some have noted, a "map" of the individual's career, or *cursus honorum*. By extension, this style would also have functioned, in and of itself, as a marker of membership in the elite cadre of **nobiles** (descendants of high magistrates, usually consuls), and so of participation in a tradition of such depictions. In this way, it describes its subject in much the same way as a Greek Hellenistic character portrait.

Verism goes further, however, as it also underscores the individuality of the subject. It is here where one sees the power of a tradition that can be traced to early Etruscan times. Italic art (especially funerary art) shows a desire, much more so than Greek art does, to explore variety in the representation of a particular subject.

If **anthropomorphic** representations in Etruscan tombs, such as canopic urns and images atop sarcophagi, were intended as depictions of the deceased, then the need to distinguish particular people is obvious enough. Additional obligations were at play in non-funerary contexts; in Roman society (and no doubt in Etruscan as well) these included the powerful force of competition among the nobility for public office at each stage of a political career. Paradoxically, at the same time that membership in the exclusive ruling class was emphasized collectively by realistic portraiture, individualization itself was a means to separate out one person from the group, as is necessary for successful candidacy. Indeed, the Roman public career is marked by one's success in negotiating the competing forces of needing to belong to and be accepted by the ruling elite, and the need to stand out from it.

During the last generations of the Roman Republic there may have been another factor, and another paradox. Especially after the conquest of the East, there was a new tightrope to walk: that between *romanitas* and Hellenism. It has been well demonstrated that an intimacy with Greek cultural traditions was a marker of membership of the upper class. At the same time, a common trait in Republican rhetoric is the importance of ancestral custom. Verism in portraiture—seen by Polybius himself as a non-Greek trait— was an effective way in which Romans could portray themselves in a traditional manner, operating clearly within the bounds of proper Roman practice, while at the same time openly Hellenizing in their personal lives, as will be seen in the next chapter. While later wielders of political power, such as the Roman emperors, would find their own means to meld the traditions, the importance of verism in Roman portraiture never disappears.

2.30 The Pseudo-Athlete, Delos, Greece, *c.* 100 BCE. Marble. H. 2.25 m (7 ft 4½ in.). The sculpture combines the *contrapposto* of Greek body sculpture and the veristic head of the Roman Republic.

2.31 Portrait of a general from Tivoli, Italy, 75–50 BCE. Marble. H. 1.9 m (6 ft 2¾ in.). This sculpture, with one arm now detached, also straddles two styles, with a Classical Greek idealized body and Republican verism used for the (partly severed) head.

3 Republican Rome and the Hellenistic World: Art of the Roman Household

76	**Evidence from Delos and Vesuvius**
76	**The Atrium House**
79	MOSAICS
82	MURAL PAINTING
86	Materials and Techniques: Linear and Atmospheric Perspective
90	**Domestic Sculpture**
90	"NEO-ATTIC" SCULPTURE AND THE ART MARKET
93	Box: The Mahdia and Antikythera Wrecks
95	Box: Cicero as Collector
98	**Roman and Hellenistic Art**
99	Box: Herculaneum: The Villa of the Papyri

Chronological Overview

DATE	EVENT
171–168 BCE	Third Macedonian War
167 BCE	Delos declared a tax-free port and awarded to Athens
Second century BCE	Wall Painting: First Style appears in Rome
Mid-second century BCE	Mosaics from the House of the Masks, Delos
149–146 BCE	Third Carthaginian (Punic) War
Late second century	House of the Faun
91–88 BCE	Social War; Roman citizenship extended throughout Italy
82 BCE	Sulla named dictator
80 BCE	Wall painting: Second Style appears
Mid-first century BCE	Villa of the Papyri, Herculaneum

The Development of Rome

Right: Map of Rome showing a key area of Rome in this chapter.

Evidence from Delos and Vesuvius

Exposure to the booty brought back to Rome, through public processions and displays, prompted a desire among members of Roman society to own such pieces themselves. The Mediterranean conquest led to improved financial circumstances for many, who were now able to indulge this zeal to acquire art. From the later second century BCE, the town homes and country villas of noble Romans came to be opulently equipped with every manner of decoration: painted walls, mosaic floors, and statues and sculptured objects in metal and marble. Nor was it in Rome alone that such tastes were indulged, reflected in evidence from varied sources: a tiny Greek island, the slopes of Mount Vesuvius, and the floor of the Mediterranean Sea.

On the eve of Aemilius Paullus's victory in 168 BCE, an embassy from the island of Rhodes arrived in Rome to intervene on behalf of the Antigonid king, Perseus, with the aim of bringing peace to the Greek East. When news of the battle at Pydna reached the Roman senate, the Rhodians were badly compromised, appearing now to have wavered in their allegiance. Rome was in no mood to negotiate; her retribution was quick and effective. The Cycladic island of Delos, independent since early Hellenistic times, was restored to Athenian control and declared a free port. After that time Delos attracted much of the commercial activity previously centered on Rhodes, and the latter suffered economic recession as a result. Owing both to its new trade status, and to the inevitable explosion of commerce resulting from the extension of Roman hegemony into the region (most notably trade in slaves), Delos saw an era of unprecedented growth and activity. The result was an influx of non-Greeks; not only merchants from the Hellenistic East, but also entrepreneurial *equites* (members of the wealthy Roman equestrian class) from the Italian peninsula. Delos's economic heyday was short-lived, however, lasting less than a century in all. The island was sacked twice (in 88 and 69 BCE) by enemies of Rome and, as commercial focus shifted to the larger mainland cities that functioned as provincial capitals, Delos sank into decline.

From the ancient remains on Delos, we can see the domestic art of late Hellenistic Greece and construct a rich picture in which the Roman elite began to build lavish homes through their exposure to and appropriation of the artistic tradition they encountered there—this artistic influence also informed and mirrored what was going on in Italy. One example was Lucius Licinius Lucullus (118–56 BCE), a respected and experienced Roman soldier and statesman whose career took him virtually everywhere in the rapidly expanding Roman world. He is best known for the extravagant decoration of his residences, with their extensive use of imported marble columns, paving, and wall **revetments**. The term "Lucullan" became synonymous with conspicuous consumption. This picture of luxury is corroborated by archaeology. The cities of Pompeii and Herculaneum, although frozen in time by the eruption of Mount Vesuvius in 79 CE, also preserve the earlier building stages of enormous and lavish town houses that date back to more than two centuries earlier. We see how Hellenistic art was used by the Romans as a vehicle to promote one's own status and standing in the Republic, and how, in this attempt to influence and impress, private spaces were anything but private.

The Atrium House

Among the ancient Greeks and Romans, the fittings in and appearance of one's home were as much a statement about the occupant as they were about creating a private living space. This statement was not confined to "curb appeal"; the exteriors of houses, in most cases, received very little attention, while interiors were lavishly adorned. These houses had a significant public function as a location for the reception of guests. A visitor's opinion of his or her hosts was important in both Greek and Roman society, but the contrast in form between the Greek and the Roman house seems to reflect a difference in the ways in which the interactions between visitor and host took place.

The Greek house generally had two important public areas, both of which were often marked off by decorative floor mosaics. An open courtyard allowed air and light to enter into a structure that

was principally closed to the outside, while it also facilitated passage among the different rooms. In Classical houses, one or more sides of the courtyard were bounded by a colonnaded portico; in the opulent late Hellenistic Delian houses, this courtyard was relatively large and completely surrounded by columns, forming a peristyle. The other important public space was the dining room (*andron*). Here the head of the household would entertain his colleagues with a symposium: an extended bout of drinking and conversation that served also in affirming the elevated social and political status of host and guests alike. The remainder of the house, often multistoried, was usually less well decorated, and included a kitchen, storage areas, workrooms, bedrooms, and a bathroom.

We marvel today at the opulence of these houses, but it is essential to understand them in the context of an important phenomenon: the centrality of the family in the social and political construction of identity in Republican Rome. The Athenian aristocracy, for example, was certainly family oriented, but business and political interactions were principally conducted outside of the home, in public (aside from the symposium, which is a separate issue), whereas the Roman noble interacted daily with his political peers and dependents within the public areas of his house (*domus*). Moreover, the further a visitor entered into the more personal spaces of the house for purposes of socializing, ever greater levels of equality with the home's owner became established, and so the plan of the house became a virtual map of relative social status. Elaborate decoration throughout the Roman house, therefore, was not a leisurely indulgence but a necessary visual embodiment of the standing and values of the house's inhabitants. And, similarly to the conspicuously displayed *imagines*, it had the ability to highlight one's ever-important family history in no uncertain terms.

Roman houses seem also not to have hidden away women and children in the way that the Greek houses were designed to do; indeed, Greek society had distinct terms for male and female quarters that have related words in Latin, but not equivalents. A Roman family derived its prestige from not only its patrilineal descent but also the mother's family history; marriage was as much a political as a social contract, and women of means could be both prominent and powerful. Additionally, given the hereditary nature of political influence, younger members of the family were promoted at an early age. Continuity was paramount in familial status, so it was to a family's advantage that both crucial elements of its identity—its past and its future—be made observable. Although domestic slaves mostly toiled away, invisibly, in the work areas of the house, which for practical reasons alone would be separated from more ceremonial quarters, they too were a sign of status, and some of the staff would have been visible as they attended to the needs of the family and visitors. The Roman house, when functioning at full force, would therefore have been a bustling space for interaction among nobles, citizens, and servants; men and women; and young and old. The relative status of each individual was defined clearly enough with respect to the others, but this very distinction was reinforced by the form of interpersonal exchange that took place in the house, and that served the purposes of the *domus* as much as the paintings on its walls, or the sculptures in its porticoes.

The Roman house shares many features with its Greek counterpart, but in terms of differences, the most marked of these was in the arrangement of public areas, owing to the much greater extent to which the Roman house was woven into political life. The generic style of a Republican town house, called the atrium house [**3.1**], centers

3.1 Plan of the typical atrium house. Featured are the pool (*impluvium*), *tablinum*, peristyle, portico, and atrium, which organized the political and social life of the household.

CHAPTER 3: REPUBLICAN ROME AND THE HELLENISTIC WORLD: ART OF THE ROMAN HOUSEHOLD

3.2 Plan of the House of the Faun, Pompeii, Italy, late 2nd century BCE. The house occupies an entire city block, with two atria and two peristyles. The villa contained the famous Alexander Mosaic.

on a partially roofed space, open to the sky only in the middle. Beneath this opening, a pool (*impluvium*) was set into the floor, collecting rainwater and functioning as a decorative centerpiece for the space around it. This was the atrium, where the Roman patron could first receive visiting clients and peers. The arrangement of this space was often symmetrical, with the corridor from the front door (*fauces*) aligning with the **tablinum**, which is a large, open room opposite the entryway, flanked on one side or the other by a *triclinium* (public dining room). The *tablinum* served as a repository of family records, and also as a place for receiving guests; here, and in the atrium, the owner displayed the items that he or she wished visitors to see, especially shrines to the family cults, portraits of ancestors annotated with their lives and achievements, and, increasingly, extensive collections of sculpture and other works of art. As in the Greek house, rooms for sleeping, working, and other necessary functions were arranged around, but removed from, the central public space, although the Roman plan usually displays far greater symmetry than the Greek design.

An especially lavish late Republican house, the House of the Faun at Pompeii [3.2], shows how the fundamental atrium house plan could form the core of a larger palatial complex and include many Hellenistic touches. Encompassing an entire residential block (it is, in fact, the largest house in Pompeii), the House of the Faun has not one but two atria that are believed to have distinguished the more elegant public spaces from the comparatively modest private living quarters. Beyond the atria are two separate peristyles, one behind the other. As a design feature, the peristyle itself borrows from the Hellenistic practice,

PART I: ROME AND ITALY BEFORE THE EMPIRE

although since the atrium in a Roman house performed the same purpose as the peristyle in a Greek home (to allow in fresh air and light, and to connect the rooms of the house), the addition of peristyles to Roman houses involved a shift in both form and function. Here, the space surrounded by the colonnade is not a paved court but a formal garden. It is less intended to connect the rooms of the house than to introduce a fragment of nature into an otherwise introspective urban structure—a very Roman trait. In a house deprived of exterior views, an atrium and peristyle can offer a multitude of complex and pleasing interior views, incorporating trees, flowers, and shrubs. Later in this chapter we will encounter many further examples of a Greek artistic model being modified to serve a Roman function.

MOSAICS

The House of the Faun is renowned for its floor mosaics. These are of the so-called tessellated type, created by the setting of small cut rectangular stones (**tesserae**) into a bed of mortar. The resulting paving could be entirely of a single color, could incorporate repeating linear and geometric patterns, or it could include figured scenes, either decorative or narrative in nature. The House of the Faun had floors of each kind, as was common in the wealthier houses, but it is in the figured scenes that we can best detect Hellenistic connections. Figural mosaic itself was a Greek development, beginning with the decorated floors of uncut river stones ("pebble mosaics") in the Classical period, then developing into tessellated mosaics during early Hellenistic times. Many of the subjects encountered in the House of the Faun mosaics have parallels on Delos. A frieze of theatrical masks within a vegetal garland, for example, is found as a decorative border at both sites [3.3 and 3.4], although the much simpler example found at Delos suggests a more highly skilled (and more costly) mosaicist active at Pompeii. Within the same Delian house, the House of the Masks, several other mosaics show greater refinement and intricacy in their execution, such as the panel

3.3 Mask mosaic from the House of the Masks, Delos, Greece, mid-2nd century BCE. The mask is similar to those used in ancient Greek theaters.

3.4 Mosaic from the House of the Faun, Pompeii, Italy, late 2nd century BCE. L. 2.8 m (9 ft 2¼ in.). The mosaic shows theatrical masks interspersed with garlands and fruit.

CHAPTER 3: REPUBLICAN ROME AND THE HELLENISTIC WORLD: ART OF THE ROMAN HOUSEHOLD

formed from extraordinarily small pieces of stone that allow for precise levels of detail and optical effects. At times, a panel (**emblema**) demonstrating this latter technique (**opus vermiculatum**, termed as such for the "wormy" slenderness of the lines of tiny tesserae) is set into a floor otherwise completed using the simpler, rougher technique. It is commonly assumed that these more delicate and pictorial works copy Greek panel paintings, although literary sources and actual finds both suggest that such Hellenistic artisans as Sosus of Pergamon (second century BCE) created equally intricate, and entirely original, works in mosaic. The subjects of his reported masterpieces—scenes of an unswept floor and doves perched on a bronze water basin are described by Pliny the Elder—are repeated often in Roman mosaics that might retain some aspects of Sosus's work.

In the House of the Faun, perhaps the most famous of all ancient floors was found—the Alexander Mosaic—which is an enormous example of vermiculate work [3.7]. The mosaic shows a confrontation between the young Macedonian king Alexander and the Persian king Darius III (381–330 BCE) during Alexander's conquest of Asia. It is generally thought to illustrate an episode from the Battle of Issus (333 BCE), in which Alexander first defeated the Persian forces under Darius's command. Two paintings of this same event, both dating to the late fourth century BCE, are mentioned in ancient literature. Far more, it seems, than a specific historical record, this scene is a dramatic presentation of the encounter between conflicting cultures, contrasting the godlike intensity of Alexander's

3.5 Mosaic of Dionysus on a panther, from the House of the Masks, Delos, Greece, mid-2nd century BCE. H. 1.07 m × W. 1.08 m (3 ft 6¼ in. × 3 ft 6⅝ in.). The finish on this mosaic is particularly intricate.

with Dionysus riding a panther [3.5], which is a subject quoted, and perhaps parodied, in a mosaic from the House of the Faun [3.6].

In Roman houses themselves, we encounter this distinction between slightly cruder mosaics, made up of larger tesserae, and other mosaics

3.6 Mosaic of Eros on a lion, House of the Faun, Pompeii, Italy, late second century BCE. H. 1.63 m × W. 1.63 m (5 ft 4¼ in. × 5 ft 4¼ in.). The mosaic scene shares many similarities with the mosaic at the House of the Masks on Delos.

80 PART I: ROME AND ITALY BEFORE THE EMPIRE

visage with the utter defeat of the Persians, as captured in the terrified aspect of Darius. Moreover, if it is a copy of an early Hellenistic painting, the mosaic provides rare visual documentation of the expertise with which Greek painters manipulated such pictorial devices as light, shadow, reflection, and foreshortening, interests mentioned often by Roman writers, including Pliny. The effects seen in the sharply receding riderless horse, or the dying Persian observing his own face in a glistening bronze shield, extend even to the illusion of three dimensions in the frame. Another border of garlands and theatrical masks (the third in this Pompeian house) further sets off this masterpiece, as did the Nilotic scene on the threshold [3.8], which is yet another allusion to the exotic world of the Hellenistic East. Indeed, scholars often compare the effect of such sumptuous mosaics to that of their modern European equivalent— Oriental rugs—not only because of the similar visual effects of color, texture, and variety, but also for their emblematic function as a reflection of wealth, status, sophistication, and worldliness.

3.7 Alexander Mosaic, House of the Faun, Pompeii, Italy, late second century BCE. H. with border 3.13 m × W. 5.82 m (10 ft 3¼ × 19 ft 1¼ in.). The scene shows the battle between Alexander and the Persian king Darius III. This is an example of *opus vermiculatum*, or mosaic using very small, fine pieces of tesserae.

3.8 Mosaic with Nilotic scene, House of the Faun, Pompeii, Italy, late second century BCE. Total H. 3.3 m × W. 6.6 m (10 ft 10 × 21 ft 7⅞ in.). The scene depicts the River Nile and its fauna, including water birds and crocodiles.

CHAPTER 3: REPUBLICAN ROME AND THE HELLENISTIC WORLD: ART OF THE ROMAN HOUSEHOLD

MURAL PAINTING

We know from literary sources that the practice of wall and panel painting was at least as well developed and highly respected in ancient Greece as marble sculpture, but the number of actual examples of it is mainly limited to a very small group of Macedonian tomb paintings. Roman wall painting, which by comparison is preserved in great quantity, therefore provides much of what we know about the use of the medium in the ancient world, primarily thanks to the finds on the slopes of Vesuvius, in the ruins of Pompeii, Herculaneum, and the surrounding area.

Information concerning the materials and techniques that were used to create Roman paintings comes from both literary and physical evidence. Vitruvius (*De Architectura*, or *On Architecture*, Book 7) provides quite detailed instructions for applying wall decoration, and Pliny (*Natural History*, Book 35) adds further information on pigments. In essence, the process has four steps: 1) prepare the wall surface for application of base coats (the techniques vary depending on the wall material being covered, but the aim is to create a surface to which the next layers will bond); 2) apply layers (Vitruvius recommends three) of lime mortar similar to that used in concrete construction; 3) add (three again) coats of stucco, which is a fine plaster of lime mixed with ground marble or limestone to make it white; and 4) apply pigment, using guidelines incised in the stucco.

By far the most common technique for the painting itself is *buon* (true) fresco, in which water-soluble pigments are applied to a still-moist surface, so that rather than simply bonding to it they become part of it, which results in the remarkable durability of the pigment. Once painted, the surface is then polished smooth with various materials to create a sheen that persists to the present day, preserving very much the appearance it had two thousand years ago. For certain pigments, however, or for adding color to an already finished wall, such bonding agents as egg white (**tempera**) or wax (**encaustic**) were occasionally used, creating *secco* (dry) fresco. Encaustic painting was used as well for the mummy portraits of Roman Egypt, and tempera for the famous wooden panel painting of the Severan family (see 12.8, p. 321)

In Pompeii and Herculaneum, mural paintings follow specific styles through time, which can be seen because one style is painted over another. These have been named as the First, Second, Third, and Fourth Style, following a classification system defined by German archaeologist August Mau (1840–1909), and still used today.

First Style

The Alexander Mosaic was installed in the central north room of the House of the Faun, off the smaller (Ionic) peristyle. The room was surely a focal point of the house, and its importance was further emphasized by its facade of **antae** (thickened wall ends) and two Corinthian columns on pedestals; the *tablinum* was similarly equipped with stuccoed *antae* [3.9]. The house provides a good example of what is defined as the first of the Pompeian styles of wall painting. In this building the walls were stuccoed throughout and painted in imitation of cut masonry in exotic marbles, and other forms of architectural ornament, such as pilasters, entablatures, and cornices. The style is aptly called a "masonry" style, or, from the use of stucco, "encrustation" style. It is the favored wall decoration of the earliest elaborate houses found at the Vesuvian

3.9 The interior of the House of the Faun, Pompeii, Italy, late 2nd century BCE. As guests walked into the atrium they would see the statue of the faun, which gives the house its name, and the *tablinum* that would have stood behind it.

3.10 (Left) House of the Wall Plasters, Pella, Greece, early 2nd century BCE. The stucco imitation of colored marble construction is strikingly similar to the arrangements seen in the First Style wall painting of the Samnite House at Herculaneum.

3.11 (Right) First Style wall painting from the Samnite House, Herculaneum, Italy, 2nd century BCE. Stucco has been added and shaped to look like carefully cut stone. These features were often colored so as to appear like unusual foreign imports.

sites, hence its definition in Italy as the First Style. A similar style of wall decoration was known in Greece centuries before the Roman conquest. A particularly well-preserved example from a house at Pella, the capital of Macedonia, illustrates the basic features of the Greek Hellenistic version [3.10]. A taste for it developed soon after among Italian merchants on Delos; their influence may have led to its adoption at such sites as Pompeii and Herculaneum.

The House of the Faun displays First Style throughout, which would be expected of a mansion built during the second century, but the owners also preserved this decoration throughout the next two centuries, while new schemes of decoration would come and go. This conscious retention of an elegant old style, with what it implies about the age and prestige of the owner's family, is all the more significant since the house appears to have changed hands at some point before its eventual destruction.

A further example of the features of Pompeian First Style is the Samnite House at Herculaneum. On a preserved section of wall within the entranceway to the house [3.11], stucco has been carefully applied and modeled to resemble precisely cut rectangular stone masonry: each block is given recessed edges, and colored to resemble exotic imported stone, for example, marble, granite, or **porphyry**. This is not to be understood as a precise reproduction in stucco of real architectural forms; rather, it is the overall effect of color, contrast, liveliness, and opulence that the artisan aims for. The projecting cornice painted above this masonry neither crowns the wall (there is a vast flat space above it), nor keys into surrounding architectural forms; it simply floats above the colored blocks as a form of visual punctuation. The larger blocks below should correspond to **orthostates** (squared blocks of stone greater in height than in depth). One example on Delos suggests a porticoed gallery at the top of its walls, complete with Doric frieze and receding **coffered** ceiling, again, entirely executed in stucco. Such features are less common in Pompeian First Style, but the atrium of the Samnite House displays something similar [3.12].

3.12 Atrium of the Samnite House, Herculaneum, Italy, 2nd century BCE. The house is one of the oldest buildings discovered in Herculaneum.

In this house, an actual gallery from the second floor overlooks one side of the atrium, while the colonnade and balustrade of this gallery is mimicked around the other three sides of the room, in stuccoed relief. The space created shows what monumental effects were possible with the modest materials of concrete, paint, and plaster.

Second Style

It seems a logical and economical step to abandon the considerable labor needed to model wall plaster in relief, and to attempt to create similar effects using paint alone. Something similar can be seen in earlier Macedonian tombs: the interior of the early Hellenistic Great Tomb at Lefkadia includes stuccoed pilasters, arranged around the walls so as to create the impression of the interior of a portico extending the more complex facade with its engaged architectural features (which superimpose the Ionic order above the Doric, as becomes fashionable in Rome as well). Nearby, the Tomb of Lyson and Kallikles [3.13], built about a century later, was similarly provided with an illusory portico, but in this case the pilasters were rendered entirely in paint. Although simple in form, the fundamental pictorial effects of diagonally receding lines, and highlights and shadows (**skenographia** and **skiagraphia**; see box: Linear and Atmospheric Perspective, p. 86), are used here to create the effect of three-dimensional vertical supports.

This rendering of architectural effects using illusionistic painting is also a characteristic of the Second Pompeian Style. If this style was not entirely a Roman invention, Italian wall-painters were quick to exploit its potential, and soon moved beyond the limitations of First Style models. Once three-dimensional effects can be achieved by pictorial techniques, the degree of spatial projection and recession that can be achieved is limited only by the abilities and imagination of the painter. Second Style painting, which was current throughout most of the last century of the Republic, is characterized by its progress in testing those limitations.

The Second Style seems to begin both at Rome and in Campania around 80 BCE, when Rome, under the dictatorship of Sulla, founded a colony at Pompeii. One of the earliest examples of the style is found here, on the walls of the Capitolium, the focal building of Pompeii's Roman-style forum, which was reorganized at that time. A contemporary example in Rome is the House of the Griffins on the Palatine hill, which preserves some of the most useful examples of early Second Style painting in its several rooms [3.14]. Colors are bright, and some panels are mottled in imitation of richly veined stone. The illusionistic cube pattern here reproduces an element found also in the First Style decoration of the House of the Faun, as well as on an inlaid stone (*opus sectile*) floor in the *tablinum* of that same structure. In addition to these features, however, the painter has added

3.13 Tomb of Lyson and Kallikles, Lefkadia, Greece, 2nd century BCE. This Macedonian tomb uses paint to convey the idea of a portico in three dimensions.

3.14 (Below) Room Two of the House of the Griffins, Palatine hill, Rome, Italy, early first century BCE. This is an early example of Second Style wall painting, which begins to reject the flatness of the wall by using techniques of shadow and linear perspective.

a distinctly separate plane in front of the wall by painting projecting pedestals that support fully freestanding columns, and an entablature. While not yet startlingly different from the previous masonry style, by denying the flatness of the wall through the use of shadow and perspective (note the diagonal edges of the pedestals), this early Second Style painting laid the groundwork for the much more radical departures that were to follow.

Once it had become possible to create the illusion of architectural features projecting forward from the wall, the next logical step would be to paint them in such a way as to project them back through the wall. In order to accomplish this, of course, the wall would need to be opened up to create this appearance of depth; in other words, part of it would have to be visually painted away. The first examples of this approach seem to date to just before the middle of the first century BCE, for example the paintings in a bedroom from the Villa of the Mysteries [3.15] in Pompeii. For the most part, the scheme here is similar to that of the House of the Griffins, although these Pompeian paintings are far more skillfully done. Here, sizeable panels are crowned by a course of masonry and a projecting cornice. Above, a rectangular portico recedes deeply into the background, again constructed through the use of shadows that characterize **linear perspective**. Another richly painted villa—that of Publius Fannius Synistor at Boscoreale near Pompeii—is slightly later, and represents how fanciful these painted vistas could become [3.16]. The open space now takes up about two-thirds of the room's height. One is invited to look beyond the wall into a variety of areas. At one short end of this small bedroom extends a rolling landscape with a delicate garden trellis and receding arcade, while the view along the long walls is somewhat less rustic. Behind a colonnaded gateway, the viewer can glimpse an extraordinarily ornate *tholos* (round building), set in a deep courtyard surrounded by a rectangular Tuscan portico (see 3.18, p. 86). A third panel opens up to an elegant cityscape, with a series of projecting balconies. Intentionally or not, the receding scenes functioned to relieve the confines of a very small room, yet each panel presents a view of a very different sort.

3.15 Bedroom Eight of the Villa of the Mysteries, Pompeii, Italy, 1st century BCE. The walls show a later form of Second Style wall painting. Here the walls are painted away and opened up using linear perspective.

3.16 Bedroom of the Villa of Publius Fannius Synistor, Boscoreale, Italy, 50–40 BCE. In this room, painted in the Second Style, large panels with extensive landscape scenes are opened up.

MATERIALS AND TECHNIQUES
Linear and Atmospheric Perspective

Perspective is a prominent feature of Roman wall painting, reflecting a painter's response to the challenge of depicting three-dimensional forms and spaces on a flat surface. We see artists grappling with this issue already, on red-figure pottery, in Greece and Etruria, around 500 BCE. According to literary sources, over the succeeding century, Greek painters developed two fundamental strategies for achieving perspective on walls and panels. The introduction of modeling three-dimensional forms using light and shadow (*skiagraphia*, or shadow painting) was credited to the fifth-century BCE Greek painter Apollodorus Skiagraphos, probably from Athens. The method of using diagonal lines to suggest a receding of space (*skenographia* or stage set painting) was attributed to Agatharchus of Samos, from the same century.

Skenographia suggests some engagement with linear perspective, which is based on the principle that objects further away look smaller; so the distance between parallel lines should decrease as they recede in space, creating diagonal **orthogonals** [3.17]. In theory, if all receding forms are perpendicular to the picture plane and, therefore, parallel to one another, the orthogonals should, as illustrated, recede to a single point (**one-point perspective**). In Roman painting, however, we frequently see the principle being applied inconsistently. For example, in the architectural vista of *Cubiculum* M at Boscoreale [3.18], the rectangular portico that surrounds the circular *tholos* on the left seems to adhere to the rule, whereas the overhanging balconies that mark the cityscape further right do not, since lines that should be parallel are actually skewed. There are paintings in which one-point perspective seems to have been applied consistently throughout (see 4.21, p. 116), yet to what degree painters were working from a theoretical understanding of perspective, and to what degree the principle was applied experimentally, but consistently, remains a point of dispute.

3.17 The rules of linear perspective. These involve the lines of an object following along orthogonals toward a vanishing point. Many Roman wall paintings used this device, though not consistently.

A second type of perspective, **atmospheric perspective**, works in a different way. This technique suggests the distance of an object by blurring its outlines and, especially, diminishing its color intensity, so as to simulate the filtering effect of the air (atmosphere) that occurs as the distance between viewer and viewed object increases. As we shall see in this chapter, examples of this are to be seen in the *Odyssey* landscape painting, which also displays linear perspective in its diminution of figures and objects in the distance, although not without some inconsistency (see 3.23, p. 89). In some scenes, there are boats of exactly the same size both in the distance and in the foreground, and the figures depicted tend to be of similar size, unless very far away. In general, it seems that these devices, used to create illusions of spatial recession, were governed more by the eye of the artist than by any abstract formulae, although the principles themselves were certainly known.

3.18 An example of linear perspective from the villa at Boscoreale, Italy, 50–40 BCE. The columns flanking the *tholos* are vanishing to a single point, but the small white balconies do not follow the same rule.

PART I: ROME AND ITALY BEFORE THE EMPIRE

The remarkable and rapid development of this architectural style of painting, as it is sometimes called, has prompted scholars to pose two related sets of questions. First, what was its origin? Was the style borrowed from the Hellenistic East (where, as we have seen, similar developments can be found) or should it be seen as an indigenous Italic development? Second, what inspired these imaginative renderings? Was it a real architectural source, be it Hellenic or Italian? The most important point to appreciate, it seems, is that this particular style of wall adornment emerged from a clear, consistent, and local process of development. The idea of decorating interiors with architectural forms is not new, as we have seen in Etruscan, Greek, and Macedonian tombs and houses, nor is the use of illusionistic devices. Roman houses of late Hellenistic times consistently display an interest in constructing actual complex vistas, as seen already in the House of the Faun. It is not surprising that the re-creation of such aspects through illusionistic painting should also develop at this time and place. It is futile to speculate what is Greek and what is Roman. These paintings show, more than anything else, how the Italic people of the last two centuries BCE took their place among, and at the head of, the empowered and enriched classes of the entire Hellenistic world, appropriating its myriad artistic traditions and adapting them to their own usages and tastes.

Megalographic Figures

Before we leave this early stage of Second Style wall painting (the next style in the sequence belongs to the empire, and will be discussed in Chapter 5), one further phenomenon should be considered: namely that, in some cases, the architectural forms of the Second Style served as a setting for elaborate figural compositions. Room H of the Boscoreale villa uses painted columns, friezes, **coffers** (decorative sunken panels in a ceiling), and porticoes to suggest a projection of form both into the room, and beyond the wall. In this case, however, the aim is not to frame an extensive vista beyond the wall, but rather to form a visually impermeable backdrop for one or two nearly life-size figures. This style of painting is called **megalographic** (following Vitruvius, 7.5.2; see discussion of this passage in the box: Vitruvius on Wall Painting, p. 149).

In this panel from the Boscoreale villa, a male with a Macedonian shield and royal headgear stands next to a seated female who is draped and wears a Persian tiara [3.19]. Commonly thought to copy a series of paintings from the Antigonid palace at Pella, the program has since been explained—more recently, and more convincingly—as an eclectic assemblage of scenes derived from several Macedonian tombs of the early Hellenistic period, such as the Great Tomb at Lefkadia, from around 300 BCE [3.20]. Just as we have seen in architecture, and will see in sculpture, the Romans drew extensively from

3.19 Fresco from Room H of the villa at Boscoreale, Italy, 50–40 BCE. An example of megalographic painting from the Second Style, in which painted architectural features frame large painted figures.

3.20 Exterior of Great Tomb of Lefkadia, c. 300 BCE. This tomb's scenes informed such works as those in the Boscoreale villa.

CHAPTER 3: REPUBLICAN ROME AND THE HELLENISTIC WORLD: ART OF THE ROMAN HOUSEHOLD

3.21 Dionysiac frieze from the Villa of the Mysteries, Pompeii, Italy, 1st century BCE. One of the best examples of a megalographic scene.

3.22 Back wall of the Dionysiac frieze, Villa of the Mysteries, Pompeii, 1st century BCE. This shows Dionysus lying in Ariadne's lap, with more mythological figures to either side.

Hellenistic traditions, and did so in a variety of ways and to varying degrees, from copies to adaptations, to principally new creations that altered Hellenic subjects and/or styles to suit Italic traditions and purposes.

Surely the most famous of such megalographic paintings is the Dionysiac frieze in the Villa of the Mysteries in Pompeii [3.21]. The illusionistically painted **socle** (low plinth) supporting the wall here is crowned by a deep cornice carrying figures that are nearly life-size. Behind them, large panels (red framed in black) form a backdrop, as well as providing a structure for the figural scene that unfolds around the room. This composition centers on the short wall opposite the entrance [3.22], where, in a temple cella, one would expect to see a cult statue placed. Here, a languid, youthful Dionysus reclines in the lap of a draped Ariadne. The group in this scene is flanked by some clearly mythological figures, including satyrs, and a winged female demon brandishing a whip. Others seem to be worshipers, priestesses, attendants, or initiates. The mortal and divine spheres depicted here are not clearly separated by any compositional device. Debate around the subject matter continues to be frequent and lengthy. It must have something to do with Dionysiac cult, and with concepts of worship and initiation, both of which require some mixing of the mortal and the divine, but does this scene represent an initiation, a sacred marriage, or something purely mythological or allegorical? What the painting depicts seems less important than what it reflects: an interest, and probably an involvement on the part of the villa's owners in such mystery religions and, by extension, their inclusion in an elite class that had strongly Hellenized tastes. This sense of involvement and inclusiveness (both the appeal and the point of a mystery cult) permeates the painting itself, as certain figures visually engage with the viewer and draw him or her—by means of action, pose, and gesture—through the initiation activities in the sequence required by the rite.

Original or Copied Mural Paintings

A clear example of how Romans referenced Hellenistic culture to their own ends has been found on the walls of a room excavated on the Esquiline hill in Rome. Here, a painted series

of rectangular Corinthian pilasters support a shallow coffered ceiling. Painted between (and as though behind) the pilasters was a conceptually continuous frieze depicting small figures within an extensive landscape [3.23]. The pilasters frame episodes from the *Odyssey* of Homer. Lest there be any doubt about the subject, the figures are labeled in Greek. The fresco functions in a similar way to the Dionysiac mystery frieze: while emphasizing the owners' literary interests and intellect rather than cultic affiliations, it no less depicts them as members of the cultured elite of Republican Rome.

Since its subject is drawn from Greek literature, and the figures are labeled in Greek, the frieze of the *Odyssey* must have been copied, so it is argued, from a Greek original—perhaps a wall painting or manuscript illumination. To copy from one wall painting to another, however, raises questions of considerable logistical difficulty. And it does not appear that polychrome painting had been added to manuscripts by this time, nor would one expect figures from the *Odyssey* to have been labeled in anything other than Greek, since any Roman aristocrat would have, at the very least, a good reading knowledge of the language. Indeed, the inclusion of Greek labels only intensifies this painting's elitist objectives.

Both the *Odyssey* frieze and the painting of Dionysus display expertise in the most sophisticated of painterly devices, including both linear and atmospheric perspective (see box: Linear and Atmospheric Perspective, p. 86). Additionally, since the repetition of figures against a continuous background provides a story told in episodes and in chronological progression, the composition embodies the principal of continuous narrative, a feature that is only rarely found in surviving Greek or Hellenistic art but which plays an important role in later Roman historical relief. It prompts us to ask whether these devices were copied from something earlier, or if they developed only at this time, and whether they were Italic or Hellenic. The question of copies and originals is rarely mentioned by Roman writers; what was far more important than the source of a figure or composition was the artwork's ability to channel such associations in order to give a particular meaning, in a particular context, for a particular purpose. Nowhere is this clearer than in the study of sculpture.

3.23 An example of atmospheric perspective from a painting in a house on the Esquiline hill, Rome, Italy, 1st century BCE. Some linear perspective is used, but diminishing color intensity is also employed to suggest distance.

Domestic Sculpture

The House of the Faun, for all its mosaic, stucco, and paint, was named for a statue (see 3.9, p. 82). Within the greater atrium a small bronze satyr was found; its spirally dancing pose and strongly characterized facial features reflect a style of late Classical and Hellenistic times. Visitors entering the space would therefore have been immediately confronted with the Hellenizing tastes that ran throughout the house. Sculpture had long played an important part in constructing the appropriate atmosphere in a Roman house or villa. Within the Republican tradition, *imagines* and household gods embodied the antiquity and nobility of the *domus*, but such displays as that found in the Porticus Metelli in Rome (see p. 55) must have suggested to the Roman viewer that Greek sculpture had the power to arrest, and to suggest meaning, on a much grander scale. Supplies of Greek sculpture were, however, finite. For the most part, the booty ended up on public display, and such influxes of art as that brought by Metellus were far less common after the mid-second century BCE. Wealthy Romans could and did buy Greek bronzes, but Classical Greek sculpture was almost entirely religious in function—whether architectural, funerary, or votive—and, with some conspicuous exceptions, the Romans mainly respected this sanctity. As supply will always find a way to accommodate demand, we see an active industry devoted to the production of new categories of sculpture emerging around 100 BCE.

"NEO-ATTIC" SCULPTURE AND THE ART MARKET

The question of imitation is again raised in the context of sculpture because it is from 100 BCE that the first evidence for copying to scale of Classical originals occurs. The eponymous statue from the House of the *Diadoumenos* on Delos is the earliest in a series of Roman marble statues so similar to one another that a common prototype is assumed [3.24]. The style of this piece is close (especially in pose and rendering of musculature) to that of the *Doryphoros* by Polycleitus (also known only through copies) and, indeed, among the works of this fifth-century master, a bronze *diadoumenos*, or "boy tying a fillet around his head," is mentioned by Pliny. The replica series represented by this Delos piece is therefore believed to reproduce Polycleitus's work, in which case this very statue would be the earliest surviving Roman copy after a Classical statue. The find is significant because the manufacture of marble replica series in Roman imperial times was an enormous industry. Figures of athletes, gods, and heroes filled architectural spaces of every variety, not only rustic villas and urban atrium

3.24 *Diadoumenos* statue from Delos, Greece, 100 BCE. Marble. H. 1.95 m (6 ft 4¾ in.). This statue is thought to be a replica of a bronze statue by the Greek Polycleitus, dating to c. 450–425 BCE. Roman reproductions of Classical Greek statues were in high demand in the first century BCE.

houses, but also stage buildings in theaters, fountains, public halls in baths, civic fora, and even structures built for the express purpose of displaying them. These arrays of statuary played a central role in imbuing spaces with meaning, conveying concepts in the service of patrons both private and public.

The prototypes for these replicas were not limited to Classical bronzes, but could equally well be new images created in Classical style, Hellenistic style, or with a mixture of stylistic features. This type of statuary is known as Neo-Attic. Applied first to a small group of late Hellenistic statues and reliefs signed by Athenian artists, this term has been extended to include a wide range of works dating from the first century BCE to the later Roman empire, not only from Athens and the Greek East but, far more commonly, from Rome itself. Some of these works are decorative panel reliefs, but many are ostensibly utilitarian pieces, such as marble vases, tables, candelabra, bases, and altars, which were often arranged within houses and gardens, but could be used as votives in sanctuaries as well. These objects bore relief scenes appropriate to their decorative purpose, especially non-narrative processions of **maenads**, nymphs, graces, personifications of the seasons, and, occasionally, Olympian deities. The figures themselves adhere to a relatively limited number of types, modified with various attributes and arranged in myriad combinations. The styles used are retrospective (that is, archaizing, Classicizing, and so on), and the degree of fidelity to the styles being referenced or revived varies greatly.

Neo-Attic works are found among the sculptures from the Mahdia shipwreck (see box: The Mahdia and Antikythera Wrecks, p. 93), the cargo of which preserves a snapshot of the Roman art market in the first century BCE. These works include both statuary and relief. Reliefs are represented by fragments of vessels of the so-called Borghese and Pisa types, named for well-preserved marble kraters [3.25]. The latter shows a Dionysiac ecstatic procession, including a group of maenads. Because the drapery style in this scene shares features with late fifth century BCE Athenian works, such as the Nike parapet on the Acropolis, the group as a whole is often thought to have copied a public monument in Classical Athens. These figural types are also seen on an amphora signed by Sosibios [3.26], including several distinct types that recur (with variations) on dozens of Roman reliefs in stone, metalwork, and ceramics; it has been claimed as having the most surviving copies of any Greek prototype.

3.25 The Borghese Vase, second half of the 1st century BCE. Marble. H. 1.72 m (5 ft 7 3/4 in.). The Pentelic marble vase is an example of a Neo-Attic work; a Roman production, inspired or reproduced from Classical Greek sources. This vase depicts a Dionysian ecstatic procession of maenads.

3.26 The Sosibios Amphora, c. 50 BCE. Marble. H. 78 cm (2 ft 6 2/3 in.). This vase is a Neo-Attic adaption from a type of metal vessel from the fifth century BCE. The relief shows a Dionysian or Bacchic procession, presided over by Hermes.

The occurrence of repetitive images would have been a matter of mass production more than a matter of reproduction. Here, as for the paintings discussed above, excessive concern with the issue of artistic originals can displace a proper analysis of these copies as works in their own right. Significant here is the emphasis on Greek, especially Dionysian, imagery on much Neo-Attic relief work. These items were clearly designed to function within the Roman *domus*, in conjunction with floor mosaics and wall paintings (and ceiling stuccoes, as well), in which such subjects also dominate. The Roman home, whether town house or villa, clearly juxtaposed spaces devoted to business and pleasure (*negotium* and *otium*); these spaces were appointed with works of art chosen to enhance the latter while at the same

time representing the owners' cultivated tastes, a marker of aristocratic status that simultaneously reflects the former.

Among the statuary found within the Mahdia cargo are at least three fragments that can be connected with the work of Pasiteles, a sculptor whom literary sources present as being the most famous practitioner of the art we call Neo-Attic. A Greek from south Italy, active in Rome during the first half of the first century, Pasiteles wrote five books on works of art, was prodigious as a maker of metal relief vessels as well as statuary, and never made a work without having made a model first. Knowing this, a picture emerges of a workshop in which the production of sculpture depended on the following of prototypes, where the history of sculptural styles was well known, and where a variety of materials and media were worked. A connection to metal vases is very clear in Neo-Attic kraters, such as the ones from the Mahdia wreck, which seem to have originated as stone translations from metal versions that were

3.27 Adaptation of the Stephanos Youth type, 1st century BCE or 1st century CE. Marble. H. 1.10 m (3 ft 7³⁄₈ in.). The sculptor of this version has replaced the early Classical head of Stephanos's work (seen in 3.28) with a late Classical head more consistent with the proportions of the body. This is a pastiche of a pastiche.

3.28 Orestes and Electra, c. 30 BCE. Marble. H. 1.44 m (4 ft 8²⁄₃ in.). This group combines the youth type signed by Stephanos with another pastiche featuring both male and female elements. The mixing and matching of prototypes recalls Neo-Attic relief work.

92 PART I: ROME AND ITALY BEFORE THE EMPIRE

very popular and expensive but are not at all well preserved (see box: The Mahdia and Antikythera Wrecks, below). Indeed, within the Mahdia cargo itself fragments of bronze kraters were found, almost identical in form to the marble examples. If more of these precious objects were recovered, the true prototypes of Neo-Attic reliefs might well be found among them.

Evidence for Pasiteles' works is indirect but suggestive nonetheless of the artist's style. A statue in the Villa Albani is signed by "Stephanos, pupil of Pasiteles." The style is reminiscent in form and pose of early Classical works but displays proportions closer to those of the late Classical epoch. This assures its identity as a creation in Classical style (rather than a copy of a Classical work), and the figure is known from several replicas and adaptations [3.27]. The use of the Classical style itself reaffirms what the ancient sources suggested about the Pasitelean school, yet more significant still is the recurrence of this same figure in an entirely different context [3.28]. This

The Mahdia and Antikythera Wrecks

The first century BCE was a very active time for the importing of goods, especially works of art, into Rome and Italy from the Hellenistic East. Given the hazards of Mediterranean maritime transport, we may assume that many ships never made it to their destination. Many of the most famous Classical bronze statues that have come down to us were found in the sea—the Artemision Zeus, the Riace Warriors, the Marathon Boy; none of these was found along with any significant remains of the ship that carried it, or the rest of the cargo. There are, however, two complete shipwrecks, both lost in the first century BCE, and discovered in the early twentieth century. These provide an invaluable snapshot of the burgeoning Roman art market of the late Republic, when Roman aristocrats of senatorial and equestrian rank, made wealthier still through the Roman conquest of the East, sought to acquire physical symbols of their status to display in their increasingly elaborate homes. As it turns out, the two recovered cargoes are quite different, and illustrate two distinct aspects of the Roman desire to collect art.

One of these ships was discovered in 1907, off the coast of Tunisia, near the city of Mahdia (al-Mahdiyah); it was excavated and the finds were published before the outbreak of the World War I. The Mahdia wreck, as it is called, was loaded with many works of sculpture, in both stone and bronze, almost all of which are datable to the late Hellenistic period, not much earlier that the wreck itself. It appears that this was not a ship laden with war booty, such as that brought to Rome by Metellus. It seems far more likely that this cargo reflects the trade in sculptures (and other works) made for the Roman market that began around the time of the Italian presence on Delos, and continued to grow thereafter. Among the works fished from the sea here are our earliest, and some of the finest, examples of Neo-Attic sculpture.

The other ship foundered off the coast of the island of Antikythera, approximately halfway between the island of Kythera and the western tip of Crete. Coins and pottery place the wreck in the second quarter of the first century BCE, not much later than the Mahdia wreck, but the cargo is quite different. Most famous for the astronomical computer ("Antikythera mechanism") dated to around 200 BCE, which has received great attention, and renewed investigation, in recent years the ship also carried a considerable quantity of sculpture. The best known of the sculptures found are the *Antikythera Youth*, a fourth-century BCE bronze statue of a young man—whose identity and activity pose a mystery to this day—and a highly characterized bronze head, probably early Hellenistic, nicknamed the "philosopher." There is also a substantial number of marble sculptures (at least three dozen) depicting various gods and heroes in late Classical to early Hellenistic style, although these could also be early copies, as the Delos *Diadoumenos* is. Renewed exploration that began in 2014 has produced additional fragments of Classical bronzes, a bronze "dolphin" (a weapon used in naval battle), and a human skeleton.

The Antikythera cargo, therefore, represents a collection of objects from a variety of periods stretching over at least three centuries, which suggests it was triumphal loot destined for Rome. While Sulla's triumph over Athens of 86 BCE has been ruled out by the discovery of later coins, the possibility that it could have been intended to celebrate Julius Caesar's triumph of 46 BCE remains. It is just as probable, however, that these ships simply bore two different types of commercial cargo: the one with newly made objects being sent to Rome to be marketed there, and the other consisting of works assembled as acquired by agents (for example Atticus) working for customers (such as Cicero—see box: Cicero the Collector, p. 95) who were awaiting their treasures in Rome.

group pairs the Stephanos Youth, as it is called, with an even more obviously mixed creation. The female figure here has a male torso and hairstyle, with breasts and a woman's garment added, it seems, almost as an afterthought. Both the copying of Stephanos's figure and its use in a different context connects statuary of this sort with Neo-Attic relief production and, by extension, reconfirms Pasiteles' identity as a Neo-Attic artist. In a similar manner to the vessels, these statues, by their obvious Greek qualities, could help reinforce the concepts and ideas of status that, as we have seen, were presented through other forms of interior ornament within the Roman home.

The finds from the Mahdia wreck represent well the stylistic variety of Hellenistic sculpture and the broad range of possibilities open to Roman nobles equipping their houses. Three small bronze figurines of dancing dwarves reflect an interest in the characterization of non-idealized subject matter, commonly found in Hellenistic art and literature [3.29]. These figures were equipped with rings for suspension and would have hung and swung freely—probably in a Roman garden portico—the manner of display coordinating with the subject matter and its spiral pose. In contrast is the strongly Classicizing bronze, the most famous of the Mahdia statues, which was formerly identified as Agon—a personification of

3.30 Eros from the Mahdia shipwreck, c. 100 BCE. Bronze. H. 1.4 m (4 ft 7 1/8 in.). The figure of Eros is strongly Classicizing, and probably created to meet a demand for Hellenistic art.

athletic contests—from its self-crowning gesture, but is now believed to represent Eros (Cupid) [3.30]. The figure is boyish and slender; its pose is early Hellenistic, while its face and hairstyle are somewhat earlier in pattern and proportions. The sculpture represents the continued use of Classical idealism in the era after Alexander, and could date anywhere in the Hellenistic period, but it probably belongs with the bulk of the cargo in dating to a time shortly before the ship was lost.

Despite the variety of forms and styles, all of these works could well have been created at around the same time in response to demand; in some cases perhaps even made to order. They

3.29 Dwarf from the Mahdia shipwreck, late 2nd century BCE. Bronze. H. 32 cm (12 1/2 in.). These would have been hung for display.

94 PART I: ROME AND ITALY BEFORE THE EMPIRE

Cicero as Collector

Marcus Tullius Cicero (consul 63 BCE) was from a wealthy Latin family in the town of Arpinum, some sixty miles from Rome. He entered political life as a *novus homo* ("new man"), a term used for the first in one's family to be enrolled in the senate, or the first to hold a consulship. Cicero's numerous publications included his speeches, treatises on philosophy and rhetoric, and personal correspondence.

Among his letters are several that deal with Cicero's assembly of artworks for his villa at Tusculum, just south of Rome. Cicero was deeply knowledgeable about all aspects of Greek culture, including art, having travelled to Greece and studied in Athens. It is all the more remarkable, therefore, to note what his chief concerns, as a collector, seem to be. The impression that he gives of a micromanaging (and impatient) approach to the procurement of decorative sculpture indicates that Cicero cared very much about what was included in his collection, yet he never mentions artists, or even styles. His comments focus entirely on the subjects of the pieces in question, and their suitability to the functions and associations of the space each statue would occupy within the villa. His notes indicate that artistic styles and artist names were entirely unrelated to Roman objectives in assembling these objects as domestic display.

As to your herms of Pentelic marble with bronze heads, about which you wrote to me—I have fallen in love with them on the spot. So, pray, send both them and the statues, and anything else that may appear to you to suit the place you know of, my passion, and your taste—as large a supply and as early as possible. Above all, anything you think appropriate to a gymnasium and terrace.
(*ad Atticum* 1.8.2)

Anything you have of the same kind which may strike you as worthy of my "Academia," do not hesitate to send...My present delight is to pick up anything particularly suitable to a gymnasium.
(*ad Atticum* 1.9.2)

As for my statues and Hermeracles, pray put them on board...and anything else you light upon that may seem to you appropriate to the place you know of, especially anything you think suitable to a palaestra and gymnasium. I say this because I am sitting there as I write, so that the very place itself reminds me.
(*ad Atticum* 1.10)

were surely destined not for public display but for the atrium houses and, especially, the vast suburban and maritime villas of the most wealthy and powerful of the Roman aristocracy. So how were these works chosen and displayed? Which type of sculpture was preferred? Was a copy, for example, valued for its resemblance to the famous original behind it or as a work in its own right? Were there governing themes vital to the choice of works and their arrangement, or were these collections put together randomly? Did buyers purchase what they could get and just put it where it fit? Fortunately, we do have the views of at least one such collector, Cicero, who appears to have placed importance on the coordination of subject matter with an appropriate context in the house (see box: Cicero as Collector, above). It was not, then, connoisseurship or aesthetics that mattered most, but rather the message communicated by the objects, both individually and together, that was the highest priority: just as it was for the more traditional categories of sculpture—*imagines* and household deities—that had been objects of domestic display for centuries.

Sculpture from the Villa of the Papyri

Are such principles of acquisition—namely purchasing pieces that are appropriate to the context of the house and the message they are intended to convey, as suggested by the literary sources and the sculptures—borne out by the art collections themselves? The evidence is less comprehensive than one might expect, given the large quantity of Roman sculpture still in existence. Much of it, however, was assembled by noble Italian families from the Renaissance onward, and was not carefully excavated but rather extricated from ruins with little if any record of where the object was found.

Since then, statues have been excavated in some Roman villas and houses; by far the best preserved of ancient private collections was sealed in the eruption of Vesuvius, with all ninety sculptures found just where they were standing in

3.31 Plan of the Villa of the Papyri, Herculaneum, Italy. All key sculpture locations are indicated.

3.32 The Archaistic Athena from the Villa of the Papyri, Herculaneum, Italy, 2nd century BCE. Marble. H. 2 m (6 ft 6²/₃ in.). The statue features a mix of styles from different eras.

late autumn of 79 CE. It was here, at the site of Herculaneum, that the beginning of modern archaeology and its investigations into the Roman world began in the eighteenth century. The centerpiece of that project was an elaborate structure named the Villa of the Papyri [3.31] because of the discovery there of the only complete ancient library ever found. Otherwise it would surely have been called the Villa of the Statues (see box: Herculaneum: The Villa of the Papyri, p. 99).

What is most striking in this collection is its variety. Marble and bronze works are mixed together. There are copies of famous Classical works, Classicizing and archaistic creations, and Hellenistic pieces in realistic or dramatic styles. There are heroes, deities, and animals both real and imaginary. There are many portraits, mostly of Greek orators and philosophers, several of Hellenistic kings, and a few veristic examples that suggest Roman subjects, perhaps from very early times. These figures seem to have been chosen as objects of admiration and emulation, an expansion from the family *imagines* and revealing an increasingly cosmopolitan worldview. It is not always easy to tell what is a copy and what is original. For example, the famous Archaistic Athena [3.32], which was centrally located in the villa's program of display, betrays by its blending of

96 PART I: ROME AND ITALY BEFORE THE EMPIRE

Archaic, early Classical, and High Classical features, a date hardly, if at all, earlier than the villa itself (*c.* 50–20 BCE). Another example of the type once stood on the Acropolis of Athens, however, so one of the statues must have copied the other, or imitated another, third, work.

As indicated by Cicero's letters, the question of originality was of no interest to the Roman patron and viewer. The images that were sought were required to be appropriate to, and reinforce, the desired functions of the spaces they adorned. For example, the inebriated satyrs [3.33] reclining on rocks within the pool of the large peristyle underscore the pleasurable and rustic aspects of the space, while at the same time reflecting the Hellenic tastes and Dionysiac interests that played so large a part in the equipping of these opulent Roman homes. Moving from *otium* to *negotium*, within the inner peristyle/*tablinum*, however, in a space dominated by the Athena, we find arranged the portraits of philosophers, statesmen, and kings, including one of Pyrrhus [3.34]. No doubt more serious matters were attended to here. It is unfortunate that no other display is nearly so completely preserved as this one, but it is surely no coincidence that what we find here in Herculaneum accords well with what we might gather from ancient literary sources, the Mahdia wreck, and the hundreds of statues without provenance that are now distributed across the world's museums.

The archaeological evidence partially supports what we learn from Cicero's letters. The arrangement of the sculpture is generally grouped: there are clusters of, for example, portraits of Greek orators and philosophers, or of Hellenistic rulers, or Classicizing works. In the large peristyle garden, the most conspicuous outdoor space, there are statues of animals, and of inebriated satyrs reclining on rocks in

3.33 The Drunken Satyr, Villa of the Papyri, Herculaneum, Italy, 2nd century BCE. Bronze. H. 1.37 m (4 ft 6 in.). The sculpture would have occupied a place in the peristyle of the villa, representing not only the Roman enjoyment of rustic open spaces but also older Hellenistic, Dionysiac tastes.

3.34 Portrait herm of Pyrrhus of Epirus, *c.* 290 BCE. Marble. H. 47 cm (1 ft 6½ in.). This portrait would have been placed in the more formal inner peristyle/*tablinum*, accompanied by portraits of other Hellenistic kings, as well as statesmen and philosophers.

3.35 Reconstructed view of the outer peristyle of the Villa of the Papyri, Herculaneum, Italy. The villa's peristyle garden would have held a variety of sculptures, most of them Neo-Attic in style, as was the fashion through the first and second centuries BCE.

the pool [3.35]. Yet the relationship of objects to one another, or of subjects to their space, is much more fluid than the approach that Cicero's correspondence suggests. Visual impact and effect, and even some deliberate thematic variation among sculptures adjacent to one another, seem to have been equally desired. If we were fortunate enough to have more such collections to examine, we would probably find that each has its own personality, reflecting the varying tastes of its patron.

Roman and Hellenistic Art

In the famous words of the poet Horace (65–8 BCE), "captive Greece made captive her untamed victor" (*Epistles* 2.1.156). From this overview of domestic art in the late Republic, it is clear that the conquering Romans were captivated by Hellenistic art and culture, of which they became insatiable consumers. Greek art and its Etruscan adaptations had long been known to the citizens of Rome; and for the Romans, as for the Etruscans, the possession of Greek-looking goods had traditionally been a sign of worldliness. During the last two centuries BCE, the amount of Greek art in Rome, and the degree of familiarity with it, increased, but that alone does not explain the wholesale adoption and adaptation of Greek subjects and styles in Roman art. One factor, of course, was economic; the extension of Roman rule brought enormously expanded sources of wealth for those Romans and Italians capable of exploiting them. The transformation of the modest Roman atrium house into a magnificent mansion—equipped from floor to ceiling with the latest in figural adornment—was, in some cases, a sign of success in this market. While the written sources suggest an early doubt about the taste of Greek art in the house of a Roman senator, these misgivings were soon swept away by the emerging role of Greek art as a sign of power—not only financial, but also political and military—reflected by the attitudes of Cicero, Lucullus, or the unknown owner of the villa at Herculaneum.

Is this art Roman or Greek? It is clear enough that the sculptures, mosaics, and paintings in question were commissioned by Roman patrons, and that they served a Roman function by supporting that patron's status within a society that valued the sophistication inherent in Greek art. So too could the chosen subjects reflect the religious and philosophical interests of the villa's owner, or they could suggest in a strongly moralizing tone, as is appropriate to the Roman obsession with custom (*mos maiorum*). The question itself—is it Roman or Greek—may simply reframe the futile question of originality. Attempts to understand each Neo-Attic sculpture or mythological painting as a copy—either perfect or flawed—after some regrettably lost original are doomed to fail because they reclassify each image as a filtered glimpse of something else, and so preclude any proper appreciation of the work itself. The Romans have left us no record indicating that they thought much about the status of a sculpture or picture as a copy or original. Both Greekness (in style or subject) and Romanness (in context or meaning) were qualities essential to the successful functioning of such monuments, and no inherent contradiction was felt. If the study of Roman art is, as it is here, our primary concern, it is pointless to focus on an issue that seemed of so little importance to the Romans themselves.

Herculaneum: The Villa of the Papyri

The Villa of the Papyri stood on the outskirts of the ancient town of Herculaneum, less than 200 meters northwest of the currently excavated site, on what was in antiquity the coastline. It was in a sense, therefore, both a suburban and a maritime villa. Exploration of the site of Herculaneum began at the beginning of the eighteenth century after antiquities were found at the bottom of a deep well. Since the depth of volcanic debris is so great here (twenty to thirty meters as opposed to four to seven at Pompeii), further investigation was done through sporadic tunneling. The remains of the Villa of the Papyri were first discovered in 1750, and explored, again through tunneling, by the Swiss architect and engineer Karl Weber (1712–1764). Weber's records remain the primary basis for our knowledge both of the villa's plan and of the location of its many sculptures (see 3.31, p. 96). A small portion was excavated, with some spectacular finds, in the 1990s, and again in 2007.

The name of the villa comes from a unique find: a complete library of around two thousand papyrus scrolls, burnt by the intense heat of the pyroclastic flow that destroyed Herculaneum and its remaining inhabitants. As one might expect from burnt paper, the remains are exceedingly fragile, but some can be unrolled and read. Recent attempts to read scrolls while still rolled up, using spectrographic scanning, have held some promise, but the project is still in progress. What is preserved consists of the writings of Philodemus of Gadara (110–35 BCE), a late Hellenistic **Epicurean** philosopher. Since Philodemus's patron is said to have been Lucius Calpurnius Piso Caesoninus (consul 58 BCE), father-in-law of Julius Caesar, it is thought that this was Piso's villa. In fact, in the past it was sometimes known as the villa of the Pisones, but the connection is speculative, and even if true, it does not necessarily indicate who put the sculpture collection together, or when, since the arrangement, as it was found, dates to 79 CE.

This villa, stretching about 200 meters along the coast, contained elaborate atria, peristyles, gardens, fountains, and pools; all brightly painted and thronged with marble and bronze sculptures, some ninety of which have been preserved, mostly intact. The effect, fortunately, is made easier for us to envision by the Getty Villa in Malibu, California: a near replica of the Villa of the Papyri that serves as home to the antiquities from the J. Paul Getty Museum [3.36]. The complex at Herculaneum was far from unique, though; literary sources indicate that the Italian countryside at this time, and especially the Campanian coast, was filled with similar conspicuous displays belonging to the wealthy Roman upper classes. Yet, there is nothing else that has come down to us that can provide so full an idea of what the sculptural program within a magnificent and expensive villa may have looked like.

3.36 The Getty Villa, Getty Museum, California. Modern replica of the Villa of the Papyri. The villa serves as a useful model for the typical peristyle garden, which in this case houses replicas of the original Roman sculptures in Naples.

4 From Republic to Empire: Art in the Age of Civil War

102 The First Triumvirate and Civil War
- 103 PORTRAITS OF POMPEY AND CAESAR
- 105 THEATER OF POMPEY
- 105 FORUM OF CAESAR
- 106 Box: Greek and Roman Theaters

109 The Second Triumvirate and Civil War
- 110 PORTRAITS OF ANTONIUS AND OCTAVIAN

111 Transforming Rome
- 112 HOUSE ON THE PALATINE
- 112 Materials and Techniques: Marble
- 115 Box: Restorations of Republican Temples
- 117 TEMPLE OF CAESAR IN THE REPUBLICAN FORUM
- 119 BASILICA AEMILIA
- 121 COMPLETING CAESAR'S BUILDINGS IN THE CAMPUS MARTIUS

Chronological Overview

DATE	EVENT
78 BCE	Death of Sulla
60 BCE	Formation of the First Triumvirate: Pompey, Crassus, and Julius Caesar
55 BCE	Theater of Pompey dedicated
49 BCE	Julius Caesar marches on Rome
46 BCE	Dedication of the Forum of Caesar
44 BCE	Julius Caesar made dictator for life (February); Caesar assassinated (March)
43 BCE	Formation of the Second Triumvirate: Antonius, Lepidus, and Octavian
38 BCE	Marriage of Octavian and Livia
31 BCE	Battle of Actium
30 BCE	Deaths of Antonius and Cleopatra; Octavian's residence on the Palatine
c. 30–20 BCE	Room of the Masks painting in the House of Augustus
29 BCE	Temple to *Divus Iulius*
28 BCE	Temple of Apollo on the Palatine
c. 27–19 BCE	Octavian given title Augustus (27 BCE); beginning of Roman empire

The Development of Rome

Right: Map of Rome showing the key buildings in existence in Rome in this chapter.

CHAPTER 4: FROM REPUBLIC TO EMPIRE: ART IN THE AGE OF CIVIL WAR 101

The First Triumvirate and Civil War

As we follow the transformation of various Mediterranean kingdoms and states into subjects, allies, and ultimately provinces of the Roman Republic, it is easy to anticipate the final outcome: the Roman empire and the principate. The Romans themselves, buoyed by their success against Hannibal in the late third century BCE, may already have visualized the creation of an empire, but it would be at least a century before anyone might reasonably have imagined the principate and the reign of a single head of state. The Roman Republic had been formed after the fall of a monarchy, and its institutions were intended to prevent the abuses of oppressive or sole rule. In Republican Rome, the strategy was to share power between co-occupants of executive positions and to divide authority among the members of a relatively large (if exclusive) governing senate. The exception was the army, the leader of which was a magistrate or ex-magistrate, named by the senate and granted *imperium* (sole authority to command a military force), which made him an *imperator*.

The far-flung, multiyear campaigns that permitted Rome's eventual annexing of the Mediterranean and northern Europe took military leaders far from Rome and, increasingly, removed them from direct senatorial control. The soldiers' allegiances naturally shifted from the Roman state to their own generals, who alone had the ability and the inclination to take care of their troops, especially after their military service had ended.

When most of the Hellenistic world had been brought under Roman control—around the end of the second and beginning of the first centuries BCE—some of these *imperatores* sought to use their power to extract concessions from the senate, especially land for veterans' colonies. Soon, they began to vie with one another for greater influence and, inevitably, civil war broke out among them. Lucius Cornelius Sulla, having vanquished his longtime rival Gaius Marius, actually seized Rome by force in 82 BCE and compelled the senate to appoint him as dictator. Having exacted horrific retributions on his enemies, Sulla retired, and the field opened up once more.

A decade or so later, a new generation of contenders emerged, chief among whom were Gnaeus Pompeius Magnus (Pompey the Great) and Gaius Julius Caesar. While only a few years older than Caesar, Pompey was in the spotlight much longer. He served during the Social War (91–88 BCE) in an army raised by his father, whose death in 87 BCE left his twenty-year-old heir in charge. Rising to prominence in the service of Sulla, the younger Pompey spent the following decades engaged in conflicts across the now widespread Roman world, helping to quell the revolts of both Quintus Sertorius, a Roman general, in Spain, and Spartacus, the slave and gladiator, in Italy; ridding the Aegean sea of pirates; defeating Mithridates VI of Pontus (long a thorn in the side of the Romans); pacifying the remnants of the Seleucid kingdom; and organizing western Asia into Roman provinces. His was an atypical career; in 61 BCE Pompey celebrated his third triumph at an age (he was forty-five) when most ex-consuls were still seeking their first. Caesar, on the other hand, came from a very old **patrician** *gens*, or family line, and although by his own time his family was neither wealthy nor powerful, he distinguished himself as a military leader and orator of rare ability, and managed to follow the standard *cursus honorum*, achieving the consulship in 59 BCE.

Caesar, a nephew of Gaius Marius, had long been on the opposite political side from Pompey, who had supported Sulla. Given the position of influence and respect that Pompey had achieved, and the unchecked ambition of Caesar, the two men would seem to have been on a political collision course, but in fact they made an alliance, bringing in as well the deep pockets of the wealthy senator Marcus Licinius Crassus to form the so-called **First Triumvirate** (rule of three men) that controlled Rome, first for five years, and then eventually a decade. Crassus was given a command against the Parthians in the East (Iran), which ended in disaster, and Caesar against the Gauls, which brought him great fame and fortune. Pompey, despite the adventurousness of his own youth, became a rallying point for conservative senatorial control—the term used to describe such politicians was an *optimate*—and therefore a buffer against the aspirations of Caesar, who, as a *popularis*, operated by currying the favor of the people.

In 50 BCE, the senate denied Caesar's request for a renewal of his Gallic command, which would have granted him immunity to prosecution by his enemies in Rome. His hand forced, in 49 BCE he marched on the capital, which was abandoned to him by Pompey, who withdrew to the East to muster resistance. The conflict between Caesar and the supporters of the senate continued in Italy, Spain, and the East, with the decisive encounter coming at Pharsalus in the region of Thessaly, Greece, in 48 BCE. Pompey, defeated, fled to Egypt where he was murdered by a functionary of the Ptolemaic kingdom, leaving the senators lost without him. Caesar brought the war to a close by 46 and in early 44 BCE was named "dictator for life," a title that he held for little more than a month.

PORTRAITS OF POMPEY AND CAESAR

That Julius Caesar was the first living Roman to be represented on a coin minted in Rome [4.1] is noteworthy for two reasons. First, it indicates the extraordinary position he held relative to all his predecessors, hinting that his appointment as dictator was a step toward something similar to kingship. Caesar refused the title of king (*rex*) but accepted some regal trappings, and a coin portrait was surely one of these; the fact that the adornment of coins with portraits of living rulers was a Hellenistic practice could not have been lost on anybody. Second, Caesar's coin image allows us to identify his portraits in other **media**. Since sculptured portraits are seldom preserved with their original inscribed bases, coins are a crucial piece of evidence in assigning them names and dates.

The image of Caesar as it appears on the coins of 44 BCE corresponds well with descriptions of the *imperator* that occur in such works as the *Life of Julius Caesar* by Gaius Suetonius Tranquillus (c. 70–130 CE). The designer of the coins did not shrink from depicting Caesar as a middle-aged man (he was fifty-five at the time of his death) with deep-set eyes, a deeply creased face, prominent thin nose, and receding hairline. Suetonius mentions that of all his honors, Caesar most prized the right to wear a laurel wreath at any occasion, a privilege that allowed him to cover his high forehead more effectively than he could with a "comb-over," which the biographer

mentions as well. Caesar, officially deified in 42 BCE, and thereafter honored as a god, plays an important role in the construction of imperial imagery, so later depictions of him tend to assume features from the time of their creation. For example, the marble head seen here [4.2] that

4.1 (Above) Coin of Julius Caesar, 44 BCE. Silver. The obverse of the coin shows Venus Victrix (Venus of Victory), drawing an obvious association with Caesar.

4.2 Portrait of Julius Caesar, Rome, Italy, 30–20 BCE. Marble. H. 52 cm (1 ft 8½ in.). The face is distinctive for the lines on its forehead, and the accentuated nose, but is also semi-stylized, following the traditions of previous Hellenistic rulers.

CHAPTER 4: FROM REPUBLIC TO EMPIRE: ART IN THE AGE OF CIVIL WAR 103

4.3 (Right) Coin, minted by Sextus Pompey, bearing the head of his father Pompey the Great, 44–43 BCE. Silver. Pompey's face is distinctive for its fleshy cheeks and creased forehead.

4.4 Portrait of Pompey the Great, Rome, Italy, c. 50 BCE. Marble. H. 25 cm (9⅞ in.). Pompey's middle-aged face has a wide, fleshy look, showing a similar seriousness of expression to his rival Julius Caesar.

posthumous image of Pompey the Great [4.3], which permits the identification of marble examples [4.4]. The general is, like Caesar, shown in middle age, with a business-like look, creased forehead, and fleshy cheeks. His face is slightly pudgy and his eyes small, deeply set, and widely spaced. His thick hair is unusually unruly, carved into clearly defined locks that spring up and out in various directions from the center of his low forehead. Although this recalls nothing of the youthful, god-like appearance of Alexander the Great (see 2.2, p. 52), we know from Plutarch that Pompey deliberately fashioned himself after the Macedonian conqueror, to the amusement, it seems, of his contemporaries: "His hair was inclined to lift itself slightly from his forehead, and this, with a graceful contour of face about the eyes, produced a resemblance, more talked about than actually apparent, to the portrait statues of King Alexander" (Plutarch, *Life of Pompey* 2).

Pompey had spent much time in the East; indeed, when challenged by Caesar, he withdrew eastward with his senatorial army to rally the support and considerable resources of the eastern provinces. He was well aware of the traditions of Hellenistic kings, so it is no surprise that he, like them, chose to represent himself as a successor to Alexander. What is striking is that his portraiture stops short of a full assimilation into the Hellenistic tradition. Characterization, of course, played a large role in Hellenistic portraiture, and monarchs were often given individual features to reflect the qualities that each dynasty wished to project about itself. Yet Roman portraiture displays a style that appears to revel both in the exploration of the effects of time on the human face—lines, creases, folds, crow's-feet—and in the illustration of identifying features, such as aquiline or bulbous noses, and projecting or receding chins. It is not, in every case, easy to distinguish the characterizing style of Hellenistic sculpture from this Roman verism, especially since the latter almost certainly developed under the influence of the former, but there are distinctions that can be made, not just in appearance but also in the contrasting functions of portraiture in the two different cultures.

post-dates Caesar bears most of the traits of the coin image—the serious aspect, lined forehead, and slightly sunken cheeks. Yet the forehead is now partially covered by a canopy of crescent-shaped curls that resemble, no doubt deliberately, the hairstyle of Augustus (who we will meet in Chapter 5) and his descendants. This smoothing or idealizing of features is sometimes described as a Classicizing trend, although it seems less likely that the intention here was to associate Caesar with the Classical past as much as it was to link him more closely with his heir and successor.

More openly Hellenizing is the image of Caesar's rival Pompey, whose sons, Gnaeus and Sextus, continued to battle on against Caesar and his successors for a full decade after their father's death. Their coins were marked with the

104 PART I: ROME AND ITALY BEFORE THE EMPIRE

THEATER OF POMPEY

The building of permanent theaters in Rome was forbidden before the late Republic (theater structures were built of perishable materials and dismantled after use), so as, some sources say, to prevent idleness among the citizenry. Surely more compelling, however, was the concern that a permanent theater, especially a very luxurious one bearing the name of its builder (similarly to a manubial building), might unduly influence voters. Despite this prohibition, Pompey undertook to build a concrete theater that was as large and every bit as opulent as its temporary predecessors (see box: Greek and Roman Theaters, p. 106). As a concession to tradition, in his proclamation of its dedication (in 55 BCE), Pompey "called [the structure] not a theater, but a temple of Venus, 'under which,' he said, 'we laid out steps for shows'" (Tertullian, *De Spectaculis* 10.5). This might seem to describe a plan resembling that of the theater temples discussed in Chapter 2, but Pompey's theater was of a different kind.

Small sections of the building survive in the basements of old structures in the Campus Martius, the arrangement of which still reflects the curve of the *cavea*, the seated section, and the plan is known from surviving fragments of the Severan Marble Plan. As we might expect from Pompey's claim, there is a shrine at the top of the *cavea*, perhaps originally flanked by others [4.5]. As is commonly found in Roman theaters, a colonnaded court is attached behind the stage building; this functioned as a public park, perhaps with a formal arrangement of plants. At the opposite end from the rear of the stage building was a meetinghouse for the senate, the Curia Pompeia. It was here that the senate met on the Ides of March in 44 BCE, when Caesar was struck down by senatorial conspirators and died at the foot of Pompey's statue. To the east of this is the sacred area of the Largo Argentina temples. If, as some think, this area was attached to the theater complex by a newly built portico, it would have closely connected Pompey's spectacular new complex with a tradition of manubial building going back to the early Republic, the kind of blending of innovation and tradition that characterizes much Roman art.

4.5 Plan of Pompey's theater complex, Rome, Italy. The plan shows the semicircular *cavea*, and the large portico behind the stage.

FORUM OF CAESAR

Central to Caesar's building program in Rome is the Forum Iulium (or Forum of Caesar), the first of five roughly similar building complexes that we term today the Imperial Fora. Caesar's forum lies directly northeast of, and adjacent to, the Republican forum, which it was intended to complement; Caesar's agents (including Cicero, one of whose letters give the date) began to secure land for the project as early as 54 BCE. It is not known when work began, but the complex was dedicated, unfinished, in 46 BCE, and completed after Caesar's death. The forum was extensively

Greek and Roman Theaters

Greek theatrical performances were religious in nature, so the buildings that housed them were connected with cult areas. In Athens, for example, Classical tragedies and comedies were performed during Dionysiac festivals, so the theater was located in the sanctuary to that god. The buildings themselves were permanent and public structures, funded by the city-state or sanctuary that housed them. In Rome, the production of religious games and festivals, including theatrical performances, was the responsibility of an aedile, one of the magistracies of the *cursus honorum*. By the first half of the first century BCE, the conservative tradition to forbid the private building of permanent theaters was being sorely tested by both Marcus Aemelius Scaurus, whose stage building had 360 columns framing three thousand bronze statues, and Gaius Scribonius Curio, who built two theaters back-to-back, each one set on a pivot. Simultaneous theatrical performances were put on in Curio's theaters; when finished, the two structures were rotated on the pivots to form an amphitheater, in which gladiatorial games then commenced. These structures, although elaborate and ingenious, were nonetheless temporary.

Although the functions of Greek and Roman theaters were similar, their siting, form, and construction were quite different. Greek theaters were usually carved, insofar as possible, into hillsides, whether in sanctuaries (as at Epidaurus, see **4.6**) or in cities, where the central hill around which most Greek urban areas developed offered a convenient location. The seating area in a Greek theater is arranged around a central circular performance area (**orchestra**) and forms an arc greater than 180 degrees (see below); the stage building was, at least early on, a painted *skene* of textile or light wood that formed a backdrop to the action in the orchestra. Access for spectators was primarily through side passages (**parodoi**), which ran between the ends of the *cavea* and the *skene*, up to the end of the orchestra and the lowest row of seating, from which stairways rose to the top. In a Roman theater, the *cavea* and orchestra are perfect half circles (see 4.5, p. 105); the *cavea* walls continue uninterrupted into a high stage building (*scenae frons*, pl. *frontes*) that was usually equipped with elaborate architectural adornment and statuary. Performers worked on an elevated stage (***pulpitum***) at the base of the stage building, rather than in the orchestra. A low wall supporting the front of the stage (***proscenium***) offered another venue for sculptural adornment.

Early Roman theaters, whether modest wooden bleachers or spectacular buildings in their materials and design, were intended as temporary structures, and were not cut into hillsides. A permanent stone theater therefore depended entirely on the Roman invention of vaulted concrete construction. With this, the *cavea* was supported by a complex network of intersecting **annular** (concentric and semicircular) and radiating barrel vaults. *Parodoi* between the *cavea* and the stage building were vaulted, rather than open to the air. The effectiveness of these theaters as a way to ingratiate their patron with the people—exactly what was feared during the Republic—was extensively exploited during the empire. Each city acquired its own Roman-style theater, while those already erected in the Greek world were modified to adopt features of the Roman form. As a showcase for imperial portraiture intermixed with divine statuary, the *scenae frons* and *proscenium* presented the audience with an impressive spectacle that was just as engaging and impactful as what might be playing out on the *pulpitum* itself.

4.6 Theater at Epidaurus, Greece. The lower section was built in the third century BCE, and the upper section added in the second century BCE. Similar to many Greek theaters, Epidaurus is carved into the hillside. Roman theaters tend to be built from the ground up.

4.7 Plan of the Forum of Caesar, Rome, Italy, 46 BCE. The forum was intended to expand the Forum Romanum. Caesar's forum consisted of a long, narrow open space flanked by porticoes. At one end, the forum held Caesar's temple to Venus Genetrix.

two long sides by a covered double portico and screened from the busy street (known as the Argiletum) at its southeastern short end by a colonnade. Opposite, filling most of the northwestern short end stood the temple to Venus Genetrix, which commanded the open space of the forum before it. In the temple stood a cult statue of Venus, the work of Arcesilaus, a Greek sculptor who was probably a student or associate of Pasiteles (see pp. 92–93). If images labeled "Venus Genetrix" on later Roman coins reproduce Caesar's statue, and this is by no means certain, it was High Classical in style, as befits a goddess [4.8]. Whether it was a reproduction, as some think, of a Classical type or a Classicizing creation by Arcesilaus himself, we cannot tell. Caesar is said to have vowed a temple to Venus Victrix (bringer of victory) on the eve of the Battle of Pharsalus. If so, the significant switch to Venus Genetrix was made only after Caesar had established himself as pre-eminent in Rome. Venus had long been claimed as the ancestress of Caesar's family (the *gens Iulia*) through her son, the Trojan hero Aeneas and his son Ascanius (or Iulus). Promoting the idea of divine lineage enhanced not only Caesar's own status, but also that of his entire family, probably anticipating the realities of sole rule and dynastic succession.

Caesar's forum functioned especially as a location for the administration of Rome by the senate. This usage is documented by ancient literary sources, and was facilitated by the physical relationship between the Forum Iulium and the old forum. Caesar's plan included relocating and rebuilding the senate house (now the Curia Julia) in a position where it served as a connecting link between the two fora. The Forum Iulium became, in some ways, a vast extension of the senate

rebuilt more than a century later, under the emperors Domitian (r. 81–96 CE) and Trajan (r. 98–117 CE), and again following a fire in the time of Diocletian (r. 284–305 CE). Most surviving remains reflect these later buildings, and the sections joining the later Imperial Fora were reworked as those complexes were added. Throughout the modifications, the plan of the Forum of Caesar remained fundamentally the same, so it is surely the best understood of his public works.

The overall scheme is relatively simple [4.7]. A long and narrow, rectangular space is flanked on its

4.8 Coins from the time of Hadrian, showing Venus Genetrix, 128–37 CE. Some scholars believe that later representations of Venus Genetrix, such as this one, mirror the form of Caesar's statue in the first century BCE.

CHAPTER 4: FROM REPUBLIC TO EMPIRE: ART IN THE AGE OF CIVIL WAR

4.9 Reconstruction of the senate house, Rome, Italy. Caesar relocated it to connect his forum to the old one.

house [**4.9**]; rooms behind its porticoes could serve as offices, meeting rooms, and archives, and the senate itself sometimes met in the Temple of Venus. The administration of Rome and the empire was therefore shifted to a space that was still public, yet closely associated with the household of Caesar through the looming figure of Venus Genetrix.

This new environment for the gathering of the populace and conducting of public business demonstrated the power of Rome (and Caesar—the distinction is deliberately blurred) through its elaborate decoration and furnishings. Accounts of the original structure describe an environment of great opulence, with lavish use of imported colored marbles complementing the Italian white marble from the quarries at Carrara (in northwestern central Italy), which was exploited now for the first time [**4.10**] (see box: Marble, p. 112). Temple, court, and colonnade were also outfitted with many works of art, including paintings, statues, and gems, as well as monuments of a more directly commemorative nature, for example portraits of Caesar himself and, in the center of it all, a statue of his horse. Moreover, it was a regular, organized space. Toward the slope of the Capitoline hill to the west, where the original relationship to surrounding spaces is easiest to recover, one can see the pains taken by the architect to mask the irregularities of topography and surrounding structures. Here, what one sees is perfect uniformity of space and repetitive architectural elegance, in contrast with the more haphazardly

4.10 Present remains of the Temple of Venus Genetrix, Forum of Caesar, Rome, Italy, 46 BCE. The temple would have included imported exotic marble, as well as white marble from central Italy.

108 PART I: ROME AND ITALY BEFORE THE EMPIRE

arranged and unevenly appointed buildings of the Republican forum next door. The historian Cassius Dio (c. 164–230 CE) noted that the Forum Iulium was considerably more beautiful than the Forum Romanum (*Roman History* 43.22); Caesar's forum was a better space, just as Caesar had made the Roman world a better place.

This use of architectural forms and spaces both to contrast and combine the ideologies of Republic and empire will be seen to be the major legacy of the design of Caesar's forum. Equally pertinent are the traditions on which it draws, since this complex, as innovative and influential as it was, evolves in a manner entirely comparable with that for painting and statuary, as demonstrated in Chapter 3. It reflects Roman Republican forms, practices and functions, while at the same time incorporating the experiences gained through the conquest of the Hellenistic Mediterranean. The Venus temple was built using the Corinthian order, and stood on a high podium; it had eight closely spaced columns in front, and nine along each side, forming wings (*alae*) that flanked the cella walls. The entire structure was built of, or faced with, marble of different varieties. There were no columns behind the **apsidal** cella, which itself projected beyond the rear edge of the podium. The arrangement derives from the tradition of Tuscan temples described by Vitruvius, the most conspicuous example of which was the Capitoline temple of Jupiter (see 1.39, p. 45), itself having been rebuilt not long before by the earlier *imperator* Sulla. The Tuscan or Italic temple form, standing on a high base and oriented unambiguously in a single direction, was perfectly suited for this kind of authoritarian temple/forum arrangement, which was, in fact, a natural outgrowth of the temple form itself. With its Italic plan, Corinthian order, and lavish use of both native and imported marbles, the Venus temple represents a blending of Italic and Greek architectural features that was by now commonplace in Rome.

The Second Triumvirate and Civil War

The Roman senators who struck Caesar down on the Ides of March in 44 BCE hoped to restore senatorial authority and end, once and for all, the sequence of *imperatores*. This hope would prove to be in vain. Rome had become increasingly accustomed to the leadership of strong individuals and, after Caesar's demise, two candidates rose to fill the resultant power vacuum. Marcus Antonius (83–30 BCE), who had been Caesar's chief lieutenant and his co-consul in 44 BCE, enjoyed the support of Caesar's troops and benefited from his experience in the field. Less obvious, indeed all but invisible at first, was Gaius Octavius (by adoption named Gaius Julius Caesar and today called Octavian, although it was not a name he used himself), Caesar's eighteen-year-old great-nephew, who was away at Apollonia in Illyricum (in the Balkan Peninsula) when news arrived of his great-uncle's death. Just a few months earlier, Caesar had adopted Octavian as his son and primary heir to his estate, although it is by no means clear whether Caesar meant to bequeath him his power together with his property. The adoption became public knowledge only after Caesar's death, upon the reading of his will, by which time Octavian had already left for Rome, recruiting two legions of Caesar's veterans along the way, an asset that considerably strengthened his hand on arrival in the capital in May of 44 BCE.

After Caesar's assassination, the ruling elite in Rome could be categorized in roughly three groups ("faction" would imply far too much unity of purpose). First were the conspirators and their supporters. Second were Caesar's colleagues and dependents, among whom Marcus Antonius (Mark Antony) was *de facto* leader for now. Finally there were those, such as Cicero, who had had no hand in the conspiracy, but firmly believed this to be the opportune time to restore Republican rule. The instability of the moment manifested itself in widespread distrust, both among and within these groups. After a year or so of manipulation, negotiation, deceit, and rapidly shifting alliances, an entirely extra-constitutional resolution evolved. Antonius, Octavian, and Marcus Aemilius Lepidus (a wealthy supporter of Caesar) came to an agreement not unlike that forged by Caesar, Pompey, and Crassus in 59 BCE. Whereas the earlier triumvirate had been an informal arrangement, the later one was given force of law (by the *lex Titia* of 43 BCE), and the three were charged with the task of, somewhat ironically, establishing the Republic (*rei publicae*

constituendae) in the five-year term of office they were granted.

Their first two orders of business were undertaken straightaway. First, resistance at Rome was eliminated by a proscription (condemnation and confiscation of property) of enemies as brutal and thorough as anything under Sulla. Second, the death of Caesar, whom the triumvirs compelled the senate to declare a god early in 42 BCE, still had to be avenged. The leaders of the conspirators, Marcus Junius Brutus and Gaius Cassius Longinus (d. 42 BCE), fled Rome some months after the assassination when Caesarian supporters, especially Antonius, in his now famous eulogy, inflamed the populace against them. The conspirators retained considerable support, however, and established themselves in the eastern Mediterranean with a formidable army. Their *imperium* was confirmed, at Cicero's urging, by a senate reeling from the horror of the proscriptions.

Antonius and Octavian (who played little role in the fighting) defeated the conspirators at Philippi in eastern Macedonia (42 BCE); far more than a symbolic act of revenge, it marked the elimination of the last serious threat to the power of the triumvirate. This alliance persisted uneasily for a dozen years. Antonius, who married Octavian's sister Octavia in 40 BCE, came to control the eastern Mediterranean, and Octavian took the west. Lepidus, whose honors were limited to his being named Caesar's successor as **pontifex maximus**, became increasingly irrelevant and eventually spent his days in luxurious house arrest in Campania. Octavian defeated the residual Pompeian forces with a naval victory off Naulochus in Sicily (36 BCE). The victory was principally attributable to the expertise of his colleague Marcus Vipsanius Agrippa (63–12 BCE), but it strengthened Octavian's military prestige, since his previous role in warfare had been limited.

Meanwhile, the relationship with Antonius was becoming increasingly strained, on both personal and strategic grounds. Antonius's flagrant adulterous relationship with the Ptolemaic queen Cleopatra VII of Egypt, who bore him three children, was a personal affront to Octavian and his family. More importantly, Egypt, the last surviving major Hellenistic kingdom, was also the wealthiest and most defensible. Antonius was the far more accomplished military leader; were he to unite his holdings in the East with Egypt as his base, the threat would have been serious. Even Octavian's connection to the Julian line, which alone legitimated his position, was at risk since Cleopatra publicly claimed that Caesar was the father of her son Ptolemy XV Caesar (Caesarion). The doomed alliance collapsed in 32 BCE, when war was declared on Egypt and the Egyptian fleet was destroyed by Octavian's forces, under Agrippa's command, at Actium in western Greece (31 BCE). Alexandria was taken the following year, Antonius and Cleopatra committed suicide, and Egypt was made a province of Rome. Whether or not anyone at the time realized it, or admitted it, the Roman empire was born.

PORTRAITS OF ANTONIUS AND OCTAVIAN

As usual, the portraits of these protagonists are best known from coins. In the months before Philippi, the triumvirs (as well as Caesar's assassins) paid their troops by minting coins, many bearing their images. This *aureus* (a gold piece worth 25 *denarii*, which was nearly six weeks' pay for a soldier), pairs portraits of Antonius and Octavian [4.11]. The former was about forty years old and the latter about half that age, a difference that is clearly reflected on the coin. Antonius has a full head of hair, blocky head, and thick neck. Octavian's image is slenderer and his features more delicate. The trace of a beard along his jawline reflects his age, as Roman youths first shaved in their early twenties. These images allow the identification of portraits in stone. This bust of Antonius [4.12], with its intense gaze, tousled hair, and idealized features seems to follow the precedent of Alexander the Great, the Ptolemies, and, for that matter,

4.11 (Right) *Aureus* of Octavian and Antonius, 41 BCE. Gold. Octavian and Antonius were two thirds of the Second Triumvirate.

4.12 (Left) Portrait of Antonius, Cairo, Egypt, 40–30 BCE. Marble. H. 68 cm (2 ft 2⅞ in.). Some parallels can be made to earlier depictions of Alexander the Great.

Pompey. Like the latter, Antonius was assuming the trappings of a Hellenistic king in order to solidify his hold on the eastern provinces.

Octavian's portrait strategies seem somewhat different. Both triumvirs occasionally paired their coin image with that of Caesar, beginning soon after the latter's death in 44 BCE [4.13]. Following Caesar's deification in 42 BCE, however, Octavian does so more frequently, naming himself DIVI F(ILIUS), or "son of a god," to resonate with the title DIVUS IULIUS, the deified name of Caesar, on the reverse of the coin, where it often occurs with the *Sidus Iulium* ("Julian Star"), the comet that served as a symbol of this **apotheosis**. Octavian separates himself from Antonius by emphasizing not simply his unique connection to the legacy of his adoptive father, but rather his affiliation to divinity itself. This would further evolve into a central theme of Octavian's assertion of legitimacy, and come to define the identity of the emperor-to-be for centuries. A portrait type, probably from 31 BCE [4.14] and so called the Actium type after this battle, emphasizes the intensity and seriousness of purpose that recall the features of Caesar and characterize the qualities of this ambitious young man. The type suggests the abilities of an accomplished leader without relying on the traditional, but here inappropriate, emphasis on age as a means of expressing experience. Similarly to Antonius and Pompey, the thick, tousled locks of hair of Octavian invoke the youthful energy and transcendence of Alexander the Great, but the visual language remains Roman. This same portrait type, modified to imply a more evolved relationship with mortality and divinity, will come to define his imagery as Augustus the emperor.

4.13 (Above) Coin pairing a portrait of Octavian with that of Julius Caesar, 43 BCE. Gold. Octavian used these coins to promote himself as Caesar's adopted son and heir, and, he intended, his successor in power as well.

Transforming Rome

Following the Battle of Actium and the death of Antonius and Cleopatra, in 29 BCE Octavian returned to Rome, where he closed the doors of the Temple of Janus, which were open during times of war and could be shut only in times of peace. Octavian was now unimpeded as ruler of Rome and all its territories but, in order to keep from making the same mistake as his adoptive father, he was careful to characterize all of his political activities as being for the good of the Republic of Rome, and serving, for example, as co-consul with his general, Agrippa. In January of 27 BCE, Octavian renounced his consulship, explaining that he wished to surrender all

4.14 (Left) Bust of Octavian, of the "Actium" type, after the Battle of Actium, 31 BCE. Marble. H. 74 cm (2 ft 5¼ in.) His face is serious and intense, implying his ability and experience without having to do so by portraying age.

CHAPTER 4: FROM REPUBLIC TO EMPIRE: ART IN THE AGE OF CIVIL WAR

powers to the senate and other bodies, including his control of the army. The senate, however, responded by returning these powers to Octavian, and, furthermore, granting him the title Augustus, meaning "the illustrious one" (see Chapter 5).

Upon his return to Rome, Augustus embarked on a large program of reconstruction and social reform. Rome was transformed with impressive new buildings of marble, which promoted his image and name throughout his empire. From the very beginning, the emperors of Rome realized the importance of public works in cultivating the public support on which even an absolute ruler naturally depends.

HOUSE ON THE PALATINE

Just as important as the role of portraiture in the strategies of self-representation devised by a ruler are the messages conveyed by the imperial residence. Octavian's house was a notoriously modest structure by the standards of his contemporaries, and it stands in strong contrast to the famously magnificent residences built by his successors next door on the Palatine hill (from which the very word "palace" derives). Soon after his rise to power, Octavian acquired a house, formerly the home of the famous orator Hortensius, and expanded it by adding a second property. Suetonius (*Life of*

MATERIALS AND TECHNIQUES
Marble

Augustus so altered the physical appearance of Rome that he boasted, not without justification, of having "left in marble that which he found made of brick" (Suetonius, *Life of Augustus* 29). He might more accurately have claimed that he left Rome in marble veneer, since building continued to occur almost entirely in concrete throughout the empire, but appearances matter, and a building faced in marble can surely look enough like a marble building.

In contrast with Greece, especially the islands, and Greek Asia Minor, ancient Italy was notably lacking in good sources of marble for building and sculpture before the opening of the Carrara quarries in the later first century BCE. In our account of Etruria and the Roman Republic, it may have been noticed that sculpture was predominantly in bronze and terracotta. Locally quarried stones like tuff and alabaster were also traditionally used. These materials are softer than marble and carve differently, giving the finished product a less refined appearance. Greek marble, especially Pentelic marble from Attica in southeast mainland Greece, had begun to appear in Rome in quantity, not surprisingly, in the wake of the Roman conquest of that region at the beginning of the second century. It was a conspicuous show of Hellenism, as seen in the temples of the Porticus Metelli (see p. 55), one of which at least was the work of the Greek architect Hermodorus, or the still-visible round temple by the Tiber. We also hear of a lavish use of imported marbles in the domestic architecture of the late Republic, and the relatively small amount of sculpted marble from Republican Italy; the Paris and Munich reliefs or the Tivoli general, for example, are also carved from Greek marble.

Italy, of course, has plenty of marble, which has been widely used for sculpture and architecture alike from the Roman empire, throughout the Renaissance, and to the present day. The primary source is Carrara in northwestern central Italy, which, according to Pliny the Elder, was first fully exploited in the time of Julius Caesar for building projects that were almost finished by the age of Augustus. The supply, as one can see in Rome, was rich. The marble is of high quality, and some of it (the visible characteristics of the marble notoriously vary, depending on which quarry it is produced from) is quite like the Greek Pentelic stone in being bright white, fine-grained, and well suited for carving. Carrara marble was, therefore, a dominant material in Augustus's own public buildings, for example in the Palatine temple, the fora of Augustus and of Caesar, and the Ara Pacis. The use of imported marbles did not diminish, however. Recently intensified studies of ancient stones have shown that their large-scale importation and use—previously believed to reflect an, allegedly, more cosmopolitan worldview of the high empire—was well established already in the time of Augustus. In fact, scholars have convincingly argued that the use of Carrara stone in the early empire was not simply prompted by the logistics and economics of proximity; it also reflects a deliberate assertion of Italic identity, in contrast with the associations of the many foreign marbles whose exotic polychrome surfaces were clearly reflective of their provincial origins. This is one more way in which Augustan art and architecture continues a Roman tradition of weaving together disparate traditions into a coherent whole, and yet transforms that tradition in order to both construct and accommodate the greatly changed world of the principate.

4.15 Palatine hill, Rome, Italy, showing the area of Augustus's residence. The Temple of Apollo, facing roughly west, is shown in the middle of the plan, next to two Augustan domestic complexes. The so-called House of Augustus abuts the temple to the north and the House of Livia lies to the northeast.

Augustus 72) comments that this house lacked marble revetments or elaborate mosaics, and that the columns in its courtyard were made not of marble, but of stuccoed *peperino*, a coarse volcanic stone quarried locally. While the structure itself might have failed to impress, Octavian carefully chose the site of his palace; flanked by both pre-existing and newly founded cult areas, it situated the political novelty of the present within the deep traditions of the past [4.15].

The southwest corner of the Palatine was already rich with areas of religious and historical significance (see box: Restorations of Republican Temples, p. 115). On the opposite side of his house, to the east, Augustus built an entirely new sanctuary, dedicated to Apollo Palatinus (Palatine Apollo). Vowed in return for victory at the Battle of Naulochus in 36 BCE, and dedicated in 28 BCE, not long after Octavian's three-day triple triumph over Egypt, Actium, and Illyricum, this temple referenced his two great naval victories, the one over Sextus Pompeius (at Naulochus) and the other over Antonius and Cleopatra (at Actium). Little but the platform and fragments of superstructure survive, but ancient descriptions suggest a sanctuary far more richly appointed than the emperor's adjacent house. The temple was built entirely of Cararra marble and was adorned with Archaic Greek sculptures on its roof that were quite probably akroteria; its doors were inlaid with ivory reliefs depicting scenes of myth and history; the cella held a marble cult statue group of Apollo, Diana, and Latona. Somewhere in the complex was included a portico of the Danaids, large enough to hold at least fifty statues of the ill-fated brides, **hermaic** figures in early Classical style [4.16], and a library sufficiently large to accommodate meetings of the senate.

It is difficult to imagine exactly how these structures were arranged, since there are few existing remains, and little space in which to imagine their existence. Nonetheless, the program is clear enough. In presenting his residence,

4.16 (Below) Danaids from the Apollo Palatinus temple, Palatine hill, Rome, Italy, 28 BCE. Bronze. H. 1.2 m (3 ft 11¼ in.). The temple was built by Octavian, referencing his two naval victories over Sextus Pompeius and Marcus Antonius. The complex held a portico of the Danaids that held fifty of these statues.

CHAPTER 4: FROM REPUBLIC TO EMPIRE: ART IN THE AGE OF CIVIL WAR 113

4.17 Short side of the Sorrento base, Augustan period, Sorrento, Italy. Marble. H. 1.17 m (3 ft 10⅛ in.). The relief shows Apollo, Diana, and Latona. The group is probably from the Apollo Palatinus temple.

4.18 Long side of the Sorrento base, Augustan period, Sorrento, Italy. Marble. H. 1.17 m (3 ft 10⅛ in.). The relief shows a procession of Vestal Virgins before the goddess Vesta.

as in other aspects of his principate, Augustus walked a fine line between projecting the image of traditional Republican practice and the reality of dynastic, monarchic rule. His house was by no means regal, but it was located so as to create myriad associations with deities, kings, and heroes of Roman history. He first placed his house next to areas of state cult, then brought cult to his house, to which the Apollo temple was even physically attached by a vaulted ramp.

Later, upon the death of Lepidus (12 BCE), Augustus was elected *pontifex maximus*, the most prestigious of Roman priesthoods, which included authority for the state cult of Vesta, goddess of the hearth. At this time, Augustus built a new temple to Vesta adjacent to his house on the Palatine, in this way transferring the cult, which had previously been located in the forum itself, to his private residence. This step was consistent with his policy of eliding the distinction between the cult of state gods and the cult of his own household gods, the worship of which was extended to the Roman citizenry around the same time. It fell short of the Hellenistic practice of setting up cults to kings, but in effect it accomplished the same end.

Two Roman sculptures may refer directly to the Apollo Palatinus complex. The first, a marble monument base from Sorrento in southern Italy shows, on one short side, the images of Apollo, Diana, Latona [4.17]—Classicizing figures in fourth-century BCE style—likely the cult statue group from the Apollo Palatinus temple. One long side of this base shows a procession of Vestal Virgins before the image of the goddess herself, and we see, within a portico in the background, a round temple that is surely Vesta's [4.18]. The opposite long side is decorated with a scene that includes the Great Mother of the Gods, an ancient eastern and Greco-Roman deity.

Perhaps also relevant to the Palatine complex is a Neo-Attic relief in the Villa Albani in Rome [4.19] that shows the same triad of Apollo, Diana, and Latona striding toward the image of Victoria (to the right), who stands by an altar pouring libations (an offering or dedicaton to the gods) into a vessel held by Apollo. Behind them is a wall, beyond which rises a Corinthian temple. The scene has been interpreted as Victory (whose temple was nearby) welcoming the cult of Apollo on the Palatine. The Corinthian order and the decidedly Archaic appearance of the roof decoration does coincide with accounts that we have of the Apollo temple. The figures themselves are found on countless other Neo-Attic reliefs, as a group of four, individually, and in sub-groupings, but there is at least one other example of the scene as it occurs here. Moreover, among the dozens of Neo-Attic terracotta relief plaques excavated at this site, and attributed to the Apollo Palatinus complex, are examples that show this same group of Apollo and Victoria, reinforcing the connection of the type to the site.

4.19 Relief of Apollo, Diana, and Latona, Villa Albani, Rome, Italy, 1st century BCE. Marble. H. 71 cm (2 ft 4 in.). The scene shows Latona and her children Apollo and Diana sacrificing with a winged Victory, or Nike, in front of the Temple of Apollo.

Restorations of Republican Temples

Immediately to the southwest of Augustus's house rose a great terrace, with two important Republican temples and a smaller shrine. The shrine was for the goddess Victoria, set up in 294 BCE, when Roman expansion in Italy was beginning in earnest, and so when securing military victory (always a central priority of the Roman state) was becoming even more crucial. About a century later, the smaller temple, dedicated to Victoria Virgo, was added, the new building almost touching the earlier temple. Around the same time (191 BCE), the second, larger temple, to the Great Mother of the Gods, was completed. This was built to house the sacred stone brought from Phrygia in Anatolia, in 205 BCE, in response to the prophecy of a Roman oracle (the Cumaean Sibyl), who had been consulted during a difficult stage of a war with Carthage. Fortunes reversed soon after, and the Romans utterly defeated Carthage by 202 BCE. A profound historical sense of victory in battle must have permeated the site. Little remains of either temple today, but both were restored or repaired by Augustus, another sign of respect, and both were, apparently, of the Corinthian order.

On a terrace immediately before and below these temples, in the bedrock, postholes from several Iron Age huts of the ninth and eighth centuries BCE were found. On this spot stood the House of Romulus, an ancient hut of this type that was preserved, rebuilt as necessary, and revered as the early home of the first king of Rome. Further down the hillside, at the foot of the Palatine, was the spot known as the Lupercal, the cave where, according to legends, the infants Romulus and Remus were suckled by the she-wolf before being discovered by the shepherd Faustulus, near where they would have washed ashore from the Tiber. Augustus's desire to be associated with Romulus is well documented, and we encounter it more than once in the monuments of his reign. He wished to be seen as the second Romulus, as the *re*-founder of Rome, in keeping with the idea of his ushering in a new golden age of Roman might. We are even told that he intended at first to take "Romulus" as his title, but decided (or was advised) that the monarchic associations of that name would not serve his purposes as well as the name "Augustus," which was essentially a clean slate, ready for him to define. Just as Augustus wanted to be seen not as a god but similar to a god, he also desired to be considered not as a king but similar to a king; Romulus, of course, was both king and god.

4.20 Room of the Masks, House of Augustus, Rome, Italy, 30–20 BCE. The room demonstrates late Second Style painting, with columns appearing to project out of the wall.

4.21 Wall painting in the House of Livia, Rome, Italy, 30–20 BCE. The painting uses linear perspective and symmetry to focus the viewer's eye on the central panels.

Late Second Style Wall Painting

What remains of Augustus's house itself are two domestic complexes that are much damaged, eroded, and built over; these are given the nicknames "House of Augustus" and "House of Livia" (see 4.21). Each structure preserves excellent examples of Second Style wall painting in its final stage—the first decade after the Battle of Actium (see Chapter 3 for the First and Second Styles of wall paintings, pp. 82–87).

The Room of the Masks in the House of Augustus [4.20] continues this theme of architectural elaboration. The painted columns, placed on a projecting plinth, stand out in front of the wall; the suggestion of spatial projection and recession is clearly effected by the use of carefully arranged orthogonals. This room has, in fact, been hailed as the first known example of true **single-point perspective** from the ancient world. The proportions of the columns, pilasters, and architraves are, however, more slender than those in the villa at Boscoreale (see 3.18, p. 86), and the figures atop the roof are more delicately rendered. Most importantly, the architecture, which now looks more than ever like a stage set, extends forward toward the viewer while, at the same time, allowing views away beyond the wall, although these panoramas are dim and hazy. The entire arrangement seems to have been designed as a frame for a large central panel that can be read either as a view to a landscape beyond or as an illusionistic painting of such a landscape on the wall itself.

The view here is of a sacred grove with a prominent object of worship (in this case a representation of Apollo) front and center. This type of "sacro-idyllic" composition would continue to enjoy great popularity in Roman wall painting. Roughly contemporary paintings in the House of Livia similarly use linear perspective and a symmetrical arrangement of slender architectural forms in order to focus attention on the dominant central panels [4.21]. Again,

we see a landscape setting, but the figures here are not at worship; they are taken from episodes of Greek mythology (Polyphemus and Galatea, Argus and Io) with figural types and compositions that derive from Greek painting from late Classical and Hellenistic times. As we have seen already with the statuary, the figural types and scenes recur, with considerable variety, in several examples at different sites, as a result suggesting that they too derive from a Hellenic, or at least Hellenizing, repertoire that was available to the artist.

TEMPLE OF CAESAR IN THE REPUBLICAN FORUM

Given the central role of *Divus Iulius* (the deified Caesar) within Octavian's self-presentation, the establishment of a temple to recognize Caesar, who had been divinized by the senate in 42 BCE, was a matter of great urgency for him. This was the first major building completed by Octavian, and was dedicated in 29 BCE, soon after his return from Alexandria. The temple [4.22 and 4.23] was traditional in form, raised on a podium

4.22 (Above) Reconstruction of the Temple of *Divus Iulius*, Roman Forum, Rome, Italy, dedicated in 29 BCE. The exact arrangement of the two staircases, whether at the front or to either side of the podium, is disputed.

4.23 Remains of the Temple of *Divus Iulius*, Roman Forum, Rome, Italy, dedicated in 29 BCE. The temple was placed between the site of Caesar's cremation and the Regia.

CHAPTER 4: FROM REPUBLIC TO EMPIRE: ART IN THE AGE OF CIVIL WAR

4.24 The Temple of *Divus Iulius*, depicted on a coin of Octavian, 29 BCE. Gold. Such coins as this offer valuable depictions of buildings that are now in ruins, in this case of the temple to the divinized Caesar.

with columns in front only, but its location was very carefully chosen. It was placed between the site of Caesar's funeral pyre and the Regia, the headquarters of the *pontifex maximus*, a position held by Caesar at the time of his death. An apsidal recess in the platform's facade accommodates a circular structure, perhaps an altar set up at the spot of Caesar's cremation. The apse was walled in not long after the dedication of the temple (14 BCE). Two small staircases at its sides offer access to the platform. The temple itself is raised from the level of the platform and has the normal frontal staircase; it was probably Corinthian order. The squat cella held a colossal statue of the *divus*, which coin images depict as dressed in a toga with the head draped in the manner of a *pontifex*, again consistent with the temple's location. This temple provides another example of an Augustan monument that is rather traditional in form but extraordinary in its function and message [4.24]. It is no coincidence that his successor, Tiberius (r. 14–37 CE), delivered his eulogy to Augustus from the Temple of Caesar, exploiting the location to suggest the divinization of the late emperor that the senate would bestow soon after.

The temple's high podium is thought by some to have allowed the structure to function as a speakers' platform, which was decorated with beaks from ships (*rostra*, from which the name comes) that had been captured during the Battle of Actium. Such a platform is mentioned in the sources, which refer to the rostra of *Divus Iulius* (or Rostra *Juli*), although some scholars think this was a separate structure in front of the temple. In either case, the temple formed a new backdrop at the east end of the open area of the Republican forum, facing the older *rostra* at the opposite end, which was itself rebuilt at this time. The context of this temple, completely unprecedented in function, and key to Octavian's elevated status, is therefore woven together with some of the most sacred structures of early Roman history. It was immediately adjacent to the Temple of Castor (and Pollux), vowed and first built at the beginning of the Republic to commemorate victory at the Battle of Lake Regillus (c. 496 BCE), fought to preserve Rome's freedom from monarchy following the fall of the Tarquins. It was said Castor and Pollux, the Dioscuri, were seen watering their horses in the forum before the battle, suggesting a great Republican victory was to come. This connection was further cemented a few years later when the temples became attached to each other physically by a triumphal arch.

Adjacent to the Castor temple was the Basilica Julia, begun under Caesar and completed under Octavian, who, as Augustus, later rebuilt and rededicated the basilica in honor of his own heirs, Gaius and Lucius Caesar. This building closed off one long side of the forum's open area, and connected the Castor temple with the equally ancient, if not older, Temple of Saturn; the Romans themselves did not agree as to whether this cult went back to the early kings, the Etruscan kings, or the first years of the Republic. The Saturn temple was also restored at this time, by Lucius Munatius Plancus (consul 42 BCE), who served under Caesar and was later an ally of the Second Triumvirate.

Closing off the forum at the foot of the Capitoline was yet another temple with a Republican political legacy, the Temple to Concordia, which commemorated the *concordia ordinum*—the peaceful coexistence of the "orders," the political classes of Rome—and mirrored the peace brought by Octavian himself, soon to become a central theme of the Augustan reign. Taken all together, the choice of location for the temple of Caesar, and the building and rebuilding of structures around it, resulted in a transformation of the Republican forum into a highly organized space resembling the Forum of Caesar itself. This had the effect of creating what we might call an architectural museum of past and present that situated the very changed

118 PART I: ROME AND ITALY BEFORE THE EMPIRE

circumstances of the present within the traditions of the past: a blurring of the distinction between the old and the new that was essential to Octavian's new order.

BASILICA AEMILIA

This shaping of the Republican forum's open space was completed by a second basilica, which stretched from Caesar's senate house to his temple, facing the Basilica Iulia opposite. The oldest basilica in the forum that was still standing in the first century, it was built by the censors of 179 BCE, Marcus Fulvius Nobilior and Marcus Aemelius Lepidus. The building went by several names in antiquity, but it is most commonly called the Basilica Aemilia, since members of that *gens* took an active part in its subsequent restorations, of which there were several. Caesar funded a major rebuilding after 54 BCE (only finished in 34); Augustus helped pay for another after the structure was damaged by fire in 14 BCE; and a third repair in 22 CE is mentioned. Perhaps it was its proximity and relationship to structures with close Julian associations that caused Caesar, and then Augustus, to take this on, or perhaps it was simply consistent with a policy of public beneficence in the name of others—a conspicuous show of modesty, one might say.

Its typical basilican plan included a high **nave** with a **clerestory**, surrounded by aisles that supported a gallery above, and an arcaded exterior on both stories [4.25]. The forum facade at ground level contained a row of shops behind a long portico. Ancient descriptions and scant remains testify to a lavish use of both white and colored marbles, and the building, as it stood in the elder Pliny's time, was impressive: the writer classes it, with two of the richly decorated imperial fora, as among the finest buildings in Rome. The most interesting of the remains is a long frieze that originally surrounded the nave atop the lower order of columns, and part of

4.25 Reconstruction of the Basilica Aemilia, Roman Forum, Rome, Italy, first erected in 179 BCE. Caesar funded a major rebuilding of the basilica in 54 BCE, followed by Augustus in 14 BCE. The building has a typical basilica plan and would have held a row of shops.

4.26 Scene of the Abduction of the Sabine women, Basilica Aemilia, Rome, Italy, c. 78 BCE. Marble. H. 76.2 cm (2 ft 6 in.). The Abduction of the Sabine Women is one of Rome's founding stories. The style is strongly Classical and reminiscent of Greek art from the fifth century BCE.

4.27 Wall-building scene from the Basilica Aemilia, Rome, Italy, c. 78 BCE. Marble. H. 76.2 cm (2 ft 6 in.). Two male figures construct fortifications, overseen by a female figure who is probably a goddess or personification. Some have seen the male behind the wall as a portrait of Cicero.

which has been restored from hundreds of small marble fragments. The subject is unusual with its various scenes from the earliest times in Rome, and the extant scenes have been associated with the era and exploits of Romulus himself. The section illustrated here, showing the Abduction of the Sabine Women (an incident in Roman mythology), displays a strongly Classicizing style [4.26]; in pose, proportion, facial features, and drapery mannerisms, the figures are strongly reminiscent of Classical works, for example the frieze from the Temple of Apollo Epicurius at Bassae, dating from around 420–400 BCE. Another section, depicting the building of Rome's walls [4.27], reflects an interest in landscape reminiscent of such Hellenistic works as the Telephus frieze of the Pergamon Altar, as does the emphasis on foundation myths. Cities, such as Pergamon and Rome, that had only recently come to a position of international power, would often fabricate or at least elaborate a mythological pedigree, including foundations that could be traced back to gods or their offspring.

While it seems certain that the building that held this frieze retained its connection with its Republican predecessors, it was funded by an autocrat, whether Caesar, Octavian/Augustus, or Tiberius. Here, as seen in the architectural development of the forum, in the written history of Livy (59 BCE to 17 CE), or poetry of Virgil (70–19 BCE), the early history of Rome is invoked and glorified, just at the moment that

Rome's most ancient political principles are being overturned. The new order, it seems, glorified the monarchy (at least the good kings) as well as the Republic. Caesar and Octavian openly advertised divine ancestry to legitimize sole rule, at the same time that they wielded power as triumvirs for reconstituting the Republic. Octavian, as we will see, addressed this paradox with considerable success and, in the process, created an imperial order that would persist for centuries.

COMPLETING CAESAR'S BUILDINGS IN THE CAMPUS MARTIUS

Caesar's premature demise left an extensive building program unfinished in the southern Campus Martius, which had been a primary locus of manubial building during the Republic. These buildings Octavian completed, or in some cases built entirely, as one of his first priorities. The most spectacular architectural complex in that area at that time was the theater and portico erected by Pompey, which was later praised, throughout the imperial epoch, for its lavish beauty. Not to be outdone, Caesar acquired land for his own theater—a somewhat larger site than Pompey's—further south, between the Porticus Metelli and the probable location of the triumphal gate. This theater was later incorporated into medieval fortifications, and then into a Renaissance palace, so much of its arcaded limestone facade can still be admired today [4.28]. Octavian erected it after he became Augustus, reflecting a later stage in his building program (see The Building Program of Augustus, p. 138).

Before turning to the theater, while he was co-consul Octavian undertook to complete one of Caesar's Campus Martius building projects, to the north of Pompey's theater. Much of the work here was done in the name of the statesman Marcus Agrippa (consul 27 BCE), which helped preserve the semblance of a Republican tradition of shared responsibilities. Agrippa completed and dedicated, in 26 BCE, the voting complex (*Saepta Julia* and **Diribitorium**) begun by Caesar, at the same time that voting was becoming increasingly

4.28 Theater of Marcellus, Rome, Italy, dedicated 12 BCE. The project was begun by Caesar and completed by Augustus, who named the building after his nephew.

irrelevant. To the west of these buildings, Agrippa built the first Pantheon (27 BCE), later replaced, first by Domitian, then by Hadrian's famous domed structure, which still stands today, bearing a dedicatory inscription copying that on Agrippa's original temple (see 10.7, p. 267).

Immediately to the south of this temple, Agrippa built the *Thermae Agrippae*, the first major public bath complex in Rome, thus initiating a building type and a building policy that became one of the most conspicuous hallmarks of romanization during the empire. Literary sources and scraps of remains indicate that these baths were not large, when compared with the giant complexes built by later emperors but, as were these later structures, they were elaborately decorated and filled with works of art. During the empire, public bathing became central to urban life: a hygienic as well as a social and commercial activity, and a welcome respite from the dingy and dangerous realities of the city. The baths were begun in 25 BCE, together with the surrounding buildings, but were probably not functional until the completion, in 19 BCE, of the aqueduct that fed them: the Aqua Virgo. Agrippa, in fact, undertook a comprehensive repair, rebuilding, and upgrade of the water and sewer system, constituting an emphasis on practical, and not just symbolic, benefits to the people, which came to characterize imperial policy across the Roman world.

Temple of Apollo Sosianus

A final building in the Campus Martius is particularly representative of the transition from Republic to empire. Around the same time that Octavian erected the opulent Palatine Apollo temple, he banned the celebrating of triumphs—and thus the funding of the buildings that commemorated them—by anyone but himself or his relatives. The last manubial temple erected by a private citizen seems to have been the Temple of Apollo [4.29 and 4.30], located between the Theater of Marcellus and the Porticus Metelli (Octaviae), which were, respectively, built and rebuilt by Octavian. The Apollo temple was probably built (or, technically, completely rebuilt, for there had been an Apollo temple here since the fifth century BCE) by Gaius Sosius, who celebrated his triumph in 34 BCE for victories

4.29 (Above) Temple of Apollo Sosianus, Campus Martius, Rome, Italy, 1st century BCE. This temple represents the change from Republic to empire.

4.30 Plan of the Temple of Apollo Sosianus, Rome, Italy, 1st century BCE. This was probably the last manubial temple built by a private citizen.

4.31 Interior battle frieze from the Temple of Apollo Sosianus, Rome, Italy, 1st century BCE. Marble. Since the temple was finished by Augustus, it is his rather than Sosius's victories that are more probably commemorated here.

won as governor of Syria and Cilicia in 37 BCE. Consul in 32 BCE, Sosius sided with Antonius, even commanding part of his fleet against Octavian at Actium, but he was later pardoned and maintained his high status: a conspicuous mark of Augustan clemency. In fact, Octavian may well have participated in planning the new temple, as the procession depicted within it is thought to have shown his triumph of 29 BCE rather than Sosius's own. How much later the temple dates is unclear, but the similarity of the carved ornament on this building to that of the Arch of Augustus, erected in the forum in 19 BCE, suggests a date as late as *c.* 20 BCE.

Fragments of the interior frieze [4.31] preserve scenes of battle between Romans and "barbarians" made up of broadly spaced and vigorously posed figures that recall the combatants of the Aemilius Paullus monument. Another section shows a triumphal procession—the earliest sculptured image of this subject—with sacrificial victims, attendants, musicians, and bound captives at the foot of a trophy being carried on a large wooden platform (*ferculum*) [4.32]. This narrative frieze rested on an interior colonnade, on which Corinthian capitals alternated with a unique construction comprised of snakes and tripods—both symbols

4.32 Interior triumphal frieze from the Temple of Apollo Sosianus, Rome, Italy, 1st century BCE. Carrara (luna) marble. H. 86 cm (2 ft 9⁷⁄₈ in.). This is the earliest sculptural depiction of a triumph, showing sacrificial victims, musicians, and a trophy on a wooden platform, called the *ferculum*.

CHAPTER 4: FROM REPUBLIC TO EMPIRE: ART IN THE AGE OF CIVIL WAR

of Apollo [4.33]. These columns framed elaborately carved *aediculae* with alternating curved and triangular pediments; the temple's interior was entirely executed in white marble, with columns in imported colored marble, and the exterior was also entirely built from, or faced in, marble. Pliny the Elder also mentions a number of important late Classical sculptures that were displayed within this building, including the famous Niobids that he attributed to either Praxiteles or Scopas, both Greek sculptors. This comment reveals much about the expertise of such elite Romans as Pliny concerning Greek art from past centuries. Given his uncertainty, these Niobids must not have been signed. Scopas and Praxiteles, although their styles were distinctive, both worked around 350 BCE, representing the very same stage in the stylistic sequence of Greek art. That Pliny is here capable of making his own attribution reveals his deep understanding of this development.

This temple, which must have cost a fortune to build, was smaller than, but just as visually impressive as, monuments set up solely by Octavian. Even more remarkable are the pedimental sculptures [4.34a], which stood originally on a mainland Greek temple (to Apollo) of the mid-fifth century BCE. A battle between Greeks and Amazons plays out on either side of a centrally placed Athena [4.34b]. This is a form of Classicism both similar to, and different from, that seen in the other Augustan buildings. The pediment was at once decoration and war booty, probably meant to function—as it would have in its original location in Greece—as an analogy for victory over barbarians (a victory that the temple as a whole was meant to commemorate). Yet, in a paradox that is probably only manifest to the modern viewer, this usage constitutes what could be considered a barbaric seizure of sacred sculptures as a symbol of military might and utter conquest—a very Republican tradition. This is a transitional monument, simultaneously Republican and imperial, and therefore it is both different from, and similar to, those monuments that came before it, as well as those that would follow.

4.33 (Left) **The interior arrangement of the Temple of Apollo Sosianus, Rome, Italy, 1st century BCE. Marble.** The columns framed elaborate *aediculae*.

124 PART I: ROME AND ITALY BEFORE THE EMPIRE

4.34a (Top left and right) Detail of (*l*) an Amazon and (*r*) a Greek from the pediment of the Temple of Apollo Sosianus, Rome, Italy, 1st century BCE. Marble. The Amazon fights from horseback and the Greek may have once held a weapon with which he fought his enemy.

4.34b (Above) Pedimental sculptures of the Temple of Apollo Sosianus, Rome, Italy, 1st century BCE. Marble. H. at center 1.6 m (5 ft 3 in.). The pediment depicts the battle between the Greeks and the Amazons, a Classical theme used to commemorate military victory and Roman conquest.

Part II
The Formation of the Roman Empire (27 BCE–96 CE)

"In the beginning, Rome was ruled by kings," reads Tacitus's introductory sentence to his history of the years following Augustus's death (*Annals*, 1.1). As much as Augustus identified with Rome's first king, Romulus, the Republic was founded by the expulsion of monarchy. The traditional aversion to rule by *rex* (king) remained strong, as the example of Caesar, slain even though refusing a crown, made crystal clear.

Augustus, beginning in 27 BCE, made use of his unprecedented pre-eminence, popularity, and longevity to contrive a quasi-constitutional position for himself, one that both gathered all significant power into his own hands, and eventually allowed him to implement the principle of dynastic succession. He achieved this with a program of commemoration and public works designed to remind the *populus romanus* (the people of Rome), time and again, how much better off it was under his stewardship, and through establishing a blurring of the distinction, especially in visual representations, between himself and members of his dynasty. In this way, he was able to provide for smooth transition to the successor of his choice by using Roman adoption and inheritance laws, and by elevating the chosen to virtual co-emperorship before his own death. Everything gave the appearance of Republican propriety, and the mechanism itself persisted unchanged in its essence down to the end of the empire.

While the empire handed down by Augustus was, relatively speaking, peaceful and stable, the form of imperial rule was fraught with difficulties and left many questions unanswered. What would happen if the emperor died suddenly without having named a successor? How would the new emperor be chosen? What if the successor were dangerously inept? How would he be replaced? Similarly, what would lead to an emperor's downfall: general unpopularity? Arrogance, or even brutality in dealing with the senate and people? Profligacy to the point of economic crisis? Failure to pay the troops?

A deeper question, of course, concerns the exact nature of the emperor's power base. Augustus assembled a set of privileges and offices that, when taken together, came to define his position. The senate assigned each of these powers and would confirm future emperors, just as they had ratified the results of the voting assemblies, both elective and legislative, during the Republic. But did the senate really have the right to *name* an emperor, or the ability to enforce its decision? If the emperor's power rested in the armies, did the armies have the ability to choose? And, if so, what part of the army: the largest part posted around the borders of the empire or only those closest to Rome—the so-called **Praetorian Guard**? Did the *populus romanus*—supposedly the ultimate authority in the Republic—have any say whatsoever? What about that great majority of subjects inhabiting the provinces? The century following Augustus's death saw circumstances that would raise each of these questions, providing a variety of answers but little in the way of final resolution. Tension among the imperial administration, the senate, the troops, the provincial population, and the urban masses (not to mention the foreign enemies at the borders) would remain a defining feature of the Roman empire to its end.

For most of the century following the death of Augustus, Rome was ruled by the emperors of two dynasties. The first is called Julio-Claudian because its members brought together both Augustus's family (the *gens Iulia*) and Livia's (the *gens Claudia*). These emperors ruled following the example of Augustus in sponsoring works of art that embody a principle of continuity in succession. This dynasty, and this principle, collapsed in 68 CE under the legendary

incompetence of its last emperor, Nero. The subsequent era of civil war—the famous year of four emperors (69 CE)—ended with the victory of Vespasian and the establishment of a new family dynasty, the Flavian. This rupture is clearly reflected in art, especially portraiture, as Vespasian, and most of those with whom he contested for power, notably rejected the Classicizing legacy of Augustus in favor of a new (and at the same time very old) inclination to realism. Nor was the concept of discontinuity limited to representations of the emperor. Flavian public building openly rejected the precedent of Nero by, for example, restoring to the people the massive tract of land taken by Nero for his Golden House, providing baths, a gathering place of legendary quietude and beauty, and the spectacular entertainments of the Colosseum. These developments were not limited to Rome itself, but reverberated around the empire, most obviously in the West, although works were also completed elsewhere.

While individual emperors had their own imprint, especially on their own palaces, portraits, and public works, there is still a great deal of continuity from Augustan times throughout the first century CE. This is true not only under the Julio-Claudian emperors, who had good reason to attach themselves to Augustus and his monumental legacy, but also in Flavian times. Two fundamental features of Augustan art persist. First, continuing Republican (and Hellenistic) tradition, different styles are used at the same time, and even on the same monument, for different subjects or effects. Second, monuments from each age continue to focus on the three central themes that dominated Augustus's "imperial message"—justification of the elevation to the principate, the benefits a ruler or dynasty provided the empire, and the provision for succession. These developments are traced in Part II from their origins in the creation of the principate under Augustus (Chapter 5), to their appearance during the subsequent century in the imperial representational arts of portraiture and sculpture commemoration (Chapter 6), in official building projects both public and palatial (Chapter 7), and finally in works commissioned and created outside the orbit of Rome and the imperial elite (Chapter 8).

Timeline

	DATE	EVENT
AUGUSTUS	27 BCE	Octavian receives the title of Augustus
	19 BCE	Augustus recovers Roman military standards from the Parthians
	17 BCE	Augustus adopts his grandsons Lucius and Gaius Caesar, sons of Agrippa and Julia
	12 BCE	Death of Agrippa
	2 CE	Death of Lucius
	4 CE	Death of Gaius; Augustus adopts Tiberius who adopts Germanicus
	c. 10 CE	Wall painting: Third Style appears
	13 CE	Tiberius granted power equal to Augustus
	14 CE	Death of Augustus. Tiberius becomes emperor
THE JULIO-CLAUDIANS	19 CE	Death of Germanicus
	c. 20 CE	Wall painting: Fourth Style appears
	26 CE	Tiberius retires to Capri, but retains title of *princeps*
	37 CE	Death of Tiberius; Caligula becomes emperor
	41 CE	Caligula murdered; Claudius becomes emperor
	43 CE	Claudius invades Britain
	48 CE	Messalina, wife of Claudius, is executed
	49 CE	Claudius marries Agrippina the Younger
	54 CE	Death of Claudius; Nero becomes emperor
	59 CE	Agrippina the Younger murdered
	68 CE	Nero commits suicide
THE FLAVIANS	69 CE	Year of the Four Emperors; Vespasian defeats Vitellius and the Flavian dynasty begins
	79 CE	Death of Vespasian; Titus becomes emperor; eruption of Vesuvius; destruction of Pompeii, Herculaneum, and other sites in the area
	81 CE	Death of Titus; Domitian becomes emperor
	96 CE	Assassination of Domitian; Nerva becomes emperor

5

Augustus, the Principate, and Art

130 Augustus in Concept and Image
- 130 Box: Augustus and the Honors of 27 BCE
- 131 Materials and Techniques: Roman Coins
- 132 PORTRAITS OF AUGUSTUS
- 134 PORTRAITURE, THE FAMILY OF AUGUSTUS, AND SUCCESSION
- 137 Box: Identity and Individuality in Roman Portraits of Women

138 The Building Program of Augustus
- 138 MAUSOLEUM OF AUGUSTUS
- 139 HOROLOGIUM
- 140 ARA PACIS
- 144 FORUM OF AUGUSTUS

147 Later Second Style Wall Painting
- 149 Box: Vitruvius on Wall Painting

150 Third Style Wall Painting

151 Augustus's Legacy

Chronological Overview

DATE	EVENT
28 BCE	Mausoleum of Augustus
c. 20 BCE	Villa Farnesina paintings
From 19 BCE	Portrait of Augustus from Prima Porta
17 BCE	Augustus adopts his grandsons Lucius and Gaius Caesar, sons of Agrippa and Julia
12 BCE	Death of Agrippa; Augustus made *pontifex maximus*
c. 10 BCE	Wall painting: Third Style appears; Boscotrecase, Villa of Agrippa Postumus
9 BCE	Consecration of the Ara Pacis
2 BCE	Temple of Mars Ultor in the Forum of Augustus dedicated
Early first century CE	Portrait of Livia from Arsinoe
2 CE	Death of Lucius
4 CE	Death of Gaius; Augustus adopts Tiberius who adopts Germanicus
After 4 CE	Portraits of Augustus, Gaius, and Lucius in Julian Basilica, Corinth, Greece
13 CE	Tiberius granted power equal to Augustus
14 CE	Death of Augustus; Tiberius becomes emperor

The Development of Rome

Right: Map of Rome showing the key buildings in existence in Rome in this chapter.

CHAPTER 5: AUGUSTUS, THE PRINCIPATE, AND ART

Augustus in Concept and Image

On his return to Rome from Alexandria in 29 BCE, after the Battle of Actium and the defeat and death of Antonius, Octavian's first priority was to confirm his new position by commemorating his victories and reinforcing his connection to Caesar. Within two years he had erected the Apollo Palatinus temple (a temple honoring his victories over both Sextus Pompey and Antonius), celebrated a magnificent triple triumph, completed the Temple to *Divus Iulius*, and resumed the building program that Caesar had begun. Very soon, he turned his attention from past accomplishments to the considerable demands of the future. With the elimination of his only colleague Antonius (thus ending the triumvirate), Octavian encountered the reality of sole rule in the face of a traditional Roman abhorrence of kings—an especially tricky situation since he seems to have had every intention of establishing a system of hereditary dynastic succession. Nor were the *mores* (customary norms) of the Romans his only worry; there was a vast empire to rule, much of which was long accustomed to the psychological security that divine kingship can offer.

To create the practical structures he needed to wield his power, Octavian and his advisors developed an ingenious system of military, religious, and civic offices for him, each of which had Republican counterparts, but which were, when viewed overall, both unprecedented and unrivalled in scope. Having also retained control, at senatorial insistence, of the several provinces where the majority of the Roman legions were stationed, his position was, in practical terms,

Augustus and the Honors of 27 BCE

Following his victory at Actium, Octavian was in a position of absolute power, but as the examples of Sulla and, especially, Caesar had showed clearly, the only existing magistracy he might have thought to employ to wield that authority—a dictatorship—was not a viable option for remaining in control. A key to understanding the principles of the newly invented principate can be found in Octavian's own account of the honors received in 27 BCE, when he was also granted the title Augustus. Having renounced his own consulship, he declared that the state should be restored to the hands of the senate and the people of Rome (*Senatus Populusque Romanus*). In response, the senate returned all his powers and granted him the title Augustus, which became the official title for emperor, and remained so to the end of the empire.

> In my sixth and seventh consulships, when I had extinguished the flames of civil war, after receiving by universal consent the absolute control of affairs, I transferred the Republic from my own control to the will of the senate and the Roman people. For this service on my part I was given the title of Augustus by decree of the senate, and the doorposts of my house were covered with laurels by public act, and a civic crown was fixed above my door, and a golden shield was placed in the Curia Julia whose inscription testified that the senate and the Roman people gave me this in recognition of my valor (*virtus*), my clemency (*clementia*), my justice (*iustitia*), and my piety (*pietas*). After that time I took precedence of all in *auctoritas*, but of power I possessed no more than those who were my colleagues in any magistracy.
> (Augustus, *Res Gestae* 34)

The laurels that Augustus describes as adorning the doorposts of his house were a clear reference not only to victory, but also specifically to Apollo, whose temple on the Palatine had been dedicated the year before, next to Augustus's own residence. This seemingly modest act served to suggest the sense of quasi-divinity that Octavian had been promoting since first taking the title *Divi Filius* and attached this same status to his *domus*, and as a result his offspring. The **corona civica**, or civic crown, was a tradition that drew on a Republican precedent of awarding a crown, made from oak leaves, to a Roman citizen who saved the life of another citizen in battle. In this case, it was given to Augustus for bringing an end to civil war, and so rescuing the entire Roman citizenship from peril. Finally, the golden honorific shield of bravery, or **clipeus virtutis**, was meant to underscore the personal qualities of Augustus, which, in addition to his relationship to Caesar and the superhuman qualities he could claim by association, could justify his being accorded *auctoritas*, beyond that held by any predecessor.

MATERIALS AND TECHNIQUES
Roman Coins

At several points in our exploration of Roman art we have looked at coins as a complement to the study of architecture, sculpture, and painting because ancient coins, and especially Roman coins, offer a rich source of both documentary and contextual evidence for artistic developments. One reason for this is the technology of coin production itself. Ancient coins were struck one at a time, by hand, by craftsmen using obverse ("heads") and reverse ("tails") **dies**, cylindrical pieces of bronze or iron, into which the designs for the coin were carved. These dies were individually hand-cut, and wore out relatively quickly (probably after a few thousand coins). Dies therefore had to be remade fairly frequently, at which point a modification could be made to the coin type; the repetition of types was thus only minimally aided by the process of production, although there were other reasons for maintaining consistency in appearance. Ancient Greek city-states, for example, carefully preserved the appearance of their coinage, sometimes even keeping imagery that was, stylistically, out of date as appropriate to its function of assuring the value of the coin, but smaller changes, such as mint-marks, were easily incorporated.

Such was also the case for Roman coinage, which began to be made at the beginning of the third century BCE, some three hundred years after its invention and adoption in the eastern Mediterranean. At first, these coins were circulated as stamped ingots or disks of bronze, but as interaction with Greeks increased, Rome began to issue silver coinage that followed a Greek standard in order to pay Roman troops stationed in Greek colonies in southern Italy. During the Second Punic War (218–201 BCE), Rome created its own silver coinage, based on the *denarius* (a day's wage for a common soldier, and the "piece of silver" of Biblical accounts), which remained the standard for Roman currency for centuries, although bronze fractions and precious-metal multiples were produced as well. Rome maintained, on the whole, the same design for its *denarii* for the first century or so after its introduction, with the standard iconography being the head of Roma on the obverse and the Dioscuri (twin deities Castor and Pollux) on horseback adorning the reverse. With the increasing social and political competition that characterized the upper classes of the late Republic, the mint officials (*monetales*), who were responsible for the production of currency in Rome, began to put their own names on the coins, then added new types that honored eminent ancestors and their accomplishments (for example, 1.35, p. 42). Since the office of moneyer marked a first step in the *cursus honorum*, it offered a valuable early opportunity to create a positive public image. As we have seen in Chapter 4, Caesar was the first living Roman to be represented with his self-portrait on a coin, but this example was soon followed by all of the protagonists in the civil war that followed Caesar's death. These included Octavian who, as Augustus, by bringing the instrument of coinage into the imperial arsenal of public visual persuasion, was, as in so many other ways, drawing on a Republican precedent and adapting it to the new realities of the principate.

unassailable. Critical to the success of this new system was the identity of the ruler himself. What was he to be called? How was he to be portrayed? The two questions found similar answers. In 27 BCE Octavian adopted the title Augustus (with the official approval of the senate), without precedent and intentionally undefined, like his position in the state (see box: August and the Honors of 27 BCE, opposite) [**5.1**]. "Augustus" means dignified, sacred, revered, almost worshiped; it does not quite imply divine status, although its Greek equivalent, "Sebastos," which derives from a verb meaning "to worship," comes closer to doing so; indeed, in the East, the emperors were venerated as gods far earlier than in Rome. From its root, *augere*, "to make greater," the title Augustus gives the suggestion of a greater status than all others. Additionally, the title shares its root with *auctoritas*, the origin of the word authority, which is precisely that quality in

5.1 *Denarius* of 27 BCE, the year of Octavian's adoption of the new title, **Augustus**. Silver. The coin shows his profile, naming him by his new title, Caesar Augustus. The reverse of the coin shows an oak wreath with text translating as "For having saved the citizens," a clear reference to his having ended the long civil war.

which Augustus claimed to have precedence (in his *Res Gestae*, see p. 130). Augustus was, then, a first among equals: not a divine king but not exactly a mortal either. He favored the designation *princeps*, borrowed from the honorific *princeps senatus*, which identified the leading member of the senate who had the right to speak first in senatorial debate; only in much later usage does the term become royal, with the title of "prince."

PORTRAITS OF AUGUSTUS

An image of an emperor was just as important in conveying his status as his title, and portraiture was everywhere in the Roman world. Statues of emperors and their families were set up in every public space; anyone who owned a Roman coin effectively held an imperial portrait in his or her hand. Such representations constituted the very presence of the ruler to his subjects, and played a large part in constructing ideas of empire and emperor alike. How, then, might one embody Augustus? A famous statue in the collections of the Vatican Museums that was found in an imperial villa at Prima Porta (a suburb to the north of Rome) has strongly influenced modern ideas about Augustan portraiture [5.2]. It gives its name to the "Prima Porta type" of Augustan portrait, a variation of which is also illustrated by an early bronze example from Meroë in Sudan [5.3]. This type is smoother, less expressive, and more idealized than the "Actium" type, which is believed to portray Octavian before he assumed august status, although the Actium type was still used well after 27 BCE (see 4.14, p. 111). The Prima Porta type preserves something of the vigor and intensity of that tradition, but it is transformed by a more controlled arrangement of forms; the result is that an idealizing veneer is laid over a still very recognizable portrait image.

5.2 (Right) Augustus from Prima Porta, Italy, from 19 BCE. Marble. H. 2.03 m (6ft 8 in.). This portrait type came in around the honors of 27 BCE, becoming the most commonly used type.

5.3 Head of Augustus from Meroë, Sudan, early 1st century CE. Bronze. H. 47.7 cm (1 ft 6⅞ in.). This Augustan bronze portrait reflects the Prima Porta type.

132 PART II: THE FORMATION OF THE ROMAN EMPIRE

The use of simplified, idealized forms and a balanced, frontal pose associates the Prima Porta sculpture with works in a Classical style, such as the ancient Greek Polycleitus' *Doryphoros* ("Spear Bearer")[5.4], a fifth-century BCE bronze created to embody the Classical ideal. In this way the Augustus portrait draws on a Hellenistic tradition of using such schemes for Olympian deities and Homeric heroes; the style underscores the separation of its subject from the temporal

5.4 *Doryphoros*, 5th century BCE. Marble. H. 2.12 m (6 ft 11 in.). This is a Roman marble copy of an original bronze sculpture by Polycleitus. *Doryphoros* significantly influenced Augustan portraiture.

and the mortal realm. By adopting these features, Augustus hoped to infuse his own image with an implied quality of quasi-divinity, a status that was more heroic than it was mortal or divine. On the basis of these traits, we call the Prima Porta statue Classicizing, but does that indicate, as is often assumed, that we are dealing with a Classical revival?

In 5.2 Augustus is depicted in military dress, his cuirass (breastplate) decorated with figures in relief, presumably reproducing bronze parade armor [5.5]. His left hand probably held a sword; it is disputed whether the right arm originally was held in a gesture of address, as presently restored, or whether it rested on a spear. The themes portrayed on the cuirass reveal the meaning of the statue. The central scene refers to a historical event of 20 or 19 BCE: the negotiated recovery, from the Parthians, of Roman military standards captured in battle a generation before (from M. Crassus in 53 BCE). The terrestrial deity at the bottom of the cuirass signifies an earth made bountiful through the ending of hostility. The

5.5 Detail of cuirass of Augustus from Prima Porta, Italy, from 19 BCE. Marble. The scenes depicted on the cuirass suggest Augustus's achievements and specifically reference the recovery of standards from Parthia in 19 BCE.

CHAPTER 5: AUGUSTUS, THE PRINCIPATE, AND ART 133

celestial deities on the chest and the geographic personifications to either side suggest that the *Pax Augusta* (Augustan Peace) is both permanent and universal. The figures of Diana and Apollo curving around the left-hand side of the body as we view it show Augustus's patron deities, credited with bringing success in his past victories over Antonius and the younger Pompey.

Although a military sculpture, the Prima Porta statue has more to do with peace than with warfare, or rather, highlights peace as the *objective* of warfare. Two features unique among **cuirass portraits** emphasize that message. First, the statue is barefoot, similar to depictions of gods and heroes and unlike representations of properly shod Roman generals. Second, the drapery wrapped around the waist rather than pinned at the shoulder reflects a fashion highly unsuited to the battlefield, but often found in depictions of divine beings. With the idealized facial features and Classical stance, such details remove Augustus from the real world of military exploits, despite his military clothing. Fighting is a part of the past; the peace and prosperity that these wars brought to the Roman world is the story of the present.

What, then, *was* the point of the Prima Porta's Classicism? Was it meant to refer to the Greek *Doryphoros*, or something else again? We recall that the image of *Divus Iulius*—that is, Julius Caesar as a god—was barefoot, stood in the Polycleitan *contrapposto* manner, and wore the wrapped mantle. Throughout his lifetime, even after he was firmly established as emperor and it no longer should have mattered, Augustus based his claim to rule on his family ties with his adopted father, not simply because he wished to be seen as the successor to Julius Caesar the man, but because he wished to be seen as the son of *Divus Iulius* the god: *divi filius*. The idealized style of the Prima Porta statue reflects the borderline status between mortality and divinity that Augustus could claim from his parentage, and this is highlighted here by the statue's supporting strut in the form of Cupid (god of desire, and usually portrayed as the son of the goddess Venus) astride a dolphin. The reference to Venus brings to mind her role as "Genetrix," the divine ancestress of the *gens Iulia*, or the family of Julius, through Aeneas, heroic founder of the Alban monarchy and, in turn, ancestor of the Roman people through his descendants Romulus and Remus. While the visual language of the Prima Porta's Classicism was Greek, the message was a Roman one; it was not the past golden age of Athens under Pericles in the fifth century BCE that mattered, it was the new golden age (*aureum saeculum*) of Augustan Rome.

PORTRAITURE, THE FAMILY OF AUGUSTUS, AND SUCCESSION

In the same manner as many works of Augustan art, the Prima Porta portrait weaves together three themes that formed the primary message of the principate. First was Augustus's right, as Caesar's heir, and his qualification, as the son of a god, to assume control of the Roman state. Second was the respite from war, the *Pax Augusta*, with its associated marks of prosperity. Third was the elevation to august status, not only of the *princeps* himself, but also of his entire extended family, a move clearly designed to pave the way for a smooth dynastic succession.

Caesar was fifty-five years of age at his death but, presumably, had given little thought to the issue of succession. Augustus, who was aged thirty-six when he assumed that title, had perhaps learned from the experience, since he clearly concerned himself from the outset with dynastic aspirations. For example, Augustus's great family **mausoleum** was among the very first buildings that he constructed, following a long-established practice of monarchs elsewhere in the Mediterranean. The first person to be interred there (in 23 BCE) was Marcus Claudius Marcellus, the young nephew and son-in-law of Augustus, not yet twenty years old. Despite his age, Marcellus had seen an accelerated political career, and this rapid advancement suggests that he was being marked out for succession. Not long after his death, Marcellus's widow (Augustus's only child, Julia) was married to the emperor's closest colleague, Marcus Agrippa, with whom she had five children. The two eldest boys were soon adopted by their grandfather, as Gaius and Lucius Caesar, and raised as his sons and heirs. They grew up in the imperial residence and were carefully groomed for eventual succession, but both perished in young adulthood (Lucius in 2 CE, Gaius in 4 CE), and in the end Augustus was

succeeded by his middle-aged stepson, Tiberius Claudius Nero, whom he had adopted as Tiberius Julius Caesar soon after Gaius's death, at the beginning of the first century CE.

Succession, then, was no easy matter for Augustus, and he was forced to reach rather further from his immediate line of descent than he probably would have liked. But it is clear that imperial portraiture was designed to merge any variations in bloodline by asserting a remarkably consistent style and look for all members of the family, as can also be seen in Hellenistic, especially Ptolemaic, and ultimately Egyptian practice. Just as Augustus's own youthful portrait image is maintained unchanged down to his death at the age of seventy-seven, so this idealized, Classicized mode of representation is maintained for all the inhabitants of the house of Augustus.

A statue group found in Corinth, the capital of the Roman province of Achaia (southern Greece), depicts the emperor and both of his grandsons, Gaius and Lucius [5.6]. These statues originally stood in the so-called Julian Basilica, a public hall that, by means of these images, functioned in part to glorify the imperial family. Included in the group is a portrait of Augustus himself, wearing a toga, with his head draped (a device called *capite velato*) in the manner of a priest. Augustus and later emperors are frequently depicted as priests, following a Republican tradition in which both religious offices and civic magistracies (and the distinction was not complete) contributed equally to an individual's status and power.

5.6 Portrait statues of Lucius (left) and Gaius (right) alongside their grandfather Augustus (center), from the Julian Basilica, Corinth, Greece, first century CE. Marble. H. 2.08 m (6 ft 10 in.). All three share striking similarities in facial features and hairstyles, highlighting their familial links and a connection to the divine.

5.7 Portrait of Livia, Arsinoe, Egypt, early 1st century CE. Marble. H. 34 cm (1 ft 1½ in.). Livia's features are highly Classicized. Her hair is typical of the virtues Augustus wished expressed by Roman women, with a *nodus* at the forehead and a bun at the back of the head.

Moreover, after Augustus's election as *pontifex maximus*, the chief high priest, upon M. Aemilius Lepidus's death in 12 BCE, every emperor thereafter would hold this office, which emphasizes the role of the *princeps* as religious, as well as civic and military, leader of the Roman world.

The images of Gaius and Lucius are of a very different type, and demonstrate a nearly nude, heroic scheme that is reminiscent of late Republican examples from Delos, such as the Pseudo-Athlete (2.30, p. 73). In this context, however, the Classical portrayal, in the same way as the portrait style itself, is more literally heroizing, intended to indicate that the quasi-divine status extended from Augustus to his relatives. Therefore these statues should possibly, but not necessarily, as some have argued, be dated after Gaius's death in 4 CE. In any case, the portrait types themselves follow a well-established scheme, beginning from when the subjects were young boys. What is most striking here is the strong similarity in facial features and hair arrangement that the two young men shared between them, and with Augustus himself. Following the Prima Porta head type, each hairstyle displays both the forked locks to the right of center and the "pincers" motif to the left. The facial structure, proportions, and highly idealized features are also very consistent from statue to statue. Despite the variation in garment, the three are also similarly posed in the High Classical Attic stance, with free leg advanced, distinct from the quite different Polycleitan stance of the Prima Porta statue. The more completely preserved of the two youths seems marginally more mature—his face is slightly less fleshy—and perhaps resembles his grandfather just a little more; he is therefore taken to represent Gaius, although the features that distinguish between the brothers are subtle. The very difficulty of making this distinction is significant, since assimilation to a general model for all male members of the *gens Julia* was clearly the intention here.

Idealized portrayal was not limited to Augustus's male relatives, but extended to the emperor's sister and daughter as well, and also to his wife, Livia, who had no blood connection with the clan. Portraits of women in the Hellenistic world had always featured a lesser degree of characterization than portraits of men. During the Republic, living women (as opposed to goddesses) were not given public statues apart from a few rare exceptions. Instead they were seen in private spheres. It is not until the Augustan period that public portraits of women become visible.

Just as it is no easy matter to distinguish between portraits of Gaius and Lucius, or between those and images of such slightly later imperial princes as Germanicus and the younger Drusus, so the identity of female portraits is often disputed when determining the subject as Livia, Octavia, or Julia. All three women are shown on coins and display similar hairstyles, although these vary somewhat from example to example. Attempts to identify individual portraits, and to divide portraits of one subject into types, as has often been tried in the case of Livia, rely on subjective judgment. A marble head in Copenhagen [5.7] is more or less typical. It bears a tightly wound and stylized hairstyle characterized by a roll of hair (*nodus*) above the forehead and bun at the back. The facial planes are hard and smooth, suggesting the features of a young face. The eyes are large and round, the nose thin and aristocratic, the mouth small and serious, and the cheeks and chin are delicate and feminine. It is, in every way, the female counterpart of the standard Augustan

136 PART II: THE FORMATION OF THE ROMAN EMPIRE

type, and the look varies little between portraits, whether the subject was related by blood to the *princeps* (such as Octavia and Julia) or not (Livia).

The impression of all imperial Augustan portraiture is one of quasi-divine dignity, authority, and reserve, qualities specifically mentioned by Roman writers as being inherent in the art of Classical Greece itself. At least one Roman writer (Quintilian, *Institutio Oratoria* 12.10.8) specifically describes Classical art as embodying *auctoritas*—which, as we have seen, encapsulates the essence of Augustan leadership—a quality (and a status) that Augustus wished to extend to his entire family. A related issue is the role of Augustus's family members as models of moral virtue. An intriguing feature of Augustan policy was his declaration of morality legislation that was designed to reward marriage, fidelity, and the production of legitimate offspring. The exact political agenda of these laws is not known, but it surely involved a desire to maintain stability among the upper classes and, probably, to ensure a steady supply of reliable aristocrats to help in the administration of empire. It is clear from historical sources that Augustus wished his family to be thought of as the embodiment of these moral principles, and the qualities suggested by the portrait style would strongly support this message. Unfortunately for Augustus, reality was not quite consistent with the desired impression. Julia and her eldest daughter, also named Julia, were both eventually banished from Rome (for adultery), as was the younger brother of Gaius and Lucius, Agrippa Postumus (for reasons unknown). These shortcomings in meeting his moral standards were a source of great grief and embarrassment for Augustus. Nonetheless, despite the inconsistency between image and reality, these Augustan portraits would set the style of imperial self-representation for generations to come.

Identity and Individuality in Roman Portraits of Women

One of the most important contributing factors to the development of styles employed in Roman portraits was the role of portraiture as an embodiment of socially constructed virtues. During the Republic, portraits emphasized specific qualities or abilities, such as military success or experience gained with age, the importance of which was inscribed into the very structure of the Republic. The result is the veristic style, as we have seen. The shift to idealism in the early empire is less an innovation than a reflection of the change in the virtues being promoted, from the pragmatic Republican catalog of accomplishments to the abstract ideas advertised on Augustus' *clipeus virtutis*, his shield of bravery (masculine courage, clemency, devotion to duty, and commitment to justice). The realities of dynastic rule, moreover, introduced two further principles: visual continuity (and discontinuity) with imperial predecessors and, occasionally, biographical features that were specific to that particular subject, such as (seen in the second and third centuries CE) Commodus's incarnation as Hercules, or Severus's Greco-Egyptian Serapis curls.

Roman portraits of women drew heavily on Hellenistic tradition. Portraits in Greece were intended to honor the aristocratic family and so representations of females were often commissioned within a family portrait group. The heads of male portraits became increasingly visually characterized during the Hellenistic period, but those of women remained Classically generic. This has been interpreted as a suppression of individuality in women as opposed to men, in which a different set of virtues was emphasized: beauty, modesty, and piety. In Roman portraits of women, both life-like and idealized images of women appear, again embodying different social merits. For example, Augustus saw the family as central to the reformation of Rome, and focused on such supposed crucial female virtues as marital fidelity and chastity. This can be seen in early examples of Livia's image, as a case in point.

Roman representations of women, in the same way as those of men, drew heavily on both Hellenistic and Etrusco-Italic imagery, with their far more realistic variety of facial expression. In private tomb sculpture, for instance, female subjects are shown similarly to their male counterparts in respect to their serious features and signs of age—for example, the portrait of Atistia from her tomb with Eurysaces the baker (see 8.6, p. 210) and the portrait of Hateria in the Haterii mausoleum (see 8.7, p. 211). While they resemble their Hellenistic predecessors in that they appear relatively more idealized than their husbands, in their features they were often, as was the custom in Roman marriages, much younger.

The Building Program of Augustus

After his rise to sole rule, Augustus began to build a complex of structures that was deeply symbolic and dynastic, some of which has already been discussed in Chapter 4. This was principally undertaken at the Campus Martius (the "Field of Mars"), which takes its name from the war god to whom it was dedicated when still undeveloped land at the beginning of the Republic [5.8]. It was used as a mustering place for troops before embarking on campaign, a training ground, and, increasingly, an area for the dedication of temples and other monuments in commemoration of military triumphs (see The Triumph and Republican Temple Architecture, p. 55). The site retained this last function throughout the empire. In Renaissance and Baroque times, as Rome again became a powerful urban center as home to the Catholic Church, the area was once more filled with monumental buildings: churches, palaces, and administrative centers. Some of the ancient monuments were preserved (such as the Pantheon, see pp. 266–67) or incorporated into new buildings (for example, the Temple to *Divus Hadrianus*, p. 283), but most of the imperial structures became buried, and remained deep below the more recent buildings.

MAUSOLEUM OF AUGUSTUS

Among the first monuments that Augustus built in the Campus Martius was his enormous mausoleum, erected in the northernmost sector, and dedicated in 28 BCE. It is one of Augustus's most blatantly dynastic monuments. The building was much built over in later periods—it was used at various times as a fortress and as a theater—but sufficient remains of the Augustan edifice, and ancient descriptions, allow us to gain a fair idea of its original appearance. A great circular structure [5.9] of concrete, patterned in a diagonal style called *opus reticulatum*, and faced with white **travertine** (limestone) and marble, it comprised a series of vaulted, concentric circular honeycombed passageways. Niches in the center chambers housed urns that held the ash remains of not only Augustus and his immediate relatives but also subsequent *Augusti*—later emperors—and their families.

Near the end of his life, Augustus installed two bronze pilasters, inscribed with an account of his honors and accomplishments (the *Res Gestae Divi Augusti*), which flanked the tomb's entrance. This entrance occupied a paved court and

5.8 (Above) Plan of the northern Campus Martius, Rome, Italy, during the time of Augustus. The new *princeps* located a number of his dynastic buildings here.

5.9 (Right) Reconstruction of the Mausoleum of Augustus, Rome, Italy, built 25 BCE. A great circular building of concrete that served as a monument to his dynasty, the structure was clad with white travertine stone and marble.

138 PART II: THE FORMATION OF THE ROMAN EMPIRE

formally planted parklands that were open to the public, above which the mausoleum would have loomed to a height of as much as 45 meters (148 feet), an impressive sight indeed. It was described in antiquity as a tumulus (a great burial mound) planted with trees, so it is not certain whether the concrete platform supported one continuous earthen mound, or if the structure was more elaborate and designed with stepped cylindrical stages, each stage with its own mound and set of trees. A bronze statue of Augustus was placed at its summit. The tumulus form contained multiple references, invoking both indigenous Italian and more exotic and regal references: Etruscan tumuli, the great royal tombs of Asiatic Lydia, and even the tomb of Alexander, which is sometimes called a tumulus.

HOROLOGIUM

Nearly two decades after the mausoleum's construction, some 400 meters to its south, another public, open-air monument was erected, which we have only recently come to understand. In 10 BCE, an Egyptian obelisk of red granite was placed on a large (160 × 75 meter) marble pavement, in which bronze markers and Greek letters were inlaid. Pliny the Elder is our only written source for the monument, and he explains that the shadow cast by the obelisk indicated on the markers the changing lengths of day and night throughout the year. Archaeologists have found sections of the inlaid pavement; some of these sections were discovered out of context and some of them *in situ*. There has been great disagreement among scholars over the function of this structure, and its relationship to another important monument at the Campus Martius, the Ara Pacis (see p. 140). The excavators interpreted the pavement as a massive **horologium** [5.10], or sundial, although the pavement that they found actually verifies Pliny's very different explanation of it as a solar *meridiem* (designed to measure the change in the length of the day throughout the year). The discovered pavement dates not from the Augustan period but from the Flavian era, some thirty to fifty-five years later, and Pliny, who was writing at that time, mentions that the device had become inaccurate over the years. The error was apparently corrected in the newer pavement.

It has been convincingly argued that Augustus set up the *meridiem* to commemorate his election as *pontifex maximus* in 12 BCE, in which role he was responsible for the calendar of Rome. Soon after he took office, in fact, Augustus undertook to correct errors that had occurred since the previous calendar revision by Julius Caesar, when Caesar had held this same office. Both the revision and its conspicuous commemoration with the obelisk and pavement would have therefore served to both revive and confirm Augustus's now decades-old self-formulation as the son of a *divus*.

The markings on the pavement, which indicate the passing days of the year, and were complemented by a sequence of signs of the zodiac, are consistent with Pliny's account. The sense of eternity evoked by the inexorable movement of the obelisk's shadow recalls the theme of Augustus's universal and permanent order, as already detected on the Prima Porta cuirass, and suggests a programmatic connection to two other overtly dynastic monuments: the mausoleum to the north and, to the east, another monument called the *Ara Pacis Augustae*, or the Altar of Augustan Peace.

5.10 Reconstruction of the *Horologium Augusti*. The shadow cast by the obelisk indicated the changing lengths of the days on pavement markers, and could be used to measure the passing of the year. It may have been set up after Augustus was elected *pontifex maximus* and became responsible for the calendar of Rome.

ARA PACIS

The construction of the *Ara Pacis Augustae* was voted for by the senate in July of 13 BCE, upon Augustus's glorious return from a three-year military tour of Gaul and Spain, which was credited with establishing peace across the empire. The altar was located immediately west of the via Flaminia, the route by which Augustus would have re-entered the city on his return. Some have seen it as analogous to a triumphal monument, voted instead of a triumph, to commemorate Augustus's success in pacification rather than conquest. It would, then, stand in relationship to a triumphal monument (such as an arch) in much the same way that the Prima Porta portrait of Augustus stands to other cuirass statues. The monument was dedicated just four years later (January 30, 9 BCE), so work on the altar and on the nearby horologium was done at the same time and probably represented an organically planned complex. It has been speculated that the shadow from the sundial fell on the doorway of the Ara Pacis on the day of Augustus's birth (also the autumnal equinox, 23 September), although modern scholars now doubt such a relationship between the two monuments.

Parts of the Ara Pacis were found in the sixteenth century by workers building a Renaissance palace; the altar's foundations were discovered, and most sections of its superstructure were subsequently excavated out from under this palace as part of Benito Mussolini's later intended "revival" of the Roman empire in the twentieth century. The monument was then re-erected, not in its original location but adjacent to remains of the Mausoleum of Augustus, where it still stands today, although its 1930s glass enclosure was replaced in 2006. The Ara Pacis was built entirely of Carrara marble and oriented toward the cardinal points of the compass. At the center stood the stepped altar itself, which was **pi-shaped**, similar to many Greek and Hellenistic examples. Surrounding this was a high enclosure wall, with doors at the front and rear (west and east); such dividing off of a sacred area (*templum*) around an altar was consistent with Italic practice, and the marble enclosure wall seems to have had Classical Greek precedents as well [5.11]. While the Ara Pacis was a relatively simple structure, it was elaborately decorated with extraordinarily fine relief sculpture displaying a richly textured program of early imperial iconography.

On the altar itself, which is not well preserved, the extant reliefs are entirely within the Italic tradition. The two preserved scenes show the assembled Vestal Virgins [5.12], who were specifically mentioned by Augustus in his autobiographical funerary inscription, the *Res Gestae* (12.2) as participating in the sacrifices held at this altar, and the procession of sacrificial victims; the side-by-side arrangement of figures strongly recalls the late Republican census relief in Paris (see 2.20, p. 66). This depiction of a relationship between a monument itself and the activity that will take place there has many parallels on Roman altars, from all periods. For a broader message concerning Augustan rule, however, one must look to the far more conspicuous exterior view of the Ara Pacis.

The marble rectangular enclosure was elaborately carved on both faces and all four sides. The interior was decorated with engaged pilasters connected by a low wall, above which hung rich garlands suspended

5.11 Exterior of the *Ara Pacis Augustae*, Rome, Italy, 13–9 BCE. Marble. W. 10.7m (35 ft). It was located immediately west of the via Flaminia, and built to commemorate Augustus's success in bringing peace to the empire.

from *bucrania* (the skulls of ox) [5.13]. The motif of garlanded columns recalls Second Style wall painting (a very close parallel occurs in the House of Livia, discussed on p. 116) and, as a means of marking off sacred space, this scheme is as old as the Archaic Etruscan tombs. The garlands hung from *bucrania* constitute a sculptural motif commonly used on both Hellenistic and Roman monuments, found, for example, on the architrave of the Republican Portunus temple (see 2.9, p. 58), as well as a plethora of marble altars and sarcophagi. These motifs reference both sacrifice and the fruits of the earth, and within this very religious context that this wall functions to define, can refer at once to the offerings made to deities and, more symbolically, to the benefits received in return.

The relationship between peace and prosperity, something as old as Classical Greece, is not only widespread here, it is also highly structured, repetitive, and worked as a theme within the design of the Ara Pacis. Order, implicit in the very image of Augustus and his family, is now explicitly presented as a gift of the Augustan peace. Much the same can be observed in the remarkable acanthus scrolls on the lower panels of the enclosure's exterior surfaces. These are deeply carved, symmetrical in scheme, but infinitely various in detail, and inhabited by a menagerie of birds, amphibians, and reptiles that play out their own dramas among the spreading leaves. In the same way that the Hellenistic world was settled under Roman rule, so here nature itself is brought under control by Augustus and his universal peace.

On its two long sides (north and south), the upper outer surface of the enclosure wall consisted of a procession that was far larger than the sacrifice reliefs on the altar proper. The figures in each procession nearly fill the 1.6-meter-high background, meaning they are only slightly less than life-size. Each procession moves from east to west and ends at the front of the altar. This recalls, but does not reiterate, the arrangement of the ancient Greek Parthenon frieze at the Acropolis in Athens, where the worshipers in the frieze also move along both sides of the building, and come together, in that case, at the east end. For this reason, namely in the large scale of the figures, the overlapping composition, the quiet mood, and the idealized features of some participants, some scholars have read the Ara Pacis procession as a Classicizing reference made directly to the Parthenon itself. As in Augustan portraiture, it is probably more accurate to conclude that the designer here chose to make use of the *dignitas* and *auctoritas* inherent in Classical style as appropriate for the subject and the purpose of the monument.

On the south side are included some clearly identifiable portrait figures, such as Augustus

5.12 Procession of Vestal Virgins, north inner wing of the altar of the Ara Pacis, 13–9 BCE. Marble. H. 39 cm (1 ft 3³⁄₈ in.). The relief shows all six Virgins participating in sacrificial rites.

5.13 The *bucrania* on the interior wall of the Ara Pacis, 13–9 BCE. Marble. The ox skulls and garlands reference sacrificial offerings.

CHAPTER 5: AUGUSTUS, THE PRINCIPATE, AND ART 141

5.14 Augustus, religious officials, and members of the imperial household, south side frieze of the Ara Pacis, 13–9 BCE. Marble. H. 1.6 m (5 ft 2 in.). Augustus is the partially fragmented figure on the far left. Agrippa appears as the prominent, hooded figure on the right.

and Agrippa, followed by figures of various ages, including children who by contrast are more idealized in form, suggesting that they are members of the imperial family [5.14]. Yet it is possible that some are barbarian princes, raised in the imperial family to ensure the allegiance of their kinsmen. Surrounding Augustus are **lictors**, bodyguards who, during the Republic, accompanied magistrates with *imperium*, such as praetors or consuls, and who continued to attend the emperor as a symbol of his absolute power over the army. At the far left, Augustus himself is togate (wearing a toga), with his head draped in the style of a *pontifex*, and he is followed by other religious officials, whose attributes signify their priesthoods, highlighting Augustus's position and status as "greatest priest." On the north, long side of the structure, most figures are togate males wearing laurel crowns. These are probably senators, whose participation here in the procession reinforces Augustus's membership of the noble class (we might recall that the family or *gens* of Augustus, the *Octavii*, unlike his adoptive one, the *Iulii*, were not members of the patrician class), reminds the viewer that the Ara Pacis was created by a senatorial decree, and implies senatorial endorsement for the principate as a whole. Moreover, Augustus himself boasts that the senatorial magistrates proceeded out of Rome to receive him on his return to the city (*Res Gestae*, 12.1). Also included, on the north side, are figures of women and children, similar to those on the south.

While the overall message of this frieze is clear enough, there is little agreement as to what exactly is being depicted. Some have seen it as a ceremony related to the vowing of the altar or the inauguration of the sacred area in 13 BCE; others have read it as anticipating its dedication and first sacrifice in 9 BCE, although by then, Agrippa, who is hooded and features prominently on the far right, had been dead for nearly three years. If an actual event is shown, the most probable is that of a **supplicatio**, a procession of thanksgiving (for Augustus's safe return or for the peace he has brought) that worked its way through the city to various sacred spots. This would stand as a non-military counterpart to the triumphal procession, as suggested above. Although a *supplicatio* for 13 BCE is not specifically documented, we know from the *Res Gestae* that Augustus conducted fifty-five of them, so it is highly likely that there was such a procession at that time. There also remains the strong possibility that here, as on the Parthenon frieze, it is the general message (namely of Augustan piety, peace, and dynastic succession) that is most important, rather than a specific event, and that no historical procession is actually shown. This would be rare to find in Roman (although not Greek) art, which inclines toward the literal, but this is an unusual, innovative, and obviously Hellenizing monument.

5.15 Aeneas and his son (right) sacrifice a sow, the Ara Pacis, 13–9 BCE. Marble. H. 1.6 m (5 ft 2 in.). The scene is one of *pietas*.

At the east and west facades of the Ara Pacis, four individual panels are placed above the floral scroll panels, two flanking each door. The panels at the west end (facing the Horologium plaza) depict subjects drawn from early Rome: fragments remain from a panel showing Romulus and Remus suckling at the she-wolf, with their father, Mars, looking on. The much better-preserved relief opposite shows the Trojan prince Aeneas [5.15], from whom these founders of Rome were originally descended, and who was central to the tradition of divine origin for the Julian family. Our knowledge of Aeneas's exploits derives principally from the *Aeneid*, Virgil's epic poem that was specifically commissioned to glorify the imperial family. Aeneas serves, in the *Aeneid*, as on the Ara Pacis, as an emblem of Augustus's faithfulness (*pietas*): to his father, to the gods, to his duty, and to his destiny. The parallelism is clearly marked here by the similarity in pose and dress between the two figures, both of whom are involved in a religious act. Aeneas, together with his son Ascanius/Iulus, is sacrificing a sow (an episode that is mentioned in the *Aeneid*) to his household gods, which he has brought from Troy and placed in the small temple in the background. Aeneas, like Augustus, is accompanied by his family, and the two youthful male attendants in the scene may have been intended to resonate with the figures of the grandsons of Augustus, Gaius and Lucius Caesar themselves, who should appear among the children on the procession frieze.

The highly pictorial use of landscape and perspective on the Aeneas panel recalls late Republican painting, as well as Hellenistic precedents. More firmly still in the Hellenistic tradition are the panels on the east facade (facing the via Flaminia), which differ from those on the back in being allegorical (having symbolic meaning) rather than mythological or historical. The far better-preserved panel on the south features a central grouping that strongly parallels the reclining earth goddess of the Prima Porta cuirass composition (see 5.5, p. 133). Here, however, the deity sits upright on a rocky landscape, surrounded by lush vegetation, with a cluster of fruit and two babies in her lap. She is strongly Classicized in her pose, proportions, facial features, and dress; the drapery slipped off her shoulder and clinging to her breast is a motif commonly found on representations of Aphrodite (as seen on the east pediment of the Parthenon temple in Athens), where the device emphasizes

has been interpreted as representing or referring to all three goddesses at once. Whatever the details, the message being communicated here is clear, and by now relentless: the prosperity that resulted from the Augustan Peace. The personifications of terrestrial and marine breezes to the left and right, respectively, remind us that this is a universal peace, as on the Prima Porta statue, and in Augustus's claim that his victories "secured peace by land and sea throughout the whole empire of the Roman people" (*Res Gestae* 13).

FORUM OF AUGUSTUS

As we saw in Chapter 4, from 54 BCE Julius Caesar began acquiring land and building his Forum Iulium, or the Forum of Caesar, the first of several "imperial" fora to be built in Rome. The next was the Forum of Augustus. This forum, and its central temple, the Temple of Mars Ultor ("the Avenger") was vowed, appropriately, before the Battle of Philippi in 42 BCE and dedicated, after much delay and considerable aggravation, in 2 BCE. This complex stretched northeastward from Caesar's forum (see 4.7, p. 107), which it abutted, to the foot of the Viminal hill, into which it was cut [5.17]. Its plan closely followed that of Caesar's, with a great **octostyle** (having an eight-column facade)

5.16 Tellus relief, the Ara Pacis. 13–9 BCE. Marble. H. 1.5 m (4 ft 11 1/8 in.). The figure known as Tellus has been identified as various deities.

her fertility and sensuality. Most often, the figure has been called Tellus [5.16], an Italic earth goddess, but others have identified her as Venus, from her resemblance to Aphrodite, and in light of the importance of this deity to the Augustan program. Others have suggested that she is Pax, or Peace, herself, as she seems to quote a famous late Classical statue of Peace (Eirene) holding the infant Prosperity (Ploutos) that stood in the Athenian Agora. More recently, as scholars have accepted that multiple meanings for single images (what we call **polysemy**) can coexist, this figure

5.17 Plan of the Imperial Fora, Rome, Italy. The Forum of Augustus contains the Temple of Mars Ultor (Mars the Avenger).

144 PART II: THE FORMATION OF THE ROMAN EMPIRE

Corinthian temple at one end, dominatimg a large portico-enclosed open space in front. This forum was shorter and somewhat broader than that of the Forum of Caesar; literary sources indicate that it was not, in the end, as sizeable as Augustus had desired, but that he preferred not to seize land that he could not buy. Yet it covered an approximately equal area as the Forum of Caesar and was likewise opulently decorated with spoils, statuary, paintings, and a wide range of imported colored marble.

The Temple of Mars Ultor [5.18] was very similar in plan to Caesar's Temple of Venus Genetrix, no doubt deliberately, but it was both broader and taller, and so would have seemed more massive when viewed from the open forum area in front. At the rear of its apsidal cella stood a triad of cult statues—Mars in the center, flanked by Venus and *Divus Iulius*—a group that makes the associations of the monument very clear. A relief from North Africa [5.19] may well represent the three statues; here, Mars is shown in full armor and Venus (with Cupid) stands in a strongly leaning pose that suggests Hellenistic Classicizing derivation. Caesar is shown in ever-youthful divinity, his identity marked by the attachment scar for a star on his forehead; Augustus had added such a symbol to each of his portrayals as a mark of his divine status. The star itself derives from the tradition that a comet (*Sidus Iulium*, or "Julian star")—a sign of apotheosis—appeared at the time of his cremation.

The facade of the Mars temple was also depicted, this time on a monumental relief from the succeeding Julio-Claudian era. Here we find Mars in the center, not dressed in armor but appearing as a semi-draped god, not unlike the image of *Divus Iulius* in 5.19. Venus, to the left, again appears with Cupid, who emphasizes her role as *genetrix*, but the type is very different from that of the statue inside the actual cella. She is balanced on the right by Fortuna, who represents the benefits brought to Rome by the Julians, a role she also has on the Ara Pacis. The tableau is completed by two seated figures, probably Roma and Romulus, and two reclining figures, no doubt geographical personifications, such as those found in the pediments of both the Parthenon at Athens and the Zeus temple at Olympia, in Greece.

The Augustan sculptural program was not limited to the Mars Ultor temple, but spread throughout the forum in its entirety. The long flanking Corinthian porticoes loomed even higher than those in Caesar's forum (continuing the impression of height created by the very tall

5.18 Reconstruction of the Temple of Mars Ultor in the Forum of Augustus, Rome, Italy. Vowed before the Battle of Philippi in 42 BCE, it was not dedicated until 2 BCE.

5.19 Algiers Relief, Carthage, Julio-Claudian dedication. Marble. H. 98 cm × W. 1.13 m (3 ft 2⁵/₈ × 3 ft 8¹/₂ in.). The relief shows statues of Venus, Cupid, Mars, and *Divus Iulius*, sculptures that may have been present in the Temple of Mars Ultor in the Forum of Augustus.

5.20 Remains of the attic story of the Forum of Augustus, Rome, Italy, 2 BCE. H. c. 2 m (6 ft 6 in.). Supports in the form of caryatids, which reference the Erechtheion in Athens, carried the shallow ceiling. Between each caryatid was a clipeate protome.

temple) by supporting an **attic** story [5.20]. Here, above each column, stood supports taking the shape of a human figure known as a caryatid. These figures, in turn, held up a shallow, coffered ceiling. Each pair flanked a sculptured relief showing the head or **protome** of a god, centered on an elaborately carved round shield: so-called **clipeate** images, from the Latin word *clipeus*, or shield. The best-preserved example shows Jupiter/Zeus Ammon, providing a clear reference to Alexander the Great, who had claimed descent from this Egyptianized form of the king of the Olypians.

Behind each portico of the forum, a broad semi-circular plinth, an **exedra**, opened out, the centers of which defined a line that ran across the forum precisely along the facade columns of the temple. The walls of the porticoes contained niches for statues, and these were flanked on either side by rectangular columns or pilasters. This pattern of niches and pilasters ran continuously along the curved rear walls of the exedrae, and the exedrae themselves were screened by a line of freestanding pilasters that continued the line of the portico columns. The niches contained large-scale statues of eminent figures from Roman history, each identified by inscriptions that detailed their offices and accomplishments. In the center of the north exedra stood a statue of Aeneas, with his father Anchises and son Ascanius/Iulus, who were flanked on either side by luminaries of the *gens Iulia*. The opposite niche centered on Romulus as a **triumphator** with the ***spolia opima***: spoils taken from an enemy commander by the hand of the *imperator* himself, an honor received by Romulus and only two others in all of Roman history. Romulus's image was flanked by those of other triumphators and great men (*summi viri*) of the Republic.

The Roman biographer Suetonius relates that the Augustan forum was built to accommodate law courts, which in Rome had become too numerous for the other two fora, the Republican Forum and Forum of Caesar, to manage. Indeed, courts may have been held here from time to time. The main functions and associations of the complex, however, seem to have been military. It was paid for *ex manubiis*, from the spoils of war, we are told; Mars Ultor was the premier Augustan manubial temple. The activities that are recorded as taking place here include: senatorial deliberations on declarations of war and award of triumphs; the housing of military standards recovered from the enemy; the setting out (*profectio*) of newly appointed provincial governors to their posts; dedications to Mars by triumphators; and a host of other military ceremonies. The sculptural adornment in the forum created an atmosphere appropriate to these functions by surrounding the spaces with reminders of great military accomplishments in Roman history. The highlight of the sculpture program—placed in the very center of the forum's open space—was a great bronze statue of Augustus in a **quadriga** (a four-horse chariot), which was a customary commemorative depiction for a general who had celebrated a triumph.

The emphasis on the institution of the Roman triumph cannot help but bring to mind the fact that, beginning already two decades before the dedication of the Mars temple, only the *princeps* and his family were permitted to celebrate

triumphs. The imagery that resulted from this was not just that of Roman triumph but of triumph by the Roman imperial family undertaken for the common good of all its subjects. In this way the viewer would be reminded that the program was not so much about the history of traditional Republican virtues as it was about Augustus as the culmination of that history: an extension of the associations with Aeneas and Romulus that permeated the monuments already discussed. It has been noted that the statuary program in the Augustan forum parallels the scheme of domestic portraits displayed in the atria of Republican homes; Augustus had expanded his functional ancestry to include all the great figures of Roman history and legend, but his elevation by association represented precisely the same way of thinking as did the tradition of *imagines* discussed in Chapter 2. It is no surprise that this essentially private concept should have been extended by Augustus to the most public of his works, when we have already seen the measures he took to appropriate public cult into his own domestic sphere. Central to his program was the elimination of the distinction between the *domus Augusti* (House of Augustus) and the state itself, so that when Augustus was no longer alive, no one would question the right to rule of his own designated successor.

Later Second Style Wall Painting

The transition of Roman wall painting styles from the First to the Second Style demonstrates a shift in the presentation of architectural forms: from the solid and substantial to the delicate and decorative, and from their status as a subject in their own right to providing a framing function for painted landscapes. This is seen clearly in examples from the Palatine houses of Augustus and Livia. The latest examples of the Second Style are especially well illustrated in a remarkable program of wall painting recovered from a wealthy Roman house excavated in the nineteenth century, under the Villa Farnesina, in a quarter of Rome across the River Tiber (Trastevere). These paintings may have imperial associations, as some archaeologists have identified the house as the property of Marcus Agrippa and Julia; although its ownership is by no means proven, the paintings can be dated to around the time of their marriage (*c.* 20 BCE).

This painted wall from a private room or *cubiculum* [5.21] shows a clear development from the earlier Palatine paintings. The columns and epistyles, slenderer still, serve to frame panels large and small. While the columns and their pedestals do still project out in front of the wall, the vistas into space created beyond the wall have disappeared. The central scene of the seated Aphrodite with a tiny facing Eros is something of a curiosity—painted in a simple, quiet style that preserves the tone of Greek painting from the High Classical period (450–400 BCE) that we see reflected in Classical ceramics but otherwise is utterly lost to us. Here, we are reminded of both the Augustan employment of Classical stylistic features and the prominent role of Aphrodite/Venus in Julian/Augustan traditions. Tradition and innovation

5.21 Farnesina painting, Aphrodite panel, Rome, Italy, *c.* 20 BCE. The panel shows a seated Aphrodite with Eros (or Cupid) facing her. The scheme combines painting styles from High Classical Greek painting, and themes of the Augustan model (the importance of Venus).

5.22 Farnesina colonnade, from a *triclinium*, or dining room, Rome, Italy, *c.* 20 BCE. The painted images of columns are very thin, with unusually slender caryatids. The walls are broad blocks of color, including black, which is rare for this painting style.

5.23 (Below) Wall painting from the Villa of Livia at Prima Porta, Rome, Italy, late 1st century BCE. H. *c.* 2 m (6 ft 6 in.). The closed room is opened up by wide vistas, with depth shown in a succession of spaces. These paintings are contemporary to those in the Villa Farnesina, making it important to remember the diversity of Roman art.

coincide especially clearly in a painting from this same house, apparently from a *triclinium* (dining room) [5.22]. The general scheme here, a simple garlanded colonnade in front of a solid wall, recalls the earliest Second Style work. It is conservative almost to the point of being archaizing, but these columns are so thin as to be nearly unrecognizable as such; neither the delicate forms of the capitals nor the slender caryatid-esque creatures atop them look capable of supporting much weight. The walls are broad panels of color (black is found here, which is another novelty), in contrast to the solid pseudo-masonry seen in the House of the Griffins or even the Villa of the Mysteries (see 3.14, 3.15, and 3.21).

The Late Second Style could also open up wall space, not with architectural forms, as in earlier paintings, but with painted garden vistas. The premier example comes from another imperial property, the Villa of Livia at Prima Porta, on the northern outskirts of Rome [5.23]. In a room that was built principally underground, the painter sought to open up the three closed walls by depicting a remarkably complex vista—a style of scene that was

148 PART II: THE FORMATION OF THE ROMAN EMPIRE

drawn, fundamentally, from the views that one had into gardens at the rear of the larger atrium houses. The space in the painting is controlled and defined by two successive barriers: a low openwork (with regular patterns of openings) wall, and a second solid wall further in the distance. At the center of each side of the room, the second wall forms an angular exedra around an evergreen tree, and a line of shrubs marks the space between the walls in relatively formal arrangement. Beyond the second wall, however, is a barely controlled wilderness of flora and fauna. The paintings are exquisitely detailed, and scholars have identified dozens of species of fruit trees, shrubberies, and birds. Everything, impossibly, is simultaneously in bloom, reflecting,

Vitruvius on Wall Painting

Vitruvius dedicated his famous treatise on architecture to Augustus early in the principate, just as the Second Style was beginning to give way to the Third. This was a development that, apparently, the architect did not much like:

1. ...the ancients required realistic pictures of real things. A picture is, in fact, a representation of a thing which really exists or which can exist... Consequently the ancients who introduced polished finishing began by representing different kinds of marble slabs in different positions, and then cornices and blocks of yellow ochre arranged in various ways.

2. Afterwards they made such progress as to represent the forms of buildings, and of columns, and projecting and overhanging pediments, in their open rooms... In these paintings there are harbors, promontories, seashores, rivers, fountains, straits...or the battles at Troy, or the wanderings of Ulysses, with landscape backgrounds, and other subjects reproduced on similar principles from real life.

3. But those subjects which were copied from actual realities are scorned in these days of bad taste. We now have fresco paintings of monstrosities, rather than truthful representations of definite things.

For instance, reeds are put in the place of columns, fluted appendages with curly leaves and volutes, instead of pediments, candelabra supporting representations of shrines, and on top of their pediments numerous tender stalks and volutes growing up from the roots and having human figures senselessly seated upon them; sometimes stalks having only half-length figures, some with human heads, others with the heads of animals.

4. Such things do not exist and cannot exist and never have existed. Hence, it is the new taste that has caused bad judges of poor art to prevail over true artistic excellence. For how is it possible that a reed should really support a roof, or a candelabrum a pediment with its ornaments, or that such a slender, flexible thing as a stalk should support a figure perched upon it, or that roots and stalks should produce now flowers and now half-length figures? Yet when people see these frauds, they find no fault with them but on the contrary are delighted, and do not care whether any of them can exist or not...
(*De Architectura*, VII,5)

This passage is illuminating, concerning the evolution of Roman wall painting in a number of ways. Vitruvius here clearly outlines the first three of the four stages of wall painting (those that developed during his lifetime), and the images he chooses to mention are remarkably consistent with the examples that have happened to come down to us, right down to the *Odyssey* landscapes on the Esquiline, which either were known to the architect or reflect a commonly used motif. The identification of the four styles, first introduced by the German archaeologist August Mau in the late nineteenth century, is surely indebted to Vitruvius's account.

As for Vitruvius's views, they preserve a rare example of a contemporary critical account of artistic developments from an observer schooled in the visual arts. His quite scathing remarks are striking indeed. Romans were, by nature, as has been often shown, culturally conservative, their status entrenched in traditional family and social connections. In Chapter 2 we noted the resistance—rhetorical, no doubt, but no less sincere—among Roman writers to the wave of Hellenism in their visual arts. In this case, however, Vitruvius' reaction may have had more to do with his profession, and identity, as an architect. His was the art of the real: creating actual, functional buildings, and solving existing, practical problems. Clearly, the introduction of fantasy forms into his craft of the here and now attacked his understanding of the very nature of existence itself, and in expressing his discomfort he included this very emotional digression into what was, for the most part, a somewhat dry professional treatise.

in a different way to the cuirass statue (5.5, p. 133) from this same villa, the abundance and prosperity made possible by the *Pax Augusta*. It is essential to keep in mind that these paintings are contemporary with those of the Farnesina villa, as we continue to consider whether there was ever anything that amounted to an Augustan style.

Not everyone was taken with this latest fashion in wall painting; contemporary Roman author and architect Vitruvius, for example, did not shrink from criticizing his patron's tastes (see box: Vitruvius on Wall Painting, p. 149). Indeed, it remains an open question as to what degree these developments do relate to a specifically Augustan context. Some have seen a reflection of Augustus's sense of humor within the private sphere in the increasingly fanciful and imaginative forms. Formally, on the other hand, much that happened in wall painting after 30 BCE can be seen to have evolved organically and logically from the stylistic developments of the previous century, and precedent for what is found on the Palatine can be traced to Campanian examples from the previous decade, such as seen at Pompeii. What might be Augustan, or rather imperial (or of an imperatorial nature) in focus, is pre-determined for the viewer by the increasing role of the architecture as a framework. The picture-gallery effect of the latest stage of Second Style painting draws the eye intentionally to large, framed panels. Whether these are sacro-idyllic landscapes with clear cultic associations (for instance, the god Apollo), or mythological scenes that can be understood as moralizing analogies, these panels structure the program and message of the painted composition. From these, the eye wanders to take in the spectacular variety and detail of secondary scenes and rich ornamentation, a feature shared with other types of Augustan monument, for example the Ara Pacis (see p. 140). The structured, clearly oriented, and controlling environment itself is reminiscent of the effect of Caesar's forum, and one that would be taken up again by Augustus and his successors. The panels themselves are reminiscent of the hundreds or thousands of Greek panel paintings taken as booty over the previous two centuries, many of which were dedicated and displayed in the fora and other public spaces, as both gifts to the state and symbols of conquest.

Third Style Wall Painting

Third Style wall painting presents a logical outgrowth of the tendencies of the later Second Style. Beginning around 10 BCE, the most typical early examples of the Third Style may again

5.24 Boscotrecase painting, near Pompeii, Italy, c. 10 BCE. H. 1.59 m (5 ft 2⅝ in.). The panel illustrates a sacro-idyllic view with painted blocks of bold color and very thin bordering.

be associated with the imperial family. A villa excavated at the village of Boscotrecase, near Pompeii, may once have belonged to Agrippa—a *graffito* (informal inscription) there refers to his youngest son Postumus (born in 12 BCE), who would have been but a toddler at most when the paintings were done [5.24]. The columns and pilasters painted here, which still retain tiny capitals, more resemble bejeweled furniture than any structural reality; the style itself is sometimes called the "candelabrum" style. Spatial projection is essentially non-existent here, and the wall, now mainly made up of large areas of bold color, is flat and impermeable. Decoration still favors floral motifs with petals and tendrils of metallic fineness. The framing effect is complete. The panel here shows a sacro-idyllic landscape, as in the Palatine complex, but this one could never be confused with a view through a window. This Third Style would undergo its own development and be a dominant mode of wall decoration for decades.

Augustus's Legacy

Cornelius Tacitus (*c.* 57–after 117 CE), whose *praenomen* is uncertain, among the greatest of Roman historians, was born in the reign of Nero (Augustus's great-great grandson, and fourth emperor of Rome, 54–68 CE), and wrote the *Annals*, a history of the four emperors who followed Augustus. Although he rose himself to high rank under the emperors Nerva and Trajan (who reigned consecutively, 96–117 CE), his writings express little love for a dynastic system that was, in his eyes, entirely the creation of Augustus. In his history, Tacitus provides what is perhaps the most concise and penetrating assessment made of the essence of the Augustan principate:

> Augustus won over the soldiers with gifts, the populace with cheap corn, and all men with the sweets of repose, and so grew greater by degrees, while he concentrated in himself the functions of the senate, the magistrates, and the laws. He was wholly unopposed, for the boldest spirits had fallen in battle, or in the proscription, while the remaining nobles, the readier they were to be slaves, were raised the higher by wealth and promotion, so that, aggrandized by revolution, they preferred the safety of the present to the dangerous past. Nor did the provinces dislike that condition of affairs, for they distrusted the government of the senate and the people, because of the rivalries between the leading men and the rapacity of the officials, while the protection of the laws was unavailing, as they were continually deranged by violence, intrigue, and finally by corruption.
> (Tacitus, *Annals* 1.2)

Tacitus goes on to characterize the climate during Augustus's last years, when the aging *princeps* was weakening, and the Romans were considering what would happen after his death. Dynastic succession, and continuation of the status quo were inevitable in Tacitus's view, as he asks rhetorically, "*quotus quisque reliquus qui rem publicam vidisset?*" ("How many were even left who had seen the Republic?").

The manipulation of traditions, laws, magistracies, priesthoods, cult activities, and, of course, art and architecture, was the infrastructure of the Augustan principate, and it succeeded both because it was brilliantly conceived, and because, as Tacitus recognized, it was concocted for a ready audience. At first its stability depended on the enormity of the ruler himself, as had Caesar's rule before. But Augustus, both luckier and cleverer (or better advised) than Caesar, had an opportunity that Caesar, following events on the Ides of March in 44 BCE, was denied: the chance to provide for the future of the empire. Again, as Tacitus recognized, perhaps the most significant factor in Augustus's great success was his longevity: he seized power young and lived long. He lived on longer still as a *divus* himself, and as the very model of an imperial ruler he was both emulated and evoked by each of his successors, to the end of the Roman empire and beyond. This was a role for which he had prepared himself well, not least through his use of art and architecture to develop and to disseminate an image of emperor and empire that was both ideal and real, both ageless and adaptable, and both timely and timeless.

6 Imperial Portraiture and Commemoration in the Early Empire

154 The Julio-Claudians
- 154 PORTRAITURE OF TIBERIUS AND CALIGULA
- 156 PORTRAITURE OF CLAUDIUS AND NERO
- 156 Box: The Julio-Claudian Dynasty and Imperial Succession
- 160 JULIO-CLAUDIAN CAMEOS
- 161 Materials and Techniques: Cameos
- 164 Box: The Cult of Roma and Augustus
- 165 JULIO-CLAUDIAN COMMEMORATIVE SCULPTURE

168 The Flavians
- 169 FLAVIAN PORTRAITURE
- 170 FEMALE PORTRAITURE: JULIO-CLAUDIAN VS. FLAVIAN
- 171 Box: Imperial Women
- 172 Box: The Flavian Portraits from Misenum
- 173 FLAVIAN COMMEMORATIVE SCULPTURE

Chronological Overview

DATE	EVENT
14 CE	Death of Augustus; accession of Tiberius
c. 14 CE	Gemma Augustea
37 CE	Grand Camée de France; death of Tiberius; Caligula becomes emperor
41 CE	Caligula murdered; Claudius becomes emperor
41–54 CE	Villa Medici reliefs; *Vicomagistri* Altar
54 CE	Death of Claudius; Nero becomes emperor
68 CE	Nero commits suicide
69 CE	Year of the Four Emperors; Flavian dynasty begins
79 CE	Death of Vespasian; Titus becomes emperor; eruption of Vesuvius
81 CE	Death of Titus; Domitian becomes emperor
c. 81 CE	Arch of Titus
90–96 CE	Flavian portrait group from Misenum; Cancelleria reliefs
96 CE	Assassination of Domitian; Nerva becomes emperor

The Development of Rome

Right: Map of Rome showing the key works in existence in Rome in this chapter.

CHAPTER 6: IMPERIAL PORTRAITURE AND COMMEMORATION IN THE EARLY EMPIRE

The Julio-Claudians

By the time Augustus died in the August of 14 CE, the question of succession had long been settled, and the transition should have been seamless. As a member of the *gens Claudia* by birth and the *gens Julia* by adoption, Tiberius unified the noble family lines of Augustus and Livia, and cemented what is called the Julio-Claudian dynasty.

PORTRAITURE OF TIBERIUS AND CALIGULA

In Julio-Claudian portraiture, the circumstances of succession played an important role in the choices made. In the dramatic accounts that we have of the Julio-Claudians, from the Roman historian Tacitus and biographer Suetonius, to the modern historian Robert Graves, Tiberius emerges as a man who came to power too late in life. Aged fifty-six when Augustus died, he inherited authority but not *auctoritas*, namely leadership and not influence, from his adoptive father, whom he had served faithfully, and been treated rather unfairly by. Tiberius hesitated to claim imperial duties at his first meeting with the senate, but the senators did not, as he had hoped, immediately press him to accept the powers of the emperor. This was a slight that he neither forgave nor forgot. Augustus had entrusted Tiberius with many important military and diplomatic responsibilities from an early age, and by all accounts he performed them well; he was an experienced general and respected by his troops. Augustus's personal affection for him, however, is said to have been limited; much is made by the ancient sources of Tiberius not having been Augustus's first (or second, or third) choice as successor.

A key feature in the traditional historical narrative of Tiberius is the influence exerted on him by his mother Livia (given the title Augusta after Augustus's death), whom later tradition pictured as a power-mad, homicidal, manipulative sorceress, although that may well differ from her reputation in her own time. Tiberius is said to have been respectful of the senate; in fact, he was criticized for consulting with it excessively, but at the same time he was suspicious of senators, and almost everyone else. Early in his reign, he made an effort to rule justly, administer fairly, and restore an economy weakened by the cost of military campaigns against Germanic tribes, which had begun as early as 17 BCE. Apparently, he was worn out by the enormity of the task of ruling, and after the deaths of his adoptive brother Germanicus and his son Drusus (19 and 23 CE, respectively), palace infighting was once again a concern for all, especially as he never named a successor. The situation was only made worse by his over-reliance on Lucius Aelius

6.1 Portrait of Tiberius, 1st century CE. Marble. Full statue H. 2.05 m (6 ft 8¾ in.). While unrelated by blood to Augustus, Tiberius's portrait often follows the Julio-Claudian norm of undefined age.

6.2 Coin portrait of Tiberius, 14–31 CE. Silver. One example of a coin portrait showing Tiberius at a more advanced age.

154 PART II: THE FORMATION OF THE ROMAN EMPIRE

Sejanus (20 BCE to 31 CE), his praetorian prefect, who was later arrested and executed amid suspicions of conspiracy against the emperor. Tiberius gradually withdrew from public life, ruling (neglectfully, we are told) from his villa on the island of Capri, from 26 CE until his death more than a decade later in 37.

Whether despite or, more likely, because of the difficulties of his succession and early principate, the official image of Tiberius as portrayed in his portraiture in sculpture and coinage suggests a message of continuity. Although there was no blood relationship between Tiberius and Augustus, his portraiture is as much in keeping with the Julian norm as that of Augustus's grandsons Gaius and Lucius [6.1]. The appearance of the "Julio-Claudian prince" had long since become standardized and, through his adoption, Tiberius was admitted to that group. Although well into middle age even at the very beginning of his reign, the portraiture of Tiberius opts for the same eternal agelessness as Augustus's, even in his later years. Interestingly, some sculptured portraits and coins minted in the provinces to pay the troops stationed there do show a somewhat more prominent indication of age [6.2]. It may have been that these particular images (see Portraits of Antonius and Octavian, p. 110–11) were chosen to stress the emperor's experience and achievements, especially on campaign, or his descent from an elite patrician family eminent from the beginning of the Republic. Primarily, however, Tiberius's portraiture is designed to underscore the smooth transition of power to him from Augustus.

Following the death of Tiberius in 37 CE, the young (twenty-five years old) Gaius Caesar, known more commonly by his nickname, Caligula, was eagerly acclaimed emperor by a populace and army that had become weary of Tiberius's advanced age and inactivity. Indeed, Caligula was responsible for renewing building activity in Rome, which had stalled since the time of Augustus. Caligula was the adopted son of Tiberius and biological son of Germanicus and Agrippina the Elder (Augustus's granddaughter). He was, therefore, the great-grandchild of Augustus. As emperor, he proved to be intolerably autocratic; historical tradition relates that he lapsed into a fever-induced insanity early in his reign, and even demanded divine honors. He is said to have transformed the ancient temple of Castor into a vestibule for his own palace, which is thought to be borne out by recent excavations in the Roman Forum. What is clear is that Caligula became increasingly erratic and dangerous; he terrified the senate and alienated the populace and, eventually, even the armies, whose support of the emperor was usually steadfast. Conspiracies, both real and imagined, only exacerbated the brutality; inevitably he fell, assassinated, in January of 41 CE.

The early portraits of Caligula, which were made to resemble those of Tiberius, accomplish the same end as those of his predecessor, and more [6.3 and 6.4]. Continuity was important, given the ambiguities of succession. Caligula's portraits also display an almost boyish quality that stress his youth in favorable contrast to the aged Tiberius, an attribute that contributed in large part to his initial popularity. He was, we are told, very sensitive about his baldness and, indeed, no hint of a lack of hair appears in any portrait. His youthful image also served to

6.3 Portrait of Caligula, 37–41 CE. Marble. H 29.8 cm (11¾ in.). Early portraits of Caligula had features that resembled those of Tiberius, maintaining continuity from emperor to emperor, although they also expressed youth, which contrasted with Caligula's aged predecessor.

6.4 Coin portrait of Caligula, 37–41 CE. This also recalls Tiberius's portraits and demonstrates an emphasis on the new emperor's youthful vigor.

CHAPTER 6: IMPERIAL PORTRAITURE AND COMMEMORATION IN THE EARLY EMPIRE 155

connect him closely with his father Germanicus, who had been portrayed as the archetypal Julio-Claudian prince, from the time of his adoption (when still a teenager) by Tiberius in 4 CE, to his death, still young and much honored, fifteen years later. Germanicus was a very successful military commander, and his popularity with his soldiers reflected positively on his son who, when still a toddler, had accompanied his father on a Germanic campaign. His nickname (Caligula means "Little Boots") derived from the tiny soldier's outfit he used to wear, which had been made for him by the troops themselves. Finally, the portraits of Caligula connected him directly with the ever-youthful imagery of the divine Augustus. Dynastic monuments set up in Caligula's reign invariably stress his Julian background over his Claudian heritage.

PORTRAITURE OF CLAUDIUS AND NERO

Tiberius Claudius Nero Germanicus, more commonly known as Claudius, was son of Drusus the Elder (Livia's son, and Emperor Tiberius's brother), who was revered for his

The Julio-Claudian Dynasty and Imperial Succession

14–37 CE	Tiberius
37–41 CE	Caligula
41–54 CE	Claudius
54–68 CE	Nero

Although it was never called a *regnum* (monarchy), the system of sole rule established by Augustus was intended to be continued by dynastic succession, ideally through the closest male blood relative, but by adoption if necessary. This practice does have connotations of kingship, repugnant to the Romans, but during the Republic it was also how property and power were conventionally handed from generation to generation, among the landed elite of the senatorial and equestrian orders. During the period referred to as the **High Empire**, beginning in 96 CE and ending in 192 CE, succession took place almost solely through adoption. Historians often attribute to this the relative peace and prosperity of the era, but adopting successors at that time was not, in fact, a matter of choice: no emperor had a living son at the time of his death until Marcus Aurelius, who named his son Commodus to succeed him, with disastrous results.

Augustus had only one child, Julia, and did everything in his power to ensure that her descendants would eventually succeed him; indeed, his great-grandson, Caligula, and great-great-grandson, Nero, actually did, for better or worse. After his two beloved grandsons, Lucius and Gaius, prematurely passed away (in 2 and 4 CE, respectively), Augustus adopted his stepson Tiberius, whom he forced to adopt Livia's grandson Germanicus, since the latter's wife Agrippina was Augustus's own granddaughter, and Germanicus himself was the grandson of both Augustus's sister Octavia and his wife Livia. Tiberius did have a son of his own, Drusus, who was promoted in parallel with Germanicus, clearly indicating their shared status as eventual successors, similar to Gaius and Lucius before them. The idea of shared responsibility, as Augustus himself had practiced with his colleague Agrippa, remained fundamental to his preservation of an ostensibly Republican way of rule.

Thereafter, Julio-Claudian imperial succession was, by comparison, chaotic. Tiberius, who was predeceased by both Germanicus and Drusus, did not clearly mark out another successor after their deaths. He named, as heirs to his estate, Drusus's son Tiberius Gemellus and Germanicus's remaining son Gaius Caligula, out of respect for Augustus's wishes or, as some sources claim, so that he himself might appear the better ruler, in the unlikely event that he could foresee the nightmare that would be Gaius's reign.

Caligula, who shortly after becoming emperor had Gemellus killed, was himself assassinated in 41 CE after four years of rule, along with his only child, Drusilla, who was not yet two years old. The Julio-Claudian dynasty looked to be at an end, but during the events that followed Caligula's demise, the Praetorian Guard, whose soldiers acted as imperial bodyguards and whose existence depended on there being an emperor, discovered (allegedly hiding behind a curtain in the palace) Claudius, the forgotten fifty-year-old son of the elder Drusus and grand-nephew of Augustus. Claudius ruled with relative effectiveness for over a decade, and provided explicitly, if unclearly, for his own succession by naming both his natural son Britannicus and his adoptive son (and grand-nephew) Lucius Domitius Ahenobarbus who, upon adoption, became known as Nero Claudius Drusus Germanicus. Britannicus outlived his father by nearly four months, being one of many to fall victim to the impetuous Nero, who became the next emperor, and lasted until he himself perished by means of forced suicide. Nero died without any living heirs, prompting a short but intense civil war that resulted in restoring stability, for a while, at least, with the new Flavian dynasty.

military achievements, and the brother of the heroized Germanicus Caesar. Afflicted with physical ailments—possibly related to cerebral palsy—he had been allowed virtually no public career. He had found his solace in books; he read and researched widely, and wrote historical works that we can only wish had survived. The Praetorian Guard needed an emperor, however, and this one was, at least, closely related to figures long admired among the troops.

Claudius was the first emperor to break visibly from the Augustan portrait tradition. Although some images, both numismatic (on coins) and sculptural, display an idealized Julio-Claudian style that was made standard by Tiberius and Gaius, many more of Claudius's portraits show some indication of his advanced years. The most famous statue of this emperor, from Lanuvium in Latium, depicts Claudius, as seen on the Augustus on the cameo known as the Gemma Augustea (see 6.9, p. 110), with the attributes of Jupiter: with a scepter in his hand and an eagle standing at his feet [6.5]. His powerful physique, Polycleitan pose, and semi-nudity also recall images of gods in a Classicizing mode that had been common, by this time, for nearly half a millennium. In contrast, Claudius's face, while displaying a typically Julio-Claudian shape, proportions, and cap of thick hair, betrays its age through lines across the forehead and a looseness of flesh around the eyes and mouth. A very similar portrait statue is set up as part of a Flavian group at Olympia in Greece, where Claudius is portrayed as Zeus (Jupiter) [6.6]. The Olympia statue is

6.5 (Left) Claudius as Jupiter, Lanuvium, Italy, *c.* **50 CE. Marble. H. 2.54 m. (8 ft 4 1/8 in.).** Claudius's Classical physique and pose are contrasted by the lines on his face and the looseness of his flesh.

6.6 (Right) Claudius as Zeus, Olympia, Greece, 50s–60s CE. Marble. H. 2.1 m (6 ft 10 3/4 in.). This is very similar in form to the Lanuvium statue.

6.7 Portrait of Nero in his early years, 54–59 CE. Marble. H. 42 cm (1 ft 4⅝ in.). His portrait follows the Augustan idealism, but also the youth and optimism seen in Caligula's likenesses, and the realism found in Claudius's.

almost certainly posthumous, but the Lanuvium Claudius could date to the emperor's lifetime.

Although Claudius, unlike his predecessor, refused to be worshiped as a deity, it was acceptable to show him in divine form, perhaps as an indication of the power of the principate itself. The juxtaposition of a heroic Classicizing body with a more realistic looking head had Republican precedents (for example, the Pseudo-Athlete and the Tivoli General, see 2.30 and 2.31, p. 73), and some have read Claudius's somewhat more straightforward portrait style as a reflection of his own Republican leanings, a sentiment that is formed largely from his personal interest in history. It is equally probable that Claudius, while portraying himself clearly as a member of the Julio-Claudian clan, was also trying to separate himself from the youthful recklessness of Caligula. In Republican times, age was used to express experience, and although experience was the one thing that Claudius clearly had very little of, his portraits suggest a maturity and competence that were desirable particularly after the horror of his predecessor. The image might also have been intended to appeal to the armies, on whose support Claudius was especially dependent. For the first time, at any rate, we see a new emperor whose image is meant to suggest a discontinuity with the immediate past rather than the continuity that was sought by earlier rulers. From this point forth, the style of imperial portraits would be designed to situate the subject with respect to his immediate predecessor (whether that be by distancing himself from the previous ruler or creating a link between them), as well as being able to draw upon the entire earlier history of imperial imagery; and the circumstances of succession would play a large role in the choices made.

By the time Claudius died in 54 CE, his wife, Agrippina the Younger, had assumed a position of great power in the imperial court, with a view to ensuring that her seventeen-year-old son, Nero, would eventually rule as sole emperor. Her wish was granted when Claudius's son Britannicus was eliminated within a year of his father's death, but with Nero's accession Agrippina found herself beginning to lose influence almost from the very start, and she was murdered, on Nero's orders, in 59 CE. In the same way as Caligula had been, the youthful, ostensibly cultured, and philhellenic Nero was popular upon his succession; sources even identified the first five years of his reign, the *quinquennium Neronis*, between 54 and 59 CE, as a time of great leadership. He dutifully saw to the deification of Claudius, and sought to usher in a new golden age after the model of Augustus. Advised by his mother, his tutor (Seneca the Younger), and the prefect of the Praetorian Guard (Sextus Afranius Burrus), the young Nero is said to have ruled well.

By the 60s the influences of his tutor and prefect, in one way or another, were gone, leaving him to indulge his own interests, extravagance, and megalomania. Support from the senate, the *equites*, and eventually the army, declined; he became increasingly autocratic and suspicious, conspiracies arose, and were brutally

suppressed—all situations that would continue to feed one another until the inevitable collapse occurred. In 68 CE, with the armies in revolt, Nero committed suicide, which threw Rome into a new civil war. Interestingly, throughout his reign, he had remained popular with the lowest classes who enjoyed his profligate distribution of gifts and entertainments, and also in the eastern provinces, perhaps because of his philhellenism. A declaration of liberty for the Greek cities at Isthmia, which he had made in 67 CE, would probably have had some appeal.

In keeping with these biographical reversals, Nero's portraiture as emperor is the first to show clear chronological development. The earliest portraits reflect the hope and optimism associated with his youth [6.7]. At the same time, they are aligned to the Julio-Claudian tradition (to which he belonged not only on his mother's side but also on that of his father, who was the son of Antonia Major, Augustus's niece), and distinct from it in ways that must simply reflect his own appearance, perhaps continuing a trend of realism in portraiture that was initiated under Claudius. The long, crescent-shaped locks of hair combed forward over the forehead, and parting just over the inner corner of the right eye, derive from what was by now an old Julio-Claudian formula, but the rendering is rather flatter. The broad skull and triangular face are traditional, but the facial structure is sculpturally clearer, with far less of the idealizing hardness seen in the youthful portraits of earlier family members.

Just as the emperor himself did, Nero's portraits age rapidly over his relatively short reign. Scholars have identified numerous types on the basis of coins, but this later example illustrates the culmination of the sequence [6.8]. The hairstyle has changed fundamentally, with the unparted row of sickle-shaped "bangs" now forming a protruding ledge (or as Suetonius called it, *gradus*, meaning "step" or "terrace"). The rendering of facial features has become progressively more three-dimensional, and as his neck and cheeks become fleshier, his chin has grown weaker, and his eyes smaller and more deeply set. His post-pubescent whiskers have been allowed to develop into a beard beneath the jawline, long after the age that Roman youths traditionally began to shave.

The end result is utterly unlike anything seen before; it recalls neither the heroic idealism of earlier emperors nor the honest, rustic verism of Republican *nobiles*. It is relatively easy to see how the development occurred, but in the end still startling to see an image that so accurately reflects the arrogant brutality, pseudo-sophistication, and simulated philhellenism that the sources writing about Nero have so fully described. One cannot help but wonder whether the portraits influenced the literary characterizations, just as the latter inform our reading of the images. Yet the fact remains that Nero chose to be portrayed in this way, so whatever the ideas were that these portraits conveyed to the Roman viewer, they were the proper reflection of the emperor's own self-construction.

6.8 Portrait of Nero in his later years, 1st century CE. Marble. H. 31.1 cm (1 ft ¼ in.). Nero's portrait shows greater age, and his hairstyle has changed to the "stepped," sickle-shaped bangs. The face shape and light beard radically break tradition with Julio-Claudian portraits.

JULIO-CLAUDIAN CAMEOS
Gemma Augustea

An object that nicely illustrates the familial interrelationships that determined potential succession is the exquisite sardonyx cameo (see box: Cameos, opposite) known popularly as the Gemma Augustea [6.9].

In the upper register at the center, Augustus and the goddess Roma are seated. To the right of the central pairing, a draped female wearing a **mural crown** holds an oak *corona civica*, a civic crown, above the head of Augustus; she is probably Ecumene, a Hellenistic personification of the inhabited world. In front of her is Oceanus, the sea. Reclining before Oceanus is a female with ivy crown and **cornucopia**, in front of and behind whom stand two young children. This crowned female repeats the earth goddess figures from the reliefs of the Ara Pacis in Rome and the Prima Porta Augustus statue (see 5.2), and the theme here is identical: the obvious benefits of the *Pax Augusta*, or Augustan Peace, to all the empire. To the left of the enthroned pair are three figures, two of which, to judge from their portrait features, are surely meant to represent notable historical figures. A togate male, with a laurel crown and scepter, steps down from a chariot driven by Victoria, who carries a whip. Between this male and the seated Roma, a military officer, in full regalia, stands in front of his own horse.

The more common reading of this upper register indicates a date in the last years of Augustus's reign, after his final provision for succession and the successful campaigns in Northern Europe of Tiberius and Germanicus. The togate male is identified as Tiberius as *triumphator*, stepping down from a chariot driven by the goddess Victoria. The cuirassed youth to the right of him is thought to be Germanicus. A togate figure seems to have originally stood to the (viewer's) left of Tiberius and, if so, it would probably have been his son, Drusus, whose career was being advanced in tandem with his one-year-older adoptive brother, Germanicus. The allusion here would therefore be to one of Tiberius's triumphs for his victories in the north (most likely that of 12 CE), or to all of his triumphs collectively. Germanicus served under his uncle in the more recent of these conflicts, and was, himself, fighting the Germanic tribes at the time of Tiberius's accession. Drusus remained in Rome at that time, achieving the senatorial magistracy of quaestor in 10 CE.

The bottom register concentrates on the traditional theme of military victory. On the left, four Romans, two wearing cuirasses, erect a trophy above two barbarian captives, who sit among a gathering of weapons and armor. To the right, a "barbarian" man and woman are being dragged toward the center by figures that differ in dress from the soldiers on the left. The figure seen from behind is female; most identify her as a personification of a western province, perhaps Spain. The other wears a cap that has been interpreted by some as Thracian and by others as Macedonian. Both figures are no doubt meant to stand for allied troops, just as the cuirassed figures represent Roman legions.

6.9 The Gemma Augustea, *c.* 14 CE. Sardonyx. H. 19.1 cm (7½ in.) × W. 22.9 cm (9 in.). This double-layered cameo was probably created by the artist Dioscurides, or one of his students.

MATERIALS AND TECHNIQUES
Cameos

The practice of carving small stones with figurative subjects is very old in the ancient Mediterranean and Near East. Cylinder seals and stamp seals had been used in Mesopotamia (since the fourth millennium BCE) as an expression of ownership, or assurance of value. Characters and images were cut in reverse into the seal, which was then either pressed (stamp) or rolled (cylinder) onto unfired clay to create the desired image in relief. These became widely used in the Bronze Age by the Minoan and Mycenaean civilizations of the Aegean basin. The technique of production was painstaking; artisans worked with small tools and, since the stone was often harder than the carving implement, powdered abrasives. The detail is often barely detectible to the human eye, and since no magnifying lenses could have been used, the result seems almost magical. A recently discovered example from the Griffin Warrior Tomb in Pylos, Greece (the Pylos Combat Agate, c. 1450 BCE) shows a skill and artistic vision that far exceeds anything previously thought possible. Indeed, many carved gems were believed to have supernatural qualities, and carvers, such as Pyrgoteles, who worked for Alexander the Great, enjoyed a renown equal to that of the most famous painters and sculptors.

By the beginning of the Hellenistic period, gems began to be carved in relief, meaning that, rather than cut the image in negative, the background was cut away, creating a positive form. These were not then **sealstones**, and were probably meant to be admired for their beauty and craftsmanship as symbols of wealth, status, and erudition. The subjects were, most often, heads of deities or portraits of royals, and they were especially popular among the Ptolemaic monarchs of Hellenistic Egypt.

A variation of this craft, more complicated to make and more impressive in its appearance, was the cameo. In order to create a cameo, a stone with naturally occurring layers of different colors was used, so that the relief image would stand out distinctly against the contrasting background. The costs and complications of this production were considerable. The stone itself, usually some form of onyx, was imported from such far-away places as southern Arabia and India. The layering of the natural colors would need to be consistent enough and flat enough to make the composition possible. For something resembling the Grand Camée de France (see 6.11, p. 162), just over a foot in height, such a stone would have been extraordinarily rare. Pliny the Elder comments on a process of creating artificial sardonyx by forging layers of contrasting stone together, reflecting the rarity and desirability of the material.

> Sardonyx, for example, is imitated by cementing together three other precious stones, in such a way that no skill can detect the fraud; a black stone being used for the purpose, a white stone, and one of a vermilion color, each of them, in its own way, a stone of high repute.
> (Pliny, *Natural History* 37.75.2-3)

Finally, the process itself was painstaking, and the freeing of the image from the many-colored onyx must have seemed miraculous, enhancing the appeal of the final product.

The most spectacular of the Hellenistic cameos is the Tazza Farnese [**6.10**], a sardonyx cup with four layers of color, made by the carver with consummate skill. The date, though, is not at all certain. The combination of Classical and Egyptian subjects and styles speak strongly in favor of a Ptolemaic origin, although some scholars have argued for an early imperial date. Either way, the commissioning of large, expensive cameos for dynastic purposes was yet another aspect of the early emperors drawing on the practices of Hellenistic monarchies, especially the Ptolemaic rulers who, by a long way, survived the longest. The actual function of these objects, which would have been privately owned, is not clear, but they are assumed to have been presentation pieces, a gift from one ruler to another. To what degree they might reflect the iconography of public monuments is yet another realm of speculation.

6.10 Tazza Farnese cameo. Sardonyx. H. 20 cm (7⅞ in.). This features Classical and Egyptian subjects.

Dominant in the Gemma Augusta as a whole, however, is the central seated pair of Roma and Augustus, the source from which all power and goodness emanates. Augustus bears the attributes of both god (represented by Jupiter's scepter and eagle) and priest (demonstrated by the *lituus*, a curved staff, in his right hand), and many believe that he is here a *divus* himself. Augustus and Roma are presented here on a double chair, a state seat of honor (***bisellium***), which is an emblem of partnership within the Republican tradition of multiple magistrates and shared power. This particular pairing is highly significant; although Augustus refused divine honors in his lifetime, it became customary in the provinces to set up temples to Roma and Augustus as an imperfectly veiled form of emperor worship. It would not be surprising if the images here recalled the cult statues of such temples, rendered in an appropriately idealized and Classicizing style.

This connection suggests an alternative historical context for the piece, in which the primary subject is the institution of the Roma and Augustus cult itself (which originated in the Hellenistic East) in the western provinces. This was, in fact, the work of Tiberius and his younger brother Drusus (Germanicus's father), first at Lugdunum (modern Lyons) in Gaul in 12 BCE, and shortly thereafter at Ara Ubiorum (see box: The Cult of Roma and Augustus, p. 164). There is much to support this reading, including its thematic resonance with the Prima Porta portrait and the Ara Pacis—both works of this time—and the western iconography of the scene with soldiers and captives. The fact that what seems explicit can be ambiguous demonstrates how successfully the artists of the early empire constructed a visual language: one sufficiently generic and adaptable in iconography and style (for example,

Augustan and Julio-Claudian portraiture) to embody a permanence and stability that ensured a sense of dynastic continuity, which was Augustus's ultimate goal.

Grand Camée de France

The similarity among portrait types of Julio-Claudian personages can sometimes make it difficult to tell them apart; this is especially well illustrated by another large cameo, called the Grand Camée de France [**6.11**]. It is clearly modeled after something similar to the earlier Gemma Augustea, but the cast of characters has increased greatly. In a reduced lower register we see a more crowded massing of foreign captives, similar in type and style to those on the earlier cameo, but who function alone—in the absence of a trophy or Roman soldiers—to represent Roman military might. The composition above has two focal points, as on the Gemma Augustea. A seated male figure with the attributes of Jupiter and holding a priestly *lituus* is dominant. His helmeted consort here has Julio-Claudian portrait features, and the shared throne implies shared

6.11 Grand Camée de France or Great Cameo of France, c. 37 CE. Sardonyx. H. 31 cm (1 ft ¼ in.). Five layers have been carved into the sardonyx. It was probably modeled after the Gemma Augustea, but with the addition of many further features.

authority. Before them stands an officer in full armor—another family member—and to his left a small boy is also fully armed. This gem includes a third register of figures, occupying the sky above, as on the Prima Porta cuirass. Augustus himself, head draped and wearing a radiate (sun) crown, is being carried across the sky, and is accompanied by Cupid. Several more figures, with various garments and attributes, surround and frame these, but it is not always easy to distinguish Julio-Claudian characters from personifications; such is the continued idealization of the imperial image.

The precise date of the gem is unknown, and only the proper identification of principal figures would solve the problem. Different scholars have convincingly argued either a Tiberian or a Claudian date for the cameo. If the former, it would identify the central group as Tiberius and Livia (perhaps portrayed as Augustus and Augusta), and the three male figures in military attire as the sons of Germanicus, including Caligula in his little soldier's suit. Alternatively, for the proposed later date, the central group has been read as Claudius and Agrippina, the armed figures on the left as Nero and a young Britannicus. The couple to the right could then be Germanicus—brother of the emperor and father of the empress—with his wife, the elder Agrippina. Other figures find their labels depending on who the central protagonists are identified as at the outset. This ambiguity is the ultimate, and no doubt intentional, product of Augustan Classicism itself.

Gemma Claudia

A third cameo [6.12], however, clearly depicts Claudius and Agrippina the Younger. On the left, Claudius is identifiable from his distinctive facial features, and Agrippina from her equally well-documented hairstyle. Their busts are shown in profile, side-by-side, emerging from cornucopias that rest on a bed of weapons and armor. Facing them are two more busts. The male figure in the foreground is distinctively but generically Julio-Claudian; the female figure behind him is helmeted, and far more idealized than the other three. Between them, Jupiter's eagle looks at Claudius, no doubt marking him as *princeps* at the time of this cameo's creation. The iconography of prosperity and armament is, of course, a continuation of the theme of peace and prosperity through conquest that ran throughout the early empire.

This so-called Marriage Cameo is thought to commemorate the wedding of Claudius and Agrippina the Younger, in the company of her parents, Germanicus and Agrippina the Elder. Indeed, Claudius restored the honor of his brother and his family, who had been marginalized, and worse, by Tiberius and Livia. Such a reading would, however, constitute a stark reminder of the incestuous nature of Claudius's marriage, which is said by the sources to have been thought scandalous at the time. It may be that the Classicizing helmeted female head (the crest is visible) is Roma and the foreground head is Augustus. The gem could then reference not only the founding of the Roma and Augustus cult at Ara Ubiorum by Drusus in 12 BCE but also Agrippina's birth there in 15 CE when Germanicus was campaigning on the Rhine. In 50 CE, Claudius founded a Roman colony on the site, and named it, in honor of it being his wife's birthplace, Colonia Claudia Ara Agrippinensium, and it is not unlikely that this gem was carved to commemorate the event.

6.12 Cameo depicting the marriage of Claudius and Agrippina the Younger. The two figures on the right-hand side may be Germanicus and Agrippina the Elder.

The Cult of Roma and Augustus

The cult of Roma was established early in the Roman conquest of the eastern Mediterranean, at least by 195 BCE when it was instituted at Smyrna on Turkey's Aegean coast, and was founded as a replacement for the increasingly irrelevant cults of Hellenistic rulers. In the same way as these previous cults, the cult of Roma and Augustus was intended to indicate respect and deference to Rome as the holder of power, and it was similarly hoped to invite kind regard for Rome in return. At first, some Roman generals, for example Titus Quinctius Flamininus, who was instrumental in bringing Greece under Roman control, were honored in this way, but soon the cult of Roma became the dominant means by which Roman power was exercised through religion. In response to requests from Hellenistic cities, Octavian allowed cults of Caesar and Roma, and then of himself paired with Roma, as early as 29 BCE at Pergamon, even before he adopted the title Augustus. It was a smooth transition from the older cults to this new focus, and one that allowed these eastern cities to express their hopes and gratitude in a manner to which they had long been accustomed.

The establishment of this cult in the northern and western provinces was an entirely different matter. Here the worship of Augustus and Roma was not a locally initiated mark of honor for the conqueror, but introduced by a deliberate act of the imperial center. It was established in Gaul and on the Rhine frontier as a physical and spiritual marker of Roman domination that was, no doubt, intended to evolve into a cultural institution, such as that which existed already in the East. This was a fundamental transformation of the nature of the cult, undertaken to adapt it to different lands and different cultures.

The most significant foundations of the Roma and Augustus cult in the north took place, not surprisingly, at two strategic centers of military presence. Both cults were instituted by Drusus, the younger of Augustus's two stepsons who, with his brother Tiberius, was campaigning there in the years following 15 BCE; whether or not Drusus was acting under direct command of the *princeps* is unclear, but these foundations surely reflect imperial, and imperialistic, policy. The better-known cult, set up in 12 BCE, was at Lugdunum in Gaul, a site already marked out by Augustus as a strategic site of Roman military presence through the establishment there of an imperial mint, which entirely supplanted the mint at Rome for coinage in gold and silver around this time. Early issues of this mint, in fact, commemorate the activities of Drusus and Tiberius there [6.13]. Lugdunum was already a regional center for the Gallic tribes; the cult of Roma and Augustus served as a pan-Gallic sanctuary, on the model of some Greek and Italic cult centers that functioned simultaneously as political leagues. It came to be known as the Sanctuary of the Three Gauls, and Lugdunum remained the most important Roman center in the northern provinces through most of the imperial epoch.

Around the same time or slightly later, Drusus founded a second cult of Roma and Augustus at the site of Ara Ubiorum on the River Rhine, which in 50 CE Claudius would establish as the colony of Colonia Claudia Ara Agrippinensium (modern Cologne). Both sites were of continued importance to the imperial family. The future emperor Claudius was born at Lugdunum in 9 BCE, while his mother, Antonia Minor, was accompanying her husband on campaign. Claudius's older brother, Germanicus, addressed his troops at the Ara Ubiorum sanctuary in 14 CE, invoking the memory of his famous father, Drusus, who had founded the cult there; his speech is recorded by Tacitus (*Annals* 1.39). While he was there, Germanicus's wife Agrippina gave birth to the future empress Agrippina the Younger, the last wife of Claudius, who founded the Roman colony there as a mark of honor to her birthplace.

6.13 Coins depicting Drusus and Tiberius. Coins issued by the imperial mint at Lugdunum in Gaul marked the achievements of the pair.

JULIO-CLAUDIAN COMMEMORATIVE SCULPTURE

Augustus made good on his intention to transform Rome into a city with a physical grandeur that reflected its political pre-eminence. Subsequent Julio-Claudian emperors looked after the needs of the empire through the construction of public works, and buildings were kept in repair, but there were no grand new public spaces to rival, for example, the Augustan forum. Inscriptions and literary sources record that commemorative monuments, such as altars and triumphal arches, were set up to honor Germanicus, Drusus, Livia, Tiberius, Claudius, and Nero. Some or all of these doubtless bore statuary and reliefs, but we know little about the appearance of any of them, aside from sketchy coin representations of a few. A handful of marble reliefs with imperial themes has survived, but often, as in the case of the Grand Camée de France, it is not possible to be certain to which reign they belong, let alone which monument. This difficulty in identifying an individual in commemorative imagery is consistent under the Julio-Claudians across sculpted portraiture, cameo, and monument.

The "Ara Pietatis/Ara Gentis Iuliae" Reliefs

Several marble relief sculptures now housed in the walls of the Villa Medici in Rome are believed to have come from a monumental altar smaller than but similar in form to the Ara Pacis. These depict a procession of priests [6.14] and a series of sacrifices before temples [6.15]. Fragments from a similar monument were found in the Campus Martius along the via Flaminia. Scholars do not agree as to whether these sculptures come from the same monument, nor on the identification of the monument(s) from which they may come. Most often, they have been associated with two dimly known dedications, the altar to Augustan *pietas* ("Ara Pietatis") and the altar to the Julian *gens* ("Ara Gentis Juliae"). Both commemorated the tradition of the imperial family, and both were probably Claudian; it is generally agreed that the Villa Medici reliefs are Claudian, and that they refer strongly to Augustan and Julio-Claudian tradition. Not only do the monuments derive their form from the Ara Pacis, but each temple depicted on the reliefs as a site for sacrifice has also been identified as an Augustan building; the one depicted here shows the Temple of Mars Ultor (see 5.18, p. 145).

The style of carving retains much of the idealization and cool Classicism of Augustan art, but there are differences. While the basic composition of the procession is quite similar to that found on the Ara Pacis, the figures on the Claudian sculpture are carved in higher relief, and demonstrate more frontal poses. The drapery is more voluminously rendered, creating channels that are more deeply carved and a stronger contrast of light and shadow. The sacrifice scene, similarly, suggests spatial depth in its arrangement of figures, with a cluster of priests and attendants behind the bull, the victim, the strong turn of the

6.14 Relief from the Villa Medici, Rome, Italy, 1st century CE. Marble. H. 1.14 m (3 ft 9 in.). The panel shows a procession of priests and is thought to have been made for a monumental altar similar to the Ara Pacis.

6.15 Relief from the Villa Medici, Rome, Italy, 1st century CE. Marble. H. 1.14 m (3 ft 9 in.). The panel shows a sacrifice in front of a temple.

animal's head down into the foreground, and the kneeling *victimarius* (sacrificial servant) in the foreground. On the other hand, the juxtaposition of sacrifice and temple facade is entirely unrealistic and artificial. The human figures are not correctly scaled, relative to the temples, nor are the temples diminished by distance (as on the Aeneas relief of the Ara Pacis). Rather, the figures and buildings are of a similar height, filling the relief ground; the concern here is with making images that are large and distinct so that the subject can be fully understood. These reliefs demonstrate continuity with the Classicism of Augustan art, but also a new conceptual trend of ensuring legibility and clarity that will become increasingly common in Roman art.

The *Vicomagistri* Altar

Similarly experimental in its rendering of form and space is a relief carved on two blocks found in the southern Campus Martius, which originally belonged to a Julio-Claudian altar, perhaps also from the reign of Claudius. The subject is a religious procession with the characteristic victims (here three bovines), *victimarii*, musicians, priests, and magistrates [6.16]. The three frontal figures in highest relief, at the center and right of 6.17, carry small statues identifiable as the *Lares* and *genius* of the emperor. *Lares* were household deities and a *genius* was the special protective deity of a person or group of persons; as we will see, the *genii* of the senate and of the Roman people were commonly depicted on Roman reliefs. Soon after his election as *pontifex maximus* in 12 BCE, Augustus established the cult of the *Lares* and *genius Augusti* in the various districts throughout Rome (*vici*), and entrusted it to the local magistrates (*vicomagistri*), freedmen who eagerly embraced this involvement in public ritual, since traditional priesthoods were generally limited to those of noble descent. Several altars that have survived from the time of Augustus were created for this cult, such as the famous Belvedere Altar [6.18]. Augustus cleverly created something resembling a cult of the imperial family without countenancing emperor worship per se; the Belvedere Altar includes depictions of Aeneas and the apotheosis (deification) of Julius Caesar, thus underscoring the association of the monument with the Julian *gens* as a whole.

On the *Vicomagistri* Altar, the togate *vicomagistri* are shown on the far left of 6.17 and the relief is most commonly named after them. Stylistically, the sculpture recalls the Republican Paris census relief (see 2.20) or the procession on

6.17 Left-hand portion of the *Vicomagistri* Altar, 1st century CE. Marble. H. 1.04 m (3 ft 5 in.). Three figures carry the emperor's *Lares* and *genius*.

6.16 Right-hand portion of the *Vicomagistri* Altar, 1st century CE. Marble. H. 1.04 m (3 ft 5 in.). This piece was probably commissioned by Tiberius but its careful Classicism gives it an agelessness, which is hard to date, perhaps intentionally.

166 PART II: THE FORMATION OF THE ROMAN EMPIRE

the altar proper of the Ara Pacis, and it stands in relation to those predecessors in much the same way that the Villa Medici reliefs compare with the enclosure panels of the Ara Pacis. The composition is made up of background figures in low relief, a middle ground in higher relief, and foreground figures carved almost completely **in the round**. Some, as we have noted, are fully frontal, while the musicians leading the victims are turned entirely around into the background, the effect of spatial penetration emphasized by their receding *tubae* (musical instruments). The style derives clearly from Augustan tradition in function, and is so typical of Julio-Claudian work that it is another example of creating careful continuity, so much so that the work could date to nearly anywhere in the first half of the century.

The Ravenna Relief

A final example of the generic quality of Julio-Claudian imagery is the Ravenna Relief. This large marble relief is from the northern Italian city of Ravenna, where it was perhaps taken from Rome in the fourth century CE. It depicts a grouping of frontally posed figures in very high relief [**6.19**], but here the depictions are almost certainly meant to depict, or at least derive from, statuary types. To the right we are shown Augustus and Livia in the guise of Mars and Venus; the figures are quotations of the pedimental statues of these two deities as preserved on the Villa Medici relief. To the left is a youthful figure in heroic semi-nudity and the star of a *divus* on his forehead; the type is precisely the same as that of *Divus Iulius* as seen on the Algiers relief (see 5.19, p. 145) and elsewhere, although this figure here is usually identified as a Julio-Claudian prince. To his left is a military figure with a Julio-Claudian hairstyle and somewhat individualized facial features, and a seated female, who is partially cut off by the edge of this slab.

The effect here recalls the dozens of Julio-Claudian dynastic portrait statuary groups that were set up in Rome and throughout the empire, and the relief might even copy such a group. In keeping with the generic quality of Julio-Claudian imagery, the panel has been variously identified. Usually it is (as is so much else) taken to be Claudian, with the youthful figure being a depiction of the emperor's revered (but never deified) brother Germanicus, the soldier their father Drusus, and the seated female their mother Antonia Minor. A less popular view would take the relief to be Neronian, and the military figure to be Nero's natural father, Gnaeus Domitius Ahenobarbus. Including a reference to his biological father does seem odd for a figure whose right to rule depended on his adoption by the emperor, but Ahenobarbus was a Julian by birth (his mother was Antonia Major). As with other Julio-Claudian representations, one individual may be easily replaced or mistaken for another, and in this case precise interpretation is impossible without the full cast of characters.

6.18 (Left) The Belvedere Altar, 12–2 BCE. Marble. H. 96.5 cm (3 ft 2 in.). An inscribed shield depicted on one side provides the date. This apotheosis scene is variously identified as Caesar's, Augustus's, Aeneas's, Romulus's, Agrippa's, or, most recently, as the funeral of Tiberius's brother Drusus. Other sides show Aeneas and a scene of the *Vicomagistri* with Augustus.

6.19 The Ravenna Relief, 1st century CE. Marble. H. 1.4 m (4 ft 7 in.). On the right are Augustus and Livia, shown as Mars and Venus. To the left is a youthful figure with the star of a *divus* on his forehead; he is probably *Divus Iulius* or a Julio-Claudian prince.

CHAPTER 6: IMPERIAL PORTRAITURE AND COMMEMORATION IN THE EARLY EMPIRE

The Flavians

While Caligula fell victim to a more or less spontaneous palace coup, Nero was ousted because of a shift of support to a military general in the field, and provincial governor, Galba (r. 68–69 CE), who seized the position of emperor following Nero's suicide in 68 CE. This was a highly significant historical development since it constituted a clear acknowledgment that control of the troops formed the basis of imperial authority, although ratification by the senate and praetorians was, eventually, necessary as well. Every innovation brings unanticipated problems, and a remarkably large number of them occurred during a short period following Nero's death, a phase famously referred to as the "Year of Four Emperors," in 69 CE. How does one maintain support that was illegally claimed? Most effectively, it seems, by delivering on promises to back one's base supporters, something that Galba failed to do. After seizing the principate, how does one keep trusted allies from seizing it in turn? Again, Galba erred here by allying himself with Nero's former friend Otho (r. 69 CE), who essentially bought the support of the Praetorian Guard, who murdered his erstwhile colleague, to become the second of the four emperors that year. Most importantly, since there were legions all over the provinces, what would prevent other generals in the field each from declaring himself emperor at the same time? Nothing, as it turns out; this is precisely what happened with the commander of the Germania Inferior army, Vitellius (r. 69 CE) having claimed himself emperor in Gaul while Galba still lived and ruled. In the future, especially in the later empire, Rome would see instances of simultaneous emperors innumerable times. Although the details of the year's events are mainly incidental to a history of art, the precedent was very important because it utterly transformed the nature of the principate and, more subtly, the messages that emperors would choose to communicate in the monuments and buildings that they commissioned.

The eventual victor in the civil war following Nero's fall was Titus Flavius Vespasianus (Vespasian), from whose *gens* is named the dynasty that he initiated, the Flavians. It consisted of Vespasian himself (r. 69–79 CE) and his two sons Titus (r. 79–81 CE) and Domitian (r. 81–96 CE). Vespasian was not only the first emperor to come from outside the large but incestuously tight Julio-Claudian brood, but he was also not a part of the traditional Roman nobility at all. His family background was Latin equestrian; only his maternal uncle had held senatorial rank. He pursued a political and military career at Rome and displayed considerable survival skills, holding the praetorship under Caligula, consulship under Claudius (under whom he served in Britain), and important military commands under Nero, whom he accompanied on the emperor's tour of Greece. At the time of Nero's death Vespasian was in Judaea, suppressing a revolt. After the fall of Galba, and of Otho, and while Vitellius claimed the throne, Vespasian was acclaimed emperor by his own troops and the forces in Egypt. Leaving his elder son Titus to finish the Judaean campaign, he set out first for Alexandria, and eventually for Rome. In the meantime, Vitellius was defeated by armies in the West that had declared for Vespasian. Rome was held on Vespasian's behalf by his brother and other allies and, nominally, his younger son Domitian, until the new emperor's arrival in Rome in 70 CE.

In the same way as Claudius before him, Vespasian effectively addressed the problems created by the excesses of his predecessors. Sources describe him as modest, conservative, and pragmatic. He restored fiscal stability to the imperial treasury, although his taxing of the provinces is reputed to have been burdensome (his father had been a tax collector). Much of this wealth was devoted to public building. His son, Titus, meanwhile concluded his campaign in Judaea, and after his return to Rome, and his triumph in 71 CE, Titus was elevated to *de facto* co-emperor status; so, when Vespasian died in 79 CE, the transition of power was imperceptible.

Although Titus was not well liked during the time of his co-regency, according to Suetonius, he proved to be an enormously popular emperor during his reign from 79 to 81 CE. He combined the military expertise and experience of his father with the sophistication of having grown up in a family that had reached consular rank. He was said to have been an intimate of Claudius's son Britannicus, and so was probably familiar with the imperial court. He continued the policies of

Vespasian and faced an extraordinary number of crises for so short a reign: a devastating plague, the eruption of Vesuvius in 79 CE, and in 80 CE, a fire that laid waste to vast portions of the city, including the Capitolium itself. Titus died suddenly at the relatively young age of forty, and the brevity of his rule may also have contributed to his sterling reputation.

The case of Domitian, Vespasian's younger son, was quite the opposite. He had neither been given military commands nor seriously groomed for succession. Domitian sought to remedy this by personally leading campaigns during the 80s, against the Germans as well as the Dacians from eastern and central Europe; the encounters with the Dacians ended inconclusively, and they would be heard from again. Historians disagree about the relative necessity and success of these expeditions. Nonetheless, Domitian celebrated elaborate triumphs. In the same way as his brother and father before him, he recognized the military basis of imperial rule, but he was less successful than they in displaying at least a pretense of respect for traditional magistracies and senatorial consultation. He is said to have insisted on being called *dominus et deus* ("master and god").

Domitian's accomplishments were many: he established peace, for a time, in the north of the empire, rebuilt the fire-damaged quarters of the city with splendid new public works, and provided lavish entertainments. These were, however, expensive undertakings that depleted the treasury. His later years were not unlike those of Caligula or Nero. Dissatisfaction and fear led to conspiracies that spawned ever-increasing suspicion, repression, and bloodshed. Domitian was murdered in his palace in 96 CE, the victim of a plot that included his wife and closest associates. He had no successor.

FLAVIAN PORTRAITURE

Portraits of the Flavians display a marked family resemblance; indeed, Titus looks like a younger version of his father [6.20]. Vespasian, who was sixty at the time of his arrival in Rome, entirely abandoned the idealized portrait style of the Julio-Claudians. He is shown as wrinkled, balding, and serious [6.21]; this straightforward depiction may have been meant to evoke

6.20 (Right) Portrait of Titus, 70–80 CE. Marble. H. 1.96 m (6 ft 5⅛ in.). The son of Vespasian, Titus's portrait shows similarities with his father, especially the wide face and three creases on his forehead.

6.21 (Below) Portrait of Vespasian, 70 CE. Marble. H. 40.6 cm (1 ft 4 in.). As the first Flavian emperor, Vespasian moved away from the idealized style of the Julio-Claudians, showing himself as older, bald, and solemn. His portraits may also reference his military experience.

Claudius, whose memory he respected, but the realism in Vespasian's portraiture is far more pronounced. The style also could reflect both his equestrian background and his military experience, as did the verism of the Republican *imagines*. The latter were still potent images; in fact, our most vivid description of them is found in Pliny the Elder's nostalgic lament, written during Vespasian's reign.

Due to Vespasian's lack of noble descent, he had no famous ancestors in the Republic. He would, therefore, have had no *imagines* himself, but his use of this style associates him with the tradition and, more importantly, the meritocratic values that it represents. Yet this is not strictly an expression of Republicanism, as some have suggested; there was nothing Republican about the Flavian style of rule. This veristic portraiture is designed to lend to itself a status rooted in a Roman tradition of *nobilitas* that pre-dates the Julio-Claudians, whose heroizing Classicism is deliberately rejected. So, paradoxically, while this portraiture may constitute a realistic depiction of its subjects, at least part of the message it conveys is as fictional as the agelessness of Augustus.

Domitian's portraits [6.22] betray a family resemblance, but at the same time incorporate features reminiscent of the Julio-Claudians, such as the slightly protruding upper lip and a hairstyle that strongly recalls Nero's. The visual reference to Nero is sometimes explained as a result of the tendency for sculptors to recut Nero's portraits into Domitian's, but that does not account for all the sculptured heads or any of the coins; it simply begs the question. It would seem that the designer of these portraits was seeking to bring together Flavian and Julio-Claudian traditions, but we are at a loss to explain exactly why. That Nero and Domitian would prove to be so strikingly similar in both reputation and portraiture surely says something about the impact of the images.

FEMALE PORTRAITURE: JULIO-CLAUDIAN VS. FLAVIAN

A final development in Flavian portraiture was the radically different look adopted by women of the imperial court and their imitators [6.23]. Facial portrayals continue to represent both idealizing and more veristic trends, seen in public and private portraiture as in earlier times (see the tombs of Eurysaces and the Haterii, pp. 208–12). What attracts attention here is the extravagant hairstyle with its mountain of curls, perhaps a bourgeois fashion, brought to the court by equestrian-class women, which reflects the exuberance of a newly empowered moneyed class. It sharply diverges from the equally complex but far more controlled and Classicizing coiffures of the Julio-Claudians. This new trend would have allowed a sculptor the opportunity

6.22 Portrait of Domitian, 81–96 CE. Marble. His portrait tends to recall those of the Julio-Claudians, especially Nero.

to create a great *tour de force* of stone carving, using elaborate patterns of drillwork to outline, and even model, intricate forms with sharply contrasting areas of stone and cavity, light and shadow. Similar textural and **chiaroscuro** (the treatment of light and shade) effects are detected in other works of the time, especially architectural ornament, and their presence has led to the suggestion of a "Flavian baroque" style. Yet if there was such a thing, it existed, as did Augustan Classicism, alongside numerous other stylistic possibilities.

Imperial Women

Turning to the imperial families, the Classicism of Augustus's portraits is embraced in images of Livia (see 5.7), Octavia, and Antonia, which makes the women all but indistinguishable, and reflects the dynastic blurring of visual difference in the portrayals of the entire Augustan household. Portraits of Flavian women (see 6.23) resist the relative realism of their male counterparts, a contrast that may mirror a preference among the equestrian class to hold to Hellenistic traditions. Plotina's portrait parallels Trajan's precisely in its balance of Neo-Augustan idealization, with a subtle hint of maturity, recalling the Republican virtues of competence and reliability. Sabina's portraits (see 10.5) fully embrace the overt cosmopolitanism and Classicism of Hadrian's. Portraits of the elder and younger Faustinas display the same determined imagery of continuity seen in the portraiture of their husbands; they themselves are similarly invoked by portraits of Julia Domna (12.6) in her hairstyle and smooth Classicizing features. Yet this later Severan version looks very different, owing to a clear abstraction of forms that, in retrospect, marks for us the beginning of a dramatic new trend in Roman artistic style. In this instance, however, the formalism is likely an orientalizing, biographical reference to the empress's own Syrian origins, just as Severus's divine Serapis curls connect him to his own North African homeland.

6.23 Portrait of a Flavian woman, 1st century CE. Marble. H. 63.5 cm (2 ft 1 1/8 in.). Flavian hairstyles were very distinctive for their pile of curls, allowing the artist to use intricate patterns of drillwork. The hairstyle may have been worn by women new to the court and in highest society.

CHAPTER 6: IMPERIAL PORTRAITURE AND COMMEMORATION IN THE EARLY EMPIRE 171

The Flavian Portraits from Misenum

Cape Misenum is a headland that marks the northwestern edge of the Bay of Naples, and thus commanded access to and from the region, especially Puteoli (modern Pozzuoli), the most important port on the west coast of Roman Italy. It was here that Pliny the Elder was stationed as prefect of the fleet in 79 CE and was positioned to observe the eruption of Vesuvius. He perished in his efforts to rescue those fleeing the disaster.

Among the finds at the site of Misenum, discovered during a salvage dig (archaeology of a site facing imminent destruction or development) in 1968, are the remains of a temple, or **sacellum**, of the municipal Augustales. The Augustales were wealthy Italians, not of noble birth (they were mostly freedmen), who formed associations (*collegia*) for the propagation of the cult of the *Augusti*. By involving this class of citizen in a form of emperor cult, this institution was not unlike that of the *Lares Augusti* practiced by the *Vicomagistri* in Rome. The complex at Misenum consisted of three parallel rooms, arranged rather similarly to three bordered spaces facing the peristyle of a Roman villa. The *sacellum* itself was central, marked off by a four-columned facade. To the viewer's right of that was an apsidal *triclinium*, a semicircular space with couches along its sides. To the left was a rectangular hall of uncertain function. The complex was built under Augustus himself and renovated several times, including under Domitian. It would not be surprising if the Flavian emperors, the first to have family roots among the equestrian class of Italy, had found special favor among this particular group. As luck would have it, an especially well-preserved dynastic portrait group was found in this complex.

Two over-life-size marble portraits [6.24] represent Vespasian and his son Titus. The two men stand in nearly identical Classicizing poses, nude but for a small mantle wrapped around the left shoulder and arm. The scheme is a common Hellenistic type used for divine and heroized figures; the pose recalls the Pseudo-Athlete, and the supporting strut is in the form of a military cuirass, such as that of the Tivoli General. The heroic nudity here does not necessarily indicate that the two are shown as *divi*, but they probably were, since the group must have been a dedication from the reign of Domitian.

Domitian himself is shown quite differently: a rarely preserved bronze equestrian statue, in this case somewhat under life-size [6.25]. The vigorous presentation of Domitian in bronze contrasts strongly with the Classicized marble images of his father and brother, emphasizing his status as *princeps* of the here and now. Two aspects of the statue are of particular interest. First, the face (not the entire head) of Domitian has been replaced with that

6.24 Portraits of Vespasian and Titus, Misenum, Italy, 90–96 CE. Marble. H. 2.13 m (7 ft 1/8 in.). Father and son stand in near identical poses, calling to mind the Classical heroes. The form also recalls such Republican statues as the Pseudo-Athlete.

6.25 Equestrian statue of Domitian, 81–96 CE. Bronze. H. of Domitian 1.3 m (4 ft 3 in.). After Domitian's death, the face of this statue was replaced by that of his successor, Nerva.

FLAVIAN COMMEMORATIVE SCULPTURE
Arch of Titus

The practice of erecting commemorative arches began during the Republic, and many were built in Augustan and Julio-Claudian times, but the earliest well-preserved example is the Flavian monument that spans the via Sacra at the eastern entrance to the Forum Romanum [6.26]. The form of the arch seems to have originated as the sculptured elaboration of a city gate, but freestanding commemorative arches were set up well before imperial times. They were, in essence, elaborate statue bases, topped by sculptural groups, usually representing a *triumphator* in his *quadriga*, if the arch was meant, as this one was, to celebrate a triumph. Its inscription states that it was dedicated to Titus, as a *divus*, by the senate and people of Rome, and so it is known as the Arch of Titus. The completion of the monument must postdate Titus's death in 81 CE and, since his deification is also alluded to in the sculptural program, most or all of the construction must have taken place under Domitian. A theory that the arch is post-Flavian has not attracted many supporters. It makes sense that Domitian, even if self-centered and jealous of his popular brother, would have wished to strengthen his claim to the imperial title by emphasizing his familial connection.

6.26 The Arch of Titus on the via Sacra, Rome, Italy, c. 81 CE. H. 15.4 × W. 13.5 × D. 4.75 m (51 × 44 × 16 ft). As reconstructed in the early nineteenth century, this is the earliest, and one of the very few preserved, examples of commeorative arches in Rome, of which there must have been dozens all around the city.

of his successor Nerva. (This phenomenon of *damnatio memoriae*—literally meaning "damnation of memory"—is explored further in the box: *Damnatio Memoriae* on p. 185.) Also, Domitian is not shown in a military context, either victorious over a defeated enemy, as with the famous statue of Marcus Aurelius on the Capitoline (see 10.24), or dispatching a foe with his spear, as figures are seen doing in so many Roman reliefs. His clothing and equipment show that he is hunting, which ties him to a tradition of Hellenistic kings that goes back to Alexander the Great, and to oriental monarchs before him. This is clearly a mark of Domitian's Hellenism, and it would recur on the roundels on the Arch of Constantine, showing the emperor hunting on horseback, reliefs that originally adorned a monument of the emperor Hadrian (r. 117–138 CE), whose love of all things Greek became the stuff of legend.

The Arch of Titus was damaged (but preserved) when it became incorporated into a medieval fortification wall; it has been reconstructed in modern times, and the restored sections are clearly differentiated from the original remains. The overall form and architectural decoration is sufficiently similar to that found on other arches to suggest that the arrangement here was quite typical. This arch has a single vaulted passageway flanked by engaged columns that combine the coiled volutes of the Ionic order with the acanthus ornament of the Corinthian order: this is known as the Composite order (see 0.6). Identical columns are placed at the four corners of the structure. These carry a low entablature consisting of a narrow architrave, and a somewhat higher frieze that is adorned with relief sculpture depicting a triumphal procession. The figures in this scene are quite broadly spaced in a side-by-side arrangement that recalls many similar friezes, for example, the Ara Pacis altar frieze, the triumphal procession from the Temple of Apollo Sosianus (see Temple of Apollo Sosianus, p. 122), or the much earlier (second century BCE) Paris census relief. The relief on the arch is very deeply carved, however, and the figures are much more three-dimensional than those of the earlier monuments. The roughly triangular spaces (**spandrels**) that are formed between the upper curve of the vault and the inner corners of the framing colonnade contain figures of Victoria with a *vexillum* (military standard). This image of Victoria is an obvious symbol of military triumph and was standard decoration, both because of its significance and because the wings and flowing drapery of the figure make it especially suitable to fill such an oddly shaped space. While the overall architectural elaboration of the arch is relatively restrained, the ornament of the capitals, entablature, and cornice is very elaborate, and deeply carved, representing an increasingly obvious taste for the effects of chiaroscuro.

The most notable of the sculptured reliefs from this monument are the three that were placed within the vault of the arch itself. At the very summit of the vault is a square relief showing the emperor being carried aloft on the back of an eagle: an obvious reference to his apotheosis (deification) and transferal into the realm of the gods [6.27]. The artist here has made a somewhat clumsy but absolutely clear attempt to show the action as if viewed from underneath the vault, thus involving the viewer directly in the experience. A similar, although subtler, use of pictorial illusion is seen on the two rectangular panels located at either side of the passageway, somewhat above eye level, which show excerpts from Titus's triumph in 71 CE. Each procession moves from east to west, in the same direction that the actual parade would have taken through this arch, as it entered the forum. The viewer is further engaged by the compositional style of each panel, which is carved in higher relief toward the center, so that each procession seems to emerge into the foreground from one side and then return into the background as it moves forward, beyond the center point. This is most obvious in the relief where the soldiers carrying spoils move through an arch that is only partially carved and, quite literally, cuts into the relief background, where it is completed in paint [6.28]. The implication of motion of the figures in turn helps get across the idea of their movement through the arch in which the viewer is standing,

6.27 Relief of Titus on the back of an eagle, vault of Arch of Titus, via Sacra, Rome, Italy, c. 81 CE. Marble. The scene refers to the apotheosis of Titus, who died as a fairly young man in 81 CE.

6.28 Relief from the Arch of Titus, via Sacra, Rome, Italy, c. 81 CE. Marble. H. 2.4 m (7 ft 10½ in.). The scene depicts soldiers carrying the spoils from a battle, including a menorah, which references Titus's victory in Judea.

and creates an effect of vivid involvement. The great **menorah** looming above these spoils indicates, unambiguously, that this is the triumph following Titus's Judaean victory, with booty taken from the sack of Jerusalem. This triumphal procession is vividly preserved for us by the detailed eyewitness description recorded in the *The Jewish War* of Flavius Josephus (37–100 CE). As is typical of a panel relief, a small excerpt from a much more extensive event allows a few figures to stand for many, a small part for the whole.

Similar in this respect is the facing relief [6.29], which is, however, more allegorical than the rather literal spoils relief. This composition focuses on the *triumphator*, elevated in his *quadriga* to the right of the scene, and accompanied by the goddess Victoria. That he is front-facing both emphasizes his importance and enhances the illusion that he moves directly out from the background, then turns sharply, as indicated by the laterally depicted team of four horses. Aside from the accompanying group of lictors, which was a necessary attribute of his *imperium*, Titus is otherwise surrounded by personifications and deities; Roma leads the chariot and the *genii* of the senate and the Roman people are at its side. Some figures are standing; others are striding. There is an ambiguity between action and stasis here that, together with the frontality and prominence of Titus's figure, gives the entire scene the quality of an epiphany. This is more a striking demonstration of the concept of triumphant emperor than any true depiction of a triumph. One might propose that, since Titus

6.29 Relief from the Arch of Titus, via Sacra, Rome, Italy, c. 81 CE. Marble. H. 2.4 m (7 ft 10½ in.). This view from below reproduces the actual experience of the viewer, revealing the depth of the carving and the dramatic impact of the relief.

CHAPTER 6: IMPERIAL PORTRAITURE AND COMMEMORATION IN THE EARLY EMPIRE

was already dead and deified by this time, it was not only acceptable but also proper to show him in the company of deities and allegorical figures, but such a mixing is not without precedent. Even so, we are moving inexorably from a tradition that conceives the *princeps* as a man to one where he is, to a much greater extent, a symbol: the concept of imperial rule itself. The effect is dramatically strengthened by the pictorial devices—perhaps used here for the first time in Roman imperial art—that function to draw the viewer into the scene; such drama is another reason one often reads of a "Flavian baroque."

Cancelleria Reliefs

Only one other major Flavian monument of commemorative sculptured relief is preserved. This final example both reinforces certain observations made about features of Flavian sculpture and warns against making excessively generalizing statements concerning the existence of a Flavian style. Two very large relief friezes (both over 2 meters high, with figures at or over life-size) were found in the southern Campus Martius in the 1930s, underneath the Palazzo della Cancelleria (palace of the Chancellery), after which these Domitianic works are named [6.30 and 6.31]. Their original location is unknown but their Flavian date is suggested by the portraits of Domitian and Vespasian on one (Relief B), although on the other (Relief A), the figure that must have been Domitian has since been recut into a portrait of his successor, Nerva. Domitian, similarly to Nero and some other emperors who would fall in disgrace, suffered a *damnatio memoriae*, which led to the disappearance of certain portrait images and inscriptions recording his names.

The subjects are not precisely known but they can be inferred within reason. The better preserved (A) of the two shows the emperor setting out (***profectio***) on a military campaign, as indicated by the military figures of Mars, Minerva, and Roma urging him forward; wings, most probably belonging to Victoria, can be seen at the left edge of the relief. Behind the emperor are the *genii* of the senate, the *genii* of the Roman people, and a small group of soldiers with spears and shields. More spear-bearing soldiers and lictors wielding **fasces** are shown in the background. Relief B, as mentioned, shows Vespasian and Domitian. They are flanked by lictors, and behind them loom the *genii* of the senate and people, here perhaps as statues, to judge from the base indicated under the foot of these guardian spirits. To the left is a group of Vestal Virgins, and behind them Roma enthroned, perhaps also as a statue. The occasion is believed to be Vespasian's arrival (***adventus***) at Rome in 70 CE, and his being greeted by Domitian, who claimed to have held the city for his father in his absence. Most scholars believe the war alluded to in Relief A to be Domitian's disastrous campaign against the Sarmatians, a confederation of tribes from the Eurasian Steppe, in the early 90s, which would separate the two events depicted in the

6.30 Relief A from the Palazzo della Cancelleria, Rome, Italy, 90–96 CE. Marble. H. 2.06 m (6 ft 9 in.). This panel shows the departure of the emperor for a military campaign. Preceded by Mars and Minerva, he is accompanied by the goddess Roma, the *genii* of the senate with a scepter, and the *genii* of the people of Rome with a cornucopia. On the left, the wing of a Victory is visible, alluding to the hoped-for success of the venture.

reliefs by a quarter century. The monument for which they were made, which may well never have been completed, would therefore have dated to late in the reign of Domitian. Upon Nerva's succession in 96 CE, the reliefs might never have been placed in their intended location, and therefore the one head (Domitian's) was recut at that time to show the new emperor. When Nerva died less than two years later, the project may have been abandoned and the reliefs discarded. It has been argued that the portraits on Relief B have also been recut, but most accept a Flavian date for the sculptures.

In composition, these reliefs differ markedly from the Arch of Titus panels. The figures are more static, even in the *profectio* scene that attempts to show a dynamic procession. Although many figures are posed frontally in both reliefs, they are still contained within the narrowly separated foreground and background planes, and with their heads entirely or largely in profile. Despite the deep carving in some of the drapery, the scenes are compositionally flat: an effect that, when combined with the highly idealized facial features of all but the emperors, makes these works seem more strongly Classicizing than the arch panels. The background is undifferentiated and impenetrable; perspective, pictorialism, and illusionism are entirely lacking. Similar, however, is the combination, on at least one relief from each pair, of the emperor with deities and personifications—an increasingly common phenomenon.

Despite the difference in pictorial depth in the Cancelleria reliefs, the carving style of individual figures on both reliefs is quite similar; one especially notes the increasing use of the drill to roughly block out folds of cloth with straight blind channels, a simplification of form that would become increasingly common over time. Many figures on Relief B show this simplification, but it can be found on the drapery patterns of the spoils relief on the Arch of Titus as well, and, of course, has also been noted on contemporary portraiture. The overall contrast between these two monuments is probably not a matter of differing workshops, tastes, or simple variation. The differences in composition are clear and deliberate, and it is tempting to think that they reflect the different ways in which the two monuments were meant to be experienced. We do not know the original location of the Cancelleria reliefs, but they were large and very long, and were probably intended to be seen from a distance. The arch panels, we do know, were viewed from below and within the confines of the arch vault, the very location of the scene depicted. They exploited that coincidence of action and imagery by involving the viewer in a performative act that was, at the same time, in the past and continuing, invoking Titus's triumph that had already taken place while suggesting a continuation of triumphs among the Roman emperors. As always in Roman art, different representational styles could be used for different effects, in different contexts. In any case, the existence of these two monuments—the Arch of Titus and the Cancelleria reliefs—should warn against any generic conception of a single "Flavian" style.

6.31 Relief B from the Palazzo della Cancelleria, Rome, Italy, 90–96 CE. Marble. H. 2.06 m (6 ft 9 in.). This panel shows the arrival of the emperor Vespasian in Rome. He is being greeted by a person wearing a toga, who is probably his son Domitian. The *genii* of the senate and the *genii* of the people of Rome are represented, together with the Vestal Virgins and the goddess Roma.

7 Palaces and Public Works in the Early Empire

| 180 | Box: New Light on Early Imperial Palaces |

181	**Imperial Palaces**
	181 DOMUS AUREA
	183 Box: The Domus Aurea—Tacitus and Suetonius
	183 DOMUS FLAVIA
	185 Materials and Techniques: *Damnatio Memoriae*
	186 INTERIORS: FOURTH STYLE WALL PAINTING
	189 INTERIORS: STATUARY
	192 Box: Sperlonga and Statuary

193	**Public Works**
	195 TEMPLUM PACIS
	196 FORUM OF DOMITIAN/NERVA
	197 AQUEDUCTS
	198 BATHS
	199 THE FLAVIAN AMPHITHEATER AND PUBLIC SPECTACLE

Chronological Overview

DATE	EVENT
c. 20 CE	Wall painting: Fourth Style appears
62 CE	Earthquake near Vesuvius; widespread damage at Pompeii
62–79 CE	Rebuilding at Pompeii; Fourth-Style painting in House of the Vettii
64 CE	Great Fire in Rome
64–68 CE	Domus Aurea
69 CE	Flavian dynasty begins
75 CE	Dedication of Templum Pacis
79 CE	Eruption of Vesuvius; destruction of Pompeii, Herculaneum, and other sites in the area
80 CE	Fire in Campus Martius; dedication of the Colosseum; dedication of Baths of Titus
c. 85–97 CE	Forum Transitorium (Forum of Nerva)
92 CE	Domitian's palace on the Palatine completed

The Development of Rome

Right: Map of Rome showing the key buildings in existence in Rome in this chapter.

CHAPTER 7: PALACES AND PUBLIC WORKS IN THE EARLY EMPIRE

New Light on Early Imperial Palaces

Suetonius reports two acts of architectural arrogance, one perpetrated by Caligula and the other by Nero:

> Having continued part of the Palatium as far as the forum, and the temple of Castor and Pollux being converted into a kind of vestibule to his house, he often stationed himself between the twin brothers, and so presented himself to be worshiped by all votaries; some of whom saluted him by the name of Jupiter Latialis…In the daytime he talked in private to Jupiter Capitolinus… until being at last prevailed upon by the entreaties of the god, as he said, to take up his abode with him, he built a bridge over the temple of the Deified Augustus, by which he joined the Palatium to the Capitol.
> (Suetonius, *Caligula* 22)

Little remains of Caligula's project, but archaeology reveals that a further attempt to join the imperial palace to the forum occurred during the reign of Domitian through a huge barrel-vaulted ramp that zig-zagged up the slope from the Republican forum to the Domus Flavia. It ensured that Domitian had a secure means of access between the two spaces, but it must also have served to impress, intimidate, and even disorient anyone approaching the palace for an audience with the *dominus et deus* (master and god—as Domitian fashioned himself) sitting enthroned in the apse of the great Aula Regia (Royal Hall). The existence of this ramp has been known for over a century, but only recently was it fully investigated, restored, and opened to the public [7.1].

> [*Of the Domus Aurea*] The chief banqueting room was circular, and revolved perpetually, night and day, in imitation of the motion of the celestial bodies.
> (Suetonius, *Nero* 31)

In 2009, excavations on the northeast slope of the Palatine uncovered remains of what is thought to be this very dining room. Overlooking the artificial lake on top of which the Colosseum would later be constructed, the room served as the focus of Nero's sprawling Golden House. It was the type of engineering marvel in which emperors, and especially Nero, took delight. The primary find made by archaeologists was a concrete pillar, 4 meters (13 feet) wide and two stories high, which was part of an encircling wall connected by a series of radiating arches at the top of each story; the second set of arches held a platform shaped like a spoked wheel. Set into this were a series of semi-spherical cuttings, which are believed to have held large bronze spheres functioning as ball bearings, allowing a circular floor above to rotate. Archaeologists have suggested that the motion was powered by a water wheel fed by an aqueduct and connected to the rotating floor by a series of gears that could control the speed of rotation. A coin from the reign of Nero depicts a domed room above an elaborate platform and some scholars think this might be the same structure; it is labeled MAC AUG (*machina augusta*, or machine of the emperor), emphasizing its roles as Nero's pleasure dome, spectacle, and man-made marvel [7.2].

7.1 Imperial ramp, Rome, Italy, 81–96 CE. The ramp connected the Republican forum to Domitian's palace (Domus Flavia) on the Palatine.

7.2 Coin of Nero, Bronze. The reverse of this coin may depict the emperor's revolving dining room, called here a *machina augusta*.

180 PART II: THE FORMATION OF THE ROMAN EMPIRE

Imperial Palaces

Suetonius, in his *Life of Augustus*, makes much of the contrast between the enormity of Augustus's power and the modesty of his abode on the Palatine hill. This might be because he could see how imperial palaces had come to be designed both to reflect the personalities of the emperors who built them and to project the particular imperial image that each *princeps* favored. The Palatine would continue to be the site of the imperial residence, but the palaces themselves, with their beginnings in the relatively small Augustan complex in its southwest corner, would come to encompass the entire hilltop.

Augustus's immediate successors, Tiberius and then Caligula, extended the original domestic complex to occupy the northwest corner of the Palatine and become what is now called the Domus Tiberiana. The palace was apparently expanded to accommodate an increasingly big and complex imperial bureaucracy, administered largely by freedmen, especially under Claudius. Nero's imperial residence was the first, however, that could be considered truly palatial, and its excesses contributed heavily to his infamy (see box: The Domus Aurea—Tacitus and Suetonius, p.183). It was not the ostentatious show of wealth and power that made the palace a symbol of Nero's failure as emperor; rather, it was his seizure of vast tracts of public and private land needed to build an enormous rural-style villa in the heart of the city. Many felt Rome itself had been violated. The ill will this generated was fueled further by the great fire of 64 CE—one of the most devastating in a city with frequent fires. Two-thirds of the city was destroyed, prompting a widespread belief that Nero deliberately had the fire set in order to make more land available to build his new abode.

Whether Nero set the fire or not, his architect (Severus) and engineer (Celer) would not have been able to contrive what they did had the fire not taken place. Nero's palace—known as the Domus Aurea (Golden House) (see 7.4, p.182)—its land covering swathes of the Palatine hill, the Oppian, the Esquiline, and a good part of the Caelian hill, where work on a huge platform temple to *Divus Claudius* had been started soon after his death in 54 but was later suspended by order of Nero. The east end of the Republican forum along the via Sacra was transformed into a monumental entrance (a kind of state *fauces*) leading to a 3.5-meter-high colossal statue (colossus) of Nero and, further beyond, to a great artificial lake that occupied the low area formed by the surrounding slopes. There were surely buildings in all parts of the complex, but these would later be eradicated by Nero's Flavian successors as part of an architectural *damnatio memoriae* (see box: *Damnatio Memoriae*, p. 185).

DOMUS AUREA

The most famous surviving section of the Domus Aurea was discovered on the Oppian hill (the southern spur of the Esquiline), preserved in the later substructures of the emperor Trajan's great imperial baths. The exploration of these remains took place during the Renaissance, and the influence that these finds had on artists of that time (for example, the statue of Laocoön, see 7.15 on p. 190) has contributed to a sense of romance. Unlike the rotating banqueting room excavated in the twenty-first century, these rooms cannot be connected plausibly with any of the elements described by Suetonius, nor does their plan alone indicate any clearly defined function, but there is no denying that they would have appeared very impressive.

Around 150 rooms have been identified, stretching for about 250 meters along the south slope of the Oppian hillside [7.3]. To the west is

7.3 Plan of a part of the Domus Aurea, or Golden House, of Nero, Rome, Italy, 64–68 CE. The palace spread across much of the Palatine and parts of the Caelian and Esquiline hills. This plan shows a section of the Esquiline portion.

a rectangular court (not seen on this plan) with a peristyle on three sides, the fourth side facing back into the hill; a large room equipped with a fountain commands its west end. Slightly to the east of this, rooms are arranged around an open five-sided exedra, this time dominated in the center by a large, well-decorated, rectangular room. Moving east again, the suite in the middle of the complex centers on an eight-sided domed room that provides the point of greatest architectural interest among all the preserved remains of the Domus Aurea. Furthest east, a truncated five-sided exedra, identical to the western one, suggests a symmetrical complex, 402 meters (440 yards) long in its entirety, centered on the domed room (see 7.3, p. 181).

The centrally located domed octagon [7.4], leading to five cross-vaulted rooms, stands out from its surroundings by virtue of its curved rather than rectilinear (consisting of straight lines) arrangement. The space is flanked by barrel-vaulted halls with elaborate painted decoration, including scenes of Greek myth (see 7.8, 7.9, and 7.10, pp. 186–87). The main hall has a fountain at its center and was originally richly veneered with exotic marbles. Trajan's workmen were thorough in stripping this valuable material from these rooms before filling them in to serve as a substructure for his baths. As a result, the exposed brick-faced concrete reveals the engineering and architectural achievements of Severus and Celer. As we saw in our discussion of concrete construction in Chapter 2 (see box: Concrete, p. 62), it became standard for bricks to be used for facing at the beginning of the empire. This allowed for more efficiency and flexibility in building more challenging curved and vaulted structures.

The octagonal hall is capped by one of the earliest domes found in ancient Rome. It springs from eight **piers**—six flanking piers that are in front of the openings to each of the five radiating halls and two others that are built into the south wall of the complex. Above each brick lintel, flattened wall surfaces rise and gradually converge into a continuous hemisphere with a large central circular opening (**oculus**) at the top (see 7.4). The dome, moreover, rises within an octagonal light well, so that light comes down both through the oculus and from around the outer surface of the dome itself. This clever invention, combined with the polychrome marbles, gilded vaults, sparkling mosaics, bright paintings, and gushing fountains, would have created a dazzling and highly dramatic interior environment. The lighting device was needed because these rooms constituted a lower story, as shown by preserved remains of rooms from a second floor arranged around the octagonal opening, and as such required their own natural light source. Renaissance explorers coined the term *grotteschi* ("grotto-like") to describe their discoveries here. It is not difficult to imagine this as a setting for such luxuriant excesses as those related by Suetonius, grotesque in quite another way and in strong contrast to the moralizing, Classicizing restraint presented by the monuments of Augustus.

Rather than describing a central living space, scholars prefer to explain the Oppian remains as a pavilion: a place to convene, dine, and stroll, and enjoy the views of the lake below, the colossus on the Velian hill opposite (where the second-century CE Temple of Venus and Rome still stands today), and the fields and forests scattered about the surrounding slopes, as it was so eloquently reported by Suetonius. The effect is often compared to the scenes of sprawling seaside villas along the Latium and Campania coasts, but it is a scene clearly unsuited to being at the center of Rome.

7.4 The octagonal hall of the Domus Aurea, Rome, Italy, 64–68 CE. The grotto-like space is roofed by a dome and oculus and would have been decorated with frescoes, mosaics, and gilded vaults.

The Domus Aurea—Tacitus and Suetonius

Tacitus and Suetonius, both of whom were writing in the early second century CE, during the era of "good emperors," provide similar but differing accounts of Nero's Golden House. Suetonius's profile of Nero, like all twelve of his *Lives of the Caesars*, is a mix of history, biography, and gossip. Tacitus's *Annals*, a history of the Julio-Claudian dynasty, is somewhat more restrained, although his accounts of these rulers are no more positive than those of his contemporary.

> There was nothing, however, in which he was more ruinously extravagant than in building. He built a palace running from the Palatine to the Esquiline which he at first called the *Domus Transitoria*, but when it was subsequently consumed by fire and again restored, the *Domus Aurea*. Its size and splendor will be sufficiently indicated by the following details. Its vestibule was large enough to contain a colossal statue of the emperor a hundred and twenty feet high [36.5 meters]; and it was so extensive that it had a triple colonnade a mile long. There was a pond too, like a sea, surrounded with buildings to represent cities, besides tracts of country, varied by tilled fields, vineyards, pastures, and woods, with great numbers of wild and domestic animals. In the rest of the house all parts were overlaid with gold and adorned with gems and mother-of-pearl. There were dining rooms with ceilings of ivory, whose panels could turn and shower down flowers and were fitted with pipes for sprinkling the guests with perfumes. The main banquet hall was circular and constantly revolved day and night, like the heavens. He had baths supplied with seawater and sulphur water. When the edifice was finished in this style and he dedicated it, he deigned to say nothing more in the way of approval than that he was at last beginning to be housed like a human being.
> (Suetonius, *Nero* 31)

> Nero meanwhile availed himself of his country's desolation, and erected a mansion in which the jewels and gold, long familiar objects, quite vulgarized by our extravagance, were not so marvelous as the fields and lakes, with woods on one side to resemble a wilderness, and, on the other, open spaces and extensive views. The directors and contrivers of the work were Severus and Celer, who had the genius and the audacity to attempt by art even what nature had refused, and to fool away an emperor's resources.
> (Tacitus, *Annals* 15.42)

DOMUS FLAVIA

It is not clear where Nero's actual personal residence was located. Perhaps he settled down wherever the spirit moved him about this vast complex. It is not entirely certain, either, where the later Flavian emperors Vespasian and Titus lived during their principates. The family house on the Quirinal remained in use, however, as perhaps did parts of the Domus Aurea that were not given back over to public building. It may well be that the imperial residence continued to exist on the Palatine, on the same spot where Domitian built the vast palace that would remain a focal point of imperial power until (and even after) Constantine built his new palace in Constantinople some two and half centuries later.

Repairs, rebuilding, and some expansion necessarily occurred to this palace over this 250-year period, yet the original plan of Domitian's architect Rabirius was retained [7.5]. The overall arrangement is highly formal, with three parallel

7.5 Plan of the imperial buildings on the Palatine hill, Rome. The Palatine served as home to the emperors from the time of Augustus until the fourth century CE.

CHAPTER 7: PALACES AND PUBLIC WORKS IN THE EARLY EMPIRE 183

7.6 The remains of the peristyle and *triclinium* of the Domus Flavia, Palatine hill, Rome, Italy 92 CE. These traditional features of a Roman *domus* were incorporated into the Flavian palatial residence.

7.7 The private quarters of the Domus Augustana, Palatine hill, Rome, Italy, c. 92 CE. The living space of the imperial family faced a garden showcasing a spectacular fountain.

adjoining rectangular sections, the first two of which themselves consist of three parts. The first and most public section encountered is in modern times called the Domus Flavia; it recalls the general arrangement of a traditional Roman *domus* in which the public spaces become more private as one proceeds further into the building: reception rooms in front, a central peristyle beyond and, finally, a highly decorative dining room (*triclinium*) used for public entertainment [7.6]. The reception rooms here are regal in the extreme and, again, comprise three rooms, two of which boast enormous interior spaces. The smaller of these, to the west, is a relatively simple apsidal vaulted hall that may have provided the inspiration for the form of early Christian churches. The "Aula Regia" to its east is larger and more complex. Both rooms had elaborate interiors with columns, *aediculae*, and statuary—by now the standard equipment of formal interior spaces in the Roman world. Each room had an apse centered at its back wall and either, or both, could have functioned as a throne/reception room, which would be in keeping with Domitian's reconfiguration of the notion of *princeps* into *dominus et deus*. If Augustus's retention of the atrium house implied his relationship with the Roman people as being one of a patron to his clients, then Domitian's palace clearly indicates that the Flavian emperor viewed his as being that of master to slave, or even god to worshiper. The small room east of the Aula Regia is thought to be a state *lararium* (chapel), reprising the melding of public and imperial household gods initiated by Augustus both on the Palatine and throughout the *vici* of Rome.

The central third of the complex is nowadays called the Domus Augustana—adopting the name that had been used to refer to the entire palace complex in ancient times. It shares the three-part arrangement of the Domus Flavia, but otherwise there was a marked change in the orientation of its plan. At the northeast end, a peristyle court was located next to the reception halls of the Domus Flavia and similarly faced toward the Roman Forum. Beyond a second, central peristyle court ranged the domestic quarters of the imperial family. In keeping with the increasingly private nature of succeeding spaces, these faced away entirely from the more public areas of the palace. These apartments were organized over two floors around a central court so that the upper story ranged around a large, square open space and the lower rooms opened out onto a spectacular sunken garden with an elaborate central fountain [7.7]. This courtyard, and the light wells strategically placed among the rooms surrounding it, ensured that the spaces were illuminated and pleasant, as well as private and secure.

This complex gave access to a great semicircular gallery that allowed the emperor to look out onto the Circus Maximus below and appear in all his imperial glory to the masses assembled for chariot races. From the same courtyard one could access, further east still, the third part of the palace, the so-called

184 PART II: THE FORMATION OF THE ROMAN EMPIRE

MATERIALS AND TECHNIQUES
Damnatio Memoriae

The term *damnatio memoriae*, although coined in Latin, is not an ancient one; it probably first appeared in the seventeenth century. The practice itself—whereby the memory or legacy of a deceased person was condemned, suppressed, or erased—was common enough in Roman times, yet the details of how this occurred could vary considerably. When carried out against Romans of high political standing, such measures focused on suppressing images of the deceased, at least in public, and removing his (or, on occasion, her) name from public inscriptions. These practices, however, generally did not extend to family members, so heirs of the deceased were able to keep family property. The intention was to punish, and therefore discourage, transgressive behavior but not to destroy entire patrician families.

Damnatio memoriae is as old as ancient Egypt where, for example, images of the heretic king Akhenaten were smashed and defaced in the fourteenth century BCE, and as recent as this century, in which crowds tore down statues of Saddam Hussein after he was deposed. During the Roman imperial age, a new ruler or dynasty might seek to distance themself from a predecessor who had fallen into disgrace. This would mainly be carried out through the destruction or defacement of sculptured portraits and the erasure of names from inscriptions. This could be a top-down imperial edict or senatorial vote, or bottom-up acts by a populace either enraged at the now infamous ruler or seeking to curry favor with the new administration.

In the study of Roman art there are clear cases of where an image or name has been erased, and we shall see several of these, for example those undertaken during the reign of Caracalla in the third century CE (see p. 329). In our treatment of the early empire we have noted other less conspicuous examples of an emperor marking transition by highlighting differences between himself and his predecessor. Portrait styles, for example, were sometimes chosen to indicate continuity or mark discontinuity without actually obliterating the memory of the predecessor. Related to this is the technique of reworking a pre-existing imperial portrait into the visage of the new emperor. This could be seen to be a purely practical matter of not wasting materials, but the motivation was more probably programmatic. In Chapter 6 we saw two monuments demonstrating reworked portraits: the Cancelleria *profectio* relief and the Misenum equestrian bronze. On the former, Domitian's face was recut to depict Nerva, and on the latter a face of Nerva was cast and applied to the head from which Domitian's had been removed. In both cases, however, accompanying images of Vespasian and/or Titus were left unchanged. We can draw from this that the modifications were intended not simply to erase and replace any memory of Domitian but to communicate Nerva's position as the rightful heir to "good" emperors whose competence, moderation, and popularity with the troops he hoped to share.

We see a similar phenomenon occurring with the Flavian repurposing of the Domus Aurea, with its clear program of returning to the people property that had been confiscated from them by Nero. This included spectacular new public baths on the Oppian hill, near the great octagonal hall; the beautiful park of the Templum Pacis at the entrance to the Golden House; and, most conspicuously, the greatest of all amphitheaters, the Colosseum, which was placed directly on the site of Nero's greatest folly, the artificial lake. If, as many think, the Flavians also transformed the face of the colossus from that of Nero to that of the sun god, Helios, then literal *damnatio* occurred as well.

hippodrome—a second but much larger sunken formal garden roughly in the size and shape of a Greek stadium. This area, which was every bit as private as the domestic quarters, offered the imperial family a wide open space to enjoy the Palatine's Olympian calm away from the urban turmoil below.

In designing the Domitianic palace, the architect Rabirius exploited the possibilities and challenges offered by brick-faced concrete, which enabled buildings to take forms that could not previously have been imagined. Each part of the palace displayed the architect's fascination with alternating curved and rectilinear spaces. For example, the vestibule centered on the north flank of the peristyle in the Domus Flavia and the two rooms either side reflect the fantasies of a draftsman obsessed with his own compass, creating engineering problems that only Roman concrete could solve. Similarly, the octagonal halls of the imperial apartments would have demanded highly complex segmented vaults. From Rabirius' imagination came an entirely new kind of architecture, characterized by the

definition and elaboration of interior space rather than exterior mass—a development so significant as to have earned the term "Roman architectural revolution." To fully appreciate its importance, we must imagine these rooms decorated with the veneer, painting, stucco, gilding, statuary, and water features that were just as essential as the bricks, aggregate, and mortar. Domitian, we are told, had the veneers polished so smoothly that they resembled mirrors, so that he could detect assassins approaching from behind. While the marble may have failed in this, the palace did evoke huge praise from such contemporary poets as Martial (c. 38–104 CE) and Statius (c. 45–95 CE), who described the palace's splendors and compared it favorably to that of Jupiter himself. This suggested that Domitian's creation did have, for these writers at least, the intended impact.

INTERIORS: FOURTH STYLE WALL PAINTING

While the interiors of imperial palaces, such as those of monumental public buildings, were fitted out with marble veneers and architectural features, many rooms were also painted. By the middle of the first century CE, the Third Style of wall painting (see p. 150) had evolved into the fourth and final Pompeian style, and some rooms in the Domus Aurea display such features. The Fourth Style is defined as a combination of the previous three styles, as is best illustrated in the House of the Vettii (see. p. 188). This transition of painting style occurred by the years 64–68 CE, a dating corroborated by the evidence from the Vesuvian sites. An earthquake in 62 CE had caused considerable damage to buildings throughout the Pompeii area, and when these were subsequently buried by the eruption in 79 CE, reconstruction was still in progress. The evidence of similar and contemporary decorative schemes found both here and in Rome itself indicates that, as in earlier times, there persisted a common Romano-Campanian painting style.

Much of the painting that has been preserved in the Domus Aurea is relatively modest and limited to secondary rooms, since the primary spaces were decorated in much more exotic materials. The master painter of the Domus Aurea, a Roman citizen named Fabullus—who is said to have painted in his toga—was famous enough that Pliny the Elder saw fit to mention him. His finest work is probably that found

7.8 Painted vaults of the Domus Aurea, Rome, Italy, 64–68 CE. Many of the fresco paintings were destroyed after Nero's death as part of his *damnatio memoriae*.

7.9 Detail of the vaults of the Domus Aurea, Rome, Italy, 64–68 CE. This panel shows the story of Achilles on Skyros, an episode from the Trojan War epic.

on the painted vaults with mythological panels located in the rooms flanking the domed octagon [7.8, 7.9]. But the painting here is combined with polychrome stucco work and, on much of the walls below, marble veneer, so it lacks the full-scale illusionism of the typical Fourth Style architectural arrangement. The Fourth Style is found only in small, remote rooms or narrow passageways, where the suggestion of space would have had the effect of opening them up [7.10], recalling the Second (architectural) Style. Indeed, it was this re-introduction of techniques creating spatial penetration and recession typical of Second Style painting into a scheme that also combined the broad flat panels and impossibly delicate decorative motifs (the so-called *grotteschi*, in this case particularly elaborate decorative elements) of Third Style with the typical incrustation features of the First Style that characterizes and defines Fourth Style painting. The sense of "roominess" in these tight spaces is further enhanced by the use of white for large, uninterrupted spaces, another characteristic of much Fourth Style painting.

The Fourth Style shows far more variety than its predecessors, both in its combination of features and its quality of execution. And, since it was the current style during the time of reconstruction in those Vesuvian cities that remain our primary source of information, owing to their exceptional preservation, there exist more examples of this than of any other style.

7.10 Painted hallways of the Domus Aurea, Rome, Italy. 64–68 CE. Parts of the hallway show Fourth Style wall painting, demonstrating the illusion of open space and light architectural framing, which gave a sense of widening the narrow passageways.

CHAPTER 7: PALACES AND PUBLIC WORKS IN THE EARLY EMPIRE

7.11 The Ixion Room at the House of the Vettii, Pompeii, Italy, 62–79 CE. The lower panel (dado) is painted to imitate marble veneer. Above the panel, windows cut into the blocks of color show architectural vistas.

To select one especially representative Pompeian example, the Ixion Room of the House of the Vettii [7.11] shows a particularly close affinity to the styles of the first century BCE that make up the Fourth Style. In this room the **dado** (the lower part of the wall, or orthostate) consists of painted stucco in imitation of marble veneer, and the faux windows with architectural vistas beyond recall those from the Boscoreale villa (see pp. 85–87).

7.12 Pentheus painting from the House of the Vettii, Pompeii, Italy, 62–79 CE. In a number of rooms in the house, the center of the wall is dominated by mythological scenes that address transgression and consequence. In this scene, the Theban king, Pentheus, is torn limb from limb after being tricked by Dionysus into watching an exclusively female Bacchic rite.

Here, however, they are juxtaposed with broad flat panels of white with Third Style garlands and floating grotesques. The individual decorative elements are traditional and familiar but the combination is something unmistakably new.

The center of each wall is dominated by a mythological panel painting, a popular feature used since early Augustan times. The subjects here deal entirely with mortal transgression and divine retaliation—such as the ancient Greek myth of Ixion, who was condemned to spend eternity tied to a spinning wheel of fire after having attempted to win the love of the goddess Hera—which reflects an element of Augustan moralizing that continued to be appropriate in the time of Pliny. At the top of each wall, architectural fantasy takes flight again with the creation of an illusionary space populated with figures. The overall effect is not unlike that of the real colonnaded facades with their statuary displays (for example, fountains, fora, stage-buildings) that were becoming ever more common across the different parts of the empire and were a clear mark of Romanization. The immediate impression of these paintings is authoritative, even overwhelming, as the decorative scheme invokes the majesty of imperial architectural forms. Yet they also invite close inspection and reflection; the mythological paintings, for example, display Classical narrative practice by suggesting or only partially depicting such gory punishments as that suffered by Ixion. This suggestion of the act is in contrast to the graphic details of a painting in a nearby, otherwise similarly decorated, room in the same house that shows Pentheus being torn limb from limb in punishment for dishonoring the rites of Dionysus [7.12]. The contrast in narrative tone is provocative and meaningful, and at the same time entirely comparable to the Roman use of multiple styles in other media—especially in statuary.

188 PART II: THE FORMATION OF THE ROMAN EMPIRE

INTERIORS: STATUARY

Statuary played an enormous role in how conceptions of the principate were publicly expressed, as seen in the Forum of Augustus, for example, but it was by no means only portraits that were used for this purpose. In such domestic spaces as the Villa of the Papyri, for example (see Sculpture from the Villa of the Papyri, pp. 95–98), ideal statuary, and artworks in other media, were chosen and arranged to create contrasting thematic environments within the different areas of a house or villa, a phenomenon implied also in Cicero's letters to Atticus. Although largely stripped of its decoration in post-antique times, two colossal statues carved from dark-green Egyptian basalt were found in the Aula Regia of the Domus Flavia (see 7.5), one depicting Bacchus and the other Hercules, both of whom Domitian strongly identified with [7.13 and 7.14]. Both are Classicizing in ways that combine High Classical and late Classical features. They have clearly been designed in relation to one another, the exaggeratedly powerful musculature of Hercules contrasting with the smooth androgynous forms of his counterpart; the style here was surely chosen to capture the essence of each deity, both continuing and developing a representational tradition originating in the Classical era itself. It is possible that the two formed part of a divine gathering, among whom philhellenic Domitian took his place when enthroned in his enormous new audience hall.

7.13 Parma Hercules, from the Aula Regia of the Domus Flavia, Rome, Italy, Domitianic era. Basalt. H. 3.65 m (11 ft 11³/₄ in.). The statue was found in Domitian's royal hall, where it may have formed part of an assemblage of gods and heroes among whom the emperor would sit.

7.14 (Below) Parma Bacchus, from the Aula Regia of the Domus Flavia, Rome, Italy, Domitianic era. Basalt. H. 3.55 m (11 ft 7⁷/₈ in.). The colossal statue demonstrates features that reflect both the High and late Classical periods and appears to have been designed in relation to the statue of Hercules seen in 7.13.

7.15 *Laocoön and His Sons*, found near the Domus Aurea, Rome, Italy. Marble. H. 2.08 cm (6 ft 10 in.). Dates for this statue are uncertain, with anything from the Republic to the Flavian period suggested. The group depicts the Trojan priest Laocoön and his two sons in the grip of snakes sent by Athena after Laocoön had questioned the Greeks' gift of the Trojan horse.

Probably the most famous surviving statue ever to have stood in an imperial Roman residence is that of *Laocoön and His Sons* (informally referred to as the Laocoön group), now in the Vatican Museums [7.15]. Discovered in 1506 near the remains of the Domus Aurea, the marble sculpture was immediately recognized as the work much admired by Pliny, who mentions:

> …the Laocoön in the palace of the *imperator* Titus, a work that must be considered superior to all other products of the arts of painting or sculpture. From one stone the most eminent artists Agesander, Polydorus, and Athenodoros of Rhodes, following an agreed-upon plan, made him, his sons, and the marvelous intertwining of snakes.
> (Pliny, *Natural History* 36.37)

Despite the fame and the relatively well-preserved condition of this statue, there is much we do not know about it. While this is almost certainly the statue group that Pliny saw, we do not know where it stood—since we also do not know precisely where Titus lived at the time—nor how the statue came to be where it was found. It is not, as Pliny says, carved from a single stone, or even from a single *type* of stone, since the figures and the altar against which they are depicted falling are made from different varieties of white marble. Dates suggested for the group range from the late Republican era to the Flavian period. Some scholars believe it copies an earlier bronze group, in part or in whole, from the Hellenistic era, either second or first century BCE, while others see it as an entirely original Roman creation.

But there is much we *do* know. If Pliny is correct, then the sculpture belonged to the emperor Titus, who displayed it in his house; therefore, whenever it was made, its style and subject matter continued to hold appeal for the Roman patron. The coordination of said style and subject matter in the work is relatively straightforward and chief among the Hellenistic legacies that we see in Roman art. The group depicts the Trojan priest Laocoön (the central figure) who, in one version of the story, warned his countrymen against bringing the wooden horse (gifted by the Greeks) within the city walls of Troy. This warning incurred the anger of the goddess Athena (protector of the Greeks), who sent serpents to attack Laocoön and his sons, giving a sign to the Trojan people that Laocoön's reasonable advice was against divine will—of course, the Trojans did not yet know that it was Athena's intention that Troy should fall to the Greeks. The highly dramatic poses and facial expressions are appropriate to the pain and grief endured by the snakes' victims, and make use of a so-called baroque mode of representation, which had been used to portray such subjects since the early Hellenistic period. The figure of Laocoön himself is, in fact, a visual quote of another opponent of Athena, Alcyoneus, who appears on the Pergamon Altar's Gigantomachy frieze [7.16]. The reference to Troy in the Laocoön group, of course, connects the theme with the origin story of Rome, and it is tempting to associate the sculpture with Virgil's *Aeneid* (II.199–233), which provides an especially moving account of the episode that also coincides closely with the portrayal seen in the sculpture.

7.16 Athena and Nike fight Alcyoneus, the Pergamon Altar, Turkey, 2nd century BCE. Marble. H. 2.29 m (7 ft 6 in.). Gaia rises up from the ground in a futile attempt to save her son, the giant Alcyoneus, who is attacked by Athena.

CHAPTER 7: PALACES AND PUBLIC WORKS IN THE EARLY EMPIRE

Sperlonga and Statuary

In 1957, on the west coast of Lazio, near the border to Campania, road workers discovered a villa, its *triclinium* situated in the mouth of a cave and equipped with a theatrical array of marble statuary groups that were meant to entertain and engage the diners. One group, set within a circular pool, shows a ship in distress with the sea monster Scylla attacking struggling sailors [7.17]. Between it and the dining area were two smaller groups, depicting the theft of the Palladion at Troy, and a warrior holding the body of his dead comrade. In the distance was a fourth group, showing Odysseus and his companions skewering the eye of Polyphemus the Cyclops.

Date, Ownership, and Usage

Ancient sources relate that while Tiberius was dining in a cave at this very location, he survived a rockfall through the intervention of his praetorian prefect Sejanus. Thereafter, the emperor had absolute trust in a man who would seek to overthrow him. Tiberius may then have been responsible for this statuary program, a conclusion that accords with both his interest in leisure—the villa was clearly a place of entertainment—and his passion for Greek mythology. Construction methods, however, support a date in the Augustan period, and further remains indicate usage as late as the third century CE.

Authorship and Nature of the Sculptural Groups

The Scylla group bears the signature of sculptors with the same names as those Pliny gives for the Laocoön group: Agesander, Polydorus, and Athenodoros of Rhodes. These names are not uncommon, being documented already in the first century BCE, so it is possible but far from certain that Tiberius had a hand in the program. Whether and how these groups might relate to supposed Hellenistic bronze "originals" is also disputed, although that question does not much affect our understanding of them as Roman works. As we have seen, all styles of Greek sculpture persisted from the Hellenistic period onward, and a sculptor of the Roman era employed them as appropriate to the subject and display context of the project at hand.

Subject and Source

Each sculpture group depicts a story that should or could involve Odysseus, so scholars have long wanted to see the large groups as illustrating Homer's *Odyssey* and the two smaller groups as episodes from the Trojan War itself. More recently it has become common to see the groups as relating stories from Virgil's *Aeneid*, a source that is precisely contemporary with the archaeological dating for the *triclinium*. Not only do Aeneas's exploits sometimes mirror those of Odysseus but also many of the latter are themselves recounted again in Virgil's poem. This argument, however, seems to miss the point. Ancient works of art were seldom, if ever, meant to illustrate literature but, like that literature, function to tell the stories themselves. Those who experienced and no doubt discussed the surrounding statuary over ample quantities of wine and exotic food were extremely well versed in the Classics and probably knew the two epic poems by heart. They would have identified elements of both works in the sculptures; indeed, the very relationship between Homeric and Virgilian narrative, and the verbal and visual styles used to construct it, is what gives the display its meaning and its relevance.

7.17 Detail of the Scylla group from Sperlonga, Italy. Marble. The scene shows an episode from Odysseus's adventures. The boat is signed by its three sculptors.

The Laocoön group must be understood within the context of the numerous statuary installations portraying scenes from Greek and Latin epic poetry. These are known from actual sculptural arrays found in Rome (including the Domus Aurea) and other sites in Italy and around the empire, as well as from statues found in shipwrecks dating to as early as the first half of the first century BCE. Laocoön and a set of sculptures from a coastal villa at Sperlonga (some 80 miles south of Rome) illustrate a trend in the sculptural decoration of interior spaces that is probably an entirely Roman invention (see box: Sperlonga and Statuary, opposite). Much more so than the Greeks before them, the Romans used art to define spaces and to create atmosphere, and in the case of such epic groups as that of Laocoön, their creation was prompted by the highly literary philhellenic tastes of the Roman elite. The difficulty of establishing an exact date for these and similar statues is ample evidence for the existence of a consistent set of artistic values and a consistently available body of artistic styles and figural types, to be employed by artists throughout the late Republican era and early empire as appropriate to the subject, theme, and message in question, and in response to particular commissions.

Public Works

The city of marble that Augustus claimed to have left behind had little need for further major public building programs. Although floods and fires would continue to create a need for rebuilding and restorations (the temple of Jupiter on the Capitoline was destroyed twice between 69 and 80 CE), with the ending of private manubial building practices under Augustus, new temples were erected only occasionally. The collapse of the Republic, and the mania for architectural self-advertisement that its politics perpetuated, brought about a new, typically imperial, building policy that focused on necessary public works, structures for the enjoyment of the populace, and monumental buildings and complexes, all of which were designed to communicate that the world was better off under imperial rule. As part of this, the most important new imperial temple commissions were those set up in honor of the cult of the deified emperor, of which there were four in the first century CE.

There is still some debate concerning the precise location of the temple to the divinized Augustus, which should have been a structure central to the idea of imperial cult. It is plausibly located south of the Basilica Julia in the Republican Forum, and its appearance is recorded on coins minted by Caligula, who dedicated the temple in 37 CE [7.18]. Coin portrayals are notoriously sketchy and often gloss over details (for example, the number of facade columns); however, these coins show a building with an elaborate program of akroteria stretched out along the facade roofline in Etruscan style, which includes a central *quadriga* and, at the corners, Romulus with the *spolia opima*, and Aeneas with his father Anchises and son Ascanius/Iulus. The formula clearly references the statuary program of the Augustan Forum as it portrays very similar themes (see Forum of Augustus, p. 144).

All the other temples built to honor *divi* in the first century CE were, in part or in whole, Flavian. Nero began work on a temple for the *divus Claudius* on the Caelian hill, but he soon suspended the project and instead transformed the initial works into an elaborate **nymphaeum**, which functioned as the source for a cascade of water terminating in the artificial lake below. Vespasian, again displaying piety toward Claudius, and rejecting the example of Nero, completed the temple (also known as the Claudianum) as a massive porticoed sanctuary on a raised platform, with the temple proper set within an expanse of formal plantings, creating a peaceful public refuge; this was part of a broader program to restore Nero's private holdings to the Roman people, as we shall see. The temple to divine Vespasian was begun during the brief reign of Titus and completed by Domitian, who with characteristic Roman pragmatism dedicated it to his divinized brother as well. A conspicuous location for the temple was chosen at the foot of the Capitoline, although the limitations of space caused by the need (or decision) to respect the very ancient (although more recently rebuilt) temples of Concord and Saturn resulted in the construction of a conventional **prostyle**

7.18 Coin of Caligula with a depiction of the Temple of Augustus, 37 CE. The image shows the temple to have had an elaborate program of akroteria (rooftop statuary).

7.19 Entablature from the Temple of Vespasian, Rome, Italy, 1st century CE. Marble. The depth of the carving and use of ornamentation is typical of Flavian sculpture.

platform temple of relatively modest dimensions. It would, however, have been a very beautiful temple, judging from the exquisite carving of its extant entablature blocks [**7.19**], which display the deep carving and love of ornament that are characteristic of early imperial, especially Flavian, works. Here the architrave is carved with the symbols of various Roman priesthoods, used as emblems of imperial authority since the time of Augustus.

Domitian later constructed a very different type of building in the central Campus Martius, which seems to have had a similar function as the temple to Vespasian. It was called the Divorum and consisted of a long rectangular colonnaded court, a gateway in the form of a monumental triple arch, and two tiny temples flanking the space just inside the entrance. It was most probably a space dedicated to the memory and divinity of his father and brother, and, like the Claudianum, appears to have had a formal garden in the courtyard. The location of this temple in the Campus Martius was perhaps inspired by the Augustan mausoleum and ***ustrinum*** (pl. *ustrina*)—the place where cremation, and thus apotheosis, would take place. The area between the Divorum and the Ara Pacis to the north would continue to be used in the second century CE for imperial *ustrina*, memorial monuments, and at least two temples to divinized emperors.

This entire area, in fact, saw reconstruction on a massive scale and entirely new buildings commenced under Domitian as a result of a devastating fire in 80 CE that destroyed large parts of Rome (see 5.8). Immediately to the north of the Divorum stood the double sanctuary of Isis and/or Serapis (Iseum), which would also have been a Domitianic rebuilding, marking the increasing re-emergence of an Eastern mystery cult that had been suppressed under Augustus and Tiberius but was reinstated around the mid-

first century CE. Such cults were widely popular and usually officially tolerated, as long as their worship did not interfere with the cults of state. The sanctuary took a form that was completely different from the traditional Roman structures we have seen: the Isis and Serapis temple proper was set within a D-shaped portico and coins show that the temple had a semicircular rather than triangular pediment. Probably most significant is the corpus of Egyptian (or Egyptianizing) statues and monuments that the site has revealed during excavations over the years. Since the fifteenth century, a number of the obelisks that once stood in this complex have been set up in various places around Rome, including the one that stands in front of the Pantheon today.

TEMPLUM PACIS

The sequence of "Imperial Fora" began, as we have seen, with those of Caesar and his successor Augustus. While the Julio-Claudian emperors made no attempt to add additional fora—in fact Nero claimed the adjacent land to the southeast for his own villa—both Vespasian and Domitian did undertake plans to formalize this space as another aspect of the Flavian policy of restoring land to public use (see box: Materials and Techniques: *Damnatio Memoriae*, p. 185). One of Vespasian's first public buildings (dedicated in 75 CE) was a large square colonnaded court (each side approximately 145 meters in length) dedicated to the goddess Pax, or Peace. It is usually called the Templum Pacis (Sanctuary of Peace) or the Forum of Vespasian [7.20]. It was an extension of the Imperial Fora complex, but our understanding of its original appearance is in large part conjectural, since the complex is known principally (there are some scattered remains and recent excavations have provided some new clues) from the much later Severan Marble Plan of Rome, the *Forma Urbis Romae*, which was in fact installed in the templum itself (see box: *Forma Urbis Romae*, p. 325).

From the plan, as well as from literary sources, we can determine unquestionably that the intentions and atmosphere of Vespasian's forum were distinctly and deliberately different from those of his predecessors. Although it was every bit as elegant, its mood was far less formal and authoritarian. Pliny tells us that it was, with the Augustan forum and Basilica Aemilia, one of the three most beautiful buildings in the world. Rather than being dominated by a temple that referenced the divine ancestry of the imperial dynasty, however, the open precinct of the Templum Pacis looked onto the facade of a temple devoted to a benign concept, peace. The courtyard space itself seems to have been organized by formal plantings, perhaps interspersed with marble monument bases—markings on the *Forma Urbis Romae*

7.20 Reconstruction of the Templum Pacis, also known as the Forum of Vespasian, Rome, Italy, dedicated 75 CE. The temple was the first Flavian addition to the Imperial Fora.

are variously interpreted, and it is not always clear what is an original Flavian feature or what may have been introduced during restoration of the complex by Septimius Severus (r. 193–211 CE). The rooms flanking the temple, according to ancient sources, functioned as a library and museum, in which were displayed both the spoils brought back from Jerusalem and works taken from the dismantled Domus Aurea. In contrast to the earlier imperial fora, this was a place of quiet contemplation. A message of imperial philanthropy still dominates, but it is not as symbolic and is more to be experienced. Vespasian brought peace and prosperity to the Roman people by the conquest of Judaea (symbolizing his military ability generally), ending the civil war, ultimately replacing the corrupt Nero after civil strife, and reversing Nero's self-serving policies. The Templum Pacis does not simply honor the goddess of Peace; it creates an environment where peace itself can be enjoyed.

FORUM OF DOMITIAN/NERVA

In the narrow space between the Forum of Augustus and the Templum Pacis, Domitian inserted a fourth forum, so long and narrow as to be a monumentalization of a passageway (see 5.17). Although built mostly or entirely by Domitian, this forum was dedicated by his successor Nerva (r. 96–98 CE), and was called the Forum of Nerva, or the Forum Transitorium in later and many modern accounts, underscoring its function as a transitional space between four separate areas. From preserved remains, representations, and literary sources, it seems this space held temples at either end, with Minerva to the northeast and Janus to the southwest. Domitian's architects dealt ingeniously with this spatial challenge, using the Minerva temple and flanking curved spur walls to mask the uneven area behind, claiming some space to the east by transforming the west portico of the Templum Pacis into a colonnade, and surrounding the open court with a decorative, unroofed colonnade supporting a continuous entablature. The small preserved section of this [7.21] recalls the Forum of Augustus with its high attic story bearing large panel reliefs, in this case depicting Minerva. The entablature includes a continuous carved narrative frieze portraying the myth of Arachne (a mortal who challenged the goddess Minerva to a weaving contest) and a gathering of women working wool. The mythological sculptured frieze is far less common in Roman than in Greek architecture, and the figural types here derive mainly from a Hellenistic, Classicizing stock. Evidence for a Domitianic Classicism is limited, although the Cancelleria reliefs (see 6.30, p. 176 and 6.31, p. 177) come to mind, and Domitian generally appears to have been more sympathetic than his father and brother to the philhellenic leanings of Nero. The myth is a clear reference to Minerva and, at the same time, a warning for anyone who may think themselves more talented than the gods, representing the theme of divine retribution for mortal transgression that we encountered in the House of the Vettii in Pompeii; the Forum Transitorium frieze has been read as conveying the same moralizing tone, which was common in Flavian times. Domitian also apparently embraced such themes in his attempt to revive Augustan morality laws.

7.21 Preserved section of the attic of the Forum Transitorium, Rome, Italy. Built primarily by Domitian, the forum was dedicated by his successor, Nerva in 97 CE. The attic is decorated with a relief of the goddess Minerva. The frieze on the entablature tells the mythological story of Arachne.

196 PART II: THE FORMATION OF THE ROMAN EMPIRE

AQUEDUCTS

While monuments and such monumental spaces as the Templum Pacis gave the idea of imperial generosity more directly than the allegorical monuments of Augustus and the Julio-Claudians, the best imperial, and for that matter Republican, architectural gifts had long been those that brought real, tangible benefits to the populace. Adequate water supply, for example, had long been a concern in Rome, and the building of aqueducts to bring in water from outside of the city was undertaken by Republican nobles who recognized it as a means at least as effective as temple building to elevate the status of their own families. The Aqua Marcia was built (or restored) in the second century BCE by Quintus Marcius Rex (praetor in 144 BCE) and was Rome's largest aqueduct at that time—it was portrayed nearly a hundred years later on a coin minted under the magistracy of Marcius's descendent Lucius Marcius Philippus—yet demand kept growing along with Rome's population and the water supply was expanded by Augustus, who built three aqueducts in his reign.

Two further aqueducts were added by Caligula and Claudius (the Aqua Claudia and Aqua Anio Novus), the courses of which coincide at the point where two roads (the via Praenestina and via Labicana) enter the city. This section of the aqueduct [7.22] was monumentalized into a double-arched gateway with decorative *aediculae*, embellished features in the form of small temples framing arched openings in each of the three large piers. The structure did not function as a true gate until it was incorporated into the defensive wall built by the emperor Aurelian (r. 270–275 CE) more than 150 years later. It is now called the Porta Maggiore, and it is notable for the deliberately rough-dressed travertine facing of the lower part of the structure, in contrast with the smooth surfaces of the attic. This intentionally rustic appearance may have been the result of an architectural affectation of Claudius, since it is known from at least one other aqueduct that

7.22 The Porta Maggiore, Rome, Italy. Dedicated by Claudius in 52 CE. The structure marked the location where two aqueducts came into Rome. Its construction is characterized by rusticated masonry, a technique possibly favored by Claudius. In the third century CE, the monument was assimilated into Rome's Aurelian wall and became a proper gate to the city.

he rebuilt, and a similar effect is also found on the Claudianum, where the Flavian designer may have intended it as a compliment to the *divus*. One can only speculate as to the motivation for this feature; perhaps Claudius was conservative or frugal, or maybe the look recalled some Etruscan town gates and appealed to the emperor's antiquarianism. It did, in any case, capture the interest of Renaissance architects who would later use the effect on countless palace facades in Rome, Florence, and elsewhere. The water carried by the aqueducts came from sources remote from the city and, insofar as possible, the courses were built underground. There were great stretches that spanned rivers or valleys, however, and we can still see the graceful chains of arches marking the outskirts of Rome, as well as locations throughout the empire that were overt outward marks of Romanization (see Art and Architecture in the Provinces, p. 213).

BATHS

Fresh water is life, and aqueducts were erected to provide this precious commodity, rare in many parts of the Mediterranean, to meet the essential needs of Roman cities and citizens. As the empire grew, however, these channels were added or expanded to serve that peculiar feature of Roman urbanism, the **thermae**, or public bath complex. These structures, which consumed both water and firewood in prodigious quantities, would later come to achieve astonishing scale and opulence. Yet the practice of providing baths as a gift to the people is as old as the empire itself, beginning with the first public bath facilities built by Marcus Agrippa in the Campus Martius (25 BCE), but at least two further, significantly larger, complexes, were built in the first century CE.

"What worse than Nero? What better than Nero's baths?" asked Martial (*Epigrams* 7.34) only a few years after the emperor's demise—demonstrating some typically Flavian Nero-bashing. These baths were located in the central Campus Martius between the Pantheon and Domitian's stadium (see 7.27, p. 203) and were completed and dedicated in the early 60s (the dates given vary). Although they were not affected by the fire of 64 CE, it is possible that the building may have been struck by lightning and rebuilt that same year. Construction of the bathhouse was certainly connected with Nero's celebration of the Neronia, a festival that he established in imitation of the athletic and artistic competitions held at the great Panhellenic sanctuaries of Greece (Olympia, Delphi, Isthmia, and Nemea), at which Nero would himself compete a few years later. The complex therefore included a gymnasium (*palaestra*) for athletic events, an innovation that became a regular part of the typical Roman bath experience. The plan of Nero's baths [7.23] has been reconstructed from remaining fragments, as well as from drawings by the Italian architect Andrea Palladio (1508–1580), who studied the remaining structures during the Renaissance before they were built over in later centuries. The baths were clearly much larger than those built by Agrippa to the south and must have been considerably more opulent, to judge from observations made in the ancient sources. Based on Palladio's plan (very little remains), they would have displayed the symmetrical planning and all the necessary elements of later, developed

7.23 Plan of the Baths of Nero, Campus Martius, Rome, Italy. Dedicated in the early 60s CE. The large and opulent complex included a gymnasium for athletic events, which would became a standard feature of the typical Roman bathhouse.

imperial bath complexes: a large swimming pool (*piscina*) to the north; a great triple-bayed, cross-vaulted central hall; an apsidal hot room (*caldarium*) with symmetrically flanking warm rooms (*tepidaria*) arranged along the south side; and colonnaded open precincts to the east and west. Nero's complex was, however, expanded and rebuilt by Alexander Severus (r. 222–235 CE) in the early third century, so it is not certain how much these features reflect later updating.

The later Flavian bath complex dedicated by Titus in 80 CE, at the same time as his amphitheater (see 7.25), has long been identified with remains on the Oppian hill that are now nearly entirely gone, but were also recorded by Palladio [7.24]. Palladio's illustrations show not only the symmetrical plan of the enormous imperial baths but also the surrounding enclosed courtyard garden that now becomes another standard feature of these complexes. Although the baths of Titus were no doubt built at this location, it has been suggested that the structures drawn by Palladio are no earlier than the second century CE. Precisely when the imperial bath form was invented, then, is still debated, but whatever Titus's baths looked like, they certainly formed part of the wider Flavian program of restoring the grounds of the Domus Aurea to public use.

THE FLAVIAN AMPHITHEATER AND PUBLIC SPECTACLE

The centerpiece of the Flavian program to return to public use space that had been appropriated by Nero was the amphitheater started by Vespasian and dedicated by Titus in 80 CE, which in later times took its name, Colosseum, from the colossal statue that had been erected by Nero at the nearby entrance to his Golden House. One of the most completely preserved ancient buildings in the city, and certainly its most conspicuous, the Colosseum has stood continuously for nearly 2,000 years as the most globally recognizable symbol of ancient Rome. Vespasian's engineers made use of Nero's artificial lake by locating this great oval structure, with its deep foundations, on that very spot. The choice was as symbolic as it was pragmatic; Vespasian replaced a highly visible private indulgence with an even more conspicuous public one.

The tradition of funding building to gain public favor, as we have often noted, goes back far into the Republic and was embraced, logically enough, by Augustus and his successors. Yet the most common and no doubt the most effective category of expenditure used to bolster popularity and cultivate *fama* (a more loaded term than its English relation "fame") was surely the production of public spectacle, not only triumphs, of course, but also theatrical performances, chariot races, and, above all, gladiatorial games. This most Roman of blood sports included combat between warriors armed with a wide variety of weapons (the word *gladius* means sword), struggles to the death between men and exotic wild animals, and even mock naval battles staged on artificial lakes created for the purpose. Julius Caesar had first thrust himself into the public eye through the festivities he sponsored as

7.24 Plan of the Baths of Titus, Oppian hill, Rome, Italy, 80 CE. There are very few visible remains of the baths today, but the architect Palladio made drawings of them in the sixteenth century.

aedile, to the point of personal bankruptcy, as a result setting an example for later rulers both good and bad. Nero's extravagance in domestic architecture was matched, or even exceeded, by his expenditure on public entertainment, which was, more than any other factor, responsible for his devastation of the imperial purse. But even Nero did not build a new permanent theater or amphitheater, although he finished the new circus begun by Caligula in the Vatican area (where St. Peter was martyred), coated Pompey's theater in gold, and erected a temporary wooden amphitheater of magnificent proportions.

Up until the time of Pompey, as we have already seen in Chapter 4, it was considered dangerous to the political order for an individual patron to sponsor a permanent structure for public entertainment, and only one permanent amphitheater—a relatively modest structure dedicated by Titus Statilius Taurus who, like Agrippa, was a trusted general under Octavian—existed in Rome up to this time. It was destroyed in the great fire of 64 CE and the construction of a new stone amphitheater was surely one of the very first elements in the new Flavian dynasty's plans to return Rome to the Romans. The policy is clearly stated in Martial's poem *De Spectaculis*, written for the occasion of the Colosseum's dedication:

> Here where the glittering solar colossus views the stars more closely and where in the central road lofty machines grow up, the hateful hall of the beastly king used to radiate its beams, at the time when a single house used to occupy the whole city. Here where the mass of the conspicuous and revered amphitheater rises up, the pools of Nero once stood. Here where we marvel at that swiftly built donation, the baths, an arrogant field had deprived the poor of their homes. Where the Claudian portico spreads its shade afar, the furthest part of the palace came to an end. Rome is restored to herself, and under your direction, O Caesar, those delights now belong to the people which once belonged to the master.
> (Martial, *De Spectaculis* 2)

The name Colosseum was not used in antiquity, when the building was called simply the Flavian Amphitheater, an apt name owing to the work done by all three emperors of that dynasty. Construction was begun by Vespasian, dedicated before being fully finished by Titus, and brought to completion under Domitian. It was long-lived (games were held there in the early fifth century CE) and much restored, but its original form can be easily understood. In plan,

elevation, and construction it is a building both elegant in its basic simplicity and dazzling in the complexity of its many spaces. The plan is a great ellipse measuring some 187 × 155 meters (615 × 510 feet), and is nearly 48 meters (157 feet) high at its outer wall—significantly taller than the colossus from which it took its name [7.25]. Five concentric vaulted corridors at the lowest level run under the seating, carried by barrel vaults that spread out from the central open area and rise

7.25 The Colosseum, or Flavian Amphitheater, Rome, Italy, dedicated by Titus in 80 CE. The building, originally referred to as the Flavian Amphitheater, was not called the Colosseum until much later in history, when it started to be called after the colossal statue that Nero had erected nearby.

7.26 Reconstruction and section of the Colosseum, Rome, Italy, dedicated by Titus in 80 CE. The plan is a huge ellipse. At its outside wall it stood at 48 meters (157 feet) high.

in three stages to support the seating itself, atop which rises a fourth story consisting only of a thin exterior stone shell and an inner portico [7.26]. From this portico, a great awning could be drawn out to shade some part of the audience below; this was a mechanical marvel. A pattern of radiating and ring-shaped passageways allowed for the channeling of enormous crowds (60–80,000 spectators) through the use of barriers and stairways, with each of the eighty entrances leading to a particular section (*cuneus* or wedge) in the spectator seating area. A similar design principle is followed in sports stadiums to this day.

The construction is remarkably conservative, with solid travertine masonry used for all of the vertical weight-bearing piers and the more flexible concrete used to form the many annular, barrel, and cross vaults. Despite the rapid development in the sophistication of brick-faced concrete construction that occurred during the first century CE, the basic structural principles of the Colosseum differ little from those of the theaters of Marcellus and Pompey. Underneath the arena itself was a veritable warren of concrete substructures that supported a wooden platform covered with a layer of sand (an *arena*, from which this part of the amphitheater was named). These spaces below accommodated the human and animal competitors, who were raised to the arena level by means of elaborate machinery, giving an apparitional quality that enhanced the already crowd-pleasing effect of the spectacle itself. These mechanisms were probably added to the structure by Domitian.

The building was as impressive for its decoration as for its engineering. Every vaulted ceiling was adorned with modeled stucco, and of course the original marble seating would have given the interior a much more majestic look. The exterior, entirely faced in travertine, displays an engaged architectural order at each story, the columns and architraves framing the arches in an entirely non-functional and equally traditional pattern, differing only in scale from the facade of the Theater of Marcellus (4.30, p. 121). The same sequence of architectural orders is found in multi-storied Classical buildings from the

fourth century BCE onward, with Tuscan style at ground level, Ionic above, Corinthian above that, and flat Corinthian pilasters on the fourth story. Each exterior arched opening, it appears, held statuary. This building was designed to impress not so much by its innovation as by its elaboration and, especially, its scale. The very idea of a huge amphitheater, looming in the city center as a permanent reminder of imperially sponsored public entertainments, was consistent with Flavian policy. While stone amphitheaters were rare before this time—the Republican one at Pompeii being the only well-known example— such buildings became common from this time on, especially in the cities of Italy, the western provinces, and North Africa, where they served as highly visible signs of Romanization (see Art and Architecture in the Provinces, p. 213).

Domitian, just as Nero before him, was fond of such public entertainment. He built facilities for training gladiators, including the Ludus Magnus, a gladiatorial school, the remains of which can still be seen near the Colosseum, and a *naumachia* for naval battles, although the location of this is unknown. Even more so, Domitian had a fondness for Greek-style athletic and musical competitions, and again as did Nero, although the games he sponsored were named for Jupiter and not, as Nero did, after himself. For these events he built an **odeum** (small roofed theater) and a Greek stadium (used for footraces) in the Campus Martius. The elongated oval form of the latter is entirely preserved in the present-day Piazza Navona [7.27]. Many parts of its substructure underlie the surrounding buildings, and part of its facade at the north end suggests a construction not unlike that of the Colosseum. The extensive but brick-faced, concrete-vaulted remains, being unadorned substructures, no doubt do little justice to its original opulence.

7.27 Piazza Navona, Rome, Italy. The site of Domitian's stadium, purpose built for footraces, may have been constructed in a similar style to the Colosseum.

8 Provincial and Private Art in the Early Empire

206 Private Funerary Art
- 206 AMITERNUM RELIEFS
- 207 Box: *Liberti* in the Early Empire
- 208 TOMB OF EURYSACES
- 210 TOMB OF THE HATERII

213 Art and Architecture in the Provinces
- 213 TEMPLES IN THE PROVINCES
- 218 Box: Corinth
- 220 Box: Temple of Dendur
- 222 COMMEMORATION IN THE PROVINCES
- 227 THEATERS AND AMPHITHEATERS IN THE PROVINCES
- 228 Box: The Stadium at Aphrodisias

Chronological Overview

DATE	EVENT
30 BCE	Tomb of M. Vergilius Eurysaces, Rome
30 BCE to 14 CE	Funerary reliefs from Amiternum, Italy; Temple of Roma and Augustus at Athens
	Maison Carrée at Nîmes (Nemausus), France; Temple of Roma and Augustus, Vienne, France
	Temple of Roma and Augustus at Ankara, Turkey; Temple of Dendur, Egypt
	Arch of Augustus at Susa (Segusium), Italy; Theater at Orange (Arausio), France
Julio-Claudian era	Temple of Augustus Soter at Olympia
14–18 CE	Arch "of Tiberius" at Orange, France
First century CE	Sebasteion at Aphrodisias, Turkey; Stadium at Aphrodisias
69–98 CE	Reinstallation of portrait statuary in Augustus's temple at Olympia; Amphitheater at Nîmes
79–80 CE	Tomb of the Haterii, Rome

The Roman Empire in the First Century CE

Since we have focused on the considerable role played by the visual arts in the competitive interactions among members of a Republican elite and the maintenance of power by its imperial successors, most of the monuments we have discussed so far were sponsored and used by the wealthy and powerful in and around Rome. In this chapter, we will expand discussion to consider two separate, but not unrelated, categories of Roman art. The first of these contains works that were commissioned by those who were not from noble families but were sufficiently wealthy to fund substantial monuments, most often tombs (see box: *Liberti* in the Early Empire, opposite). The second comprises works made in the provinces during the first century of the empire.

Roman art is notable for, and even defined by, its tendency to employ, blend, and juxtapose differing and sometimes contrasting traditions and styles. What these two groups of art have in common is that they do so in a way that results in works that often vary, sometimes distinctly, from those made by and for the Roman elite. This not only illustrates the kaleidoscopic variety of Roman art across time, space, and class, but also helps explain the distinct stylistic turns that come to define Roman art in its entirety during the later empire.

Private Funerary Art

In Chapter 1 we noted the distinct variety in styles represented by Etrusco-Italic art from the eighth to the third centuries BCE, a feature that resulted from the fundamentally different ways in which it evolved, when compared with the artistic developments of the eastern Mediterranean. Early Greece, for example, encountered the arts of foreign, especially Near Eastern, cultures in a similar way as did the Etruscans; in both cultures, that contact can be detected in the visual arts, but the impact of this interaction manifested itself in different ways. In Greece, a mainly unified style emerged early on and changed over time with remarkable consistency and little desire to retain outdated modes of representation. Italic art, on the other hand, was far more varied, with some works appearing to follow a more strongly native tradition of abstract forms and straightforward representation, and others seeming more inclined toward imported styles and expression through mythological or allegorical means. Assuming that members of the wealthy ruling class were more eager to adopt exotic models in order to promote their economic status and so their social standing, scholars have termed this type of art patrician, as opposed to the more traditional or conservative **plebeian** art. Of course, some of the wealthiest patricians were among the most culturally conservative, if we believe their rhetoric, so we should accept these terms only as useful conventions.

AMITERNUM RELIEFS

It is true, however, that an Italic style persisted in the art of non-elites in the late Republic and early empire. In the Sabine hills northeast of Rome (around 80 miles away) was the town of Amiternum, which had been given Roman citizenship already in the third century BCE, and by the time of Augustus was fully Romanized. Remains of late Republican/Augustan tombs were discovered there over a century ago, including inscriptions that give the names of wealthy freed slaves, and two well-preserved limestone reliefs.

The better known of these provides a rare depiction of a Roman funeral precisely as it is described in literary sources [8.1]. The deceased person reclines on a platform carried by pallbearers; he is posed in the same way as the figures atop late Etruscan sarcophagi (see Etruscan Tombs, p. 28), so it is not certain whether it is actually the body of the deceased that we see here or his portrait, but his position strongly suggests the latter. On the right of the relief there are seven musicians and two professional mourners (these were women employed to demonstrate the appropriate level of grief—the number of mourners signified the deceased's wealth and importance) tearing at their hair, wailing, and beating their chests. The group behind appears to include the widow with her daughters, slaves, and attendants. All the figures are depicted as being stocky, they are given ample space, and are simply rendered with abstract drapery patterns. The composition is strikingly artificial, a lateral view of each figure

combining with an imagined aerial view of the whole scene. Figures that are intended to be understood as being behind the foreground figures, and among the mourners and musicians, are shown standing on short, elevated sections of ground. Among the bearers of the bier, the scheme is different: all figures stand on the same ground level, and those in the background are given perspectival diminution. In the case of the musicians, however, the far figures and near figures are precisely the same height.

8.1 Amiternum funerary relief, Italy, 1st century BCE. H. 66 cm (2 ft 2 in.). This is one of the best surviving examples of art from the tombs of wealthy freed slaves or *liberti*. Here the deceased is shown reclining on a bier carried by pallbearers (it alternatively depicts a portrait of the individual), followed by family members and attendants.

Liberti in the Early Empire

In a consideration of Roman art, attention usually focuses on the Roman nobility as consumers and patrons of art and architecture both public and private since, during the Republic, such works functioned primarily for the promotion of status and political power among the patrician elite. With the transition to empire, all real power and authority came to lie in the hands of the *princeps*, his family, and associates. To fill the void left by the elite's decreased interest in public display, a new aspect of the market came to the fore, as freed slaves (m. *libertus*, *liberti*; f. *liberta*, *libertae*) amassed the means to fund elaborate works, both funerary (tombs, reliefs, and portraits) and domestic (decorative sculptures, wall painting, and sumptuous smaller-scale sculptures and ceramics).

As was the case in many ancient societies, the Romans made extensive use of slaves, who were in plentiful supply due to Rome's ongoing expansionist warfare. Roman slaves, unlike those in many other cultures, had reasonable opportunities to acquire freedom through provision in the will of a deceased owner, as a reward for loyal service, and/or simply because they were not needed any more. Freedmen could achieve the rights of citizenship, including the vote, so it was logical that they were expected to remain in the political orbit of their former owner, in the role of a client to patron. They could not be enrolled in the senate or serve in a senatorial magistracy or priesthood, although Augustus found a clever way to involve male freed slaves in the cult of the emperor's family gods by creating the office of *vicomagister*, which was reserved for them. The offspring of freed slaves had full citizen rights from birth.

Many *liberti* achieved extraordinary wealth, as shown by the tombs discussed in this chapter. Often this was done through craft or commerce, the latter in the case of the baker and government contractor Eurysaces. His is a Greek name, suggesting that his family could be traced back to the wars of the Republic in Greek southern Italy or the Hellenistic kingdoms. Freed Greek slaves from an educated class could enjoy prestigious status as teachers and artists. In some cases a *libertus* could serve as a front for a wealthy noble, since senators were traditionally excluded from banking or trading. In the early empire many *liberti* achieved wealth and influence though service to the imperial family. Claudius created an extensive administrative structure staffed by freedmen, sometimes termed a bureaucracy by modern scholars. Incompetent or distracted emperors, such as Nero, might yield considerable authority to these functionaries, which brought good money and aroused resentment toward them among the nobility. One reflection of this can be found in the fictional character of Trimalchio, from Petronius's *Satyricon*, a novel written in the time of Nero. Trimalchio is presented as a caricature of the arrogant, classless, newly rich freed slave. His excesses are displayed at a overly ostentatious dinner held in his equally gaudy mansion, where he announces, interestingly, his plans for an inappropriately showy tomb. The humor and satire here are based in exaggeration, true, but would not have been amusing had the characterization of Trimalchio not been accurate in some way.

8.2 Gladiator relief from Amiternum, Italy, 1st century BCE. H. 66 cm (2 ft 2 in.). The relief, made from local stone, shows two gladiators who dwarf their attendants behind them. The proportions of the figures are not Classical, therefore probably demonstrating native Italic work.

For these reasons, it is not easy to interpret the variety of scale among the mourners—whether it is meant to reflect age, status, or position in space. What is clear, however, is that the designer was far less interested in creating a relief that presented a perceptually realistic tableau than we might be in reading one; the priorities here are clarity, detail, accuracy, legibility, and filling the available field. There was in Italic, especially Etruscan, art a long tradition of funerary processions, but those are more symbolic, with the deceased shown as a living participant. The more literal treatment seems to be in agreement with Roman tastes.

Another relief from the same group [8.2] shows a similar lack of interest in naturalism. Here, in a scene of staged combat as part of funerary games, the gladiators dwarf the figures behind them, probably slaves, boys, or both. The fighters themselves have impossibly large feet and legs, as well as compressed torsos. Whether this was an intentional exaggeration or bad planning by the relief carver, we are far from the elegant Classical style of most imperial work. There is certainly vigor here, however—such as in the daring twist of the gladiator on the left, in the tradition of native Italic work in local stone.

TOMB OF EURYSACES

In the Roman world, as in Greek and other ancient societies, burial sites were established outside the city limits—a location helpful to ensuring public hygiene and, more importantly, within sight of major routes leading into and out of town for greatest visibility. Regal and early Republican Rome has not produced the wealth of funerary material that has been found in Etruria or some locations in Latium and southern Italy; during the late Republic, however, and throughout the imperial era, many tomb structures sprang up along the grand roads (*viae*) radiating from the capital, since burials were forbidden within the city limits. These were often family tombs, if one's family was wealthy enough, and sometimes the tomb of a single individual. Many middle-class Romans were interred in communal tombs (*columbaria*) [8.3] constructed

8.3 A typical Roman *columbarium*. These buildings were places for the public storage of cinerary urns, and are still used today.

by funerary guilds (*collegia*) set up for the purpose. The tomb structures were almost infinitely variable in form, and many were outfitted with identifying inscriptions and sculptures, including pictorial reliefs and full-length portraits or busts. By the time of Augustus, a strikingly large percentage of the existing funerary sculptures came from the tombs of *liberti*, many of whom, after manumission (the release from slavery), had achieved the necessary wealth that allowed them to indulge in this vanity.

Perhaps the most famous of these sculptures belong to the tomb built by Marcus Vergilius Eurysaces at the point where the via Praenestina and via Labicana converge, just outside the Porta Praenestina (now known as the Porta Maggiore, see 7.22, p. 197). The tomb of Eurysaces is a tower-like polygonal structure of concrete clad in travertine, the exterior of which was carved in the form of tubes set vertically and horizontally [8.4]. Inscriptions on three sides give Eurysaces' name and his profession—he made bread and supplied it to the Roman armies. An explicit reference to his trade is to be found on the frieze running around all four sides of the monument at its top. This depicts in great detail the manufacture of bread, from grinding the grain to kneading the dough, forming the loaves, baking, weighing, and transporting the finished product [8.5]. The style of the relief shows none of the Classicizing figural types seen on such state monuments as the Ara Pacis; the participants are simply formed,

8.4 Tomb of Eurysaces, Rome, Italy, *c.* **30 BCE. Concrete clad in travertine.** The large round cylinders may represent grain measures, reflecting Eurysaces' occupation as a baker.

8.5 Detail of the frieze on the Tomb of Eurysaces, Rome, Italy, *c.* **30 BCE. Concrete clad in travertine. H. 58.4 cm (1 ft 11 in.).** The frieze depicts people at work in a bakery.

CHAPTER 8: PROVINCIAL AND PRIVATE ART IN THE EARLY EMPIRE 209

different tradition than that of the frieze above. Eurysaces is shown with the Republicanizing verism typical of portraits of nobles and freedmen alike, and Atistia, whose face is badly eroded, has a hairstyle that openly imitates the upper-class coiffure worn by women of the Augustan court. The drapery of both figures is far more detailed and carefully rendered than the treatments found on the bakery frieze.

Stylistic variety is the rule rather than the exception in Roman art, and here at Eurysaces' tomb we can detect a number of variables at work. This is not a monument set up by a member of the privileged upper class, although he must have had considerable means to be able to afford it. The style of the bakery frieze might therefore be seen as simply middle-class or plebeian—more rooted in native Italic tradition and not the Hellenizing styles favored by the nobility. This style is also appropriate to its subject—a literal and straightforward depiction of how the baker became rich enough to build something such as this. It clearly differs in style from that used in the portrait relief depicting Eurysaces and his wife, but to judge from other surviving portraits of freed slaves, this mixture of Republican verism and imperial fashion (seen in Atistia's hairstyle) was typical. Moreover, there is the difference of material: the portraits in marble and the frieze in concrete clad in travertine. Marble simply lends itself to more detailed articulation, and it is very probable that the two different materials involved different tools, hands, and even workshops. This tomb reminds us that there are very many issues at play when unraveling the stylistic complexities of Roman art, including the social standing and origin of the patron, and the subject, the function, the traditions, the materials, and the artisanry of the work.

TOMB OF THE HATERII

Literary sources relate much about the domestic luxuries enjoyed by wealthy *liberti*, and the tomb monuments that survive offer us a glimpse of their tastes. An example is the Tomb of the Haterii, named after the head of the family, Quintus Haterius Tychicus. This tomb was located along the via Labicana outside the Porta Maggiore; the reliefs are now in the Vatican

8.6 Relief portraits at the Tomb of Eurysaces, Rome, Italy c. 30 BCE. Marble. H. 1.9 m (6 ft 2⅞ in.). The portraits are of Eurysaces and his wife Atistia, whose ashes are described as having been put in a breadbasket.

display a great variety of pose, and rarely overlap. Clarity and detail are paramount; this is the same direct style one finds on many Etruscan funerary urns and other forms of Italic art, and it reflects the existence of a carving workshop unaware of, or uninterested in, the trends followed by many artists employed on imperially sponsored works.

On the fourth side of the tomb was a panel relief depicting Eurysaces and his wife Atistia [8.6], whose epitaph appeared underneath, stating that her remains had been placed in a breadbasket. Surely what is meant is a cinerary urn in the shape of a basket, just as the tubes on the exterior of the tomb are believed to represent grain measures. The portrait relief of the couple, which is executed in marble, reflects a somewhat

8.7 Busts of the Haterii and his wife, Rome, Italy, 79–80 CE. H. of busts 54 cm (1 ft 9³⁄₈ in.); H. of *aediculae* 74 cm (2 ft 5¹⁄₄ in.). The Haterii family had its origins as freed slaves. Both husband and wife are depicted in a typically serious, veristic manner.

Museums. The portraits of Haterius and his wife [8.7] preserve the serious aspect and veristic portrayal that was, by now, typical of this category of monument.

One of the low reliefs shows, like the relief from Amiternum, the deceased (a woman here) on her bier with musicians, mourners, and attendants; the figures are carved with a similar use of contrasting scales, apparently as an indicator of status [8.8]. The composition, however, with its architectural setting and far greater interest in the scene's representation of space, is far more complex than that of the Amiternum relief (8.1).

8.8 Relief from the Tomb of the Haterii, Rome, Italy, 79–80 CE. H. 89 cm (2 ft 11¹⁄₈ in.). The relief depicts a deceased woman on her bier accompanied by musicians and mourners.

CHAPTER 8: PROVINCIAL AND PRIVATE ART IN THE EARLY EMPIRE

8.9 Relief from the Tomb of the Haterii, Rome, Italy, 79–80 CE. H. 1.03 m (3 ft 4⅝ in.). Known as the "tomb-building" relief, this image depicts a temple-form tomb as well as what appears to be a crane used for construction.

8.10 Relief from the Tomb of the Haterii, Rome, Italy, 79–80 CE. H. 43 cm × 1.57 m (1 ft 5 in. × 5 ft 1⅞ in.). The relief depicts a series of monuments from the Flavian period. These could refer to Domitian's ARCUS AD ISIS, his Iseum; the Colosseum; the ARCUS IN SACRA VIA SUMMIA, presumably the Arch of Titus; and his Pantheon or odeum.

Similar in this regard is the so-called tomb-building relief. This depicts the temple-form tomb, above which is placed another portrayal of the deceased, this time showing her sitting up on her couch with her children playing at her feet [8.9]. Is it some sort of sarcophagus (although those are not yet common at this time) resembling an Etruscan type, or is it a representation of the actual body of the deceased on a funeral couch? The drapery behind is a common Roman stylistic device used to suggest interior space. Equally mysterious is the structure to the left that is probably a crane used to lift building materials onto the tomb, but the basket and flowers or plants at its summit suggest something other than simply a literal building scene, perhaps relating to the Dionysiac mystery cult. Here again, composition and figural style contrast strongly with those seen in state reliefs and clearly derive from a parallel tradition.

The tomb also suggests that the Haterii were acquainted with Flavian public monuments. A third relief [8.10] depicts a series of five buildings, two of which—an amphitheater and an arch "at the head of the via Sacra," as noted on the relief—must refer to the Colosseum and the Arch of Titus, respectively, although the correspondence to the actual building is inexact. The other three buildings can also be associated with Flavian constructions and the relief interpreted as a reference to the Haterii family's occupation in the building trade, in the same way that Eurysaces' baking scenes identified him as a baker. An alternative explanation for the depiction of the Flavian monuments is that, in light of the distinctly funerary nature of the other reliefs on the Haterii tomb, the structures marked the route of a funeral cortege. The images are approximations, recalling the references to buildings that one finds on coins, but they record impressions made and memories retained, and in this way reflect for us a very real and also very personal picture of Rome in Flavian times.

PART II: THE FORMATION OF THE ROMAN EMPIRE

Art and Architecture in the Provinces

The expansion of Rome, and the process of cultural Romanization, occurred through the establishment of provinces—territorial subdivisions of areas outside Italy placed under direct Roman authority. The first such province was Sicily, created at the end of the First Punic War in the third century BCE; by the end of Augustus's reign, nearly all of what the Roman empire would ever be was arranged into provinces ruled by governors selected by the senate or, in a few cases, such as Egypt, a prefect appointed by the *princeps*. A primary aim in managing these provinces was the Romanization of provincial populations, most of which had been brought under the Roman yoke during the Republic, and their cultural assimilation to the realities of imperial rule. Just as Augustus assembled his principate in Rome to resemble the structure and recall the principles of the Republic, so too in the provinces local tradition played a large part in the physical realities of empire. In consequence, this Romanization took on different forms in different places.

The empire was far-flung and diverse, and, just as it was in Rome, urban development through public building was a core tactic for unification and control, both cultural and physical. As in so much else, Caesar had already paved the way by founding colonies of Roman veterans and citizens at sites outside of Italy and building them up, as had previously been done at Pompeii, in ways that reflected, and referred to, Rome itself. The relationship between the center (Rome, including Italy) and the periphery (the provinces) was always a dynamic one; buildings and other monuments set up in the provinces looked both to Rome and to local traditions of forms, functions, materials, and workmanship. In general, one can identify two broad geographical categories of Romanization. The eastern provinces, those that had been part of the Hellenistic kingdoms, had well-established urban structures and traditions of monarchic rule (often by a foreign dynasty), both of which were modified to Roman authority but did not need to be created anew. The eastern provinces therefore tended to be somewhat less thoroughly Romanized than the western European and African provinces. From a Roman perspective, the latter offered more of a clean slate within which new physical, social, and political structures could be modeled directly on those in Rome. That many of them originated as military encampments and/or veteran colonies also made them appear more conspicuously Roman.

A central element in the process of cultural assimilation was the spread of a distinctively Roman form of urbanism. This included categories of public building devoted to the necessities of life, government, and commerce, such as streets and roads, aqueducts and fountains, markets, baths, and the characteristic basilica/forum complex. These are best represented by examples erected in the second century CE, for reasons we shall consider in Chapter 11. In this chapter, we shall focus on temples, commemorative monuments, and buildings devoted to public entertainment and spectacle, all of which were widely used in the first century CE to spread the message of the developing principate, expanding its reach to a broader audience.

TEMPLES IN THE PROVINCES

During the Republic, it was common for ambitious Roman nobles, especially victorious generals, to underwrite the costs of building temples, and the name of the patron often attached itself permanently to the building. Temples were conspicuously located and regularly used, so this practice served as effective public advertisement; moreover, since the temples were locations for cult activity, the link between a building and the sponsor's family could suggest an association with divinity for the latter. Octavian took this a step further by seeing to it that his adopted father was actually deified, and among his first priorities was the temple to *Divus Iulius* in the middle of the Republican Forum (see Temple of Caesar in the Republican Forum, p. 117). Following this precedent, temples—especially those with clear connections to the Julian family—were erected in important public places across the empire, and variations in their forms and functions reflect the varying traditions of the provinces and locales in which they were set.

Maison Carrée at Nîmes (Nemausus)

The territory of southern Transalpine Gaul (modern Provence in southeastern France) had seen a Roman presence since the Punic Wars, when the entire coastal belt from Liguria in northwest Italy to Gibraltar in Spain took on particular strategic importance. Caesar brought the entirety of Gaul under Roman control, but prior to this the Gallic portion of this southern strip was organized as Gallia Narbonensis, with its capital at Colonia Narbo Martius (or Narbo, now Narbonne). Augustus especially honored the city of Nemausus (modern Nîmes), which was given colony status by 28 BCE and made the capital of the province during his reign. There are a number of especially well-preserved structures here that follow models in Rome closely, as was characteristic of the western provinces.

The temple called the Maison Carrée ("Square House") bore a dedicatory inscription on its entablature in bronze letters set into the stone. The letters were removed in the Middle Ages but the marks they left behind were used to reconstruct the text of the inscription two centuries ago. As restored, it shows that the temple was dedicated to the grandsons (and adopted sons) of Augustus, Gaius and Lucius Caesar, presumably soon after the death of Gaius in 4 CE. It gives their highest titles, consul and consul designate respectively, and also names each as *princeps juventarum* (*princeps* "of the youth"), implying a prospective equivalence to the emperor himself; this became a standard designation for a successor, together with the name/title Caesar. The temple was the act of a grief-stricken emperor, to be sure, but, given Augustus's constant elevation of his immediate family, the divinization of his successors was a political move as well.

The building is a **pseudoperipteral** temple of the most conventional Roman sort. Its plan is strikingly reminiscent of the Republican Portunus temple (see Temples by the Tiber, p. 57), although considerably larger, with freestanding columns in front and engaged columns all around the cella, a feature that is traditional of Italic temples. Its Corinthian order [**8.11**] is closely modeled after that of the Mars Ultor temple, which was dedicated only a few years earlier, and the decorative acanthus scroll on its frieze is very close to the patterns found on the Ara Pacis (see Ara Pacis, p. 140). The Maison Carrée constituted a strong visual marker of the Roman presence in Gaul, and as such is typical of early imperial buildings, especially in the western provinces. It also came to be the very emblem of architectural Classicism in early modern Europe, when it was much imitated in the neoclassical style (see Roman Models in Modern Times, p. 383).

Temple at Vienne (Vienna)

Just how standardized such temples could be is illustrated by a counterpart to the Maison Carrée in the city of Vienne, about 140 miles up the River Rhone from Nîmes [**8.12**]. This area, which would become the province of Gallia Lugdunensis, was initially brought under Roman rule by Julius Caesar, who founded a colony at Vienna (modern Vienne) late in his Gallic campaigns (*c.* 47 BCE). Shortly after, the provincial capital of Lugdunum (modern Lyons) was founded, about 20 miles further north.

8.11 Maison Carrée, Nîmes, France, dedicated c. 4 CE. The temple was dedicated to Augustus's grandsons shortly after their deaths. Its format is typical of Italic temples and it marked a strong Roman presence in the province of Gaul. Note the freestanding columns at the font and engaged columns around the cella.

Lugdunum was a central gathering place for Roman Gaul, and is was here that the cult of Roma and Augustus was established by Drusus and Tiberius around 12 BCE (see box: The Cult of Roma and Augustus, p. 164). The nearby temple at Vienne is thought to have been dedicated to this same cult soon after, again based on the reading of cuttings for letters on the architrave; it has also been suggested that it was rededicated to Augustus and Livia following the delayed deification of the latter in 42 CE by Claudius. Both of these dedications correspond to the physical evidence of the temple in two ways, since one can detect two distinct styles in the building's capitals and entablature (the front is different from the back), as well as the two stages of the dedicatory inscriptions. The previous readings of the inscriptions have since been judged by some scholars to have been excessively optimistic, and the dates for the two building phases are now disputed, with some putting the second a century later.

As it was first built in the early empire, however, the Vienne temple much resembles the Maison Carrée, although there are important differences. The former, for instance, has no columns at the back, whereas the Maison Carrée has engaged columns that preserve the illusion of a peristyle. The freestanding flank columns of the Vienne temple, which end only with the two engaged pilasters flanking the rearmost columns, recall a Tuscan temple feature termed *alae* (sing. *ala*—a wing or alcove on either side of a room) by the ancient architectural writer Vitruvius. The view from the front of both temples would have been very similar, though, and would have echoed the many structures of the same type in Rome. Yet the Vienne temple seems to draw more strongly on an Italic tradition than does the Maison Carrée, which more closely follows the compromise between Italic and Hellenizing forms represented by the Portunus temple.

All these design options would have been well known to early imperial architects, schooled in Vitruvius's handbook, and the distinction between forms and features would have been visible and significant. In fact, the presence of the *alae* might support a Claudian date for the temple's first stage of construction, given the idea that the emperor liked to see his antiquarian interests reflected in such monuments as the Porta Maggiore (see Aqueducts, p. 197). Moreover, Claudius was deeply involved in the northern provinces, where he himself was born, where his father Drusus and brother Germanicus achieved their greatest glory, and through which he passed on his way to and from his own conquests in Britannia. Just as we saw in the case of public sculpture, the stylistic and iconographic precedents set in the time of Augustus remained highly influential throughout the Julio-Claudian era, making stylistic dating highly problematic. Regardless, both the Maison Carrée and Vienne temples offer the standard program of Roman visibility in the western provinces that is built upon in various ways.

Temple of Roma and Augustus at Ankara (Ancyra)

While in such western provinces as Gallia Narbonensis and Gallia Lugdunensis, Roman

8.12 **Temple of Roma and Augustus, Vienne, France, 1st century CE.** The temple bears a strong resemblance to the Maison Carrée, but there are differences, such as it having no columns at the back. Instead pilasters are used, which is a Tuscan trait.

8.13 Temple of Roma and Augustus, Ankara, Turkey, 1st century CE. In contrast to the cult temple in Gaul, the architectural order is Ionic and peripteral, a style that continues an Asiatic tradition going back to the fourth century BCE.

architecture closely followed that of Rome, in the eastern provinces the architecture borrowed more from local styles, in the same way as its administration borrowed from local traditions. The cult of Roma, which from the time of Augustus became paired with a Roman ruler, originated in the Hellenistic East during the Roman campaigns there in the last two centuries BCE. The cult emerged as a natural successor to the cults of Hellenistic kings that preceded it—it had been common for Hellenistic rulers to share divine honors with an Olympian deity in her or his temple. As well as some repurposing, newly built temples to Roma and Augustus were also established in that territory, although these too are rooted in local tradition, especially in form.

Among the most important of these was built at Ancyra (modern Ankara, Turkey), the capital of the Roman province of Galatia, created by Augustus in 25 BCE [8.13]. The province took its name from the Gauls who had invaded Macedonia and Asia Minor in the early third century BCE but, after being repelled by the Hellenistic kingdoms, settled here in central Anatolia. As at Lugdunum, the cult of Roma was established here, near the edge of the Roman empire, on land only recently brought under Roman rule, and it clearly played a key part in transmitting the messages of the newly formed principate to remote corners of the Roman world. The text of Augustus's *Res Gestae* that was inscribed, in both Latin and Greek, on the walls of the temple toward the end of his reign [8.14] is the most complete of several copies that were set up publically in Asia Minor, mirroring the version on bronze plates that was installed at the entrance to his mausoleum in Rome (see Mausoleum of Augustus, p. 138). Scholars disagree on whether the temple was erected soon after the creation of the province or later, closer in date to the *Res Gestae* itself.

This temple is distinctly different from those in Gaul (see 8.11, p. 214 and 8.12, p. 215). Rather than a smallish temple mirroring the tradition of Roman Italy, this was a large Ionic peripteral temple, with eight columns at the front (octastyle) that continues a local Asiatic custom of looking back to the much larger Ionic temples of the late

8.14 *Res Gestae* inscription on the Temple of Roma and Augustus, Ankara, Turkey, 1st century CE. The inscription echoes that engraved on bronze plates at the entrance to Augustus's mausoleum.

Classical period. It is Classicizing, then, in much the same way as is the Prima Porta Augustus (see 5.2, p. 132), which also draws on a continuous tradition of retaining and imitating Classical styles. The cult, therefore, used the conspicuously local form of the temple to transmit its message from the capital at Rome.

Temple of Roma and Augustus at Athens

Another temple to the cult of Roma and Augustus was set up in Athens, not far from the Parthenon. Athens was never named as the capital of a Roman province—that honor fell to Corinth (see box: Corinth, p. 218)—but for centuries the city had been recognized as the cultural heart of the Greek-speaking world and was therefore much revered, and coveted, by the Hellenistic kings. Augustus, who never really forgave Athens for siding with Antonius during the civil wars, nonetheless recognized both its status as a cultural center and its potential as a pilgrimage destination for the learned and curious for his program of imperial advertisement.

The temple to Roma and Augustus is not mentioned in any surviving literary source but it is represented by several fragments of its marble superstructure. These include an inscribed dedication by the *demos* (citizen population) of Athens to Roma and Augustus and the names of the priest of this cult, the priestess of Athena, and the chief *archon* (magistrate). Sadly, none of these names enable us to date the building to a specific year. It certainly was set up after Octavian became Augustus and probably during his only visit to Athens in 22/21 BCE. The inscription is found on the curved frieze block from a small, circular **monopteros** (open colonnade without a cella), suggesting it was a round temple or *tholos* probably designed to display cult images of Roma and Augustus within [8.15]. Remains of its Ionic columns show them to be reduced copies of those on the nearby Erechtheum, which was heavily restored at this time and whose famous caryatids were copied for the attic of the Forum of Augustus portico (see 5.20, p. 146). There was clearly an architectural dialogue taking place between the two great cities of Classical antiquity. The cult temple is generally believed to have stood on a stepped rectangular base, the foundations of which are preserved, and where the remains of the temple are stacked still today. Nestled between the Parthenon and the Erechtheum, two of the greatest architectural achievements of Classical Athens, in an area where the most sacred rites of Athena and the heroic-age kings of Athens took place, this building was by no means located or designed randomly; in both its plan and elevation it places itself in the Greek Classical tradition, at the same time that it highlights the new cult to signify a fresh political reality in the center of old Greece.

Round temples and temple-like buildings had a long history in both Greece and Rome. Roman temples dedicated to Vesta especially took this form, probably owing to the goddess of the hearth's connection with fire, which suggests a radial form. There are a number of important late Classical examples, most conspicuously those at the two great sanctuaries of Delphi and Epidaurus, although the function of both of these is not definite. Perhaps a closer model for the Augustan *tholos* is that erected by

8.15 Temple of Roma and Augustus, Athens, Greece, 1st century CE. Little remains of the temple other than a few fragments, which include the dedication by the people of Athens.

Corinth

The ancient city of Corinth developed at the base of a highly defensible acropolis (Acrocorinth) from which it controlled the Isthmus of Corinth and therefore all ground connections between the two geographic halves of the Greek mainland. By building ports to the north and east, Corinth could exploit sea routes through the Saronic Gulf to the Aegean Sea and the east as well as through the Corinthian Gulf to the Ionian Sea and the west. Not surprisingly, Corinth was at the forefront of colonization and the expanding commercial networks of the eighth and seventh centuries BCE. Its orientalizing pottery was, as we saw in Chapter 1, avidly acquired and imitated by such Italic cultures as the Etruscans. The city was destroyed by L. Mummius Achaicus in 146 BCE, and after a century of relative desolation, a Roman colony was established there by Caesar in 44 BCE. After Augustus separated Greece from the province of Macedonia in 27 BCE, Corinth became capital of this new province, named Achaea after the Greek region.

As a veterans' colony and a provincial capital, Corinth was the most Roman-looking city in the Greek-speaking east [8.16]. At the foot of the hill below the sixth-century BCE Doric temple to Apollo, the primary north–south road to the port at Lechaion, now monumentalized as the *cardo maximus* of the Roman settlement, enters the open area of the forum, apparently built atop the ruins of the Greek agora [8.17]. This space was bounded at its other end by the South Stoa, a Greek covered walkway or portico that revives an arrangement going back well before Mummius's destruction of the city, perhaps to Classical times. Behind that, however, was a basilica, a Roman building type of which there are several examples in this area. There are a number of temples located around the forum in Corinth as well, mostly Italic in form, or Italo-Greek hybrids. Especially noticeable would have been the elongated *sine postico* (without any columns along its back side) platform temple set within a large rectangular colonnaded courtyard that was perched on a hill to the west, dominating the forum below. The location suggests a capitolium, a temple to the Capitoline Triad of Jupiter, Juno, and Minerva, but the temple does not have the three cellae that are a distinctive feature of this type of temple, so that seems unlikely. In fact, it is not known for certain which deities were worshiped in any of the temples here. In the area below and between this complex and the Archaic Apollo temple were built a covered odeum and a theater, both of purely Roman plan. There were also Roman baths, and traces remain of an amphitheater.

Many of these buildings, and especially the basilicas, housed provincial administrative functions, and there would have been a great need for them in the province's capital. Yet the use of Roman forms here in Corinth was not simply utilitarian. The city was not only the center of the Roman presence in Greece but also its symbol. While the creation of an environment of Roman architectural forms was designed to accommodate the many Roman settlers here, it was equally intended to overawe the local and visiting Greek population with a grandeur invoking that of Rome itself.

8.16 Plan of the forum and surrounding areas of Roman Corinth. The plan shows how a Hellenistic agora was transformed to more closely resemble a Roman forum.

8.17 Remains of the forum of Roman Corinth. The Archaic temple to Apollo (*c.* 560 BCE) looms above the vast extent of Roman remains below; it must have served as a reminder to its conquerors of Corinth's long and distinguished history.

Philip II of Macedon at the greatest of Greek sanctuaries, Olympia. The so-called Philippeion contained portraits of Philip and his father (Amyntas III), mother (Eurydice I), and successor (Alexander III). This was a blatantly dynastic and imperialistic monument, as was Augustus's; the similarity between Augustus's and Philip's dedications represents one of many ways in which the kingdom of Macedon set examples for the Hellenistic kings who succeeded them, and the *imperatores* and emperors who supplanted the kings. Moreover, the small-scale and temple-like forms of such buildings recall Greek treasuries. Such buildings, usually quite small, were set up at Panhellenic sanctuaries (especially Delphi and Olympia) by Greek city-states as communal votives marking the continuing presence and piety of their dedicators within the sacred area of the *temenos*. The Macedonians, Hellenistic kings, and Romans were all non-Greeks ruling over Greek states. Such a dedication as this one can serve as a claim to inclusion in the cultural traditions of a state now under foreign rule.

Temple of Augustus Soter (Savior) at Olympia

Olympia, located on the western side of the Peloponnese peninsula, was an important panhellenic religious sanctuary in the Greek world, and the original location of the Olympic Games. Immediately below the terrace of treasuries at Olympia, a late Classical **metroon**, or temple to the Mother of the Gods, was converted into a temple honoring Augustus, and perhaps also Roma, although she is not mentioned in the preserved portion of the dedicatory inscription. Augustus, significantly, was honored here as savior of the "Greeks and the entire ecumene" (inhabited world); the personification of the ecumene, we remember, figured prominently on the Gemma Augustea (see 6.9) where, in the form of a human figure, she crowns Augustus himself. It is not known if the rededication of the metroon followed or preceded Augustus's death in 14 CE. It was certainly not impossible that Augustus was figured, even worshiped, as a god in the East in his lifetime, following the example of Hellenistic kings (see box: Temple of Dendur, p. 220).

The cult of the Mother was the Greek version of the Asiatic cult of Cybele, which was of special importance to the Romans (as Magna Mater), who imported it at the end of the Second Punic War, at the beginning of the Mediterranean conquest. If a marble torso found nearby belongs to this temple, as was thought until the attribution was recently questioned, it would have housed a colossal (4 meters or 13 feet high) cult statue of Augustus in the guise of Jupiter [8.18]. Such a statue would have dominated the cella of this small temple in a manner comparable to the colossal Phidian Zeus in the famous temple nearby, forming a visual link between the emperor and the king of the Olympians. The Flavian arrangement, better known, included portraits of Claudius, again as

8.18 Colossal portrait of Augustus from the metroon at Olympia, Greece, Augustan or Julio-Claudian. Marble. Restored H. 3.96 m (13 ft). The statue, of which only the torso survives, would have shown the *divus* Augustus in the guise of Jupiter, a form the better-preserved portrait of Claudius also took.

8.19 Portrait of Claudius, from the Metroon at Olympia, Greece, Flavian period. Marble. H. 2.1 m (6 ft 10¾ in.). The installation of this statue was part of a conversion of the temple, in the Flavian era, to one dedicated to Augustus.

Jupiter (see 6.5, p. 157), Vespasian, and Titus, all along the south wall of the cella; facing them to the north were Agrippina the Younger opposite her husband Claudius [**8.19**], and two headless draped females, surely members of the Flavian family. This is consistent with the message propagated by the Flavians in Rome, linking themselves to the legitimacy of Claudius (and, as always, Augustus) while excising the memory of Nero.

The metroon at Olympia is not an isolated example of the reuse of a Classical Greek temple or its rededication to a Roman ruler or deity.

Temple of Dendur

Augustus's strategy in building a structure of control that reflected familiar traditions and customs included a careful consideration of the local practices already established in the eastern provinces. One by one he brought the Hellenistic kingdoms within the Roman world, through the process of adaptation of existing cults and religious traditions to fit Roman customs (for example, the cult of Roma and Augustus was based upon the existing cults of Alexander and the Hellenistic kings).

A similar phenomenon can be seen in Egypt, which was among those Hellenistic kingdoms but, as can be seen throughout antiquity, was a kingdom resembling no other. Egypt was incomparably blessed with both natural resources and strong physical boundaries, so it was, throughout most of its history, exceptionally wealthy, easily defensible, and unusually stable. A central principle of Egyptian culture was a belief in repetition and timelessness that manifests itself, in art and architecture, in reiterative and abstract forms. Alexander's boyhood comrade (and, some have said, illegitimate half-brother) Ptolemy acted quickly upon the death of his friend in 323 BCE and claimed for himself a regency over Egypt, which by 305 BCE he had turned into the Ptolemaic monarchy. Egypt was not only among the earliest of the Hellenistic kingdoms but also it was the last to be brought under Roman rule, by Octavian after the suicide of Cleopatra VII in 30 BCE.

In the same way as the Ptolemies had done before him, Augustus promoted traditional Egyptian religion, building new Roman temples alongside Pharaonic ones. The new temples were similar in form to the Egyptian buildings but much reduced in scale and complexity. One such Augustan temple is now located in the Metropolitan Museum of Art in New York City [**8.20**], having been moved from the far reaches of Upper Egypt where it originally stood in what was the borderland between Egypt and Nubia (which was never controlled by Rome), thus marking the presence of Augustus at the edge of his sphere of control. The temple was dismantled and relocated in the twentieth century in order to save it from being submerged following the construction of the Aswan Dam, and it was presented to the United States government as a gift in 1965.

8.20 (Left and right) Temple of Dendur, Egypt, 1st century CE. The form is typical of New Kingdom pylon temples in Egypt.

The Temple of Dendur consists of a freestanding gateway (**pylon**) in front of a small **distyle** (two columns in the porch) temple housing the inner sanctuary. The form is characteristic of New Kingdom (sixteenth to eleventh centuries BCE) pylon temples but here is reduced to the bare essentials. Some of the original Egyptian pylon temples encompassed areas as large as 250 acres. The Dendur temple is covered in relief sculpture, which includes traditional scenes of the pharaoh making offerings to various Egyptian deities, but on this temple, as on others of the time, the pharaoh is labeled as the emperor (*autokrator*, Greek for *imperator*) and as Caesar (*Kaisaros*) in hieroglyphics [**8.21**]. The representation of the emperor with the attributes and activities of pharaoh, which was previously adopted by Antonius and the Ptolemaic kings before him, extends also to statuary. In Egypt, images have been found bearing the unmistakable features of Augustus that are identical in pose, dress, and attributes to those that had been used to portray Egyptian kings since the Old Kingdom (ending in the twenty-second century BCE) [**8.22**]. It has been argued that the inspiration for the creation of a highly idealized and unvarying portrait type for Augustus emerged from his experience with Egyptian royal imagery, which employed indistinguishable facial features over many centuries.

8.21 (Left) Relief from temple of Dendur, Egypt, 1st century CE. Images that would usually include the pharaoh were replaced by that of the emperor Augustus.

8.22 Egyptianized statue of Augustus, 1st century CE. The Roman facial features are combined with the dress of an Old Kingdom pharaoh. Augustus's preference for the use of idealized features in all his portraits may even have been influenced by his experiences of Egyptian art.

CHAPTER 8: PROVINCIAL AND PRIVATE ART IN THE EARLY EMPIRE

The temple of Nemesis at Rhamnous in Attica (the region surrounding Athens) shows on its architrave a dedication to the goddess Livia, suggesting that it was repurposed for her cult after her elevation to divine status by Claudius in 46 CE. Another example is the Classical temple that stood in Roman times in the center of the Athenian Agora, beneath the similar but somewhat earlier temple of Hephaestus, which dominates the area still today. The temple was moved there in the time of Augustus, block by block, from a town outside Athens, some nine miles away; the mason's marks that served as directions for reassembly are preserved on some blocks. In its new location the temple was rededicated to Ares (the Greek god of war), echoing the prominence of Mars in Augustan Rome, as manifested in the Forum of Augustus (see Forum of Augustus, p. 144), with its many visual references to Athens and its Classical past. The temple, it now appears, was originally dedicated to Apollo, who was equally significant in Augustus's intricate weaving of his own identity into the Greco-Roman pantheon.

COMMEMORATION IN THE PROVINCES

Among the most characteristically Roman methods of expressing power is the visual depiction of both military victory itself and its ritual celebration through the triumph or other religious rites. Its history goes back to the triumphal paintings of the middle Republic and there are many conspicuous examples from the early imperial period in Rome. The practice did not take long in spreading to the provinces of the empire.

Arch of Augustus at Susa (Segusium)

In the years 9–8 BCE at Susa near Turin, in what is now northern Italy but was then called Cisalpine (literally "this side of the Alps" from the Roman perspective) Gaul, an arch was constructed to commemorate the signing of a treaty between Augustus and a Gallic king, who is described by an inscription on the arch as Marcus Julius Cottius, son of King Donnus.

The treaty rendered the king a client of Rome; he became fully Romanized and was given the Roman title of prefect of the fourteen local tribes. This arch, like the portrait of Augustus from Prima Porta (5.2, p. 132), uses what was conventionally a military form—the triumphal arch—to mark a diplomatic victory [8.23]. While built of local stone, it displays a simple, single bay form with restrained but well-executed Corinthian engaged columns (at the corners) and pilasters that would be at home in Rome itself. The only narrative ornament is found on the narrow frieze, slightly more than half a meter (2 feet) tall, atop the engaged columns. This is a straightforward depiction of the treaty signing (on each short side) and accompanying *lustratio* with procession of boar, ram, and bull for the *suovetaurilia* (on each long side) [8.24]. The subject and arrangement of figures is not so different from, for example, the Republican Paris census relief (see 2.20, p. 66). The style of rendering, however, shows none of the refined Classicism of that monument and contrasts with what we have come to expect from Augustan art in the capital. The togate representatives, including the clearly identifiable figures of Augustus at the center of each composition, are flat, blocky figures with extremely simplified,

8.23 Arch of Augustus at Susa, Italy, end of 1st century BCE. The monument was constructed to record a treaty between Rome and the ruler of this region, in which the latter became an imperial client. The arch is a mixture of Roman and native Italic traditions, is built of local stone, and has engaged Corinthian columns.

8.24 Frieze from the Arch of Augustus at Susa, Italy, end of 1st century BCE. Marble. H. 60 cm (2 ft). This section of the frieze depicts the leading of a boar for sacrifice as part of the *suovetaurilia*, the ritual that accompanied the treaty made between Augustus and the local ruler. While placed on a typical Roman arch, the relief figures are not Classical and are rendered in a local Italic style.

almost geometric, drapery patterns. The sacrificial procession is similarly rendered, with oversized victims dwarfing their *victimarii*. The style is reminiscent of, but even less Hellenizing than, such central Italic works as the Amiternum relief (see 8.1, p. 207 and 8.2, p. 208).

Arch "of Tiberius" at Orange (Arausio)

Several decades earlier, in 35 BCE, soon after the death of Caesar and during the ascendency of Octavian and Antonius, the colony of Arausio (modern-day Orange) was founded in southern Gaul to provide land for veterans of a legion that had served first under Caesar and then under Octavian. The site, as was typical of veterans' colonies, adopted town planning and building types from Rome itself as a mark of the cultural and political transformation of the area. Among the monuments erected at Arausio was a triple-bayed arch that has consistently been connected with the emperor Tiberius, again following the reconstruction of a lost dedicatory inscription from the cuttings and traces on the architrave that once held it.

The arch is especially large and elaborate, not only because it has three bays (one central with two smaller arches on either side) rather than the more conventional early imperial style of a single bay, but also because virtually every space defined by the surrounding engaged architectural elements is filled with representational sculpture [8.25]. The effect recalls the fantasy architecture found in advanced Second Style painting (see p. 84). At the first level of the monument, the space above the flanking arches is filled with carved piles of Gallic weaponry and standards. The spandrels of the larger central arch are now blank but cuttings in the stone suggest that winged Victoria figures (perhaps here in bronze) had been dowelled on; such figures can often be found in this location on many Roman arches. Above the entablature crowning the lower level, to the left and right of the central section, are more carvings of captured armaments, in this case the prows of ships as well as other items that indicate naval warfare. The theme continues to the short sides of the arch, where a row of four engaged Corinthian columns frame three panels, each of which contains a trophy flanked by two

8.25 Long side of the Arch of Tiberius at Orange, France, 14–18 CE. The arch has three bays and is covered in figurative reliefs.

CHAPTER 8: PROVINCIAL AND PRIVATE ART IN THE EARLY EMPIRE 223

8.26 Short side of the Arch of Tiberius at Orange, France, 14–18 CE. This side bears Corinthian columns framing markers of victory.

bound captives [8.26]. The iconography, which emphasizes victory by illustrating the vanquished, recalls such artworks as the Gemma Augustea and Grand Camée (see 6.9 and 6.11). The battle panels on the upper attic [8.27], which display a complex pictorial illusion, are comparable to, if not exceeding, that seen in the Alexander mosaic from the late second century BCE (see 3.7).

A peculiarity of these reliefs, especially the battle reliefs, is the use of deeply carved channels to outline, in sharp linear shadow, the individual forms of the figures and objects portrayed. This would seem to be aimed at enhancing the legibility of complex compositions, but is a feature found commonly in Roman sculpture only much later, beginning in the late second century CE and evolving into the abstraction of the late antique style.

Sebasteion at Aphrodisias

By far the most spectacular dynastic Julio-Claudian monument in the Roman east was unearthed at the site of Aphrodisias in the Roman province of Asia (in modern-day Turkey), some 60 miles inland from the provincial capital at Ephesus. This city was devoted, as its name indicates, to Aphrodite (Venus), whose significance as the divine *genetrix* of the Julian *gens* resulted in it being especially favored by the Roman emperors from Augustus onward. It was exempt from taxes and tribute and so was unusually wealthy, and, as its monumental building program suggests, appropriately grateful. Excavations here from the 1970s to the present have unearthed one of the East's best-preserved Roman provincial cities, and one that was exceptionally adorned with luxurious public buildings. The style of sculpture at Aphrodisias is important to note since the city continued to be a key center of marble carving throughout the imperial epoch; signatures of Aphrodisian sculptors and other signs of their work are found all across the Mediterranean.

A lavishly decorated building, the Sebasteion [8.28 and 8.29], consisted of a long, narrow court bounded by three-storied porticoes on either side, entered through a monumental **propylon** (gateway) similar to the Aphrodite sanctuary [8.30]. At the other end, opposite the gate, was a broad stairway leading to a terrace, which originally held a podium temple in the Corinthian order. The arrangement recalls the Imperial Fora, although the extremely high porticoes and narrow

8.27 Battle panel on the upper attic of the Arch of Tiberius, Orange, France, 14–18 CE. Limestone. H. 1.5 m (4 ft 11 1/8 in.). The composition is evocative of battle scenes ranging from the Hellenistic Alexander Mosaic to the sculptured sarcophagi of the later empire.

224 PART II: THE FORMATION OF THE ROMAN EMPIRE

8.28 (Left) Sebasteion, Aphrodisias, Turkey, mid-1st century CE. Named with the honorific *Sebastos*, the Greek equivalent of Augustus, the building served as a shrine to the imperial family.

8.29 (Below) Reconstruction of the Sebasteion, Aphrodisias. The facade is an early example of the colonnaded screens that become common across the empire as a mark of Romanization.

8.30 (Below) Tetrapylon, Aphrodisias, 2nd century CE. It shares certain decorative features with the Sebasteion.

courtyard here would have created a darker, more enclosed atmosphere. Epigraphical evidence indicates that the building was constructed over the course of several decades, spanning each the reigns of Tiberius to Nero, and was funded by two local wealthy families.

Everything about the rich sculptural program here had to do with the glorification of the Julio-Claudian family. The complex was dedicated to "Aphrodite, the Augusti, and the people." The gateway that bore this dedication contained small shrines, *aediculae*, bearing statuary; inscriptions there attest to the inclusion of portraits of Gaius and Lucius Caesar, Drusus the Younger, Aeneas, and Aphrodite, who is identified in Greek as "ancestral mother of the divine Augusti," or in other words, Venus Genetrix. It is safe to assume that Augustus, the Julio-Claudian emperors, *Divus Iulius*, and perhaps other family members were also included, recalling such a group as that reflected by the relief at Ravenna (see the Ravenna Relief, p. 167). Inscriptions from this building refer to the emperors depicted as *Theoi Sebastoi Olympioi*, or "Olympian emperor gods." Since "Sebastos" is the Greek equivalent of the honorific name Augustus, the building is thought to constitute a shrine to the imperial family and is thus called the Sebasteion.

The interior was decorated with dozens of large marble panel reliefs placed between the columns of the second and third stories. For subject matter, these drew on both local and Roman traditions. Some depict episodes from Greek mythology, others show personifications

CHAPTER 8: PROVINCIAL AND PRIVATE ART IN THE EARLY EMPIRE 225

of such concepts as "day" and "ocean"; an entire series was devoted to the *ethne* or various peoples of the Roman empire, and another series illustrated emperors, empresses, and other Julio-Claudians in various scenes, most or all of them allegorical in nature. One of these, for example, shows Claudius subduing a personification of the province of Britain (Britannia) [8.31]. Another shows Nero, as a victorious general, being crowned by his mother Agrippina the Younger in the guise of Tyche, goddess of good fortune (Fortuna in the Roman pantheon)—obviously a work of the early Neronian period [8.32]. The message that resides in these scenes, as in the entire series, is straightforward and consistent with imperial self-representation as known from Rome and elsewhere.

These reliefs represent one of the very earliest major public sculptural programs at the site. Many examples display a marked reliance on

8.31 Relief from the Sebasteion, Aphrodisias, Turkey, mid-1st century CE. Marble. H. 1.65 m (5 ft 5 in.). This relief depicts Claudius slaying Britannia (the personification of Britain). The image refers directly to a Hellenistic statuary group showing Achilles killing the Amazonian queen Penthesilea.

8.32 Relief from the Sebasteion, Aphrodisias, Turkey, mid-1st century CE. Marble. H. 1.5 m (4 ft 11⅛ in.). This relief depicts Nero as a general being crowned by his mother Agrippina in the form of Tyche, goddess of good fortune.

Aphrodisias was considered a special city, owing to its unique relationship with the imperial family, and this monument provides an informative early example of a provincial, obviously imperial monument that both draws on local traditions and employs an imagery developed in the empire's capital.

THEATERS AND AMPHITHEATERS IN THE PROVINCES

During the Republic, as we have seen, the first manubial buildings were temples, dedicated and erected by individuals ostensibly to fulfill a sacred vow but, in fact, primarily to facilitate political advancement of themselves and their families. Over time, the favor of the Roman populace was gained through the sponsoring of public games and spectacles and, later, through providing permanent structures for entertainment. As in so many ways, the emperors drew on Republican traditions and used much the same methods to convince people throughout the empire that they were better off under imperial protection and control. Roman theaters were established throughout the empire but in the eastern part, since most Greek towns and cities were already equipped with such structures, the Romans usually used the existing buildings, adapting them for Roman purposes, although in many ways these would retain their distinctly Greek character. In the western provinces of northern Europe and North Africa, where such buildings did not exist already, many theaters designed to a purely Roman plan were erected, no small number of which have remained remarkably well preserved.

The case of amphitheaters (large, circular arenas) is somewhat different, since there were no permanent examples anywhere before the empire, and the building type itself is distinctively Roman, tied as it is to a Roman tradition of

Classical or Hellenistic figural types; Claudius and Britannia form a direct quote of a Hellenistic statuary group showing the story of Achilles and Penthesilea, known from several Roman versions. The Agrippina/Tyche figure is a modified version of the Tyche from the pediment of the Mars Ultor temple in Rome (see Forum of Augustus, p. 144), itself derived from a common Hellenistic figure. In carving style, the reliefs on the Sebasteion continued the local Asiatic tradition that favored deep carving, strong chiaroscuro effects, and exaggerated versions of Classical features of style, as we can see, for example, in the heroic, powerfully muscled, nearly nude figure of Claudius with his Classicizing windblown cape. It is tempting to speculate that the increasing interest in using three-dimensional effects, as seen in Julio-Claudian sculpture in Rome, might have derived from some increased contact with or influence from the artists working here.

The Stadium at Aphrodisias

Excavations at Aphrodisias have brought to light a remarkably well-preserved urban center with many impressive and archaeologically significant buildings. At most of the other many great Roman cities of Anatolia, such as Ephesus, the majority of building is dated to the second century CE or later as a result of a construction boom in the Greek-speaking East during and following the time of Hadrian. At Aphrodisias, however, owing to its special connection to the Julio-Claudian family, there is an unusually high number of important early imperial structures, and one of the more interesting of these is the stadium.

While amphitheaters are Roman in origin, stadia are closely connected with the Greek **agonistic** festivals (sporting, dramatic, or musical competitions) and especially with the Panhellenic sanctuaries; they were not part of the corpus of typical Roman building forms. The Piazza Navona in Rome, discussed on p. 203 (see 7.27), preserves the outline of Domitian's stadium, which is an openly Hellenizing structure in both form and function.

The stadium at Aphrodisias is one of the best preserved and, with a capacity of 30,000 spectators (twice the population of the city), it is the largest (nearly 275 meters long) from the ancient world [8.33]. Although it has remained visible since antiquity, the site was not extensively quarried for building stone, probably owing to its distance from the center of the post-Antique settlement. The building is elongated, its length being about four-and-a-half times its width, no doubt to accommodate a track for the footraces that took place within, although any number of other athletic contests requiring less space could be held there as well. Early running tracks, such as examples found at Corinth and its neighbor Isthmia (evidenced by excavated starting lines), may not have had any fixed seating—the famous track at Olympia was viewed from earthen embankments, both natural and built, to which formal seating was later added. The practice of building up stadia began after the Classical period when stone construction became used for an expanded range of building types as part of the monumentalization of cities and sanctuaries by Hellenistic kings; this practice, as so many others, was continued by the Roman emperors. The stadium at Aphrodisias can be dated to the early empire by its form and construction. Although there are some vaulted tunnels used for the circulation of spectators and participants, the seating is largely supported by banking, similar to the early stadia and unlike later imperial constructions that used the extensive vaulting, such as the Colosseum or Roman theaters.

What is notable about this building (although not unique) is that, in contrast with Classical stadia, or Domitian's in Rome, it has two curved ends (*sphendonai*) rather than terminating in a straight wall at the end where the starting line is located. Such an arrangement was called a *stadion amphitheatron* in Greek, and indeed, it would make the building resemble a long, very narrow amphitheater. That this was not simply a formal but also a functional descriptive term, however, is indicated by epigraphical and archaeological evidence that gladiatorial games did take place inside. Moreover, during the later empire, a small oval structure was walled in within one curved end of the stadium (here in the foreground), designed to accommodate a smaller audience and, it is thought, staged animal hunts (*venationes*). This building, then, represents a local modification of the many amphitheaters closely modeled on the Colosseum that one sees in the West, one that takes into account both the strongly Roman population and local Hellenistic building traditions.

8.33 The stadium at Aphrodisias, Turkey, 1st century CE. The stadium is one of the largest of its type, with a capacity of 30,000 spectators.

blood sport. Amphitheaters therefore appear more frequently in the more thoroughly Romanized west, after the example of the Flavian Colosseum in Rome, which many later buildings imitate quite closely. In the east, gladiatorial games and similar displays, such as mock naval battles, were primarily limited to areas of intense Roman presence, especially provincial capitals, for example Corinth. Otherwise, public shows were housed in other types of buildings, such as theaters or stadia, which could be adapted for the purpose (see box: The Stadium at Aphrodisias, opposite).

Theater at Orange (Arausio)

One of the best preserved of all Roman theaters was built in southern Gaul, just outside the center of Arausio at the foot of a hill thought to have served as the Capitolium of this very strongly Romanized city [8.34] The theater, along with much of the construction in this area, was built during the early empire, probably under Augustus, but the style of columns preserved on the stage building indicates that restoration took place in the second century CE. The plan of the theater is of the characteristically Roman type, although the architect was practical enough to make use of the terrain, as much of the central *cavea* is supported by the lower slopes of the hillside behind. The remainder is propped up by radiating barrel vaults, built in the cut-stone masonry of local origin that is used throughout the theater. True Roman concrete was not much used outside of central Italy, presumably because of the lack of any volcanic sand that worked as well as *pozzolana* from Campania.

The *cavea* and orchestra are semicircular and the former runs continuously into the ends of a soaring stage building around 37 meters (120 feet) in height as restored, the same as the

8.34 Theater at Orange, France, 1st century CE. This was probably built under Augustus and restored in the second century CE. Part of the theater cuts into the hillside while the remainder is supported by barrel vaulting.

CHAPTER 8: PROVINCIAL AND PRIVATE ART IN THE EARLY EMPIRE

cavea, which was nearly 104 meters (340 feet) in diameter. All but the top section of the stage-building backdrop (*scaenae frons*) is made up of three large niches, curved at the center and rectilinear at either side. The low wall at the front of the stage and back of the orchestra is similarly organized. All of these niches would have held sculpture. Those of the *scaenae frons*, which had marble *aediculae* on three stories (as one can see at the lower right of the center), would most likely have contained statues of emperors and their families, making the imperial message clear to the assembled Gallic citizenry, some 7,000 people. Pride of place was given to the apsidal niche at the top and center, in which a portrait of Augustus appears today. This work is an imitation (pastiche) of different statues, so it is unlikely to be the sculpture that originally stood here, although the original probably did portray Augustus. The building and sculptural program function together as a unit, as is typical of Roman public building, to enhance the illusion of Arausio as a miniature version of Rome herself. The presence of Rome in this area of Gaul could not be more tangible.

Amphitheater at Nîmes (Nemausus)

Amphitheaters functioned in much the same way as theaters. Following the opening of the Colosseum in Rome in 80 CE, the important cities of the western provinces apparently strived with one another in hurrying to build their own amphitheaters, not only for the entertainment of their strongly Romanized, indeed by now better termed Roman, population, but also as a conspicuous model of the modernity and sophistication of the city itself. Consequently, from northern Italy and Gaul, to Spain and western North Africa, one finds dozens of finely built stone amphitheaters, each incorporating and modifying the structural principles and exterior decoration of the Colosseum itself. None was as big as the model in Rome, but these were impressive buildings. Several were at least two-thirds the size, with two rather than the Colosseum's three vaulted stories, also supporting an attic story. These went up quite rapidly and many can be attributed to the reigns of Domitian or Trajan, although later examples are known.

Among the early examples in Gaul are those at Arles (Arelatum) and Nîmes; since the latter, probably Domitianic, is somewhat better preserved, it is illustrated here [8.35]. As in Rome, the *cavea* rests on radiating and annular vaulting, here in stone masonry. The arches on the outer wall, formed by the ends of the radiating vaults, are framed by an engaged colonnade, although the architectural orders do not follow the Colosseum nor agree with one another. Here (and at Arles) the Doric pilasters that occur on the attic of the Colosseum are used on the first story and Tuscan engaged columns are used on

the second (these are Corinthian at Arles). Also, these local versions lack the elaborate system of substructures and lifts that functioned to dazzle the audience in Rome. Architects in the area therefore took liberties with the type, no doubt deliberately introducing variant styles as they would strive with one another for originality and even notoriety. At Nîmes, the architect has left us his name, T. Crispius Reburrus, which is preserved on two inscriptions in the building's basements.

These amphitheaters, then, appeared suddenly, as massive markers of Roman identity, yet Gaul had long since been brought under a Roman rule based on the dissemination of Roman culture. These were by now Roman, not Romanized, cities; the great emperors of the second century CE, from Trajan to Marcus Aurelius, were all offspring of Roman families that had long ago settled in Gaul and Spain. Some never saw Rome until adulthood. The work in the West had been done, and these very emperors would, out of necessity, turn their attention to less secure borders along the Danube and Euphrates rivers to the north and east. We may now turn to this second stage of the story.

8.35 Amphitheater in Nîmes, France, opened c. 80s CE. Such massive structures as these were built rapidly across the provinces as indicators of Roman identity.

CHAPTER 8: PROVINCIAL AND PRIVATE ART IN THE EARLY EMPIRE 231

Part III
The High Empire
(96–192 CE)

Writing his *History of Ancient Art* in the eighteenth century, Johan Joachim Winckelmann noted that there are in all things five stages: beginning, progress, state of rest, decline, and end. This organic model of growth, perfection, and decline created by Winckelmann has come to dominate approaches to art history. Such a scheme, as we have been observing, is not nearly so applicable to the artistic styles of the Romans as it is to those of the Greeks, and it was the latter who most interested Winckelmann.

As a historical model, the lure of "rise and fall" persists to this day, and scholars are frequently drawn to self-constructed eras of perfection. In the study of ancient Greece, the "golden age" is associated with the mid-fifth century BCE, especially Athens's Periclean democracy with its now famous works of not only sculpture, architecture and painting, but also tragedy, comedy, philosophy, and history. For the Roman empire, it is the era of the "five good emperors": Nerva, Trajan, Hadrian, Antoninus Pius, and Marcus Aurelius, whose reigns span from 96 to 180 CE. Yet while High Classical Greece is remarkable for its concentration of cultural activity in one *polis*, where even many non-Athenian artists chose, or needed, to live and work, the achievements of the Roman "High Empire" are equally striking in their decentralization. No longer are the provincial centers of population and administration conceived of as merely regional versions of Rome herself, but rather each takes on its own personalities, respectful of and responsive to its own local traditions.

A perhaps less obvious but equally significant development of this new form of "hybridity" in Roman art and architecture is the entry into Rome itself of forms and styles from around the Mediterranean, especially under the emperor Hadrian, the "little Greek." This new Hellenism is subtly but significantly different from that of the era of conquest in the later Republic. While Hadrian and his successors were, like the Republican *imperatores*, not averse to self-promotion, the primary objective of this Hellenism was a visual weaving together of the far-flung reaches of the empire into a coherent and consistent whole, not one imposed from a single model emanating from the capital, as in the early empire, but one derived from the diversity of its many provinces. Rome needed to be made a part of this.

Equally astonishing is the sheer quantity of material from this era. The empire was large, to say the least, so for that reason alone much building was needed; the role of urbanization in exercising political control is obvious enough, as settled populations are easier to motivate and control. Just as in Rome from the Republic onward, ruling entities all across the empire—more often, in the second century, wealthy local magistrates rather than the emperor himself—erected structures and monuments that illustrate and commemorate their achievements and, perhaps more important, provided facilities—theaters and amphitheaters, baths and gymnasia, libraries and marketplaces—that would improve the lives of the public.

What, then, were the circumstances that made these developments not just possible, but necessary? One factor, certainly, was that four emperors were born to families whose origins were in the Roman nobility of the provinces—Trajan, Hadrian, and Marcus Aurelius in Spain, and Antoninus Pius in Gaul. Their provincial backgrounds surely contributed to the emergence of this new cosmopolitanism, which played a significant role in bringing together the dispersed and diverse corners of the empire.

Second, these four emperors of the second century CE were conscientious and competent, they were respectful of and generally acceptable to the senate, and they were

popular both with the troops and among the vast majority of the empire's inhabitants. Most obvious in this respect was Trajan, a man already of military accomplishment when he became emperor. His most famous commemorative monument, Trajan's column, illustrates these hard-won victories less by focusing on battle itself than by portraying the many necessary supportive tasks of warfare far from home—travel, construction, worship, oration, and negotiation. Against a historical backdrop in which most emperors who failed did so through incompetence, careful attention to detail and duty may have been qualities more desirable than mere divine descent.

Third, there was unprecedented political stability. Through a combination of fortuitous childlessness and good judgment, each emperor (until Marcus Aurelius) chose to name his successor from among his experienced and qualified associates rather than adhere, as emperors since Augustus had done, to a policy of familial dynastic succession. Each transition was peaceful and Rome did not suffer crippling civil wars, such as that of 68–69 CE (known as the year of the four emperors), or palace coups, as occurred with the assassination of Domitian in 96 CE.

Finally, the High Empire was a period of relative peace. There were campaigns—both major and minor—on the borders of the empire during the reigns of some of the "good" emperors, but even in those times the empire's Mediterranean core remained secure. Upon Trajan's death at the close of his campaign against Parthia (117 CE), Hadrian relinquished his predecessor's gains across the Euphrates, believing them too costly to keep, and therefore marking a firm eastern edge to the empire. Sometime later, he built an actual and substantial wall in what is now northern England, to define that border even more clearly. This process continued with Antoninus Pius, in whose time a series of fortresses defined the empire's northern limits (*limes*) along the Rhine and Danube. Armies were not disbanded of course, but their role was primarily defensive rather than offensive.

This respite from warfare and consequent economic flourishing enabled communities to adorn their cities like never before. Less happy times would come in the reign of Marcus Aurelius, though, as the unity and security of the empire began to unravel with the return of serious campaigning on the northern and eastern borders, an abortive civil war, and, in the end, the disastrous selection of his son as successor. The seeds of future collapse were sown.

Timeline

DATE	EVENT
96 CE	Nerva becomes emperor
97 CE	Nerva adopts Trajan as heir
98 CE	Trajan becomes emperor
101–102 CE	First Dacian War
105–106 CE	Second Dacian War
109 CE	Dedication of the Baths of Trajan
112 CE	Dedication of the Forum of Trajan
113 CE	Dedication of Trajan's column and Trajan's Markets
117 CE	Death of Trajan; Hadrian becomes emperor
122 CE	Construction of Hadrian's Wall in Britain begins
c. 126 CE	Hadrian completes the Pantheon, Rome
138 CE	Death of Hadrian; Antoninus becomes emperor
145 CE	Dedication of the Temple of *Divus Hadrianus*, Rome
161 CE	Death of Antoninus; Marcus Aurelius and Lucius Verus become co-emperors
169 CE	Lucius Verus dies
177 CE	Commodus made co-emperor with Marcus Aurelius
180 CE	Death of Marcus Aurelius; Commodus becomes sole emperor
192 CE	Death of Commodus
c. 193 CE	Completion of the column of Marcus Aurelius

(NERVA, TRAJAN, AND HADRIAN: 96–138 CE; THE ANTONINES: 138–193 CE)

9 Art in the Reign of Trajan

236 Nerva's Successor
 236 Box: Adoption in Rome
 237 IMPERIAL PORTRAITS

239 Trajan's Buildings in Rome
 239 BATHS
 240 Box: Seneca and Life in a Roman Bath
 241 MARKETS
 242 FORUM OF TRAJAN
 244 Box: Where was the Temple of *Divus Traianus*?
 246 Material and Techniques: Colored Marbles and Exotic Stones
 250 TRAJANIC FRIEZE ON THE ARCH OF CONSTANTINE

251 Trajan's Buildings outside Rome
 251 ARCH AT BENEVENTUM
 253 *TROPAEUM TRAIANI* AT ADAMKLISSI
 254 OSTIA

257 From Trajan to Hadrian
 257 *ANAGLYPHA HADRIANI* (FORMERLY *TRAIANI*)

Chronological Overview

DATE	EVENT
96 CE	Nerva becomes emperor
97 CE	Nerva adopts Trajan as heir
98 CE	Trajan becomes emperor
101–102 CE	First Dacian War
c. 103	Portworks at Portus (Ostia)
105–106 CE	Second Dacian War
109 CE	Dedication of the Baths of Trajan; *Tropaeum Traiani* at Adamklissi, Dacia (Romania)
112 CE	Dedication of the Forum of Trajan
113 CE	Dedication of Trajan's column and Trajan's Markets
c. 114 CE	Arch of Trajan at Beneventum
114–117 CE	Trajan's Parthian campaign
117 CE	Death of Trajan; Hadrian becomes emperor
117–120 CE	*Anaglypha Hadriani / Traiani*

The Development of Rome

Right: Map of Rome showing the key works in existence in Rome in this chapter.

Nerva's Successor

The emperor most responsible for setting in motion the events that led to the period known as the High Empire was Marcus Cocceius Nerva (r. 96–98 CE), who ruled for only sixteen months and would otherwise have been a minor figure in Roman imperial history. The conspirators responsible for Domitian's assassination in 96 CE seem not to have had a definite successor in mind, and the senate, in an uncharacteristic display of initiative, chose Nerva as *princeps*, not only because he was a respected and experienced statesman, but also because he was elderly, childless, and relatively inexperienced in military affairs and therefore not expected to constitute a major threat to senatorial authority. It was not long, however, before this last perceived benefit of the new emperor turned out to be a weakness, and he alienated the armies both in Rome and the provinces. He salvaged his position by adopting as his successor Marcus Ulpius Traianus, known today as Trajan. Trajan was a statesman-soldier whose career recalled the purported meritocracy

Adoption in Rome

The practice of adoption by emperors during the High Empire has often been credited as a source of the period's unparalleled stretch of peace and prosperity. Adoption, however, was no novelty; it had a very long tradition in Roman culture and, just as in many other aspects of imperial rule, its usage was deeply rooted in Republican social and political practice. The family was at the center of Roman constructions of identity and status. Each was headed by a senior male (*paterfamilias*) whose authority over family members included power over their lives and deaths. Although many Romans lived to a ripe old age, infant and child mortality rates were high; women often bore many children to compensate and began giving birth at a much younger age than is customary today. Nonetheless, a large number of offspring was a luxury that even, in fact especially, the most powerful Roman families could not afford. Status and political prestige of one's progeny was paramount, so it was necessary to secure the best marriages for one's daughters and the most eminent political careers for one's sons; both endeavors were very expensive. Therefore, Romans of the senatorial class normally did not have a large number of children. Since medicine was not advanced and wars were fought continually, it was not unusual for one's children to die in young adulthood, and for a *paterfamilias* to outlive his sons.

It was unthinkable to die without an heir, so it was common for a young man from another family, ideally of comparable social, political, and economic standing, to be adopted. A famous example from the Republic was Publius Cornelius Scipio Aemilianus (189–125 BCE), the second son of L. Aemilius Paullus (who triumphed over Perseus of Macedon at Pydna in 167 BCE); Aemilianus was adopted by Publius Cornelius Scipio, son of Scipio Africanus, who bested Hannibal in the Second Punic War, saving Rome from near certain defeat. It should have been all but impossible to outdo such ancestry but Aemelianus did so, celebrating two triumphs, one over Carthage (146 BCE), which he burned to the ground, and one over Numantia in Spain (133 BCE). Another example is Caesar's adoption of his grandnephew Octavian, having no male offspring, taking the latter as his heir and, as it happened, his successor in power.

Adoption, then, was entirely a legal issue of designating status as heir, not simply a matter of taking someone into one's family. When Octavian married Livia in January of 38 BCE, her son Tiberius was but a toddler and she was pregnant with Drusus, both of whom remained the legal sons of her former husband Tiberius Claudius Nero. After the latter's death in 32 BCE, the two boys were raised in Augustus' household and promoted by him as if they were his own sons, but he adopted only his direct descendants, grandsons Gaius and Lucius. Only after their deaths did he turn to his stepson Tiberius, with whom he had no blood connection, on the proviso that he, in turn, adopt Germanicus, whose offspring were Augustus's own great-grandchildren.

Although the sequence of adoptions of the consecutive emperors Trajan, Hadrian, Antoninus Pius, and Marcus Aurelius resulted in a long era of good government—and suitability for the considerable responsibilities of the principate was surely a factor in their selection—it could also be considered chance, based in the childlessness of Nerva, Trajan, and Hadrian and the death of Antoninus's two sons before his adoption by Hadrian in 138 CE. Marcus Aurelius abandoned the practice; six of the seven sons borne him by his wife Faustina pre-deceased him, but the surviving Commodus was advanced by his father and succeeded him in 180 CE. Certainly, adopting a successor while having living male offspring could be considered an invitation to civil war, but the civil war would come anyway, following Commodus's assassination in 192 CE.

of the Republic; indeed, he was the first to achieve the principate by neither birth nor civil war. He was from a consular family raised to patrician status by the Flavians, and held the quaestorship, praetorship, and in 91 CE, the consulship. He had spent the better part of his adult life on military campaign; he was governor of Upper Germany at the time of his adoption by Nerva in 97 CE at the age of forty-three—coincidentally the same age that the Republican *cursus honorum* had determined to be most suitable for highest office. Most important for Nerva's purposes was Trajan's popularity with the troops, who were pacified by the prospect of his succession. Of more lasting significance still was Trajan's origin. His distinguished family was originally from Italy but had for centuries lived in Baetica (southern Spain), where Trajan himself was born (in Italica); consequently he represented the growing influence of a provincial aristocracy that was to effect the transformation outlined above. Although Nerva's decision was probably a necessary expedient rather than a conscious policy change, his choice of Trajan, who was unrelated by blood, not Italian-born, and chosen solely on the basis of merit, initiated a practice that contributed in no small way to the stability and good fortune of the following century.

Owing to Trajan's absence from Suetonius's biographies, which end with Domitian, and from the narratives in the anonymous *Historia Augusta* (*Augustan History*), which begin with Hadrian, our sources for his personality are indirect; his character is best inferred from his actions, which are, however, well documented. A military man, Trajan lost no time in initiating his first major campaign. Domitian had acceded to (from the Roman, or at least Trajan's, point of view) excessively generous terms with the Dacian king Decebalus, an agreement for which he celebrated a triumph in 89 CE. The Dacian, supposedly now a Roman client king, whose realm lay north of the Danube (in modern Romania), was making incursions into the Roman province of Moesia south of the river, and Trajan set off in 101 CE in order to drive him back and punish him. He may also have wished, as did many emperors before him, to enhance his already considerable military prestige by celebrating a triumph as *princeps*. He would, moreover, solidify his reputation among the armies by completing business left unfinished by Domitian, who was never as unpopular with the troops, whom he treated generously, as he was with the senate, which feared and despised him. Dacia was also rich in certain resources, especially gold, and spoils from the war would offer Trajan the chance to adorn Rome in a manner not seen since the time of Augustus.

It took two campaigns (in 101–2 and 105–6 CE) and the suicide of King Decebalus himself to entirely subdue Dacia, which was then made a province with Decebalus's capital, Sarmizegethusa, now a Roman colony. After a brief interlude spent on his building program in Rome, Trajan left again in 113 CE on an eastern campaign, similarly prompted by the interference of a foreign power, the Parthian king Osroes, in the affairs of a client kingdom (Armenia). After initially meeting with great success, but ultimately encountering some setbacks, Trajan took ill and died (117 CE) in Cilicia (Asia Minor) while on his way back to Rome. During Trajan's reign, new provinces were added in the Near East (Armenia, Arabia, and Mesopotamia), which, with the previous addition of Dacia, pushed the borders of the Roman empire to their greatest extent. Trajan had well earned his title **Optimus Princeps**, voted to him by the senate already in 114 CE.

IMPERIAL PORTRAITS

The portraits of Nerva and Trajan were, as were the men themselves, serious and straightforward. Nerva opted for a slightly idealized veristic style, reflecting his advanced age, senatorial experience, and, no doubt, his noble Italian origin. Analysis of his portraiture is hampered by the fact that most, at least, of his extant portraits were recut from images of Domitian, as seen in the previous chapter (on the Cancelleria relief, see 6.30, p. 176 and 6.31, p. 177 and the equestrian bronze from Misenum, see 6.25, p. 173). The row of curls across the forehead probably reflects the need to modify forms from an earlier head, since on his coins [9.1] he chose to be represented with a row of sickle-shaped locks that resemble more the Augustan and early Julio-Claudian pattern than that of Nero and Domitian. His aristocratic aquiline profile, however, is consistent and unmistakable.

9.1 Aureus of Nerva, 96–97 CE. Gold. Depictions of Nerva tended to adopt an idealized veristic portrait style reflecting his age and senatorial experience.

Trajan invoked the image of Augustus more openly. His portrait similarly captured its subject at the point of accession to power and, over a long reign, maintained that image with only minor changes. In Trajan's most typical portrait from the middle of his reign [9.2], his hair is arranged in a simple pattern of clearly defined locks that fall loosely and far down over the forehead, with a typically Julio-Claudian part over the right eye. Trajan's face, however, does not strongly remind us of the first emperor, although his serious, intense facial expression, with its firmly set mouth and piercing eyes, is not unlike portraits of Augustus, especially early ones. Trajan's portrait admits the lines of a man in early middle age, reflecting precisely the qualities for which he was chosen to succeed.

A second portrait of Trajan, from Ostia, resembles those of Augustus more closely, especially through the much greater sense of volume in carving the locks of hair and the distinct "pincers" motif over his left eye [9.3]. The facial features are unmistakably Trajanic, but the expression is less intense and momentary, and the total effect is more Classicizing than in typical earlier portraits. The portrait is carved from Greek marble and therefore might be of Greek manufacture and workmanship; Classicizing styles remained popular in Greece from Hellenistic times to the end of the empire. The portrait is also thought to be posthumous and showing Trajan as *divus*, so the Classicism may also be related to his recently achieved status as a deity, connecting him directly to the iconography of imperial *divi* that started with Caesar and Augustus. Finally, if it was made after Trajan's death, the portrait would belong to the subsequent era of Hadrian, who, as will be seen in Chapter 10, is notable for his use of Classical sources.

9.2 Portrait of Trajan, Italy, 2nd century CE. Marble. H. 74 cm (2 ft 5¼ in.). While Trajan's face is dissimilar to Julio-Claudian portraiture, particular elements, such as certain features of his hairstyle, the set of his mouth, and intense stare in this typical mid-reign portrait, do faintly echo Augustus.

9.3 Portrait of Trajan from Ostia, Italy, 2nd century CE. Marble. H. 49.2 cm (1 ft 7⅜ in.). The "pincer" hair motif above the left eye is a direct allusion to portraits of Augustus.

Trajan's Buildings in Rome

As the first emperor of provincial birth, Trajan inaugurated a century of increasing cosmopolitanism. It should come as no surprise, then, that his chief architect was a Greek from Syria—Apollodorus of Damascus. Literary sources connected Apollodorus with a number of Trajan's major works in Rome, and he was plausibly involved with Trajan's entire program. In addition, Apollodorus accompanied Trajan on campaign and became famous for such feats of engineering as a great bridge built over the Danube by Trajan's troops. Though commissioned by an emperor born in a province, and designed by an architect from a provincial background, what is most striking about Trajanic monuments in Rome is their adherence to very Roman traditions of plan, elevation, materials, and decoration. The style of architecture was not conservative by any means, since traditional elements were recombined in imaginative, even unprecedented ways, but architecture and sculpture created under Trajan still referred to conventions set by Augustus and, before him, the Republic. Extensive importation of foreign forms would await the innovations of Trajan's successor, an architect himself and, as we shall see, no friend of Apollodorus.

BATHS

Apollodorus's first great work in Rome was an extensive bathing complex built on the Oppian hill, on top of the remains of the Domus Aurea. The Baths of Trajan, as they are called, were dedicated in 109 CE as a continuation of the Flavian program of restoring to public use the grounds of Nero's villa, this part of which had been damaged by fire five years earlier. As seen in Chapter 7, remains of earlier imperial baths suggest that Apollodorus probably did not invent the classic, symmetrical plan, but his baths were on a scale that had not been dreamed of previously. Trajan's baths occupied over five times the area of Titus's, a comparison that no one could miss, since the two complexes were only a few feet apart [9.4]. Indeed, the central bathing block alone of Trajan's baths was larger than Titus's entire complex, circuit wall and all. The bathing rooms were, in what was from now on a conventional arrangement, organized symmetrically about an axis running through a sequence (from northeast to southwest) of three great spaces: the porticoed *piscina*; the great triple-bayed, cross-vaulted central hall with plunge pools (*frigidarium*); and the heated area facing south (*tepidarium* and *caldarium*).

The bathing block was set within a surrounding structure that was not simply a wall but a building in itself, incorporating dozens of rooms as well as exedrae with niches for statuary. Throughout the complex, with its curvilinear rooms and vaults both enormous and intricate, Apollodorus showed his mastery of brick-faced concrete construction in the tradition of Domitian's architect Rabirius. Moreover, this, the first of what would be several very large imperial bathing complexes, was far more than simply a place to bathe (see box: Seneca and Life in a Roman Bath, p. 240). Thousands of Romans could meet, mingle, socialize, and transact business at the baths. At the same time both bath and forum, these complexes were among the most conspicuous, and most thoroughly enjoyed, of the emperor's architectural gifts to the Roman people. The idea of this more expanded version of a Roman bath may have been influenced by

9.4 Plan of the Baths of Trajan, Rome, Italy, dedicated 109 CE. Built by the architect Apollodorus of Damascus, Trajan's baths were of an unprecedented scale.

Seneca and Life in a Roman Bath

1. Imagine what a variety of noises reverberates about my ears! I have lodgings right over a bathing establishment. So, picture to yourself the assortment of sounds, which are strong enough to make me hate my very powers of hearing! When your strenuous gentleman, for example, is exercising himself by flourishing leaden weights; when he is working hard, or else pretends to be working hard, I can hear him grunt; and whenever he releases his imprisoned breath, I can hear him panting in wheezy and high-pitched tones. Or perhaps I notice some lazy fellow, content with a cheap rubdown, and hear the crack of the pummeling hand on his shoulder, varying in sound according as the hand is laid on flat or hollow. Then, perhaps, a professional comes along, shouting out the score; that is the finishing touch.

2. Add to this the arresting of an occasional roisterer or pickpocket, the racket of the man who always likes to hear his own voice in the bathroom, or the enthusiast who plunges into the swimming-tank with unconscionable noise and splashing. Besides all those whose voices, if nothing else, are good, imagine the hair-plucker with his penetrating, shrill voice—for purposes of advertisement—continually giving it vent and never holding his tongue except when he is plucking the armpits and making his victim yell instead. Then the cake-seller with his varied cries, the sausage-man, the confectioner, and all the vendors of food hawking their wares, each with his own distinctive intonation.
(Seneca, *Epistles* 56.1-2)

This letter to his friend Lucilius was written by Seneca, a philosopher, playwright, and advisor to the young Nero, by whom he was forced to commit suicide in 65 CE. It is the most vivid of several passages from his writings that refer to the disparate functions, and somewhat chaotic environment, of a Roman bath. A great public-bath complex, such as Trajan's, provided many spaces, both large and small, for a wide variety of activities. The bathing process itself took place in the central block. A hot room, fed by wood-fueled furnaces (believed to be a primary cause of deforestation in the Roman-era Mediterranean), was placed at the south end of the complex, taking advantage of greater exposure to the sun. This *caldarium* included a dry hot area surrounded by heated pools in apses. To the north ranged rooms of decreasing temperature, with their obvious designations: *tepidarium*; *frigidarium* (here was a great cross-vaulted central hall with plunge pools in its projecting alcoves); and swimming pool (*piscina*). These spaces were flanked by exercise yards (*palaestrae*) for wrestling, weight lifting, and other forms of workout. The entire bathing block was entered and exited from the north through locker rooms (*apodyteria*) in which slaves would look after one's belongings as well as provide massages, depilation, and other services on request.

The bathing area, however, often comprised less than half of the complex's total footprint. It was enclosed by a circuit structure of myriad rooms and apses, elaborately adorned with veneer, stucco, mosaic, and paint. The open area was for social and commercial interaction; surrounding structures included lecture halls (as in Greek gymnasia, with which the Roman bath had much in common), fountains, and elaborate statuary displays. These displays included statuary appropriate in scale and subject to the space (see Baths of Caracalla and its Decorative Program, p. 326) as well as imperial portrait groups. The many small rooms were surely shops, many of which, as Seneca suggests, were for the purveyance of snacks, and so resembling a food court in a modern shopping mall. All the exercise must have given everyone a hearty appetite.

Seneca's comments do seem somewhat condescending, and one must remember that these complexes were not restricted to the elite but open to all, including women, who had their own baths or limited hours of exclusive use of public baths, although mixed bathing did take place in some cases. The baths were not free but the admission fee was nominal, so they were affordable for all but the most destitute. The Romans took the activity of bathing very seriously; it was a central practice of their culture, and the building of luxurious public baths was one of the most conspicuous ways in which an emperor might remind bathers whom to thank, not just for this temporary respite from urban filth and mayhem, but for making their lives more secure and pleasurable in every way.

the Greek gymnasium, where men had bathed, exercised, and philosophized since the Classical era; Cassius Dio, the Asiatic Greek historian who listed the baths among Apollodorus's works, in fact referred to the structure as a gymnasium, and the bath/gymnasium hybrid was a common feature in the cities of Roman Asia Minor. In form and construction, however, Trajan's baths

reflected a direct continuation of a Roman tradition that began with the public bathing complex built by Agrippa in the Campus Martius (see 7.23, p. 198).

MARKETS

Literary sources attributed three more architectural works in Rome to Apollodorus—an odeum (a musical hall), a bridge over the Danube, and the Forum of Trajan. The only odeum known to have been erected in Rome was built during the rule of Domitian. It is possible that Trajan restored this building, or perhaps Apollodorus had previously worked for Domitian. There is no proof for either hypothesis, although the fact that Domitian appeared to have been planning a forum in the location where Trajan's was later built might lend some credence to the latter possibility.

There is no documentation of Apollodorus's involvement in one of Trajan's great architectural contributions to Rome, namely the markets that are terraced around and above Trajan's forum up the Quirinal hill to the northeast [9.5]. Yet the close physical relationship between markets and baths, and the brilliant and imaginative application of traditional building forms and techniques to an enormously challenging site, suggest that Apollodorus was involved.

A complex of approximately 170 rooms was arranged on six levels around the northeast hemicycle of the Forum of Trajan, which was screened by a high wall. As in the bath complex, the architect here exploited the cohesive strength and flexibility of brick-faced concrete, and also began to explore its decorative possibilities. Behind the high, curved forum wall at the second story, invisible from the forum square and barely seen from the curved roadway below, an arcaded row of windows was framed by an architectural order not rendered in applied travertine masonry but in the brick facing itself, accented by stone capitals and bases [9.6]. This was a fanciful pattern, as much wall painting as architecture in concept, with alternating triangular, broken, and lunate (crescent-shaped) pedimental moldings crowning each arched window. Whether the whole was stuccoed is disputed, but this decorative manipulation of brick facing marked an innovation that would be continued extensively in the second century, most conspicuously at the port of Ostia (discussed p. 254). The curve of the apse, street and facade here can be seen repeated in a second street at a

9.5 Plan of Trajan's Markets and the Forum of Trajan. The forum contains the Basilica Ulpia at one end.

9.6 The curved facade of Trajan's Markets, Rome, Italy, 113 CE. The brick-faced concrete was treated as decoration in itself.

CHAPTER 9: ART IN THE REIGN OF TRAJAN 241

9.7 The Aula Traiana of Trajan's Markets, Rome, Italy, 113 CE. The modern name is used for the large, multi-storied, cross-vaulted space.

higher level (the via Biberatica) and the rooms in this section radiate out from this curved connecting armature at each level.

Structurally, the markets' most interesting element is the so-called Aula Traiana, a modern name given to a large, cross-vaulted space that is reminiscent of a basilica with its two-storied arrangement and lighting from openings in the upper stories (clerestory) [9.7]. Architecturally, however, this hall is as different as it can be from the post-and-lintel planning of the traditional Roman basilica. The split-level structure accommodates "shops" at three levels on its downhill side and two levels uphill from the central space, the vault of which is cleverly reduced in **span** by **corbeling** out its **springing point** from the supporting pilasters. The substantial remains today show us just the brick-faced core, with door and window frames carved in stone. Fragments of architectural marbles suggest a more magisterial effect, and most or all of the interior space's brick, as mentioned, should have been originally stuccoed and painted, modeled, or veneered. This was surely an area allocated for carrying out official activities, but just what all these rooms were used for is not at all certain, and the markets are not mentioned in the ancient sources. Fewer scholars today than previously view this complex as having been a real center of commerce—a Trajanic shopping mall, as it were—and most prefer to see it as having been an imperial administrative center that may have been used for the direct distribution of money and grain to the populace.

FORUM OF TRAJAN

Contrasting in every way with the markets, which were only possibly designed by Apollodorus, is Trajan's forum, which most certainly was. If the markets demonstrated a significant advance in the "new" architecture of curve, vault, and concrete, then the forum was a culmination of centuries of development in the "old" rectilinear architecture of colored marble, columns, and entablatures. Much was borrowed from the plans of previous imperial fora. From the Augustan forum we see quoted: the semicircular exedrae (repeated at the short ends of the basilica); a centrally located colossal image of the emperor (in this case equestrian); figured supports in the attic story (in this case Dacian prisoners rather than Classical caryatids); and, between these figures, clipeate heads. Instead of depicting Greco-Roman deities, these were portraits of earlier imperial personages, therefore citing, in function at least, the assemblage of ancestors and predecessors that

242 PART III: THE HIGH EMPIRE

appeared in the porticoes in the Augustan Forum. From the Templum Pacis, Apollodorus borrowed the features of formal plantings for the forum square, and the Greek and Latin libraries. In a further nod to the tradition of imperial fora, Trajan's forum includes a large, open porticoed space that constitutes the greater part of the complex. In many other ways, however, it is different.

The open forum space occupied the southeast sector of the complex, stretching toward the Forum of Augustus. At the northwest end of the forum stood the huge and spectacularly ornate Basilica Ulpia. This arrangement reflected a longstanding tradition, going back to the mid-Republic, in which a basilica would be constructed with its long side flanking the forum, as can be seen in the Forum Romanum and innumerable city squares all around the empire. Basilicas did not occur in any of the other imperial fora in Rome, though. Centered on its forum facade, the basilica was entered through a monumental gateway, resembling a triumphal arch. The interior of the basilica [9.8] was entirely composed of traditional post-and-lintel forms, colonnaded nave and aisles, and a second-story gallery, all no different in principle from, for example, the much earlier Basilica Aemilia in the Republican forum. Passing through the Basilica Ulpia along the short axis, one would enter a surprisingly constrained space, flanked on either side by a tall library, one for Greek texts and one for Latin, and come face to face with an enormous commemorative column (see p. 247).

The most striking difference from the fora of Caesar, Augustus, and Domitian is the apparent absence of a temple overlooking the open area of the forum (its point of focus is replaced here by the Basilica Ulpia). The Templum Pacis (see Templum Pacis, p. 195) of Vespasian reflects a step toward such an arrangement, since its temple was incorporated into the east portico, marked out only by its minimally projecting, pedimented facade. If the Forum of Trajan did include a temple, it did not dominate the open space of the forum but was possibly placed within a relatively small, semi-elliptical colonnaded court that opened onto the small courtyard containing the

9.8 Reconstruction of the interior of the Basilica Ulpia, Forum of Trajan, Rome, Italy, 2nd century CE. Based on the Packer reconstruction. Reliefs decorating the basilica's interior included Classicizing depictions of military victories, referencing Trajan's victory in the Dacian wars.

Where Was the Temple of *Divus Traianus*?

Each of the first four imperial fora in Rome consisted of a courtyard surrounded, at least in part, by porticoes and a temple centered on one short end. In the case of the fora of Caesar, Augustus, and Domitian, these were high podium temples of significant scale relative to the spaces that they overlooked. The Temple of Peace in Vespasian's forum was similarly placed, but less dominant, as it was principally built into a surrounding colonnade. The excavated area of the Forum of Trajan, however, has yielded no platform or even foundations for a temple. The temple of *Divus Traianus* is specifically mentioned in the ancient sources, particularly in the *Historia Augusta*, which tells us (incorrectly) that it was the only temple on which Hadrian placed his name. The temple is also mentioned in the Fourth Century Regional Catalogs of Rome together with Trajan's forum, which suggests that it was nearby. Early (eighteenth-century) soundings in the area west of the forum found fragments of grey granite columns with marble Corinthian capitals, similar in material and style to (but larger than) those in the lower interior order of the Basilica Ulpia. Part of the temple's dedicatory inscription was found in a nearby church, and is presently held in the Vatican Museums. A coin type from around 111 CE shows a tall podium temple inside a portico around which runs an inscribed dedication from the senate and the Roman people to "*Traiano Optimo Principo*"; although the coin is considerably earlier than the Hadrianic temple. it is often used as a guide for reconstructing it, which could suggest that the plans for its eventual inclusion were quite detailed. From this disparate evidence the most commonly reproduced plan of the west end of the forum was created, showing an octostyle Corinthian temple, similar in scale and form to the temple of Mars Ultor, set within a semi-elliptical portico that opened onto the courtyard containing the commemorative column. Some scholars have theorized that this entire section of the complex west of the basilica was added by Hadrian, the column having previously stood in the north apse of the forum.

The area in which the temple is assumed to have stood is in the modern Piazza Venezia (a central square of Rome) and now occupied by two small churches and two palaces (*palazzi*). In the basements of one of the latter, Palazzo Valentini, soundings were taken in the 1990s and no trace of a temple was found where it had been traditionally thought to be located. Archaeological excavations of the Roman imperial levels underneath the *palazzo* produced the fourth-century CE remains of a private bathhouse and large townhouses for wealthy Romans, which are now on public display.

Controversy continues over the location of the temple. Some maintain the traditional arrangement. Others had suggested that the temple complex might be at the very opposite end of the forum, in unexamined space between its east end and the west wall of Augustus's forum, but excavation has since disproved that theory. It has been proposed that other buildings in Trajan's forum, such as the libraries or the courtyard containing the column, were locations of imperial cult and therefore a kind of temple to the emperor. A compromise theory keeps the temple in the traditional location but shifts it slightly so as not to be occluded by excavated remains. This would mean a smaller temple, which contradicts the coin evidence (which is spurious as evidence in any case, given its earlier date) and places it off axis with the forum. In this hypothesis it was not part of the forum *per se*, but another Hadrianic complex that included Trajan's (and eventually his wife Plotina's) tomb (by this theory they were not buried in the column base—see p. 247) and temple in a curved courtyard, bordered by large radiating rooms that included a library and lecture hall. Until foundations of the temple can be definitively identified, however, it seems unlikely that the debate over its location will end.

immense commemorative column and flanked by the libraries. The location of a temple is presently a point of significant debate among scholars (see box: Where was the Temple of *Divus Traianus*?, above). If this suggested location does actually represent the original arrangement, then the column, along with the basilica, entirely blocked the temple from the view of those in the forum proper—a significant deviation from the design of the earlier fora.

Trajan's forum shares with all the imperial fora an extravagant use of colored marbles and the creation of a space meant to impress and overwhelm the viewer. While Trajan's Markets are not mentioned in ancient literature, the forum most certainly was, most famously by Roman solider and historian Ammianus Marcellinus (c. 330–395 CE), who related the first visit to Rome in 357 CE by the later Roman emperor Constantius II (r. 337–361 CE). Constantius, of

course, ruled from the equally impressive city of Constantinople.

> [Constantius] came to the Forum of Trajan, a structure which, in my opinion, is unique under the heavens, and a marvel which even wins the acceptance of the divine powers, he stopped in his tracks, astonished, while his mind tried to grasp the gigantic complex, which cannot be described by words and could never again be attempted by mortal men.
> (Ammianus Marcellinus, *History* XVI.10.15)

Even an emperor was awed. Modern computer reconstructions, aided by a thorough recent study of the site and building remains, help provide some idea of the splendor of the structure. The view would have been one of columns of grey granite (inside the basilica, those standing still today, green *cipollino* (upper order of the basilica interior), golden *giallo antico*, violet *pavonazzetto*, similarly colored pavements and wall revetment, and white marble capitals and column bases. Add to this the statuary and reliefs in *pavonazzetto* (the draped portions of the Dacians), white marble, and glimmering polished and/or gilt bronze. The effects of color, texture, mass, light, shade, and reflection would have been dazzling (see box: Colored Marbles and Exotic Stones, p. 246).

The forum was dedicated, probably unfinished, in 112 CE, to commemorate Trajan's victories in Dacia, shortly before his departure for the Parthian campaign. The references to the Dacian wars are clear enough to see: in the captives depicted on the attic; the frieze of Neo-Attic victories (quoting groups that appear on the Classical Nike parapet on the Temple of Athena Nike on the Acropolis in Athens) that adorned the basilica's interior [9.9]; the reliefs with captured arms on the basilica's facade; the gateway into the basilica from the forum in the form of a triple-bayed triumphal arch; and the "Great Trajanic Frieze" (now on the Arch of Constantine, see p. 250).

9.9 Frieze from the Basilica Ulpia, Forum of Trajan, Rome, Italy, 2nd century CE. Marble. H. 75 cm (2 ft 5⅝ in.). The relief depicts victories sacrificing in thanks for military success; the figural types are drawn from the parapet of the Temple of Athena Nike in Athens, erected c. 425–420 BCE.

CHAPTER 9: ART IN THE REIGN OF TRAJAN

MATERIALS AND TECHNIQUES
Colored Marbles and Exotic Stones

Used for the lavish decoration of privately funded public buildings since the late Republic, colored marbles and other imported stones of all varieties were secured at great expense, such as in the home of Lucullus or theater of Scaurus (see discussions on pp. 76 and 106). The practice was clearly derived from the palaces of Hellenistic kings, who exploited many of these same sources for their own buildings. The so-called Roman First Style of wall painting, which is characterized by its imitation of such polychrome veneered interiors, appeared extensively in the palaces and tombs of Macedonia well before the Roman conquest.

In public building works, materials could also be chosen programmatically with reference to their sources, with Italian stones (and terracotta) asserting the importance of local tradition, and imported marbles and foreign, colored stones, such as the Egyptian stones in the Temple of Apollo Palatinus, signifying the incorporation of their place of origin into the possession and control of the senate and the Roman people. The practice began in the Republic, but the emperors continued it in public buildings and complexes, for example the Forum of Trajan, to achieve remarkable visual effects.

There follows a brief list of some typically used stones and their characteristics; the Italian nicknames that are used for some were assigned by early archaeologists in Rome. (For illustrations, see: http://www.livius.org/articles/misc/natural-stones-and-minerals/.)

Carystian Marble (*cipollino*): Green-veined whitish marble from Carystus, at the southern tip of the island of Euboea in Greece. Its Italian nickname reflects the resemblance of its veining to a cut onion. Popular for architectural elements, especially decorative columns.

Giallo Antico: Bright-yellow granite from Numidia in North Africa. A similarly colored marble sometimes bears the same name.

Granite: Pink granite, from Aswan, was used for the many obelisks imported into Rome at great cost. The reference to Egypt in the frequent use of this material for massive columns, such as those in the porch of the Pantheon, would be obvious. Grey granite from the same area was also popular.

Luna Marble: The most commonly used Italian marble from Luna (Carrara) in northern Tuscany, close to the border with Liguria. A fine-grained white marble, often with grey veins, that closely resembles some Greek marbles, especially Pentelic. It was used extensively for sculpture, for example in the Ara Pacis and the columns of Marcus Aurelius and Trajan, as well as for architectural columns and entablatures, such as in the Forum of Augustus.

Nero Antico: Black, or nearly black, marble from Mount Taygetus, which separates Laconia from Messenia in southern Greece. A similarly named stone comes from Tunisia.

Pavonazetto: Grey (sometimes reddish) veined white marble from Docimium in northwestern Asia Minor. Generally referred to as Phrygian by the ancient sources. Used for the pavements of the Forum of Trajan. Whitish varieties were used for sculpture, sometimes juxtaposing the two different colors for contrast. The quarries were imperially owned and this type of marble was extensively used in Rome.

Porphyry: Very hard dark-purple stone from quarries along the central Red Sea coast of Egypt (Mons Porphyrites). Popular especially for portrait sculpture in the later empire, as well as sarcophagi, altars, and bases.

Proconnesian Marble: Grey-veined white marble from the island of Proconnesus in the Sea of Marmara (which takes its name from Greek for "marble"). Its veining often runs in parallel lines, in contrast to marble from Docimian, which is more reticulate. Used for sculpture and architecture, especially columns.

Rosso Antico: Dark-red marble with black and/or white veining from the Southern Peloponnese in Greece.

Travertine: Whitish, sometimes marble-like limestone deposited by mineral springs. It was widely available in the environs of Rome, especially Tibur (Tivoli). Much of Rome, both ancient and modern, bears the stone on its exterior, most conspicuously on the Colosseum.

Tuff/*peperino*: Tuff refers to local volcanic stones, easily worked when freshly quarried and extensively available, and used, in Etruria and Latium. It had a very rough surface when cut, and was principally used by Etruscans and Romans alike for building substructures and temple podia. A finer variety called *peperino* was believed to be fireproof, and appears conspicuously in Rome in the great wall separating the Forum of Augustus from the Subura tenement area to the north.

Column of Trajan

The most conspicuous monument in the forum, which also constitutes its most radically innovative element, is the approximately 30-meter-tall (100 feet) Carrara-marble commemorative column erected in the small square portico between the two libraries and the north wall of the Basilica Ulpia [9.10]. It was set on a large rectilinear base, with a dedicatory inscription and reliefs of armor, which served to elevate the column nearly another 6 meters (20 feet) and ultimately provided a resting place for the emperor's cremated remains. The surviving inscription on the column base makes no mention of this funerary function—indeed some deny that it ever served in this way—but simply states that the column indicated the amount of earth that was removed to make way for the forum. This is a clear indication that the complex was meant to impress not only with its opulence and its enormity but also, by implication, the amount of labor and expense that was entailed in bringing it about.

It is possible to read a similar intention in the reliefs that wound around the column in a continuous spiral frieze depicting, from bottom to top, Trajan's two Dacian campaigns. Twenty-three bands of relief can be divided into over 150 individual scenes comprising some 2,500 figures, with the emperor himself depicted around sixty times. As one would expect, battles and sieges are shown [9.11], but these make up barely a quarter of the total frieze. Most of it has to do with the necessary adjunct activities of war—marches, camp-building, sacrifices to ensure

9.10 Trajan's column, Trajan's forum, Rome, Italy, dedicated in 113 CE. H. c. 30 m (100 ft) without base. The column was set on a rectangular base. A continuous frieze winds around the column depicting Trajan's two campaigns against the Dacians.

9.11 Battle scene from Trajan's column, Trajan's forum, Rome, Italy, dedicated in 113 CE. Barely a quarter of the 150 individual scenes on the column depict scenes of combat or sieges.

CHAPTER 9: ART IN THE REIGN OF TRAJAN 247

9.12 Oration scene from Trajan's column, Trajan's forum, Rome, Italy, dedicated in 113 CE. Many of the relief scenes on the column depict activities that took place before and after the Dacian battles, including the emperor's orations to the troops.

good fortune, receiving of embassies, orations before the troops [9.12], inspection of camps—with the emperor himself attending to every detail. Unlike the two Flavian monuments we considered (the Arch of Titus and the Cancelleria reliefs), Trajan's column does not concern itself with portraying the emperor in divine company; indeed, there are only two instances of myth or allegory of any kind. At the base of the column troops cross the Danube, the river here shown as a personification, and the figure of winged Victoria is shown in her characteristic activity of inscribing a shield, serving to divide the accounts of the two campaigns [9.13]. What is emphasized here is less a Homeric-style heroism of armed combat than the vast set of complex logistical problems it presented, especially for the typical Roman campaign carried out far from home base. The emperor, on this monument, lacks the quasi-divine elevation suggested in such portrayals as found on the Gemma Augustea or Arch of Titus. Here he is seen as the supremely competent administrator who adheres to protocol, trusts in the Roman gods, attends to detail, and selflessly serves Rome and her people. Trajan was a great soldier, as everyone knew, but the qualities stressed in these reliefs were transferable to all aspects of imperial rule, not limited to warfare alone.

The style of relief is relatively conventional. Foreground figures stand firmly on the ground, other figures are sometimes elevated to suggest their placement in a deeper plane. Figures do not fill the ground, as in Classical relief, nor are they realistically small in comparison to the landscape and buildings. Most are about half the height of the relief band, which increases from 0.89 to 1.25 meters from the lowest to the highest sections of the column. Most action takes place, as is the case also in Classical art, within a narrow space between the foreground and background planes. There is not much spatial penetration or projection, and the vast majority of figures are in profile or three-quarter view. The relief itself is not exceptionally high and it is debated whether the reliefs were painted. Visibility is therefore an oft-discussed and disputed aspect.

Only the top of the column would have been visible from any viewpoint in the forum complex outside the tiny square courtyard in which the column stood. Even standing there, the very lowest bands of relief were at least 6 meters (20 feet) away, and the angle of viewing from this spot would have been extremely sharp.

It was once thought that the second-story galleries on the library facades were provided for a better view of the column, but it is now generally accepted that the view would only have been minimally better and only for the lower portion. We have to assume that the clearly designed and defined relief compositions, which derived from stock scenes known from many earlier Roman depictions, would have allowed a reading based on concepts conveyed to an eye conditioned to comprehend the scenes depicted—such as battle, the emperor addressing his army (*adlocutio*), and sacrifice. The general message of the column would have been clear enough, and it certainly was reinforced by the profusion of martial iconography throughout the forum complex.

If this was the modest purpose of the relief, however, then why the extraordinary degree of detail in the rendering of armaments, equipment, and battle techniques? Was this the result of working from written eyewitness accounts brought back from the front, or does it (just as the invisible finished backs of the Parthenon pediments are believed to) reflect the pride of the stonecutter, to whom it mattered little if others could not admire his craft so long as he did himself? This would be completely consistent with the objectives of the monument. While much of the detail itself would be lost to the distant viewer, certainly one could see it in the most legible sections, especially if painted, and could imagine its presence elsewhere on the column. As in the literary genre of realism, detail is a narrative device used to enhance the veracity of what the reader perceives. Similarly, there is an imagery of detail in play here; that is, the very idea of detail is invoked by a depiction meant to express as its main theme the attention to detail shown by the emperor himself.

While the inscription informs us that the column was dedicated in 113 CE, in recent years some scholars have hypothesized that it was first erected elsewhere (in the north apse of the forum, where it would have been much easier to see) and only later moved to its current location. There are indications that extensive work took place in the library area during the reign of Hadrian, and the temple, if there was one there, was certainly Hadrianic, so some consider all of the built area north of the basilica as dating to the time of Trajan's successor. Moreover, at least one respected scholar has suggested that the reliefs themselves were not cut until after this move, but that theory is not yet widely followed. Possibly the most intriguing aspect of the column is its apparent uniqueness at the time. Although the later emperor Marcus Aurelius would be honored by a near-copy toward the end of the second century CE, nothing at all resembling Trajan's column had existed before.

Yet, if, as seems likely, the monument was conceived by Apollodorus, it fits perfectly with his demonstrated ability to blend traditions and, employing his cosmopolitan outlook, create a work of imagination and brilliance. Smaller honorific columns, topped with statues of the honoree, as indeed this one was, were commonplace in the Roman Republic, and many surely still stood in Trajan's Rome. Some were adorned with the actual spoils of battle, for example the prows (*rostra*) of captured ships, but none had the sort of relief found on Trajan's column. Sculptured columns had been used for millennia in the East, especially Egypt;

9.13 Scene with Victory from Trajan's column, Trajan's forum, Rome, Italy, dedicated in 113 CE. The personification of Victory (Victoria) is shown inscribing a shield, and functions to separate the narratives of the two campaigns.

9.14 Frieze from the interior of the Arch of Constantine, 315 CE. Marble. H. 3 m (9 ft 10 in.). The frieze was reused from a Trajanic monument, probably in Trajan's forum. The relief shows two distinct subjects, a *adventus* (returning to a city) at left and a scene of warfare at right, separated from each other by composition rather than framing.

carved marble column drums occur as marks of Orientalism in the massive marble temples erected by the tyrants of Asia Minor in the sixth century BCE, and they recur on their later Hellenistic replacements. But these, as befits their religious function, tend to portray mythological, ritual, or at least allegorical subjects, as does a commemorative column dedicated to Jupiter by Nero in Mainz (Germany).

For his depiction of Trajan's Dacian campaign, Apollodorus most likely drew on the long tradition of triumphal battle painting (see Chapter 2), and the scenes here are probably quite similar to what would have been painted on the placards and canvasses carried in Trajan's triumph of 106 CE. The spiral arrangement is the real innovation, but it seems unnecessary to identify its source in long painted scrolls, which in any case do not seem to have existed in a form similar to that seen on the column. There were many examples of episodic narrative painting and sculpture that worked out stories against a continuous landscape background—for example, the *Odyssey* landscapes or the Telephus frieze at Pergamon (see 3.23. p. 89). The desire to portray the Dacian campaign as one long continuous account consisting of a very large number of individual and temporally sequential episodes, when combined with the decision to erect an honorific column, resulted in the solution worked out on Trajan's column itself—a simple but entirely original synthesis that bears all the marks of Apollodorus's work.

TRAJANIC FRIEZE ON THE ARCH OF CONSTANTINE

One of our richest sources of commemorative sculpture originally commissioned by three "good" emperors, Trajan, Hadrian, and Marcus Aurelius, is the arch erected by Constantine some two centuries later (see Constantine's Building Program in Rome, p. 370). The four battle panels (two within the main bay and one at either end of the arch) are believed to derive from a much longer frieze set up in an unknown location within Trajan's forum, although often in these reused works the heads of the main protagonists have been changed to portray Constantine; one recent reconstruction puts it atop the colonnade surrounding the spiral column. The remains on Constantine's arch represent by far the largest extant portion of this frieze. The subject, not surprisingly, is the Dacian wars, and as on the column reliefs, scenes of battle are interspersed with stock emblems of imperial activity and virtue.

Here we see on the left an *adventus* of the emperor (a scene in which the emperor is welcomed into a city after a military campaign) [9.14], the success of which is suggested by the gathering of soldiers and standard-bearers in the background along with with the divine figures of Roma and Victoria on either side of the emperor. A mixture of the mortal and divine is commonplace in such emblematic scenes as this. Separated only by composition is the far more matter-of-fact scene to the right, showing Roman soldiers defeating their Dacian opponents. The arrangement is innovative, blending the closed, self-defining designs of panel reliefs with the continuous narrative of the spiral frieze. The effect is all the more striking from the fact that a long continuous frieze was itself cut up for reuse. The resulting juxtaposition of the divine and prosaic may be jarring to a viewer seeking a literal interpretation, but all Roman art, however historical it appears, is fundamentally representative; the images here, each in its own way, signifies victory as "mission accomplished."

Trajan's Buildings outside Rome

ARCH AT BENEVENTUM

Rome was filled with triumphal arches, dating back to the Republic, yet as we have seen already, arches could be set up to celebrate events other than warfare, and in places other than Rome. One of the best preserved anywhere was erected in about 114 CE, in honor of Trajan, at the city of Beneventum (modern Benevento) in southern Italy. Similar to the column, it illustrates the expanding range of responsibilities assumed, and commemorated, by the emperor. The arch stood just outside the ancient city, at the point where the via Appia was extended by Trajan (as the via Traiana) to Brundisium (modern Brindisi), which was then, as now, the primary departure point for sea travel to Greece and the eastern Mediterranean. Beneventum was therefore a place much traveled through by Romans moving back and forth between Rome and the eastern provinces, and the arch itself is often interpreted as incorporating a sense of dichotomy between Rome and its provinces, which was a dominant theme of the second century CE. In fact, many scholars have tried to identify a program in which the side of the arch facing the city of Beneventum concerns itself with themes of Rome (the city side) [9.15] and that facing the road to Brundisium with more provincial subjects (the countryside) [9.16]. That may be forcing the issue, but what one can clearly see is a much greater variety of activities and accomplishments cited than in any earlier extant monument of this type.

The form of this single-bayed arch so closely resembles that of the Arch of Titus in Rome that some have tried (unconvincingly) to see that also as having been built by Trajan. Yet here, as elsewhere, Trajanic style clearly continues the major trends of the previous Domitianic era. The primary difference between this monument and the Arch of Titus is the inclusion here of several panel reliefs on the facing sides of the piers (supporting elements) and attic in addition to those at the sides and summit of the vaulted interior. Predictably, some of these have to do with military conquest, but most deal with other matters of Trajanic social, political, and economic policy: assurance of the grain supply by providing Rome with proper port facilities; establishment of the *alimenta*, a state-supported welfare program for poor children; founding of colonies of veterans; traditional scenes of

9.15 (Below left) and 9.16 (Below) Arch of Trajan, Beneventum, southern Italy, 114–17 CE. The arch was built across the via Appia/via Traiana, which connected Rome with the Adriatic coast of Italy and the eastern provinces beyond. The side facing the city of Beneventum included reliefs of Rome (9.15), while the side facing toward Brundisium involved more provincial subjects (9.16).

profectio and *adventus*; and the building of the via Traiana itself.

The style and composition of the vault reliefs strongly recall those of Titus's arch—foreground figures in high relief, their height designed to leave a small amount of ground above, and their arrangement (as also seen on Trajan's column) in a pattern that draws the eye to the emperor. The panel shown here [**9.17**], which refers to the *alimenta*, also mingles historical and allegorical figures, such as the mural-crowned Fortunae of the Italian cities. One should also note the group on the right, with a poor Italian (identified as such by his modest tunic) leading and carrying his two children, which quotes the standard figural motif of Aeneas fleeing Troy with Anchises and Ascanius/Iulus. The vault compositions display **isocephaly**—that is, all heads are at the same level—but on some others, such as **9.18** (which shows, most probably, Trajan's activities at Ostia), the figure of the emperor is much larger than those surrounding him. Various devices for establishing a focus on the emperor develop over time—composition, scale, frontality, and some of them, such as hierarchic use of scale, have a long history in Italic or plebeian art. As we will see, the increasingly obvious location of the *princeps* as the center of attention rather than as "*primus inter pares*" ("first among equals") is one defining characteristic of Roman art across the second and third centuries.

The attic reliefs on the city side of the arch are of especial interest [**9.19**]. The panel to the left of the inscription consists entirely of gods and goddesses—the Capitoline triad of Jupiter, Juno, and Minerva in the foreground and, behind them, Hercules, Mercury, Ceres, and Apollo. As befits their divine status, these figures are purely Classicizing in style, although it is the dramatic, chiaroscuro Classicism of the Hellenistic era rather than any direct imitation of Classical sources. Jupiter, who, similarly to Trajan elsewhere is picked out only by his compositional prominence, seems to stretch out his right hand with the thunderbolt. To the right of the inscribed panel is a relief depicting the emperor in front of an arch and temple, perhaps the Capitoline temple, in the company of personifications, which appear as two small *togati*, and a bearded man in military garb. Trajan holds out his right hand, apparently to receive the symbol of power from Jupiter, an action that therefore traverses the intervening dedication. Such violation of the frame is not unprecedented in ancient art, but it is unusual in such reliefs. Some scholars believe that these two panels do not simply allude

9.17 *Alimenta* relief from the Arch of Trajan, Beneventum, southern Italy, 114–17 CE. H. 2.4 m (7 ft 10½ in.). The *alimenta* was a public fund set up by Trajan for the benefit of poor Italian children.

9.18 Port building relief from the Arch of Trajan, Beneventum, southern Italy, 114–17 CE. Marble. H. 2.7 m (8 ft 10⅜ in.). Trajan here commemorates his work at Ostia, making a sacrifice in the foreground alongside images of deities, including Portunus, the port god, and Hercules as a god of commerce.

to Trajan's receipt of authority from the king of the gods but that they refer specifically to the apotheosis of the emperor, whereby he took his place within the depicted divine assemblage. In this case the arch, although dedicated in 114 CE, would have to have completed after 117 by Hadrian, who may be shown here as the bearded armored figure at Trajan's right hand.

TROPAEUM TRAIANI AT ADAMKLISSI

Sculptured monuments commemorative of imperial accomplishments remain less common in the provinces than in Rome itself, but at Adamklissi (modern Adamclisi) in Romania, the Dacian locals erected in 109 CE the *Tropaeum Traiani* (Trophy of Trajan) to celebrate the pacification of the area. This was, in essence, an extremely large (approximately 30 meters high and 30 meters wide at its base) version of the trophies that had been set up on battlefields since early Greek times, an example of which is depicted on the lower register of the Gemma Augustea (see 6.9). Here, however, the trophy was set atop a great cylindrical drum with a conical roof. The concrete core was faced in local limestone, a material used also for the various reliefs that both decorate and commemorate it. In addition to panels showing conventional scenes of bound captives, a series of metopes were set into the drum-shaped base. The similarity between these scenes and those on such monuments as Trajan's column (for example, battles, *adlocutio* scenes, and forced relocation of the Dacians in carts) suggests a parallel derivation from a stock repertoire. Yet the sculptures at Adamklissi are not at all similar to those carved at Rome and were clearly the work of local stonecutters lacking the Classical training of sculptors working nearer the Mediterranean coast. Figural outlines are simple and the rendering of detail is reduced to incised lines and patterns of drill holes. One metope [9.20] shows a particularly lively and imaginative, if highly conceptual and visually unconvincing, composition in which a tree-borne Dacian archer takes aim at a Roman footsoldier. The unlikely relative scale of those two figures is even more apparent in the overlarge collapsed corpse in the foreground, which as a figural type has a long Classical pedigree. A reversed example on the Aemilius Paullus monument (see 2.22) shows the same thrown-back arm and

9.19 Attic reliefs from the city side of the Arch of Trajan, Beneventum, southern Italy, 114–17 CE. Marble. 2.7 m (8 ft 10³⁄₈ in.). The figure of Trajan is more prominent than the others, demonstrating a developing visual device that focuses on the emperor.

9.20 Metope from the *Tropaeum Traiani*, Adamklissi, Romania, 109 CE. H. 1.6 m (5 ft 3 in.). The relief—local work derived in part from Roman models—depicts elements of the Dacian wars. In this scene, a Dacian archer is up a tree fighting a Roman footsoldier.

CHAPTER 9: ART IN THE REIGN OF TRAJAN

foreshortened leg, although the Dacian artist appears to have misunderstood this last feature. The sculptors here were clearly working from models sent out from the capital, although the execution admitted considerable deviation and bears the stamp of local, provincial work. This underscores the effectiveness of this remarkable act of commemoration by the very people defeated in battle, as it marks what appears to be a willing inclusion within the boundaries of the Roman empire, although it is impossible to know if that effect was in any way intentional.

OSTIA

Ostia (some 24 kilometers downriver from Rome, near the Tiber's mouth) was one of the very first Roman colonies, founded in the fourth century BCE. The core of the city [9.21] retains the basic plan of a square military camp (*castrum*), which goes back to the fortification originally placed here to protect the mouth of the Tiber, which served both as a source of salt and a gateway to Rome itself. At Ostia, seagoing vessels would offload to shallower-drafted boats that could convey cargo to Rome's own riverside docks.

As the empire grew over the succeeding centuries, so Ostia grew in importance. Continual problems with silting at the river's mouth were addressed by Claudius and, more successfully, by Trajan, who built an artificial seaport at Portus, to the north of Ostia, although the latter remained a center of administration and commerce. Owing to the effectiveness of Trajan's harbor works and the vastly increased communication between Rome and the provinces during the High Empire, by far the majority of the extensive remains here are from the second and early third centuries CE, although the town continued to be occupied until the sixth century. Moreover, the finds interest us not only because of what they tell us about Ostia, but also because many building types commonly found here (shops, warehouses, apartment buildings) are largely or entirely missing from the capital. Since Ostia is so close to Rome, identical building materials and techniques were used in both locations, and so through Ostia we get a glimpse of Rome itself.

The clearest mark of *romanitas* in any town was its central forum/Capitolium (temple to the Capitoline triad) complex, and Ostia is no exception. While this was surely the center of the original settlement, in its final form (and surrounded by solid brick-faced concrete structures) it is a work of the second century CE.

9.21 Plan of the city of Ostia, with inset of forum, the harbor city of Rome, Italy, founded in the 4th century BCE. Ostia was one of the first Roman colonies and the city retains the basic plan of a military camp.

9.22 (Below) The Capitolium of Ostia, Italy. This Capitolium, dedicated to Jupiter, Juno, and Minerva, is a key marker of a Roman town. Its current form is from the second century CE, replacing an earlier structure.

The expected elements are here: a large Capitolium on a high podium [9.22] dominating an elongated rectangular open space, alongside which is placed a basilica with its long side facing the forum. There are other civic and religious buildings, including a temple of Roma and Augustus opposite the Capitolium and closing the forum's southern end; only the substructures of this temple are preserved, in reticulate concrete of the early empire. Immediately to the east of this temple is a fine set of baths (the Baths of the Forum, built by the praetorian prefect of Antoninus Pius as a public gift), associated with which is an exceptionally well-preserved latrine.

As one would expect in a prosperous imperial city, Ostia was well equipped with bathing complexes. Smaller city baths, such as those near the forum, usually differ from the giant imperial *thermae* in having a linear arrangement of bathing rooms adjacent to one other, rather than a symmetrical plan. Similar in this respect but much larger than the forum baths are the Baths of Neptune in the northeastern sector of the city, in which the heated and unheated rooms range along the east side of a long porticoed *palaestra*. These baths were entered from the main east–west avenue (*decumanus maximus*) through two sizeable vestibules, each of which preserves extraordinarily fine floor mosaics, datable to around 139 CE, that give the baths their name. The mosaic in the outer room depicts Salacia atop a hippocamp (fish-tailed horse) and riding, we are to imagine, into the inner room to join her husband Neptune [9.23] who drives his own team of four hippocamps. Around him on this huge floor is arranged every variety of sea creature, real and fantastic, some of which must have been made up on the spot. The composition has two parts. The central scene, with the figures immediately surrounding it, faces, and therefore engages, the viewer on first entering the room. The outer rank of fish-like creatures is arranged radially, inviting the viewer to move around the periphery of the room; since this room opens into several others around it, there is an inherent logic in the arrangement.

9.23 Mosaic from the inner room of the Baths of Neptune, Ostia, Italy, c. 140 CE. The mosaic depicts Neptune driving a team of hippocamps.

9.24 Mosaic from the Square of Corporations, Ostia, Italy, *c.* 190 CE. An example of the mosaics that were set in front of the door to each business, depicting some aspect of their activity.

This mosaic, like most of the hundreds of mosaics at Ostia, is made up entirely of black and white tesserae, reflecting the typical style of Italy and the western provinces. This contrasts with the Hellenistic polychrome style that we saw at Delos and in the Hellenized Republican houses and villas located around Vesuvius (see Mosaics, p. 79), and which persisted in the eastern empire. Dated somewhat later than the Neptune mosaic are the emblems in the adjacent Square of the Corporations, a portico into which a series of shipping offices was set, giving the complex an oddly modern feel in its similarity to the rows of competing ticket booths and storefronts found in Mediterranean ports today. A small mosaic was set in the floor in front of the entrance to each business, depicting some aspect of its commercial activity and, in some cases, functioning as a placard as well, such as this one for the "shippers and merchants from Karales (Cagliari)" that depicts both merchant ship and cargo [9.24].

Another business that is well represented at Ostia, and to be expected in any port, is the tavern or inn. These, too, feel strikingly modern in their features: elegant marble counters and, behind them, sinks, shelves on the wall for storing bottles, and sometimes paintings of the food available to accompany beverages that were surely consumed in prodigious quantities [9.25]. These occupied the street-facing first floors not of atrium houses, as at Pompeii, but of large apartment blocks (*insulae*, sing. *insula*, literally meaning island) built up in several stories from beautifully laid brick-faced concrete, often with balconies solidly constructed into the wall masonry and projecting above the street [9.26]. Perhaps what is most striking about Ostia is the expertise that had developed here, after a century or more of experimentation, in making best use of this adaptable building material. The theater here, for example, has architectural orders flanking its arcades, but these are entirely rendered within the brick facing rather than in the applied travertine

9.25 A taverna, Ostia, Italy, *c.* 150 CE. These inns were strikingly similar to modern taverns, with counters, sinks, shelves for bottles, and illustrated menus painted on the wall.

that we see at the Colosseum. While it is commonly assumed, and must generally be true, that the brick facing in Roman buildings was hidden behind stucco or veneer, it is hard to believe that some of the most decorative treatments, such as the famous gateway to the Antonine *Horrea Epagathiana* (a warehouse), were not left uncovered [9.27]. Ostia was, in any case, a lively, well-equipped and attractive town—a fitting gateway between Rome and the empire.

9.26 (Above) Balconies, Ostia, Italy, c. 150 CE. Buildings were often of several stories with projecting balconies.

9.27 Brickwork of the *Horrea Epagathiana*, Ostia, Italy, 145–150 CE. Usually brickwork was covered in stucco, though some careful and attractive brick arrangements suggest this might not always have been the case.

From Trajan to Hadrian

Hadrian was a relative of Trajan and also came from Italica. He was orphaned and taken into Trajan's household as his ward, but not, as far as we can tell, officially adopted until the day after Trajan's death. It was widely speculated that this succession was contrived by Trajan's wife Plotina, long a supporter of Hadrian. On the other hand, Hadrian had been elevated to high office by Trajan and given important commands; there was no other obvious favorite, so Hadrian was very likely Trajan's intended successor. Hadrian, nonetheless, appreciated his position could have been given more clearly and wasted no time in trying to secure his popularity. Upon his return to Rome in 118 CE, the new emperor extended Trajan's alimentary policy and, in addition, ordered a cancellation of public debts, sponsoring a famous burning of records in the Forum of Trajan. So successfully was this continuity in rule asserted that there are a number of monuments that appear to have overlapped the reigns or that could have been differently attributed.

ANAGLYPHA HADRIANI (FORMERLY *TRAIANI*)

Among the monuments that demonstrate the continuity from Trajan to his successor is a pair of reliefs that, it is now agreed, depict events from the beginning of Hadrian's reign—the *Anaglypha Hadriani* (formerly *Traiani*)—found in the Forum

Romanum near the imperial rostra. The term **anaglyph** is used to describe an object carved on both sides. For the *Anaglypha Hadriani*, the reverse of each relief shows a ram, boar, and steer—the *suovetaurilia* sacrifice [9.28]. These two-sided reliefs probably served as a balustrade or other barrier, possibly on the speakers' platform at the west end of the forum. The front of one relief depicts, to the left, an address by a *togatus* atop such a rostrum (note the attached prow) before an assemblage of citizens of various ranks. At the far right, on a raised base is shown a statue group (replicated also on coins) with an enthroned togate Trajan facing a standing female (perhaps a personification of Italia) with two children [9.29]. This is a clear reference to the Trajanic *alimenta*, celebrated extensively on the Trajanic arch at Beneventum. The *adlocutio* figure is less clearly discerned, especially since the missing head of the main figure prevents identification. It might be Hadrian extending the duration of the alimentary program or Trajan bestowing a donation (*congiarium*) to the people.

The front of the other relief clearly shows a burning of debt records [9.30]. The style is reminiscent of the panels on both the arches of Trajan and Titus, with very similar compositional schemes and figural forms, but the designer has left far more open space at the top, creating a more pictorial effect. Each relief shows, at one far side, a fig tree with a statue of a satyr; these are surely the symbolic *Ficus Ruminalis* and Marsyas statue that were both prominent landmarks of the Forum Romanum. Both backgrounds include, in low relief, architectural backdrops that can be identified with specific buildings around the northwestern part of the Republican forum, although it is not always agreed exactly which building is which. Some scholars are more concerned than others by the factual inconsistency that puts the debt-burning in the wrong forum, so much so as to date the reliefs to Trajan's time and suggest another, undocumented debt cancellation. Roman art, with its emphasis on detail, can sometimes seduce us into excessively literal readings, and there were both artistic and programmatic reasons to maintain a consistent setting for both reliefs.

But it is also true that one can detect a distinct iconographic adjustment in imperial visual commemoration under Trajan. Under Augustus and the Julio-Claudians, for example the Ara Pacis or the monumental cameos, one sees the extensive use of myth, ceremony, and especially allegory to convey, in an abstract way, the concepts that were intended to be associated in the mind of the viewer with the idea of the *princeps* and the institution of the principate. The core of that message is quasi-divine status and dynastic continuity that ensures empire-wide peace and prosperity. The tools of narrative, if not the message, shift somewhat with Trajan. On his famous column we see an emphasis on a very specific and detailed accounting of what Trajan attended to as the leader of the expeditions against Decebalus, although we must remember

9.28 The *Anaglypha Hadriani* or *Traiani*, Roman Forum, Rome, Italy, c. 117–120 CE. H. 1.68 m (5 ft 6¼ in.). The relief here shows the *suovetaurilia*, the sacred rite of sacrificing a pig, a sheep, and a bull to the deity Mars.

that this entire account was itself an allegory for the superhuman competence of Trajan as emperor, not simply as a general on campaign. On the Beneventum arch, the vault reliefs depict very specific, even mundane, acts of imperial administration, as do many of the pilaster panels, although these make extensive use of deities and allegorical figures as well.

Various explanations for these differences can be proposed. As suggested above, the employment of specifics might have been designed simply to make the statement more convincingly, but it is also true that a more diverse audience, in an increasingly integrated empire, might more easily comprehend a message that is more explicit and less allegorical. In the same way as Apollodorus's architectural plans, these reliefs both build on tradition and move in a new direction that is reflective of changes all across the empire. Whatever the particulars may be, the objective, and historical message, of the anaglyphs is clear: they were meant to assure the viewer that Hadrian had every intention of continuing, and in fact exceeding, the record of beneficence established by Trajan, the *optimus princeps*, in Rome.

9.30 The *Anaglypha Hadriani* or *Traiani*, Roman Forum, Rome, Italy, *c*. 117–120 CE. H. 1.68 m (5 ft 6¼ in.). The relief here shows the burning of debt records.

9.29 The *Anaglypha Hadriani* or *Traiani*, Roman Forum, Rome, Italy, *c*. 117–120 CE. H. 1.68 m (5 ft 6¼ in.). An anaglyph is an object carved on both sides. These were formally dated to Trajan but are now thought to have been made during the reign of Hadrian. The relief here shows the emperor in a scene of *alimenta*.

CHAPTER 9: ART IN THE REIGN OF TRAJAN

10 The Art of Hadrian and the Antonines

262 Hadrian
- 262 HADRIAN'S PORTRAITURE
- 263 RELIEF SCULPTURE
- 266 HADRIANIC BUILDING IN ROME
- 268 Materials and Techniques: Roman Brick Stamps and the Dating of the Pantheon
- 270 Box: Hadrian and Apollodorus
- 273 Box: Excavations at the Athenaeum

274 The Antonines
- 274 SUCCESSION
- 275 PORTRAITURE
- 276 COMMEMORATIVE RELIEF SCULPTURE
- 280 Box: Bronze Sculpture and the Equestrian Portrait of Marcus Aurelius
- 283 ANTONINE BUILDING IN ROME

Chronological Overview

DATE	EVENT
c. 126 CE	Hadrian completes the Pantheon, Rome
130–138	Roundels on the Arch of Constantine
134–139 CE	Hadrian's Mausoleum
135 CE	Temple of Venus and Roma, Rome dedicated
137–138 CE	Apotheosis and *adlocutio* reliefs in Conservatori
138 CE	Death of Hadrian; Antoninus becomes emperor
141 CE	Temple of Antoninus and Faustina
145 CE	Dedication of the Temple to *Divus Hadrianus*, Rome
161 CE	Death of Antoninus; Marcus Aurelius and Lucius Verus become co-emperors; base reliefs of Column of Antoninus Pius
c. 175 CE	Bronze equestrian statue of Marcus Aurelius
180 CE	Death of Marcus Aurelius; Commodus becomes sole emperor
192 CE	Death of Commodus
c. 193 CE	Completion of the column of Marcus Aurelius

The Development of Rome

Right: Map of Rome showing the key buildings in existence in Rome in this chapter.

Hadrian

Following the death of Trajan in 117 CE, Hadrian's succession was quickly secured in order to negate any questioning of his right to rule. The new emperor lost no time in demonstrating that, although he respected his popular predecessor and his policies, he was a different sort of emperor—one who was perfectly suited to rule what had become a very different sort of empire. While Trajan was the first emperor *from* the provinces, Hadrian was the first emperor *of* the provinces. Trajan came from a family that had risen to prominence through the traditional Roman route of senatorial advancement and had lived in Spain for generations. Hadrian entered the emperor's orbit at a young age and grew up in close proximity to the workings of imperial rule, enabling him to see the responsibility it entailed; in the course of his early career he witnessed Trajan's accomplishments in warfare and administration; and he personally explored the furthest reaches of the empire. These opportunities allowed him to reflect on the empire's nature, as well as that of the principate itself. Accounts provided by Hadrian's later biographers reflect an enigmatic character, impossible to categorize within the traditional models of imperial behavior. He was said to be as skilled a soldier and leader as any emperor before him (he was infamous for his fastidious attention to military discipline), yet more accomplished in the literary, musical, and visual arts than either Nero or Domitian. His love for things Greek was such that he was referred to, derisively, as the *greculus* ("little Greek"). "Alternately aloof and friendly, serious and playful, a delayer and a hastener, miserly and generous, cruel and merciful, he was at all times changeable in all things" (*Historia Augusta*, Hadrian 14.11).

The most striking distinction between Trajanic and Hadrianic policy is the latter's disinterest in imperial expansion. Hadrian had personally participated in both the glories of the Dacian conquest and the far more mixed results of the recent Parthian campaign (in modern-day Iran and Iraq). Similarly to Augustus before him, he recognized that the empire had limits and that these should be defined and respected. The great wall that Hadrian constructed between the Britons and Caledonians was as symbolic as it was functional—a clear representation of his "line in the sand" mentality. He fought wars when necessary to defend only existing Roman territory rather than, as so often in Roman history, a pretext for new conquests. While it may be a historical truism that empires that cease to expand are doomed to contract and collapse, the effects of Hadrian's policy would not be strongly felt until half a century or so later. Yet Hadrian did not sit idly in Rome. He spent most of his principate inspecting the legionary camps at the empire's boundaries (*limes*, pl. *limites*) and touring provincial cities to the east and west, where his visits often prompted substantial new building programs.

HADRIAN'S PORTRAITURE

Among the portraits of Hadrian there is great variety; quasi-divine depictions using stock Classical body types are more common than the more "mortal" togate portrayals. Those showing him in military guise, as was the case for Augustus, symbolize his status as *imperator* of the armies and preserver of peace rather than any specific military accomplishment [10.1] (see also 11.16, p. 298, and the discussion there); warfare was in fact all but entirely absent from his reign. There is some variety in the particular details of hair and beard, but overall there is great consistency and Hadrian can be easily identified. Despite the possible existence of a sequence of types, the portraits of Hadrian, like Trajan's, do not reflect the aging process; they usually portray a vigorous man of about forty years of age, as he was at his succession.

Of course, what one first notices about the portraiture of Hadrian is its clear break with imperial tradition. His images are the first to show an emperor wearing a full beard—a style that succeeding emperors would follow—and if he is properly identified on such Trajanic monuments as the Beneventum arch (see 9.16, p. 251), then Hadrian adopted this fashion well before he became emperor. Although it was rumored that he did so to mask facial blemishes, this was probably not his primary objective. Hadrian's beard was a powerful statement.

This portrait was found at Ostia, as was a head of Trajan (see 9.3, p. 238); they were not

10.1 Hadrian in cuirass, 117–38 CE. Marble. H. 90 cm (2 ft 11½ in.). Although Hadrian fought no wars during his reign, his portraits often show him in military attire, and literary sources related that he was an excellent soldier.

10.2 Portrait of Hadrian from Ostia, Italy, c. 120 CE. Marble. H. 54 cm (1 ft 9⅜ in.). Hadrian was the first emperor to wear a beard, a physical trait adopted by successive emperors.

found together (this one comes from a lime kiln and thus not from its original context), but both are over life-size and of Greek marble [**10.2**]. Whether they ever stood together or not, they share a strongly Classicizing aspect. In the case of Trajan's, the style is explained as a reference to Augustan portraiture and/or its being a posthumous work. By contrast, the Classicism of Hadrian's portrait, in its hairstyle, beard and expressionless aspect, is an unambiguous reference to a very specific period in Greek art, the early Classical period. While the degree of Classicism is extreme in this example, the use of Classical forms to situate Hadrian within a broadly cosmopolitan Hellenizing context is typical of his portraiture and suited to his personality, as revealed in the literary sources. Believed to be reflective of his aspirations to Hellenism, his beard in particular would have had an effect of mitigating his "otherness" in the eastern provinces, as well as being seen to mark a decisive rejection of the Roman practice followed by his predecessors. Hadrian's choices therefore occasioned a mixed reception, and this is reflected in such literary sources as the Latin *Historia Augusta*.

RELIEF SCULPTURE
Conservatori Reliefs

Relief sculptures from the time of Hadrian also demonstrate a break from conventional Roman practice. Important examples are two reliefs, now in the Palazzo dei Conservatori Museum in Rome, which had been removed from their original location and reused in a later structure. These reliefs are almost precisely the same size and shape as the panels on Trajan's arch at Beneventum and may have originally decorated a similar Hadrianic arch. One panel shows a standard scene of public address with the emperor on a small base (standing for the *rostrum*, or speaker's platform). At his back are

10.3 Conservatori relief, depicting an *adlocutio*, Rome, Italy, 137–38 CE. Marble. H. 2.68 m (8 ft 9⅝ in.). The reliefs were probably originally placed on an arch. This panel shows an *adlocutio* or public address scene of Hadrian.

10.4 (Above) Conservatori relief showing the apotheosis of Sabina, Rome, Italy, 137–38 CE. Marble. H. 2.68 m (8 ft 9⅝ in.). Sabina is shown carried from her funeral pyre by a winged figure. A seated Hadrian looks on.

allegorical figures who form the audience: the *genius senatus*, or protective spirit of the senate, and the *genius populi romani*, the protective spirit of the Roman people, together with a small boy [10.3]. There are two idealized figures rendered in low relief on the background; the soldier beneath the podium could be an imperial bodyguard or may simply signify the imperial legions. In any case, most or all of the figures are allegorical or symbolic. The other relief shows the apotheosis of Hadrian's wife Sabina, who predeceased him by a year or two [10.4]. Although there were rumors that they did not get along (and that she had an affair with the writer Suetonius, who was also the emperor's secretary), Hadrian did secure her deification; an altar to *diva Sabina* is depicted on some of his latest coins. Here on the relief, the emperor is seated below, to the right, while the empress is carried aloft by a torch-bearing winged personification. The reclining youth to the lower left is a personification of the Campus Martius, where the imperial *ustrina* were located.

The visage of Sabina here accords entirely with her sculpted and numismatic portraits, which, even within the Greco-Roman tradition of idealized female faces, is strongly Classicizing, compared with Flavian and Trajanic examples [10.5]; this is especially evident in her hairstyle,

10.5 (Above) Portrait of Sabina, c. 130 CE. Marble. Sabina married Hadrian as a teenager, and her youthful image persists in portraits throughout her life, mirroring the Classicizing styles favored by her husband.

which departs from the bourgeois towering curls of her predecessors and assimilates to the much simpler arrangements found on late Classical and Hellenistic images of goddesses. There are marked differences between these panels and those on Trajan's arch in the fewer, often larger, figures filling up more of the ground. The effect is flatter because of the lower relief and the depiction of each figure in pure profile, creating a very shallow space between foreground and background. These features are characteristic of Greek Classical relief sculpture, especially the grave and votive reliefs so frequently found in the vicinity of Athens, much favored and often visited by Hadrian.

Roundels on the Arch of Constantine

Also reused from an unknown earlier monument are eight circular reliefs, or **tondi** [10.6a–d], incorporated into the Arch of Constantine, four on either face. The form is unparalleled in official state sculpture, although round decorative reliefs were found in domestic contexts and *clipeate* (on round shields) portraits adorned the Forum of Augustus. The style of the tondi is consistent with that of other Hadrianic works; each bears a small number of relatively large figures, both posed and draped in a Classical manner. Although the heads of the protagonists have been replaced by portraits of Constantine, the presence of at least one apparent image of Antinous (Hadrian's young lover, see Chapter 11) in the boar hunt scene suggests that it came from a Hadrianic monument, the location, function, and form of which are a complete mystery. The design of the reliefs, with a ground line that forms a space (**exergue**) below, is decidedly similar to the arrangement seen on coins, and it has been theorized that the tondi reflect commemorative medallions. Another suggestion is that they could

10.6a–d Roundels from the Arch of Constantine, Rome, Italy, 130–38 CE. D. *c.* 2 m (6 ft 6 in.). From the time of Hadrian, these reliefs were later reused by the emperor Constantine. They depict, clockwise from top left: (a) Hadrian setting out in a *profectio* scene and sacrifice to Silvanus; (b) a stag hunt and sacrifice to Diana; (c) a boar hunt and sacrifice to Apollo; (d) a lion hunt and sacrifice to Hercules.

CHAPTER 10: THE ART OF HADRIAN AND THE ANTONINES

have decorated a memorial in honor of Antinous, although it is not known for certain whether the youth was laid to rest in Egypt, where he drowned and was deified, or back in Italy, perhaps at Tivoli.

The subject matter of the tondi, a hunting trip, is very different from what one would expect to see on an official state monument in Rome, and it is as revolutionary in its own way as Hadrian's own bearded appearance. Other reliefs that were reused to decorate Constantine's arch (the Trajanic frieze and panel reliefs of Marcus Aurelius), feature conventional iconography common in Rome, while the novelty of Hadrian's **roundels** has led some scholars to postulate that the reliefs were made for a monument to be erected somewhere in the Greek-speaking east. To be sure, the hunting theme invokes a tradition associated with eastern royalty that went back to earliest Mesopotamia, revived by Assyrian and Persian kings, and made famous in the Mediterranean by Alexander and his followers. It did not enjoy equivalent currency in the Italic tradition, but if the bronze statue from Misenum of the Hellenophilic emperor Domitian (see 6.25, p. 173) has been correctly identified, then there is precedent in imperial iconography.

Although it is impossible to know if the arrangement of the roundel scenes on the arch repeats or reflects that of any original usage, their placement on the Arch of Constantine has been carefully considered. Two pairs of reliefs adorn each side of the arch, set just above the Constantinian friezes that crown each flanking bay. On the long side facing away from the city (roughly facing south), to the left, is a *profectio* scene (just where one would expect a departure scene, given its location relative to the city) next to a scene of sacrifice to a rustic, archaized, ithyphallic (that is, with an erect penis) god identified as Silvanus, a forest deity. The right-hand pair on this side of the arch and the left-hand pair on the other side each show a hunt from horseback (of a stag and boar respectively) and a sacrifice to the appropriate deity (Diana and Apollo). The stag was sacred to Diana and both god and goddess were associated with mythological boars (Erymanthian with Apollo and Calydonian with Diana). If it is the Erymanthian boar sent by Apollo here on the side facing the city, then the transition is smooth to the final pair of reliefs, which show Hadrian (and Hadrian alone of his group) with one foot on a dead lion, and a sacrifice to Hercules. The assimilation of the emperor to the hero is clear. Not only did Hercules famously vanquish the Nemean lion as his first labor, but on the relevant metope of the Temple of Zeus at Olympia, probably the most famous and important of all Greek temples in antiquity, Hercules stands with one foot on the dead feline.

The references, however, are not just to Greek art and tradition. Hadrian has also appropriated standard Roman martial iconography from, for example, the column of Trajan, on which the campaign begins, according to custom, with a *profectio*, and the emperor himself makes sacrifices before and after battle to express both hope and thanks for success. The transformation of imagery of warfare into that of more leisurely pursuits in times of peace strongly reflects Hadrian's view of the empire, as does his melding of elements of Greek and Roman public visual culture, which mirrors his attempts to weave a disparate empire together into a seamless, mutually enriching, whole.

HADRIANIC BUILDING IN ROME

Hadrian added several important buildings to the Roman cityscape but, according to the *Historia Augusta*, he placed his name on only one, the temple to *Divus Traianus*, wherever it was (see p. 244). It was among the first acts of a successor, following a convention begun already by Octavian, to ensure the deification of his predecessor and thereby to assume for himself, as heir, a quasi-divine status. This may have been all the more important if the succession was in any way questionable, as may have been the case for Hadrian. Hadrian also continued the programs of Domitian and Trajan to rebuild the Campus Martius buildings destroyed by the fire of 80 CE.

Pantheon

By far the most significant of these was the Pantheon [10.7], which, true to the literary sources, bears a dedicatory inscription naming Marcus Agrippa, who built the original temple bearing that name on this same site in 27 BCE. That building was damaged or destroyed in the

fire of 80 CE and then restored by Domitian. In Trajan's reign it was struck by lightning and burned once again. Today's Pantheon has long been thought to have been built in the first decade of Hadrian's reign. No dedication is recorded, and the date has been surmised from brick stamps, a re-evaluation of which now indicates that its rebuilding program was at least begun, and therefore planned, before Trajan's death. If so, the question of whether Apollodorus, Trajan's favorite architect, was possibly involved must be considered (see box: Roman Brick Stamps and the Dating of the Pantheon, p. 268). The sources characterize Hadrian as a polymath, apparently with a particular interest in architecture. He is said to have put Apollodorus to death for having criticized Hadrian's architectural knowledge, in one account doing so during a specific consultation on building with Trajan; given the revised dating for the Pantheon, and the nature of Apollodorus's insult, one wonders whether this was a planning meeting for this very structure (see box: Hadrian and Apollodorus, p. 270).

Despite being included in the list of Hadrian's restorations of Augustan monuments, this was no refurbishment but an entirely new structure—and the boldest known example of the new Roman architecture of concrete, curve, vault, and interior space. The building is remarkable for a number of reasons—for the state of its preservation, for the ingenuity of its engineering, and for its highly constructed psychological effects. The plan of the

10.7 The Pantheon, Rome, Italy. An original version was built by Agrippa in 27 BCE, then restored by Domitian when it burned down in the fire of 80 CE. It was struck by lightning during Trajan's reign, after which the current building was constructed. The existing inscription still dedicates the structure to Agrippa.

MATERIALS AND TECHNIQUES
Roman Brick Stamps and the Dating of the Pantheon

Brick-faced concrete construction began around the beginning of the empire and, owing to the intrinsic economic efficiencies of the method, it soon became far and away the most commonly used building technique. At first, discarded or repurposed roof tiles were used, but these were soon displaced by bricks produced for the purpose and, given the scope of imperial building in Rome, this became a big business. Almost from the outset, some bricks were stamped with the name of the manufacturer, whether to indicate ownership, advertise the manufacturing, or ensure quality. In the early second century CE, the stamps began to include the names of the annual consuls and thus provide their date of manufacture. The date of their usage, however, could be later, as bricks from one building could be reused in another. As with all such evidence, there is strength in numbers, and scholars study brick stamps in the aggregate to estimate the beginning date and endpoint of a construction project. If the bricks are in situ with their stamps exposed, it is even possible to determine, within tolerable limits, a dating of the sequence of construction.

Important recent evidence for the usage of brick stamps concerns the Pantheon (10.7, p. 267), the best-preserved Roman building in the capital, and probably in the entire Roman world. No ancient source tells us that Hadrian was responsible for the actual planning or construction of the Pantheon—the most complete source on the issue, the *Historia Augusta* (19.9–10), relates that he restored the "Pantheon, Saepta, Temple of Neptune, very many temples, the Forum of Augustus, the Baths of Agrippa, and dedicated all in the names of their original builders." These were Augustan structures and all but the forum were part of Augustus's completion of a Caesarian Campus Martius building program carried out in the name of Agrippa around the beginning of the principate. These structures were, moreover, damaged or destroyed in the fire of 80 CE and restored to varying degrees by Domitian. Of the Pantheon, we hear in Paulus Orosius's *Historiae Adversus Paganos* that it was struck by lightning and "burned entirely" (*concrematum*) in 110 CE; there may have been collateral damage at that time to the neighboring buildings that Hadrian "restored," but the degree of damage to the Pantheon implied by the verb "*concremare*" would have prompted action fairly soon. Of Hadrian's involvement with the Pantheon we hear only that he dedicated the current building and held court within it (among other buildings).

It was therefore most probably completed by and dedicated in 126 CE, at the beginning of his brief residence in Rome between his two great journeys across the empire, since the latest stamped bricks date to just before that time.

But, more importantly, when was the building begun? And who was responsible for its innovative plan and magnificent engineering? It has long been known that stamped bricks in the fabric of the Pantheon include those manufactured in the reigns of both Trajan and Hadrian. Scholars supporting a Hadrianic date for the building as a whole explain the use of the earlier bricks as being left over from Trajanic projects. A recent study, however, records that 88 percent of stamped bricks in situ in the Pantheon's huge domed rotunda are either Trajanic or late Trajanic/early Hadrianic, concluding that the building must have been planned, begun, and to a large extent built already under Trajan and probably finished and certainly dedicated by Hadrian. This accords with the literary evidence as well, and, in addition, establishes a strong probability that this most architecturally significant edifice was the work of Apollodorus of Damascus, cementing his status as the greatest of Roman imperial architects.

present Pantheon [10.8] is now thought less novel than was once the case, since the Domitianic replacement, and perhaps the Augustan original, all faced north and one or both may also already have combined a rectilinear porch with curvilinear cella. None of this, however, diminishes the Pantheon's importance in the history of Roman architecture.

In this final version of the Pantheon, one fully experiences the surprising combination of a traditional massive columnar facade with a cella in the form of a vast domed rotunda. The transition between these two discordant elements is effected by a large rectangular structure often compared to a triumphal arch. The combination of forms representing the "old" and "new" architecture was not without precedent. Non weight-bearing decorative orders had long been applied to vaulted structures (culminating in the Colosseum, but common already in the Republic), and Domitian's palace combined old-fashioned basilican halls with highly imaginative vaulted spaces. Yet nowhere is

this contrast more focused than in the Pantheon, which juxtaposes a porch creating the impression of a forest of massive granite columns with a rotunda that forms the largest uninterrupted interior space in the ancient world, capped by the largest dome (about 43 meters in diameter) built before the Renaissance [10.9].

The massive bronze doorway between the porch and the cella marks a transition between the two different styles of building and creates a point of contrast that serves to heighten the impact of each. Inside the rotunda, the viewer is immediately swept into a sense of the vastness of the space, and, especially on a sunny day, is struck by the amount of light flooding in through the oculus at the peak of the dome. The porch is dark, so, counter-intuitively, when one walks inside the building the result is akin to exiting it. This was an effect well known to Greek architects and especially exaggerated in such great Hellenistic **hypaethral** (unroofed) temples as that of Apollo at Didyma, which channels visitors through a dark passageway into a massive open cella containing a tiny temple in its midst.

In addition, the expansiveness of the open space contrasts with the focus provided by a disk of bright light that moves around the room over the course of the day, reflecting and suggesting the movement of celestial bodies above. We know little of the building's function aside from the name itself, which indicates a temple to all gods, and it seems to have been an enigma already in antiquity; its implied connection with the heavens has prompted theories of its associations with the seven planetary deities. The inclusion here of a statue of *divus Iulius* (mentioned by Cassius Dio) may have served to connect Augustus, in whose reign the first Pantheon was built, and the imperial family to their *genetrix* Venus and her divine companions.

Images of these, then, could have been housed in the apse opposite the entrance door and six *exedrae*, three to either side, the external corners of which are formed by engaged Corinthian pilasters, between which two Corinthian columns were placed. Atop these supports an engaged entablature runs all around the room. Between the exedrae are *aediculae* with alternating curved and triangular pediments. A second story ranges up from the cornice of the lower story,

10.8 Reconstruction and section of the Pantheon, Rome, Italy. The combination of Roman concrete and ingenious design allowed it to be the largest interior space in the ancient world with a dome some 43 m (142 ft) in diameter.

10.9 (Below) Interior of the Pantheon, Rome, Italy. The opening (*oculus*) at the very top of the dome creates a distinctive feature: the disk of light that moves about the Pantheon's floor and walls as the sun crosses the sky.

terminating in a second entablature above, from which rises the coffered (decorated with sunken panels) dome ceiling, which originally displayed gilt bronze stars in each recess, enhancing the celestial imagery. The wall surfaces of the two lower stories have been veneered with colored marbles in a relatively simple geometric pattern that complements the paving of the floor. Despite later restorations of the interior, the Pantheon still gives by far the most authentic impression of the effect of the kind of Roman interior decorative scheme that would have been found in virtually every public building in the empire. For its preservation we should be most grateful.

The interior architecture is purely decorative, giving a nod to traditional Roman architecture in the same way as the porch, yet the recesses do relate to the actual structure of the building, which, as we can see in section (see 10.8, p. 269), was not a solid mass. Rather, it was built up using a veritable honeycomb of intersecting concrete vaults and arches, all designed to lighten the building without compromising its strength or integrity. One clever device was the formation of what appears to be the lowest part of the dome through cutting coffers into the vertical concrete structure of the rotunda itself. The section of what appears to be dome, corresponding to the two lowermost rings of coffers, is actually coffered vertical wall. The dome is therefore smaller and was easier to construct than if it had actually sprung from the cornice above the ornamental niches, as it appears to do. Another intelligent feature was the gradation

Hadrian and Apollodorus

1. [Hadrian] first banished and later put to death Apollodorus, the architect, who had built the various creations of Trajan in Rome—the forum, the odeum, and the gymnasium.

2. The reason assigned was that he had been guilty of some misdemeanor, but the true reason was that once when Trajan was consulting him on some point about the buildings he had said to Hadrian, who had interrupted with some remark: "Be off, and draw your pumpkins. You don't understand any of these matters." (It chanced that Hadrian at the time was priding himself upon some such drawing.)

3. When he became emperor, therefore, he remembered this slight and would not endure the man's freedom of speech. He sent him the plan of the temple of Venus and Roma by way of showing him that a great work could be accomplished without his aid, and asked Apollodorus whether the proposed structure was satisfactory.

4. The architect in his reply stated, first, in regard to the temple, that it ought to have been built on high ground and that the earth should have been excavated beneath it, so that it might have stood out more conspicuously on the Sacred Way from its higher position, and might also have accommodated the machines in its basement, so that they could be put together unobserved and brought into the theater without anyone's being aware of them beforehand. Secondly, in regard to the statues, he said that they had been made too tall for the height of the cella.

5. "For now," he said, "if the goddesses wish to get up and go out, they will be unable to do so." When he wrote this so bluntly to Hadrian, the emperor was both vexed and exceedingly grieved because he had fallen into a mistake that could not be righted, and he restrained neither his anger nor his grief, but slew the man. (Cassius Dio, *Roman History* 69.4)

While this passage, written nearly a century after the event it relates, is entertaining and informative, scholars have accepted it only with reservations. The text constitutes much of what we know about Apollodorus, especially the brief list of his projects in Rome. Yet what seems to interest Dio more is the drama of the resentment and perhaps jealousy between the architect and future emperor. The rather negative assessment of Hadrian is consistent with the *Historia Augusta*, but that work is a century or more later than the *Roman History*. Dio himself was born toward the end of Pius's reign (c. 155 CE) and enjoyed a distinguished public career over nearly half a century from the reign of Commodus to that of Alexander Severus (c. 235 CE). He had certainly seen both good and bad imperial rule, and it appears that already by his time Hadrian's legacy reflected some of both. As a provincial from a prominent consular family, one might expect Dio's treatment of Hadrian to be wholly positive, but, as a historian focused on the truth, he also betrays the discomfort that apparently came with efforts by ancient sources to categorize an emperor who defied traditional standards and definitions.

of the weight of the concrete, using progressively lighter materials for the aggregate the higher the building rose, which culminated in the use of light volcanic pumice for the top of the dome. The deep coffering helped lighten the dome further. By Hadrian's day, the Romans had been building concrete vaults for centuries and experimenting with the highly flexible and adaptable brick-faced version since the beginning of the empire. The Pantheon stands today as its ultimate product: the crowning achievement of Roman architectural genius.

Temple of Venus and Roma

In contrast to the Pantheon, Hadrian's other great temple, dedicated to Venus and Roma, bore no mark of the new vaulted concrete architecture, but in both plan and the cult it housed, the temple was a novelty in the capital city. The remaining (vaulted) superstructure of the Temple of Venus and Roma [10.10] dates from Maxentius's rebuilding in the early fourth century CE (see Basilica of Maxentius p. 368), but it still keeps a sense of the majesty of Hadrian's building and, for the most part, its plan [10.11]; sufficient remains have been identified to establish the materials and carving style of the earlier temple. This is the one building explicitly attributed to Hadrian as architect—the plan that Apollodorus criticized, to his demise. Nonetheless, Hadrian seems to have taken his criticism into account, at least his point of providing storage for equipment to be used in the amphitheater (see box: Hadrian and Apollodorus, opposite). The temple may have been a long time in construction; it was dedicated near the end of Hadrian's reign (135 CE), and it reflects in many ways his experiences in the eastern Mediterranean, especially with the Temple of Olympian Zeus in Athens, which Hadrian himself completed (see p. 293).

The temple stood on the elevation of the Velian hill, still occupied at this time by the remains of the vestibule of the Domus Aurea. The placement of a temple within a portico is a familiar scheme, often repeated in imperial fora, but Hadrian's design owes little to these Roman precedents. His building is centered in the court, resembling many Hellenistic examples, and the portico itself ran along only the two long sides of Hadrian's temple. The temple is not only peripteral, and set on a seven-stepped platform rather than a high podium, it has two cellas (one for each goddess) set back-to-back and facing in opposite directions. The most fundamental feature of the Roman temple—its strict, frontal orientation—was entirely ignored in this design.

The marble of the temple is Asiatic, not Italian, as is usually found in Rome, and undertaking close study of the remaining ornament suggests that workers came from Asia Minor as well. The other striking feature of the temple is similarly eastern Greek—its enormous scale. Measuring (with its flanking porticoes)

10.10 Temple of Venus and Roma, Velian hill, Rome, Italy, dedicated 135 CE. The remaining structure dates to the fourth century CE, but Hadrian's own plan is still visible.

10.11 Plan of the Temple of Venus and Roma (as restored by Maxentius), Velian hill, Rome, Italy, dedicated 135 CE. Hadrian's plan draws from Hellenistic precedents, such as the use of seven steps rather than a podium, the peripteral style, and the abandonment of a frontal orientation that was so fundamental to Roman temples.

110 m × 53 m (361 × 174 ft), it dwarfed, laterally if not vertically, the Capitoline temple, which loomed over the Forum Romanum at the opposite end and had previously been the largest sacred structure in Rome. This was a Greek temple, in plan, scale, materials, elevation, and workmanship, set down in the heart of Rome—as conspicuous a sign of Hadrian's philhellenism as the emperor's beard. The cult of Roma itself was essentially a provincial phenomenon, fostered by the Romans (usually in connection with the cult of Augustus) as a means to accommodate the Hellenistic inclination toward ruler-worship, cultivated under Alexander and the Hellenistic kings. Temples of Roma and Augustus sprang up everywhere in provincial cities as symbiotic marks of fidelity to the emperor and imperial favor toward the municipality in question. Hadrian had incurred unpopularity at home in appearing to treat Rome as if the city were at the periphery rather than the center of the empire, through such measures as establishing imperial legates as governors in Italy itself (a practice later rescinded by Hadrian's successor, Pius). Nowhere in his building program do we see a more compelling symbol of Hadrian's desire to integrate the capital and the provinces than in this, one of the largest Greek or Roman temples ever built.

10.12 Hadrian's Mausoleum, Rome, Italy, 134–139 CE. The mausoleum was connected to the Campus Martius on the other side of the River Tiber by a bridge called the *Pons Aelius*.

Hadrian's Mausoleum

Workers from the temple to Venus and Roma are also believed to have carved the ornament of Hadrian's other great structure in Rome—the mausoleum that was built in the latter part of his reign and perhaps finished by Antoninus Pius [10.12]. The marble used here was Italian, however, and not Asiatic; the architectural workshop may have settled permanently in Rome and adopted local materials. The location chosen for the mausoleum was across the River Tiber in an area near where the border of Vatican City now begins; the mausoleum was later converted to a papal fortification known today as Castel Sant'Angelo. The building was connected to the northwestern end of the Campus Martius by an elegant Hadrianic bridge (*Pons Aelius*) that also formed a monumental approach. It must have appeared to be a much more elaborate and ornate version of the Augustan mausoleum across the river, sharing the stepped rotunda, elevated plantings, and crowning statuary of the earlier building. Here, Hadrian followed Augustus's lead in marking out multiple stages of dynastic succession and similarly provided a new monument that would serve to entomb each successive emperor until Caracalla in 217 CE.

Excavations at the Athenaeum

Excavations for a third metro (subway) line (the C line) in Rome began in 2006 and are projected to last until 2022. The train lines themselves are tunneled well beneath any archaeological layers but the new stations can be constructed only by digging from the surface down. Just as was the case for the new subway line built in Athens for the 2004 Olympic Games, this project has been conducted with careful respect for archaeological remains, the most important of which have been preserved for public display. The last leg of the project, running from San Giovanni to the archaeological center of the city has, as one would expect, come upon very important ancient relics. In fact, plans for a further extension of the line, ending at Largo Argentina in the Campus Martius, have been scrapped for just this reason.

Work on the final station in Piazza Venezia, between the north end of Trajan's forum, the north slope of the Capitoline, and the southeastern end of the Campus Martius, in the very heart of the ancient city, predictably produced ancient remains, but what was found there was somewhat unexpected. Excavations revealed what appear to be three halls arranged radially around a courtyard just to the west of the Trajan's column. These were large spacious structures with graded seating arranged along the long sides, with an open area running down the middle. This arrangement calls to mind what one can see today in the slightly larger Curia Julia, the restored senate house in the Republican Forum. These newly found halls, some 23 × 13 m (75 × 44 ft) long, are more elegant still. The whole was covered over with a great barrel vault soaring over 30 meters (100 ft) above the floor, and the interior surfaces were veneered in luxurious colored marbles similar to those found in the Forum of Trajan. The building is said to have had a capacity of 900 spectators [**10.13**].

While these halls share features with other building types, such as the senate house and covered theaters, they seem to constitute a type of their own best termed an auditorium or lecture hall. The remains are therefore identified as the Athenaeum, a structure that is mentioned in literary sources as having been built by Hadrian as a center of learning. We hear nothing of its form but the few brief references in ancient sources suggest a sort of "school of liberal arts" where, among other things, the art of declamation (a form of public speaking) was taught and practiced. It seems very probable, therefore, that Hadrian was providing a facility to house cultural activities similar to those that were already popular among the Greek-speaking elite of his time, especially in Athens and Asia Minor, and termed the Second Sophistic (see Athens and the Hellenistic East, p. 292). At least one source places the creation of the Athenaeum at the end of Hadrian's reign, after his final tour of the provinces and his extensive building program in Athens, which included another center of learning in the building there that is known as Hadrian's Library. In keeping with what we know of Hadrian and his well-documented philhellenism, it seems he intended to shift to or duplicate in Rome the centuries-old status of Athens as the center of philosophical and rhetorical study and education in the Mediterranean basin.

10.13 Reconstruction of the Athenaeum, Rome, Italy, 2nd century CE. The structure was said to have been built by Hadrian as a place of learning.

The Antonines

SUCCESSION

The much greater attention that Hadrian paid to the issue of succession, in comparison to Trajan, was perhaps influenced by his own uncomfortable experiences during his transition to *princeps* in 117–18 CE. Near the end of his life, Hadrian, who like Trajan had no son of his own, adopted Lucius Ceionius Commodus (who was renamed Lucius Aelius Caesar) as his successor. When his choice of heir died, Hadrian then selected Titus Aurelius Antoninus (r. 138–161 CE) from a distinguished consular family with provincial ancestry (his father was from Nemausus in southern Gaul). Again, following the example of Augustus, Hadrian further specified the next level of succession by having Antoninus adopt as his own two heirs the seven-year-old son of Ceionius Commodus—who shared his father's name but would later become the co-emperor Lucius Verus (r. 161–169 CE)—and Marcus Annius Verus (the later emperor Marcus Aurelius). The latter was the teenage grandson and heir of the elder Marcus Annius Verus, a relative of Antoninus, trusted associate of Hadrian and, like the emperor, from a noble Spanish family.

Antoninus carried out Hadrian's wishes in the matters of adoption, and as the new emperor he prevailed upon a reluctant senate to vote Hadrian divine honors, earning for himself the cognomen Pius. Antoninus Pius held true to Hadrian's policies as well. The twenty-three years of his rule were without doubt the most peaceful the Roman world would ever see. No campaigns of any significance were waged, and new fortified imperial boundaries were established in Scotland and along the Rhine. The emperor himself spent the entire time in or near Rome, often to be found at his suburban villa in Lorium. He ruled with fairness and moderation, and was effortlessly voted divine honors at his death by a grateful senate.

The empire inherited in 161 CE by Marcus Aurelius, however, was beginning to show the strains resulting from two generations of military inactivity. The Roman empire would, many years later, eventually fall victim to the combined pressure of division from within and invasion from without, and both types of crisis hounded Marcus Aurelius, in addition to a plague that ravaged the Roman world during much of his reign. The great eighteenth-century historian Edward Gibbon, whose *History of the Decline and Fall of the Roman Empire* remains a classic treatment to this day, began his story of deterioration with the era of Marcus Aurelius.

Although Antoninus Pius had conferred imperial honors on Marcus alone, true to Hadrian's wishes Marcus Aurelius embraced as co-emperor his younger adoptive brother Lucius Verus and compelled the senate to vote him full powers. As it happened, it almost immediately became necessary to conduct campaigns on two fronts. In 162 CE, Verus was sent, more or less as a figurehead accompanying a group of competent generals, to fight the Parthians. Leaving them in 166, Verus returned to Rome and joined up with Marcus, marching north to meet a threat on the Danube frontier from a number of tribes, including the Marcomanni. Due to plague, among other factors, Marcus did not manage to engage the enemy until 169 CE (in which year Lucius Verus died, perhaps of the same plague, leaving Marcus as sole emperor). The first encounter was disastrous, with invaders crossing the Alps and spreading into the Balkans as far as Greece, but eventually the imperial troops were able to drive them back across the Danube. To make matters worse, Marcus was forced to cut short his wars in the eastern Danube in 174 CE in order to quell a revolt of the legions in Syria, where troops had declared as their emperor Gaius Avidius Cassius (130–175 CE), Marcus's erstwhile trusted general and victor over the Parthians after Verus's return. It had been centuries since the Mediterranean core of the Roman world had felt the threat of barbarian invasion and decades since imperial authority had been seriously challenged.

The sense of security that Hadrian and Antoninus Pius had established was forever shattered. Indeed, less than two years after his triumph, Marcus was compelled again to campaign on the Danube, where he died in 180 CE. He was accompanied there by his sole surviving son, Lucius Commodus, who had turned nineteen only days before his father's death. Commodus had been granted the title of Augustus shortly after the triumph of 176 CE celebrating the defeat of the Marcomanni and he

was clearly marked out for succession. Marcus Aurelius is often criticized for this unfortunate decision but, in fact, the practice of succession by adoption that had been standard since Nerva had been as much the result of childlessness as choice. Born to a father who was already emperor, the first Roman emperor of whom this is true, Commodus proved not to be up to the demands of the job. He became increasingly obsessed with gladiatorial sport—he is said to have competed (if that is what one could call it) in the Colosseum himself—and was proportionately disinterested in the manifold and mundane responsibilities of government. The sheer size of the empire lent it considerable inertia and resistance to change, but such entities can last only so long. Military generals held the borders against restless enemies; imperial functionaries and praetorian prefects, in turn, filled the power vacuum in Rome. Inevitably, reprising the pattern of the reigns of Caligula, Nero, and Domitian, a period of palace plots, executions, and senatorial paranoia had the predictable outcome. On the last night of 192 CE, Commodus was strangled in his bath. As the new year dawned in 193 CE, the Antonine dynasty—and with it the High Roman Empire—had come to an end.

PORTRAITURE

The portraiture of Hadrian's Antonine successors follows his own in sporting thick curly hair and a beard, but there is a distinct development both in sculptural style and in the mood conveyed by these images, consistent with the changing tenor of the times. Antonius Pius's portraits are, at first glance, very close to Hadrian's—similarly to Tiberius, he opted for an image that emphasized continuity—although his face is somewhat narrower and often betrays signs of a more advanced age (he turned fifty-two in 138 CE, the year he became emperor) [10.14]. One sees also a trend toward longer hair and beards, a development that continued with the portraits of his successors, Marcus Aurelius and Lucius Verus [10.15 and 10.16], both of whose portraits sport long, intricately carved beards and hairstyles.

Antonine portraiture displays, more than any other, the virtuosity of the marble-carvers' craft, with its deeply drilled and chiseled forms creating elaborate patterns of light and shadow designed both to define and suggest great masses of curls

10.14 Portrait of Antoninus Pius, 138–61 CE. Marble. H. 40.2 cm (1 ft 3⅞ in.). Antonius Pius opted for an image that expressed continuity from Hadrian, though his face shows signs of more advanced age.

10.16 (Below) Portrait of Lucius Verus, Rome, Italy, c. 161–69 CE. Marble. H. 76 cm (2 ft 6 in.). Verus's portrait reflects Marcus Aurelius's in its continued emphasis on curled hair and beards.

10.15 (Above) Portrait of Marcus Aurelius, 161–80 CE. Marble. H. 37 cm (1 ft 2⅝ in.). Successors of Antonius Pius also follow Hadrian's portrait style, with longer hair and long, intricate beards.

10.18 (Right) Commodus as Hercules, 192 CE. Marble. H. 1.33 m (4 ft 4 in.). The emperor has taken on the guise of a mythical hero, with the lion skin and club of Hercules. The association is probably due to Commodus's intense interest in combat sports.

10.17 (Above) Portrait of Commodus, 180–85 CE. Marble. H. 55.9 cm (1 ft 10 in.). Early portraits of Commodus follow those of his father Marcus Aurelius.

and waves in both hair and beard. There is a marked emphasis on textural contrast, between the glassy polished surfaces of the skin and the variegated patterns of hair. Eyes, too, are more sculpturally treated with deeper drilling and the incision of iris and pupil, again continuing a feature first popularized in Hadrian's day. The aspects of the co-emperors as defined in their portraits seem also to reflect what we know of their personalities. The youthful, somewhat foppish Verus sports a carefully bifurcated beard and look of mock-seriousness. In contrast, Marcus Aurelius's portrait favors a more thoughtful gaze, his penetrating eyes and creased brow continuing, and exaggerating, a feature seen in some of Antonius Pius's portraits. Marcus's mature portraits show a man who appears worn down by countless burdens and challenges, borne in the manner of the Stoic philosopher that he was, as recorded in his *Meditations* (a series of personal notes and reflections).

Early portraits of Commodus [10.17] continue this tradition, and he rather resembles his father, although it is tempting to see in his more hooded eyes and thicker features signs of the brutish, dullard, deranged personality that is recorded in the literary sources. Commodus's most famous portrait represents both a masterpiece of late Antonine carving and the emperor's fixation on Hercules, with whom he identified as an unvanquishable combatant [10.18].

COMMEMORATIVE RELIEF SCULPTURE
Column of Antoninus Pius

In the tradition of commemorative columns, but very different from Trajan's, was the lofty pink-granite monolith set up by Lucius Verus and Marcus Aurelius in honor of Antoninus Pius's passing and apotheosis. It was destroyed in the eighteenth century, its stone used to restore several Egyptian obelisks that still stand in Rome, but the well-preserved base is now prominently displayed in a courtyard of the Vatican Museums. The marble relief carving on the face opposite the dedicatory inscription shows the apotheosis of Antoninus and his wife Faustina (who had died and been deified more than twenty years before her husband), a scene that clearly quotes Hadrian's Conservatori relief (10.4, p. 264), although most of the principals have changed [10.19]. A personification of Campus Martius clasps an obelisk, of which there were many in that part of the city. It is here Roma herself on the lower right who hails the imperial couple, which is carried toward the sky here by a male, not female, *genius*. The differences are as striking

10.19 Base of the Column of Antoninus Pius, c. 161 CE, Rome, Italy. H. 2.48 m (8 ft 1¾ in.). The column was set up by co-emperors Lucius Verus and Marcus Aurelius to honor the deification of Antonius Pius. The column itself was destroyed but its base survives. This side of the column shows the apotheosis of Antoninus and his wife Faustina.

10.20 Base of the Column of Antoninus Pius, c. 161 CE. H. 2.48 m (8 ft 1¾ in.). The *decursio* scene depicts a ritual circling of Antoninus's funeral pyre and a military parade.

as the similarities, and reflect developments similar to those detected in portraiture. The figures project more boldly; the bodily forms, hair, and drapery patterns are far more deeply drilled; contrast of light and shadow is dramatic; and the central figures are nearly frontal on the later relief. Yet there is still no real spatial penetration, especially into the unadorned and impermeable background, and the basic principles of Greek relief are preserved.

Entirely original in this context are the reliefs on the other two sides, which are nearly identical to each other. These depict the ***decursio*** (pl. *decursiones*), a ritual circling of a funeral pyre by a military parade held to honor the emperor as commander-in-chief of the legions [10.20]. The style and composition are here markedly different from those of the contemporaneous apotheosis relief. Here, the relief work is very high; the individual figures are carved nearly in the round and are markedly un-Classical with their large heads and squat proportions. Treatment of space is conceptual and artificial; while each soldier and horseman is shown from a lateral viewpoint, the overall composition of the cavalry that circles the infantry and standard-bearers is

CHAPTER 10: THE ART OF HADRIAN AND THE ANTONINES 277

arranged in an oval, bird's-eye view, implying both penetration and motion into the background space. The repetition on both sides of the pedestal itself may be another example of conceptualism, intending to show two views of the same scene from two different viewpoints, 180 degrees apart.

While the actual carving here is fundamentally consistent with that of the apotheosis relief, the proportions of the figures, the conception of the scene, and the artistic principles used to render it are entirely different. This base is conventionally seen as a transitional monument in the development of Roman sculpture, with the apotheosis representing the traditional Greco-Roman origins of imperial art and the *decursiones* exemplifying the more abstract, artificial approach that characterizes late antique works. Scholars have noted that much of what distinguishes the two styles had been present in the distinction between so-called patrician and plebeian art since the late Republic, as seen, for example, in the Amiternum relief (see p. 206). The views are not mutually exclusive and, as we have seen, it is typical in Italic, Hellenistic, and Roman art for differing stylistic approaches to co-exist, each being used as appropriate for the subject matter and to achieve the desired effect.

Panel Reliefs of Marcus Aurelius

It is clear that the artistic traditions of Trajan and Hadrian are embraced rather than abandoned in other works of Antonine commemorative sculpture. Three panel reliefs in the Palazzo dei Conservatori Museum in Rome are consistent in both scale and composition with the Trajanic and Hadrianic examples and probably, like them, came from an arch. The subject of these panels suggests a triumphal monument set up to commemorate the Marcomannic triumph of 176 CE [10.21]. There are differences from the earlier reliefs, however; the compositions are rather less Classical, with smaller figures and a larger space left at the top of the relief, creating a more pictorial effect. A more conceptual treatment of space is reflected by the emperor in profile, who stands in a frontal chariot that is drawn by horses in profile through a three-quarter view arch that recedes diagonally into the background. Yet the effect is not entirely unlike that of the chariot procession on Titus's arch from a century earlier, of which this later relief seems to be a truncated quotation. The deeply carved, highly textured surfaces are characteristic of the era. The odd, empty space in the chariot and botched temple rendering (there are, erroneously, steps on the side of the podium) indicate that Commodus originally accompanied his father on this panel, as he did in the actual procession; he has been erased here as a *damnatio memoriae*, and the space left over reworked by a mason who did not understand the actual form of the building that he was depicting.

A second relief [10.22] shows the culmination of this triumph in the sacrifice to Jupiter on the Capitoline. Again, the relief is deeply carved, and closely packed figures are defined by a

10.21 Relief panel from the Arch of Marcus Aurelius, Rome, Italy, c. 176 CE. H. 3.2 m (10 ft 6 in.). The scene depicted the shared triumph of emperor Marcus Aurelius and Commodus, celebrated in 176 to commemorate victories over Germanic tribes.

chiaroscuro effect very similar to what one sees in contemporary portraiture. The figures themselves are still very Classical, both in terms of their contrappostal poses and the careful outlining of forms by the sharp linear pattern of drapery. Very un-Classical, though, is the scale of the figures, which are scarcely more than half the height of the field, with the prominently depicted buildings looming above them.

Similar in composition and style is a third relief [10.23], but the iconography here is somewhat different. The triumph panels refer, in a very traditional way, to the accomplishments, especially military victories, of the emperor, continuing a practice that began long before the empire itself. This panel, however, illustrates not so much an event but an imperial virtue, *clementia* (clemency), as Marcus on horseback—a quote of the famous bronze statue that now stands on the Capitoline hill (see box: Bronze Sculpture and the Equestrian Portrait of Marcus Aurelius, p. 280)—appears to grant a pardon to the defeated enemies prostrate before him. This, of course, is not in itself new but goes back to Augustus and his *clipeus virtutis*, voted to him with his extraordinary authority by the Senate in 27 BCE and prominently displayed in the Julian senate house—those virtues were *virtus, clementia, justitia, and pietas* (courage, clemency, justice, and piety). There is much about the compositions that seems extracted from such scenes as those found on Trajan's column (see Column of Trajan, p. 247), but whereas the earlier monument emphasized tangible skills of competency and accomplishment, we now appear to see a return to an approach that invoked more abstract qualities of character in order to justify trust in leadership.

It is in this way that this last of the three reliefs resembles the eight rectangular relief panels that decorate the attic of the Arch of Constantine (see 14.4 and 14.5, p. 371). The panels on

10.22 (Above left) Relief panel from the Arch of Marcus Aurelius, Rome, Italy, c. 176 CE. H. 3.2 m (10 ft 6 in.). Marcus Aurelius's triumph finishes with a sacrifice to Jupiter on the Capitoline.

10.23 (Above right) Relief panel from the Arch of Marcus Aurelius, Rome, Italy, c. 176 CE. H. 3.2 m (10 ft 6 in.). The emperor shows his clemency to his defeated enemies, recalling an earlier approach by which emperors displayed character traits they wished to have highlighted.

CHAPTER 10: THE ART OF HADRIAN AND THE ANTONINES 279

Bronze Sculpture and the Equestrian Portrait of Marcus Aurelius

The Romans made extensive use of marble statuary, especially in the many public buildings that were constructed across the empire and which, with their elaborate colonnaded walls and facades, provided the perfect context for their conspicuous display. Throughout the Republic, however, the Romans, like the Greeks, preferred to use bronze for large-scale statuary. Locally quarried marble suitable for sculpture was all but unknown in Italy until the later first century BCE. Copper, however, was plentiful and there was some tin mining in coastal Etruria. The Etruscans were renowned bronze workers; indeed, their copper and bronze were important trade materials that drew Greeks and Phoenician merchants during the orientalizing period; some examples were examined in Chapter 1. Literary sources indicate that the early Republican portraits that so crowded the forum that they had periodically to be cleared out were all of bronze. Bronze artworks, however, are rarely preserved. During and after the collapse of Classical societies there was widespread destruction of bronze statuary. In some cases, this was prompted by Christian discomfort with images of the gods, which were felt to be inhabited by the abominable, and dangerous, spirits of pagan deities. Perhaps more impactful was the fact that bronze objects that were no longer needed could easily be melted down and cast into tools, weapons, coins, and Christian works of art.

Therefore, from the ancient Roman world, as is also the case for Greece, there is but a very small number of preserved bronze sculptures—a tiny fragment of what once existed. The story of the bronze equestrian statue of Marcus Aurelius on the Capitoline is therefore all the more remarkable [10.24]. This nearly perfectly preserved over-life-size (about 4.2 meters high) statue of the emperor on horseback was set up sometime during his campaigns of the 170s, possibly during his sojourn, and triumph, in Rome in 176 CE, between his two campaigns on the Danube frontier. Supporting this theory is the observation that the design of his saddlecloth is characteristic of the Sarmatians, one of the tribes over which that particular triumph was celebrated.

The scheme of the statue, its gilding preserved in places and more fully revealed during its recent conservation, is reminiscent of one of the set pieces illustrating imperial virtues seen in the emperor's panel reliefs, specifically the "*clementia*" in the Palazzo dei

10.24 Equestrian statue of Marcus Aurelius, Rome, Italy, *c*. 175 CE. Bronze. H. 4.2 m (14 ft). This sculpture is remarkable for having lasted to the present day given the paucity of surviving work in this material.

Conservatori Museum (see 10.23, p. 279). It is thought that a prostrate adversary similar to that in the scene on the relief was also included here but has since gone missing. This theory is based also on a brief note that appears in a medieval guidebook to Rome. An obvious difference between the two artworks, however, is that in the statue Marcus Aurelius is not wearing armor, which would be unusual if he were on campaign, even during a lull in fighting. One recalls the Prima Porta Augustus (see 5.2. p. 132), which also blends iconography of war and peace, underscoring a fundamental imperial principle of warfare for the purpose of establishing harmony and prosperity, a message as intrinsic to the policies of the Antonines as to those of the first *princeps*. It is not known where the statue of Marcus Aurelius originally stood; the emperor's funerary complex in the Campus Martius is one possible location, if the statue is posthumous rather than contemporary with his triumph.

Unusually, the statue seems always to have been above ground. Where the statue was located in Late Antiquity, and how it survived the fate of most ancient bronze statues, is not certain. Some think it was mistaken for Constantine, who was revered as a Christian. It is noted in historical documents as being in the possession of the papacy in the twelfth century, when it was located in front of the Lateran Palace. In the sixteenth century, it famously became the centerpiece of Michelangelo's redesign of the square and buildings on the Capitoline hill, and it was around that same time that the identity of the statue as Marcus Aurelius was accepted once and for all. It was much admired at that time for its lifelikeness, was often copied in miniature, and appeared in numerous paintings during and after the Renaissance. How it survived is unknown; an often-repeated explanation that Christians in the Middle Ages thought it represented the sainted emperor Constantine is implausible, given that the appearance of the beardless Constantine would have been well known from his portrait displayed on his arch. Perhaps it came early into the possession of the church, before the widespread repurposing of bronze in the Middle Ages. Its secular subject should have protected it from programmatic Christian destruction.

the arch are so similar, despite the reworked heads, that their attribution to a monument of Marcus Aurelius is beyond doubt, although the question of whether all eleven pertain to the same monument is not yet settled. There is a strong comparability of framing and scale, and the compositions are quite similar across the group. The scenes depicted on the arch are all drawn from the now familiar repertoire—*profectio*, *adventus*, *adlocutio*, *lustratio*, submission scenes, and the virtues of clemency and justice. These subjects were by Constantine's time both traditional and generic, and therefore eminently transferable for the purposes of the later emperor. Some scholars detect a stylistic distinction between these eight and the other three, especially in the greater abstraction, on the arch reliefs, in the rendering of details, but different hands could account for the variation.

Column of Marcus Aurelius

It is to the piety of Commodus (however short-lived) that we can attribute the most conspicuous surviving commemorative monument dating to the Antonine period: the Column of Marcus Aurelius [**10.25**]. Located in the northern Campus Martius, it is believed to have stood in a rectangular porticoed forecourt in front of a temple to the deified emperor (and his wife Faustina the Younger), but no trace of the temple remains. The column both commemorates and depicts the Marcomannic wars of the 170s, and at the same time honors Marcus as *divus*. Work must have begun immediately after Commodus's return to Rome from the Danube in 180 CE and was surely finished by around 193 CE, and perhaps well before. The column repeats in most ways the arrangement of Trajan's monument. It

10.25 Column of Marcus Aurelius, Rome, Italy, *c.* 180–193 CE. *c.* 30 m (98 ft). Raised by Commodus to commemorate his father, the column is approximately the same height as Trajan's column, with an internal spiral staircase. Its top held a bronze statue of the emperor.

10.26 River battle from the Column of Marcus Aurelius, Rome, Italy, *c.* 180–93 CE. Similar to Trajan's column, the Column of Marcus Aurelius depicted the emperor's greatest campaign, in this case his war across the Danube. Here the Romans are engaged in a river battle.

10.27 Column of Marcus Aurelius, Rome, Italy, *c.* 180–193 CE. In this scene, Marcus Aurelius is atop the camp walls; the composition of the relief demonstrates elements of perspective.

is approximately the same height (30 meters), although its base was originally much higher (a good deal of the base is nowadays underground); it also has an internal spiral staircase and was originally topped by a gilt bronze statue of the emperor. The spiral relief comprises one fewer bands, maintains a height of about 1.2 meters (4 feet) throughout, and is carved in substantially higher relief than the Trajanic structure. These developments probably reflect a concern with greater legibility and are certainly consistent with the overall changes we have observed in Roman sculpture of the second century CE.

The individual relief scenes portray, as do those on Trajan's column, the manifold activities entailed in a military campaign and, similarly, repay close scrutiny. Here we will summarize the differences of rendering and mood. Although many scenes are very similar to those on the earlier column, some show an increasingly artificial, almost topographic, rendering of space [10.26]. Here two groups of figures are separated by a river that is rendered as if on a map. Similarly, there is a greater willingness to penetrate background space as with this figure of a messenger rushing into a city gate [10.27]. Above him, a symmetrical arrangement with two flanking figures who turn toward a facing, slightly larger figure of the emperor presents an image of imperial power that is crystal clear in its use of centrality and frontality; the device would continue to live long into the periods of late antique, early Christian, Byzantine, and medieval art. Trickier, because it projects modern values onto an ancient culture, is a popular reading of the frieze that detects an increased brutality and suggestions of Roman disgust, or at least ambivalence, concerning warfare. "Barbarians" are treated more sympathetically in places; especially striking is a scene of allied troops beheading captives who are physically indistinguishable from themselves [10.28]. This was an inevitable result of the second-century process that broke down the distinctions between Rome and outlying lands, as is clear from the account of the provinces in Chapter 11, and in art it is enhanced by the, now common, adoption of beards by Romans; before Hadrian this proved the easiest means to identify the Roman from the other.

While it is difficult not to sympathize with the tribulations of a highly reflective philosopher-emperor, we also work

10.28 The slaughter scene from the Column of Marcus Aurelius, Rome, Italy, c. 180–93 CE. While explicitly showing the execution of captives, Roman and enemy are physically indistinguishable, suggesting an increased blending between Rome and the lands around it.

from hindsight (like Gibbon, we can recognize the seeds of Rome's demise) as well as from a principally modern aversion to warfare, which even in difficult times seems not to have characterized a Roman culture that would continue to glorify conquest as the primary means to peace and prosperity.

ANTONINE BUILDING IN ROME

Just as the Julio-Claudians built sparingly in a Rome utterly transformed by Julius Caesar and Augustus, so the Antonines saw little need to add extensively to the massive public-building programs of Trajan and Hadrian. This was, for the most part, an era of relative peace and prosperity; there were few triumphs to celebrate, but private construction flourished, as did building in the provinces, locally initiated and locally funded. Counting Hadrian, four Antonine emperors died and were deified at this time; temples to two of them remain in part, rebuilt into later structures.

Temple to *Divus Hadrianus*

The piety of Antoninus displayed itself not only in his adhering to Hadrian's wishes concerning succession, but was also demonstrated immediately upon his becoming emperor, when he prevailed upon a highly resistant senate to grant his predecessor divine honors. Despite ruling for more than two decades, Hadrian had spent very little time in Rome itself as a result of his travels and being at his villa at Tivoli. The senate felt disrespected by this, its attitude surfacing in the highly ambivalent evaluation of Hadrian that is preserved in the literary record. The temple to Hadrian was the first such one to be built in the Campus Martius; Caesar's temple, of course, was in the Roman forum; that of Vespasian and Titus stood opposite at the foot of the Capitoline; and Augustus's was nearby, in the saddle between the Capitoline and the Palatine hills. Claudius's temple was somewhat different: it stood in its own, imperial forum-like colonnaded platform; it was large but not prominent owing to the fact that Nero had started it in the residential area of the Caelian hill but then subsumed it, unfinished, in his Domus Aurea. It was later finished by Vespasian. From Antonine times, there was a cluster of funerary monuments in the Campus Martius, sandwiched between Augustus's Horologium complex to the north and the Caesarian/Agrippan complex to the south. The commemorative columns of Antoninus Pius and Marcus Aurelius stood here, with associated *ustrina*, as did Hadrian's temple and probably Marcus's temple as well.

Adjacent to a temple to Salonia Matidia, dedicated by her son-in-law Hadrian, was the temple to *Divus Hadrianus*, similarly arranged but better known since one side of it has been preserved in a later building, which serves today as the Roman stock exchange [10.29].

10.29 Temple to *Divus Hadrianus*, Campus Martius, Rome, Italy, 138–145 CE. The building serves today as the Roman stock exchange.

CHAPTER 10: THE ART OF HADRIAN AND THE ANTONINES 283

The complex, as reconstructed, is appropriately hybrid. Similarly to the Temple of Venus and Roma, it consists of a peristyle temple surrounded by, but freestanding within, a colonnaded portico—a Hellenistic arrangement long known in Rome (for example, the Porticus Metelli in the southern Campus Martius, see 2.4, p. 55). The temple was Corinthian and, although peristyle, traditionally Roman in form, standing on a high podium with the staircase only in the front. This form is shared with the other known temples to divinized *imperatores* (Caesar, Claudius, Titus/Vespasian, Antoninus and Faustina) so it was probably a fixed tradition. Indeed, rooting the concept of the principate in the traditions of the Republic was a fundamental principle.

Within these traditional forms one finds the inclusion of elements of the "new" Roman architecture. Novel is the coffered vaulting, rather than flat ceiling, of the **pteroma** (the space between the peristyle and cella walls); the cella, also, was covered with a large coffered barrel vault, its interior walls further elaborated with an engaged colonnade. The remains suggest a close connection with the Temple of Venus and Roma and its intricately carved architectural ornament and extensive use of imported marbles. It is probable that some of the same craftsmen worked on both buildings. A series of reliefs found nearby are believed to have adorned the plinths of the interior column, an attic above them, or, less probably, the temple podium [10.30]. These depict, in typical, deeply carved Antonine Classicizing style, a series of personifications of provinces, a motif as old as the empire itself and already found in monumental form in the *ethne* of the Julio-Claudian Sebasteion at Aphrodisias (see 8.31, p. 226). Dedicated in 145 CE by Pius, this subject was a fitting tribute to Hadrian, as was the mixture of Italic and Asiatic materials and stylistic features that characterizes the architectural ornament—both features recall Hadrian's desire to bring the provinces to Rome.

Temple of Antoninus and Faustina

Roughly contemporary with Hadrian's temple is the relatively modest and highly conventional podium temple built on the northeast flank of the Republican forum by Antoninus in honor of his deified wife Faustina the Elder, who died in 141 CE [10.31]. The first such building to be put in the old forum since Vespasian's temple, the choice may have been designed to connect Pius with these earlier, Italian emperors. Perhaps to fit in, its plan is purely Italic, with no columns whatsoever to the sides or at the back of its cella. The temple overlooks the Regia (headquarters of the *pontifex maximus*, the old Republican office of chief priest that was held by Caesar and every emperor thereafter), which is immediately behind the temple to *Divus Iulius*. It was rededicated in honor of Antoninus after his death and deification in 161 CE, an uncharacteristic but not unprecedented act of imperial parsimony, since the same was done in the case of Titus (and the temple to Vespasian). One assumes that the conservative and self-effacing Pius had ordered this himself, but by 169 CE, Marcus Aurelius was peddling imperial treasures in the Forum of Trajan in order to fund his Marcomannic campaign.

Thanks to its incorporation into the church of San Lorenzo in Miranda by the twelfth century (the present baroque facade of the building

10.30 Relief from the Temple to *Divus Hadrianus*, Rome, Italy, 138–45 CE. H. 2.08 m (6 ft 10 in.). The panels depict personifications of Roman provinces. This one was no doubt Asiatic, to judge from its "Phrygian" headdress.

is obviously much later), a good portion of the temple superstructure remains. The Temple of Antoninus and Faustina, although a minor building in its own time, is today among the most conspicuous elements of the forum complex. Although perhaps bolder in its location in the monumental heart of the old city, and adjacent to Caesar's temple (which it quotes, perhaps, in the altar on its front steps), it is more modest in scale, and more Italic-looking than Hadrian's temple. To be sure, there are formal and technical similarities to that and the Temple of Venus and Roma, but the entablature seems much less exuberant, its griffin frieze is almost archaizing in its formal restraint [10.32], and the proportions of the facade are much taller and narrower, owing to its six rather than eight columns (or ten on the Venus and Roma temple). Whether a response to the cosmopolitan, philhellenic excesses of his predecessor or simply a reflection of the tastes of one whose roots were entirely in the West is impossible to say. Nonetheless, there is a break, in this building at least, with the tradition of Hadrian, although the creation of a pan-Mediterranean empire undertaken by the latter had too much momentum, and timeliness, to be resisted. How this played out in the provinces themselves is a subject of the next chapter.

10.31 Temple of Antoninus and Faustina, Rome, Italy, 141 CE. Originally dedicated to Faustina after her death, it was renamed and rededicated following the death of Antoninus in 161 CE.

10.32 Entablature from the Temple of Antoninus and Faustina, Rome, Italy, 141 CE. The reliefs show a break from previous Hadrianic traditions in moving away from Hellenistic influences to a more restrained style.

CHAPTER 10: THE ART OF HADRIAN AND THE ANTONINES 285

11 Provincial Art in the High Empire

288 The Provinces
- 288 Box: Herodes Atticus and Euergetism
- 290 URBAN DEVELOPMENT
- 296 COLONNADED STREETS
- 297 COLONNADED FACADES/STATUARY DISPLAY
- 300 THE BATH-GYMNASIUM
- 300 STAGE BUILDINGS
- 301 HADRIAN'S VILLA AT TIVOLI
- 304 Box: Hadrian's Wall and the Limits of the Empire
- 306 SCULPTURE IN THE PROVINCES
- 308 Box: Antinous and the Travels of Hadrian

310 Funerary Art and Sarcophagi

Chronological Overview

DATE	EVENT
c. 100 CE	Timgad founded: construction of the theater, Arch of Trajan, and mosaics
114–117 CE	Library of Celsus, Ephesus
c. 118–128 CE	Hadrian's villa at Tivoli
131 CE	Hadrian completes Temple of Olympian Zeus, Athens
c. 132 CE	"Library" of Hadrian, Athens; Arch of Hadrian in Athens
c. 153 CE	Nymphaeum of Herodes (Regilla) Atticus, Olympia
161 CE	Odeum of Herodes Atticus
c. 169 CE	Panathenaic Stadium, Athens
Second century CE	Marble sarcophagi

The Roman Empire in the Second Century CE

The Provinces

During the second century CE, the nature of the empire was utterly transformed—politically, economically, and socially—through Rome's relationship with Italy on the one hand, and with the provinces that ringed the "Roman Sea" on the other. With the accession of Trajan in 98 CE, the Roman emperors would no longer be members of Roman, or even Italian families, but rather emerge from the growing provincial senatorial elite (and later not so elite) from Spain, Gaul, North Africa, Syria, and the Balkans. Since the composition of the senate, imperial administrative posts, and military commands were largely determined by imperial patronage, the entire ruling apparatus of the empire became much more representative of the provinces being ruled. There was no diminution in the centralization of power, which, more so than ever, lay in the hands of the *princeps* himself. These emperors were, however, more broadly experienced in leadership terms and, as provincials themselves, they more fully comprehended the symbiosis that existed between Rome as a center of authority and the provinces as places of production, most notably of food, but of many other resources as well.

Much more extensively than ever before, provincial cities were embellished with magnificent public buildings and monuments, sometimes financed by the imperial purse but more often underwritten by wealthy local potentates who, in the same way as the senators of the Roman Republic before them, funded public architecture to demonstrate (and maintain) their position of civic leadership (see box: Herodes Atticus and Euergetism). As seen in Chapter 8, Augustus, strongly influenced by the traditions of Hellenistic rule, Republican customs, and Classical culture, forged a uniquely Roman imperial society, and during the first years of the empire a conscious effort was made to visually "Romanize" the provinces through the erection of buildings that were distinctly Roman in form and function. Constructions of the second century, however, more strongly reflected a blending of Roman types with native traditions that provided buildings and public spaces with a distinct local flavor. At the same time, there was so much movement of materials and workmen that, for example, styles of architectural

Herodes Atticus and Euergetism

Perhaps the individual most fully representative of the world described in Part III of this book was the Greco-Roman aristocrat Lucius Vibullius Hipparchus Tiberius Claudius Atticus Herodes (101–177 CE). His lifespan encompasses almost perfectly the most prosperous and secure years of the Roman empire, from the early years of Trajan's reign to the later years of Marcus Aurelius. As his name Atticus suggests, he was an Athenian to the core; in Herodes' homeland the name Hipparchus calls to mind the ill-fated co-tyrant of Archaic Athens, but more famous still was the Hellenistic scholar and astronomer by that name, and Herodes was, to say the least, a learned and cosmopolitan man. "Hipparchus" also means cavalry commander, which in ancient Athens would be understood as a reference not only to his dedication to civic duty but also his aristocratic status. Herodes (also known as Atticus Herodes) traced his ancestry back to the eminent Alcmaeonid family of early Athens, which included Miltiades the Younger, the victorious general at the Battle of Marathon during the Persian invasion of Greece, and further back through his ancestors to the legendary kings of Athenian prehistory.

Herodes is also a perfect example of how the system of Roman imperial rule enlisted the assistance of local aristocracy in its processes of provincial administration. He was from a provincial senatorial family and he himself became, in 143 CE, the first Greek to be an ordinary consul—that is, one of the first pair of consuls for the year, for whom

that year was named, as in the Republic, as opposed to a **suffect consul**, which in the empire became a primarily honorary title but was of a lesser status than the role performed by Herodes. He was also delegated real as well as symbolic power (consuls during the empire were all symbolic since real power lay in the emperor's hands) when, in 125 CE, he was appointed by Hadrian as a prefect in Asia. He was very much a man of both the Greek and Italic worlds, owning a large estate outside of Rome and traveling between Greece and Italy with regularity. Similar to many men of his status at that time and place, Herodes was also a leader in the Second Sophistic, as his demonstrated devotion to the antiquities of his homeland indeed suggests. His written works are lost, but he is reported to have been an orator, author, and teacher of distinction.

11.1 Odeum of Herodes Atticus, Athens, Greece, completed in 161 CE. The odeum, or covered theater, was set into the Acropolis's south slope.

Herodes' most lasting legacy, however, is his conspicuous participation in the practice of **euergetism**. The term literally means the doing of good deeds, and in this context it refers to the personal sponsorship of public works by the local upper classes, as was expected of their socio-economic status. These benefactors were, as Herodes was, rewarded with powers and prestigious titles that reinforced their hereditary standing in their homeland; in some cases, Herodes included, the reputations of these individuals spread throughout the empire. This tradition can be traced to the custom of providing private funds for building in the Roman Republic, and in the eastern Mediterranean it recalls the building activities of Hellenistic royalty even outside their own realms, especially in the cities and sanctuaries of Greece proper.

The public buildings that Herodes sponsored were many and widespread; from the nymphaeum dedicated by his wife Annia Regilla at Olympia (see Nymphaeum of Herodes Atticus at Olympia, p. 297), they ranged across all

11.2 The Panathenaic Stadium, Athens, Greece. The stadium was first built in the fourth century BCE, restored in the second century CE, and entirely rebuilt for hosting the first modern Olympics in 1896, which it did again in 2004.

of mainland Greece, from the Peloponnese to Thessaly, and abroad to Asia Minor and Italy. The two that most closely retain, or repeat, their original form are both found in Herodes' home of Athens. His odeum (covered theater), which was built into the southwest slope of the Athenian Acropolis, was damaged badly by invaders in the later empire; since re-erected, it now provides an excellent impression of its original form. Performances are held there today with regularity and are among the prime tourist attractions of the city [11.1]. His stadium [11.2], built entirely in marble to house the already centuries-old Panathenaic Games, was restored to its original form to host the first modern Olympics in 1896, served as a venue for field events for the 2004 Olympics, and is used daily by local running clubs. Herodes' legacy has surely exceeded even his own expectations, at least in longevity.

carving that originated in Asia Minor could be detected in the buildings of North Africa and even Rome itself. While the cities that grew up during this most fertile era of Roman urbanism retained distinctive Roman qualities—so much so that the thousands of citizens who regularly traveled the empire would feel at home in its far-flung reaches—there was within these consistent patterns a decorative richness of spectacular variety.

In short, the empire of the second century was both unprecedented and unrepeated, a coherent aggregate of interdependent communities that, despite myriad languages, cultures, and traditions, were governed by a universal respect for the inevitable truths of Augustus's creation—that prosperity depends on peace and that peace depends on the display, and use when necessary, of military force. It was not, by any means, a society to be commended from the standpoint of modern-day values of individual human rights, liberty, and self-determination, although these concepts were far from alien to philosophers and statesmen of Greco-Roman antiquity. But, for a time, the Roman system actually worked, and certainly some of those who came under its authority were able to recognize its benefits, or at least articulate its justification.

Aelius Aristides (117–181 CE), an eminent Asiatic Greek rhetorician, praised these accomplishments of Rome in his *Roman Oration*, delivered at Rome in 155 CE:

> As on holiday the whole civilized world lays down the arms which were its ancient burden and has turned to adornment and all glad thoughts with power to realize them…Cities gleam with radiance and charm, and the whole earth has been beautified like a garden…Thus it is right to pity only those outside your hegemony, if indeed there are any, because they lose such blessings…Homer said, "Earth common of all," and you have made it come true…You have become universal guides for all; you threw wide all the gates of the civilized world and gave those who so wished the opportunity to see for themselves; you assigned common laws for all…and you organized all the civilized world, as it were, into one family.
> (Aristides, *Roman Oration* 97f)

Whether or not Aristides believed this imperial message, he surely understood it.

URBAN DEVELOPMENT

Building work in the provincial cities during the second century CE was motivated, funded, and experienced in various ways. It was no longer simply a case of Romanization or of social control, although those imperialistic ends would never cease to matter. As Aristides indicates, these beautiful new cities reflected Roman power as much as the splendor of Rome herself. At the same time, such provincial intellectuals as Aristides, Plutarch, and Pausanias (c. 110–180 CE)—some of whom, such as Herodes Atticus, were wealthy patrons themselves—became obsessively devoted to their own local traditions and culture, which they sought both to revere and revive. Just as Rome's physical beauty was meant to represent its *auctoritas*, so the newly (or once again) elegant cities of the provinces received such adornments, both as a demonstration of local prestige and to mark them as jewels in the Roman imperial crown. Therefore, buildings were meant to be impressive, to be functional, and to invoke both Roman and local traditions.

Within a commonly accepted pattern of development consistent with Roman ideas about how a city should look and what services it should offer, there was a rich variety of local expression in plans, materials, and ornamentation. The geographical trends of the first century CE generally persisted. In those lands that were never a major part of the Hellenistic world—Spain, Gaul, Britain, the Rhineland, the Balkans, and most of North Africa—Roman architectural and artistic forms tended still to dominate, since there was no true urban history preceding their incorporation into the empire. The results were rather more complex in those cities that once were part of the Antigonid, Attalid, Seleucid, and Ptolemaic kingdoms. Although new settlements were surely founded, more often the Romans worked within a pre-existing urban framework, which was then modified to function in the same way as, and to varying degrees resemble, a Roman imperial city.

Timgad

Early in the reign of Trajan, the town of Timgad was built in the province of Numidia (in

modern-day Algeria), near the permanent base of a Roman legion stationed there. The town plan [11.3] closely follows that of a *castrum*, or military camp, not dissimilar to that of early Ostia (see Ostia, p. 254). The starkly military aspect of this town may have resulted from its function as a veterans' colony or perhaps the local availability of military architects and builders, but the general principles of organization are typically Roman, if in a somewhat extreme form. The streets are laid out in a perfect grid, with main avenues intersecting at the center (*cardo* running North–South and *decumanus* East–West), and running from that center out to each gate. The intersection of the two avenues is marked (as at the much less rectilinear Pompeii) by the forum, with its porticoed square open area, dominant temple, adjacent basilica, and *curia* for the meetings of the municipal council. Nearby was a theater of purely Roman form [11.4], which must also have served for gladiatorial games, as often was the case in such smaller towns as this. Amphitheaters and circuses were popular in the larger cities to the west. There was also a magnificent three-bayed arch [11.5], following a form used in Rome for triumphal arches, although this one, according to its inscription, was meant to commemorate the foundation of the colony by Trajan, whose name it therefore bears. The form and decoration, however, are thought to fit better in the Antonine period, or even later, showing that even (or especially) newly founded communities were committed to promoting their own historical legacy. Comparable to the early imperial foundations of Gaul, the Roman cities of Spain and North Africa, with the patronage of their native son emperors, such as Trajan and Hadrian (and later Septimius Severus) in the second and third centuries, adopted the formal architectural trappings of the capital itself as a physical sign of their own homegrown *romanitas*.

11.4 Theater at Timgad, Algeria, Trajanic era. The theater is Roman in its form; as is the case in many smaller provincial towns, it probably also held gladiatorial games.

11.5 Triumphal Arch of Trajan, Timgad, Algeria, Trajanic era. The inscription on the arch commemorates the founding of the colony by Trajan.

11.3 (Above) Town plan of Timgad, Algeria. The town's purpose as a veterans' colony may have informed its military character and plan, which followed that of a *castrum*.

CHAPTER 11: PROVINCIAL ART IN THE HIGH EMPIRE 291

Timgad Mosaics

North Africa is notable for the quality and quantity of its Roman-period floor mosaics. These features can be attributed to the increasing wealth of the area, deriving from both agriculture and trade, that in turn led to the construction of well-appointed public and private buildings, and to the combination of a dry climate and relative lack of later building at many sites that has enhanced preservation of the floors. The area had its own history of floor construction, as did Italy and the Hellenistic world, but the Romanization that began during the Republic in the wake of the Punic and Jugurthine wars, and accelerated during the imperial extension of Roman control from Egypt to the Atlantic, brought Africa its own versions of both black-and-white and polychrome mosaics, with considerable regional variation. Here, as elsewhere, are myriad decorative styles usually used in combination—geometric, floral, and figural with subjects including myth, allegory, and ceremony, and such activities as hunting, agriculture, and gladiatorial games. Timgad has produced some particularly fine examples, especially of the floral style.

It is impossible to capture this variety in one example but this mosaic from Timgad does illustrate the quality that these works achieved, as well as a certain level of iconographic and stylistic variability [11.6]. The floor here consists mostly of acanthus scroll, arranged in a carefully composed radial form that both recaptures the shape of the room and frames the small panel within. The scrolls themselves are rendered with an intricacy that rivals those of the Ara Pacis. The use of light, shadow, and color gradation in the vegetal forms creates a three-dimensionality that calls to mind early Hellenistic mosaics, themselves probably inspired by late Classical painting. The overall effect captures the texture and color of a woven floor tapestry.

The central panel shows a nude female supported by a pair of hippocamps. She reminds us of the sea nymphs from a marine *thiasos*, but here, given her prominent centrality, the canopy held over her head, her jewelry, and the dolphin at her feet, she is more probably Venus herself, born from the sea. The anatomy of each figure is carefully modeled, the bulging bronze muscles of the sea beasts emphasizing, by contrast, the smooth pale surfaces of the goddess's form and underscoring her status as the embodiment of feminine beauty. There is, however, a certain abstraction of style despite the obvious figurative skill of workmanship, suggesting a date somewhat after the second century.

Athens and the Hellenistic East

Probably no other city in the east was held in such high esteem in Roman times as Athens, which was the central location for many revivalist intellectual movements. Although it had had limited economic or political importance since at least the time of Philip II of Macedon—the cities of Asia Minor had long since outstripped their Ionian cousin—Athens remained a center of learning and culture and, as today and

11.6 Mosaic of Venus and Hippocamps, Timgad, Algeria, 2nd to 3rd century CE. H. 2.9 × W. 4.9 m (9 ft 6¼ × 16 ft 1 in.). Timgad has produced some particularly fine examples of floor mosaics.

for many of the same reasons, an enormously popular tourist destination. It was similar to Timgad in that it was not a typical example of a Roman city, but the selection and arrangement of Roman buildings here illustrated well how a pre-existing city of significant physical and historical stature could be accommodated and modified without being excessively transformed or violated.

Hadrian had a special relationship with Athens, a city he visited a number of times and where he was honored as *archon* (chief magistrate) already in 112 CE, well before his accession. As emperor, he was initiated into the Mysteries at Eleusis and the Athenians named a tribe (a political division of the citizenry, named for the legendary hero-kings of Athens) after him, an honor accorded to no other Roman emperor. Although he was a native of Spain, Hadrian's activities at Athens revealed his desire to be perceived as a full citizen of the eastern empire, a desire reflected also in his portraiture. In Athens he founded the Panhellenium, an organization of Greek-speaking cities from around the eastern Mediterranean that were bound by a mutual interest in Greek history and culture as well as loyalty to Rome and the worship of "Hadrian Panhellenios." It is in this context that we are to interpret Hadrianic Classicism and the entire phenomenon of the so-called Second Sophistic, which fostered the revival of Classical rhetoric among influential and intellectual Greeks, including Plutarch, and such public benefactors as Herodes Atticus.

Hadrian's relationship with Athens manifested itself in a flurry of building activity there so significant that the geographer Pausanias, who wrote his *Description of Greece* very much in the spirit of the Second Sophistic, and who rarely mentions Roman monuments at all, provided a full account of Hadrian's Athenian building program. Hadrian expanded the city to the east, extending the walls to enclose the new area and building a new aqueduct to supply it. Between the old and Hadrianic quarters he erected an arch (a combination, found elsewhere on Hadrianic buildings, of arched and post-and-lintel forms in the Corinthian order) on one side of which was inscribed, "This is the city of Hadrian, not of Theseus," and on the other, "This is Athens, the ancient city of Theseus" [11.7]. Not far from Hadrian's arch stood the Temple of Olympian Zeus [11.8], laid out in the sixth century BCE and principally built with funds provided by the Seleucid king Antiochus IV in the second century BCE (his architect, Decimus

11.7 Arch of Hadrian, Athens, Greece, 132 CE. On one side is inscribed "This is the city of Hadrian, not of Theseus," and on the other, "This is Athens, the ancient city of Theseus."

11.8 Temple of Olympian Zeus, Athens, Greece. The temple had existed since 174 BCE but was completed and dedicated by Hadrian in 131 CE.

11.9 Gateway to the Roman Market in Athens, Greece, 1st century BCE. The columns are in the Doric order, rarely used in Roman architecture. Here it refers to the Parthenon and Archaic Greek temples.

Cossutius, was a Roman). Partially dismantled by Sulla after his sack of Athens in 86 BCE, the temple was completed and dedicated by Hadrian in 131 CE, at the time of the foundation of the Panhellenium. It was an enormous Corinthian temple, on a scale comparable to the Temple of Venus and Roma (which it resembles considerably) or the great Asiatic temples of Ephesus and Didyma, and its completion established Hadrian, once again in the tradition of Hellenistic kings, as benefactor of Athens.

The center of Athens consisted of the sanctuary of the Acropolis, with the Parthenon and other Classical temples, at the foot of which ranged important civic and religious public areas to the south and north. In Chapter 8 we looked at some Augustan additions to the Acropolis and the Athenian Agora. Just east of the latter, in what may have already been the Athenian marketplace, Caesar and Augustus also built a new enclosed, rectangular portico in a form that resembled the Roman market building (**macellum**), as known from Pompeii and many other sites. This was an elegant building of cut-stone masonry in local blue-gray (Hymettian) and white (Pentelic) marble. The gateway leading in from the west (the direction of the "old" agora) was in the Doric order [11.9], which was rarely used even in the Hellenistic period and all but absent from Roman architecture. Here it was clearly a tribute to the style not only of the Classical Parthenon but also the Archaic temples that were destroyed by the Persians, from which stone blocks were reused and figure prominently in the north Acropolis wall, looming just above this very building [11.10]. This was later topped by acroterial portrait statues of Gaius and Lucius Caesar, introducing a current element into this archaizing setting. The whole complex was a remarkable combination of local materials and forms with a Roman plan, function, and message.

Immediately to the north of this early imperial market, and aligned with it, across a major street through Athens, Hadrian added his own public square. He did so in much the same way that Augustus, Vespasian, Domitian, and Trajan (but not Hadrian) attached their fora to those of their predecessors; Hadrian decided to leave his imprint here rather than in Rome. This so-called Library of Hadrian [11.11] is mentioned in two sources. Pausanias, roughly contemporary, writes:

11.10 A view of the Acropolis from the markets of Caesar and Augustus. The remains of ancient Greece stood prominent atop the Acropolis, and were also built into its walls, where they served as a model for emulation for Romans centuries later.

11.11 The "Library" of Hadrian, Athens, Greece, c. 132 CE. Referred to by ancient sources as a library, its plan is reminiscent of imperial fora in Rome, especially the Templum Pacis.

Hadrian constructed other buildings also for the Athenians…most famous of all, a hundred pillars of Phrygian marble. The walls too are constructed of the same material as the cloisters. And there are rooms there adorned with a gilded roof and with alabaster stone, as well as with statues and paintings. In them are kept books. (Pausanias, *Description of Greece* I.18.9).

By the fourth century, the building was known as a library, based on a comment in the *Chronicle* of St. Jerome (*c.* 347–420 CE): "Hadrian, when he had constructed many notable buildings in Athens, held games and erected a library of wondrous construction."

The complex was built around 132 CE, about contemporary with Hadrian's completion and dedication of the Olympieium. What exists is a large rectangular porticoed courtyard with an entrance through a monumental Corinthian propylon centered on the west exterior wall; this was articulated to either side by a further line of Corinthian columns bearing an entablature of **re-entrants**, forming a series of decorative recesses. This arrangement reproduces the western exterior wall of Vespasian's Templum Pacis in Rome (see Templum Pacis, p. 195), after the additions of the Forum Transitorium—a similarity that could not be accidental.

Indeed, Hadrian's square is often compared to Vespasian's forum, with its large open space, and was probably also formally planted, offering a respite from the hubbub of the city's public center. The architecture is opulent, with ornately carved capitals and moldings, similar to the Olympieium and its Hadrianic cousins in Rome—the Temple of Venus and Roma and the Mausoleum. At the end opposite the entrance is a large open room, again calling to mind the Templum Pacis, although in this case the room is even more inconspicuously placed behind the portico. This is thought to be the library itself, flanked by reading rooms and perhaps lecture halls. Both the fora of Vespasian and of Trajan had libraries, of course, and in a real way, Hadrian's structure in Athens is every bit as much a forum as those are, despite its modern name. We do not know what it was called in Hadrian's time. Pausanias, whose brief assessment is our fullest ancient testimony, does not really answer the question.

The process of Romanization through urban development was therefore very sophisticated—responsive to local traditions and patronage and

at the same time supportive of, and supported by, the emperor himself. The variety of forms in which this process developed is as great as the empire was vast, and the number of monuments is staggering. There is room here to look at only a handful of especially representative and particularly well-preserved examples of some characteristically Roman imperial building types and architectural features.

COLONNADED STREETS

In many provincial cities, another type of formalized public space was the colonnaded street, which was especially favored in the eastern provinces with their tradition of building in stone. In a sense, Domitian's Forum Transitorium in Rome was designed and did serve as a monumentalized passageway, as its name suggests. Indeed, the idea of the colonnaded street perhaps emerged from the extension of a forum portico along one or both of a Roman town's main avenues, the crossing of which generally occurred at the forum. One of the most famous colonnaded streets was the great Arkadiane (named after the emperor Arcadius (r. 395–408 CE) in Ephesus, which led from the city center down to the harbor, some 700 or so yards away (the distance is about seven times that today) [11.12].

In its final form, the Arkadiane is quite late in its date, but a much earlier and better preserved example can be seen at Palmyra, an oasis site that was, until its demise in the later third century CE, an important caravan stop between Mediterranean Syria and the Euphrates River to the east [11.13]. Trade passing through here led to a significant accumulation of wealth and the embellishment of the city with a series of street-side colonnades. The stretch of Corinthian columns shown here, dating to the second century, are noteworthy for the inclusion of brackets designed to hold statuary, which would have given this avenue an even more monumentalized and commemorative aspect.

11.12 (Above) The Arkadiane at Ephesus, Turkey, reconstructed 4th century CE, originally Hellenistic. The colonnaded street extended from the city center down to the harbor.

11.13 The colonnaded street and monumental arch at Palmyra, Syria, 2nd to 3rd century CE. The Corinthian columns date to the second century CE and carry a series of brackets to support statuary.

COLONNADED FACADES/ STATUARY DISPLAY

While colonnaded streets occur sporadically in the Roman provinces, sculpture in the service of empire was ubiquitous. Sculptural groups of the imperial family were common already in Augustan times and continued to be set up in public spaces, both religious and secular, across the empire. An increasingly popular arrangement was the great columnar facade, two or three stories high, consisting of projecting *aediculae* that were used to contain and display statues. Possibly originating in the *scenae frontes* of such theaters as that at Orange, the form exists also in the Julio-Claudian entrance facade of the Sebasteion at Aphrodisias. In the second century CE, with the explosion of public building across the empire, these columnar facades became very popular and took on many different forms in different types of buildings.

Nymphaeum of Herodes and Regilla at Olympia

Among the better-documented structures of this type, in terms of its statuary program, is the nymphaeum [11.14a] built by Herodes Atticus and his wife Regilla at Olympia, which must have dominated the main sanctuary area. It was dedicated by Regilla, a priestess of Demeter (Ceres), and the dedication is inscribed on a marble bull [11.14b]. Regilla was awarded the priesthood in 153 CE, and the fountain was probably built around the same time, during the reign of Antoninus Pius. The building included an enormous rectangular basin at the front, with small *tholoi* at each end. Its backdrop was a great apsidal screen of *aediculae* in two stories, filled with portrait statuary. Although fragmentary, the surviving portraits, plus inscriptions, allow a realistic identification of the characters portrayed.

As reconstructed by the excavators, the upper row of *aediculae* included ten members of Herodes and Regilla's family. On the lower story were Hadrian, Antoninus Pius, Marcus Aurelius, Lucius Verus, their wives, and several children.

11.14a (Above) Nymphaeum of Herodes and Regilla, Olympia, Greece, c. 153 CE. The marble bull is seen above the rectangular basin.

11.14b (Left) Bull from the Nymphaeum of Herodes and Regilla, Olympia, Greece. H. 1.05 × L. 1.6 m (3 ft 5³⁄₈ × 5 ft 3 in.). The bull is inscribed with a dedication to Zeus, written by Regilla.

At the center of each rank was an over-life-size figure of Zeus, each of which was in a Classical or Classicizing statue type [11.15]. The designer of the monument was acutely aware of its location in Olympia, the greatest of Greek Panhellenic sanctuaries. Zeus was Olympia's deity and the bull was his sacrifice of choice. The fountain stood just above and to the east of the Metroon, and the designer must have also been conscious of the array of portraits of Augustus, Claudius, and the Flavians contained within the Metroon itself. The nymphaeum surely draws on that tradition, adding to the traditional imperial group portraiture a family sculptural group of the patron herself.

The portraits of the four emperors—past, present, and future—were presented at the nymphaeum in the form of cuirass statues. Since none of them had campaigned as either *princeps* or designate by the time of the monument's construction, the statuary type signifies, in this case, the status of the *imperator* as general over all the Roman legions, whether or not he actually had fought. The cuirass type worn by Hadrian and Antoninus (it seems, at least: Antoninus's portrait is known only from fragments) was more elaborate than those worn by the designated successors, indicating their elevated status [11.16]. Hadrian is shown in his typical cuirass statue type, which was found all around the empire and used both during his lifetime and after his death. As expected, he stands in a Classicizing weight-shift pose. The central relief on his breastplate shows an image of Athena, with an owl and snake at her feet to either side, who is perched on the back of a wolf suckling Romulus and Remus. The goddess is being crowned by Classicizing Nike/Victoria figures from both sides.

This Athena figure is of a type that references the ancient Palladium statue of the goddess, on which, in the story narrated in Homer's *Iliad*, the safety of Troy depended. The owl of wisdom and the snake either side of her symbolized the ancient indigenous kings of Athens. This founding goddess of Athens represented the great antiquity of Herodes' Attic homeland in particular and the Greek-speaking East more generally. The image was, in turn, supported by the primary symbol of Rome's foundation, Romulus and

11.15 (Above) Classicizing Zeus from the Nymphaeum of Herodes and Regilla, Olympia, Greece, *c.* **153 CE. H 1.91 m (6 ft 3¼ in.).** The statues of Zeus would have been flanked by statues of Herodes and Regilla's family, and the imperial family.

11.16 Statue of Hadrian from the Nymphaeum of Herodes and Regilla, Olympia, Greece, *c.* **153 CE. Restored H. 2.3 m (7 ft 6⅝ in.).** Hadrian's cuirass is particularly elaborate, suggesting his seniority over his successors.

Remus, similarly indicating its greatness and antiquity. Rome is shown here as not just the ruler but the champion and preserver of Greece and its heritage, with a history and traditions just as deep. The image also suggests Hadrian's double identity as Roman by birth and Greek by aspiration, and, it seems, acclamation. A similar sense of cultural dualism applies to the dedicator of the monument herself, Regilla, whose family connections with the Roman aristocracy were both old and deep, having enjoyed Roman citizenship for generations and being able to claim ancestry from among the originally Roman families of Corinth.

Library of Celsus

To experience the architectural effect of columnar facades, one need only look at the fully reconstructed nymphaeum/facade of the Trajanic Library of Celsus in Ephesus, located prominently at the intersection of two main avenues of this provincial capital, the *cardo* and the *decumanus*. This facade, which was funded by a wealthy local consular family, was richly carved in the local Hellenistic tradition and was especially fanciful. The upper *aediculae*, with their alternating curved and triangular pediments, do not align with those below but straddle them instead, and are therefore rendered useless as frames for sculpture [11.17]. Rather, they frame windows, useful in a library. As is often the case with these purely decorative facades, this is fantasy architecture, strikingly reminiscent of the imaginative constructs of Second or Fourth Style wall painting. **Trabeation** (posts and lintels) remained one the most beloved forms of embellishment throughout Roman art. Also visible here, in the excellent restoration work undertaken by the Austrian Archaeological Institute, are the portrait statues in niches cut between the library's three entrances, and the bases for further statues above, which were, owing to the peculiar non-alignment of the *aediculae*, open to the sky. The interior of the building was equipped on two stories for the storage of scrolls, with an arrangement perhaps inspired by the libraries in Trajan's forum. In the same way as that complex, this library at Ephesus served as both a public donation and a private commemoration, since it was built as the mausoleum of the Roman senator Tiberius Julius Celsus Polemaeanus, whose son funded the construction.

11.17 Library of Celsus, Ephesus, Turkey, 114–17 CE. The structure was funded by a wealthy family and demonstrates fanciful architectural features that are reminiscent of Second and Fourth Style wall paintings.

THE BATH-GYMNASIUM

In addition to such columnar facades described above, there were other structures designed for public enjoyment that made use of similar columnar screens. A phenomenon especially popular in Asia was the bath-gymnasium complex. We have already noted, in our discussion of Roman baths (see Seneca and Life in a Roman Bath, p. 240), that bathing and exercise were combined from the beginning in both Roman and Hellenic tradition. What distinguishes the type in question here is the addition of a spacious assembly hall corresponding to the lecture or meeting room of a Greek gymnasium (*ephebeum*). Through the inclusion of a colonnade screen equipped with statuary, these rooms were often transformed into what is called a "marble hall" or "emperor's hall." Ephesus boasted at least three such bath-gymnasia, but the most visually compelling today, again owing to extensive reconstruction, is the somewhat later marble hall at Sardis in Phrygia (modern-day Sart in Turkey) [11.18]. This is similarly fanciful with arcuated (arch-like) and trabeated forms, upper orders that both align with and straddle lower orders, and both vertically and spirally fluted columns. Many (although not all) of the bathing suites from these complexes were, being under influence from Rome, symmetrically arranged about a large central hall, as were many other provincial baths, especially in North Africa. At the same time, the asymmetrical linear form of the small city baths (as seen at Ostia) remained popular throughout the empire. These basic forms were applied and adapted with almost infinite variety. Sumptuous and plentiful public bathing establishments (and the waterworks to support them) constituted perhaps the most conspicuous, and doubtlessly most appreciated, hallmarks of Roman urbanism in every corner of the empire, and the opportunities for experimentation with local variation were great.

STAGE BUILDINGS

No doubt the earliest use of columnar facades was as a backdrop for the stage buildings in theaters, and it may well have been that these ubiquitous *scenae frontes* served as the ultimate inspiration for the many other ways that we see these facades used; certainly Pompey's theater (see Theater of Pompey, p. 105), the earliest permanent theater structure in Rome, was so equipped and even the elaborate temporary theaters of the Republic, noted by Pliny the Elder (see box: Greek and Roman Theaters, p. 106), were admired for the large number of columns that they featured. The most completely restored imperial stage building is found at Sabratha in Tripolitania (Libya) [11.19], which can stand as a representative of dozens of such buildings in every city across the empire. Visible here, too, are the reliefs installed in the alternating curved and rectangular niches fronting the elevated stage surface (*pulpitum*), another common feature of Romanization in theater buildings. Following this pattern of Romanization, new theaters of Roman form were set up in the provinces of western Europe and North Africa, as well as in newer cities to the east. In the old cities of Greece and Asia Minor, existing theaters were modified through the addition of Roman-style stage buildings and, when needed, barriers to allow the staging of gladiatorial games. The amphitheaters that were so popular in Gaul, Spain, or North Africa are therefore rarely found in the eastern provinces, as is true for circuses, which were not needed where Greek tracks for chariot racing (hippodromes) already existed.

11.18 Hall from the bath-gymnasium at Sardis, Turkey, 2nd to early 3rd century CE. The upper *aediculae* straddle the lower here, as at the Library of Celsus at Ephesus.

HADRIAN'S VILLA AT TIVOLI

No other site encompasses the blending of the private and public, and of the Roman and provincial, as does the great and fortuitously well-preserved villa built by Hadrian at Tivoli (ancient Tibur) just outside Rome. As Hadrian's biography tells us, "He built up his villa at Tibur in a marvelous manner, and even went so far as to apply the highly renowned names of provinces and places to it, such as the Lyceum, the Academy, the Prytaneum, Canopus, the Poecile, and Tempe" (*Historia Augusta* 26.5). We assume that Hadrian endeavored to construct associations between individual parts of this incredibly vast and complex array of buildings and specific favorite places he had visited around the empire—effecting the construction of a kind of "mini-empire" for his personal enjoyment. The design and construction of specific areas of a Roman villa to perform certain functions had a long history, as discussed in the case of the Villa of the Papyri at Herculaneum.

The provinces and places specifically mentioned in the *Historia Augusta* as being inspiration for Hadrian in naming his villa are significant. All but one are in Greece; the four in Athens were locations for discussions on topics around philosophy or governance: the Academy and Lyceum were the philosophical schools of Plato and Aristotle, respectively; the Stoa Poecile was the birthplace of Stoicism under Zeno; and the Prytaneum was the headquarters of the Athenians' elected governing body. The Vale of Tempe, between Thessaly and Macedonia, was a wilderness sacred to Apollo; it was here that the laurel used to create the crowns for winners at the Pythian Games (Delphi) was gathered. Canopus, a town in the Hellenized Nile Delta, was the seat of the cult of Serapis and, in Roman times, notorious for debauchery.

The imagery conjured up by these names chosen by Hadrian is entirely consistent with the villa remains, which comprise a dazzling number and variety of structures that enclose

11.19 The Theater of Sabratha, Libya, 2nd century CE. One of the most completely restored imperial stage buildings.

11.20 Teatro Marittimo, Hadrian's villa, Tivoli, Italy, c. 118–28 CE. Complete with moat and drawbridge, this was an island retreat within the villa complex.

11.21 Mosaic from Hadrian's villa, Tivoli, Italy, 2nd century CE. The mosaic is a sacro-idyllic scene: a rocky landscape with goats by a stream and a standing statue of a deity believed to be Dionysus.

complex vaulted interiors or define formal open spaces, interspersing them with formal gardens, waterworks, and forested ridges and ravines. Hadrian's villa at Tivoli is the most elaborate known expression—made possible by limitless resources and an unbridled intellectual curiosity—of the blending of *negotium* and *otium* ("work" and "leisure," in modern terms) that characterizes suburban and rural villas of the traditional Roman nobility. In the same way as these villas, Hadrian's residence was designed to accommodate the transaction of public business, which, for the emperor as much as it had been for a Republican senator, entailed much discussion and consultation, including conversations both practical and philosophical in nature. At the same time, the facilities provided an escape from these responsibilities—peaceful garden retreats, spectacularly appointed *triclinia*, and cool, quiet libraries.

We have the names of the parts of the villa, but of course do not know which names apply to which buildings; archaeologists have provided now-conventional nicknames—some are based on ancient terms, but most are Italian. Architecturally, the most interesting might be the so-called Piazza d'Oro, a large portico that includes, at either end, two rooms demonstrating highly innovative design. Its small vestibule was vaulted (now mostly collapsed) by a segmented dome with convex sections—perhaps the eventual product of the "pumpkin" drawings derided by Apollodorus. The room at the opposite end shows an imaginative experiment with curving forms built from traditional trabeated masonry, a playful use of curved elements reminiscent of, but larger and more complex than, the small vestibule in the Domus Flavia (which was, in fact, restored under Hadrian). Columns combine with concrete piers to support entablatures forced into unprecedented elasticity by a ground plan featuring curving going one way then the next. Identical in concept is the so-called Teatro Marittimo [11.20]—an island retreat replete with circular moat and tiny drawbridges, and the envy of every tourist who seeks a quiet place to read and reflect.

As one would expect, Hadrian's villa was equipped with a complete array of decorative elements: statuary, floor and wall mosaics, and multicolored veneers. Our knowledge of these features is limited as; although the site has long been known, it was for centuries a papal possession and mined for building materials and treasures to fill the Vatican collections; many objects also made their way into the early art

302 PART III: THE HIGH EMPIRE

market. The provenance of some pieces is well documented, however, and twentieth-century excavations have produced more sculpture that is still standing on the site, so evidence is not entirely lacking. The flooring of choice, as was typical in the imperial West, was monochrome mosaics, some in exquisitely rendered geometric patterns. Especially interesting are the polychrome works in vermiculate style, common enough in the Republican houses of Pompeii, but rarely found during the empire outside the Greek-speaking world. Some of these mosaics are copies of Hellenistic set pieces, but others are clearly Roman inventions, such as the sacro-idyllic landscape showing grazing goats around a bronze statue (in Classical style) of a god, probably Dionysus [11.21].

As with most grand buildings of the Roman empire, the different structures that made up Hadrian's villa would have been fully equipped with statuary. Some 250 pieces have been documented, but the original number was, no doubt, very much larger. Most buildings contained many niches designed for statuary display, and the large number of fountains, *triclinia*, gardens, and other waterworks would typically have been packed with sculpture, which would have complemented the various moods that Hadrian's plan was intended to evoke.

Unlike the villa of Cicero or the Villa of the Papyri, however, this artwork was not in what we would call a "collection" — that is, from different sources. The sculpture here seems to be consistently contemporary with the villa; the architecture and statuary were designed and created to function as a unit. The extant statues represent a remarkable variety of styles and subject matter — portraits, gods and goddesses (mostly Greek and Greco-Egyptian), exotic and fantastic animals, and mythological narrative, such as that at Sperlonga. Archaizing, Classicizing, Egyptianizing, and Hellenistic styles were all used, each as appropriate to the subject matter. Some of these were copies of pre-existing types, even famous Greek masterpieces, but many more were new creations in an older style. It is more difficult than is often claimed to distinguish among these categories. Two especially famous pieces are the colored marble centaurs in the Capitoline Museums, rendered in a highly dramatic, even realistic, Hellenistic style that strongly contrasts the torment of the older centaur with the jubilation of his younger companion [11.22a and 11.22b]. These were found together, early in the

11.22a and b Centaurs from Hadrian's villa, Tivoli, Italy, 2nd century CE. Marble. H 1.4 m (4 ft 7 1/8 in.). The two sculptures present an allegory of youth (*l*) and old age (*r*).

eighteenth century, in the Piazza d'Oro, where they formed an allegory of youth and old age. They are generally thought to copy Hellenistic bronzes, but they are just as apt to be original creations of Roman Asia Minor—the pride of Aristias and Papias of Aphrodisias, the makers who signed them.

One well-preserved array of sculpture comes from the long, narrow water basin most commonly called Canopus by modern scholars, since the basin is thought to recall the canal connecting that coastal Egyptian town to Alexandria [11.23]. It is worth noting also that the structure at the south end of the pool is semicircular, resembling a part of the Domitianic Serapeum (dedicated to the Greco-Egyptian deity Serapis) in Rome, as indicated by the Severan Marble Plan. But the identity and function of this complex at Tivoli is uncertain; apsidal structures are far from unusual here. The so-called Serapeum was fitted out as a nymphaeum and semicircular *triclinium*. Arguments rage for and against the Egyptianizing nature of this complex, depending in large part on statuary of insecure find-spot. The sculptural material actually found

11.23 The Canopus of Hadrian's villa, Tivoli, Italy, c. 118–28 CE. The long water basin was surrounded by an impressive display of sculptures.

Hadrian's Wall and the Limits of the Empire

"[Hadrian] was the first to build a wall eighty miles long to separate the Romans from the barbarians."
(*Historia Augusta*, Hadrian 11.2)

The period from the Parthian War of Trajan (113–17 CE) to that of Lucius Verus (161–66 CE) marked a respite from warfare that was rare in imperial history. As seen in Chapter 10, the emperors of this half-century, Hadrian and Antoninus Pius, preferred to maintain peace through an effective and attentive administration that sought to provide for the social and economic needs of the provinces. Their individual styles of leadership, however, were very different. Hadrian traveled constantly, personally overseeing the physical and economic enhancement of nearly every corner of the empire. Antoninus never left Italy during his rule, preferring to trust the structure of provincial governance and the work of local administrators to maintain peace and prosperity. Both strategies were largely successful, for a time. Much of Marcus Aurelius's reign was embroiled in campaigns on both major frontiers (the Euphrates and the Rhine/Danube) and, following the inactivity of the deranged and self-engrossed Commodus, there was near-incessant warfare, as much of it internal conflict as that directed against Rome's external enemies.

Nonetheless, even during the halcyon days of Hadrian and his successor, the "barbarians" at the gate did not go away, and a different strategy was tried in order to contain them—walling them out. The divisions between Roman and non-Roman territory had mostly been established by the beginning of the empire, and the adjustments made over the centuries following Augustus's reign were remarkably few, limited to Claudius's addition of the province of Britain and the areas annexed following Trajan's successes against the Dacians and the Parthians. Mesopotamia, won from the Parthians, was relinquished by Hadrian almost immediately, while Dacia was held much longer, until 271 CE when Aurelian abandoned it and cleverly renamed the province of Upper Moesia (south of the Danube) "Dacia Aureliana" to disguise his loss. The lines of demarcation (*limites*) were therefore

fairly stable over a long period of time, maintained by legions in the field through a series of local forts supplemented, where deemed necessary, by ditches, earth mounds, and wooden barriers. The building of such forts is featured on the reliefs of Trajan's column (see 9.10, p. 247).

Britain, however, held by the Romans, was protected from the intractable Caledonians (of what is now Scotland) by more substantial means. Chief among them is Hadrian's Wall, still standing in many places and a popular tourist destination in northern England. It runs across the shortest distance between the Irish and North seas, a stretch of about 84 miles, ranging from one to sixty-eight miles south of the modern border between England and Scotland. Unlike the *limites* in some parts of continental Europe, Asia, and Africa, this was a substantial and continuous wall, as much as 6 meters (20 feet) high and 2.4 meters (8 feet) thick, and built of stone [11.24]. It incorporated a series of fortified settlements for quartering troops at intervals of about 8 kilometers, smaller forts every mile or so, and a series of lookout towers. Historians do not agree on the primary purpose of the wall, whether it was to keep out enemies, as the *Historia Augusta* says, or to control their passage through its territory and exact tax revenues from any related commerce. It is generally agreed, however, that whatever its intended purpose, it was not worth the trouble and expense incurred by its construction, maintenance, and defense.

In an uncharacteristic act of expansionism, Antoninus Pius moved troops beyond this wall and constructed a new, less physically substantial fortification, closing the much narrower passage between the firths (estuaries) of the rivers Clyde and Forth. Ultimately this initiative was unsuccessful, and Hadrian's wall came again to define the northern edge of the Roman world until late antiquity, when Roman legions were gradually withdrawn from Britain, needed to address crises closer to home. But the visible impact of Romanization did not disappear, nor did Hadrian's wall, which still stands today, symbolizing his view of an empire with physical boundaries rather than theoretical borders.

11.24 Remains of Hadrian's Wall in Britain, c. 128 CE. The wall was 135 kilometers long and included a series of forts along its length.

here includes Egyptian (mostly Greco-Egyptian) pieces, such as a depiction of Isis, a crocodile, and a personification of the Nile (together with a Tiber), but a much greater proportion of it is purely Greek, including copies of the Erechtheion caryatids along one side of the pool, two copies of well-known Classical Amazon types, and a Classicizing Mars set within a Hadrianic favorite, the colonnade with alternating horizontal and curved entablatures. On a base in the pool itself was a group of statues illustrating the sea monster Scylla and her victims—just as at Sperlonga, but a different version.

This structure may have been the Canopus mentioned in the *Historia Augusta*, but the name is most probably a reflection of the activities and mood of the place rather than describing its form or function. It was surely an elaborate and entirely Roman dining grotto complete with water features, in the tradition of the cave at Sperlonga, and, in Rome, the Domus Flavia *triclinium* and the Neronian predecessor found beneath it. Its sculptural program, also drawing on a purely Roman tradition, reflects inspiration from Hadrian's experiences around the empire and this therefore supports the idea that names of provinces or places were associated with particular elements of the villa.

Overlooking a hillside at the edge of the property was a scale copy in marble of the Doric Temple of Aphrodite at Knidos, which housed one of the most famous statues in antiquity (the fourth-century BCE statue of Aphrodite by Praxiteles), proving that prominent Greek buildings could easily be replicated, if that was the desire. Yet the purely Roman materials, engineering, plan, and artistic adornment demonstrate that the complex as a whole was not about re-creating famous buildings, but (re)producing lived environments, as had been the case in Roman villas for centuries.

SCULPTURE IN THE PROVINCES
Palmyra

In addition to its once spectacular, now severely damaged, architectural remains, Palmyra (in modern-day Syria) is especially known for its characteristic style of sculpture. The early imperial temple of Bel (the Semitic Jupiter), with its portico added a century or so later,

11.25 Temple of Bel, Palmyra, Syria, founded 31 CE. Bel was the Semitic Jupiter. The temple demonstrates a blend of Hellenistic, Roman, and Near Eastern styles, and the Ionic (*cella*) and Corinthian (*peristyle*) orders.

represents a unique blend of Hellenistic, Roman, and Near Eastern features reflective of the cultural crosscurrents that would occur in such eastern sites as this [11.25]. It bore a sculptured frieze, as was characteristic of some Greek Ionic temples, but situated in a peculiar location—on the faces and lower surface of the stone beams connecting the cella with the peristyle. Moreover, the subject and style of this frieze draw more on Near Eastern than Hellenistic Greek precedent [11.26]. The relief shows, among other subjects, a procession of worshipers, as is found on Mesopotamian and Persian monuments of all periods, and the very flat linear style of depiction gives the relief an even stronger Oriental aspect.

Among the most striking of Palmyrene monuments, however, are the dozens of limestone funerary reliefs [11.27] that have made their way into many museums in the West. These strongly call to mind the funerary portraits of *liberti* (for example, 8.1, p. 207) found in the tombs of Rome. Many represent married couples or other family groups; the male figure is conventionally shown in a veristic style while females are much more idealized with their Classicizing features and coiffures. Yet these reliefs, especially the rendering of drapery and hairstyles, are at the same time noticeably different from those found in the capital. The renderings, often demonstrating superb quality in their carving, depend heavily on an abstract linear patterning that reflects a strong influence from Parthian traditions with their Persian roots. Although well within the Roman political orbit, Palmyra stands, in art as in geography, firmly between the Roman West and the Parthian East.

11.27 Palmyrene relief, Syria, 2nd century CE. Limestone. Dozens of limestone funerary reliefs exist, many showing abstract linear pattern that suggests influence from Parthia and its Persian history.

Ephesus Altar

Also from an eastern province, but very different in style from the Palmyrene works, is the Great Antonine Altar at Ephesus. Whereas the Adamklissi monument (see p. 253) was executed in an area devoid of sculptural tradition, this altar was set up in the very heart of the richest area for the production of marble sculpture in the entire Roman empire. The form of the altar, which seems to have been inspired by the Great Altar at Pergamon, has been reconstructed on the basis of a series of marble slabs re-erected as a fountain balustrade near the heart of the ancient city. The various subjects all have to do with the glorification of the imperial family, although the details of depiction are sometimes disputed. There are scenes of apotheosis, personifications of cities and provinces, imperial figures in divine company, as

11.26 Frieze from the Temple of Bel, Palmyra, Syria, founded 31 CE. Limestone. The scene depicts a procession of worshipers similar to those found in Mesopotamian and Persian monuments.

11.28 Succession scene, the Great Antonine Altar, Ephesus, Turkey, c. 169 CE. H. 2.1 m (6 ft 10¾ in.). The altar is carved in high relief and depicts the Antonines: Marcus Aurelius, Antoninus Pius, and Lucius Verus.

well as a succession scene [**11.28**], and a series of battles.

In the succession scene, Hadrian is shown (at right) with Antoninus Pius flanked by the teenage Marcus Aurelius, and Lucius Verus as a boy. It has been thought by some that the monument was set up around the time that Pius adopted both children, contemporary with the event depicted, although the emphasis on war (the battle scenes) in a late Hadrianic or early Antonine monument is unusual. It is now generally accepted that the altar was set up rather later, in or just after 169 CE, to commemorate the Parthian triumph and, perhaps as well, the divinization of Lucius Verus in that year.

Across the great range of subject and mood on this monument, the style of rendering is quite consistently in the tradition of Asiatic Hellenistic sculpture with its Classicizing forms and, where the topic demands, dramatic exaggeration.

Antinous and the Travels of Hadrian

Antinous too was deified by them; his temple is the newest in Mantineia. He was a great favorite of the Emperor Hadrian. I never saw him in the flesh, but I have seen images and pictures of him. He has honors in other places also, and on the Nile is an Egyptian city named after Antinous. He has won worship in Mantineia for the following reason. Antinous was by birth from Bithynium beyond the river Sangarius, and the Bithynians are by descent Arcadians of Mantineia.

For this reason the emperor established his worship in Mantineia also; mystic rites are celebrated in his honor each year, and games every four years. There is a building in the gymnasium of Mantineia containing statues of Antinous, and remarkable for the stones with which it is adorned, and especially so for its pictures. Most of them are portraits of Antinous, who is made to look just like Dionysus. There is also a copy here of the painting in the Cerameicus which represented the engagement of the Athenians at Mantineia.

(Pausanias, *Description of Greece* 8.9.7–8)

While Trajan spent much time away from Rome campaigning, twice against the Dacians (101–2 and 105–6 CE) and once against the Parthians (113–17 CE), Hadrian spent nearly all of his reign away from Rome not fighting at all, until briefly, at the very end. On his return to Rome after being acclaimed emperor in Syria (117 CE), Hadrian toured extensively through Asia Minor and the Danubian provinces, returning to Rome the following year. He began work on his villa at Tivoli at that time, leaving again in 121 CE for a trip to the western provinces of northern Europe as far as Spain (but not his hometown of Italica). He then struck out eastward back to Syria and Asia Minor, and subsequently south to Greece, spending two years there, mostly in Athens. He returned to Rome in 126 CE, when the Tivoli villa became his official residence, and left again two years later, on a four-year journey first to western North Africa, back to Rome, and then to Greece—which he used as a base for his trips

11.29 The Egyptianizing Antinous, 130–38 CE. H. 1.35 m (4 ft 5¼ in.). The favorite companion of Hadrian drowned in the Nile in 130 CE, after which Hadrian produced many portraits of him, three of which were found at Hadrian's villa at Tivoli.

11.30 Antinous from Delphi, 130–38 CE. H. 1.84 m (6 ft ½ in.). Here Antinous is represented in a purely idealized Greek style, suggesting that the piece was made for a Greek audience.

to Egypt, the Near East, Asia Minor, the lower Danube, and Thrace—where he stayed until 132 CE. From there he went to Judaea to lead the suppression of a revolt, thereafter returning to Rome and Tivoli, probably in 133 CE, where he remained until his death in 138 CE. It is safe to say that no emperor since Augustus (who reigned twice as long) ever traveled so much and fought so little.

The impact of his travels, of course, was a primary theme of his villa at Tivoli, where an installation of Egyptianizing sculpture, now in the Egyptian Museum of the Vatican, included three portraits of Antinous in pharaonic costume [11.29], of a total of eight sculptures of Antinous at the villa. This Bithynian youth was a favorite companion of Hadrian, whom he met during the emperor's longer tour of the East (c. 125 CE). Antinous drowned in the Nile in 130 CE and Hadrian founded the city Antinopolis at the spot, deified him, and spread his cult through the Greek-speaking East especially. A large number of images of Antinous have come down to us; most, such as a famous statue from Delphi [11.30], show him in a purely idealized Greek style, both because this best captures his eternal youthfulness and because it was a Greek audience for whom these images were devised. Pausanias tells us that Antinous was often associated with Dionysus (who from late Classical times onward is often shown as an androgynous youth) and was the recipient of mystic rites. It seems that Hadrian was not simply indulging his grief but mobilizing the increasing gravitation of Roman provincials toward Hellenized mystery cults, by providing a mystery cult with direct state associations. In Greece, at least, the worship of Antinous became the focus of guilds set up for its perpetuation, especially by those not of the aristocratic classes that dominated traditional priesthoods. In this way Hadrian took advantage of the non-elite individual's desire for inclusion in state religion, as had Augustus's cult of the *lares Augusti* in Rome.

CHAPTER 11: PROVINCIAL ART IN THE HIGH EMPIRE

As becomes increasingly popular in Antonine sculpture, at least partially as a result of the increasing prominence of Asia as a source of sculpture and sculptors, the relief is high, the figures project from the background, and individual features of drapery and hairstyle are deeply cut, creating expressive forms of light and shadow. In the battle scenes, one can detect, just as on the Pergamon altar, the Hellenistic fashion of creating strong contrasts between idealized, Classicizing victors and more pathetic, brutish barbarian opponents. In reality Parthian culture was far from barbarous, but the conflict between barbarism and civilization was a visual convention long used in the Hellenized East to convey concepts of order and disorder, those very benefits that the Romans claimed to have bestowed.

Even this highly limited overview of Roman art in the provinces during the second century can suggest a period of extensive building activity and economic well-being, as well as the evolution of a Roman empire that was increasingly homogeneous, while at the same time dazzlingly diverse in its expressions of "Roman-ness." Both by design and by chance, the firm divisions between Roman and non-Roman, in art and culture as in politics, were becoming increasingly blurred, creating a more unified image of the empire as a unit. The conventional imperialist model could not stand up to the pressures exerted both from within and without, and cultural unification played a central role in creating a Roman world that was more resistant to such pressures. In the succeeding eras, under imperial administrations that were increasingly less invested in Italo-Roman traditions, the challenges would become greater than ever, and the division between Roman citizen and provincial citizen would disappear altogether.

Funerary Art and Sarcophagi

During the second century CE, among the most striking and perhaps unexpected developments in funerary customs, and therefore sculptural production, was the re-emergence of funerary sarcophagi. Much used by the Etruscans as early as the Archaic period (see Etruscan Sculpture, p. 36), especially in the cities of southern Etruria where inhumation burial was practiced, sarcophagi went out of fashion during the Roman Republic, when cremation became the favored means of interment. Gradually, during the empire, the use of sarcophagi (this time carved in marble) was revived. There are rare examples from the first century CE, but by the Antonine period this was a vibrant industry located especially in Italy, Greece, and Asia Minor, where marble supplies were most plentiful.

There were regional variations in form and usage. Examples from the west of the empire were designed to be set up against the wall inside a tomb and so were carved only on one long side and the two ends, whereas in the east, especially Asia, sarcophagi were self-standing monuments carved on all four sides. Some were relatively modest in decoration; a garland pattern similar to that on the interior of the enclosure wall of the Ara Pacis finds continual use. Of particular interest, however, are those with figural friezes, either filling the entire sides of the sarcophagus or, again as is common in Asia, with figures arranged within an architectural framework. We know from the analysis of marble sources and the evidence of shipwrecks that the trade in sarcophagi was considerable; they were usually shipped partially finished, in some cases together with their sculptor who then completed the work once they arrived at their destination. It is also clear that local sculptors imitated imports, so the geographic variations were not absolute.

For a history of Roman art, the sarcophagi are of interest chiefly for their style and subject matter. Most are not inscribed nor have any external evidence of a date, so stylistic comparison with contemporary dated monuments, usually those decorated with official state relief, plays a critical role in establishing a sequence. It is not unlikely that the same schools of stonecutters worked on both sarcophagi and state monuments; indeed, it may be that the increased patronage of sculptural activity under Trajan and, especially, Hadrian resulted in the establishment of many marble-carving workshops, which then turned to carving sarcophagi in the leaner Antonine years when fewer state projects were commissioned. Certainly, the number of examples increases markedly after the death of Hadrian. Much the same circumstances were responsible for the

sudden re-appearance of marble grave reliefs in Athens after the completion of the Parthenon. Also similarly to these Classical grave reliefs, Roman sarcophagi were produced on various scales and different levels of complexity. While such objects were not cheap, and some were as large and elaborate as small temples, others would have been more affordable. These were not strictly the preserve of the uppermost classes, and the tradition of tomb monuments for merchant or artisan-class freedman (see box: *Liberti* in the Early Empire, p. 207) was continued through the use of sarcophagi during the middle and later periods of the empire.

As for iconography, the categories of subject matter are largely the same as those found on the Etruscan stone sarcophagi and ash-urns of late Classical and Hellenistic times. Scenes include myth (almost always Greek) and biographical themes (including military, civic, and ceremonial events as well as hunting scenes). The categories are not, however, as exclusive as they might appear. Mythological battles or hunts (the story of Meleager and the Calydonian boar is very common), or the labors of Hercules (also popular) can serve as analogues for the virtues, accomplishments, and status of the person interred, just as the more prosaic subjects seek to illustrate those qualities directly. The fact that mythological *and* historical (or sometimes perhaps generic) battles and hunts occur suggests that all these types function similarly to reflect basic Roman virtues and values. Other myths, especially those dealing with transgression and retribution, may have been intended as allusions to a tragic death, or could also be interpreted as typically Roman moralizing statements, such as is found in Pompeian wall painting.

Certainly the popularity of Greek myth is due to the persistence, and revival, of Hellenism as a sign of elevated status and sophistication for the Roman elite. The essentially new sarcophagus industry of the middle and later empire clearly does not reflect a continuity of production from its Etruscan predecessor, which had disappeared centuries earlier. Nor is there any real reason to believe that the later funerary monuments were consciously modeled after the earlier ones. The remarkable similarity of theme and form between the Roman and Etruscan examples must derive from a shared set of cultural values concerning the exemplary function of myth, the role of the deceased as an inspirational paradigm for his or her progeny, and the socio-political importance of private funerary commemoration. There are several thousand extant Roman sarcophagi; many have been known continuously since ancient times and, more than any other class of sculpture, sarcophagus reliefs helped to form the conception of antiquity during the many centuries separating the ancient and modern worlds, before systematic study and excavation began in the eighteenth century. Only a very few can be discussed here.

This Amazon sarcophagus [11.31] in Rome is typical of early (mid-second century CE) examples in being relatively low in proportion

11.31 **The Amazon sarcophagus, Rome, Italy, 2nd century CE.** Marble. H. 90 cm × W. 2.5 m (2 ft 11 1/2 × 8 ft 2 1/2 in.). The sides are decorated by scenes of the Amazonomachy, symbolic in Greece of the conflict between civilization and barbarism, and in Rome for membership into a Hellenized, literate elite.

to its length. The choice of an Amazonomachy is strongly reminiscent of the much earlier Etruscan sculptured and painted examples. In Greek art, this theme is interpreted as a metaphor for conflicts between civilized and "barbarian," order and disorder, the East and the West—a meaning that might also apply here. At the same time, since this is most probably from early Antonine times when Hadrianic Classicism was still strong, the scene is also a hallmark (as were the Etruscan examples) of membership of a literate, Hellenized ruling class. The figures themselves all reflect a repertoire of Classical types that ultimately derive from the Amazonomachy of the shield of Athena Parthenos, cult statue of the Parthenon. These were repeated and reinterpreted in late Classical and Hellenistic battle scenes—in both Greece and Etruria—and persisted into Roman times on Neo-Attic reliefs. It was at just this time in the second century CE, in fact, that a series of marble panel reliefs copying, at scale, the Athena Parthenos Amazonomachy was carved [11.32]. These reliefs were discovered in the port of Athens at Piraeus, from where, no doubt, they were to be dispatched to a Roman customer.

Far more direct in its means of commemoration is the famous Portonaccio sarcophagus, another Roman work [11.33]. This late Antonine work is taller than the pieces just discussed and thus offers a more spacious ground for pictorial development. The surface is entirely devoted to a single scene of military conquest, with the main protagonist in full armor at the center, shown in the rearing equestrian mode that was now commonplace for honoring *imperatores*. The scene is neatly framed by groups of trophies with barbarian captives—another old motif—but all around the central general the chaos of battle plays out, with figures in the background above and in the foreground below. Yet the deeply carved figures are woven together into a pattern of light and shadow that seems applied to the stone's surface and admits little in the way of spatial penetration. The effect is so similar to that of Marcus Aurelius' commemorative column that it would be no surprise if the carvers of the sarcophagus had worked on that monument.

The carved lid continues the biographical mode but the composition is different in both form and mood. Here, three separate scenes comprise figures that take up the entire height of the ground and which are posed quietly in contrast to the melée below. The scene to the right is, like the battle scene, military in theme; here the general receives the obeisance of the defeated—a *clementia* scene as old as imperial art itself. This is juxtaposed with two scenes from the general's private life—his wedding at the center and a birth (his own, or perhaps of a son) to the left. The subjects themselves and the joining of official and domestic themes on a single monument were both characteristic of Etruscan and early Roman times; we are reminded that these public and private spheres of life were not nearly so separate for the Romans as we might consider them to be today.

11.32 Reliefs from Piraeus, Athens, Greece, 2nd century CE. H. 53.3 cm (1 ft 9 in.). The panels show a Neo-Attic Amazonomachy scene, in this case the mythical defense of Athens from invading Amazons; the figural groupings derive from reliefs on the shield of the cult statue of the Parthenon in Athens.

312 PART III: THE HIGH EMPIRE

11.33 Portonaccio sarcophagus, Rome, Italy, late 2nd century CE. H. 1.14 m (3 ft 9 in.). The textured composition of integrated figures conveys the confusion of a battle, with the honoree seeming to emerge heroically at the center. Composition and style recall the contemporary Column of Marcus Aurelius.

11.34 Sarcophagus from Melfi, southern Italy, c. 165–70 CE. H. 1.7 m (5 ft 7 in.). The lid displays the female figure of the deceased. The sides are carved so as to resemble niches within which high-relief carvings look like placed sculptures.

Representative of the Asiatic columnar sarcophagi is a famous Antonine piece from Melfi in southern Italy, where it surely had been imported [11.34]. The intricately carved *aediculae* with alternating curved and triangular pediments was probably influenced by the theatrical columnar facades (see Stage Buildings, p. 300) found on so many structures around the empire during this period. The effect would have been even stronger on other columnar sarcophagi on which the structure was expanded to a second story. Just as on the buildings they mimic, the niches here contain "statues" or, rather, relief figures of various gods and heroes from Greek mythology that clearly quote Classical statuary types. On the lid reclines a female figure—a portrait of the deceased that continues a tradition going back to the early Etruscan times.

These marble sarcophagi, which appear suddenly in the second century and soon proliferate across the empire, do more than simply illustrate the stylistic variety among its regions or the many possibilities in an iconography of death and commemoration. As already noted, these were expensive objects, but not, as one might suppose, the preserve of the economic elite. Inscriptions indicate that middle-class Romans, across the empire, also invested in sarcophagi for their own burials and those of their family. They no doubt stretched budgets to do so, but the fact that they could do this at all reveals that the prosperity resulting from the peaceful times of the High Empire extended far from the *princeps* down the social ladder, and, of course, broadly across the distant reaches of the empire itself.

CHAPTER 11: PROVINCIAL ART IN THE HIGH EMPIRE

Part IV
Collapse and Recovery: Art across the Later Roman Empire (193–337 CE)

In 260 CE, the emperor Valerian, while defending the Mesopotamian city of Edessa against the Sassanid Persians, was captured, humiliated by King Shapur I (who is said to have used the emperor as his footstool), and died imprisoned some years later. Although tradition relates that Valerian's army was compromised by plague and that Valerian himself was arrested through subterfuge, the specter of a Roman emperor in the hands of a "barbarian" king represented an unthinkable turn of events in the eyes of Rome's millions of subjects around the Mediterranean.

A decade later, the emperor Aurelian, who had temporarily pacified the northern and eastern frontiers, set about walling in Rome itself with an enormous fortification in brick-faced concrete, much of which still stands today. No new walls had been built in Rome since the early Republic, and none had been needed (against a foreign foe, at least) since the time of Hannibal. The impressive Aurelianic bastion must have appeared, in the eyes of the Roman people, at once a reassurance and a cause for concern.

How did things get so bad? Rome was not built in a day, nor did it decline and fall overnight. These events were but symptoms of a general crisis in the third century that would not result in imperial collapse for another two centuries in the West or for another millennium in the East. What did occur at this time, however, was a culmination of pressures that were built in to the form of both the empire and the principate. Valerian was the exception in falling at the hands of a foreign foe. Although warfare during the third century was incessant, and the emperors themselves, as had Trajan and Marcus Aurelius before them, led the troops in the field, very few *principes* in this period were killed in battle against non-Roman enemies compared to the much greater number who died of plague or, more often, were assassinated by their own closest associates.

While the sixty-plus years following 117 CE were made up of the reigns of just three emperors, the fifty years following 235 CE saw well over a dozen men serve legitimately as *princeps*, with dozens more acclaimed emperor by their troops in the field. These emperors' inability to establish political stability was a development parallel to their inability to establish peace simultaneously on multiple frontiers, especially on the often volatile borderlands of the Rhine, the Danube, and the Euphrates. The imperial economy could not support active fighting forces sufficiently to meet the task at hand; there simply weren't the resources to recruit, supply, and pay the legions needed, and attempts to do so only worsened an already weak economy. Recovery would come, though, first in Diocletian's implementation of the idea of the tetrarchy, a form of imperial administration that was rooted in the division of empire rather than resistant to it, and second by the innovations of Constantine, who promoted both religious and imperial reunification, yet these innovations simply delayed the inevitable.

Part IV is organized into three chapters, each of which deals with a particular era of the late empire. The first, Chapter 12, looks at the Severan dynasty (193–235 CE), which both patterned itself openly on the Antonines and inherited from it the obstacles outlined above. Despite some early successes, the latter part of the Severan period was marked by an increasing instability, both at the empire's borders and within the imperial family itself. The second, Chapter 13, begins with the parade of *principes* and pretenders of the following half-century—a phase aptly named the era of "soldier emperors." In 284 CE Diocletian, the last of the soldier emperors, seized control and succeeded in restoring order by adopting radical changes across the political, military, and economic spheres. The system of shared rule that he developed, called the

"tetrarchy," resulted in the emergence of Constantine the Great (r. 306–337) as sole emperor, the focus of the third chapter (Chapter 14). His reign, like that of Augustus, was long, and also like the first *princeps*, Constantine did not shrink from radical change in his effort to restore stability after a period of great unrest. Two of his innovations stand out especially: his embracing and fostering of the Christian faith and his creation of a new imperial capital, far from Rome. For his city, aptly named Constantinople (in Greek, "city of Constantine") he chose a site in the eastern empire, strategically located on the Bosporus, commanding movement from both north to south and east to west.

This shifting of the empire's center to what had been its periphery reflected a reality of the empire already recognized by Hadrian—the role of the Greek-speaking East as its cultural and economic center. Constantine's Christianization of the empire promised to provide a spiritual means to secure a unification of the various peoples under Roman rule where warfare had repeatedly failed. In the end, the religion outlived the empire, but the association between them persisted. The western empire fell apart in the fifth century CE, but Constantine's East persisted as the Byzantine empire for a millennium. Beginning in the ninth century, western Christian rulers posed, at least, as Roman emperors, although their kingdoms were never really imperial in extent. In the medieval epoch, Crusader knights who, like Constantine himself, fought in the name of the cross, invaded the East once more, yet any realm they established was as limited as those in the West. Meanwhile much, and eventually all, of what had been the Byzantine empire came under Islamic rule.

East and West therefore remained separated both by rule and by religion. While no serious attempt to reunify Rome's empire would recur, the trappings of Romanism endure, in art and architecture, both public and private. Countless governments—monarchic, autocratic, and democratic alike—have exploited Roman art's physical impressiveness and iconographic adaptability in attempts to lend grandeur, authority, and thus legitimacy to their positions of power. At the same time, the European elite, especially after the discovery of the treasures buried by Vesuvius, emulated the *nobiles* and wealthy freedmen of Rome in their conspicuous display of Greco-Roman visual emblems of elevated status. Examples persist through modern into post-modern times, and this account of Roman art concludes with a brief look at this legacy.

Timeline

DATE	EVENT
	THE SEVERANS
193–97 CE	Wars of succession; Septimius Severus becomes sole emperor
211 CE	Severus dies in York; Caracalla and Geta are co-emperors; Caracalla murders Geta
212 CE	Caracalla grants Roman citizenship to most free inhabitants of the empire
217 CE	Caracalla murdered; Macrinus proclaimed emperor
218 CE	Elagabalus leads revolt, defeats Macrinus
222 CE	Praetorian Guard murders Elagabalus; Alexander Severus becomes emperor
235 CE	Alexander Severus is murdered; Maximinus becomes emperor
	SOLDIER EMPERORS AND THE TETRARCHY
238 CE	Gordian I and II proclaimed co-emperors in Africa, but both are killed; Pupienus and Balbinus proclaimed emperors and Gordian III proclaimed Caesar; Maximinus is murdered; Pupienus and Balbinus are murdered; Gordian III becomes sole emperor
244 CE	Gordian III murdered by his soldiers; Philip becomes emperor
249 CE	Decius revolts; Philip is killed and Decius becomes emperor
251 CE	Decius is killed, Gallus becomes emperor
253–83 CE	Series of successions of Aemilian, Valerian, Gallienus, Claudius Gothicus, Quintillus, Aurelian, Tacitus, Florianus, Probus, Carus and Carinus, and Numerian as emperors
284–86 CE	Numerian murdered and Diocletian proclaimed Augustus, appointing Maximian as Caesar, then as Augustus
293 CE	Constantius and Galerius made Caesars
305 CE	Diocletian and Maximian abdicate; Constantius and Galerius become *Augusti*
	CONSTANTINE
306 CE	Constantius dies; Constantine proclaimed Caesar
307 CE	Constantine elevated to Augustus
312 CE	Probable date for Constantine's conversion to Christianity at the Battle of the Milvian Bridge against Maxentius
324 CE	Constantine becomes sole Augustus after defeat and execution of Licinius
337 CE	Death of Constantine

12 Art in the Age of the Severans

318 Severan Portraiture
- 318 PORTRAITS OF SEPTIMIUS SEVERUS
- 320 THE IMPERIAL FAMILY
- 322 Box: Mummy Portraits
- 323 LATER SEVERAN PORTRAITURE

324 Building in Rome
- 324 RESTORATIONS
- 325 Box: *Forma Urbis Romae*
- 325 PALATINE
- 326 BATHS OF CARACALLA AND ITS DECORATIVE PROGRAM
- 328 ARCH OF THE *ARGENTARII*
- 330 PARTHIAN ARCH IN THE ROMAN FORUM
- 332 LEPTIS MAGNA
- 336 Box: Leptis Magna and the Severans

337 Private Art after the Antonines
- 337 BACCHIC AND SEASONS SARCOPHAGI
- 338 ANTIOCH MOSAICS
- 340 Materials and Techniques: Roman Mosaics

Chronological Overview

DATE	EVENT
193–197 CE	Wars of succession; Septimius Severus becomes sole emperor
c. 200 CE	Severan tondo portrait; the painted Severan family group
203 CE	Forum Arch of Septimius Severus dedicated; *Forma Urbis Romae*; Septizodium, Rome; Arch of Septimius Severus at Leptis Magna; Severan Forum, Leptis Magna
204 CE	Arch of the *Argentarii*
211 CE	Severus dies in York, Britain; Caracalla and Geta are co-emperors; Caracalla murders Geta
211–217 CE	Baths of Caracalla, Rome
212 CE	Caracalla grants Roman citizenship to most free inhabitants of the empire
217 CE	Caracalla murdered; Macrinus proclaimed emperor
218 CE	Elagabalus leads revolt and defeats Macrinus
222 CE	Praetorian Guard murders Elagabalus; Alexander Severus becomes emperor
235 CE	Alexander Severus is murdered; Maximinus becomes emperor

The Development of Rome

Right: Map of Rome showing the key buildings in existence in Rome in this chapter.

The assassination of Commodus on the last day of 192 CE was the result of a palace plot, but its outcome in establishing a successor was not as successful as the conspiracy that had brought down Domitian (and also ended a dynasty) nearly a century earlier. A successor to Commodus had been chosen—an experienced senator and general named Pertinax (r. 193 CE)—but he dealt less skillfully than Nerva had with the inevitable demands from the army and, after three months, was murdered by the Praetorian Guard, which then auctioned off the title of emperor to the wealthy senator Marcus Didius Iulianus. Senate, people, and armies were outraged, Iulianus was assassinated two months later, and within the year, three different military commanders had been acclaimed emperor by their troops: Pescennius Niger (r. 193–94 CE) in Syria, Clodius Albinus (r. 193–97 CE) in Britain, and Lucius Septimius Severus (r. 193–211 CE), a general born in Leptis Magna in Tripolitania in Libya. At the time, Severus was governor of the province of Pannonia, and he took advantage of his proximity to the capital. Of the three contending generals, Severus reached Rome first and secured the support of both the senate and the Praetorian Guard (thus legitimizing him), which he immediately disbanded and replaced with his own soldiers.

The next six years saw almost continual warfare. Severus formed an alliance with Clodius Albinus by granting him the title of Caesar; he then set off for Syria, where he defeated Pescennius Niger in 194 CE. He campaigned against the Parthians, then returned west and defeated his erstwhile ally Albinus at Lugdunum in 197 CE. After a brief stay in Rome, he left to finish his war with Parthia and returned to Rome in 202 CE, where he remained, aside from a brief visit to his North African homeland in 203, until 208 CE. The last three years of his life were spent on campaign in Britain.

When Severus died at York in 211 CE, he was, as he had planned, succeeded by his sons Geta (r. 211 CE) and Caracalla (r. 211–17 CE), both of whom had been groomed for the role. He admonished them to "agree with one another, enrich the soldiers, and despise everyone else" (Cassius Dio, *Roman History* 77.16). Since Geta was killed by Caracalla within the year, Severus got only two of his three wishes, and they were taken seriously indeed. Caracalla doubled the pay of the troops, and his openly militaristic, brutish behavior and policies seem to have alienated many, most especially in Rome. For example, Caracalla famously extended citizenship to all free men of the Roman empire, ostensibly to increase the tax base or the supply of potential troops, but his move was perceived by those in the west as a downgrade for the status of inhabitants of Roman Italy. Caracalla spent little time in Rome in any case, campaigning first on the empire's northern frontier and thereafter in the east, where he was murdered at the behest of his praetorian prefect Marcus Opellius Macrinus in 217 CE.

Macrinus (r. 217–18 CE) then succeeded Caracalla. His success was short-lived, though: he suffered defeat at the hands of the Parthians and lost the support of his troops, who abandoned him in 218 CE. The remaining years of the Severan dynasty (218–35 CE) saw power shift to the female relatives of Julia Domna, the influential Syrian widow of Septimius Severus. Although she died soon after Caracalla in 217, her sister Julia Maesia and Maesia's daughters (Julia Mamaea and Julia Soaemias) exercised their rule through the daughters' teenage offspring, Elagabalus (r. 218–22 CE), the son of Julia Soaemias, and Alexander Severus (r. 222–35 CE), the son of Julia Mamaea. Alexander Severus's rule saw some restoration of order, and a brief revival of senatorial prestige, but he bought off rather than fought his adversaries and eventually lost support of the armies. Assassinated in 235 CE at a conference with his own officers, he was replaced by Maximinus Thrax (r. 235–38 CE), reputedly a Thracian peasant of "barbarian" stock who had risen through the ranks to command a legion. So ended the Severan dynasty and began the era of the soldier emperors.

Severan Portraiture

PORTRAITS OF SEPTIMIUS SEVERUS

Septimius Severus was, in the model of the "good" emperors who preceded him, a noble of provincial origin and consular rank who had served with distinction in the army. To fully legitimize his accession, he secured the deification

of Commodus's successor Pertinax and, in 195 CE, declared himself the adopted son of Marcus Aurelius, also having his "brother" Commodus deified and renaming his own elder son (who we know as Caracalla) Marcus Aurelius Severus Antoninus. Severus made a pretense of respecting the senate, as the Antonines had openly done, while at the same time he initiated a series of policy changes that would result in the senate's ultimate disempowerment. Severus's portrait image, too, was highly evocative of the Antonine fashion, with thick wavy hair and curly beard [12.1], features found also in the coin portraits of Pertinax, Didius Iulianus, and Clodius Albinus [12.2]. Each wished to be seen as the legitimate heir to the Antonine emperors who had preceded the hated Commodus.

Severus's earliest portraits recall those of Antoninus Pius, but after his "auto-adoption," they begin to imitate images of Marcus Aurelius more closely, with a longer beard divided into two or three sections [12.3]. This was coupled with a divinizing feature found on many of his portraits: that of corkscrew curls falling down over the forehead, which was a reference to similar renderings found on statues of Serapis, the chief among the Hellenized Egyptian deities that came to prominence in the Ptolemaic era [12.4]. The type may have been inspired by Severus's trip to Egypt in 199, but he was also a native of North Africa himself. As we will see, Oriental and North African religious practices made rapid inroads in Roman society during the Severan and subsequent eras, as men and women from the provinces of Africa and Syria (homes to Severus and his wife, Julia Domna, respectively) came to play a larger role in the exercise of imperial power.

The Serapis-inspired statue is not the only example of Severus taking on god-like features. This rare over-life-size bronze

12.1 (Right) Early coin with a portrait of Septimius Severus, 202–10 CE. Severus adopted the thick wavy hair and curly beard in the Antonine fashion.

12.2 (Above) Coin portraits of Pertinax, Didius Iulianus, and Clodius Albinus. Each displays an image similar to those of the Antonines, which equally are not far removed from that of Septimius Severus.

12.3 (Left) Portrait of Septimius Severus, 200–11 CE. Marble. H. 76 cm (2 ft 6 in.). Severus's corkscrew-style forehead curls are similar to those that characterize images of the Hellenized Egyptian deity Serapis.

12.4 Bust of Serapis, 2nd to 3rd century CE. H. 93 cm (3 ft 5/8 in.). The comparison between Severus and Serapis is obvious.

CHAPTER 12: ART IN THE AGE OF THE SEVERANS 319

statue in Cyprus [12.5] is of the Classicizing nude type that was used by Roman rulers from the late Republic onward, and while the bodily proportions are rather bulky, and the articulation of his musculature is oddly indistinct for a Classically inspired work, the sculpture gives a clear message that there is a connection to a Classical divinity.

Carving on Severan portraits, like their Antonine predecessors, is deep, chiaroscural, often quite abstract, and formalized, as on the column of Marcus Aurelius. This trend toward ever deeper carving and drilling is especially evident in the eyes; it is disputed when pupils and irises were first cut into the stone (as opposed to simply painted), but it is clear that the practice became regular only under Hadrian and then became increasingly pronounced through Antonine and Severan periods. At the same time, the eyes became proportionately larger and were often shown as uplifted, lending the subject a thoughtful, even remote and otherworldly, aspect.

THE IMPERIAL FAMILY

Portraits of Severus's family are well known because, like Augustus especially, he took great pains to highlight the associations between images of his entire family, marking a departure from many emperors of the High Empire who practiced succession by adoption. Just as Severus had overlooked the precedent of Commodus's portraits, so too his wife Julia Domna ignored Commodus's spouse, Crispina, to invoke Marcus Aurelius's wife Faustina the Younger and Antoninus Pius's wife Faustina the Elder (10.19, p. 277), both of whom favored a Classicizing hairstyle with simple repetitive waves emanating from a central parting, forming the shape of a crown above the forehead. On portraits of Julia Domna [12.6], this arrangement has been stylized into a more rigid version of the Antonine coiffure,

12.5 Statue of Septimius Severus, Cyprus, early 3rd century CE. Bronze. H. 2.1 m (6 ft 10³/₄ in.). Severus's portraiture imitates that of Marcus Aurelius, with a beard divided into two or three sections.

12.6 Portrait of Julia Domna, 2nd to early 3rd century CE. H. 70 cm (2 ft 3⁵/₈ in.). The abstraction of Julia Domna's hairstyle can be linked to her Syrian background.

while its deep drilling and extreme abstraction of form can be connected with her own Syrian origin (see Palmyra, p. 306). The style recalls the strongly formalized, orientalizing nature of Palmyrene sculpture of even the early empire. The resulting helmet-like mass of hair becomes an immediately recognizable hallmark of the Severan queenly image and established a precedent followed by Julia Domna's equally influential sister and nieces.

Severus's two sons, Caracalla and Geta, were born in 188 and 189 CE respectively; they were small children when their father assumed the imperial title and still young men when Severus died eighteen years later. As can be seen in the cases of Gaius and Lucius Caesar, or Marcus Aurelius and Lucius Verus, who were also marked out at a young age for succession, there is considerable development in their portraiture. Early on, Caracalla [12.7] and Geta are shown as chubby-faced boys with often long swirling locks, but as they grow up and assume magistracies and military commands, their images mature as well. Their hair may still be curly, but it is cropped shorter and in some cases the beginnings of beards can be seen.

It is as young boys that the brothers appear in a circular (tondo) family portrait from Egypt, painted on wood and preserved by the dry climate, much like the more numerous mummy portraits from the same region [12.8] (see box: Mummy Portraits, 322). Unlike most mummy portraits, which were usually painted in encaustic and used wax as the binding medium for the pigment, the painter of this tondo has employed tempera, which uses egg white.

Since some documents needed to be signed in the presence of the imperial image, painted portraits of Roman emperors were probably set up all across the empire in administrative buildings, just as today when heads of state similarly look down on the operations of government at the local level. We cannot know if this tondo painting was unique in portraying the entire family, but it is the only one to have come down to us, and the convention of the imperial family portrait is as old as the Ara Pacis (see Ara Pacis, p. 140).

This tondo portrait may also have been cut down in modern times to make it smaller, and perhaps more suitable for sale, since the scepter of the youth to the left seems sliced off at the top. The three male figures are dressed in white tunics with gold and purple trim; each of them wears a gold bejeweled and leafy crown, similar to the headpiece long worn by emperors and derived from Augustus's treasured oak *corona civica* (see box: Augustus and the Honors of 27 BCE, p. 130). If the males are thus all depicted as *Augusti*, co-emperors, then the painting dates to or after 209 CE, when Geta was formally designated as such. He was, however, twenty years old then, and the boys in this image appear to be much younger, so it may date to 198 CE, when the title was granted to Caracalla at the age of ten. (Geta and Caracalla's elevation to *Augusti*

12.7 Younger portrait of Caracalla, c. 196–204 CE. Marble. H. 74 cm × W. 75 cm (29¼ × 29⅝ in.). In early portraits, Caracalla is shown as a young boy, though later on he assumed the stature of a military leader.

12.8 Severan Tondo, c. 200 CE. W. 36 cm (1 ft 2¼ in.). The circular wooden panel depicts the imperial family: Julia Domna, her two sons Geta and Caracalla, and Septimius Severus.

CHAPTER 12: ART IN THE AGE OF THE SEVERANS 321

Mummy Portraits

"Egyptian mummy portrait" evokes the picture of something like Tutankhamun's gold death mask and lifelike yet eternally youthful visage. In ancient Egypt, however, cheaper materials than gold were also used to make mummy cases: wood, plaster or, later on, cartonnage—a composite material of scraps of wood, paper and adhesive that would dry hard, like papier mâché. The papyrus paper was generally reused discarded material, and this process was responsible for most of the paper documents from ancient Egypt that have been preserved, including correspondence, administrative records, shopping lists, and Classical literature.

In such mummy cases, the portrait masks were generally modeled into the case's material, just as in the gold or wooden examples, but around the beginning of the Roman imperial era, painted portrait panels were incorporated into the mummy wrappings themselves [12.9]. Since the vast majority of these were found in the area of the Fayum oasis in Middle Egypt, they have commonly been called "Fayum portraits," although they are found elsewhere. A significant number of examples come from the city of Antinopolis, founded by Hadrian in Upper Egypt in honor of his beloved Antinous, who drowned nearby.

12.9 Portrait mummy of a youth, 50 CE. Encaustic on wood. H. 1.33 m (4 ft 4³/₈ in.). The portraits on these mummies were painted directly onto the wrappings on the body.

The wooden panels were painted in the encaustic technique, which used beeswax as a binding medium for the pigment. This was the favored method in Classical Greece, not only for the application of color to marble statuary, but also for panel painting. The light permeability of the wax in which the pigments are suspended, when applied properly to translucent white marble, can result in a gently glowing appearance that is ideal for bringing out the natural colors of living subjects. A similarly naturalistic effect can be created in the mummy portraits, which were usually painted on a smooth white surface of fine plaster applied to the wood before painting. Some examples, especially later portraits, demonstrate the tempera technique using egg whites (also seen on the portrait of the Severan family), which results in a more opaque surface, flatter colors, and a less lively appearance.

Unlike the images on pharaonic Egyptian and later examples, these Romano-Egyptian representations, when considered as a group, appear strikingly individualized [12.10]. Earlier Egyptian funerary reproductions of the deceased, in painting and sculpture, were meant to establish a sense of permanence, since each had the potential to serve as an alternative resting place for the immortal soul (*ka*), and unchangeability was established through the use of an idealized style. The continued practice of mummification suggests a persistence of such beliefs in these Roman-era monuments, but the subjects resemble real people, not idealized forms. This change to realism likely resulted from exposure to the traditions of Rome, where a focus on representing the specific over the ideal had a long history, although "realistic" does not always mean "real," as we have often noted when exploring verism. A related question is at what point in the lives of their subjects were these portraits painted. Some preserve a worked border, and others appear to have been cut down from a framed form, so they were possibly painted during the subject's lifetime and hung in the house until final use. It is, on the other hand, also argued that the portraits were produced specifically for the subject's funeral. In either case, most attempt to capture the individual in the prime of his or her life, which of course is exactly how one would want to spend eternity.

12.10 Mummy portrait of a young woman, 3rd century CE. This mummy shows a heightened level of realism probably influenced by more natural Roman artistic traditions.

represented their roles as successors and nominal co-emperorship rather than true co-rule.) Julia Domna, whose classicized face, prominent eyes, and formalized tresses correspond closely to her sculptured portraits, wears a much smaller gold tiara. Severus himself is shown with the long, segmented Aurelian beard that he began to sport around the turn of the century. The painter has introduced substantial elements of white into his beard, and this corresponds with an observation made in the *Historia Augusta* that the emperor had thick, curly white hair and beard.

What is most striking in this painting is that the face of one of the boys has been erased. This should be Geta, who was ordered killed by Caracalla soon after their succession and then suffered a *damnatio memoriae* reflected in numerous altered relief sculptures and inscriptions. But this figure is noticeably taller, especially if we consider that he is standing further away than the smaller boy, and the garment he wears is more ornate and closer to that of the emperor. It can be argued, therefore, that it is actually Caracalla whose face was erased by order of the senate, or on the order of the emperor who succeeded him, Macrinus.

LATER SEVERAN PORTRAITURE

Whatever the chronology of Caracalla's early portraits, nothing prepares us for the image that came to be favored during his principate [12.11]. However differently they chose to be shown, each previous emperor adopted a portrait image meant to project an elevated concept of the *princeps* and principate: from Augustus's idealized quasi-divine beneficence to the Flavians' pseudo-Republican verism, to Trajan, Hadrian, the Antonines, and even Severus, all of whom employed these same traditions in various combinations. Caracalla was the first, but far from the last, to choose a portrait designed to highlight his qualities, genuine or alleged, as a fighting man.

Caracalla is said to have entered the senate house dressed in military garb, whereas tradition—respected by all earlier emperors—held that arms were to be laid down even before crossing the city boundaries; indeed, his nickname Caracalla refers to a style of Gaulish military overgarment that he favored. Severan policy constituted an open recognition that the empire had become a military autocracy, but Caracalla's father had at least pretended to respect senatorial input and Republican tradition, however hollow those gestures were. Caracalla threw off all pretense. The Antonine image of the Hellenized philosopher king gave way entirely to the image of a soldier, one to whom any Roman legionary might relate as both colleague and *imperator*. The intended audience for the imperial image changed utterly, openly, and, as it would turn out, lastingly.

In contrast to previous young emperors—for example Augustus, who made an asset of the godlike, smooth, idealized visage—Caracalla favored a portrait that actually made him look *older*. We see a face that is lined, especially around the mouth and across the forehead, and his brow contracts tautly into a scowl that suggests a severity, perhaps even a brutality, that would lend him credibility with the troops, his most cherished constituency. Moreover, Caracalla is known to have adopted as one of his role models Alexander the Great—also a crown prince, youthful king, and world conqueror—as had Julius Caesar, Pompey, and other eminent Romans. Certain portrait features—the turned head, intense eyes, and emotional expression—may have been thought to call to mind this Macedonian demigod, even if the likeness is, to modern eyes, not obvious. Whatever the roots of Caracallan portraiture, the transformation in style is striking, as is the degree to which the imperial image now openly reflected the harsh realities of Severan times.

Caracalla's portrait type set a standard that was to be followed by his successor Macrinus, and the many later soldier emperors of the third century. The portraits of his two teenage Syrian cousins, Elagabalus and Alexander Severus—the

12.11 Portrait of Caracalla as emperor, from a statue reworked as a bust, 212 CE. Marble. H. 71 cm (2 ft 4 in.). Caracalla ignored the traditions of his predecessors and was the first emperor to be portrayed as a soldier.

CHAPTER 12: ART IN THE AGE OF THE SEVERANS 323

12.12 Portrait of Alexander Severus. 222–35 CE. Marble. H. 40 cm (1 ft 3¾ in.). Unlike those of Caracalla, Alexander Severus's portraits showed a calmness and suggested a sense of stability seen in the Classicizing images of Augustus's dynasty.

last two Severan emperors—were, however, different. The official image of Elagabalus, who became emperor at the age of fifteen and died at eighteen, resemble the early, more boyish portraits of Caracalla. As emperor, he adopted Caracalla's official imperial name, Marcus Aurelius Antoninus Augustus; indeed, rumor was planted that they were father and son in an attempt to secure the boy's popularity with the troops. The title Antoninus Elagabalus, which was based on his devotion to the Syrian sun god by that name (see p. 325) was connected with him only well after his death.

The more successful of the two cousins, Alexander Severus [**12.12**], assumed the throne at the age of thirteen and managed to survive and rule for thirteen years more. He was invariably shown as the youth that he was, although he sported the short-cropped hair of Caracalla, who was also claimed to be his biological father. In strong contrast to Caracalla, Alexander Severus's portraits are devoid of emotion, and this evokes the sense of permanence and stability inherent in the Classicizing images of Augustus and his kin. Such representation reflects the moderate policies of his reign, which were overseen by his mother, Julia Mamaea. During this period, senatorial support was more openly solicited than had been the case under the earlier Severans, while the fidelity of the army remained a necessary prerequisite to rule.

Despite his efforts, and those of his well-born mother and aunt, Alexander proved incapable of maintaining the trust of the troops, primarily because of his avoidance of battle and policy of purchasing terms of peace. He was assassinated in 235 CE and replaced by the legionary commander Maximinus, a soldier from Thrace who had risen to the position of legionary commander. At this point the increasing militarization that characterized the Severan period gave way to and, in fact, brought about the half-century known as the era of the soldier emperors.

Building in Rome

RESTORATIONS

In contrast with their Antonine predecessors, the Severans were active builders. The Severan era was certainly the last period of significant architectural activity in Rome itself until the time of Maxentius (r. 306–12) and Constantine (r. 306–337) a century later. Indeed, much was in need of refurbishment; the *Historia Augusta* (Severus 23.1) states that Septimius Severus restored "all the public sanctuaries in Rome, which were then falling to ruin through the passage of time. And seldom did he inscribe his own name on these restorations or fail to preserve the names of those who built them." The last comment resonates with a similar assessment of Hadrian, yet in the case of both it was obviously well known even in later times who had paid for what, despite the absence of evidence through inscription. In his building program, Severus was intended to be understood as a benefactor in the tradition of the best of his predecessors.

Some buildings restored by Severus were associated with the earliest days of Rome, such as the temple of Vesta in the Forum Romanum and the adjacent house of the Vestals, the Severan remains of which still stand today. Further work on Vespasian's forum was also extensive, and the great marble map of Rome known as the *Forma Urbis Romae* (see box: *Forma Urbis Romae*, opposite) was a creation of this time. The new temples that the Severans built in Rome are not well preserved, but there is a clear emphasis on Syrian and Hellenized Egyptian cults associated with these buildings. Caracalla is said to have introduced the cult of Isis to Rome, a statement that although obviously untrue—there was a sanctuary to Isis built by Domitian in the Campus Martius—does reflect his devotion to that goddess. Remains of a massive temple on the Quirinal hill in Rome have been identified as a Serapeum, or temple to the Greco-Egyptian god Serapis, built by Caracalla, as inscriptions show. Surviving sections of architectural ornament recall Hadrianic style, and some have seen this as another of the many Severan restorations, rather than a Severan foundation per se. In addition to his work on the Baths of Nero in the Campus Martius, Alexander Severus rebuilt

Forma Urbis Romae

Vespasian's Templum Pacis burned in 191 CE and was restored by Septimius Severus. As part of this restoration, in a room to the southwest of the temple proper, Severus commissioned the *Forma Urbis Romae*: a huge (18 × 13 m) detailed plan of the city of Rome inscribed on marble slabs. The map showed individual buildings in Rome, with inscriptions and cuttings filled with red paint for greater legibility. It may have replaced a Flavian original, fragments of which have been identified. Many of the buildings discussed throughout this book, including the Flavian Divorum, the Claudianum, the Theater of Pompey, the *Saepta Julia* conceived by Caesar, and the *Diribitorium* completed by Augustus, to name just a few, are primarily, or even entirely, known through this precious relic. Since marble was a valuable resource, the slabs on which the plan was carved were plundered and broken apart after the building went out of use, many no doubt ending up in lime kilns. Unfortunately, therefore, the plan is preserved only to about 10 percent of its original state, in, at last count, 1,186 surviving pieces and 87 more that are now lost but known from early drawings.

The plan is not mentioned in any literary source. It can, however, be dated from 203 CE since it depicts the Septizodium (see p. 326), which was built in that year. An inscription on the plan also mentions Caracalla as co-emperor, which indicates a date before the death of Septimius Severus in 211 CE. The section of the Templum Pacis, in which it was originally placed, was later incorporated into a sixth-century church and here the *Forma Urbis Romae* formed an exterior wall of the nave (the central part of the church). Many of the fragments we have today were found in this area in the sixteenth century; some of the pieces were taken during the Renaissance by the influential Farnese family and transferred to a garden near their palace, next to the Tiber. These fragments were rediscovered three centuries later. Around three dozen further pieces were found in the area around the Roman forum in the nineteenth and twentieth centuries, most recently in 2001. The surviving pieces of the plan are today stored in the Museum of Roman Civilization in Rome. All the evidence for the plan, including digital scans of the fragments, has been collected and is available online through the website of the Stanford Digital *Forma Urbis Romae* Project for future students to explore.

Most of the attention paid to this monument has concerned its function as a documentation of Roman topography, but more recently scholars have come to view it as a historical document and ask why the project was undertaken at all. Given its size and location, it surely was not intended as a working map in any real sense. Similarly, as with the columns of Trajan and Marcus Aurelius, much of the detail would have been invisible to the unaided eye, and what detail was visible, as well as any labeling, could not have sufficiently served any administrative purpose. Indeed, more detailed and functional official state maps would have been drawn on scrolls, which may have served as a guide or model for the marble plan. Minimally the plan, just like the two great spiral columns, was a monument and a marvel, meant to impress the viewer with its massive scale and intricate detail that could be seen but not really read. Its fundamental point must have been to demonstrate the scope and grandeur of the Roman world's greatest urban center, as extensively restored by Severus himself. Visitors would be awed by it and, no doubt, local viewers would delight trying to locate their own little place in it, just as modern map-readers do today.

Domitian's Iseum (temple to Isis), and his cousin and predecessor Elagabalus had erected a great temple to his own namesake, Sol Invictus Elagabalus—a Roman version of the Syrian sun god (El-Gabal) for whom the young emperor himself officiated as hereditary high priest. A massive platform, originally built in the early empire, probably for a temple to Jupiter, was used for this. It was apparently a hybrid temple, peripteral but with a podium and a deep porch in front. The temple was rededicated to Jupiter by Elagabalus's successor Maximinus. Indeed, the lavish expenditure on architecture, added to the emperors' restoration of such social programs as the *alimenta* that supported Italian children, the extraordinarily generous treatment of the legions, and frequent campaigning would lay the foundations for the subsequent fiscal crises of the third century CE.

PALATINE

Elagabalus's temple was erected on the Palatine, not far from Septimius Severus's biggest new building project, his huge extension of the Domus Flavia, which included expanded living quarters and a bath complex. Work undertaken throughout the complex during the Severan period may have contributed to the

12.13 Drawing of the Septizodium, Rome, Italy, built 203 CE. The remains of the great nymphaeum were torn down in the sixteenth century, but such illustrations as this one survive to give an idea of how it looked.

stood at the foot of the Palatine with the Severan extensions above and behind.

Some 90 meters in length (almost precisely the length of an American football field), as suited its location in the capital, the Septizodium was an especially colossal version of the many provincial prototypes outlined earlier. The name tells us little but suggests that statues of the seven planetary deities adorned its *aediculae*. The emperor's late antique biographer indicated that, "When he built the Septizodium, he had no other thought than that his building should strike the eyes of those who came to Rome from Africa" (*Historia Augusta*, Severus 24.3). Indeed, the facade overlooked the area within sight of one of the main southern points of entry to Rome, the Porta Capena, where two roads, the via Ostiensis (which ran to the west coast) and the via Appia (running to the east) converged, so it would have greeted travelers from the eastern empire whether they had come by land or by sea. Given the popularity of this type of architectural display in the great cities of Asia and North Africa, the Septizodium would have provided such visitors to Rome with a familiar face.

close similarity between Severan and Flavian architectural ornament, often noted on the two Severan arches that are discussed below. The most conspicuous, and significant, element of the program is now lost, having been torn down by Pope Sixtus V in the sixteenth century, but it has been preserved in earlier drawings. This was the Septizodium [**12.13**], a great, three-storied, colonnaded facade, a nymphaeum, that

BATHS OF CARACALLA AND ITS DECORATIVE PROGRAM

As always, the most conspicuous and most appreciated, no doubt, of public buildings were the baths. Septimius Severus built baths across the Tiber and others southeast of the Palatine (neither complex exists today), and Alexander

12.14 Remains of the Baths of Caracalla, Rome, Italy, 211–17 CE. These are among the largest and best preserved of all imperial *thermae*.

326 PART IV: COLLAPSE AND RECOVERY: ART ACROSS THE LATER ROMAN EMPIRE

Severus extensively refurbished the Baths of Nero. But the greatest of the Severan baths, and the best preserved of all the great imperial *thermae*, were the Baths of Caracalla. This complex was the major focus of his building program, opened to the public in 216 CE—a year before Caracalla's death—and finished somewhat later. They were located outside the Porta Capena along the via Appia and would, in the same way as the Septizodium, have been an impressive sight for visitors approaching Rome from the south. The complex was very close in size to the massive *thermae* of Trajan but, unlike those baths, nearly the entire footprint of Caracalla's is preserved within largely unrestored concrete walls soaring to a substantial portion of their original 40 meters (131 feet) in height. There are no other remains in Rome that are quite so overwhelming to view [12.14].

In plan [12.15], these baths follow the precedent of the earlier imperial *thermae*. The center of the baths is occupied by the now standard triple-bayed cross-vaulted great hall with unheated pools (*frigidarium*), placed on an axis with an unroofed swimming pool (*piscina*) to the north, and to the south, a small room with warm pools (*tepidarium*) and the main hot room (*caldarium*). This last room in Caracalla's baths is especially noteworthy—a domed rotunda that is four-fifths the size of the Pantheon cella (see Pantheon, p. 266). To either side of this core complex are symmetrically arranged additional bathing rooms, changing rooms, *palaestrae*, and other exercise areas. The great rectangular structure that encloses the baths accommodated many functions; in addition to the conventional shops, service areas, and cisterns there was a large Mithraeum (temple to Mithras) and directly opposite the *caldarium* dome, facing across the intervening garden, was an area for watching sporting events, in form reminiscent of one half of a Greek-style stadium.

The complex was fully embellished with carved marble ornaments, colored revetments, painting, stucco, and mosaics, some traces of which remain [12.16]. Following the excavation of the site in the sixteenth century and the passing of major finds into the Farnese collections, we have established an unusually full understanding of the statuary display within Caracalla's baths, which is assumed to be have been more or less typical of other Roman baths. Niches for sculptures, some furnished with water features, adorned in particular the *piscina*, *frigidarium*, and rooms off the *palaestrae*; statues were rare or absent in the warm rooms. The surviving sculptures attributed to these niches include Classical and Classicizing images of gods and heroes, a collection similar to those found on the colonnaded facades in the eastern provinces. Indeed, the north wall of the *piscina* was itself articulated on three stories in precisely the manner of a monumental nymphaeum.

12.15 Plan of the Baths of Caracalla, Rome, Italy, 211–17 CE. The plan follows that of earlier imperial *thermae*, with a central cross-vaulted hall and rooms either side on a vertical axis.

12.16 Surviving decoration from the Baths of Caracalla, Rome, Italy, 211–17 CE. The baths were richly decorated using a variety of materials and techniques, including colored revetments, painting, stucco, marble, and mosaics. The sculptural display of this complex is especially well preserved.

12.17 Farnese Hercules, Baths of Caracalla, Rome, Italy, c. 211–17 CE. Marble. H. 3.17 m (10 ft 6 in.). An exaggerated version of an early Hellenistic statuary type, perhaps created by the famous Lysippus of Sicyon.

What is striking about this particular bath complex is the unusual number of colossal statues and statue groups, each of these well over three meters in height. They included images of gods and complex multi-figured mythological groups, in the tradition of the much earlier Sperlonga sculptures (see box: Sperlonga and Statuary, p. 192). The best-known piece is the Farnese Hercules, which repeats a motif of a leaning, weary hero that can be traced to early Hellenistic or perhaps late Classical times [12.17]. The Farnese statue is an extremely exaggerated version, with a bloated musculature carved into an impossibly complex surface that disguises any rational explanation of structure or stance; it is simultaneously Classicizing and unclassical—a Roman work rather than a copy of an earlier Greek masterpiece. It bears the signature of its sculptor Glycon of Athens, not the signature of a Classical master, and is clearly a work representing its own time. Its dramatic and excessive character, similar to that of some of the other colossal pieces elsewhere in the bath complex, has suggested to a number of scholars a Severan revival of Flavian bourgeois Hellenistic tastes, which are detectible as well in the unusually dramatic impression of Caracalla's portraiture. It does appear to be the case that the embellishment of the baths with statuary—one of the more expensive elements in building a great public thermal complex—was largely accomplished with other works of earlier dates that happened to be at hand. This element of economy within an extravagant building program reminds us of the decline in economic circumstances that had resulted from Severan military expenditures. The colossal statues, however, were works of the Severan era, carefully designed to complement the soaring spaces of the baths and made for the very locations in which they were placed. Building and sculpture alike were intended to overwhelm and impress.

ARCH OF THE *ARGENTARII*

In Rome, two commemorative monuments help to create our picture of Severan art in the public sphere. One was privately commissioned by the *argentarii* and *negotiantes* (bankers and businessmen) of the Forum Boarium, the old cattle market near the Tiber. This monument is located on the Velabrum, a low saddle between the Palatine and Capitoline hills, and faced the *vicus* Tuscus, which led to the Forum Boarium from the Republican forum. Built into the medieval church of San Giorgio in Velabro, much of it, though damaged and weathered, is still preserved [12.18].

12.18 (Right) Arch of the *Argentarii*, Rome, Italy, 204 CE. H. 6.15 × W. 3.3 m (20 ft 2¼ in. × 10 ft 10 in.). While called an arch, it is not actually vaulted. Its inscription tells us who dedicated and paid for it.

328 PART IV: COLLAPSE AND RECOVERY: ART ACROSS THE LATER ROMAN EMPIRE

12.19 (Far left) Panel from the Arch of the *Argentarii*, Rome, Italy, 204 CE. The relief depicts Septimius Severus in his role as *pontifex maximus*. He stands with his wife Julia Domna, the figure (probably Geta) to her side since removed.

12.20 (Left) Panel from the Arch of the *Argentarii*, Rome, Italy, 204 CE. Only Caracalla's portrait survives on this panel. It is assumed that portraits of Gaius Fulvius Plautianus, Severus's praetorian prefect, and his daughter, Caracalla's wife Plautilla, were removed; both were killed on the orders of Caracalla.

Although it is called the Arch of the *Argentarii*, its span consists of a lintel supported on two piers; it was probably a monumental gateway, perhaps into the headquarters of the guild of those who dedicated it. Faced in white marble and extraordinarily ornate, with deeply carved architectural moldings and figural reliefs on every available surface, it was set up in appreciation for some benefit that the dedicators received from the emperor. The surviving reliefs mostly allude to the religious offices of the emperor through the depiction of sacrifices and priestly implements, with only one surviving subject (a bound Parthian captive) referencing military accomplishments. The facing panels are badly preserved but possibly depict individual members of the dedicating guild.

Most striking among the reliefs are those that portray the entire imperial family, on either side of the gate's interior [**12.19** and **12.20**]. The relief on the left side depicts Septimius Severus togate and *capite velato* (covered head), identifying his role as *pontifex maximus*. He holds an offering dish over a tripod altar, behind which stands his wife Julia Domna. The right portion of this same panel has been chiseled smooth; presumably Geta was originally shown here. The opposite panel has been similarly defaced; the only surviving figure is a youthful Caracalla, posed similarly to his father. Cut away from this panel, no doubt, were Gaius Fulvius Plautianus, Severus's praetorian prefect, and Plautianus's daughter Plautilla, Caracalla's wife. Soon after this gateway was dedicated, Caracalla contrived the execution of Plautianus, whose influence over his father he feared; he later had Plautilla killed (211 CE) as well as his brother Geta (at the end of that year). This effacement of their portraits constitutes a *damnatio memoriae* of his enemies as well as of his brutal crimes. The dedicatory inscription was also recut to eliminate mention of the three individuals.

The carving style displays the "neo-Flavian" decorative excess that typifies Severan architectural ornament in Rome. Yet there is a distinct flatness and linearity in the execution, even compared with Antonine work. The individual elements of the ornamental molding framing the imperial family reliefs seem as much drawn as carved. The drapery, hair, and beards of the figures themselves are also roughly blocked out, while the drapery patterns and poses

CHAPTER 12: ART IN THE AGE OF THE SEVERANS

themselves remain consistent with the Roman tradition of Classical forms. Also striking is the frontal view of the figures, and the symmetry of the compositions. This device is not new, but it becomes increasingly dominant in representations of imperial authority, and within a century becomes standard. While this could be seen as a style influenced by the tradition of so-called middle-class art, as these were surely middle-class patrons, the following look at imperial commissions reveals much the same stylistic trends.

PARTHIAN ARCH IN THE ROMAN FORUM

Chief among these imperial projects, and the second Severan commemorative monument to be considered here, is the triple-bayed arch erected in the northwest corner of the Republican forum, as conspicuous today as it was in antiquity [12.21]. It was set up in 203 CE to commemorate Septimius Severus's conquest of the Parthians. The first of his two campaigns against them (195 CE) was conducted immediately after the defeat of his rival Pescennius Niger, both to secure his authority in the area and punish those who had sided against him. The second campaign (197–99 CE) responded to incursions by the Parthian king Volosges into purportedly Roman lands. Erected at the west edge of the forum, beneath the Capitoline and opposite the temple to Caesar, it closed off the forum's still somewhat open central area. The only other triumphal arch that had been constructed in the forum was that of Augustus, also as a victor over the Parthians. Severus here is situating himself with carefully chosen company: other emperors who fashioned themselves Parthian conquerors included Trajan and Marcus Aurelius (led by Verus)—all among the "best" of the *principes*.

Of course, none of these previous Parthian "victories" had been an unqualified military success. Augustus's was diplomatic, accomplished, as befit him, with no warfare whatsoever. Trajan's campaign ended with a lack of resolution underscored by Hadrian's immediate forfeiture of its ostensible acquisitions. Whatever gains Verus's army made were attributable to his generals, especially Avidius Cassius, and those, too, quickly disappeared. But that mattered little if the objective was adding another title of *imperator*. Severus was somewhat more successful and captured one of Parthia's capitals, Ctesiphon. There followed yet another Roman campaign, under Caracalla and then Macrinus, followed by turmoil within Parthia's ruling family. Soon there arose a new dynasty from old Persia to the south, the Sassanians, who would create serious problems for the Romans a half century later.

Despite its apparently innovative features, most elements of this monument had precedent, if not always in Rome. Arches with three bays existed at least as early as the Augustan era, and freestanding framing columns were used in the first century CE. The style of architectural ornament is also consistent with the elaborate, sharply carved forms seen in other Severan building work. The iconography of most of the figured relief sculpture of the arch is conventional as well, and is entirely devoted to conquest: Parthian captives on the pedestals, victories and river gods in the spandrels, and the triumphal procession itself. This is carved on a very low frieze surrounding the monument at a level just above the crowns of the lateral archways rather than, as on the arches of Titus and Trajan, on the entablature proper, which here has been left blank. Not only is the procession scene more legible in this position

12.21 Arch of Septimius Severus in the Republican Forum, Rome, Italy, 203 CE. Aside from Augustus's "Parthian" arch, such victory monuments as this one were not usual in the old forum in such a conspicuous location.

but also its direct juxtaposition with scenes of critical episodes from the campaign itself imbue the whole monument with a more strongly narrative aspect. The quality of execution found on these sculptures is somewhat higher than that on the Arch of the *Argentarii*, but both share a tendency toward forms that are deeply cut and simplified, nearly abstract, which is emerging as a characteristically Severan trait.

Far more innovative are the scenes of warfare, comprising square panels installed above each lateral archway, two facing the forum and two facing the Capitoline. Although panel reliefs were common enough on earlier arches, none of them are at all similar to these. The relief panels of Trajan, Hadrian, or Marcus Aurelius each focus on a particular imperial quality or activity; a sacrifice, for example, or imperial clemency, or an *adventus* that references the conquest from which the emperor returns. They tell their story using a small number of relatively large figures in a distinctly Classical manner. The four panels of Septimius Severus's arch operate more in the tradition of chorographic (map-like) triumphal painting and the spiral commemorative columns of Trajan and Marcus Aurelius. The point of such triumphal art is to create a sense of immediacy on the military action itself, its temporal celebration in ritual procession, and its lasting commemoration in painting and sculpture. The co-location of battle and triumph on this monument strongly underscores that intent.

Severus's Parthian campaign included the taking of a number of cities, some defended more vigilantly than others, and each of the panels deals with one specific capture. The sack of Ctesiphon, the Parthian capital on the River Tigris, was the centerpiece of the campaign, but the legions attacked and overcame such cities as Seleucia, Edessa, Nisibis, and others. While these victories provide the subjects of the four reliefs, opinions vary on exactly which panel shows which city. There is both consistency and variety among the four compositions. Each is divided by horizontal ground lines into two or more separate scenes that are sequential in time, moving from bottom to top.

The two panels illustrated here [**12.22** and **12.23**] are on the west facade, facing away from the open forum but toward the Capitoline, which seems to have protected it to an extent from the effects of weathering, so the figures here are better preserved than on the east side of the arch. The overall sequence appears to be chronological and runs counter-clockwise from southeast to southwest, thus left to right on both facades. What we see here, then, are the final two episodes of the Parthian campaign, with the taking of Parthian cities in central Mesopotamia—Seleucia and/or Babylon in the first and, as the finale, the capital of Ctesiphon again.

In both reliefs, the lower register shows Roman troops attacking a walled city, and the upper depicts the emperor addressing troops, with the town itself (or another town) in the background, following the successful siege. The two sieges employ very different compositional devices. The first shows the town from above, reduced in

12.22 Detail of the Arch of Septimius Severus in the Republican Forum, Rome, Italy, 203 CE. The northwest panel shows the capture of a Parthian city in Mesopotamia, possibly Seleucia or Babylon.

12.23 Detail of the Arch of Septimius Severus in the Republican Forum, Rome, Italy, 203 CE. Southwest panel depicting the capture of Ctesiphon, the Parthian capital.

scale to a virtual hieroglyph. Troops attack with weapons and rams from the foreground, while fugitives flee across the background, abandoning the defenders to their fate. The composition, with its convergence and divergences, is essentially radial. The battle on the other (Ctesiphon) relief is more lateral. A massive siege engine is brought up from left to right, with soldiers massed nearby ready to rush through the breach. A single figure—perhaps the Parthian king himself—slips off to the upper right.

There are many conceptual visual conventions here. The abrupt combination of lateral and bird's-eye views, the clustering of a few small figures standing for many, the drawing of the viewer's eye toward a focal point (the emperor, the city) through the composition, the continuous narrative moving back, forth, and up the picture—all are features of the spiral columns of Trajan and Marcus Aurelius and originated in triumphal paintings. Many of these paintings were panels themselves, and may have looked very similar to those we see on the arch. The compositional schemes also call to mind such middle-class works as the reliefs from the tomb of the Haterii (see Tomb of the Haterii, p. 210), and the image on the Severan arch of masses of squat, abstractly rendered figures (seen also in the triumph relief) both connects with this plebeian tradition and anticipates late antique developments (see Chapters 13 and 14). On the other hand, the designer of this arch, as it is often suggested, may have consciously combined the traditions of the spiral columns and panels into a new creation, one that constitutes an experiment not repeated on any known later monument.

LEPTIS MAGNA

Even more impressive than his building program in Rome is the array of structures that Septimius Severus commissioned in his hometown of Leptis Magna in Libya (see box: Leptis Magna and the Severans, p. 336). The sculptural program there demonstrates an ever-increasing internationalization of style, best illustrated by Severus's sculptured arch. While entirely different in form from the Parthian Arch in the Roman Forum, the two share many stylistic features. Set up around the time of Severus's visit in 203 CE [12.24], it is a four-sided (*quadrifrons*) structure, located at the intersection of the town's primary north–south (*cardo*) and east–west (*decumanus*) roads. As also seen on the arch in Rome, freestanding Corinthian columns on pedestals flank each archway, yet these support not entablatures but fanciful truncated pediments that more resemble images found in Fourth Style wall painting (see Interiors: Fourth Style Wall Painting, p. 186) than those in real architecture. The limestone structure is encased in marble, with relief carving in many places. Images of bound Parthian captives adorn the exterior surfaces of the four great piers (upright supports) and highly pictorial reliefs showing battle scenes, not entirely different from those in Rome although more vertical in form and less pictorially expansive, have been placed at each of the inner pier faces. In the spandrels we see elegant representations of the goddess Victory

12.24 Arch of Septimius Severus, Leptis Magna, Libya, 203 CE. Limestone and marble. Essentially a cross-vault supported on four piers, this monument was built at the intersection of the town's two main roads.

with the conventional flowing, windblown drapery of the late fifth century BCE, which is, however, cut with characteristic Severan hardness and linearity [12.25].

The dominant element of the arch is provided by the large reliefs at the attic level of each of the four surfaces, stretching across the arch from edge to edge. Each relief is a ceremonial depiction of the imperial family: enthroned as Roman deities; establishing succession; performing a sacrifice; and in a chariot procession. The latter panel may show an imitation Roman triumph performed at Leptis as it shares some features with the formally comparable scene from the Arch of Titus, most especially the juxtaposition of a frontal emperor with a laterally rendered team of horses [12.26]. But the overall impression of the Leptis arch is entirely different. The composition is not dynamic and illusionistic but formal and static. The emperor, who is visually framed by the gaze and pose of all the accompanying figures, appears almost holy and remote. The cavalry at left is portrayed using a conventional device, common in earlier Roman art, to indicate that the figures are receding in space by arranging them in strict registers.

The figures in the sacrifice panel are similarly arranged [12.27]. They are Classically posed with weight shift and drapery arranged to accentuate stances, but the execution itself is dry, deep, and linear—even more so here than in work of a similar style in Rome. Again, both composition and figure style hark back to plebeian traditions, but given the origins of the emperor in Tripolitania in North Africa and of the empress in Syria, and the fact that many from those areas were elevated to power at this time,

12.25 Panel from the Arch of Septimius Severus, Leptis Magna, Libya, 203 CE. Limestone and marble. The scene shows a standard personification of victory (*Victoria*) with origins in the Greek Classical period. The abstraction of the figure is typical of Severan art.

12.26 (Below) Panel from the Arch of Septimius Severus, Leptis Magna, Libya, 203 CE. Limestone and marble. H. 1.7 m (5 ft 7 in.). The scene perhaps depicts an imitation triumph at Leptis Magna.

12.27 (Left) Panel from the Arch of Septimius Severus, Leptis Magna, Libya, 203 CE. Limestone and marble. H. 1.7 m (5 ft 7 in.). This sacrifice scene also derives from Roman prototypes, such as on the Arch of the *Argentarii*.

12.28 (Above) Plan of the forum at Leptis Magna, Libya, 203 CE. The Severan forum follows a traditional plan of an imperial forum transported to a provincial city, such as "Hadrian's" Library in Athens.

12.29 (Right) Ornamentation from the Severan forum, Leptis Magna, Libya, 203 CE. Limestone and marble. The "peopled scrolls" with Hercules and Bacchus call to mind Asiatic work.

it is tempting to see this stylistic development as at least partially resulting from the Near Eastern formalism that had been long established at such sites as Palmyra. At the same time, the Asiatic Hellenism that characterizes Antonine work is still strongly felt; indeed, materials and workers from regions in Asia Minor, in particular the city of Aphrodisias, are known to have been employed here.

The most ambitious Severan structure at Leptis Magna is, without doubt, the Severan forum, with adjacent basilica. Its plan [12.28] is very traditional. A porticoed open space is dominated by a high podium temple at one end and at the other a basilica that adjoins on its long side. Indeed, this complex is the closest approximation that one finds to an imperial forum anywhere in the empire after Hadrian and, just as that one was not in Rome but in the emperor's favorite city and spiritual homeland of Athens, so Severus is in his African hometown. The plan, however, displays typical Roman ingenuity in the irregular spaces used to mask the oblique angle between basilica and forum. The basilica is double-apsed, like the Basilica Ulpia, and its marble ornamentation, especially the intricate "peopled scrolls" with Hercules and Bacchus (possibly another Flavian/Severan connection) is deemed the work of Aphrodisian sculptors [12.29]. The forum is decorated with protomes (frontally viewed ornamental heads); in this case the heads are of Medusa, and surrounded an arched rather than trabeated (post-and-lintel) portico [12.30]. This is a common Asiatic motif, with prominent examples from Didyma and Aphrodisias [12.31].

Opposite the basilica rises the lofty temple to the Severan family, which is fronted by a

12.30 (Above) Section of arcade flanking Severan forum at Leptis Magna, Libya, 203 CE. Limestone and marble. The ornamental heads (protomes), here of Medusa, are common Asiatic motifs.

12.31 (Left) Gorgon head from Aphrodisias, Turkey. Limestone and marble. The Medusa head is similar to those found at Leptis Magna.

Leptis Magna and the Severans

Leptis Magna, on the Mediterranean coast of Africa in western Libya, was founded by the Phoenicians in the seventh century BCE as a port of call for ships traveling from the Levant to Carthage. It soon developed an important agricultural economy, based especially on the cultivation of olives. With Rome's final conquest of Carthage in 146 BCE, Leptis passed to the ancient Berber kingdom of Numidia until, in 112 BCE, Leptis allied with the Romans during the war between Jugurtha, the Numidian king, and Rome. It remained an independent allied state, with its own local government and minimal Roman interference, through the Augustan period. Leptis became ever wealthier through commerce, eventually prompting Tiberius to add it to the province of Africa Proconsularis. The provincial capital at Utica, however, was well over 800 kilometers (500 miles) to the west, and Leptis enjoyed substantial autonomy and increasing Roman rights, becoming a *colonia* (the highest status possible) under Trajan.

The city featured an artificial harbor, built under Nero, with two long pier-like structures of stone (moles) that enclosed an area of some 81,000 square meters (20 acres). Adjacent was the early imperial Roman forum (see 12.28, p. 334), with temples (to Roma and Augustus, Liber Pater, and local god Hercules Melqart) aligned on the northwest side, facing the open space, and a *curia* (meeting house) and basilica opposite —a typically Roman arrangement. A Roman-style *macellum* (market building) was added to absorb the commercial activities that had previously taken place in the forum.

The city was expanded along a principally orthogonal plan southwestward from the sea, its east–west (*decumanus*) axis bending at one point. Near that bend was constructed an arch to Trajan, in thanks for the elevation of the city's status to a *colonia*. In the time of Hadrian's rule sumptuous baths were added, decked out in marble with an aqueduct to feed them. Later, Antoninus Pius and Marcus Aurelius were both honored with commemorative arches.

The arch for Marcus Aurelius was dedicated in 173 CE by Gaius Septimius Severus, governor of Africa, and kinsman of Lucius Septimius Severus, who likewise pursued the distinguished military and civic career expected of the provincial elite, achieving the consulship in 190 CE, shortly before the death of Pertinax and his own acclamation as *princeps* in 193 CE. To celebrate his visit in 203 CE, the community erected the quadrifrontal arch. The emperor himself responded lavishly, enlarging the aqueduct and restoring the baths, as well as adding his imperial forum here, rather than in Rome, and connecting it to the port with a great colonnaded street. This favorite son of Leptis Magna, as emperor, brought an element of Rome itself to his home town, his monuments emulating those in the capital in both form and iconography, while similarly demonstrating materials and workmanship from around the empire.

12.32 Gigantomachy panel from the Severan Forum of Leptis Magna, Libya, 203 CE. Column bases bear reliefs depicting a Gigantomachy stylistically similar to that on the Hellenistic altar at Pergamon.

semi-pyramidal staircase. Its exterior columns stood on sculptured pedestals, following Hellenistic models. The pedestal reliefs themselves show a Gigantomachy, and many scenes here are explicit visual quotes of the Great Pergamon Altar [12.32]. Severan Leptis Magna does not just illustrate the obvious benefaction of a provincial emperor for his own native city. It also represents how Roman imperial art becomes, paradoxically, ever more homogenous in its diversity. It is no longer simply a question of the mutual dynamic between capital and province, but now of equal importance are the interrelationships between and among the provincial centers themselves.

12.33 *Lenos* sarcophagus showing the triumph of Bacchus, 3rd century CE. Marble. L. 2.16 × H. 0.92 × W. 0.86 m (7 ft 1 1/8 in. × 3 ft 1/4 in. × 2 ft 9 7/8 in.). The god rides on the back of a lion amid a scene representing life, death, and rebirth.

Private Art after the Antonines

BACCHIC AND SEASONS SARCOPHAGI

By the period of the Antonines, as discussed earlier, the use of sarcophagi to inter the deceased had re-emerged as a funerary practice among Romans who could afford to commission them. During the time of the Severans, a new form of tub-shaped, or *lenos*, sarcophagus became popular. As a group, these reflect a strong interest in various mystery cults, providing a significant precedent for the wealthy Christians who, given their exclusive practice of inhumation, began to embrace the use of sarcophagi in the third century CE.

One exquisitely carved example now in New York [12.33] centers on the triumph of Bacchus, returning from the east on the back of a lion. We have seen the motif before on Hellenistic mosaics in both Greece and Italy, and Bacchic themes, like Bacchic cults, remained popular throughout the empire. The mystery cult of Bacchus, or Dionysus, drew on the subjects of death and restoration to life, the idea of which is here reinforced by the four figures of the Seasons who stand also for the cyclic nature of life, death, and rebirth. The very deep carving, extensive drillwork, and the distinctly non-Classical poses and astructural anatomical rendering of the Seasons' body types (that are nonetheless Classicizing) fit well with a third-century CE date. The physiognomy of these androgynous male deities is strikingly reminiscent of the female Victory figures on the arch at Leptis Magna. It is important to note, however, that the drapery here remains consistently Classical and bears none of the simplification and abstraction noted on the Severan arches. Roman sculpture was, in all periods, diverse in its stylistic options.

A popular variant of the sarcophagus with scenes of Bacchus is those that show the Seasons alone, without any specific scene of myth. One third-century CE example, from Rome and now in the Capitoline Museums, employs the same basic figural types for the personifications of the deities [12.34]. The iconography, however, in terms of pose, hairstyle, or attribute, is by no means fixed, but simply follows a general but recognizable scheme—a youthful, idealized, loosely Classically

12.34 Sarcophagus of the Four Seasons, Capitoline Museum, Rome, 3rd century CE. Marble. H. 1.04 × W. 2.39 m (3 ft 5 in. × 7 ft 10 1/8 in.). *Putto* Seasons feature on the door to a passageway to the underworld.

CHAPTER 12: ART IN THE AGE OF THE SEVERANS

posed male with long wavy hair and a small cloak that conceals little. Here the Seasons alone suffice to convey the same themes as detected in the Bacchic sarcophagus above.

This sarcophagus frames each pair of Seasons with an arched niche formed by decorative spiral Composite columns. At first glance, these columns mask the significance of the central architectural feature. In such sarcophagi as this there is usually a niche with a triangular pediment in the center, but in this particular example the pediment crowns not a niche but a passageway, its firmly closed doors divided into four panels, each decorated with a Season in the form of a **putto**, a small winged child. The door is flanked by statues on pedestals, their cornucopias suggesting that they might be representations of Fortuna/Tyche or some other sign of divine benevolence. Behind these statues rise two figures (now both headless) wearing the Greek **peplos**—a garment that was typically worn by women in Greece by the fifth century BCE—and holding torches. The figures probably reference Hecate, the goddess of liminal spaces. These motifs combined represent a passage to the afterlife—Hades, the god of the underworld, is indicated by suggestion rather than by representation. This more explicit version of an iconography of sarcophagus reliefs underscores the object's function as a transitional space itself between life and the afterlife.

ANTIOCH MOSAICS

Julia Domna and her family were natives of the Syrian city of Emesa (present-day Homs). Located some way down (northward) the Orontes river from Emesa was Antioch (modern-day Antakya in Turkey), capital of the Hellenistic Seleucid empire and one of the great urban cultural centers of the Hellenistic era. The city continued to function as capital of Roman Syria, and while much of the ancient urban center remains entombed under the modern town, several opulent suburban villas have been excavated and preserve some of the most spectacular floor mosaics of the later empire (see box: Roman Mosaics, p. 340).

Two important examples of these mosaic floors portray a similar scene—the drinking contest between Bacchus and Hercules. The mosaics

12.35 Mosaic of Bacchus and Hercules from Antioch, Turkey, 2nd century CE. The polychrome style of these mosaics from the Hadrianic period is commonly found in the eastern provinces of the empire and North Africa.

probably decorated a room where the aristocracy of Roman Syria would take part in banquets, and the mosaics would have functioned to associate this dining activity with that of the guests' anthropomorphic gods. They might even have served as a prompt to contemplation and conversation.

One version of the Bacchus and Hercules mosaic dates from the Severan period and the other is from about a century earlier [12.35 and 12.36]. The polychrome style of these mosaics was commonly found in the eastern provinces and North Africa, while the monochrome mosaic style, for example, the mosaics from Ostia studied in Chapter 9, remained typical of the western part of the empire. The similarities and differences between the two Bacchus and Hercules mosaics are illuminating. One first notices the very different forms of framing—the earlier mosaic (12.35) is surrounded by subdued **guilloche** and **meander** patterns; the later mosaic has an elaborate architectural frame. The figural types of the two protagonists are consistent in all essentials. As in statuary, there is the temptation to suggest that there was an "original" work on which this was based, such as a monumental painting, especially given the very fine work here, detailed in a similar way to the vermiculate work of the later Hellenistic period, known from both Greece and Italy (see Mosaics, p. 79). It is by now clear, however, that throughout Roman art, there were figural repertoires from which artists and artisans drew with considerable variety and ingenuity, and it is seldom easy to discern among media and sources.

There is no disputing, however, the change in style between the two mosaics, and it is entirely consistent with what has already been observed in sculpture. The second-century mosaic models its figures with subtle gradations of light and shadow; the third-century relies on sharper contrasts and more abstract forms. Which is more pleasing? More striking? More legible? These are questions that can be debated, but it is absolutely clear that the stylistic transformations marking the change from the High to the late periods of the empire existed across artistic media and had been fully established by the end of the Severan era. In art, as in politics, the Severans—despite their obvious efforts to appear Antonine—ushered in a fundamentally different set of values and, with them, different artistic forms as well.

12.36 Mosaic of Bacchus and Hercules from Antioch, Turkey, early 3rd century CE. H. 2.95 × W. 2.29 m (9 ft 8¼ in. × 7 ft 6¼ in.). Another version of the Bacchus and Hercules scene, created a century after the reign of Septimius Severus.

MATERIALS AND TECHNIQUES
Roman Mosaics

In the Classical cultures of Greece and Rome, the technique of mosaic was used primarily to pave floors, occurring only occasionally on walls. This differs from the practice of the Christian cultures of late antiquity, the Byzantine East, and early medieval Italy. The technique itself evolved from paving floors in polished river stones set in mortar, which provided a comfortable surface to walk on and was more durable than the normal plaster floors most commonly used. Already in the Classical era, Greek artisans began to arrange these naturally colored pebbles, first in abstract patterns but soon figural scenes became popular as well. By the beginning of the Hellenistic period, very complicated figural scenes and floral borders were possible in such pebble mosaics [12.37]. The cutting of stones into smaller, mostly rectilinear forms (*tesserae*, thus, tesselated mosaics), in order to render the patterns and images in greater detail, began later in the Hellenistic era. This technique allowed the inclusion of such a level of detail that the mosaics could be mistaken for paintings, which, indeed, many mosaics have been assumed to copy. Some examples, such as the Alexander Mosaic from Pompeii, have been discussed in earlier chapters.

During the course of the Roman empire, the styles of mosaics varied geographically, but since there was such great cultural interaction among the provinces and with Italy itself, the

12.37 Floor mosaic from Pella, Greece. c. 300 BCE. L. 3.17 × W. 3.24 m (10 ft 4⁷⁄₈ in. × 10 ft 7⁵⁄₈ in.). One of several large and impressive polychrome pebble mosaics found in the capital of the Macedonian kingdom. This one bears a signature by its artist, named Gnosis.

stylistic boundaries were not absolute. The Antioch mosaics (see 12.35, p. 338, and 12.36, p. 339), for example, with their painterly polychrome effects, reflect a continuation of Hellenistic practice, which is not surprising since Antioch, capital of Seleucid Syria (and the Roman province of the same name), was one of the great Hellenistic urban centers. The forms in the later Hercules mosaic (12.36) are somewhat less detailed and more abstract than the earlier work, which not only followed stylistic changes from the second century CE to the third but also came to resemble, in this way, the polychrome mosaics of North Africa. These, in turn, influenced developments in mosaic design in Sicily (such as the Villa Romana del Casale near Piazza Armerina), Italy, and Spain, which were combined to form an administrative unit (diocese) with Africa in the later third century CE.

Finally, the black-and-white mosaics that we saw in Ostia from the second century CE were of a style known mostly from the western regions of the empire, but a large well-preserved example, the equal of anything in Italy, adorned the central hall of a bath building built outside the sanctuary of Poseidon at Isthmia

12.38 Black-and-white-style mosaic, Isthmia, Greece, 2nd century CE. L. 7.6 × W. 20.2 m (24 ft 11¼ in. × 66 ft 3⅜ in.). This building and mosaic displays features typical of Roman forms more common in the West.

[**12.38**]. This was one of the four canonical Panhellenic sanctuaries of Greece (with Olympia, Delphi, and Nemea). Built over a Greek bath used by the athletes at the games (early bathing complexes also exist at Delphi and Olympia), its Roman form and decoration is not surprising, given that the sanctuary had long been under the control of nearby Corinth, capital of the Roman province of Achaea.

13 The Art of the Soldier Emperors and the Tetrarchy

344 Soldier Emperors
- 344 PORTRAITURE
- 345 Materials and Techniques: Roman Pottery across the Empire
- 349 BIOGRAPHICAL SARCOPHAGI

351 The Tetrarchy
- 352 Box: The Tetrarchy: Tradition and Innovation
- 353 PORTRAITURE
- 355 COMMEMORATIVE SCULPTURE
- 360 PALATIAL ARCHITECTURE ACROSS THE EMPIRE

Chronological Overview

DATE	EVENT
235 CE	Alexander Severus is murdered; Maximinus becomes emperor
238 CE	Various emperors proclaimed until Gordian III becomes sole emperor; Balbius sarcophagus
244 CE	Gordian III murdered by his soldiers; Philip becomes emperor
249 CE	Decius revolts; Philip is killed and Decius becomes emperor
250–260 CE	Ludovisi sarcophagus
251 CE	Decius is killed and Gallus becomes emperor
253–283 CE	Series of imperial successions
284–286 CE	Diocletian proclaimed Augustus, appoints Maximian as Caesar, then as Augustus
293 CE	Constantius and Galerius made Caesars; Arcus Novus, Rome
298–306 CE	Baths of Diocletian, Rome
303 CE	*Decennalia* monument, Rome
Early fourth century CE	Palace of Diocletian, Split; Palace of Galerius, Thessaloniki; Arch of Galerius, Thessaloniki
c. 310 CE	Aula Palatina, Trier

The Development of Rome

Right: Map of Rome showing the key works in existence in Rome in this chapter.

CHAPTER 13: THE ART OF THE SOLDIER EMPERORS AND THE TETRARCHY

During the half-century following the death of Alexander Severus, turbulent times and the economic strain created by steady foreign incursions, incessant campaigning, and serial civil conflicts were not conducive to major public building or the commissioning of conspicuous commemorative monuments. Few emperors during this period spent enough time in any one place, let alone Rome, to develop anything resembling a building program, and although there were many victories in the field, there was precious little to commemorate before another external or internal threat would arise and divert both attention and resources.

Although few in number, the era was not entirely without new built structures. Trajan Decius (r. 249–51) built *thermae*; Aurelian provided Rome with an impressive set of fortifications and an elegant temple to Sol Invictus, the god of the unconquered sun, marking a continuation of Severan interests. A concentration of wealth in private hands funded luxurious villas with opulent decoration, especially polychrome mosaics; this was particularly the case in North Africa, generally unaffected by troubles occurring on the distant Rhine, Danube, and Euphrates frontiers and now becoming an important center for pottery production (see box: Roman Pottery across the Empire, opposite). In this way the later empire became increasingly de-centered; influences and materials moved in many directions, all while local traditions continued to be respected.

Soldier Emperors

PORTRAITURE

Given the economic and political instability of the period, the evidence for developments in the realm of official state art consists mostly of portraiture, which was conceived and disseminated under somewhat different circumstances than during the earlier empire. Reigns were short, for the most part, and some emperors sought to mark out a successor, usually a son, by elevating him to the status of Caesar or even Augustus, which was the sign of co-emperor status. Often, however, this planned succession never took place.

Throughout previous periods, imperial portraits had been constructed as a visual reference to past traditions, both immediate and remote. A new emperor sought first to define himself with respect to his predecessor, choosing to emphasize either continuity or discontinuity, as the circumstances suggested. Some rulers seem also to have attempted an association with one or more of the much earlier emperors; for example, Trajan's hairstyle is often read as an allusion to Augustus. Others looked outside the tradition of imperial portraiture, most conspicuously Hadrian, who adopted the guise of a Hellenic intellectual and statesman. Along the same lines, Caracalla adopted an image that drew elements from various traditions but transformed them into something quite new and overtly militaristic.

Consequently, by 235 CE there was a set repertoire of styles and features in portraiture that could be used to make a range of different statements about the subject. Augustan idealism was already, at the time of its adoption, a style of many meanings, suggesting peace, permanence, and stability as well as youth, Classical timelessness, moral authority, and quasi-divinity. By the time of the late empire, one could add to the list senatorial status and/or support, which was implicit in the traditional fiction of Augustus as *primus inter pares*, first among equals. Contrasting with this is the so-called veristic style, older even than Augustan Classicism. Verism, at various times, signified age, experience, military success, fiscal restraint and responsibility, Republican sympathies (as theorized for Claudius), equestrian origin or affiliation (as perhaps for the Flavians), or, paradoxically, patrician status (such as with Nerva). In the matter of style, meaning lay in difference, and each mode of representation told its story by implied comparison with the other alternatives.

Yet this was no simple polarity of idealism and realism, since one must also consider both Hadrian's new version of Classicism that emphasized his learning and erudition, and Caracalla's transformation of verism to highlight military seriousness and strength. It is easy to see how the rapidly changing faces of imperial power during the mid-third century CE came to generate an official portraiture of kaleidoscopic

MATERIALS AND TECHNIQUES
Roman Pottery across the Empire

13.1 Arretine-ware krater, 20 BCE–20 CE. H. 19.1 cm (7 in.). Frieze of figures representing the Seasons, with columns in between, and, above, a row of beads, wreaths, and rosettes.

Scholars of Greek devote much attention to fine painted ceramics, since pottery produced for Greek social and ritual practices, such as funerals, weddings, and symposia, constituted a major category of artistic production. These wares were of exceptional quality and provide nearly all the extant evidence for the appearance and development of painting in Greece. Mural and panel painting (what we call free painting) certainly existed, and were perhaps the most respected of all the arts, but given the fragility of media used they are all but entirely lost, making the ceramic record all the more valuable.

In contrast, examples of Roman free painting are many, owing to its extensive use as interior decoration and the preservation of many examples by the eruption of Vesuvius. Moreover, Roman pottery, unlike Greek, was much more commonly mass-produced and utilitarian.

Especially characteristic of the first century BCE is so-called Roman red ware. Shapes, as also for Greek pottery, are often shared with and derive from contemporary metal vases, a more expensive alternative for those who could afford them. There were three primary categories of Roman ceramics, the production of which stretches from the late Republic to the end of the empire and beyond. All were widely exported, while at the same time there were shifts in the centers of production, making this an industry that encompassed the entire empire.

Arretine Ware: Named after Arretium (modern Arezzo) in Etruria, its major source of production, these very fine vases date from the late Republic and early empire [**13.1**]. Many bear embossed decoration of figural and non-figural ornament (*sigilla*), leading to the commonly used name of **terra sigillata**, even for undecorated examples. Vases with figural scenes revive or continue a Hellenistic tradition of the so-called Megarian bowls, produced in Athens and elsewhere from the third century BCE onward.

Samian Ware: Produced initially in southern Gaul, not eastern Greece as its name implies, this **red ware** became common in the early empire, spreading out from Gaul to compete successfully with the continuing production of Arretine ware, which it imitates [**13.2**]. Many examples were plain, but there are also a great variety of decorated examples, which in Gaul often bore tightly packed and intricate floral ornament.

Red Slip Ware from the East and Africa: Local versions of red ware were produced in the eastern provinces; some, for example those from Cnidus, were adorned with figural scenes in higher relief than in *terra sigillata*, suggesting a closer derivation from metal vessels [**13.3**]. From the later second century CE onward, an important source of red ware (African red slip) was the province of Africa Proconsulares (modern Tunisia and western coastal Libya). These were usually simpler versions of the Samian ware, but the production was large, widely exported, and long lasting, some workshops being active into early Byzantine times.

13.2 Samian ware bowl, CE. H. 11.8 cm × D. 23.8 cm (4 × 9 in.). This red-ware vessel depicts Diana with a hind, perhaps preparing for a sacrifice, in a pattern of alternating repeating panels.

13.3 Red-slip-ware bowl, c. 400 CE. H. 21 cm × D. 21 cm (8³/₈ × 8³/₈ in.). This red-slip-ware vessel from Lavinium shows Mithras slaying the bull.

13.4 Portrait of Maximinus, 235–38 CE. Marble. H. 33 cm (1 ft 1 in.). Having succeeded Alexander Severus, who had become unpopular with the troops, Maximinus fashioned himself on the brutal and militaristic Caracalla.

complexity. One unchanging technical feature in the third century, however, was the prominence that continued to be given to the rendering of eyes. As we saw on Caracalla's portraits, the eyes were distinguished with deeply drilled irises and pupils, and were often large and uplifted; the result of this technique was to create an otherworldly, masklike quality that coincided with the increasingly conceptual, and decreasingly human, nature of the principate.

Maximinus, who led the revolt against Alexander Severus and replaced him as emperor in 235 CE, fashioned himself entirely in the tradition of Caracalla, as whose successor he wished to be seen [13.4]. In his portraits, he sports the same short-cropped hair and beard, furrowed brow, and deep creases around the mouth, and he exudes an emotional intensity reminiscent of, if somewhat less brutal than, that of Caracalla. Alexander Severus, who claimed Caracalla as his father, fell from power because of his lack of credibility as a military ruler, and Maximinus was clearly using Caracallan imagery to bolster his support among the troops.

Maximinus himself suffered a different fate. His demise resulted from a revolt centered among the wealthy senatorial landholders, especially in North Africa, who put forth one of their own as emperor.

Five emperors were proclaimed in 238 CE, of whom only one, the youthful Gordian III (r. 238–44 CE) survived beyond the year [13.5]. His image reflects his tender years (only thirteen at accession), but his portraits mark a break from the harsh, foot-soldier-like image of Maximinus. Gordian most resembles Alexander Severus, and similarly sought to foster co-operation with the senate. After his demise in 244 CE—whether in battle or by treachery is disputed—the soldier type is revived, but in a slightly different form.

The portrait of another emperor at this time, Trajan Decius, is typical of the soldier emperor [13.6]. While the traditions of Caracalla are visible, the furrowed brow seems not stern or forceful but is suggestive of a level of unease; given the political situation, it is tempting to

13.5 Portrait of Gordian III, 238–44 CE. Bronze. Proclaimed emperor at the age of thirteen, his depictions are youthful, breaking the trend of harsh, soldier-like emperor portraits.

346 PART IV: COLLAPSE AND RECOVERY: ART ACROSS THE LATER ROMAN EMPIRE

13.6 Portrait of Trajan Decius, 249–51 CE. Marble. H. 36 cm (1 ft 2¼ in.). The portrayal of Decius follows the style used for Caracalla, although less intense in its expression.

interpret these portraits as reflections of the turbulence of the times. Portraits of Decius, similarly to those of his predecessor Marcus Julius Philippus (known as Philip the Arab) (r. 244–49 CE), or his successor Trebonianus Gallus (r. 251–53 CE), sometimes seem to bear the expression of someone worried for his life— as though a potential rival or assassin might be stealing up behind him. Such a reading is counterintuitive. An insecure emperor should logically favor an image of stability, not of concern and insecurity. More likely, these portraits reflect an experimental stage wherein the artist sought to mitigate the bestial fierceness of the earlier soldier images while keeping the basic military type; the purely military conception of the *princeps* was clearly not providing them with the desired effect, and these portraits may have been thought to appeal to citizen and soldier alike.

Four emperors later than Decius, in 253 CE, the emperor Valerian (r. 253–60 CE) and his son Gallienus (r. 253–68 CE) found a more effective compromise in portraiture [**13.7**]. At a time when most of the men claiming the imperial title were professional soldiers of provincial (most often Danubian) origin, Valerian hailed from a very old and prestigious senatorial family and his portraiture (only one sculptured example is extant) recalls the portraits of the early empire, especially of Augustus and Trajan. Gallienus retained the short hair and beard of the soldier emperors, but both features are rendered with far greater substance and texture. An especially Classicizing feature is Gallienus's hair, depicted in a pattern of longish wavy locks, as well as his beard, which is created with a pattern of tightly packed curls. There is a clear reference here to the tradition of Hadrian and the Antonines, whose philhellenic worldview Gallienus shared. Thus, on Gallienus's portraits the uplifted eyes and slightly furrowed brow make him look thoughtful rather than violent, in the tradition of Marcus Aurelius or, some have said, even Alexander the Great. In this Gallienus succeeded where Caracalla had failed.

Gallienus fell victim to his own officers, men of Illyrian origin (upper Danube valley) who replaced him with one of their own, Claudius II (r. 268–70 CE), known as Claudius Gothicus. It is

13.7 Portrait of Gallienus, co-emperor with his father Valerian from 253–60 CE and sole emperor from 260–68 CE. Marble. H. 36 cm (1 ft 2¼ in.). The images of Valerian and Gallienus demonstrate Classicizing aspects of portraiture, referring back to portraits of Augustus, Trajan, and Hadrian.

CHAPTER 13: THE ART OF THE SOLDIER EMPERORS AND THE TETRARCHY

13.8 Portrait of Aurelian, 270–75 CE. Marble. Typical of the soldier-emperor group, Aurelian's face is portrayed as serious, though not overly emotional. His beard is trimmed but is not the stubble of a regular soldier.

thought that Gallienus's policy of protecting the empire's Mediterranean core may have caused a rift with the large contingent of military leaders from the Danubian provinces; in any case, there began a new sequence of soldier emperors, all from Illyria.

The most successful of these emperors was surely Aurelian who, in addition to his building program in Rome, recovered the province of Gaul as well as Palmyra and the eastern provinces—regions that had become virtually independent entities under Gallienus—and instituted important economic and social reforms for the empire. Indeed, Aurelian may have established even greater stability had he not been assassinated in 275 CE by officers of his Praetorian Guard, allegedly acting on a false rumor created by an administrative official seeking to avoid getting into trouble for a minor wrongdoing. Aurelian's portrait is typical of the soldier-emperor group [13.8] in being a compromise: expressions are serious, not intensely emotional; faces bear traces of age and experience, but are not deeply lined; hair and beard are trimmed, but we do not see the facial stubble of a foot soldier. These are straightforward, no-nonsense images, increasingly unremarkable and interchangeable, anticipating the revolutionary changes to the status of the emperor affected by Diocletian's tetrarchy a generation later (see The Tetrarchy, p. 351).

The portraiture of Probus (r. 276–82 CE) continued the tradition of abstraction from any natural representation of a subject to the point at which one wonders if portraitists were striving for individualization at all [13.9]. The shape of the head is considerably blockier than that of Aurelian, but the very short-cropped hair and beard and especially the shape and set of the eyes and mouth, where character and personality ultimate reside, are all but identical. It appears that the objective here is to assert and establish a sense of continuity and stability in an era that was characterized by neither. With this aim a precedent was set, and the next generation of emperors would pursue this same end to an extreme.

13.9 Portrait of Probus, 276–82 CE. Marble. H. 40 cm (1 ft 3¾ in.). Portraiture of Probus followed the soldier emperor tradition, being almost identical to Aurelian.

348 PART IV: COLLAPSE AND RECOVERY: ART ACROSS THE LATER ROMAN EMPIRE

BIOGRAPHICAL SARCOPHAGI

Besides sculpted portraits, the other major category of stone sculpture during this era of instability was the sarcophagus, the production of which continued throughout the third and fourth centuries CE. While the practice of inhumation, and with it marble sarcophagi, became popular in the second century among private Romans of means, Antonine and Severan emperors retained the old tradition of cremation, their ashes interred in the Mausoleum of Hadrian. In the third century, however, emperors began to follow the fashion for burial, and at least one of these imperial sarcophagi may be preserved. In 238 CE, after the deaths of Gordian I and Gordian II, the senate named Balbinus co-emperor, alongside Pupienus, who died in that same year. Biographical information for this era is notoriously unreliable, but indications are that Balbinus had as distinguished a Roman pedigree as any who claimed the highest office during this time of military usurpers and upstarts. He was a senator from a consular family that could claim patrician status going back at least a century. Balbinus himself held two consulships and an important priesthood and appears to have enjoyed the favor of the Severan emperors.

Balbinus's sarcophagus reflects the traditional attitudes one would expect of a high-ranking senator [13.10]. He is shown reclining on the lid together with his wife in ancient Etruscan fashion. The sarcophagus itself is decorated with two ceremonial scenes. On the right is a wedding ceremony, and the conventional clasping of the right hands of the bride and groom (*dextrarum iunctio*). The couple recurs at the center performing a sacrifice, probably not related to the wedding but rather an imperial scene, since Balbinus is identified already as emperor with his eagle-tipped scepter and his empress is depicted in the guise of Venus Genetrix (like Livia, for example). The couple is shown in the company of a now-standard assemblage of deities—from right, Mars, Victoria, Virtus, and Fortuna.

Appropriate to both the iconography and the elite status of Balbinus, all the figures, both mortal and divine, are strongly Classicizing, with solidly three-dimensional weight-shift poses and

13.10 Sarcophagus of Balbinus, Catacomb of Praetextatus, Rome, Italy, 238 CE. Marble. H. 2 m (6 ft 6¾ in.). Balbinus, named co-emperor in 238 CE, broke away from the practice of cremation preferred by the Antonines and Severans and opted for burial instead. The lid of his sarcophagus shows him reclining with his wife in Etruscan fashion.

artfully modeled drapery patterns outlining and describing their physical forms. This is all the more striking in the mortal figures, especially Balbinus, whose figure is markedly more idealized than his portrait image reclining on the lid, as though we were seeing him in life and then in afterlife. In this relief of mingled portraits, deities, and personifications, each figure has, despite the rather crowded composition, a statuesque presence that is reminiscent of, for example, the Julio-Claudian relief from Ravenna (see The Ravenna Relief, p. 167). The isocephalic (heads brought to the same level) figures fill the field of decoration in a single row and the relief background is spatially impenetrable, calling to mind the styles seen in the Augustan era.

The execution of the Balbinus sarcophagus attests to the continuation of Classicizing carving at the highest level, no doubt a deliberate reaction against the abstraction and linearity of much of the Severan official sculpture both in Rome and the provinces. The apparently inexorable march toward an increasing simplicity of form and composition, leading toward a style classed as "late antique," was not, therefore, uninterrupted by deliberate reversions to more traditional modes of representation. The explanation here must lie in Balbinus's background and status as senator rather than soldier (although all emperors at this time were of course both), and, perhaps even more so, as Roman rather than provincial. In any case, the reference to a past aesthetic was a, by now, futile gesture, at least for an emperor; Balbinus ruled for barely three months.

Also dated to the middle of the third century CE is the Ludovisi sarcophagus discovered near the Porta Tiburtina in Rome, the lid of which is now in Mainz, Germany [13.11]. This was the last of the sarcophagi depicting complex battle scenes (battle sarcophagi) we know of, which were common in Antonine times, but rare thereafter. It appears that the soldier emperors and their lieutenants were less prone to advertise their primary occupation than were their second-century counterparts, perhaps because the reality of the power base was not something they desired to foreground. In most respects, the Ludovisi scene calls to mind the Portonaccio sarcophagus (see 11.33, p. 313), with its similar tapestry of Roman soldiers, defeated enemies, bound captives, and framing trophies (although reduced here). The figures on the later Ludovisi piece are larger and fewer, and the carving somewhat harsher and sharper; the mostly clean-shaven Romans form a strong distinction with the hairier foreign enemy, suggesting a cultural contrast familiar from Trajanic art, but merged in the scenes depicted on the column of Marcus Aurelius and the Portonaccio sarcophagus.

The primary central equestrian figure here stands out more clearly from the background than his earlier counterpart on the Portonaccio piece. He is not engaged in battle but turns frontally and gestures broadly with his right arm, rather as if giving an *adlocutio*, demanding attention. He alone among the Roman figures is not helmeted, so his portrait is clearly identifiable. The Classicizing hairstyle evokes that of Gallienus, but it is not similar enough to suggest that this was his monument. The disengagement from the action of the figure, however, employs a compositional device that was developed to embody the increasing conceptualization of the emperor. Here on the Ludovisi sarcophagus, though, the technique is used to mark out the deceased himself, whose compositional separation might suggest an emergence from the melée of contemporary existence and a direction toward a life beyond this one.

On the sarcophagus lid, Dionysiac masks appear at each corner, a common ornament on sarcophagi. Between the masks, three vignettes have been carved. One, a female holding a rolled-up scroll and framed by a draped background, is surely a portrait of the occupant's wife or other relation, her wavy hairstyle familiar since Antonine times. At the center, below the blank inscription panel, appears the cliché of a trophy with "barbarians," a conventional reference to the outcome of the conflict on the panels on the body of the sarcophagus below.

Most interesting is the scene on the left, showing a male figure seated on a folding stool set up on a podium. His gesture repeats that of the mounted figure in the battle scene below him, surely equating them, and draws the eye to the assembled multitude before him, from which he is separated by scale, elevation, and the two soldiers flanking and facing his podium. Horizontal ranks of figures include more soldiers who loom

large behind a cluster of figures of various ages, including small children. The composition is strongly evocative of the Antonine panel reliefs devoted to imperial virtues, and the iconography is similarly ambiguous. If the occupant of the sarcophagus is not imperial, then the scheme may have been borrowed to display some act of benevolence on his part, perhaps as victor toward a defeated enemy or as magistrate toward fellow citizens. If this male figure was an emperor, however, any number of candidates from the mid-third century CE can be proposed, yet there is little agreement among scholars. More notable, perhaps, than the subject of the carving on this lid is the style, which, in its strong abstraction and simplification, is markedly different from that of the coffin itself, recalling trends we began to detect in Severan sculpture where different styles could account for very different effects in the same work; one mode of representation not displacing another but, rather, multiple modes being used in parallel.

The Tetrarchy

A year after the unjust murder of Aurelian in 275 CE, his lieutenant Probus emerged to establish some semblance of order during a six-year reign, but he too then fell victim, as so many before him, to the treachery of his prefect, in this case

13.11 Ludovisi sarcophagus with lid (top), Porta Tiburtina, Rome, Italy, 250–60 CE. Marble. H. 1.5 m (4 ft 11 1/8 in.). Named for its seventeenth-century owner, it shows a familiar scene of Roman soldiers, defeated enemies, taken captives, and trophies.

CHAPTER 13: THE ART OF THE SOLDIER EMPERORS AND THE TETRARCHY 351

Carus (r. 282–83 CE). Within a year, Carus celebrated both German and Persian victories as emperor, but immediately thereafter died mysteriously. His sons Carinus (r. 283–85 CE) and Numerian (r. 283–84 CE), who had already been named Augustus and Caesar, respectively, succeeded him as co-emperors. When the younger son died a year later, his troops named as successor his cavalry commander, another Illyrian officer named Diocletian.

Diocletian proceeded to blame Numerian's death on his prefect Aper (who perpetrated what is not at all clear), whom he murdered. Diocletian then marched west to face Carinus, who he defeated on the upper Danube, becoming sole emperor in 285 CE. The revolving door of Illyrian emperors seemed doomed to continue turning, and it may well have done so had Diocletian not learned something from the successes and failures of his predecessors. The new emperor soon initiated wide-ranging political, military, and economic policy changes that would transform the nature of the Roman empire forever. In doing so, he managed to enjoy a longer reign than any emperor since Antoninus Pius and, unprecedented for a *princeps*, to retire voluntarily from command.

The framework for Diocletian's accomplishments was a revamped administrative system rooted in a redefinition of the principate itself (see box: The Tetrarchy: Tradition and Innovation, below). Diocletian reconfigured the number of

The Tetrarchy: Tradition and Innovation

It had long been recognized that holding the empire together was more than one man could accomplish; indeed, the practice of appointing colleagues and successors had been done since early imperial times. Augustus used the title Caesar to designate his heirs from the very beginning; Vespasian appointed his elder son Titus as Augustus soon after he assumed the title himself. The weaknesses of the imperial defenses on the frontier, as established by Hadrian and Antoninus Pius, were already clear in the time of Marcus Aurelius. The danger of powerful senatorial governors with large armed forces was apparent even before the beginning of the empire, in the examples of Marius, Sulla, and even the revered Julius Caesar. A century later, this threat was brought home, literally, in the year of four emperors in 69 CE. Nonetheless, aside from the brief and abortive uprising around Avidius Cassius in the 170s, the second century CE was stable, although after the death of Commodus the structure began to show fault lines, which were strained under Caracalla and gave way completely with the assassination of Alexander Severus in 235 CE.

Solutions to address the weaknesses in the governance structure were sought throughout the third century. Provincial commands were made smaller and were more frequently entrusted to loyal equestrian officers rather than ambitious senators. The total number of troops was increased considerably, but beyond the limits that the economy could support. Soldiers were stationed in relatively smaller groups in many more places, and cavalry units, more mobile than infantry, came to play a larger role.

Diocletian inherited these policies, amplified them, and—most obviously—institutionalized them into a rigid (perhaps brittle) but at least temporarily stable system of social organization based on principles of uniformity and consistency similar to those that governed his concept of the principate. He increased both the overall size of the army (now perhaps half a million soldiers) and the number of units into which it was divided. He sought to underwrite this expense by strengthening a weak economy, employing reforms that included: a revision of a totally debased coinage; an extreme simplification of the tax system to increase revenue; and, to curb rampant inflation, price controls.

Nor were his reforms limited to the economic realm, extending as well to law and religion. The Roman legal system was increasingly formalized across the empire to ensure consistency, together with a shift of military responsibility from provincial governors to imperially named *duces* (literally "leaders," a usefully vague title), allowing the governors to concentrate on legal matters. Persecution of those who refused to follow Roman state religion, which traditionally had been more sporadic and locally initiated than systematic and centrally sponsored, was now pursued with increased determination. Trajan Decius had already initiated a practice of compulsory sacrifice to Roman gods, an expression of cultural uniformity that was adopted by both Diocletian and Galerius during the tetrarchy. Ironically, Galerius, who pursued these persecutions strongly, and primarily for political advantage in the personal intrigues among the tetrarchs, would also be instrumental in ending the persecution of Christians in the East even before the famous fourth-century CE edict of Constantine and Licinius. Ever the pragmatist, his reason was that the practice simply did not accomplish much.

provinces from forty to around 105; within each province, military and administrative control was split between two mutually dependent individuals who, in turn, answered through formally defined channels to the emperor. The provinces were collected into twelve dioceses, each with its own administrator, and the dioceses grouped into four prefectures, two in the East and two in the West. At the head of each prefecture stood a tetrarch, all nominally equal in power, each with absolute control over his quarter of the empire. The strategy in appointing tetrarchs was to place one full emperor with the title of Augustus in a western prefecture and another in an eastern prefecture. The other two prefectures would then be governed by an heir designate, with the title of Caesar. This meant that when an Augustus in either the West or the East died or resigned, the Caesar in that half of the empire would become an Augustus himself, and the new body of tetrarchs would appoint a new Caesar to govern the vacant prefecture. The system developed over time. In 285 CE, Diocletian named his old ally Maximian (r. 286–305 CE) as Augustus and co-emperor, and assigned him to defend the western empire, while Diocletian himself took the East. Eight years later, he appointed two Caesars—Galerius (d. 311 CE) in the East and Constantius Chlorus (d. 306 CE) in the West, who were the designated successors of himself and Maximian.

This arrangement was designed to bring stability to a pattern of succession that had become haphazard at best, and by 293 CE the tetrarchy was firmly in place. As did the previous third-century emperors, the tetrarchs spent much of their time on campaign and pacifying the provinces; seldom did any of them ever come to Rome, which had been declining in prestige. Each had his own seat of administration much closer to his sphere of activity: Diocletian at Nicomedia in Bithynia; Galerius at Sirmium in Pannonia (also Thessaloniki in Macedonia); Maximian at Mediolanum (modern-day Milan); and Constantius Chlorus at Augusta Treverorum (modern-day Trier). The principles that governed the tetrarchy, then, were the equality of the four rulers (in public, at least) and an unquestioned succession from Caesar to Augustus. Although the two *Augusti* were senior, each Caesar wielded absolute authority within his own realm, and he was assured by the system of eventual advancement. Diocletian's innovation of retirement (along with his colleague as Augustus, Maximian), moreover, meant that an Augustus did not have to die for a Caesar to advance, which may have been the most stabilizing principle of all.

PORTRAITURE

From 287 CE, the two *Augusti* of the tetrarchy assumed names associating them with gods, Diocletian taking Jovius (of Jupiter) and Maximian taking the name Herculius (of Hercules), thus presenting themselves as the earthly embodiments of those two very traditionally Roman deities. The two tetrarchs, ceremonially garbed in ornate cloaks and jewelry, demanded a level of ritual obeisance comparable to (and likely inspired by) the great kings of Persia, recalling Alexander the Great himself toward the end of his life. In doing this, Diocletian was simply amplifying the increasing trend for the emperor to be perceived less as a human and as more of an abstract figure, and for visual representation of him to carry an otherworldly character rather than be a simple physical depiction. While his promotion of Jupiter and Hercules, rather than the Syrian or Iranian sun gods that were favored by emperors earlier in the third century, has been seen as a return to western Roman values, the notion of kingship this promotion represented is purely eastern.

Images of Diocletian and Maximian on early coins follow the style of their immediate predecessors in being more emotionally remote versions of the traditional soldier-emperor image [13.12]; sculptured portraits therefore become

13.12 Coin portraits of Diocletian (*l*) and Maximian (*r*). Bronze. The two emperors' calm expressions are typical of the recent depictions of a soldier emperor.

13.13 (Right) Portrait of Diocletian, 284–305 CE. Marble. H. 39 cm (1 ft 3 3/8 in.). The founder of the tetrarchy shares many similarities with previous soldier emperors, for example the short-cropped beard and hair, but standardization typical of the tetrarchy has already begun.

13.14 (Right) Portrait of Galerius, 293–311 CE. H. 35 cm (1 ft 1 7/8 in.). While carrying on the soldier emperor tradition, there is an exaggerated Severan character to Galerius's portrait, giving him an ethereal quality.

increasingly difficult to distinguish owing to growing standardization. Those identified as Diocletian have much in common with images of the later soldier emperors, with very short-cropped hair and beard in soldierly fashion [13.13]. The eyes are emphasized by arching brows, and the firm set of the mouth and creased forehead seem almost a re-employment of the now age-old traits of verism, used to emphasize experience and reliability.

A portrait of Galerius [13.14], who was appointed co-emperor a decade into Diocletian's reign, marks developments that extended into the fourth century CE. Still in the tradition of a soldier emperor, the viewer's gaze is immediately drawn to his strikingly prominent, even oversized, eyes and, even more so, to the deeply drilled and upturned pupils. We see something of this in late Severan portraiture, but here the effect is exaggerated and gives Galerius a spiritual, even otherworldly, quality that embodies the increasingly conceptual nature of the principate, and ultimately its eastern (Persian or Egyptian) influence.

By the time of the tetrarchy proper, coin portraits of these rulers become abstracted and interchangeable, being indiscernible from one another without the help of legends [13.15]. This tendency to standardization is most obvious in a surviving group portrait in porphyry stone, quarried and carved in Egypt. The most famous of these portraits [13.16a] was worked into a corner of the facade of St. Mark's Basilica in Venice, Italy, in the Middle Ages, but it was previously located in the imperial palace at Constantinople (present-day Istanbul).

Here we see two pairs of tetrarchs, each pair including a bearded and beardless figure; otherwise all four figures are essentially identical. Facial features and drapery alike are reduced to simple, nearly geometric forms. Although the two figures in each pair

13.15 Coins of Galerius (left) and Constantius Chlorus (right), 293–305 CE. Bronze. Identification of the portraits on coins of this era is made difficult by extreme standardization.

354 PART IV: COLLAPSE AND RECOVERY: ART ACROSS THE LATER ROMAN EMPIRE

both reach to embrace the other, the weight of each shifting to his inner leg, there is no rational indication of weight-shift; Classical *contrapposto*, and with it any sense of a momentary pose, has been abandoned. Facial expressions follow the tradition of previous soldier emperors—firmly set mouth, large staring eyes, pinched brow, and lined forehead [13.16b]—but the simplification of forms and repetition of scheme among the four images obscures any sense of individuality. Everything is fixed, permanent, stable, and unnatural. The extremely hard stone reinforces the impression, and its deep purple color resonates with an expression of imperial splendor. The sculptor has found the perfect vehicle for conveying the ideals of the tetrarchic system—the non-mortal nature of imperial rule, the establishment of peace, and the restoration of order from chaos. These were exactly the principles that governed the original principate, but three centuries later, in very different circumstances, a new imagery was found to embody them.

COMMEMORATIVE SCULPTURE
Arcus Novus

Much the same style found in portraiture at this time recurs in two sculptured monuments set up by tetrarchs in Rome: the Arcus Novus and the *Decennalia* Monument (see p. 357). Diocletian is said to have erected an arch, the Arcus Novus, on the via Lata; it was later destroyed and its marbles dispersed. Two sculptured pedestals now in Florence were likely among them. These would have supported freestanding columns flanking the arch's central bay, as seen on the arch of Septimius Severus (see 12.21, p. 330). Each pedestal is carved on three faces with similar subjects: on its front, a Victoria figure that originally faced toward the arch's central opening; on its inner surface one of the Dioscuri, facing

13.16a and b Tetrarch group, originally in the imperial palace at Constantinople (modern-day Istanbul), Turkey, c. 300 CE. Porphyry. H. 1.3 m (4 ft 3¼ in.). The figures represent the four co-emperors, two *Augusti* (senior) and two Caesars (junior). The stylistic abstraction here is intended to embody the hoped-for stability of the tetrarchic system of governance.

13.17a, b, and c Pedestals of the Arcus Novus, originally on the via Lata, Rome, Italy, 293 (or 303) CE. Marble. H. of *a* 1.63 m (5 ft 4¼ in.), H. of *b* and *c* 1.86 m (6 ft 1¼ in.). They were perhaps reused from a temple to Sol, which was built not much earlier by Aurelian. The middle and right-hand images (*b* and *c*) show two views of the same pedestal, which stood to the right of the arch's central bay. The other pedestal (*a*) stood to the left.

inward toward the arch itself; and on its outer surface, a Roman soldier leading a bound captive away from the arch [13.17a, b, and c].

All of these motifs are drawn from the traditional Roman repertoire, and two of them—the victory and the defeated—are ubiquitous on monuments commemorative of military success. The Dioscuri, according to popular legend, were seen watering their horses in the forum, portending a great Roman victory at Lake Regillus in the fifth century BCE. They were thus honored with a temple to commemorate the win and seen ever after as bringers of success in battle, here emphasized by swords cradled in their arms. The arrangement and posing of figures is symmetrical, with mirror-image poses, although monotony is relieved by the representation of the Victories, one of whom stands next to a palm (another symbol of victory) and the other with the standard trophy/foreign captive emblem. There can be no doubt that a theme of the arch was, as would be expected, success in warfare, since this was a central concern of and justification for the tetrarchy itself. The carving style is consistent with what has been seen elsewhere. The nearly nude males and fully draped females derive directly from Classical prototypes, the rendering of both anatomy and drapery reflect long traditions that use pattern to describe and analyze organic form, and the faces of all are smooth and idealized.

The sharpness of the carving, prominence of drilled, linear forms, and the vaguely unnatural structure of the bodies are, as we have seen, reflective of third-century developments.

A substantial collection of other fragments has also been attributed to the Arcus Novus. Some, in a distinctly different, earlier style, probably Julio-Claudian or Antonine from their Classicizing forms, can now be seen worked into the walls of the Villa Medici in Rome, as were the Ara Pietatis reliefs discussed earlier. Most significant of these are four fragments from one frieze that includes, on a shield, the inscription VOTIS X et XX (vows for the anniversary of ten and twenty)—a formula that can be connected to the tetrarchy [13.18]. The inscription, cut or recut when this relief was used for the Arcus Novus, can be interpreted in two ways. If it refers to the tenth anniversary of Diocletian and anticipates the twentieth, then (as most maintain) it dates the arch to 293 CE. If it alludes to the twentieth anniversary of Diocletian and the tenth of the tetrarchy, then the date becomes 303 CE, on which occasion Diocletian visited Rome for the only time in his reign.

The Arcus Novus also, therefore, introduces a phenomenon that becomes increasingly common in late-antique Rome—the use of earlier building material, so-called *spolia*, in later monuments. The motivations behind reuse are hotly debated. Many have argued that a decline in the sculpture industry during the mid-third century resulted

13.18 Frieze fragment, probably re-used in the Arcus Novus, 293 (or 303) CE, now in the Villa Medici. Marble. H. 1.82 m (5 ft 11¾ in.). This originally came from a Julio-Claudian or Antonine arch.

bore an image of Jupiter (Diocletian's patron), flanked on either side by columns of the two *Augusti*, with the columns of the Caesars at the ends. The sculptured marble base of the northernmost column is largely surviving. On its front, two victories flank and hold a shield inscribed with the words CAESARUM DECENNALIA FELICITER, which indicates the tenth anniversary of the Caesars and the tetrarchy.

To the right is a conventional *suovetaurilia*, which moves from the pedestal's front to back and, conceptually at least, continues to the sacrifice scene on the back surface [13.19]. Opposite this, and similarly moving toward the sacrifice, is a procession of togate figures [13.20]; interpreted by some as being a group of

in a diminished supply of experienced sculptors, or that the general economic decline created financial hardships that forced emperors to pillage and reuse rather than pay for new commissions. A more positive, programmatic argument is also put forth. Tetrarchs, similarly to the emperors before them, sought to situate themselves in comparison with previous emperors—to be seen as better than the bad ones, and equal or superior to the good ones. By appropriating the emblems of success set up by good emperors and making them their own, the tetrarchs could have for themselves the good reputation, and perhaps the good luck, of their more successful forebears. The question of why material was repurposed is not easy to resolve, nor are the options mutually exclusive, but it is important to realize that the use of *spolia*, which plays so large a role in modern analyses of Constantine, was not, as is sometimes implied, an invention of the fourth century CE.

Decennalia Monument

The later possible date for the Arcus Novus would make it contemporary with another anniversary monument, a group of five commemorative columns erected behind the great imperial rostra at the northwest end of the Republican forum. Honorific columns were as old as the Republic itself, and here each tetrarch receives his own; the central column

13.19 Sacrifice scene from the *Decennalia* monument, Roman Forum, Rome, Italy, 303 CE. Marble. H. 1.8 m (5 ft 10⅞ in.). This was located on the back surface of the pedestal.

13.20 Tetrarch scene from the *Decennalia* monument, Roman Forum, Rome, Italy, 303 CE. Marble. H. 1.8 m (5 ft 10⅞ in.). This relief displays the principle of the tetrarchy conspicuously in Rome, where emperors of the time were rarely present.

magistrates, these are more likely the tetrarchs themselves, shown, as appropriate to Rome, in the garb of senators rather than generals. All four figures, similarly dressed in toga and **contabulatio**, fill the foreground, while soldiers holding military standards in the background represent the military nature of the tetrarchy. The repetitive nature of both lines of figures reflect the spirit of equality among rulers at the core of tetrarchic art and policy. The small togate figure standing in front of the final tetrarch is a curiosity; some have seen him as a son/prospective successor—perhaps Constantine himself.

The sacrifice scene (13.19, p. 357) involves one tetrarch only, *capite velato* as *pontifex maximus* (each tetrarch held this priesthood), surrounded by mortal priests and attendants as well as deities: Mars (recipient of the sacrifice), Genius Senatus (indicative of senatorial endorsement), seated Roma and, behind her, Sol Invictus. The monument is quite distinct from the more overtly Classicizing style of the Arcus Novus pedestals. While the subject matter is distinctly Roman, carvers from the eastern provinces may have worked on this monument, or perhaps the contemporaneous stylistic possibilities in Rome around 300 CE were multiple—as, in fact, had always been the case.

Diocletian's Architecture in Rome

The *Decennalia* monument was part of an extensive renovation in the western area of the Roman Forum, undertaken under Diocletian following a fire in the time of Carus (283 CE). Rome had been neglected during the turmoil of the third century and fallen into disrepair. Diocletian's program was both practical and symbolic, a show of respect for the antiquity and traditional status of the city. He rebuilt the rostra at either end of the forum's open space, which he surrounded with freestanding honorific columns, emulating the effect of a porticoed court. He also rebuilt the Curia Julia, which offers in its present state our most complete vision of tetrarchic building in Rome. Diocletian seems a traditionalist; the *curia* repeats the plan of its predecessor and his most conspicuous commission—the imperial *thermae* on the Esquiline hill—closely followed the model of Caracalla's baths.

Compared with Caracalla's baths, however, those of Diocletian, built entirely in his reign and dedicated soon after his abdication, boast a considerably larger central bathing complex, which mostly fills the circuit structure surrounding it [13.21]. This site was more heavily populated than that of the earlier baths, so efficiency of space may have been a factor, but by any standards the complex is enormous. A major difference in plan between the two occurs in the *caldarium*, which in Diocletian's complex takes the form of a triple-bayed cross-vaulted space (a smaller reflection of the central *frigidarium*) rather than a domed rotunda.

Diocletian's baths are, like Caracalla's, preserved in sizeable sections, but since they are nearer the heart of the city many of the remains have been worked into later structures and even the modern city's plan. Therefore, although they

13.21 Plan of the Baths of Diocletian, 284–306 CE. The complex was even bigger than Caracalla's.

13.22 (Above) Interior of the Aula Ottagona, Rome, Italy, 284–306 CE. The hall, which was part of Diocletian's baths complex, is now an exhibition space.

13.23 (Left) The Terme Boxer, Aula Ottagona, Rome, Italy. Bronze. H. 1.2 m (3 ft 11¼ in.). The date of this highly realistic Hellenistic sculpture is debated, but most likely it is second or first century BCE.

must be among the most commonly experienced ancient structures in modern Rome, the public is not always conscious of the fact that they are actually ruins. Several rooms of the central block's west wing formerly housed the Museo Nazionale Romano (the national museum of Roman antiquities). One display area that does remain, however, is a well-preserved domed, octagonal room in the western corner of the bathing block (Aula Ottagona), which was used as a planetarium in the twentieth century [13.22], and currently houses a handful of sculptures mostly from baths in Rome, including two late Hellenistic masterpieces: the famous bronze boxer cited for its graphic realism [13.23] and a nude heroic portrait often called the Hellenistic Prince. Into the remains of the *tepidarium* and *frigidarium* was built the church of Santa Maria degli Angeli e dei Martiri after a plan by Michelangelo, much modified in the eighteenth century. The nave of this church, although entirely post-ancient in its present form, presents the most effective impression anywhere of this most

CHAPTER 13: THE ART OF THE SOLDIER EMPERORS AND THE TETRARCHY 359

13.24 Interior of Santa Maria degli Angeli e dei Martiri, Rome, Italy. The church retains the form of the *frigidarium* in Diocletian's baths.

13.25 Piazza della Repubblica, Rome, Italy. The piazza preserves the outline of the baths' southern exedra.

Roman of building forms [13.24] with its soaring spaces, massive columns, and complex views.

The circuit structure of the *thermae* has left its traces as well, especially the outline of the great southern exedra, which is preserved in the nineteenth-century semicircular portico framing the Piazza della Repubblica, providing an impression of the massive scale of the complex [13.25]. The Baths of Diocletian is a structure that has most definitely left its imprint on the modern city, as indeed Diocletian left his mark on the empire, more conspicuously than any emperor since Septimius Severus.

PALATIAL ARCHITECTURE ACROSS THE EMPIRE
Trier: Aula Palatina

The division of authority among tetrarchs created multiple centers of power. Each prefecture had its own seat of administration, with its own imperial palace. The ex-*Augusti* also built elaborate retirement villas, each suggesting its owner's past power and enduring prestige. Parts of each palace have been certainly or plausibly identified, including in the Gallic city of Trier in Germany.

Trier was founded by the emperor Augustus toward the end of the first century BCE and

called Augusta Treverorum after the local Gallic tribe of the Treveri. It served as capital of Gallia Belgica, northeasternmost province of Gaul, and became an important base of operations for the endless campaigns against the Germanic tribes, owing to its strategic location with easy access to the frontier. It was a logical selection for his western capital by Maximian and, thereafter, his Caesar Constantius, who was responsible, with his son Constantine, for a massive building program there.

Although the site remained an imperial residence throughout the fourth century, the most important buildings—circus, imperial baths, palace—date to the tetrarchic period. Most conspicuous is the so-called basilica or Aula Palatina, an imperial audience hall from the palace complex [13.26 and 13.27]. Partially restored, but still preserving much of its original construction, this was a monument to grandiose simplicity on both its exterior and interior. The building, similarly to a basilica, encloses a large, flat-ceilinged, rectangular space terminating in an apse opposite the door, but there are no interior columns forming side aisles, nor interior gallery, nor clerestory. Its real prototypes are the earlier audience halls, especially Domitian's on the Palatine in Rome (see Domus Flavia, p. 183). The unobstructed interior space draws the visitor's attention to the apse, where the emperor would sit magisterially enthroned; this focus is intensified by clever optical tricks creating an impression of greater length in the room— the apse windows are smaller and lower than those on the sides, and the central apse windows are narrower than those flanking them, falsely enhancing the effect of linear perspective.

The exterior is also a model of simple elegance. A series of unadorned high, narrow, blind arches frame the two stories of windows, invoking the idea of an arcade but with none of its decorative elaboration. External galleries below each row of windows would have upset the uninterrupted lines seen today, and the loss of stucco on the exterior and marble veneer on the interior make the structure appear somewhat more austere than it would have originally. Nonetheless, the Aula Palatina does reflect some of the principles reflected in tetrarchic portraiture, by reducing complex forms to their simple bare essentials and by using abstraction to embody authority. In this, as in its use of solid mortared brick walls rather than brick-faced concrete, it formed a ready model for early Christian and Byzantine church architecture in both plan and construction.

Split: Palace of Diocletian

Different forms and materials were used for much the same reason at the retirement palace that was built by Diocletian at Spalatum (modern-day Split)

13.26 (Above) Interior of the Aula Palatina, or Basilica of Constantine, Trier, Germany, 310 CE. The unobstructed interior space draws the visitor's attention to the apse, where the emperor would sit.

13.27 (Left) Exterior of the Aula Palatina, or Basilica of Constantine, Trier, Germany, 310 CE. Now partially restored, the building functioned in the manner of a basilica in enclosing a large interior space, but its exterior is far less ornate.

13.28 Reconstruction of Diocletian's Palace, Split, Croatia, early 4th century CE. Diocletian retired to his hometown near Split and constructed this palace fortress in the form of a *castrum* (military camp).

13.29 The imperial arch, Diocletian's Palace, Split, Croatia, early 4th century CE. The design is not regional but imperial, recalling such styles as those seen at Leptis Magna and Hadrian's villa.

near his hometown of Salona in Croatia [13.28]. This is in essence a huge palace fortress in the form of a quadrangular Roman *castrum* or military camp, surrounded by impressive fortification walls, the south flank of which face directly onto the Adriatic Sea. Gates with eight-sided towers guard entrances at the center of each of the other three sides, and a colonnaded street connecting the east and west gates intersects with that running south from the north gate to create a forum-like monumental complex at the intersection. This structure includes Diocletian's octagonal mausoleum on the east side, a small temple (perhaps to Jupiter, his favourite deity) on the west, and, to the south, a monumental archway marking the entrance to the imperial residence proper.

Unlike the palace at Trier, the construction has been achieved using cut stone and each space is elaborated with arcades, engaged columns, and statuary niches. The central arched lintel above and paralleling the arched doorway proper [13.29] reflects a development in the eastern provinces of the High Empire, seen at both Ephesus and Hadrian's villa at Tivoli, and the flanking arcades call to mind the forum at Leptis Magna. This is imperial rather than regional architecture. The gateway itself focuses attention on the center of power—the emperor as concept.

Most striking in this complex is the overtly militaristic plan and mood. As the first emperor to retire from office, was Diocletian concerned about security? During the trying and often lawless years of the third century CE, wealthy villa owners increasingly took matters into their own hands by fortifying their estates. While the palace at Split might well have kept out raiders and brigands, would it really have stopped an imperial army whose ruler was convinced that Diocletian constituted a threat? Or is this simply an allusion to a Roman camp—a symbolic statement of his status as *imperator Augustus emeritus* that is similar to the many symbolic statements made by the architecture at Hadrian's villa? Whatever the answers to these questions, one could hardly hope for a more articulate architectural expression of the very principles of Diocletian's most important creation—the tetrarchy itself.

Thessaloniki: Palace and Arch of Galerius

Another tetrarchic palace complex was built by Galerius at Thessaloniki, capital of the Roman province of Macedonia since 146 BCE. The city owed its importance to its location on the via Egnatia, the primary east–west Roman road across the southern Balkan peninsula, at the point where that road meets the Aegean Sea. Galerius used the via Egnatia itself as a focal point for his palace complex, adding a colonnade and building an intersecting north–south colonnaded street that connected his mausoleum at the north to his palace toward the south. Excavations of the palace are ongoing and indicate an extensive complex adjacent to a circus, as seen also at Trier and, of course, Rome itself.

Galerius's intended mausoleum (his successor Licinius forbade its use for Galerius's interment) was transformed in the later fourth century CE into a church of St. George [13.30]. It is well preserved, a domed rotunda about 24 meters (80 feet) in interior diameter with two stories of arched windows (as in the Trier basilica) in the rotunda proper and a clerestory of low arched windows at the base of the dome. Its construction is a compromise between that used at Trier and local fashion; the arches and vaults are constructed in brick, the vertical walls in

13.30 Interior of the Rotunda of Galerius, Thessaloniki, Greece, 305–11 CE. The interior here is much less austere than was typical at the time, providing a model for Byzantine architects in succeeding centuries.

CHAPTER 13: THE ART OF THE SOLDIER EMPERORS AND THE TETRARCHY

brick and stone-faced mortared rubble. In good Roman fashion, the interior walls were veneered in marble while the vaults and dome were decorated with mosaics; the effect is preserved in the spectacular gold-ground Christian mosaics from around 400 CE. Such decoration demanded illumination, and the many windows here create a very different atmosphere from the solid domed structures in Rome, such as the Pantheon, that admit light through only an oculus and a doorway. Such structures as this would have great influence on early Byzantine church design.

The crossing of the two colonnaded streets was supported on four great brick-faced concrete piers, each of which bore applied marble reliefs marking Galerius's Parthian victories (293–96 CE). Although termed the Arch of Galerius [13.31], this monument does not resemble traditional triumphal arches in any way, but rather, in typical tetrarchic fashion, draws on several Roman and provincial traditions to create something entirely new. The pier reliefs most strongly recall those on the quadrifrontal arch of Septimius Severus (see 12.24, p. 332) at Leptis Magna, but here each relief is separated horizontally into four broad, relatively low fields for decoration. The result is a series of panels that in shape and compositional scheme resemble, more than anything else, sculptured sarcophagi. The marble carvers working on this monument would, no doubt, have been trained in sarcophagus workshops, the primary source of figural marble carving over the previous several decades; whether that fact affected the form of these reliefs is unknown, but the similarities are striking. Each pier bore fourteen such scenes (the face toward the smaller arch on each pier had room for only two), giving a total of fifty-six. Only two piers survive, but a sufficiently representative sample allows for some observations.

Although there has been considerable discussion of the iconographic program (for instance, in what order are the reliefs to be read? Is there a division between historical and allegorical scenes? How does the arrangement relate to the surrounding architecture?) and little agreement, the general thrust of the monument is clear enough. As is typical of Roman commemorative monuments previously discussed, there is a mixture of battle scenes with all manner of representations of "ancillary" activity; one can document from the remaining half of the monument sacrifices, *adlocutiones* (orations), parades of captives and of captured loot, the reception of embassies from the enemy, processions of Persians bearing gifts (itself an old Persian theme), *clementia* scenes, *adventus*/*profectio* scenes, triumphal processions, suicidal defeated enemies, and the *concordia*, or harmony, of the tetrarchs.

Here, typically, it does not repay to distinguish too strictly between the historical and the ahistorical representations. Roman commemorative relief can tell its story with a wealth of detail, often very specific as here with the capture of King Narses' harem, a deed of which Galerius was proud since it symbolized the utter defeat of his Sasanian enemy. Yet both the particular and the

13.31 Arch of Galerius, Thessaloniki, Greece, 305–11 CE. H. 12.5 m (41 ft ¼ in.). Typical of tetrarchic architecture, the arch draws on both Roman and provincial traditions. The stacked rectangular panels on each pier resemble those of sarcophagi.

generic, as on Trajan's column and elsewhere, function similarly to convey ideas about the emperor and his accomplishments, and the distinction between them as being more or less real is more modern than ancient. The ideas here are those of the tetrarchy: success in warfare, effectiveness in rule, and the equality of the four emperors. The visual language used to convey this new order is entirely traditional.

The best preserved of the extant eight pier faces offers a representative range of subject and composition [**13.32**]. At the top, Galerius sets out for one city (at the left edge) and arrives at another (right), the whole scene flanked by mirror-image Victory figures. This may indicate the transfer of his seat of power from Sirmium to Thessaloniki, but other readings are possible. Scale and composition are non-representational. The emperor is larger than other figures, picked out by the pose and/or gaze of his companions, and is framed, nimbus-like, by the arched back of his chariot. The panel below shows Galerius and Narses in dual combat, compositionally and thematically referencing such works as the Alexander Mosaic (see 3.7, p. 81). Indeed, in his Persian victory Galerius invited comparison with Alexander, as had so many emperors before him. Galerius's central position on a rearing horse reproduces precisely the arrangement seen on the Portonaccio and Ludovisi sarcophagi (see 11.33, p.313 and 13.11, p. 351), which serve as precedents much closer in time.

The panel below is much quieter in tone. The four tetrarchs are in the center, *Augusti* enthroned and Caesars standing, recalling that Galerius triumphed in the name of the tetrarchic system. They are surrounded by deities and personifications, variously identified and interpreted, but reprising, in more abstract form, figural types that go back to the beginning of the empire. It is a more static version of such *concordia* scenes as that on the Severan arch at Leptis Magna, its orderly composition reflecting the order of the tetrarchy itself. The lowest panel, here as on several of the piers, bears a seven-part arcade forming shell-topped niches containing personifications—in this case all Victories. Visually, these function as a support, and the architectural form is derived from the Asiatic columnar sarcophagi.

The carving style of these reliefs is consistent. The figures are deeply sculpted, and the legibility of the scenes depends heavily on chiaroscuro and sharply drilled linear patterns. Figures are often stumpy and large headed; many assume traditional Classical poses but are usually not rendered with the Classical appreciation for anatomical structure and the descriptive function of drapery. The same approach extends to the flat, deeply drilled architectural ornament. Its roots can clearly be detected on certain works of the Severan period, and on some third-century sarcophagi. Such simplified, abstract forms constitute the preferred mode of sculptural expression at this time, being the most effective means to convey the conceptual nature of the tetrarchy, a system, like the style, deeply rooted in developments of the third century CE.

13.32 Southwest pier of the Arch of Galerius, Thessaloniki, Greece, 305–11 CE. Marble facing on brick-faced concrete. The reliefs constitute a mixture of battle scenes and ancillary activities, such as sacrifices, parades of captives and of captured loot, and *clementia* (an emperor showing mercy) scenes.

CHAPTER 13: THE ART OF THE SOLDIER EMPERORS AND THE TETRARCHY

14 Constantine and the Legacies of Roman Art

368 Constantine the Emperor
- 368 Box: Basilica of Maxentius
- 369 CONSTANTINE'S PORTRAITURE
- 370 CONSTANTINE'S BUILDING PROGRAM IN ROME
- 373 LATE ANTIQUE STYLE
- 374 CHRISTIAN ROME
- 377 THE "NEW" ROME OF CONSTANTINE
- 378 Box: Catacombs in Rome
- 380 Materials and Techniques: Ancient Statuary in Constantinople

382 Epilogue: Rome's Lasting Legacy
- 382 ROMAN EMPIRES RETAINED AND REVIVED
- 383 ROMAN MODELS IN MODERN TIMES
- 384 Box: Otto III and Rome

Chronological Overview

DATE	EVENT
305 CE	Diocletian and Maximian abdicate; Constantius and Galerius become *Augusti*
306 CE	Constantius dies; Constantine proclaimed Caesar
307 CE	Constantine elevated to Augustus
312 CE	Probable date for Constantine's conversion to Christianity at the Milvian Bridge
315 CE	Arch of Constantine dedicated
c. 319 CE	St. Peter's Basilica begun
324 CE	Constantine becomes sole Augustus after defeat and execution of Licinius
330 CE	Dedication of Constantinople
337 CE	Death of Constantine; sons Constans and Constantius II become co-emperors
c. 350 CE	Santa Costanza
354 CE	Sarcophagus of Constantia
359 CE	Junius Bassus sarcophagus
Fourth century CE	Catacomb of Saints Peter and Marcellinus, Rome
c. 390 CE	Obelisk base of Theodosius

The Development of Rome

Right: Map of Rome showing the key buildings in existence in Rome in this chapter.

CHAPTER 14: CONSTANTINE AND THE LEGACIES OF ROMAN ART

Constantine the Emperor

The stability promised by Diocletian's imperial restructure and reforms turned out to be an illusion. While the tetrarchy proved to be an efficient method of administration, it was the figure of Diocletian himself, rather than the inherent structure of governance, that held his system together. In 305 CE, Diocletian retired and compelled his colleague Maximian to do likewise. The two Caesars Galerius and Constantius Chlorus became *Augusti* and new Caesars were appointed. This soon dissolved, forcing Galerius to call a conference (308 CE) with the retired former *Augusti* in an attempt to restore order. This, too, was in vain.

By 310 CE, there were three players of significance. The first, Constantius Chlorus's son, Constantine, had been declared Augustus by the troops of his deceased father in 306 CE, but he strategically accepted only the title of Caesar (he was elevated to the role of Augustus the following year). In 310 CE, however, his ambitions grew, and he declared himself a descendant of Claudius II, implying a claim to the sole rule that the pre-tetrarchic emperors had held. The second player was Maximian's son Maxentius (r. 306–12 CE), who in 306 CE, annoyed at being passed over for any tetrarchic position, had simply seized Rome—a symbolic if not, at that time, a functioning seat of power—and declared himself Augustus. The Romans, having

Basilica of Maxentius

Maxentius was the first emperor in half a century to make Rome his base of operations, and his tenuous legitimacy did not prevent him from rewarding its residents with a building program that is remarkable in light of the scant six years of his ascendancy.

Between the Temple of Venus and Roma, which Maxentius restored, and the western end of the Republican forum rise the substantial remains of his most enduring and impressive structure, which is variously termed the Basilica of Maxentius, Basilica Nova, or Basilica of Constantine [14.1a and b]. It was completed by Constantine, who added the west porch and east apse—rotating its orientation by 90 degrees—and installed his own colossal **acrolithic** (composite, made of stone and other materials) portrait. While the building faces the forum along its long side, as basilicas conventionally did, the plan is anything but typical. The fundamental elements of a basilica are present, in its high central nave lit through a clerestory with flanking aisles and apses on the axes, but they are brought about in an entirely different

14.1a and b The Basilica of Maxentius, or Basilica Nova, Roman Forum, Rome, Italy, 312 CE. Begun under Maxentius and completed under Constantine, the building follows the fundamental aspects of a basilica plan, but unlike previous basilicas this structure uses concrete vaulted architecture.

368 PART IV: COLLAPSE AND RECOVERY: ART ACROSS THE LATER ROMAN EMPIRE

felt somewhat ignored when imperial power became focused elsewhere, embraced him (see box: Basilica of Maxentius, below). The third protagonist, Licinius (r. 308–24 CE), had been made Augustus in the western empire through the influence of his friend Galerius at the conference of 308 CE, although on Galerius's death in 311 CE he shifted his rule to the eastern provinces (while retaining those in the West) and made an alliance with Constantine, who invaded Italy to expel the usurper Maxentius. The latter was defeated and killed at the famous Battle of the Milvian Bridge (312 CE) by Constantine, who fought, according to later lore, under the sign of the Christian cross. The empire was thereafter divided in two, with the west under Constantine and the east under Licinius. Just as Octavian and Antonius had three centuries earlier, the two emperors cemented their bond through marriage (Licinius wed Constantine's sister), continued their shared rule uneasily for over a decade, and finally came to blows. In 324 CE Constantine prevailed, united the empire for the first time in nearly half a century, and ruled until his death in 337 CE. Constantine was the last of the tetrarchs just as Octavian was last of the *imperatores*; also like Octavian, he utterly transformed the basis of imperial rule and promoted a new form of portrait to symbolize his new order.

CONSTANTINE'S PORTRAITURE

Constantine's earliest coin portraits conform to the standard tetrarchic image, but by the time he took Rome, a radically different portrait type was adopted [14.2]. The short-cropped military hairstyle has given way to a Classicizing pattern of continuous locks hanging long over the forehead. The brow is unfurrowed, the face is unwrinkled; he is beardless and youthful (he was probably around forty years old at this time).

The most prominent of the sculptured examples of his portraiture was set up by Constantine in an apse of Maxentius's Basilica Nova at some point after 312 CE [14.3]. This was a colossal acrolithic image, which in its form and its location clearly resonated with the giant Classical **chryselephantine** (made with ivory and gold) cult images of Zeus at Olympia and Athena Parthenos in Athens, which

14.2 (Below) Coin portrait of Constantine, 315–37 CE. The depiction of the emperor reflects a return to a Classic style of portraiture.

14.3 (Below) Colossal Constantine portrait from the Basilica Nova, Rome, Italy, c. 312 CE. H. 2.6 m (8 ft 6³⁄₈ in.). It has clear tetrarchic and Classical influences, and through a suggestion of peace and military strength refers to earlier rulers' attempts to convey stability.

manner. The traditional basilica (such as Trajan's Basilica Ulpia) is entirely post and lintel (trabeated) in construction, with two rows of columns dividing the nave from the aisles and supporting the high ceiling over the nave. The aptly named Basilica Nova ("New"), in contrast, was created in the tradition of concrete vaulted architecture. Four massive piers, together with the north and south exterior walls, support a soaring 35-meter high (115 feet) triple-bayed cross-vaulted ceiling over the nave; at a lower level, barrel vaults cover each of the three bays in each of the two aisles. The aisle constructions function also as buttresses (supports) for the great central vault. With this design, the architect localized the load of the building in such a way that it was possible to introduce huge arched windows in the exterior walls at both levels, flooding the interior with light. In fact, architecturally speaking, this was not a basilica at all, but rather it resembled the great central hall from an imperial *thermae*—in this case set up as a freestanding structure—although it was considerably larger than any of the halls seen in the earlier bath complexes, even Diocletian's. The basilica was a marvel of both planning and construction and, as an imperial commission, difficult to reconcile with the concept of an empire in decline, as this era is often construed.

were about the same size (around 12 meters high). Constantine was just as determined as Diocletian to portray himself as the holder of divinely sanctioned, even godly, power. This head of Constantine, in its blocky form, abstract rendering, and huge emotionless eyes, betrays its tetrarchic roots. The hairstyle, however, with its "comma" locks and "pincers" motif, the smooth cheeks, and impassive aspect signify something entirely different. Given his aspiration to sole rule, one might expect Constantine to have adopted a portrait of pre-tetrarchic form, similar to the somewhat Classicizing style of Claudius II, but this image reaches much further back in time to Trajan, *optimus princeps*, and to Augustus himself. This portrait is of a ruler whose imagination and ambition far exceeded the limitations of Diocletian's system. He sought nothing less than the restoration of the Roman empire at its happiest and mightiest of times—combining the peace of Augustus with the military invincibility of Trajan. By joining both, Constantine's portraits, like his policies, initiated a new form of both emperor and empire.

CONSTANTINE'S BUILDING PROGRAM IN ROME

The taking of Rome in 312 CE marked Constantine's ascendancy, his position as Augustus having been ratified by the senate, but he did not follow Maxentius's lead in restoring Rome as a center of imperial rule. His aspirations to sole rule were clear enough, but at first this did not manifest itself in the creation of any single imperial administrative center. He was, like all tetrarchs, mobile as emperor, spending most of his early reign in Gaul or the Balkans; he returned to Rome only twice after 312 CE (in 315 and 324), and when he did establish a new permanent imperial residence it was at his "New Rome," the city of Constantinople (modern-day Istanbul).

Yet Constantine did much to enhance Rome's prestige as a continuing symbol of his empire's greatness. He sponsored the last of the imperial bath complexes built in the city, on the Quirinal hill, although these were notably smaller than Diocletian's and Caracalla's. He built mausolea for his mother Helena and daughter Constantia (the present church of Santa Costanza), and the first of the great Christian churches.

The Arch of Constantine: Location, Subject, Style

Constantine's most conspicuous memorial in Rome is the marble arch erected between the Colosseum and the looming platform of the Temple of Venus and Roma. It stands today in much the same state in which it was built over 1,700 years ago, and it remains as much a symbol of the eternal city as does the adjacent Colosseum. Although the arch is not mentioned in ancient literary sources, inscriptions indicate that it was set up in 315 CE to commemorate the year of Constantine's *decennalia* (signifying the tenth year of his reign) as well as his "liberation" of Rome from Maxentius three years earlier. The arch was part of a broader plan monumentalizing the approach to the city from the south, and it spanned the route of the triumphal procession at the point after it emerged from the Circus Maximus and before climbing the via Sacra toward the Arch of Titus, but it is not, strictly speaking, a triumphal arch. It acknowledges Constantine's victory over Maxentius, and the arch's inscription refers explicitly to his role in releasing Rome from tyranny, but Constantine did not celebrate a triumph for his success in what was essentially a civil conflict.

In its general form, the arch follows the Roman arch of Septimius Severus (see Parthian Arch in the Roman Forum, p. 330), including the triple-bayed arrangement, the freestanding columns on sculptured pedestals, and the relief band that runs above the peak of the flanking bays [14.4 and 14.5]. Much of the extensive array of sculptural adornment was clearly reused from significantly earlier monuments. The statues of Dacian captives atop each column at the attic level were originally located in the Forum of Trajan, where similar material has been excavated. The four battle panels, two within the main bay and one each from either end of the arch, are believed to derive from a much longer frieze also from Trajan's forum. The roundels above each side arch are Hadrianic and the attic panels from the time of Marcus Aurelius. These reused reliefs, on which the heads of the main protagonists have been replaced or recut to portray Constantine (and on the roundels, allegedly, Licinius as his companion) were discussed in earlier chapters (see Trajanic Frieze on the Arch of Constantine,

p. 250, and Roundels on the Arch of Constantine, p. 265), as appropriate to their original creation in the time of the High Empire.

The remaining sculptures, created for this arch, take a variety of forms. The spandrels bear representations of Victoria and river gods, repeating a centuries-old tradition. At either end, roundels similar to the Hadrianic hunting *tondi* depict the sun (Sol) and moon (Luna), creating a temporal framework similar to that found on the cuirass of the Prima Porta Augustus, or, for that matter, the east pediment of the Parthenon in Athens. The subjects of the column pedestals are quite similar to those seen on Severus's forum arch as well as on the Arcus Novus pedestals: Victory figures, trophies, and Roman soldiers with captive enemies.

The frieze that continues around the monument, corresponding in position to the triumphal procession on Severus's arch, provides a narrative progression (reprising the organization of Severus's siege panels) illustrating Constantine's defeat of Maxentius. Beginning on the west side with Constantine's departure from Mediolanum (Milan), it continues on the south side with the siege of Verona and the battle at the Milvian Bridge, to his ceremonial welcome into Rome on the east, culminating in famous scenes of oration and largesse on the north side of the arch. The continuity of this visual account moves

14.4 (Above) View from the south of the Arch of Constantine, Rome, Italy, 315 CE. Marble. H. 21 m (69 ft) × W. 26 m (85 ft) × D. 7 m (23 ft). Its triple-bayed arrangement, freestanding columns and sculpted pedestals are reminiscent of the Arch of Septimius Severus.

14.5 View from the north of the Arch of Constantine, Rome, Italy, 315 CE. Marble. H. 21 m (69 ft) × W. 26 m (85 ft) × D. 7 m (23 ft). The sculptural program included earlier works set next to those created at the time of the monument's dedication, illustrating the shift to late-antique art styles.

CHAPTER 14: CONSTANTINE AND THE LEGACIES OF ROMAN ART 371

the viewer around the arch rather than through it, diminishing the arch's intrinsically bifacial nature. Viewing the arch in this manner, moreover, clarifies the deliberate juxtapositions across the arch (*profectio* on the west side, leading away from the city, versus *adventus* on the east, leading toward it; warfare on the south side versus peace and prosperity on the north). These were, as we have seen, traditionally paired polarities: two sides of the same coin.

The arch shows the final development of trends detected already during the middle period of the empire and, similar to the slightly earlier arch of Galerius, marks the change from a style rooted in Classical humanism to one that will evolve into medieval conceptualism. A comparison between the frieze panels on the north face [14.6] with the conveniently adjacent Hadrianic roundels (see also 10.6c, p. 265) demonstrates this shift well. The oration scene on the frieze panels, for example, presents Constantine on the rostra, with seated statues of Marcus Aurelius and Hadrian at either end and the *decennalia* monument rising in the background—a grand framing device, and an obvious allusion to the emperor's forebears, both recent and remote. The emperor himself (now headless) is absolutely frontal, his centrality further emphasized by the positioning and postures of the figures around him, both on the platform and to either side of it on the forum paving below. Most of these flanking figures have their gazes fixed on the emperor, although in the interest of realism some look back toward their companions, engaged in conversation and evoking similar groups on the solemn Ara Pacis and Parthenon friezes. Compositional focus on the emperor is as old as imperial art, but the degree of rigidity, symmetry and frontality, although anticipated in the art of Septimius Severus, is here unprecedented.

The figures on these friezes are overtly unclassical. Although many stand with their weight shifted, there is no hint of *contrapposto* stance. And if there were, we wouldn't see it, since the linear drill channels in the simply formed tunics and togas do not permit the drapery to model underlying limbs. It is difficult to imagine a sculptural style more different from the strongly Classicizing style (see Roundels on the Arch of Constantine, p. 265) of the sacrifice scene on the Hadrianic roundel.

The Arch of Constantine: Date

In the section of north frieze above the other side bay [14.7], Constantine has now taken his place among the senators, in a toga with *contabulatio*, but he is no less the center of attention. Traditionally, this scene has been understood to show Constantine, having secured his victory and pacified Rome, distributing that most tangible of public benefits—cash—as the culmination of his Italian exploits of 312 CE. In recent years, however, considerable controversy has arisen among scholars concerning the later sculptures on this arch. They are beyond doubt tetrarchic—the style is conclusive, and the representation of Diocletian's columnar monument in the forum assures us that the *adlocutio* relief, which depicts it, at least dates to after 303 CE. But on technical grounds it has been argued that any number of the reliefs, and especially the pedestal panels and frieze, were recut to fit their present locations and thus also represent reused materials, most probably from the time of Maxentius. It has also been suggested that much

14.6 Comparison between the frieze and the Hadrianic roundels from the Arch of Constantine, Rome, Italy. Marble. H. of roundels c. 2 m (6 ft 6 in.); H. of frieze 1.02 m (3 ft 4¼ in.). The roundels display a typical Classical style, the figures on the oration frieze are shorter and show no *contrapposto*.

14.7 Section of the north frieze from the Arch of Constantine, Rome, Italy. Marble. H. 1.02 m (3 ft 4¼ in.). The frieze shows Constantine distributing money to the populace after his battles in Italy.

of the assemblage ultimately used on the arch was already in place before Constantine took Rome, and that this was a monument that he appropriated more or less wholesale, just as he did with the Basilica Nova.

How much, therefore, of the Arch of Constantine is Constantinian? Two important issues hinge on this question. One is our reading of the ostensibly historical narrative that is depicted on the monument. It appears to be one of the more explicit and detailed visual accounts of an actual campaign that has come down to us, far more abbreviated than the spiral columns of Trajan and Marcus Aurelius but every bit as specific, perhaps even more so. Yet it has been argued that these are either stock scenes, for example the *profectio* and *adventus*, or simply generic representations of siege, battle, oration and largesse—or, if they are historical, they originally depicted the exploits of an earlier emperor. Is this distinction even valid? We have seen that most scenes of this sort are essentially generic, the particulars being introduced by the patron and the interpretation of the audience. The scene of the battle at the Milvian Bridge is seductively appropriate, but could it not be some other battle at a river, a theme found on both spiral columns? Indeed, where did the tetrarchs fight other than near river frontiers—the Rhine, the Danube, the Euphrates? If this theory proves accurate, or even if the issue cannot be resolved, must we question our ability to discern, in Roman art, the particular from the emblematic? Similar questions arise in considering the issue of *spolia*. In reusing older material, a well-established tetrarchic tradition is clearly being followed, as illustrated in the Arcus Novus (see Arcus Novus, p. 355). Constantine's appropriations, however, are thought to represent a step beyond tetrarchic practice. Since his portraiture overtly harks back to the *optimi principes* in a way the tetrarchs' never did, this, the most elaborate program of reuse known from antiquity, should have been similarly motivated.

Therefore, while it would be useful to know how much of the arch was the work of Constantine, on another level the question is moot. Once he had the arch inscribed and dedicated, it became his. The friezes, whatever they originally were designed to show, now depicted Constantine's campaigns and beneficence. Whoever collected them, the *spolia* now constructed associations that served Constantine's ends. Thus, the Arch of Constantine has, since 312 CE, been entirely his, and his it will remain.

LATE ANTIQUE STYLE

The Arch of Constantine offers an especially appropriate means to bring one story of Roman art to a close. Not only was it the last major commemorative state monument within a pagan tradition but also its assemblage of sculptural material summarizes and re-emphasizes the development of sculptural relief—in fact, of Roman representational style—over the previous two centuries.

The roots and objectives of this stylistic development are much debated; in some ways it is *the* defining question in histories of Roman art. Does it result from the increasing domination by non-Italians of the principate, from which artistic tastes emanate? Is it, in this case, the chiaroscuro of Asiatic Hellenism taken to a geometric extreme or, more convincingly, the influx of a formalism typical of the Near East,

home of the later Severans? Or does it reflect the rustic approximations of styles current in Rome that characterize the art of the northern provinces, home of nearly all the emperors of the later third century? Or is it the emergence of non-elite plebeian art alongside the rise of simple foot soldiers to the status of Augustus? Or is it simply bad art made by inexperienced artisans in difficult times? Moreover, wherever the style came from, did its emergence just happen or was it a deliberate choice? Did it displace other options, especially on official state monuments, because of its legibility and clarity as a visual narrative language or because it embodied the monolithic simplicity and conformity of a worldview imposed by the tetrarchs, or both?

While we may not be able to answer any of these questions definitively, it should now be clear why each of them is pertinent. Roman artistic style never developed in the organic, exclusionary pattern that applies to some periods, at least of earlier Greek and later European art. The Romans, in the same way as the Hellenistic kings before them, employed multiple styles from the different stylistic eras that preceded them and the variety of cultural traditions that had fallen under their authority and responsibility. These options were always available and found steady employment. Each patron used what was most appropriate and comprehensible; the tetrarchs, including Constantine, were entirely traditional in this respect.

To turn from the retrospective to the prospective, this transition from a stylistic approach still firmly rooted in the Classical and Hellenistic traditions of the late Republic and early empire to one based on more inorganic, anti-Classical abstract forms comes definitively to prevail in Christian art of both the Byzantine East and Medieval West. Constantine himself played a transitional role in this development. Raised in the traditions of the tetrarchs, and respectful of still earlier Roman traditions, Constantine made two decisions that would change the empire forever: he promoted Christianity as a state-supported (and supporting) religion and he founded a new imperial seat of administration at Constantinople. The Roman empire surely did not end with Constantine, but just as surely it became, with him, the beginning of something entirely different. All the same, aspects of the old empire persisted, not only in early Christian and Byzantine times, but right up to the present day.

CHRISTIAN ROME

In early Christian Rome, it would be logical, and expected, to see the employment of Roman modes of visual expression. These Roman styles, figural types, and architectural forms, representing centuries of historical development, were ready at hand and each had traditionally associated networks of meaning, which would now come to be re-employed in the service of the newly sanctioned religion. Before Constantine's extension of religious toleration (the Edict of Milan in 313 CE protected all religions from persecution), there were few, if any, public or monumental expressions of Christian teachings. What exists tends to be funerary. Owing to beliefs concerning resurrection, Christians practiced only inhumation, and two types of resting places developed to accommodate both wealthy Christians and those of more limited means. The former, in the same way as pagans who preferred

14.8 Sarcophagus of Junius Bassus, Rome, Italy, 359 CE. Marble. L. 2.44 × H. 1.18 m (3 ft 10½ in. × 8 ft ⅛ in.). The sarcophagus follows the form of earlier Asiatic coffins, but instead of depicting pagan gods on the carved reliefs, the *aediculae* contain scenes from the Old and New Testaments.

burial, could be interred in sarcophagi while the latter had to opt for a simple **loculus** (pl. *loculi*, a burial niche) in a catacomb (see box: Catacombs in Rome, p. 378). Both practices continued into the fourth century CE, which has produced some of the most striking examples.

A good case in point is the sarcophagus of Junius Bassus [14.8], a prefect of Rome (one of the highest offices beneath the emperor) in the mid-fourth century. It is of the Asiatic columnar type, here worked out on two levels. Instead of Greek gods, however, the ten *aediculae* contain scenes from the Old and New Testaments, displaying Bassus's newly found Christianity for all to see. The upper central scene of Christ enthroned, symmetrically flanked by principal disciples Saints Peter and Paul, and perched above a pagan-looking sky god as king of creation, is drawn directly from the tradition of emperor representations, for instance those seen on the column of Marcus Aurelius and the Arch of Constantine. Christ's youthful, beardless aspect was conventional in early Christian art and adopted, not coincidentally, by Constantine and his successors. As the empire became Christian, so the imagery used for Christ and the emperor was ever more conflated; the emperor was to be perceived as God's mortal earthly emissary, continuing a concept only somewhat modified from the *divi filius* of the earlier *principes*.

Of the remaining nine *aediculae*, five show episodes from the New Testament, relating episodes from the Passion of Christ, from the entry into Jerusalem (reprising the formula of an *adventus*) to the procession to the crucifixion, which itself is not shown here and is extremely rare in early Christian art. Old Testament themes prefigure Christian ones, such as Adam and Eve (original sin), Daniel and Job (deliverance through faith), and Abraham and Isaac (the crucifixion as the sacrifice of Christ by his holy father). There is a distinctively learned, textual basis to this monument that is shared not only with written manuscripts of this period but also with the interior decoration of catacombs and churches.

Indeed, the institutionalization of Christianity now allowed the building of great public structures for worship; several of the most significant were built in Rome, funded by Constantine. These churches were modeled not after Greek or Roman temples, but more secular structures. The Christian basilica, which owes its form not only to the Roman structure of the same name (for instance, the Basilica Ulpia) but also to imperial audience halls (such as those on the Palatine hill or at Trier) from which the basilican church took its dominant longitudinal axis, focusing attention on an apse opposite the entrance. The original basilica of St. Peter, in what is now Vatican City, was built in the middle of Constantine's reign [14.9]; its association with the disciple who came to be counted as the first head of the church, and whose relics the basilica housed, led to its status as the religious center of western Christendom.

Its plan is adapted from a Roman tradition of the basilica that goes back at least to the mid-Republic. This was decidedly a secular building type, used for commercial and administrative purposes, and it is often supposed that it was this absence of intrinsic cultic associations that prompted its selection for use within the context of a Christian faith that was uncomfortable, to say the least, with pagan religious practice. More important was the manifest practical unsuitability of the Greco-Roman temple structure for any aspect of Christian worship. Religious rites of official Roman state cults, similarly to those of the Greek *polis* before them, were principally excluded from the sacred structure itself. In Roman religious practice, sacrificial rituals were performed by priests at altars set outside a temple that housed the image and treasury of the deity. Worshipers would solemnly process

14.9 Reconstruction of the original basilica of St. Peter, in what is now Vatican City, Italy, 319–330s CE. The original structure was built near the end of Constantine's reign. The plan is a traditional basilica design that dates back to the Roman Republic and was well suited to the practices of the Christian faith.

CHAPTER 14: CONSTANTINE AND THE LEGACIES OF ROMAN ART

to the area, gather around the sacrifice, and participate in a celebratory meal. In contrast, the more inclusionary Christian faith (as with other mystery religions) was more about belonging, as manifested in rites of initiation, by sacraments of advancement and through a Eucharist that took place indoors.

The basilican plan was uniquely suited to these functions. Churches needed to, or needed to appear to, accommodate large numbers of worshipers, in order both to house the performance of the liturgy and to embody the majesty of the entity catechumens (those studying in preparation for baptism or confirmation) were seeking to become a part of. Moreover, the internal organization of a basilica, with its central nave and side aisles, and in its Christian form, the **narthex** (entrance area) and atrium that preceded the nave itself, could serve to separate (and therefore identify) those in different stages of initiation. The stages of access, and axial symmetry, were strikingly similar to those of an Egyptian pylon temple, or for that matter a Roman imperial audience hall, but in this case the barriers were permeable to those advancing in the Christian faith.

Another feature that distinguishes the Christian from the Roman basilica is the relationship between interior and exterior. The Basilica Ulpia, for example, was opulently equipped with colonnades of polychrome marbles both within and without, as the functions it served flowed continually between outside and inside. Its early Christian counterparts made a firm distinction in this respect with plain brick exteriors, but interiors adorned not only with columns and entablatures but also with sparkling wall mosaics and brightly colored frescoes. These served to illustrate scenes from scripture, lives of saints, and other didactic subjects, assisting in the spiritual education and advancement of initiate and novice alike, whether literate or not. Primarily, however, the distinction between interior and exterior was intended to capture the distinction between belonging and not belonging to the faith and, for each individual, the primacy of the inner spirit over the physical body.

While the early Christian basilicas were conservative in plan and construction, and similar to the Basilica Ulpia in this regard, the art of building vaulted concrete structures did not disappear. Another option for architects was the radially planned church, which derived its form from such domed rotundas as that of the Pantheon but was adapted to admit large quantities of light, such as was already achieved in Galerius's mausoleum in Thessaloniki, which was itself converted to a church (see 13.30, p.363). Round churches may have been inspired by the circular imperial mausolea built by, in addition to Galerius, Augustus, Hadrian, Diocletian, and Maxentius; many were built to honor Christian martyrs and thus were, in a sense, funerary monuments themselves.

14.10 (Below) Reconstruction of the church of Santa Costanza, Rome, Italy, c. 350 CE. The church was later rededicated to Constantia.

14.11 (Right) Interior of Santa Costanza, Rome, Italy, c. 350 CE. The church was originally a mausoleum that held the sarcophagi of Constantine's daughters Constantia and Helen, the wife of the emperor Julian.

The church of Santa Costanza in Rome was originally a mausoleum that held the sarcophagi, preserved today, of Constantine's daughters Constantia (d. 354 CE) and Helena (d. 360 CE), who was wife of the emperor Julian (r. 360–63 CE) [14.10]. The original occupant, and thus the date, of the mausoleum is debated, but it was very probably built around or after the middle of the fourth century CE. At some point after that it was rededicated as a church to Constantia, whose veneration is recorded only very late.

The architecture certainly draws on the basilican tradition, with its central nave lit from a cylindrical clerestory supporting a shallow dome [14.11]; as a centrally planned church, however, the aisle framing the nave is circular, defined by pairs of radially set granite columns with marble capitals and bases, reprising a form well known in such imperial buildings as the Pantheon. The church also preserves a sense of the now lost interior/exterior distinction of the old St. Peter's Basilica. The apse mosaics of Christ with apostles are probably later, but the beautiful tapestry-like polychrome mosaics that line the annular vault of the **ambulatory** (here, the aisle formed by the paired circles of columns) date to the original construction. There is nothing patently Christian here: the subjects are either decorative, with floral and animal motifs as well as geometric ornament and inanimate objects, or Dionysiac, with scenes of *putti* making wine [14.12]. The latter appear also on one of the sarcophagi, probably Constantia's [14.13], made of red porphyry and decorated with garlands, grapes, acanthus scrolls, and cupids, as well as on the ends of the coffin of Junius Bassus (see 14.8, p. 374). This continues a practice commonly found on early Christian monuments of employing pagan motifs capable of bearing Christian meaning; the wine of course refers to the Eucharist and the Dionsyian imagery serves as an allegory for the resurrection of Christ. Although Christianity was now fully legal, and in fact strongly promoted by the Constantinian dynasty, the use of these symbols with their multiple meanings does not die out.

14.12 (Above) Mosaic from the interior of Santa Costanza, Rome, Italy, c. 350 CE. While later figurative mosaics of Christ exist in the apses, the polychrome mosaics belonging to the mausoleum's original construction included only decorative floral, faunal, and geometric motifs as well as scenes of wine-making.

14.13 (Left) Sarcophagus of Constantia, Rome, Italy, c. 354 CE. L. 2.3 × H. 1.6 × W. 1.3 m (7 ft 6⅝ in. × 5 ft 3 in. × 4 ft 3¼ in.). Made from red porphyry, the coffin is decorated on all four sides with garlands and grape vines, large acanthus scrolls, and cupids treading grapes. Below there are two peacocks, a ram and a cupid with a garland.

THE "NEW" ROME OF CONSTANTINE

Constantine's choice of the Greek city of Byzantium as the site for his "New" Rome is not a surprising one. Situated on a narrow strait that both separates Europe from Asia Minor and connects the Sea of Marmara (and the Mediterranean) to the Black Sea, Byzantium's

Catacombs in Rome

Among the earliest and most extensively preserved early Christian structures in Rome are catacombs. Since the resurrection of the faithful at the second coming of Christ was central to Christian belief, and the body should exist in order to be resurrected, early Christians practiced inhumation exclusively, unlike their non-Christian compatriots, who practiced both cremation and burial. The development of catacombs in Rome was prompted as well by two more practical concerns. First, land just outside the city boundaries, where the deceased were required to be interred, had always been very costly, and Christians at that time tended mostly to be of modest means. Second, the carving of catacombs was facilitated by the soft, volcanic bedrock of the area, which cuts easily when first exposed to air. Economic imperatives, therefore, rather than a need for privacy or security, led to the creation of Christian catacombs.

A catacomb—the derivation is unclear but it may come from the Greek κατά ("below") and κυμβή ("a hollowed vessel")—is a tunneled-out necropolis consisting of passageways (*ambulacra*) lined by carved-out shelf-like niches for bodies called *loculi* ("little places"), which they surely were, especially if they held multiple bodies. A more wealthy family could secure a hollowed-out room (*cubiculum*, pl. *cubicula*) with numerous *loculi* to accommodate its deceased together in one place. The complex of tunnels could be repeated downward for several layers, allowing the interment of as many as 150,000 bodies (in the case of the Catacombs of Santa Domitilla). Saint names came to attach themselves to catacombs as martyrion churches (built in memory of a martyr) were built over the locations where the saint was (or was believed to have been) buried.

Some parts of catacombs were decorated with figured frescoes, especially the *cubicula*, chapels, and *arcosolia* (curved recesses, sing. *arcosolium*). While Christians were not the only Romans to bury their dead in catacombs, these cemeteries have provided us with an especially rich and rare corpus of early Christian figural art. The catacomb of Saints Peter and Marcellinus preserves a rich collection of Christian frescoes from the fourth century CE that have very recently been restored. These paintings closely reflect the developments in style and iconography that are seen in other early Christian media, such as sarcophagi and mosaics. Radially arranged decoration on the shallow-domed ceiling of a *cubiculum* is divided into segments by a cross [14.14]. In the center is a typically early Christian image of a youthful Christ standing among his flock and bearing a sheep across his shoulders, implying the relationship between him and his followers, whom he protects and sustains.

14.14 *Cubiculum* ceiling of the Catacomb of Saints Peter and Marcellinus, Rome, Italy, 4th century CE. The ceiling is divided by a cross, in the center of which is a youthful Christ among a flock of sheep, shown in a late antique style.

The style is formally simplified in the late antique manner, but the landscape setting is three-dimensional and Christ stands in a Classical weight-shift pose. The arms of the cross terminate in half-moon-shaped fields called, appropriately, lunettes. Here, as on Bassus's sarcophagus, is an Old Testament scene rendered with sequential, but not continuous, narrative. Jonah falls overboard, is swallowed by the sea monster, escapes, and feasts in gratitude within a paradise-like setting. The last scene draws heavily on those of Hercules banqueting, as in the Antioch mosaics (see p. 338). This is a prefiguration of the resurrection of Christ himself, and ultimately his faithful, who are present here in the form of his sheep at the center. Nor are actual renderings of episodes from the New Testament lacking, as shown by this scene from an *arcosolium* showing the raising of Lazarus and offerings being brought to the infant Christ [14.15].

14.15 *Arcosolium* from the Catacomb of Saints Peter and Marcellinus, Rome, Italy, 4th century CE. The fresco shows the raising of Lazarus and offerings made to Christ.

378 PART IV: COLLAPSE AND RECOVERY: ART ACROSS THE LATER ROMAN EMPIRE

strategic location had long been recognized. It was also, physically, a compellingly dramatic site, its uneven and picturesque terrain looming above the Bosporus strait. For over a millennium and a half, following its dedication by the emperor in 330 CE, it served as a center of power and civilization in the East, as the seat of the rulers of the Roman, Byzantine, and Ottoman empires.

Because of its long history, Constantine's "Great Palace" was modified, destroyed, abandoned, and subsequently built over by this series of later emperors and sultans. Some parts did remain, however, and excavations in the twentieth century have shed further light on them [14.16]. The first palace was, not surprisingly, modeled on those at Rome—a synthesis of the Palatine complex and Hadrian's villa at Tivoli. Set on high ground, providing impressive views both from and toward it (similar to the Palatine), simultaneously contained and sprawling, it encompassed all the essential parts one would expect—living quarters, baths, porticoed retreats, state reception halls, formal *triclinia*—and, in addition, a central church for the Christian faith: Agia Eirene ("Holy Peace"), which was Constantine's Christian version of the *Pax Augusta*.

One aspect of the complex that we can experience today is the hippodrome (horse track), set below the palace, just as the Circus Maximus was made, visually at least, part of the Palatine residence by the architects of Nero and Domitian. Today the area is a paved park, the original racecourse is outlined by trees, and a few monuments are set up in their original location along the *spina*—the long, narrow central platform around which the chariots raced [14.17]. Among these monuments are the remains of a bronze column, once 8.5 meters (28 feet) tall, formed of intertwined serpents. This originally supported the enormous gold tripod set up by the Greek city-states at Delphi to commemorate the great victory at the Battle of Plataea, which brought an end to the Persian war of 480–479 BCE [14.18]. Paid for by the spoils taken from the invader, the monument was often mentioned in ancient Greek and Roman sources. Although set up using common funds, it was originally dedicated by the Spartan general Pausanias

14.16 (Above) Reconstruction of the Great Palace of Constantinople, Istanbul, Turkey, 330 CE. The first palace was modeled on those of Rome, set on high land similar to that of the Palatine hill.

14.17 (Above) Aerial view of the hippodrome, Constantinople, Istanbul, Turkey. The ancient horse track is a paved park today, but the original course is outlined by trees.

14.18 (Left) Column of intertwined serpents, hippodrome, Constantinople, Istanbul, Turkey. H. 3.53 m (11 ft 7 in.). Once standing 8.5 m (28 ft) tall, the column originally supported a golden tripod to commemorate the Greek victory over the Persians in the fifth century BCE. Constantine moved the column to Constantinople.

CHAPTER 14: CONSTANTINE AND THE LEGACIES OF ROMAN ART

(c. 510–465 BCE); his epigram on the monument gave himself credit for the outcome of the battle. Whatever the veracity of Pausanias's claim, this act of arrogance escalated, according to the sources, into suspicions of his collusion with the Persians, and ultimately led to his downfall and death at Sparta. Pausanias's inscription was replaced with one that attributed credit to all the city-states that had fought against the Persians, each of which is listed on the coils of the snakes. One wonders if Constantine was sufficiently reflective and historically astute to understand the tripod's relationship to Greek concepts of liberty and divine justice, or to apprehend that he was removing a lasting symbol of East–West conflict to the very spot where East and West were meant to come together (see box: Ancient Statuary in Constantinople, below).

MATERIALS AND TECHNIQUES
Ancient Statuary in Constantinople

One aspect of the urban landscape in Rome, referenced by ancient sources and modern scholars alike but nonetheless difficult to visualize now, is the forest of statuary sometimes referred to as Rome's "second population." Bronze honorific portraits of prominent Roman magistrates and generals so thronged the forum by the mid-Republic that there were periodic purges to thin them out. Images of Roman deities, and the names of some sculptors who fashioned them, are known from as early as the Roman monarchy. The triumphs of the later Republic paraded cartloads of statuary before the rapt eyes of the Roman citizenry; their subsequent installation for public perusal in opulent structures built for the purpose resulted in our first Roman "museums." As varied as all these sculptures may have been in origin, function, material, and form, they had something in common—they were created and displayed in order to promote both the prevailing power structure and those elite families who supported, and were supported by, its perpetuation.

It would have been astounding, then, if Constantine had *not* sought to populate his own "new" Rome similarly, although there were some critical differences between the old and new cities. The most important difference was in religion. From their very beginning, the traditional pagan religions of the Greco-Roman world, mirroring their Near Eastern and Egyptian predecessors, involved figuration. Images of worshipers set up in the presence of images of deities silently re-performed prescribed acts of piety in order to ensure continuing good fortune. Judeo-Christian traditions and teachings, however, unequivocally forbade the figural representation of the divine.

The pagan belief that statues could, and in fact should, contain the spirit (δαίμων) of the god or goddess took on a decidedly negative cast among Christians, for whom the spirits were malevolent (thus, "demons") rather than benevolent. Yet, as the evidence makes clear, sculptures of ancient gods formed a substantial portion of the statuary in the new capital, and they continued to be added long thereafter. One explanation for this is that the Roman empire in the fourth century CE, despite Constantine's revolutionary adoption and promotion of Christianity, remained substantially pagan across all socio-economic classes. The first official acts to ban paganism date to the reign of Constantine's successor Constantius II (r. 337–61 CE), yet even after this point Classical statuary was being set up in Constantinople. It was Constantine's avowed purpose in founding his city to create a "new" Rome, and it could no more live up to that purpose without traditional statues as it could without an imperial palace, or a hippodrome.

Three important sources for the ancient statuary of Constantinople are, in effect, catalogs of their destruction: the Byzantine chronicler John Zonaras (1074–1130) and the historian George Cedrenus (also twelfth century) enumerate the statues lost in the burning of the palace of Lausus, a high official of the emperor Thedosius II (r. 402–50 CE), in 475 CE; and the historian Nicetas Choniates (1155–1217) relates in detail the deliberate obliteration of statues that were still present in the capital in 1204, during its sack by the Franks of the Fourth Crusade. From these writers we learn that among the myriad objects acquired and displayed in Constantinople were the colossal chryselephantine Zeus from Olympia and the marble Aphrodite from Knidos, the works of Phidias and Praxiteles respectively—the two most eminent artists of Classical Athens. Neither work was lacking in religious significance. The Zeus was unquestionably the most important statue in Greece, as the very emblem of the Panhellenic worship of the king of the Olympians. The lascivious Aphrodite from Knidos may well have been the most famous, and infamous, for less elevated reasons. As might be expected, then, the statuary displayed in Constantine's city was no random collection, but rather was carefully chosen to situate it as the heir to, and new Christian center of, Greco-Roman culture.

Although Constantine retained sole rule to his death in 337 CE, he was succeeded by all three of his sons, and emperors with regional responsibilities ruling the empire simultaneously became the pattern for most of the rest of the fourth century. In 379 CE, the emperor Theodosius I (r. 379–95 CE) inherited the throne and added another surviving monument to the Great Palace complex. As had many Roman emperors before him, Theodosius set up an Egyptian obelisk on the *spina* of a horse track, its base carved in reliefs that reflected a continuation of the style and figural repertoire developed under Constantine in Rome [14.19]. Each side of the base is substantially preserved and each relief is, in many ways, the same, calling to mind the repetitive form of tetrarchic monuments, but no two scenes here are identical. All show the emperor front and center in an elaborate, multilevel grandstand, framed by ranks of figures that mark out his importance. The northern and southern panels appear simply to present him as an apparition with his court, without performing any obvious activity. The western panel is similar, the lower rank taken up by begging "barbarians" (identified by their beards and garments, as on Trajan's column) who are holding offerings.

The eastern panel is the most compositionally interesting [14.20]. Theodosius is standing here, making his figure even more prominent, again framed by figures and also by a Corinthian *naiskos*. He holds forth a victor's crown, no doubt for a winner in the horse race, and in the lowest rank of figures we see celebratory dancing, accompanied by what is taken to be a water organ—an invention of Ptolemaic Egypt, perhaps brought to Constantinople from Alexandria, just as the obelisk was itself. The four compositions of this base strongly call to mind those of the *largitio* and *oratio* friezes on the Arch of Constantine, although the figures here, while more three-dimensionally carved, are universally frontal and repetitive, and the design is more highly structured. All the forces that emerged under the tetrarchy and that led to the late antique style under Constantine remained in force here nearly a century later and would lead to the decided preference for formalized renderings that came to dominate Christian art of both the East and the West.

14.19 (Left) Theodosius's obelisk, Constantinople, Istanbul, Turkey, c. 390 CE. Granite. H. with base 25.6 m (83 ft 11⅞ in.). The obelisk was originally erected in Egypt in 1479–1425 BCE, but was taken by the emperor Constantius II to Alexandria in the fourth century CE. Constantius's successor Theodosius later transported it to Constantinople.

14.20 (Below) Eastern panel relief from the base of Theodosius's obelisk, Constantinople, Istanbul, Turkey, c. 390 CE. H. 4.2 m (13 ft 9⅜ in.). Theodosius stands holding a victor's crown, probably for the winner of a horse race. Celebratory dancing is depicted in the lowest register, as well as an instrument that could be an Egyptian water organ.

Epilogue: Rome's Lasting Legacy

ROMAN EMPIRES RETAINED AND REVIVED

14.21 Interior of the Hagia Sophia, Constantinople, Istanbul, Turkey, 537 CE. Constructed by Justinian I, the Hagia Sophia was the culminating architectural achievement of late antiquity.

In 395 CE, the empire was officially divided between the two sons of Theodosius I, with eleven-year-old Arcadius (r. 395–408 CE) continuing to rule the eastern half of the empire from Constantinople, and his older, still teenage, sibling Honorius (r. 395–423 CE) sent to Milan to govern the West. Honorius was forced in 401 CE to move to Ravenna in northeastern Italy for protection from the invading Goths, who would sack Rome in 410 CE. Romulus Augustulus (r. 475–76 CE), ironically named (in the diminutive) for Rome's founder and self-styled "re-founder," proved to be its last western emperor, deposed in 476 CE by the Germanic Roman legionary Odoacer. The latter, in turn, was murdered in 493 CE by Theodoric, whose Ostrogothic kingdom was then established in Ravenna.

In the following century, Justinian (r. 527–65 CE) became the last emperor to seek to restore the empire to its pan-Mediterranean form. He achieved success by recovering Ravenna from the Goths and restoring Italy, Sicily, North Africa, and part of Spain to imperial rule. His reign marks the closest the world would see again to anything similar to the old Roman empire. Roman precedent, therefore, played a large role in the art of that time, although it remained, of course, Christian in its focus. Justinian's crowning accomplishment was his church of Hagia Sophia (532–37 CE), which blended the traditions of central and longitudinal planning in an unprecedented manner [14.21]. Although the church is massive and its colonnades intricately decorative, its architecture is entirely one of interior space, light, and color that, with complete success, captures the spiritual transformation reflective of the ideal Christian experience. Its Roman roots are deep but subtle; it looks forward rather than back.

A more modest monument from around this time, and usually attributed to the reign of Justinian—the so-called Barberini Ivory—wears its *romanitas* more openly [14.22]. This large ivory, from a diptych and comprised of five pieces, incorporates so many traditional imperial symbols that one wonders if something resembling the Gemma Augustea (see 6.9, p.160) was still in the hands of the emperor; in fact, already in the seventeenth century a noted antiquarian observed the plaque's similarity to the Grand Camée de France (see 6.11, p. 162). In the center of the piece the emperor is shown mounted, his horse rearing above a matronly earth deity, replete with signs of fertility in her lap, similar to a figure already noted on several Augustan monuments. He is crowned by a Victoria with properly Classicizing drapery, and the theme is reprised in the extant side panel to the left, which shows a figure in military dress

holding a statuette with a wreath and palm, both Roman signs of victory. The lower panel repeats the motif of "barbarians" from both famous cameos mentioned above, but here, as on the Theodosian obelisk base, they are suppliants with offerings rather than vanquished captives. This reflects an eastern tradition that goes back to the Sassanian and Persian empires and even earlier, to most ancient Mesopotamia. Finally, in the space above the central figure (which on the Julio-Claudian cameo is occupied by the *divus* Augustus) looms Christ himself, flanked by angels all but indistinguishable in form from the Roman Victory figure below. A more compelling synthesis of Christian and Roman imperial iconography is difficult to imagine.

While in the eastern Mediterranean Justinian's successors sought, with declining success, to perpetuate their Roman empire, several kings in western Europe exerted considerable effort to create one anew. After the abdication of Romulus Augustulus in 476 CE, the entire area of western Europe came under the control of various tribes of Goths and many others from beyond, often far beyond, the old limits of the Roman empire; there was no semblance of unification, or much order of any kind, during these darkest of the "Dark Ages." By the seventh century, however, Frankish kings were emerging as a force in Gaul. The Barberini Ivory seems to have come into their possession, since several of these kings' names are inscribed on its reverse. In 800 CE, perhaps inspired by the ivory's message, the Frankish king Charlemagne (Charles the Great) had himself crowned emperor by the pope in Rome and ruled until his death in 814 CE. After the power of Charlemagne's kingdom waned, the Germanic king Otto did much the same in 962 CE; the monarchy he founded evolved into the Holy Roman Empire, which in some form lasted into early modern times. His grandson Otto III (r. 996–1002 CE), whose mother was a Byzantine princess, decided to rule his empire from Rome itself, and the art of his time clearly reflects a profound interest in the antiquities and imperial traditions of his new home (see box: Otto III and Rome, p. 384).

14.22 The Barberini Ivory, first half of the 6th century CE. H. 33 cm (13 in.). These five pieces of ivory once covered one half of a diptych, two pieces of wood forming a writing tablet that could be folded in two. These sometimes bore imperial greetings or commands.

ROMAN MODELS IN MODERN TIMES

If we must identify an endpoint for the existence, or even plausible pretense, of a Roman empire, it is probably here with the reign of Otto III; there was never to be another such empire as Rome's. Those of both Otto and Charlemagne developed into European kingdoms, neither being substantially more extensive than the modern countries of Germany or France. Nor did Justinian's considerable realm long outlast him, falling victim first to the spread of Islam across his eastern holdings and later to the depredations by these same European monarchies, dislodging his western foothold and then, during the Crusades, taking Constantinople itself (in 1204), and ruling Byzantium as another Frankish kingdom. By that time any real vestige of the Roman empire, or hope of its revival, had long disappeared; the Ottoman capture and conquest of Constantinople of 1453 was but the final punctuation.

The memory, appeal, and impact of ancient Rome—and its usefulness as a signifying force—

Otto III and Rome

The position of "emperor" claimed by Charlemagne in 800 CE passed from his dynasty at the end of that century and was disputed for some time until claimed by the German king Otto I (the Great) in 962 CE. Although the title did not exist for another three centuries, some historians consider Otto, rather than Charlemagne, the first Holy Roman Emperor, a position that remained Germanic until the time of Napoléon Bonaparte, crowned emperor by the pope in 1804. Not surprisingly, Otto's presumptuous act prompted the ire of the Byzantine emperor John I Tzimiskes (r. 969–76 CE), not only by his claiming a title that the Byzantines had continually borne since Constantine but also because both were attempting to extend their sphere of influence in Italy and Sicily. A treaty was signed and Otto's son (later Otto II) was married to the Byzantine princess Theophanu. She bore him three daughters and one son, who succeeded his father as Otto III, king of Germany, at the tender age of three. He ruled under the regency first, briefly, of his cousin, then his mother, then upon her death his grandmother, until, in 996 CE at the age of sixteen, he marched on Italy, took on the title of emperor himself, and was crowned by the pope in Rome.

Although she died well before these events (in 990), the legacy of Theophanu on the Germanic royal court was palpable, as we shall see. The Byzantines, of course, had continuously ruled as emperors of the Roman empire since Constantine and, although there were vicissitudes of fortune in the Byzantine domain, until the time of the Crusades (still a century away) the court remained prosperous, cosmopolitan, and deeply rooted in the traditions of Rome installed by Constantine himself. Theophanu's lasting

14.23 Facing pages of the Gospel of Otto III, c. 1000 CE. On one page the emperor is shown enthroned holding an orb of the Christian world.

14.24 Justinian Mosaic from the Church of San Vitale, Ravenna, Italy, 547 CE. It is probable that Otto was influenced by this work, replicating the flanking of the emperor's image with the military on one side and the clergy on another to bring together the traditional role of *imperator* with his new role as head of the Christian Church.

influence, having instilled in Otto an affinity for the culture of his maternal ancestors, may explain the dramatic step taken by Otto III of moving his court to Rome, where he built his palace and sought to revive ancient Roman traditions, adding to his titles "Consul of the Senate and People of Rome." His reign, however, was short and unpopular; he died of disease without a successor at the age of twenty-one in early 1002, having barely survived into the new millennium.

The influence of Otto's Byzantine mother and of his own Roman aspirations can be seen in the gospel book produced for his personal use. Such texts were beautifully hand lettered and illuminated and were among the most treasured luxuries of the time [14.23]. One full-page illustration shows the emperor enthroned, holding the orb of the Christian world in his left hand and scepter in his right. He is frontal and framed by the military to his left and clergy on his right side, showing the emperor as both *imperator* and, as initiated by Constantine, head of the Christian Church. The image recalls a mosaic of Justinian in the Church of San Vitale at Ravenna, which Otto most certainly had seen [14.24]. Both scenes evoke the heraldic symmetry seen on the reliefs of Constantine's arch and earlier monuments. Reaching further back, to the temple of *Divus Hadrianus* and beyond, is the facing page with four suppliant personifications of "provinces" in Otto's realm, including Gaul, Germany, Sclavinia (eastern Europe), and Roma herself, bearing offerings to the enthroned emperor. One also sees, despite the similarities, a stylistic distinction from the Justinianic mosaic in the much bolder, flatter colors of the later work, its far more conceptual treatment of space, and its angular, geometric forms. This development, which distinguishes early Western medieval art from the late antique, also characterizes the change from early to middle Byzantine, around this same time. The consequent dematerialization of natural forms, and the optical effects of bright colors and gilding, were appropriate to the figuration of the otherworldly in a medieval art that strived to convey, yet not portray, the realm of the divine. This is one significant way in which the medieval world would leave antiquity behind, although the roots of the style itself remain manifestly Roman.

could not, however, be extinguished. Renaissance rulers were inspired by Greco-Roman culture in the creation of a new humanism, and such monarchs as Louis XIV of France, who openly identified himself as a new Augustus, eagerly adopted the Classicism of the Renaissance and employed it for imperialist ends—as had the Romans themselves—as an expression of wealth, power, and grandeur. An even more programmatic re-employment of Roman forms would occur in the eighteenth century, facilitated by a corpus of models vastly expanded by the new finds from Herculaneum and Pompeii, and prompted by the rise of modern republics. These exploited Roman art's capacity to embody centralized control and distributed responsibility through its associations with both the Republic and empire.

Neo-Classical architecture was especially espoused in the United States as an expression of authority, grandeur, and self-rule. The United States Capitol building in Washington, D.C. [14.25], completed in 1800 and the very icon of modern democracy, centers on a domed rotunda fronted by a pedimental facade—an incongruous juxtaposition that goes back, through several intermediaries, to the Pantheon. Precisely like the Capitoline temple in Rome, for which it is named, this building dominates not only the nation's capital, by its elevation and size, but also the entire country, by serving as a model for local capitol buildings in every state. In this

14.25 United States Capitol, Washington, D.C., completed in 1800. Named after the Capitoline temple in Rome, its domed rotunda and pedimental facade call to mind the Pantheon.

way in the modern United States we see a pattern of architectural diffusion for the extension of political authority comparable to that exercised by the Romans of the empire, some half a world and two millennia away.

The appeal of Roman art and architecture as a model for new works has continued undiminished, but over time somewhat different modes of reference have emerged. Generations of American architects, for example, have studied the remains of ancient Rome facilitated by residencies at the American Academy. This institution, founded in 1894 as the American School of Architecture in Rome, has since broadened its scope to embrace all the visual, musical, and literary arts, including both practitioners and scholars. One of its co-founders and early presidents was Charles Follen McKim, whose firm designed the old Pennsylvania Station in New York City, completed in 1910. The station's central space was a close re-creation of that of the Baths of Caracalla in Rome [14.26a and b], representing not only the architects' profound respect for the achievements of Roman architects but also their astute attention to issues of form and function. While a train station might seem very different from a bath complex, there are distinct functional similarities. Both needed to accommodate large numbers of people and provide for efficient circulation; both incorporated a large number of facilities for the transaction of business and social interaction; both used massive piers and soaring spaces to create spaces that reflected the majesty and competence of the sponsoring city, each asserting primacy among its peers. Both *thermae* and train station are simultaneously democratic and authoritarian.

During the intervening century, postmodernism ushered in two cultural shifts that further fostered a revival of interest in ancient Rome. The first was an underlying principle of relativism. Modernism asserted a positive, even positivistic, and fundamentally optimistic view of a world governed by universal truths, revealed to human beings capable, through intellectual achievement, of discovering them. In a "postmodern" reading, meaning is reader-determined—a product of the observer's own experiences and the mental associations suggested by the monument itself. The second was the increased attention paid to situating the present relative to the past. This was not quite the same as the revivals or re-creations of Classical forms. It was a far more self-conscious, often ironic, quotation, the interpretation of which, more often than not, was deliberately viewer-determined.

The work of an Academy fellow from later in the twentieth century, Robert Venturi, illustrates this development [14.27a and b]. The use of a Classical order in this private residence situates it in a long, distinguished architectural tradition. That it is an architectural tradition of mass is suggested by the choice of the Doric order, since this is the most massive of the three Classical

14.26a and b McKim, Mead, and White's Pennsylvania Station, New York City, 1910. The station's plan closely recalled the Baths of Caracalla.

options, and the exaggerated swelling (entasis) of these columns both amplifies and parodies that massiveness. On the other hand, the columns are perfectly flat, so their immensity is at the same time stressed and denied. This house, with its thin, screen-like walls and aptly named cathedral ceiling that arches over the vast open space within, reflects the architecture of space, with intricate, fanciful pseudo-Gothic ribs, rendered, as are the columns, by flat slabs of wood, similarly denying their supporting function. The result is a playful yet learned hybrid of architectural contradictions that go back to the Pantheon, without bearing any real resemblance to it, or any other ancient building.

McKim's and Venturi's buildings, therefore, reflect two very different ways of understanding and appropriating the works of the Romans—one straightforward and reverential, the other iconoclastic and wry. Roman art is especially suited to this associative form of meaning and interpretation. First, Roman art was born from a series of relationships with other cultures (namely Etruscan, Punic, Greek, Egyptian, Near Eastern, Celtic, and so on), from which it borrowed forms chosen for their associated implications. Second, Roman imperial art was designed to make sense when taken as a whole; that is, the arrays of statuary, relief, painting, stucco, mosaic, and architectural forms—both real and faux—drew meaning from one another, functioning together to construct a cleverly orchestrated atmosphere within the soaring and complex interior spaces that were the grandest achievement of Roman architects.

Returning to the question we posed at the outset: what is Roman about Roman art? Roman art is, more than any earlier art, the art of the individual. As we have observed, it was first developed to serve the needs of members in a ruling elite, who simultaneously desired to belong to their group and stand out from their peers. Its notable achievements in representational art concern the portrayal of the particular—the individual patrician noble, emperor, or prosperous freedman, the specific ritual, battle, virtue, or accomplishment. This emphasis on the individual is what separates Roman art from Greek; its de-emphasis in later antiquity is what eventually transforms Roman

14.27a and b Robert Venturi, House in New Castle County, Delaware, 1978–83. Venturi's use of the Doric order in an idiosyncratic way demonstrates the very different ways of apprehending the works of the ancient Romans.

art into medieval—another generic style, but one utterly different from the Greek. That Roman art developed generalized schemes to depict specific subjects in no way diminishes the very particular nature of the message itself, but rather it was the very quality that permitted Roman art to function effectively. Its derivation from and membership in a pan-Mediterranean Greco-Roman system of universally recognized artistic forms suited it especially well to serve as a visual language for a global empire. Roman art spoke to and for each individual; it was understood by one and by all. It served later cultures in similar ways—equally adaptable and equally meaningful. It was thus both personal and universal, both temporal and, in the end, eternal—just like Rome herself.

Glossary

Words in **bold** appear as terms elsewhere in the glossary.

abacus (architecture) Square, slab-shaped part of a Doric capital, above the **echinus**.

acrolith, acrolithic A statue in which the undraped parts of the body (such as the head or limbs) are rendered in stone, especially marble, and the rest is made from another material.

adlocutio (pl. *adlocutiones*) Public address.

adventus A ceremonial arrival, usually of the emperor, often shown in official public art.

aedicula (pl. *aediculae*) Literally "little temple." Decorative additions—each usually consisting of a floor, two supports and a pediment, and thus resembling a small temple facade—which were commonly applied, usually in two or more stories, to extensive wall surfaces on Roman buildings.

aedile Elected office, generally given oversight of public buildings, religious facilities and practice, and/or public order.

agonistic Referring to competition and competitive games.

akroterion (pl. *akroteria*) Sculptured statue or statues (or non-figural ornament) placed atop the roof of a building.

Amazonomachy From Greco-Roman mythology, a battle of Amazons with humans, usually Athenians.

ambulatory Walkway within a church, usually defined by one or more lines of columns.

amphora (pl. *amphorae*) Jar with upright handles on either side of the neck, used for storing wine or olive oil.

anaglyph Relief sculpture carved on both sides of the slab.

annular vault A **barrel vault** in the form of a circle, arc, or ellipse. Often these are multiple and concentric.

anta (pl. *antae*) Thickened wall ends, used to emphasize the entrance to an architectural space, generally used in temple porches and monumental gateways.

anthropomorphic Of human form.

apodyteria Changing room in a bath complex.

apotheosis Deification.

apse (architecture) The curved, semicircular part of any building, shaped roughly like a horseshoe. A building with an apse is **apsidal**.

Archaic Period c. 600–480 BCE.

architrave The horizontal blocks resting atop the columns.

arcosolium (pl. *arcosolia*) Arched niche in a catacomb that housed a sarcophagus.

atmospheric perspective The use of indistinct edges and muted color values to indicate the greater distance of the background elements in a painting.

atrium Open central room in an early Roman town house (**atrium house**), located immediately after an entrance passage (*fauces*), and around which other rooms are arranged.

atrium house Typical form of early Roman town house, with rooms arranged around an **atrium**.

attic The upper story of a portico, above the entablature.

Attica, Attic The region around Athens.

auctoritas Influence, in contrast with officially sanctioned authority (*potestas*).

Augustus (pl. *Augusti*) Title given to Octavian in the honors of 27 BCE, meaning "the illustrious one." Subsequently used as the title of senior emperors in the High and late empire.

aureus Roman gold coin, worth about a month's pay for a laborer or foot soldier. These were usually special commemorative issues, and types are therefore often of particular historical value.

barrel vault Roofing form created by the extension of an arch in space.

biconical Shaped like two cones joined at their wide ends.

bisellium A seat for two individuals that could be used to symbolize shared power, as of the consuls.

bucchero Black ceramic fabric, finer and later than—and no doubt developed from—impasto.

bucranium (pl. *bucrania*) Ox-skull.

caldarium (pl. *caldaria*) Hot room in a bath complex.

cameo Stone gem with naturally occurring layers of different colors carved so that a relief image would stand out in one color against a contrasting background.

canopic urn A **cinerary urn** with a lid in the form of a human head. Used in Archaic Etruria and named for the similar-looking Egyptian vessels in which the preserved organs of the mummified deceased were interred.

capital (architecture) Element crowning a column and supporting the **architrave**.

capite velato "With head draped." An image of a figure wearing a toga, with the fabric pulled over the top of his head, indicating a priest; in the case of imperial portraits it is meant to reference the emperor as *pontifex maximus*.

caryatid Support in the form of a female figure. Could serve as columns on buildings or, at a much smaller scale, in a similar function on ivory or ceramic footed cups, connecting bowl to base.

cavea Seating area of a theater or amphitheater.

cella The main room of a Greek or Roman temple, usually holding a cult statue.

censor Roman statesmen experienced in the highest magistracies, having reached the end of the *cursus honorum*, charged with the undertaking of the **census**.

census Periodic review of citizen and senatorial rolls undertaken by **censors**.

chiaroscuro Literally (Italian) "lightdark." In art, the use of contrasting areas of light and shadow to model three-dimensional forms.

chryselephantine An opulent and showier version of **acrolithic**. The flesh parts are in ivory and the drapery in gold.

cinerary urn Vessel used to hold ashes in cremation burials.

cista (pl. *cistae*) A container, often cylindrical.

Classical Period 480–323 BCE.

clerestory The upper part of a **nave**, where the windows are.

client (Latin: *cliens*, pl. *clientes*) A Roman senator's clients were non-noble citizens who supported him politically in exchange for benefits received.

clipeate From *clipeus* ("shield") meaning "in the shape of a shield."

clipeus virtutis "Shield of courage, clemency, justice and piety" voted to Augustus in 27 BCE and displayed in the senate house of the Republican forum. Originated the concept of imperial virtues that would become the centerpiece of much public commemorative art in the empire.

coffers/coffered Rectangular or square panels used to cover the rectangular spaces created by the intersecting beams of a ceiling—thus "coffered" ceilings. In vaulted concrete architecture, where they have no structural function, they are often used decoratively as insets into the concrete.

Composite Roman hybrid order of architecture combining elements of **Ionic** and **Corinthian** columns.

consul Chief civic, judicial, and military leaders, and chairs of the senate during the Republic; two were elected annually, each with veto power over the other. If a Republican consul died in office, he was replaced with a **suffect consul**. The original consul was called the "ordinary" consul. During the principate, consuls were nominated by the emperor, and there were often several pairs of consuls in the year. The suffect consulship became then an honorary title.

contabulatio Broad, plank-like fold that runs diagonally across the chest of a *togatus*. It is common in representations from the third century CE and later, as drapery forms become increasingly formalized.

continuous narrative Representation that depicts sequential episodes in a single story against a continuous background, with the main protagonist(s) repeated.

contrapposto Balanced pose: a straight, weight-bearing leg is matched by a straight, weight-bearing arm on the opposite side of the body; a bent, relaxed leg is matched by a bent, relaxed arm on the opposite side of the body.

corbel, corbeling (architecture) An arch or vault in which all stones are laid horizontally with the end of each course slightly overlapping that beneath it to cover an open space below.

Corinthian order Order of architecture invented in the late fifth century BCE as an alternative to **Doric** and **Ionic**; features a **capital** carved to resemble acanthus plants.

cornucopia A "horn of plenty," usually used as an attribute of a deity or as a personification of prosperity and/or fertility.

corona civica "Civic crown," granted to a Roman soldier who saved the life of a fellow citizen in battle. The senate granted a golden version to Augustus as part of his honors of 27 BCE.

cross vault or **groin vault** Two perpendicular, intersecting barrel vaults.

cubiculum (pl. *cubicula*) (i) Bedroom in a Roman house (ii) Recess in a catacomb, the size of a small room, which could be owned by a single family and in which numerous *loculi* and, thus, interments could be placed together.

cuirass portraits Portrait of a subject wearing a **cuirass**, thus emphasizing military accomplishment.

cuirass Military breastplate, usually leather.

cursus honorum Prescribed sequence of elective offices, with set interval, sought by Roman nobles to advance to the highest office (**consul**).

dado See orthostate.

damnatio memoriae "Damnation of Memory." Destroying or transforming verbal and visual references to a dishonored individual in an attempt to wipe out the record of their existence.

decennalia The ten-year anniversary of an event.

decursio (pl. *decursiones*) A ritual circling of a funeral pyre by a military parade held to honor the emperor as commander-in-chief of the legions.

denarius (pl. *denarii*) Roman silver coin, so called because it was worth ten Ases (smaller bronze coins); a *denarius* was about a day's pay for a soldier or laborer, so these were common and widely circulated.

dentil cornice A crowning element consisting of a row of rectangular projects.

die The metal form used to make ancient coins.

dignitas A quality cultivated and much sought by Roman aristocrats, which derived from personal virtue and manifested in the respect of one's peers.

diribitorium Area or room where votes were counted, part of the **Saepta** complex.

distyle Consisting of two columns.

domus House.

Doric order The "masculine" order of architecture. A Greek creation, it is rarely used in Roman-era buildings.

echinus Distinctive cushion-shaped part of a **Doric capital**, just below the **abacus**.

emblema Pictorial panel in *opus vermiculatum* located within a large mosaic floor set with bigger **tesserae**.

encaustic Painting technique that uses wax as its binding **medium**.

engaged columns/entablature Built into and partially protruding from a wall.

entablature Everything between the top of the columns and the bottom of the roof; **architrave** plus **frieze**.

Epicurean, Epicureanism Referring to the teachings of the **Hellenistic** philosopher Epicurus (341–270 BCE). He taught that one should seek pleasure through virtue and moderation.

eques (pl. *equites*) "Knight." Wealthy Roman not of the senatorial class.

euergetism Public beneficence, especially in the funding of buildings and programs of direct benefit to the populace.

exedra (pl. **exedrae**) Projection of an architectural feature (for example a wall or **portico**) creating a curved or rectangular recessed space that can be devoted to a particular activity and/or used for display, especially of statuary.

exergue Space at the bottom of a coin (especially) or other circular field that is set off by an upper horizontal border.

fasces Bundle of rods, sometimes surrounding an ax, held by a **lictor**.

fauces Literally "throat," the entrance passage into a Roman **atrium house**.

fibula Clothing fastener, often elaborately decorative; functioned like a modern safety pin.

First Triumvirate Extra-constitutional share of rule among three men established by Caesar, Crassus, and Pompey, 59 BCE. Renewed 54 BCE.

flute (architecture) A vertical groove in a column, roughly semicircular in section.

frieze (architecture) A horizontal zone running around the outside of a building immediately above the **architrave**. The Doric frieze alternates **triglyphs** and **metopes**; the Ionic frieze is unbroken and may or may not be decorated. Also used for any decorated, horizontal band.

frigidarium Cold room in a bath complex.

genius (pl. *genii*) The divine spirit within a person, place, or thing. Often given human form in art, and were worshiped as protective spirits.

Gigantomachy Battle of Olympian deities against giants.

graffito Inscription scratched into a wall or other surface, rather than painted or formally carved into stone.

granulation Technique of applying tiny beads of metal (usually gold) to create figures and ornament on a piece of gold jewelry.

guilloche pattern Border ornament composed of two tightly intertwined helices, also called a "cable pattern."

gymnasium (pl. **gymnasia**) Greek building type used for the physical and academic education of youths, usually males of social standing. These included, or were adjacent to, exercise areas, lecture halls, and often, especially later, libraries and bathing facilities.

Hellenism A feature considered characteristic of Greek (Hellenic) art or culture, or the general quality of being "Greek-like."

Hellenistic Period 323–27 BCE.

herm, hermaic A sculptured monument that consists of a human head (ostensibly but not necessarily of Hermes) atop a rectangular pillar. The form came to be used by Romans for the display of portrait heads, especially those copied from Greek bronze full-length portraits of Classical and Hellenistic times.

High Empire Period of relative peace and prosperity comprising the reigns of Trajan, Hadrian, and the Antonines. Roughly the second century CE.

hippodrome A facility for horse races. The term is Greek, and functionally equates to the Roman "circus."

horologium Sundial that uses a shadow created by sunlight to indicate time of day.

hypaethral A structure without a roof.

idealism Here, quality of artistic styles that avoid specific depictions and incline toward the generic (ideal). Often implies that the generic form is intended to illustrate a "perfect" example of what it represents.

imago (pl. *imagines*) Wax portrait of ancestors displayed in the houses of the elite and publicly at funerals.

impasto Coarse dark gray or black pottery common in northern Italy during the ninth and eighth centuries BCE.

imperator (pl. *imperatores*) Literally, one who holds *imperium*. Came to mean one who had celebrated a **triumph**, for which one had to hold *imperium*.

imperium Absolute power, specifically that granted the general of an army for a particular campaign.

GLOSSARY 389

impluvium Rectangular basin set in the floor of the **atrium** of a Roman house to collect rainwater fallen through the *compluvium*.

in the round Freestanding statuary as opposed to **relief sculpture**.

Ionic order The "feminine" order of architecture features fluted columns, a **capital** with **volutes**, and often a **frieze** bearing figural sculpture.

isocephaly Arrangement of figures in a horizontal row with all heads at the same height.

Lar/Lares Roman protective household gods.

late antique Belonging to late antiquity—a variously defined period between, and connecting, Classical antiquity and early medieval times, conventionally from Constantine to Charlemagne during the fourth to eighth centuries CE.

legatus (legate) High-ranking Roman military officer.

lictor Attendant to a Roman magistrate holding **imperium**. A lictor carried a bundle of bound rods (**fasces**) that symbolized the magistrate's authority.

limes (pl. *limites*) Boundaries of the Roman empire.

linear perspective Suggesting spatial depth in a flat medium (especially painting) by using **orthogonals**.

lituus Hooked staff used by an augur, a Roman priest who would foretell the future by reading the flight of birds. In Roman art it symbolized such a priesthood, augury in general, or (when included in clusters of such symbols) the multiple priesthoods of the emperor.

loculus (pl. *loculi*) The recessed, shelflike space in a catacomb where the body of the deceased is laid.

lost-wax casting Technique for casting bronze in which a wax prototype is embedded in clay, the wax is melted out, and melted bronze is poured into the resulting cavity.

low-relief *See* **relief sculpture**.

lustratio Religious ritual of purification.

macellum Market building, most often a rectangular courtyard surrounded by a portico containing shops.

maenad Female follower of Dionysus (Bacchus). Usually shown wearing an animal hide over her clothes.

manubial A monument funded *ex manubiis*, "from the spoils of battle," technically to fulfill a vow to a particular deity made before the battle.

mauseoleum (pl. *mausolea*) Originally tomb of Mausolus, Satrap of Caria under the Persian King (*c.* 350 BCE); thereafter, a monumental public tomb generally.

meander frieze Distinctive Greek pattern of sharply twisting lines.

medium (pl. *media*) Here, a category of artwork: painting, sculpture, architecture, etc. Sometimes used to designate material: metal, stone, clay, etc.

megalography, megalographic Describes a composition, usually in painting, in which a few large figures are used to fill the field.

menorah The seven-lamp (six branches) lampstand of gold placed in the Hebrew temple in Jerusalem and taken to Rome as part of the spoils of Vespasian's and Titus's Judaean War (66–73 CE).

meridiem Sundial that uses the changing position of the sun's shadow, as cast at noon, to indicate the time of year.

metope Square or rectangular panel, part of a **Doric frieze**. Can be decorated with paint or relief carving. Alternates with **triglyphs**.

metroon Temple to the Mother of the Gods.

monetales Junior elected magistrates of the rank of **quaestor** responsible for the operation of the mints in Rome.

monopteros A temple- or treasury-like structure without a **cella**, consisting only of **peristyle** and roof.

mos maiorum "Custom of our forebears"; Roman cultural, social, and political tradition.

mural crown Headgear in the form of a crenellated fortification, usually worn by a personification (or the Tyche/Fortuna) of a city.

narthex A shallow space, usually running the width of the church, preceding the entrance into the nave proper. Worshipers could gather here before proceeding within.

naumachia A mock naval battle staged for entertainment, or a facility used for such.

nave The central part of a basilica or church building.

necropolis Literally "city of the dead," the location where the dead are interred.

negotium Business or responsibility.

nenfro A kind of tuff, volcanic rock, occurring in Etruria and Latium. Used as building material and, especially in early Etruscan art, sculpture.

Neo-Attic Sculptures from late Hellenistic and Roman times that employ Classical or classicizing styles. They tend to use stock, repetitive figural types. These are mostly relief sculptures but some types exist also in statuary.

nobilis (pl. *nobiles*) Noble, specifically one whose relative had held the consulship.

novus homo A man who has no senators (or, sometimes, **consuls**) among his ancestors.

nymphaeum In Roman architecture a nymphaeum is usually a grotto, building, or sanctuary consecrated to nymphs, containing a fountain.

octostyle "Having eight columns," almost always referring to a facade, usually that of a temple.

oculus Circular opening ("eye" in Latin) in the center of a dome.

odeum Covered space (similar to a small indoor theater) for musical performance and competition.

one-point perspective Linear perspective consistently applied to a scene in which all orthogonals depict lines that are parallel to one another, and thus are seen to converge at a single point directly facing the viewer.

optimate Roman senator who favored conservative policies, guarding the traditions of the senate, and avoiding concessions of authority to the common citizenry.

optimus princeps "The best **princeps** (emperor)."

opus incertum Style of concrete facing composed of unshaped stones.

opus reticulatum Style of concrete facing composed of stones cut with diamond-shaped facing stones arranged in a net-shaped pattern.

opus sectile Decorative technique that uses cut sections of thin-colored stone to create patterns and figures in walls and on floors.

opus testaceum Style of concrete facing composed of terracotta roof tiles (*testae*).

opus vermiculatum Mosaic technique that uses tiny ("worm-like") tesserae to depict finer detail for a painting-like effect.

orchestra Floor of an ancient theater, between the seating (**cavea**) and the stage building.

order (architecture) Formula for designing buildings. Doric, Ionic, Corinthian, Composite, and Tuscan are the most important.

orientalizing Containing stylistic and/or iconographic features typical of objects manufactured in the Near East.

orthogonal *See* **receding orthogonal**.

orthostate The lower course or courses of a wall, decoratively or structurally set off from the masonry above.

otium Pleasure, relaxation, respite from work.

palaestra (pl. *palaestrae*) Greek term for a facility used for wrestling; in Roman baths an exercise courtyard.

palmette An ornament of radiating petals.

parodos (pl. *parodoi*) Passageway(s) from interior to exterior of an ancient theater, which led from the orchestra out through the spaces between the ends of the **cavea** and the stage building.

patrician Technically, a member of a family descended from the original families of Rome, by some accounts from the first 100 senators appointed and named the *patres* (fathers) by Romulus himself.

patron, patronage The relationship of a prominent Roman, especially a senator, to his **clients**.

pediment A gable, the triangular open end of a pitched roof.

peperino A volcanic tuff quarried in central Italy and renowned for its supposed resistance to fire.

peplos Heavy woolen garment worn by both women and girls, most typical in art of the Greek Classical period (480–323 BCE).

peripteral Surrounded on all sides by columns, usually of a temple.

peristyle Row of columns running around all four sides of a temple or a courtyard.

perspectival diminution The phenomenon of objects looking smaller as they are further away.

Phoenician Native of Phoenicia, an ancient area on the Mediterranean coast of the Near East corresponding roughly to modern Lebanon.

pi-shaped Shaped like the Greek letter *pi*.

piece-casting Casting a metal object in separate pieces then joined together.

pier Vertical support, generally rectangular.

pilaster Engaged architectural support; usually rectilinear in cross-section.

piscina (pl. ***piscinae***) "Fishpond"; swimming pool in a bath complex.

plebeian Free Roman citizen who is not a **patrician**, also known as a pleb.

polis (pl. ***poleis***) Greek term for a city-state, the typical local form of political and social organization in Greece.

polysemy The quality of multiple coexisting meanings for something.

pomerium Traditional religious boundary of the city of Rome, established, allegedly, by Romulus and periodically extended.

pontifex maximus Chief priesthood of the Roman state, held for life. After Augustus assumed the office in 12 BCE on the death of its occupant, M. Aemilius Lepidus, it was held by all emperors.

popularis Roman senator who cultivated support of the voting public in order to wield power.

porphyry Hard, dark purple stone from Egypt.

portico Colonnade surrounding an open space, such as a forum, or in a domestic context, a courtyard or garden.

post and lintel Architectural support system based on vertical elements (posts) supporting a horizontal element (lintels); the lintel is perpendicular to its posts. Also called **trabeated**.

praetor During the Republic, an elected magistrate second only to consul in power, with similar military, judicial, and other duties, usually more strictly defined. The title could be assigned to an appointed military commander or other official.

Praetorian Guard Body of troops stationed in Rome that served as a personal guard for high magistrates during the Republic and, from the time of Augustus onward, the ***princeps***, when it grew greatly in size, power, and influence.

princeps (pl. ***principes***) "First." Taken by Augustus as an official title and used by his successors.

princeps senatus "First of the senate." Senior senator with right to speak first in deliberations. Augustus's adoption of "*princeps*" included this right.

principate System of government rule by the "*princeps*," established by Augustus.

profectio A ceremonial departure, usually of the emperor, often shown in official public art.

propylon Front gate.

proscenium Long, low vertical wall at the front of the **pulpitum** of a Roman theater, between the stage surface and the **orchestra** below. It often held **relief sculpture**.

prostyle Refers to a temple or temple porch with a row of columns set entirely in front of the front wall(s).

protome Face, used as an applied decorative element.

pseudoperipteral Describes a building entirely surrounded by columns, some of which are engaged rather than freestanding.

pteroma The space between the **cella** of a **peripteral** temple and the **peristyle** itself.

pulpitum In a Roman theater, a raised stage on which performances took place.

putto (pl. *putti*) An infant or small child, usually winged, when it is indistinguishable from a young Cupid.

pylon Gate.

quadriga Four-horse chariot.

quaestor Entry-level magistracy for young men from noble families that granted senate membership. Responsibilities were various, but usually financial, including the minting of money (*monetales*).

radiocarbon dating Scientific dating technique based on the rate at which a certain type of carbon atom decays over time.

receding orthogonals Lines in a painting that recede into space perpendicular to the picture plane but appear diagonal because of perspectival diminution of the space between them.

red ware The most common type of Roman fine ware. *Terra sigillata* is one type.

re-entrant (architecture) A section of **entablature** that projects out from another section of entablature engaged in the wall behind, and which is supported by a freestanding or **engaged column** beneath.

relief sculpture Sculpture in which the figures project from a block or slab of stone. In high relief the figures project more; in low relief they project less.

repoussé A technique for making relief images in metal by hammering the material from behind.

revetment Protective element, often terracotta, applied to wooden architectural features.

romanitas Latin for "Roman-ness."

roundel Disk-shaped object; in this book generally a stone relief sculpture.

saepta Building that was designed to separate (thus the name, meaning a fence or space enclosed by one) people into groups or lines and thus used for voting.

sarcophagus (pl. **sarcophagi**) Container for the inhumed remains of the deceased, usually rectangular and covered with a lid. Etruscan and Roman sarcophagi were terracotta or stone.

scaenae frons (pl. *scaenae frontes*) Architectural backdrop, usually large, permanent, and extensively decorated, of a Roman stage building immediately behind the raised stage (*pulpitum*) itself.

sealstone Stone with an image or pattern cut into it (intaglio), which creates a relief image when pressed into soft clay, wax, or other material, thus functioning as a seal.

Second Sophistic Activity, especially popular in Athens and Asia Minor during the High Empire, that fostered the revival of Classical rhetoric among influential and intellectual Greeks. It centered on public declamation and rhetorical competition.

skene (Greek: "tent") Backdrop of a Greek theater, usually made of perishable materials.

skenographia Greek for "scene painting." Refers to the rendering of three-dimensional form in painting through linear perspective.

skiagraphia Greek for "shadow painting," refers to the rendering of three-dimensional form in painting through the depiction of light and shadow.

socle A low plinth supporting a wall, column, urn, or statue.

span Space or distance covered by an arch or vault.

spandrel The almost triangular area between the outer curve of an arch and the perpendicular elements (usually a **pilaster** and **entablature**) that frame it.

spolia Reused building material from an earlier monument or structure.

spolia opima "Rich spoils," armor and weapons taken by an army general with *imperium* from an opposing commander whom he personally killed.

springing point Resting point of an arch or vault above which it begins to curve.

stucco A fine plaster used in the coating of wall surfaces or for molding into wall decorations.

suffect consul *See* **consul**.

suovetaurilia Sacrifice of a boar, a ram, and a bull.

supplicatio A procession of thanksgiving, stopping to make offerings at a sequence of cult locations.

symposium (pl. **symposia**) After-dinner gathering of Greek men for the purposes of drinking and socializing, often accompanied by musicians and courtesans.

tableau Here, a decorative scene including patterns and/or images.

tablinum Primary reception room at back of the atrium, where *imagines* and family records were kept.

tempera Egg white, used as a binding medium in painting.

tepidarium (pl. *tepidaria*) Warm room in a bath complex.

terra sigillata "Stamped clay or earth," a class of Roman pottery found from the later Republic through the empire, with decoration stamped onto the clay before firing.

tessera (pl. *tesserae*) Individually cut stone used to make a mosaic.

testa (pl. *testae*) Terracotta roof tile.

thermae From the Greek for "hot," a common Latin term for baths, especially large public baths.

thiasos Procession of Dionysos/Bacchus with his retinue of satyrs and maenads.

tholos (pl. *tholoi*) Building or tomb with a circular plan.

titulus (pl. *tituli*) Inscription associated with a portrait, especially an *imago*, indicating offices held.

toga picta Decorated Roman garment worn by the commanding general during a *triumph*.

togate (Latin sing. *togatus* pl. *togati*) Wearing a toga.

tondo (pl. *tondi*) A circular relief or painting.

trabeated Built using a **post-and-lintel** system of supports.

travertine Locally available white limestone sometimes used like marble in Roman architecture.

tribune (military) Junior military officer, first post in the army for men from wealthy families, both noble and equestrian.

tribune (of the **plebeians**/plebs) Elected office established in the early Republic responsible for representing the interests of the people (plebs) in the deliberations of the senate.

triclinium Dining room.

triglyph Grooved panel, part of a **Doric frieze**. Alternates with **metopes**.

triumph Ritual held in Rome to commemorate a military victory. It included a parade of troops and spoils through a fixed route winding from a gate near the Campus Martius to the Capitoline hill, where a sacrifice to Jupiter took place.

triumphator One who has been voted a triumph by the senate.

tumulus Earthen mound surmounting a tomb, associated especially with the rock-cut chamber tombs of southern Etruria.

Tuscan Roman hybrid order of architecture deriving from local Italic form and used to replace Doric columns, with slenderer proportions but retaining unfluted columns, bases, and smooth capitals.

tyrant Sole ruler of a Greek city-state not selected through normal political process who maintains rule primarily through popular support.

ustrinum (pl. *ustrina*) Location of a cremation, especially a permanent monument marking such a spot.

verism, veristic Portraiture that depicts individual facial features in direct, even exaggerated, detail. Derives from the Latin *verus* ("true"), which suggests a highly realistic style.

vexillum Military banner carried in battle as the rallying point, and therefore symbol, of a single maniple (a unit of 60–120 men).

vicomagister (pl *vicomagistri*) A magistrate of a particular *vicus* of Rome.

victimarius (pl. *victimarii*) Religious attendant who brings a victim to sacrifice.

vicus (pl. *vici*) An administrative district of Rome, of which, in the empire, there were 265.

volute Spiral, the distinctive lower part of an Ionic capital, just below the abacus.

votive Something offered to a deity in hopes of securing favor.

voussoir Trapezoidally cut block of stone used to make an arch.

Further Reading

A select list of books and monographs with an emphasis on more recent studies. Several older works of fundamental importance are also included.

HISTORY AND CULTURE

Barchiesi, A., and W. Scheidel, eds., *Oxford Handbook of Roman Studies*. Oxford University Press, 2010.

Beard, M., *SPQR: A History of Ancient Rome*. Liveright, 2016.

Beard, M., *The Roman Triumph*. Harvard University Press, 2009.

Beard, M., J. North, and S. Price, *Religions of Rome* vol. 1 and 2. Cambridge University Press, 1998.

Galinksy, K., et al., eds., *Cultural Memories in the Roman Empire*. J. Paul Getty Museum, 2012.

Gruen, E. *Culture and National Identity in Republican Rome*. Cornell University Press, 1992.

Pollini, J., *From Republic to Empire: Rhetoric, Religion, and Power in the Visual Culture of Ancient Rome*. University of Oklahoma Press, 2012.

Potter, D., *Ancient Rome: A New History*, 3rd edn. Thames & Hudson, 2018.

Strauss, B., *Ten Caesars: Roman Emperors from Augustus to Constantine*. Simon and Schuster, 2019.

ART AND ARCHAEOLOGY: GENERAL

Beard. M., and J. Henderson, *Classical Art from Greece to Rome*. Oxford University Press, 2001.

Brendel, O., *Prolegomena to the Study of Roman Art*. Yale University Press, 1979.

Brilliant, R., *Visual Narratives: Storytelling in Etruscan and Roman Art*. Cornell University Press, 1984.

Claridge, A., *Rome: An Oxford Archaeological Guide*. New York: Oxford University Press, 1998.

Clarke, J., *Art in the Lives of Ordinary Romans: Visual Representation and Non-Elite Viewers in Italy, 100 BC–AD 315*. University of California Press, 2003.

D'Ambra E., and G. Metraux, eds., *The Art of Citizens, Soldiers, and Freedmen in the Roman World*. Archaeopress, 2006.

Elsner, J., *Art and Text in Roman Culture*. Cambridge University Press, 1996.

Fredrick, D., *The Roman Gaze: Vision, Power, and the Body*. Johns Hopkins University Press, 2002.

Gazda, E., ed., *Roman Art in the Private Sphere*. University of Michigan Press, 1991.

Holscher, T., *The Language of Images in Roman Art*. Cambridge University Press, 2004.

Isager, J., *Pliny on Art and Society: The Elder Pliny's Chapters on the History of Art*. Routledge, 2013.

Kampen, N., *Family Fictions in Roman Art*. Cambridge University Press, 2009.

Kleiner, D., and S. B. Matheson, eds., *I, Claudia I: Women in Ancient Rome*. Yale University Art Gallery, 1996.

Kleiner, D. and S. B. Matheson, eds., *I, Claudia II: Women in Roman Art and Society*. University of Texas Press, 2000.

Pollitt, J., *The Art of Rome, 753 BC–AD 337: Sources and Documents*. Cambridge University Press, 1983.

Richardson Jr., L., *A New Topographical Dictionary of Ancient Rome*. Johns Hopkins University Press, 1992.

Rutledge, S., *Ancient Rome as a Museum: Power, Identity, and the Culture of Collecting*. Oxford University Press, 2012.

Stewart, P., *Roman Art*. Oxford University Press, 2004.

Strong, D., and R. Ling, *Roman Art*, 2nd edn. Yale University Press, 1988.

Taylor, R., *The Moral Mirror of Roman Art*. Cambridge University Press, 2008.

ARCHITECTURE AND TOPOGRAPHY

Adam, J., *Roman Building: Materials and Techniques*. Routledge, 2001.

Anderson, J., *Roman Architecture and Society*. Johns Hopkins University Press, 1997.

Bomgardner, D., *The Story of the Roman Amphitheatre*. Routledge, 2000.

Carandini, A., ed., *The Atlas of Ancient Rome: Biography and Portraits of the City*. Princeton University Press, 2017.

Clarke, J., *The Houses of Roman Italy, 100 BC–AD 250*. University of California Press, 1991.

Conlin, D., and P. Jacobs, *Campus Martius: The Field of Mars in the Life of Ancient Rome*. Cambridge University Press, 2014.

Ellis, S., *Roman Housing*. Duckworth, 2000.

Evans, H., *Water Distribution in Ancient Rome: The Evidence of Frontinus*. University of Michigan Press, 1994.

Hales, S., *The Roman House and Social Identity*. Cambridge University Press, 2003.

MacDonald, W., *The Architecture of the Roman Empire I: An Introductory Study*. Yale University Press, 1982.

MacDonald, W., *The Architecture of the Roman Empire II: An Urban Appraisal*. Yale University Press, 1986.

Marzano, A. and G. Métraux, *The Roman Villa in the Mediterranean Basin: Late Republic to Late Antiquity*. Cambridge University Press, 2018.

Orlin, E., *Temples, Religion, and Politics in the Roman Republic*. E. J. Brill, 1997.

Rowland, I., and T. Howe, *Vitruvius: Ten Books on Architecture*. Cambridge University Press, 1999.

Stambaugh, J., *The Ancient Roman City*. Johns Hopkins University Press, 1988.

Stamper, J., *The Architecture of Roman Temples: The Republic to the Middle Empire*. Cambridge University Press, 2005.

Taylor, R., *Roman Builders: A Study in Architectural Process*. Cambridge University Press, 2003.

Ulrich, R., and C. Quenemoen, eds., *A Companion to Roman Architecture*. Wiley-Blackwell, 2013.

Ward-Perkins, J., *Roman Imperial Architecture*. Yale University Press, 1981.

Welch, K., *The Roman Amphitheatre: From Its Origins to the Colosseum*. Cambridge University Press, 2005.

Wilson-Jones, M., *Principles of Roman Architecture*. Yale University Press, 2000.

Yegul, F., *Baths and Bathing in Classical Antiquity*. MIT Press, 1992

SCULPTURE

Davies, P., *Death and the Emperor: Roman Imperial Funerary Monuments from Augustus to Marcus Aurelius*. Cambridge University Press, 2000.

DeGrummond, N. and B. Ridgway, *From Pergamon to Sperlonga: Sculpture and Context*. University of California Press, 2001.

Fejfer, J., *Roman Portraits in Context*. Walter de Gruyter, 2008.

Friedland, E., M. Sobocinski, and E. Gazda, *The Oxford Handbook of Roman Sculpture*. Oxford University Press, 2015.

Gazda, E., ed., *The Ancient Art of Emulation: Studies in Artistic Originality and Tradition from the Present to Classical Antiquity*. University of Michigan Press, 2002.

Hallett, C., *The Roman Nude: Heroic Portrait Statuary 200 BC–AD 300*. Oxford University Press, 2005.

Kleiner, D., *Roman Sculpture*. Yale University Press, 1992.

Kousser, R., *Hellenistic and Roman Ideal Sculpture: The Allure of the Classical*. Cambridge University Press, 2008.

Longfellow, B., *Roman Imperialism and Civic Patronage: Form, Meaning, and Ideology in Monumental Fountain Complexes*. Cambridge University Press, 2011.

Madigan, B., *The Ceremonial Sculptures of the Roman Gods*. Brill, 2012.

Marvin, M., *The Language of the Muses: The Dialogue between Roman and Greek Sculpture*. J. Paul Getty Museum, 2008.

Mattusch, C., *The Villa dei Papiri at Herculaneum: Life and Afterlife of a Sculpture Collection*. J. Paul Getty Museum, 2005.

Prusac, M., *From Face to Face: Recarving of Roman Portraits and the Late-Antique Portrait Arts*. Brill, 2011.

Stewart, P., *Statues in Roman Society*. Oxford University Press, 2003.

Torelli, M., *Typology and Structure of Roman Historical Reliefs*. University of Michigan Press, 1982.

Varner, E. R., *Mutilation and Transformation: Damnatio Memoriae and Roman Imperial Portraiture*. Brill, 2004.

Zanker, P., and B. Ewald, *Living with Myths: The Imagery of Roman Sarcophagi*. Oxford University Press, 2013.

PAINTING AND MOSAICS

Dunbabin, K., *Mosaics of the Greek and Roman World*. Cambridge University Press, 1999.

Hachlili, R., *Ancient Mosaic Pavements: Themes, Issues, and Trends*. Brill, 2008.

Jones, N., *Painting, Ethics, and Aesthetics in Rome*. Cambridge University Press, 2019.

Leach, E., *The Rhetoric of Space: Literary and Artistic Representations of Landscape in Republican and Augustan Rome*. Princeton University Press, 1988.

Leach, E., *The Social Life of Painting in Ancient Rome and on the Bay of Naples*. New York: Cambridge University Press, 2004.

Ling, R., *Ancient Mosaics*. Princeton University Press, 1998.

Ling, R., *Roman Painting*. New York: Cambridge University Press, 1991.

Mazzoleni, D., *Domus: Wall Painting in the Roman House*. J. Paul Getty Museum, 2004.

Pappalardo, U., *The Splendor of Roman Wall Painting*. J. Paul Getty Museum, 2009.

Richardson Jr., L., *A Catalog of Identifiable Figure Painters of Ancient Pompeii, Herculaneum, and Stabiae*. Johns Hopkins University Press, 2000.

Walker, Susan, ed., *Ancient Faces: Mummy Portraits from Roman Egypt*. Metropolitan Museum of Art, 2000.

PERIODS

Etruscan Italy and the Roman Republic

Barker, G., and T. Rasmussen, *The Etruscans*. Blackwell, 2000.

Boethius, A., *Etruscan and Early Roman Architecture*. Yale University Press, 1978.

Brendel, O. J., *Etruscan Art*. Yale University Press, 1995.

Davies, P., *Architecture and Politics in Republican Rome*. Cambridge University Press, 2018.

Flower, H., *Ancestor Masks and Aristocratic Power in Roman Culture*. Clarendon Press, 1996.

Haynes, S., *Etruscan Civilization: A Cultural History*. J. Paul Getty Museum, 2000.

Holliday, P., *The Origins of Roman Historical Commemoration in the Visual Arts*. Cambridge University Press, 2002.

Spivey, N., *Etruscan Art*. Thames & Hudson, 1997.

Torelli, M., ed., *The Etruscans*. Rizzoli, 2001.

Turfa, J. M., ed., *The Etruscan World*. Routledge, 2017.

Augustus and the Early Empire

Ball, L., *The Domus Aurea and the Roman Architectural Revolution*. Cambridge University Press, 2003.

Bartman, E., *Portraits of Livia: Imaging the Imperial Woman in Augustan Rome*. Cambridge University Press, 1999.

Boyle, A. J., *Flavian Rome, Culture, Image, Text*. Brill, 2002.

Castriota, D., *The Ara Pacis Augustae and the Imagery of Abundance in Later Greek and Early Roman Imperial Art*. Princeton University Press, 1995.

Conlin, D., *The Artists of the Ara Pacis*. University of North Carolina Press, 1997.

D'Ambra, E., *Private Lives, Imperial Virtues: The Frieze of the Forum Transitorium in Rome*. Princeton University Press, 1993.

Darwall-Smith, R., *Emperors and Architecture: A Study of Flavian Rome*. Latomus, 1996.

Favro, D., *The Urban Image of Augustan Rome*. Cambridge University Press, 1996.

Galinsky, G., *Karl. Augustan Culture*. Princeton University Press, 1996.

Rehak, P., *Imperium and Cosmos: Augustus and the Northern Campus Martius*. University of Wisconsin Press, 2009.

Rose, C. B., *Dynastic Commemoration and Imperial Portraiture in the Julio-Claudian Period*. Cambridge University Press, 1997.

Zanker, P., *The Power of Images in the Age of Augustus*. University of Michigan Press, 1988.

High Empire

Beckmann, M., *The Column of Marcus Aurelius: The Genesis and Meaning of a Roman Imperial Monument*. University of North Carolina Press, 2011.

Boatwright, M., *Hadrian and the City of Rome*. Princeton University Press, 1987.

Kampen, N., *Image and Status: Roman Working Women in Ostia*. Mann, 1981.

MacDonald, W. L., and J. Pinto, *Hadrian's Villa and Its Legacy*. Yale University Press, 1995.

Opper, T., ed., *Hadrian: Art, Politics, Economy*. British Museum Press, 2012.

Packer, J. E., *The Forum of Trajan in Rome: A Study of the Monuments*. University of California Press, 1997.

Thomas, E., *Monumentality and the Roman Empire: Architecture in the Antonine Age*. Oxford University Press, 2007

Late Empire

Bassett, S., *The Urban Image of Late Antique Constantinople*. Cambridge University Press, 2007.

Bowersock, G. W., P. Brown, and O. Grabar, eds., *Late Antiquity: A Guide to the Postclassical World*. Harvard University Press, 1998.

Elsner, J., *Imperial Rome and Christian Triumph*. Oxford University Press, 1998.

Holloway, R. R., *Constantine and Rome*. Yale University Press, 2004.

Kulikowski, M., *The Triumph of Empire: The Roman World from Hadrian to Constantine*. Harvard University Press, 2016.

Mathews, T., *The Clash of Gods: A Reinterpretation of Early Christian Art*. Princeton University Press, 1999.

L'Orange, H. P., *The Roman Empire: Art Forms and Civic Life*. Rizzoli, 1985.

Wilkes, J. J., *Diocletian's Palace, Split*. Oxbow, 1993.

Wood, S., *Roman Portrait Sculpture. AD 217–260*. Brill, 1986.

REGIONS

Italy and the Western Mediterranean

Anderson Jr., J. C., *Roman Architecture in Provence*. Cambridge University Press, 2012.

Bromwich, J., *The Roman Remains of Southern France*. Routledge, 1993.

Cleere, H., *Southern France: An Oxford Archaeological Guide*. Oxford University Press, 2001.

Coarelli, F., ed., *Pompeii*. Riverside, 2002.

Deiss, J. J., *Herculaneum: Italy's Buried Treasure*. J. Paul Getty Museum, 1989.

Dunbabin K. M. D., *The Mosaics of Roman North Africa: Studies in Iconography and Patronage*. Oxford University Press, 1978.

Laird, M., *Civic Monuments and the Augustales in Roman Italy*. Cambridge University Press, 2015.

Neal, D., and S. Cosh, *The Roman Mosaics of Britain* (4 vols). Society of Antiquaries, 2002, 2006, 2009, 2010.

Parrish, D., *Season Mosaics of Roman North Africa*. Giorgio Bretschneider, 1984.

Potter, T., *Roman Italy*. University of California Press, 1987.

Richardson Jr., L., *Pompeii: An Architectural History*. Johns Hopkins University Press, 1988.

Wightman, E., *Roman Trier and the Treveri*. Praeger, 1971.

Zanker, P., *Pompeii: Public and Private Life*. Harvard University Press, 1999.

Eastern Mediterranean

Bagnall, R., and D. Rathbone, eds., *Egypt from Alexander to the Early Christians*. J. Paul Getty Museum, 2004.

Bianchi Bandinelli, R., E. Vergara Caffarelli, and G. Caputo, *The Buried City: Excavations at Leptis Magna*. Praeger, 1966.

Boatwright, M. T., *Hadrian and the Cities of the Roman Empire*. Princeton University Press, 2002.

Goldhill, S. ed., *Being Greek under Rome: Cultural Identity, the Second Sophistic, and the Development of Empire*. Cambridge University Press, 2001.

McKenzie, J., *The Architecture of Alexandria and Egypt, 300 BC–AD 700*. Yale University Press, 2007.

Smith R., *Aphrodisias VI: The Marble Reliefs from the Sebasteion*. Von Zabern, 2013.

Spawforth, A., *Greece and the Augustan Cultural Revolution*. Cambridge University Press, 2011.

Taylor, Jane. *Petra and the Lost Kingdom of the Nabataeans*. Harvard University Press, 2002.

Vermeule, C., *Roman Imperial Art in Greece and Asia Minor*. Harvard University Press, 1968.

Sources of Quotations

Introduction
p. 17: Vitruvius, *De Architectura*, tr. by Morris Hicky Morgan (Cambridge, MA: Harvard University Press; London: Oxford University Press, 1914).

Chapter 1
p. 22: Dionysius of Halicarnassus, *Roman Antiquities*, tr. Earnest Cary, Loeb Classical Library 319 (Cambridge, MA: Harvard University Press, 1937).

p. 46: Pliny the Elder, *Natural History*, tr. H. Rackham, W. H. S. Jones, and D. E. Eichholz (Cambridge, MA: Harvard University Press, 1961).

Chapter 2
p. 51: Plutarch, *The Art of Rome c. 753 B.C.–A.D. 337: Sources and Documents*, tr. Jerome Jordan Pollitt (Cambridge: Cambridge University Press, 1983), p. 32.

p. 52: Florus, *The Art of Rome c. 753 B.C.–A.D. 337: Sources and Documents*, tr. Jerome Jordan Pollitt (Cambridge: Cambridge University Press, 1983), p. 25.

p. 59: Velleius Paterculus, *The Art of Rome c. 753 B.C.–A.D. 337: Sources and Documents*, tr. Jerome Jordan Pollitt (Cambridge: Cambridge University Press, 1983), p. 47.

p. 63: Pliny the Elder, *The Art of Rome c. 753 B.C.–A.D. 337: Sources and Documents*, tr. Jerome Jordan Pollitt (Cambridge: Cambridge University Press, 1983), p. 51.

p. 71: Polybius, *Histories* 6.53, tr. Evelyn S. Shuckburgh, "Roman Funeral Rites," from www.perseus.tufts.edu (London, New York: Macmillan, 1889).

p. 71: Polybius, *The Art of Rome c. 753 B.C.–A.D. 337: Sources and Documents*, tr. Jerome Jordan Pollitt (Cambridge: Cambridge University Press, 1983), p. 53

Chapter 3
p. 95: Cicero, *The Letters of Cicero: The Whole Extant Correspondence in Chronological Order* vol. 1, tr. Evelyn S. Shuckburgh (London: G. Bell and Sons, 1920).

Chapter 4
p. 104: Plutarch, *Lives* vol. V, tr. Bernadotte Perrin, Loeb Classical Library 87 (Cambridge, MA: Harvard University Press, 1917).

p. 105: Tertullian, *De Spectaculis* 10.5, tr. Mark D. Fullerton.

p.112: Suetonius, *The Art of Rome c. 753 B.C.–A.D. 337: Sources and Documents*, tr. Jerome Jordan Pollitt (Cambridge: Cambridge University Press, 1983), p. 104.

Part II opener
p. 126: Tacitus, *The Annals* 1.2–1.3, tr. Mark D. Fullerton.

Chapter 5
p. 130: Augustus, *Res Gestae Divi Augusti*, tr. Frederick W. Shipley, Loeb Classical Library 152 (Cambridge, MA: Harvard University Press, 1924).

p. 151: Tacitus, *The Annals* 1.2–1.3 in *Complete Works of Tacitus*, tr. Alfred John Church, William Jackson Brodribb, and Sara Bryant. From www.perseus.tufts.edu (New York: Random House, Inc. Reprinted 1942).

Chapter 6
p. 159: Suetonius, *Lives of the Caesars* vol. II: Nero 51, tr. J. C. Rolfe, Loeb Classical Library 38 (Cambridge, MA: Harvard University Press, 1914).

p. 161: Pliny the Elder, Natural History, tr. John Bostock and H. C. Riley. From perseus.uchicago.edu (London: H. G. Bohn, 1855).

Chapter 7
p. 180: Suetonius, *The Lives of the Twelve Caesars: Caligula* 22, tr. Alexander Thomson. From www.perseus.tufts.edu (Philadelphia: Gebbie & Co., 1889).

p. 180, 183: Suetonius, *The Lives of the Twelve Caesars: Nero* 31, tr. Alexander Thomson. From www.perseus.tufts.edu (Philadelphia: Gebbie & Co., 1889).

p. 183: Tacitus, *The Annals* 15.42 in *Complete Works of Tacitus*, tr. Alfred John Church, William Jackson Brodribb, and Sara Bryant. From www.perseus.tufts.edu (New York: Random House, Inc. Random House, Inc. Reprinted 1942).

p. 191: Pliny the Elder, *The Art of Ancient Greece: Sources and Documents*, tr. Jerome Jordan Pollitt (Cambridge: Cambridge University Press, 1990), p. 114.

p. 198: Martial, *The Art of Rome c. 753 B.C.–A.D. 337: Sources and Documents*, tr. Jerome Jordan Pollitt (Cambridge: Cambridge University Press, 1983), p. 158.

Chapter 9
p. 240: Seneca, *Epistles* vol. I: Epistles 1–65, tr. Richard M. Gummere, Loeb Classical Library 75 (Cambridge, MA: Harvard University Press, 1917).

p. 245: Ammianus Marcellinus, *The Art of Rome c. 753 B.C.–A.D. 337: Sources and Documents*, tr. Jerome Jordan Pollitt (Cambridge: Cambridge University Press, 1983), p. 170.

Chapter 10
p. 262: *Historia Augusta*, Hadrian 14.11, *The Art of Rome c. 753 B.C.–A.D. 337: Sources and Documents*, tr. Jerome Jordan Pollitt (Cambridge: Cambridge University Press, 1983), p. 124.

p. 268: *Historia Augusta* vol. I: Hadrian 19.9-10, tr. David Magie, Loeb Classical Library 139 (Cambridge, MA: Harvard University Press, 1921).

p. 268: Paulus Orosius, *Seven Books of History against the Pagans*, tr. A. T. Fear (Liverpool University Press, 2010).

p. 270: Cassius Dio, *Roman History* vol. VIII, tr. E. Cary and H. B. Foster, Loeb Classical Library 176 (Cambridge, MA: Harvard University Press, 1925).

Chapter 11
p. 290: Aelius Aristides, *The Ruling Power: A Study of the Roman Empire in the Second Century after Christ through the Roman Oration of Aelius Aristides*, tr. James H. Oliver (Philadelphia: American Philosophical Society, 1953) p. 906.

p. 295: Pausanias, *The Art of Rome c. 753 B.C.–A.D. 337: Sources and Documents*, tr. Jerome Jordan Pollitt (Cambridge: Cambridge University Press, 1983), p. 178.

p. 295: St. Jerome, *Chronicle*, tr. Roger Pearse et al., www.tertullian.org, 2005.

p. 301: *Historia Augusta*, *The Art of Rome c. 753 B.C.–A.D. 337: Sources and Documents*, tr. Jerome Jordan Pollitt (Cambridge: Cambridge University Press, 1983), p. 176–77.

p. 304: *Historia Augusta*, Hadrian 11.2, *The Art of Rome c. 753 B.C.–A.D. 337: Sources and Documents*, tr. Jerome Jordan Pollitt (Cambridge: Cambridge University Press, 1983), p. 177.

p. 308: Pausanias, *Description of Greece* tr. W. H. S. Jones. From www.perseus.tufts.edu (Cambridge, MA: Harvard University Press; London: William Heinemann Ltd., 1918).

Chapter 12
p. 324: *Historia Augusta*, vol. I: Severus 23.1, tr. David Magie, Loeb Classical Library 139 (Cambridge, MA: Harvard University Press, 1921).

p. 326: *Historia Augusta*, vol. I: Severus 24.3, tr. David Magie, Loeb Classical Library 139 (Cambridge, MA: Harvard University Press, 1921).

Sources of Illustrations

0.1 Peter Bull © Thames & Hudson Ltd; 0.2 Peter Bull © Thames & Hudson Ltd.; 0.3 Adam Eastland Art + Architecture/Alamy Stock Photo; 0.4 Russo Daniele/123RF; 0.5 Erin Babnik/Alamy Stock Photo; 0.6 Peter Bull © Thames & Hudson Ltd.; 1.1 Peter Bull © Thames & Hudson Ltd.; 1.2 Peter Bull © Thames & Hudson Ltd.; 1.3 A. De Gregorio/De Agostini/Getty Images; 1.4 I Musei Vaticani, Rome; 1.5 De Agostini/Getty Images; 1.6 De Agostini/Getty Images; 1.7 C. Moessner/De Agostini/Getty Images; 1.8 G. Nimatallah/De Agostini/Getty Images; 1.9 G. Dagli Orti/De Agostini/Getty Images; 1.10 Peter Bull © Thames & Hudson Ltd.; 1.11 Adam Eastland Art + Architecture/Alamy Stock Photo; 1.12 De Agostini/Getty Images; 1.13 I Musei Vaticani, Rome; 1.14 DEA/S. Vannini/Getty Images; 1.15 DEA/S. Vannini/Getty Images; 1.16 Adam Eastland Art + Architecture/Alamy Stock Photo; 1.17 Erich Lessing/akg-images; 1.18 Perseomedusa/123RF; 1.19 Peter Bull © Thames & Hudson Ltd.; 1.20 The Picture Art Collection/Alamy Stock Photo; 1.21 DEA/Getty Images; 1.22 DEA/Getty Images; 1.23 Photo Scala, Florence; 1.24 Metropolitan Museum of Art, New York; 1.25 Leemage/Getty Images; 1.26 Museum of Fine Arts, Boston/Scala, Florence; 1.27 Museum of Fine Arts, Boston/Scala, Florence; 1.28 Museum of Fine Arts, Boston/Scala, Florence; 1.29 Museum of Fine Arts, Boston/Scala, Florence; 1.30 M. Carrieri/De Agostini/Getty Images; 1.31 Photograph by Kevin Montague, Eskenazi Museum of Art, Indian University, 74.23; 1.32 Leemage/Getty Images; 1.33 Peter Bull © Thames & Hudson Ltd.; 1.34 Leemage/Getty Images; 1.35 Araldo de Luca/Getty Images; 1.36 British Museum, London; 1.37 Viacheslav Lopatin/123RF; 1.38 Peter Bull © Thames & Hudson Ltd.; 1.39 Peter Bull © Thames & Hudson Ltd.; 1.40 Sovrintendenza di Roma Capitale-Foto in Commune; 1.41 Peter Bull © Thames & Hudson Ltd.; 1.42 Araldo de Luca/Getty Images; 1.43 Leemage/Getty Images; 2.1 ML Design; 2.2 Photo Scala, Florence; 2.3 De Agostini/Getty Images; 2.4 Peter Bull © Thames & Hudson Ltd.; 2.5 Stoyan Haytov/Dreamstime.com; 2.6 Peter Bull © Thames & Hudson Ltd.; 2.7 Peter Bull © Thames & Hudson Ltd.; 2.8 Ciolca/Dreamstime.com; 2.9 romasph/123RF; 2.10 Andersastphoto/Dreamstime.com; 2.11 LPLT/Wikimedia Commons; 2.12 Ivan Vdovin/Alamy Stock Photo; 2.13 Peter Bull © Thames & Hudson Ltd.; 2.14 DEA/G. Carfagna/Getty Images; 2.15 Peter Bull © Thames & Hudson Ltd.; 2.16 Peter Bull © Thames & Hudson Ltd.; 2.17 Photo Scala, Florence; 2.18 Leemage/Getty Images; 2.19 Photo Bibi Saint-Pol; 2.20 Photo RMN-Grand Palais (musée du Louvre)/Hervé Lewandowski; 2.21 Peter Bull © Thames & Hudson Ltd.; 2.22 Archaeological Museum, Delphi; 2.23 Archaeological Museum, Istanbul; 2.24 Photo Scala, Florence/bpk; 2.25 Archaeological Museum, Istanbul; 2.26 Sovrintendenza di Roma Capitale; 2.27 Fondazione Torlonia, Rome; 2.28 Metropolitan Museum of Art, New York; 2.29 Metropolitan Museum of Art, New York; 2.30 Universal History Archive/Getty Images; 2.31 Museo Nazionale Romano—Palazzo Massimo alle Terme, Rome; 3.1 Peter Bull © Thames & Hudson Ltd.; 3.2 Peter Bull © Thames & Hudson Ltd.; 3.3 Bernard Gagnon; 3.4 David Mann/123RF; 3.5 Getty Images; 3.6 Werner Forman/Getty Images; 3.7 Adam Eastland Art + Architecture/Alamy Stock Photo; 3.8 Museo Archeologico Nazionale, Naples; 3.9 De Agostini/Getty Images; 3.10 Carole Raddato; 3.11 akg-images/Bildarchiv Steffens; 3.12 Neil Harrison/Dreamstime.com; 3.13 Elias Eliades; 3.14 Photo Scala, Florence—courtesy of the Ministero Beni e Att. Culturali e del Turismo; 3.15 Bjanka Kadic/Alamy Stock Photo; 3.16 Metropolitan Museum of Art, New York; 3.17 Peter Bull © Thames & Hudson Ltd.; 3.18 Metropolitan Museum of Art, New York; 3.19 A. Dagli Orti/De Agostini/Getty Images; 3.20 Egisto Sani; 3.21 Kristyna Heneová/123RF; 3.22 bloodua/123RF; 3.23 Photo Scala, Florence; 3.24 Aristidis Vafeiadakis/Alamy Stock Photo; 3.25 Photo RMN-Grand Palais (musée du Louvre)/Hervé Lewandowski; 3.26 Photo RMN-Grand Palais (musée du Louvre)/Hervé Lewandowski; 3.27 Metropolitan Museum of Art, New York; 3.28 Leemage/Getty Images; 3.29 Art Media/Print Collector/Getty Images; 3.30 André Held/akg-images; 3.31 Peter Bull © Thames & Hudson Ltd.; 3.32 G. Nimatallah/akg-images; 3.33 Marie-Lan Nguyen; 3.34 Marie-Lan Nguyen; 3.35 Peter Bull © Thames & Hudson Ltd.; 3.36 Rostislav Bychkov/123RF; 4.1 Private Collection; 4.2 Photo Scala, Florence; 4.3 Private Collection; 4.4 Photo Ole Haupt, Ny Carlsberg Glyptotek, Copenhagen; 4.5 Peter Bull © Thames & Hudson Ltd.; 4.6 saiko3p/123RF; 4.7 Peter Bull © Thames & Hudson Ltd.; 4.8 British Museum, London; 4.9 Peter Bull © Thames & Hudson Ltd.; 4.10 Anthony Dezenzio/123RF; 4.11 British Museum, London; 4.12 Chronicle/Alamy Stock Photos; 4.13 British Museum, London; 4.14 Interfoto/Alamy Stock Photo; 4.15 Peter Bull © Thames & Hudson Ltd.; 4.16 Museo Archeologico Nazionale, Naples; 4.17 Deutsches Archäologisches Institut, Rome; 4.18 Deutsches Archäologisches Institut, Rome; 4.19 Photo Scala, Florence/bpk; 4.20 Bildarchiv Steffens/akg-images; 4.21 Stefano Montesi/Getty Images; 4.22 Peter Bull © Thames & Hudson Ltd.; 4.23 Bildarchiv Steffens/akg-images; 4.24 British Museum, London; 4.25 Peter Bull © Thames & Hudson Ltd.; 4.26 Photo Scala, Florence—courtesy of the Ministero Beni e Att. Culturali e del Turismo; 4.27 Marie-Lan Nguyen; 4.28 Alexander Medvedkov/123RF; 4.29 Vito Arcomano/Alamy Stock Photo; 4.30 Peter Bull © Thames & Hudson Ltd.; 4.31 G. Nimatallah/De Agostini/Getty Images; 4.32 G. Nimatallah/De Agostini/Getty Images; 4.33 Lalupa/Wikimedia Commons/CC-BY 2.5; 4.34 Sovrintendenza di Roma Capitale-Foto in Commune; 5.1 British Museum, London; 5.2 I Musei Vaticani, Rome; 5.3 British Museum, London; 5.4 G. Nimatallah/De Agostini/Getty Images; 5.5 I Musei Vaticani, Rome; 5.6 Greg Balfour Evans/Alamy Stock Photo; 5.7 Ny Carlsberg Glyptotek, Copenhagen; 5.8 Peter Bull © Thames & Hudson Ltd.; 5.9 Peter Bull © Thames & Hudson Ltd.; 5.10 Peter Bull © Thames & Hudson Ltd.; 5.11 Andrea Jemolo/Electa/Mondadori Portfolio/Getty Images; 5.12 Wieslaw Jarek/Alamy Stock Photo; 5.13 Brenda Kean/Alamy Stock Photo; 5.14 Saveri Maria Gallotti/Alamy Stock Photo; 5.15 Wieslaw Jarek/Alamy Stock Photo; 5.16 Davide Montalenti/123RF; 5.17 Peter Bull © Thames & Hudson Ltd.; 5.18 Peter Bull © Thames & Hudson Ltd.; 5.19 Deutsches Archäologisches Institut, Rome; 5.20 image Broker/Alamy Stock Photo; 5.21 C. M. Dixon/Print Collector/Getty Images; 5.22 Photo Scala, Florence/Luciano Romano; 5.23 Leemage/Universal Images Group/Getty Images; 5.24 Photo Scala, Florence; 6.1 Adam Eastland Art + Architecture/Alamy Stock Photo; 6.2 British Museum, London; 6.3 Ny Carlsberg Glyptotek, Copenhagen; 6.4 Metropolitan Museum of Art, New York; 6.5 ton koene/Alamy Stock Photo; 6.6 Deutsches Archäologisches Institut, Athens; 6.7 Ontario Ltd. Spirer/123RF; 6.8 Marie-Lan Nguyen; 6.9 Kunsthistorisches Museum, Vienna; 6.10 Museo Archeologico Nazionale, Naples; 6.11 Marie-Lan Nguyen; 6.12 Leemage/Universal Images Group/Getty Images; 6.13 British Museum, London; 6.14 Wieslaw Jarek/123RF; 6.15 Sovrintendenza di Roma Capitale-Foto in Commune; 6.16 G. Nimtallah/De Agostini/Getty Images; 6.17 G. Nimatallah/De Agostini/Getty Images; 6.18 Deutsches Archäologisches Institut, Rome; 6.19 De Agostini/Getty Images; 6.20 Granger Historical Picture Archive/Alamy Stock Photo; 6.21 Prisma/UIG/Getty Images; 6.22 Altes Museum, Staatliche Museen zu Berlin; 6.23 Granger Historical Picture Archive/Alamy Stock Photo; 6.24 Museo Archeologico dei Campi Flegri, Baiae; 6.25 Photo Scala, Florence; 6.26 Sonia Halliday Photo Library/Alamy Stock Photo; 6.27 William Perry/123RF; 6.28 Matthew Ragan/123RF; 6.29 sedmak/123RF; 6.30 I Musei Vaticani, Rome; 6.31 I Musei Vaticani, Rome; 7.1 Vito Arcomano/Alamy Stock Photo; 7.2 British Museum, London; 7.3 Peter Bull © Thames & Hudson Ltd.; 7.4 Giovanni Lattanzi; 7.5 Peter Bull © Thames & Hudson Ltd.; 7.6 Vico Arcomano/Alamy Stock Photo; 7.7 EPX/Alamy Stock Photo; 7.8 Steven Heap/123RF; 7.9 Mimmo Frassineti/Agf/Shutterstock; 7.10 marcovarro/123RF; 7.11 Eric Vandeville/akg-images; 7.12 akg-images/Album/Prisma; 7.13 Realy Easy Star/Toni Spagnoni/Alamy Stock Photo; 7.14 Realy Easy Star/Toni Spagnoni/Alamy Stock Photo; 7.15 wrangel/123RF; 7.16 AGTravel/Alamy Stock Photo; 7.17 Erich Lessing/akg-images; 7.18 British

Museum, London; **7.19** José Luiz Bernardes Ribeiro; **7.20** Peter Bull © Thames & Hudson Ltd.; **7.21** Russo Daniele/123RF; **7.22** ImageBroker/Alamy Stock Photo; **7.23** Peter Bull © Thames & Hudson Ltd.; **7.24** Peter Bull © Thames & Hudson Ltd.; **7.25** Alexander Medvedkov/123RF; **7.26** Peter Bull © Thames & Hudson Ltd.; **7.27** DEA/M. Borchi/Getty Images; **8.1** DEA/G. Nimatallah/Getty-Images; **8.2** Photo Scala, Florence—courtesy of the Ministero Beni e Att. Culturali e del Turismo; **8.3** Mgallar/Dreamstime.com; **8.4** Jeff Bondono; **8.5** Jeff Bondono; **8.6** Musei Capitolini, Rome; **8.7** (left and right) Photo Scala, Florence; **8.8** DEA/A. Dagli Orti/Getty Images; **8.9** DEA/G. Nimatallah/De Agostini/Getty Images; **8.10** DEA/G. Nimatallah/De Agostini/Getty Images; **8.11** nito500/123RF; **8.12** milosk/123RF; **8.13** PE Fosberg/Alamy Stock Photo; **8.14** Hirmer Fotoarchiv; **8.15** Lothar Steiner/123RF; **8.16** Peter Bull © Thames & Hudson Ltd.; **8.17** Boris Breytman/123RF; **8.18** Mel Longhurst/akg-images; **8.19** Archaeological Museum, Olympia; **8.20** Metropolitan Museum of Art, New York; **8.21** Metropolitan Museum of Art, New York; **8.22** Staatliche Sammlung für Ägyptische Kunst, Munich; **8.23** Massimo Pivano/123RF; **8.24** Ermanno Ferrero, *L'Arc d'Auguste à Suse*, Turin, 1901; **8.25** Santiago Rodriquez Fontoba/123RF; **8.26** milosk/123RF; **8.27** DeAgostini/Getty Images; **8.28** Bernard Gagnon; **8.29** Peter Bull © Thames & Hudson Ltd.; **8.30** Valery Shanin/123RF; **8.31** New York University Excavations at Aphrodisias (G. Petruccioli); **8.32** Ugur Ucan/123RF; **8.33** Tynrud/123RF; **8.34** Luca Quadrio/123RF; **8.35** Kavram/123RF; **9.1** British Museum, London; **9.2** Tades Yee/123RF; **9.3** Leemage/Getty Images; **9.4** Peter Bull © Thames & Hudson Ltd.; **9.5** Peter Bull © Thames & Hudson Ltd.; **9.6** Alex Postovski/123RF; **9.7** Agenzia Sintesi/Alamy Stock Photo; **9.8** Peter Bull © Thames & Hudson Ltd.; **9.9** Sovrintendenza di Roma Capitale-Foto in Commune; **9.10** Calin-Andrei Stan/123RF; **9.11** World History Archive/Alamy Stock Photo; **9.12** Wieslaw Jarek/123RF; **9.13** akg-images; **9.14** MM/Wikicommons public domain; **9.15** Witold Skrypczak/Alamy Stock Photo; **9.16** milosk/123RF; **9.17** Photo George W. Houston/Institute for the Study of the Ancient World; **9.18** Vito Arcomano/Alamy Stock Photo; **9.19** Vito Arcomano/Alamy Stock Photo; **9.20** Cristian Chirita; **9.21** Peter Bull © Thames & Hudson Ltd.; **9.22** Paolo De Gasperis/123RF; **9.23** AA World Travel Library/Alamy Stock Photo; **9.24** Adam Eastland Art + Architecture/Alamy Stock Photo; **9.25** Vito Arcomano/Alamy Stock Photo; **9.26** jojobob/123RF; **9.27** Prisma/UIG/Getty Images; **9.28** Stefano Montesi/Getty Images; **9.29** Cassius Ahenobarbus; **9.30** Cassius Ahenobarbus; **10.1** Adam Eastland Art + Architecture/Alamy Stock Photo; **10.2** Photo Scala, Florence—courtesy of the Ministero Beni e Att. Culturali e del Turismo; **10.3** G. Dagli Orti/De Agostini/Getty Images; **10.4** De Agostini/Getty Images; **10.5** Altes Museum, Staatliche Museen zu Berlin; **10.6** Carole Raddato; **10.7** tomas1111/123RF; **10.8** Peter Bull © Thames & Hudson Ltd.; **10.9** John Dambik/Alamy Stock Photo; **10.10** Alexandre Fagundes De Fagundes/Dreamstime.com; **10.11** Peter Bull © Thames & Hudson Ltd.; **10.12** Sophie McAulay/123RF; **10.13** Peter Bull © Thames & Hudson Ltd.; **10.14** Metropolitan Museum of Art, New York; **10.15** Adam Eastland Art + Architecture/Alamy Stock Photo; **10.16** British Museum, London; **10.17** J. Paul Getty Museum, Malibu; **10.18** Araldo da Luca/Getty Images; **10.19** Prismo Archivo/Alamy Stock Photo; **10.20** De Agostini/Getty Images; **10.21** Adam Eastland Art + Architecture/Alamy Stock Photo; **10.22** Adam Eastland Art + Architecture/Alamy Stock Photo; **10.23** Adam Eastland Art + Architecture/Alamy Stock Photo; **10.24** Viacheslav Lopatin/123RF; **10.25** Silvia Crisman/123RF; **10.26** Jebulon; **10.27** Vladislav Gajic/123RF; **10.28** Art Directors & Trip/Alamy Stock Photo; **10.29** krivinis/123RF; **10.30** Azoor Photo Collection/Alamy Stock Photo; **10.31** Visions of America LLC/123RF; **10.32** Bernard O'Kane/Alamy Stock Photo; **11.1** Anastasy Yarmolovich/123RF; **11.2** saiko3p/123RF; **11.3** Peter Bull © Thames & Hudson Ltd.; **11.4** imageBroker/Alamy Stock Photo; **11.5** G. Witr/Dreamstime.com; **11.6** G. Dagli Orti/De Agostini/Getty Images; **11.7** Nicolas De Corte/123RF; **11.8** Gannis Katsaros/123RF; **11.9** Constantinos Illiopoulos/Alamy Stock Photo; **11.10** Milan Gonda/123RF; **11.11** Larry Ebbs/123RF; **11.12** arabianEye FZ LLC/Alamy Stock Photo; **11.13** meinzahn/123RF; **11.14a** Peter Bull © Thames & Hudson Ltd.; **11.14b** Marie Mauzy/Scala, Florence; **11.15** Archaeological Museum, Olympia; **11.16** Vasilis Ververidis/123RF; **11.17** bloodua/123RF; **11.18** Okan Akdeniz/123RF; **11.19** frans lemmens/Alamy Stock Photo; **11.20** Zanner; **11.21** Carole Raddato; **11.22** Carole Raddato; **11.23** Valerio Mei/123RF; **11.24** PaylessImages/123RF; **11.25** Anton Ivanov/123RF; **11.26** Ny Carlsberg Glyptotek, Copenhagen; **11.27** Gianfranco Gazzetti/Gruppo Archeologico Romano; **11.28** Erich Lessing/akg-images; **11.29** Peter Horree/AlamyStock Photo; **11.30** villorejo/Alamy Stock Photo; **11.31** Heritage Image Partnership/Alamy Stock Photo; **11.32** Erin Babnik/Alamy Stock Photo; **11.33** 22tomtom/Dreamstime.com; **11.34** Ml.Ti/Alamy Stock Photo; **12.1** British Museum, London; **12.2** (left) Hoberman Collection/Getty Images; (center) British Museum, London; (right) British Museum, London; **12.3** Photograph by Kevin Montague, Eskenazi Museum of Art, Indiana University, 75.33.1; **12.4** Jastrow; **12.5** Carole Raddato; **12.6** Marie-Lan Nguyen; **12.7** Metropolitan Museum of Art, New York; **12.8** Altes Museum, Staatliche Museen zu Berlin; **12.9** Museum of Fine Arts, Boston/Scala, Florence; **12.10** Photo RMN-Grand Palais (musée du Louvre)/Gérard Blot; **12.11** Museo Archaeologico Nazionale, Naples; **12.12** Peter Horree/Alamy Stock Photo; **12.13** Metropolitan Museum of Art, New York; **12.14** Valerio Rosati/123RF; **12.15** Peter Bull © Thames & Hudson Ltd.; **12.16** Kevin Tietz/123RF; **12.17** Adam Eastland Art + Architecture/Alamy Stock Photo; **12.18** Adam Eastland Art + Architecture/Alamy Stock Photo; **12.19** Adam Eastland Art + Architecture/Alamy Stock Photo; **12.20** Diletta Menghinello; **12.21** Matyas Rehak/123RF; **12.22** Robert Hilscher/123RF; **12.23** Robert Hilscher/123RF; **12.24** Davie Gunn; **12.25** Hemis/Alamy Stock Photo; **12.26** Gilles Mermet/akg-images; **12.27** Gilles Mermet/akg-images; **12.28** Peter Bull © Thames & Hudson Ltd.; **12.29** Bernard O'Kane/Alamy Stock Photo; **12.30** Peter M. Wilson/Alamy Stock Photo; **12.31** Prisma Archivo/Alamy Stock Photo; **12.32** Gilles Mermet/akg-images; **12.33** Metropolitan Museum of Art, New York; **12.34** Musei Capitolini, Rome; **12.35** Worcester Art Museum, Massachusetts/Bridgeman Images; **12.36** Princeton University Art Museum; **12.37** History and Art Collection/Alamy Stock Photo; **12.38** Yiannis Mitos; **13.1** British Museum, London; **13.2** British Museum, London; **13.3** Carole Raddato; **13.4** Adam Eastland Art + Architecture/Alamy Stock Photo; **13.5** Prisma Archivo/Alamy Stock Photo; **13.6** Adam Eastland Art + Architecture/ Alamy Stock Photo; **13.7** Photo BPK, Berlin, Dist. RMN-Grand Palais/Jürgen Liepe; **13.8** Royal Athena Galleries; **13.9** Adam Eastland Art + Architecture/Alamy Stock Photo; **13.10** Gianni Dagli Orti/Shutterstock; **13.11** Jastrow; (bottom) Römisch-Germanisches Zentralmuseum, Mainz; **13.12** (left and right) British Museum, London; **13.13** BiblelandPictures.com/Alamy Stock Photo; **13.14** Photo Ole Haupt, Ny Carlsberg Glyptotek, Copenhagen; **13.15** British Museum, London; **13.16a** Martin Hatch/123RF; **13.6b** Andreas Zerndl/123RF; **13.17** Photo Scala, Florence; **13.18** Sailko; **13.19** akg-images/Pirozzi; **13.20** akg-images/Pirozzi; **13.21** Peter Bull © Thames & Hudson Ltd.; **13.22** DeAgostini/Getty Images; **13.23** DeAgostini/A. Dagli Orti/Diomedia; **13.24** Lev Tsimbler/123RF; **13.25** Alessandro Vasari/Mondadori Portfolio/akg-images; **13.26** bloodua/123RF; **13.27** lexan/123RF; **13.28** Peter Bull © Thames & Hudson Ltd.; **13.29** Stefano Politi Markovina/Alamy Stock Photo; **13.30** Engin Korkmaz/123RF; **13.31** Engin Korkmaz/123RF; **13.32** Stoyan Haytov/123RF; **14.1a** Jipen/123RF; **14.1b** Peter Bull © Thames & Hudson Ltd.; **14.2** British Museum, London; **14.3** legacy1995/123RF; **14.4** Sergej Borzov/ 123RF; **14.5** nchristian/123RF; **14.6** Prisma/UIG/Getty Images; **14.7** Paul Williams/Alamy Stock Photo; **14.8** Lanmas/Alamy Stock Photo; **14.9** Peter Bull © Thames & Hudson Ltd.; **14.10** Peter Bull © Thames & Hudson Ltd.; **14.11** Adam Eastland Art + Architecture/Alamy Stock Photo; **14.12** DeAgostini/Getty Images; **14.13** akg-images/Nimatallah; **14.14** Heritage Image Partnership Ltd/Alamy Stock Photo; **14.15** akg-images/Andre Held; **14.16** Peter Bull © Thames & Hudson Ltd.; **14.17** Ahmet Ihsan Ariturk/123RF; **14.18** Eleni Seitanidou/123RF; **14.19** Ihsan Gercelman/123RF; **14.20** evrenkalinbacak/123RF; **14.21** rognar/ 123RF; **14.22** Marie-Lan Nguyen; **14.23** Bayerische Staatsbibliothek, Munich; **14.24** Peter Horee/Alamy Stock Photo; **14.25** Andrea Izzotti/123RF; **14.26a and b** Library of Congress, Prints and Photographs Division, Washington, D.C.; **14.27a and b** The Architectural Archives, University of Pennsylvania by the gift of Robert Venturi and Denise Scott Brown.

Index

Note: Page numbers in *italics* refer to illustrations

A

Abduction of the Sabine Women 120, *120*

abstraction 15; in architecture 361; and Christian art 374; Column of Antoninus Pius 278; and Eastern art 221, 307, *307*, 321; in Greek art 14, 340; Italic tradition 23, 206; Ludovisi sarcophagus 351; Severan 171, 320, 321, 331, 332, 333, 339; in soldier emperors' portraiture 348; in tetrarchal imagery 354–55, 365, 370; *see also* late antique style

Acropolis, Athens 97, 289, 294, *294*

Actium, Battle of 110, 113, 130

Actium type portraits 111, *111*, 132

Adamklissi, Romania: *Tropaeum Traiani* 253, *253*–54

adlocutio (public address) scenes 248, *249*, 258, 263–64, *264*, 372, *372*

adoption 156, 236

adventus scenes 176, *177*, 250, *250*, 375

aediculae 124, *124*, 197, 225, 230, 267, 297, *297*; offset on different stories 299, *299*, 300; on sculpted sarcophagi 313, *313*, 374, *375*

Aemilius Paullus, Lucius 51, 64, 67; monument (Delphi) 67, *67*–68, 253–54

Aeneas 18, 22, 107, 143, *143*, 193

Africa 246, 319, 333, 341, 344, 382; mosaics 292, 339, 341; pottery 345; Roman buildings 203, 227, 230, 290, 300; *see also* Carthage; Egypt; Leptis Magna; Timgad

Agrippa, Marcus Vipsanius 110, 111, 134; Ara Pacis frieze 142, *142*; possible dwellings 147, 151; Roman building projects 121–22, 198, 266, 268

Agrippina the Elder 155, 156, 163, *164*

Agrippina the Younger 158, 163, *163*, 164, 220, 226, 227

Ahenobarbus, Gnaeus Domitius 167

alae (architectural) 215

Alexander Mosaic 80–81, *81*, 82

Alexander Severus, emperor 199, 318, 323–24, 324, 324–25, 326–27, 346

Alexander the Great 50, 52, 53, 80, 272; evocation by later leaders 104, 110, 111, *111*, 146, 173, 323, 365

Algiers Relief 145, *145*

alimentary policies 251, 252, *252*, 257, 258, 259, 325

Amazons 38, *38*, 124, *125*, 311, *311*–12, *312*

Amiternum reliefs 206–8, *207*, *208*

Ammianus Marcellinus 244–45

amphitheaters 199, 200–203, 227, 228, 229, 230–31, 291; temporary 106

amphorae: Corinthian-style 25; Pontic 26, *26*; Sosibios Amphora 91, *91*

Anaglypha Hadriani 257–59, *258*, *259*

ancestral portraits (*imagines*) 71, 72, 147, 170

Ankara (Ancyra), Turkey: Temple of Roma and Augustus 216, *216*–17

Antikythera shipwreck 93

Antikythera Youth 93

Antinous 265, 266, 308, *309*, 309

Antioch 338, 341

Antonine dynasty 274–76, 308, *308*; *see also* Antoninus Pius; Commodus; Lucius Verus; Marcus Aurelius

Antoninus Pius, emperor 232, 236, 272, 274, 283, 304; border fortifications 233, 305; column of 276–78, *277*; portraiture 275, *275*, 298, 308, *308*; temple of Antoninus and Faustina 284–85, *285*

Antonius (Mark Antony) 109–11, *110*, *111*, 130

Aphrodisias, Turkey 224, 227, 228, 334; Medusa head *335*; Sebasteion 224–27, *225*, *226*, *227*, 297; stadium 228, *228*

Aphrodite 143, 224, 225; Aphrodite of Knidos (Praxiteles) 306, 380; on Etruscan mirror 40; Farnesina painting 147, *147*; *see also* Venus

Apollo 68, *68*, 69; Veii temple akroterion 46–47, *47*

Apollodorus (architect) 239, 241, 249, 267, 268, 270; known works (*see* baths: of Trajan; Forum of Trajan); possible works (*see* Pantheon; Trajan's column; Trajan's Markets)

Apollodorus Skiagraphos (painter) 86

apotheosis 194; depictions of 166, *167*, 174, *174*, 253, 264, *264*, 276–77, *277*; star as symbol of 111, 145, 167; *see also* divinization

aqueducts 122, 197–98

Ara Pacis 140, 140–44, *141*, *142*, *143*, *144*, 214

Ara Pietatis/Ara Gentis Iuliae reliefs 165, *165*–66

Ara Ubiorum 163, *164*

Arausio *see* Orange

Arch of the *Argentarii* 328, *328*–30, *329*

Arch of Augustus, Susa 222, *222*–23, *223*

Arch of Constantine 14, *15*, 173, 279, 281, 370–73, *371*, *372*, *373*; Hadrianic roundels 265, *265*–66, 372, *372*; Trajanic frieze panels 250, *250*

Arch of Galerius, Thessaloniki 364, *364*–65, *365*

Arch of Hadrian, Athens 293, *293*

Arch of Marcus Aurelius, reliefs from *278*, 278–79, *279*, 281

Arch of Septimius Severus, Leptis Magna 332, *333*

Arch of Septimius Severus, Republican forum 330, *330*–32, *331*

Arch "of Tiberius," Orange 223, *223*–24, *224*

Arch of Titus 173, *173*–76, *174*, *175*, 212, *212*

Arch of Trajan, Beneventum 251, *251*–53, *252*, *253*, 259

Arch of Trajan, Timgad 291, *291*

arches 62, 173, 251; *see also* Arcus Novus; named arches above

architectural orders 17, *17*, 202–3

Arcus Novus, Rome 355–57, *356*, *357*

Aristides, Aelius: *Roman Oration* 290

Aristonothos Krater 27, *27*

Arkadiane, Ephesus 296, *296*

Arretine ware 345, *345*

L'Arringatore 47, *47*, 71

art collecting 95–98, 380

Athena 191; Archaic terracotta akroterion 45, *45*–46; Archaistic statue, Herculaneum 96, *96*–97; Athena Parthenos statue 64, 312, 369–70; cuirass of Hadrian, Olympia 298; Etruscan depictions 40, *41*; Pergamon Altar *191*; *see also* Minerva

Athenaeum, Rome 273, *273*

Athens 288–89, 292–95, *294*, 301; Arch of Hadrian 293, *293*; "golden age" 232; grave reliefs 311; Library of Hadrian 294–95, *295*; Odeum of Herodes Atticus 288–89, *289*; Panathenaic Stadium 289, *289*; Temple of Ares, previously Apollo 222; Temple of Olympian Zeus 293, *293*–94; Temple of Roma and Augustus 217, *217*

Atistia (wife of Eurysaces) 137, 210

atmospheric perspective 86

atrium houses 76–79, *77*, *78*

Attalus I of Pergamon 53

398 INDEX

auctoritas 130, 131–32, 137

audience halls: Aula Palatina, Trier 361, *361*; Aula Regia, Palatine 184, 189

Augusta Treverorum *see* Trier

Augustales 172

Augustus, emperor (formerly Octavian) 12, 18, 19, 151; apotheosis 163; and Athens 217, 294; Campus Martius building projects 121–24, 138–44; cult of *Lares* and *genius Augusti* 166; cult worship of 162, 163, 164, 215, 216, 217, 219; depiction as Augustus 131, *132*, 132–34, 135, *135*, 142, *142*, 160, 162, 167, *167*, 219, *219*, 221, *221*; depiction as Octavian 110, *110*, 111, *111*; as *divi filius* 130, 134; dynastic ambitions 126, 134–35, 154, 156; and Egypt 220–21; extent of empire 213; Forum of 144, 144–47, 195, 242–43; mausoleum of 134, 138, 138–39; morality legislation 137; and Nemausus (Nîmes) temple 214; Palatine residence 112–14, *113*, *116*, 116–17; Parthian "victory" 133, *133*, 330; Republican Forum building projects 117–21; route to power 109–10, 111–12, 126, 130; as second Romulus 115; and the senate 112, 130, 142; temple of (Rome) 193, *193*; temple roof sculptures 46; title and honors 130–32; and Trier 360–61

"Augustus," title 115, 131–32, 321, 352, 353

Aula Ottagona 358, 359, *359*

Aula Palatina, Trier 361, *361*

Aula Traiana 242, *242*

Aurelian, emperor 197, 304, 314, 344, 348, *348*

B

Bacchus 189, *189*, 334, *334*, 337, *337*; and Hercules 334, *334*, 338, 338–39, *339*; *see also* Dionysus and the Dionysiac

Balbinus, emperor 349, 350; sarcophagus of 349, 349–50

"barbarians" 310, 312, 318, 381, 383; conquest of 123, 142, 160, 282, 312, 350; threat of 274, 304, 314

Barberini Ivory 382–83, *383*

barrel vaults 61, *61*, 62, *62*

Basilica Aemilia 119, *119*, 195; frieze 119–21, *120*

Basilica Julia 118

Basilica of Constantine *see* Basilica of Maxentius

Basilica of Maxentius (Basilica Nova) 368, 368–69; statue of Constantine 369, 369–70

Basilica Ulpia 241, 243, *243*, 245; frieze 245, *245*

basilicas 119, 218, 243, 369, 375–76; Aula Palatina, Trier 361, *361*; Julian Basilica, Corinth 135; Leptis Magna 334; of St. Peter 375, *375*; *see also named basilicas above*

baths 122, 198–99, 239–41, *240*, 326, 386; of Agrippa 122; bath-gymnasium complexes 240, 300; of Caracalla 326, 327, 327–28, 386; of Constantine 370; of Diocletian 358, 358–60, *359*; at Isthmia 341, *341*; at Leptis Magna 336; of Nero 198, 198–99, 324, 327; at Ostia 256; of Titus 199, *199*, 239; of Trajan 239, 239–41

battle scenes: Aemilius Paullus monument 67, 68; Alexander Mosaic 80–81, *81*, 82; Amazonomachy 38, *38*, 124, *125*, 311, 311–12, *312*; Apollo Sosianus frieze 123, *123*; Arch of Septimius Severus 331, 331–32; Arch of Tiberius, Orange 224, *224*; Aristonothos Krater 27, *27*; Column of Marcus Aurelius 282, *282*; Gigantomachy 68, 69, 336, *336*; Great Antonine Altar, Ephesus 310; Ludovisi sarcophagus 350–51, *351*; Portonaccio sarcophagus 312, *313*; tomb paintings 33–34, *34*, 63, 63–64; Trajan's column 247, *247*; *Tropaeum Traiani*, Adamklissi 253, 253–54

beards: and age of subject 110, 159, 321; in Antonine portraiture 275, 275–76; Constantine and Christianity 369, 375; Gallienus 347; Hadrian 262, 263, *263*; as mark of "barbarian" 282, 381; Republican era 42–43; in Severan portraiture 319, *319*, 320, 323; soldier emperor style 346, 348, 354, *354*

Belvedere Altar 166, *167*

Beneventum: Arch of Trajan 251, 251–53, *252*, *253*, 259

Borghese Vase 91, *91*

Boscoreale: Villa of Publius Fannius Synistor 85, *85*, 86, *86*, 87, *87*

Boscotrecase paintings 150, *151*

boxer sculpture, Baths of Diocletian 359, *359*

brick facing 62, 185, 241, 256–57, 268

brick stamps 268

Britain (Britannia) 226, *226*, 290, 304, 305, 318

Britannicus 156, 158

bronze statuary 71, 280, 380; Alexander statuette 52, *53*; Capitoline Wolf 43, *43*; Danaids, Apollo Palatinus temple 113, *113*; Drunken Satyr 97, 97–98; equestrian Domitian 172–73, *173*; equestrian Marcus Aurelius 280, 280–81; Etruscan and early Roman 42–43, 47, 71, 280; faun/satyr, House of the Faun 82, 90; marble replicas 90–91, 133; Meroë Head 132, *132*; portrait of Septimius Severus 319–20, *320*; shipwreck finds 93, 94; Terme Boxer 359, *359*

bronzeware: Etruscan 40–41, 280; serpent column of Delphi 379, 379–80; Villanovan 29

Brutus, Lucius Junius 42, 43

"Brutus" bronze 42, 42–43, 71

bucchero 30, *30*

bucrania 141, *141*

bulls 298; Farnese sculpture 13; Nymphaeum of Herodes and Regilla sculpture 297, *297*; *see also suovetaurilia*

burial customs: canopic urns 37–38, *38*, 73; Christian 374–75, 378; Egyptian 322; Etruscan 25, 28, 30; Villanovan 23, 23–24; *see also* funerals; sarcophagi; tombs

Byzantine empire 315, 384–85

Byzantium *see* Constantinople

C

Caelian hill 181, 193; via San Gregorio pediment 69–70

Caesar, Gaius Julius 12, 93, 102–3, 199–200, 214, 294; assassination 105, 109, 126; colonies founded by 213, 214, 218; deification 110, 111, 134, 145, 166; depictions of 103, 103–4, 145, *145*; Roman building program 105, 107–9, 119, 121; temple to 117, 117–18, *118*, 130, 213

"Caesar," title 352, 353

Caesarion (Ptolemy XV Caesar) 110

Caligula (Gaius), emperor 155, 155–56, 180, 181, 197

cameos 160, 160–63, *161*, *162*, *163*

Campus Martius 55–57, *57*, 121–22, 138, 138–39, 324; Ara Pacis 140, 140–44, *141*, *142*, *143*, *144*, 214; baths 198–99; Column of Antoninus Pius 276–78, *277*; Column of Marcus Aurelius 281, 281–83, *282*, *283*; Domitianic buildings 194–95; Paris-Munich reliefs 65, 65–67, 66–67; personified 264, *264*, 276, *277*; Temple of Apollo Sosianus 122, 122–24, *123*, *124*, *125*; Temple to Hadrian (*Divus Hadrianus*) 283, 283–84; Theater of Pompey 105, *105*, 121, 300; *Vicomagistri* Altar 166, 166–67; *see also* Cancelleria reliefs; Pantheon

Cancelleria reliefs 176, 176–77, *177*

candelabrum style 151

canopic urns 36–37, *37*, 73

Canopus, Hadrian's villa (Tivoli) 301, 304, *304*, 306

capitolia 45, 218; Ostium 254, *255*; United States Capitol building 385, 385–86

Capitoline hill: mid-Republican temples 57; sixteenth century 281; Temple of Jupiter Optimus Maximus 44–46, *45*, 109, 193, 272; temple to Vespasian 193–94

Capitoline Wolf 43, *43*

Caracalla, emperor 318, 319, 321, 323, 324, 329, 330; baths of 326, 327, *327*–28 (*see also* Farnese bull); depictions of 321, *321*, *323*, 323, 329, 344

Carandini, Andrea 22

Carinus, emperor 352

Carrara marble 65, 108, 112, 246

Carthage 22, 24, 50–51, 115, 336; Algiers Relief 145, *145*

Carus, emperor 352

caryatids 30, *30*, 146, *146*, 217; Trajan's forum variation 242

Carystian marble (*cipollino*) 246

Cassius Dio 109, 270, 318

Castel Sant'Angelo, Rome 272, *272*

Castor and Pollux *see* Dioscuri

catacombs 378; of Saints Peter and Marcellinus 378, *378*

Catulus, Quintus Lutatius 57

censors 11, 66

census 66

centaur sculptures, Tivoli 303, *303*–4

Cerveteri 27, 28; Regolini-Galassi tomb 28, 28–29; sarcophagus 37, *37*

Charlemagne 383, 384

Chiusi: canopic urns 36–37, *37*

Christianity 280, 281, 315, 337, 340; burial practices 374–75, 378; church architecture 184, 361, 364, 375–77, *376*–77; and pagan symbols 377; persecution 352; and statuary 380; *see also* Barberini Ivory

Cicero, Marcus Tullius 53, 54, 95, 109, 110

cipollino (Carystian marble) 246

Circus Maximus 184

cistae 40–41, *41*

cities 16, 288, 290; bathing provision 122, 301; capitolia 45; colonnaded streets 296; street plans 218, 254, 291, *291*; *see also* urbanization

citizenship 47, 207, 310, 318

civil wars: of Marius and Sulla 60, 102; of Pompey and Caesar 102–3; of Octavian 109–10, 217; on death of Nero 159, 168; third-century 344; fourth-century 369

Classicism 70, 94, *94*, 134, 189, 238, 252, 263; Antonine 284, 298; Ara Pacis 141, 143; architectural 214, 217; Basilica Aemilia frieze 120, *120*; Cancelleria reliefs 177; civilization *vs.* barbarism 124, 310; and depiction of gods 107, 114, 143–44, 162; Farnese Hercules 328; Hadrianic period 344; sarcophagus of Balbinus 349–50; Second Style wall painting 147; Severan period 320, 323, 324, 333, *333*; Valerian and Gallienus portraits 347, *347*; *see also* idealized portraiture; Second Sophistic

Claudius, emperor 156–57, 163, 164, 197–98, 215; administration 207; Aqua Claudia and Porta Maggiore 197–98, 215; and Britannia 226, *226*, 227; portraiture *157*, 157–58, 163, *163*, 219–20, *220*; temple to (Claudianum) 181, 193, 198, 283; and Vespasian 168, 170; works at Ostia 254

Claudius II Gothicus, emperor 347–48

clementia scenes 279, *279*, 280–81, 312

Cleopatra VII of Egypt 110, 220

clipeus virtutis 130, 137, 279

Clodius Albinus, Caesar 318, 319, *319*

coin portraits 103, 131; of Antonius 110, *110*; of Augustus/Octavian 110, *110*, 111, *111*, 118, 131, *131*; of Caligula 155, *155*; of Constantine 369, *369*; of Drusus 164; of Julius Caesar 103, *103*; of Marcus and Lucius Junius Brutus 42, *43*; of Nero 180; of Nerva 237, *237*; of Pompey the Great 104, *104*; of post-Antonine imperial claimants 319, *319*; of tetrarchs 353, *353*, 354, *354*; of Tiberius 154, *155*, 164

coinage 110, 131, 164; as evidence for buildings and statues 107, 118, *118*, 180, *180*, 193, *193*, 244; *see also* coin portraits

Colonia Claudia Ara Agrippinensium (Cologne) 163, 164

colonies 102, 223, 336; founded by Julius Caesar 213, 214, 218; Greek 24, 218; *see also* Colonia Claudia Ara Agrippinensium; Corinth; Nîmes; Orange; Ostia; Pompeii; Timgad

colonnades 225, 296–97, 299; in the atrium house 77; and display of statuary 188, 297; painted 148, *148*

colossal statues: of Augustus 219, *219*; in baths of Caracalla *13*, 328, *328*; of Constantine 369, *369*–70; of *Divus Iulius* 118; in Domus Flavia 189, *189*; of Nero 181, 182, 183, 185, 199; Phidian Zeus 54, 380; of Trajan 242

Colosseum *see* Flavian Amphitheater

columbaria 208, *208*–9

columns: of Antoninus Pius 276–78, *277*; of Marcus Aurelius 281, 281–83, *282*, *283*, 312; orders of (*see* architectural orders); tradition of sculpting 249–50; of Trajan 233, 247, *247*–50, *248*, *249*, 258–59

commemorative monuments 65–70, 146, 165–67, 173–77; *see also* Ara Pacis; arches; columns; *Decennalia* monument; manubial buildings; *Tropaeum Traiani*

Commodus, emperor 156, 274–75, *276*, 276, 304, 318, 319; and Column of Marcus Aurelius 281; *damnatio memoriae* 278

Composite order 17, *17*, 174

concordia ordinum 118

concrete 60, 62, 182, 229

Conservatori reliefs: Hadrianic 263–64, *264*; of Marcus Aurelius 278, *278*–79, *279*, 281

Constantia (daughter of Constantine) 377

Constantine, emperor 314, 315, 374, 381; accession and unification of the empire 368–69; and Christianity 369, 374; Great Palace, Constantinople 379–80, 381; portraiture 369, *369*–70; Rome under 370; *see also* Arch of Constantine

Constantinople 315, 370, 377, 379–81, 383; Great Palace 379, *379*; Hagia Sophia 382, *382*; obelisk of Theodosius I 381, *381*; tetrarch group sculpture 354–55, *355*

Constantius I Chlorus, Western emperor 353, *354*, 368

Constantius II, emperor 244–45

continuous narrative 41, 68, 89, 250, 332

copies *see* replicas and copies

Corinth 46, 218, *218*, 228, 341; imperial statue group *135*, 135–36

Corinthian order 17, *17*, 59, 214, 296

corona civica 130, 160, 321

Crassus, Marcus Licinius 102

cross vaults 62, *62*, 332

Crusades 315, 380, 383

Ctesiphon 330, 331

cuirass statues *132*, *133*, 133–34, *172*, 172, 263, 298, *298*

Cupid *see* Eros

Curia *see* senate house

Curio, Gaius Scribonius 106

cursus honorum 39, 55, 66, 106, 131, 237

D

Dacia 237, 245, 304; and Domitian 169; *Tropaeum Traiani* 253, 253–54; *see also* Trajan's column

damnatio memoriae 173, 176, 181, 185, 278, 323, 329

debt cancellation 257, 258, 259

Decebalus, king of Dacia 237

Decennalia monument 357, *357*–58

Decius (Trajan Decius) 344, 346–47, *347*, 352

decursiones 277, *277*–78

deification: declaration of (*see* divinization); experience of (*see* apotheosis)

400 INDEX

Delos 76; *Diadoumenos* 90, 90–91; First Style wall painting 83; House of the Masks 79, 79–80, *80*; Pseudo-Athlete 72, *73*

Delphi 217, 219; Aemilius Paullus monument 67, *67*–68; Antinous statue 309, *309*; serpent column 379, *379*–80

Demaratus 46

Dendur, Temple of 220–21, *221*

Diadoumenos statue, Delos 90, 90–91

dictatorship 130

Didius Iulianus, Marcus, emperor 318, 319, *319*

Diocletian, emperor 314–15, 352–53, 355, 368; buildings in Rome 358–60; palace of (Split) 361–63, *362*; portraiture 353, 353–55, *354*, *355*; visit to Rome 356

Dionysius of Halicarnassus 25, 54; *Roman Antiquities* 22

Dionysus and the Dionysiac 91, 97, 212; Antinous's association with 308, *309*; Christian allegory 337; Dionysiac frieze, Villa of the Mysteries 88, *88*, 89; Dionysus and panther mosaic, Delos 80, *80*; Drunken Satyr statue 97, *97*; Greek festivals 106; Ludovisi sarcophagus lid 350, *351*; mosaic with goats, Hadrian's villa *302*, 303; Neo-Attic vase reliefs 91, *91*; Pentheus Painting, Pompeii 188, *188*; *see also* Bacchus

Dioscuri 118, 131, 355–56, *356*; Pollux on Ficoroni *Cista* 41, *41*; Temple of Castor 118, 155, 180, 356

divinization: of Antinous 308, 309; of Antoninus Pius 274; of Hadrian 274, 283; iconography of 238; of Julius Caesar 103, 111; of Livia 215; and political legitimacy 214, 266; temples to *divi* 117–19, 193–94, 214, 283–85; *see also* apotheosis

Divorum, Campus Martius 194

domes 62, *62*, 182, *182*; Baths of Caracalla 327; Rotunda of Galerius 363, *363*–64; *see also* Pantheon

Domitian, emperor 168, 169, 176–77, 203; assassination and succession 169, 236; Dacian agreement 237; depictions of 170, *170*, 172–73, *173*, 176, *177*; and Flavian Amphitheater 200, 202; Forum Transitorium 196, *196*, 296; Hellenism 173, 196, 203, 228; and memory of Titus 173, 193; palace of 180, 183, 183–86, *184*, 189, 268; rebuilding works 107, 122, 172, 194–95, 267, 268

Domitius Ahenobarbus, Gnaeus 167

Domus Augustana 183, 184, *184*

Domus Aurea (Golden House) 127, 180, *181*, 181–82, 182, 183, 283; later repurposing of site 185, 199, 239; wall paintings 186, 186–87, *187*

Domus Flavia 180, *183*, 183–84, 325–26, 361; statuary 189, *189*

Domus Tiberiana 181

Doric order 17, *17*, 294, *294*; modern evocation of 386, *387*

Doryphoros 42, 90, 133, *133*

Drunken Satyr, Villa of the Papyri 97, *97*–98

Drusus (the Elder, brother of Tiberius) 162, 163, 164, *164*

Drusus Julius Caesar (the Younger, son of Tiberius) 154, 156, 160

E

Eastern influences 206, 383, 387; Asian sarcophagi 310; hunting imagery 173, 266; Palmyrene sculpture 307, 321; sculpted columns 250; *see also* Egypt: artistic influence; Hellenism

ecumene 219; personified 160, *160*

Edict of Milan 374

Egypt 220, 249, 381; annexation by Rome 51, 110, 220; and Antinous 308, 309, 322; artistic influence 30, 135, 195, 221, 319, 354; *damnatio memoriae* 185; gods 30, 146, 319, 325; and Hadrian's Tivoli villa 304, 306, 309; Hellenistic (Ptolemaic) kingdom 50, 103, 110, 161, 220; mummy portraits 322, *322*; Praeneste Mosaic 64, *65*; province of 213; Severan family tondo portrait 321, *321*, 323; stone from 246, 354; Temple of Dendur 220–21, *221*; *see also* obelisks

Elagabalus, emperor 318, 323–24, 325

empire, Roman *see* Roman empire

encaustic 82, 321, 322

Ephesus, Turkey 300; Arkadiane 296, *296*; Great Antonine Altar 307–8, *308*, 310; Library of Celsus 299, *299*

Epidaurus, Greece 217

equestrian statues 172–73, 280–81

Erectheum, Athens 217

Eros 80, 94, *94*, 147, *147*

Esquiline hill 181; Baths of Diocletian 358–60; *Odyssey* frieze 88–89, *89*, 149; tomb fresco 63, *63*–64

Etruscans 11, 22–23, 25, 310; bronze work 40–43, 280; burials 23, 28–30, 310; funerary sculpture 36–39, 208; gold fibula 29, *29*–30; pottery and links with Greece 24, *25*–26, *27*, 46; Romanization and legacy 47, 206; Tarquin monarchy of Rome 11, 18, 22, 34, 44–45, 46; temples 44–47; tomb painting 30–36; Villanovan culture 23–25

euergetism 289

Eurysaces, Marcus Vergilius 207; tomb of *209*, 209–10, *210*

F

Fabullus (painter) 186–87

Farnese bull *13*

Farnese Hercules 328, *328*

Faustina the Elder (wife of Antoninus) 284

Fayum portraits 322

festivals 106, 198, 228; *see also* games and entertainments

Ficoroni *Cista* 41, *41*

First Style wall painting 82–84, 246

First Triumvirate 102–3

Flavian Amphitheater (Colosseum) 199, 200–201, 200–203, 202, 212, *212*, 230

Flavian baroque 171, 176

Flavian dynasty 127, 168–69; commemorative sculpture 173–77; portraiture 169–73; *see also* Domitian; Titus; Vespasian

Florus 52

Forma Urbis Romae (Severan Marble Plan) 105, 195–96, 325

forum, Leptis Magna 334, 334–36, *335*

forum, Ostia 254–55

forum, Pompeii 84

Forum Boarium, Rome 45, 58

Forum Holitorium 57

Forum of Augustus 144, 144–47, 195, 242–43

Forum of Caesar (Forum Iulium) 105, 107–9, *108*, 144

Forum of Domitian/Nerva (Forum Transitorium) 144, 196, *196*, 296

Forum of Trajan 144, 241, *241*, 242–45, 250, *250*, 370; *see also* Trajan's column

Forum of Vespasian (Templum Pacis) 144, *195*, 195–96, 243, 244, 295, 325

Forum Romanum *see* Republican forum

Fourth Style wall painting 186–88

François Tomb, Vulci *33*, 33–36, *34*, *35*, 63

Franks 380, 383

freed slaves *see* liberti

fresco 82

friezes (painted): Dionysiac frieze, Villa of the Mysteries 88, *88*; *Odyssey* frieze, Esquiline 88–89, *89*

friezes (sculpted): Aemilius Paullus monument 67, *67*–68; Ara Pacis 141, *141*–42, *142*; Arch of Augustus, Susa 222–23, *223*; Arch of Constantine 371–72, 373, *373*; Arch of Titus 174; Basilica Aemilia 119–21, *120*; Basilica Ulpia 245, *245*; Forum Transitorium 196, *196*; Palazzo della Cancelleria 176, *176*–77, *177*; Pergamon

Altar 68, 69, 191, *191*; repurposed as panel reliefs 250, *250*; Temple of Apollo Sosianus 123, 123–24; Temple of Bel, Palmyra 307, *307*; Temple of Hecate, Lagina 68, 68–69, *69*; Tomb of Eurysaces 209, 209–10

functions of art 15–17, 193, 387; domestic display 78, 91–92, 95, 96–98, 339

funerals 16, 71, 206, 207, 208, 211, *211*, 310, 349; cortege route represented 212; *decursiones* 277, 277–78; *see also* sarcophagi

G

Gaius, emperor *see* Caligula

Gaius Caesar (grandson of Augustus) 134, 135, *135*, 136, 143, 156; Nemausus temple to 214

Galba, emperor 168

Galerius, Eastern emperor 352, 353, 354, *354*, 368; Thessaloniki structures 363–65

Gallia Belgica 361

Gallia Lugdunensis 214, 215–16

Gallia Narbonensis 214, 215–16

Gallienus, emperor 347, *347*, 348

Gallus, emperor 347

games and entertainments 199–200, 203, 208, *208*, 227, 229; Greek 228, 289; *see also* festivals

garland motif 141, *141*, 148, *148*, 188, 310

Gaul 164, 214, 290, 348, 383; Cisalpine 222; Samian ware 345; *see also* Lugdunum; Nîmes; Orange; Trier; Vienne

Gauls 18, 53, *53*, 216

gem carving 161; *see also* cameos

Gemma Augustea 160, *160*, 162, 219, 253

Gemma Claudia 163, *163*

genii 166; of the senate and people 176, *176*, 264, *264*

Germanicus 154, 155, 156, 160, 163, *163*, 164, 167

Geta, emperor 318, 321, *321*, 323, 329

Getty Villa 99, *99*

giallo antico marble 246

Gibbon, Edward: *History of the Decline and Fall of the Roman Empire* 274

Gigantomachy 68, 69, 336, *336*

gladiatorial games 199–200, 208, *208*, 228, 229

golden age 232

Golden House of Nero *see* Domus Aurea

goldwork, Etruscan 29, 29–30

Gordian III, emperor 346, *346*

Gospel book of Otto III 384, *385*

Grand Camée de France 162, 162–63; *see also* Barberini Ivory

Granicus monument 53

Greece *see* Athens; Corinth; Delos; Delphi; Epidaurus; Isthmia; Macedonia; Olympia; Thessaloniki

Greek art and culture 13–15; Amazonomachy theme 312; architecture 17, 58–59, 76–77, 106; at Constantinople 379–80; early traders in Italy 22–23; and Etruscans 24, 25–26, 27, 31, 33, 40, 46–47; evolution of style 13–14, 54, 206; mosaics 340; painting 81, 147, 344; Roman attitudes to 54; as war booty 51, 52, 53, 93, 124; *see also* Hellenism

Greek colonies 24, 218

gymnasia 198, 240, 300

H

Hadrian, emperor 232–33, 262, 283, 304, 305, 308–9; accession and continuity with Trajan 253, 257–59, 262; and Antinous 265, 266, 309; and Apollodorus 267, 270; Athenaeum 273; and Athens 273, 293–95; depictions of 262–63, *263*, 264, *265*, *266*, *298*, 298–99, 308, *308*, 344; mausoleum of 272, *272*, 349; and the Pantheon 267, 268; philhellenism 232, 262, 263, 271–72, 272, 273, 293; succession planning 274, 308; Temple of Venus and Roma 271–72; temple to 283, 283–84, *284*; Tivoli villa 301–4, *302*, *304*, *306*, 308, *309*

Hadrian's Wall 304–5, *305*

Hagia Sophia, Constantinople 382, *382*

hairstyles: Alexander evoked by 104, 110, *111*; Antonine portraits 275–76; Constantine 369, *370*; Diocletian 354, *354*; Domitian 170; Etruscan Hellenism 38; Gallienus 347; Julio-Claudian portraits 103–4, 136, 157, 159, *159*; Nerva 237; Palmyrene abstraction 307; Serapis curls 319, *319*; soldier emperors 346, 348; Trajan 238, *238*; women's 72, 136, *136*, 170–71, 210, 264–65, 320–21; *see also* beards

Haterii, tomb of 210–12, *211*, *212*; portrait of Hateria 137

Helena (daughter of Constantine) 377

Hellenism 51, 88–89, 232; of Domitian 173, 196, 203, 228; of Gallienus 347; of Hadrian 232, 262, 263, 271–72, 273, 293; at Leptis Magna 334; and social status 73, 81, 311, 312

Hellenistic art 227, 308, 310, 359; allegory 143; carved gems and cameos 161; mosaics 340, *341*; *see also* Laocoön and His Sons

Hellenistic kingdoms 50, 213; cities under Roman empire 290; Egypt 220

Hellenistic monarchs 70; euergetism 289; portraiture 104, 110–11, 161; *see also* Perseus of Macedon

Hellenistic portraiture 137

Hellenistic rulers 216, 219

Hellenistic style (sculpture) 65–66

Herculaneum 76, 99; Samnite House 83, 83–84; Villa of the Papyri 96–98, *98*, *99*, 189

Hercules/Herakles 266, 276, 311, 334, 353; Archaic terracotta akroterion 45, 45–46; Farnese statue 328, *328*

Herodes Atticus 288–89, 297

Herodotus 25

hippocamps 255, *255*, 292

hippodrome, Constantinople 379, 379–80

Historia Augusta 237, 244, 262, 266, 268, 270, 301, 304, 323, 324, 326

Holy Roman Empire 383, 384

Homer: *Odyssey* 27, 192

Honorius, Western emperor 382

Horace 98

Horologium Augusti 139, 140

Horrea Epagathiana, Ostia 257, *257*

House of Augustus 116, *116*, 147

House of Livia 116, 116–17, 147

House of Romulus 115

House of the Faun, Pompeii 78, 78–79, 78–79, 82, 82–83, 90; Alexander Mosaic 80–81, *81*, 82

House of the Masks, Delos 79, 79–80, *80*

House of the Vettii, Pompeii 188, *188*

housing *see* atrium houses; *insulae*

hunting 173, 266

I

idealized portraiture 344; of Antinous 309, *309*; combined with verism 73, 157–58; Egyptian 221, 322; Etruscan 37, *37*, 38, 42; Julio-Claudian 132–33, 134–37, 163, 221; of Julius Caesar 104; of women 136–37, 170, 171, 264, 307; *see also* Classicism

imagines 71, 72, 147, 170

impasto 23

Imperial Fora, Rome 105, 144; Forum of Augustus 144–47, 195, 242–43; Forum of Caesar (Forum Iulium) 105, 107–9, *108*; Forum of Domitian/Nerva (Forum Transitorium) 196, *196*, 296; Forum of Trajan 241, *241*, 242–45, 250, *250*, 370 (*see also* Trajan's column); Forum of Vespasian (Templum Pacis) 195, 195–96, 243, 244, 295, 325

imperial forum-type developments, provincial: Athens (Library of Hadrian) 273, 294–95, 295; Leptis Magna (forum of Severus) 334, 334, 336

imperial portraiture: Antonine 275–76, 280–81; Augustus and family 132–37; Constantine 369–70; Flavian 169–73; Hadrianic 262–63, 264, 298; Julio-Claudian 154–59; Nerva 237; Severan 318–21, 323–24; soldier emperors 344, 346–48; Trajan 237, 238; tetrarchy 353–55; use of 297–98, 344; *see also* damnatio memoriae

individualism 15, 72–73, 137, 322, 387

insulae 256, 257

interior decoration 76, 77, 78, 189; Basilica Ulpia 245; baths 13, 240, 255, 327, 327, 328, 341, 341; domestic sculpture displays 90–92, 95–98, 189; Domus Aurea 182, 183; Hadrian's villa, Tivoli 302–4, 306; palace of Domitian, Split 184, 186; Pantheon 269–70; *see also* mosaics; wall painting

Ionic order 17, 17, 58, 216–17

Iseum, Rome 194–95, 324, 325

Isis 324; Iseum, Rome 194–95, 325; *see also* Serapis

isocephaly 252

Istanbul *see* Constantinople

Isthmia, Greece 159, 198, 228; sanctuary of Poseidon 341, 341

Ixion Room, House of the Vettii (Pompeii) 188, 188

J

Jerome, Saint: *Chronicle* 295

John I Tzimiskes, Byzantine emperor 384

Judgement of Paris 40, 40

Julia (daughter of Augustus) 134, 137, 147

Julia Domna (wife of Septimius Severus) 318, 338; depictions of 171, 320, 320–21, 321, 323, 329, 329

Julian Basilica, Corinth 135

Julio-Claudian dynasty 126–27; portraiture of 154–59; Sebasteion, Aphrodisias 224–27; *see also* Augustus; Caligula; Claudius; Nero; Tiberius

Julius Caesar *see* Caesar, Gaius Julius

Junius Bassus, sarcophagus of 374, 375

Jupiter 252; Caligula and 180; Capitoline temple of 44–46, 45, 109, 193, 272; Diocletian and 353, 357, 362; imperial use of iconography of 157, 157, 162, 162, 163, 219, 219–20, 220, 252–53; *see also* Zeus

Jupiter Column, Mainz 250

Justinian, Eastern emperor 382, 383

K

kings of Rome 11; *see also* Romulus; Tarquin monarchy

kraters 92–93, 345; Aristonothos Krater 27; *see also* Borghese Vase

L

Lagina: Temple of Hecate frieze 68, 68–69, 69

Lake Regillus, Battle of 118

Lanuvium: statue of Claudius as Jupiter 157, 157, 158

Laocoön and His Sons 190, 191, 193

Lares and *genius Augusti* cult 166, 172

Largo di Torre Argentina 56, 56–57

Lars Pulena, sarcophagus of 39, 39

late antique style 15, 224, 278, 350, 381; Arch of Constantine 372, 373–74; *vs.* early medieval 385

Lefkadia: Great Tomb 84, 87, 87

lenos sarcophagi 337, 337

Lepidus, Marcus Aemilius (censor 179 BCE) 119

Lepidus, Marcus Aemilius (triumvir) 109, 110, 114, 136

Leptis Magna, Libya 332, 335, 336; Arch of Septimius Severus 332, 332–34, 333; Severan forum 334, 334, 336

liberti 207, 209, 210

libraries: Forum of Trajan 243, 249; Library of Celsus, Ephesus 299, 299; Library of Hadrian, Athens 273, 294–95, 295

Licinius, emperor 369

lictors 142, 175

linear perspective 86, 86, 116, 361

Livia (wife of Augustus) 136, 136–37, 154, 167, 215, 222

Livy 18

Louis XIV of France 385

Lucius Caesar (grandson of Augustus) 134, 135, 135, 136, 143, 156; Nemausus temple to 214

Lucius Verus, emperor 274, 275, 308, 308, 330

Lucullus, Lucius Licinius 76

Ludovisi Gaul 53

Ludovisi sarcophagus 350–51, 351

Ludus Magnus 203

Lugdunum (Lyons) 162, 164, 214–15, 318

Luna marble 246

Lupercal 115

lustratio 66, 70, 222

Lyons *see* Lugdunum

Lysippus 53, 54; *see also* Farnese Hercules

M

Macedonia, art of: mosaic 340; wall painting 82, 83, 83, 84, 84, 87, 87

Macedonian rulers 15, 50, 51, 219; *see also* Alexander the Great; Perseus of Macedonia

Macrinus, emperor 318, 323, 330

Mahdia shipwreck 91, 92–93, 94–95; dancing dwarf figurine 94, 94; Eros (Agon) statue 94, 94

Maison Carrée, Nîmes 214, 214, 215

manubial buildings 55, 63, 122, 227

marble 108, 112, 210, 246, 294; availability 65, 280; Severan Marble Plan 325

Marcellus, Marcus Claudius 134

Marcomannic wars 274, 281

Marcus Aurelius, emperor 156, 232, 233, 274–75, 330; column of 281, 281–83, 282, 283, 312; commemorative reliefs 278, 278–79, 279, 281, 331; equestrian bronze 280, 280–81; Great Antonine Altar, Ephesus 308, 308; portraits 275, 275, 276

Marius, Gaius 57, 60, 102

Mars: Augustus as (Ravenna Relief) 167, 167; Cancelleria reliefs 176, 176; *Decennalia* monument 357, 358; Paris reliefs 66, 66

"Mars" sculpture, Todi 42, 42

Martial 186, 198; *De Spectaculis* 201

martyrion churches 378

masks, theatrical: mosaic depictions 78–79, 79

mass production 91

Mau, August 149

mausolea 376–77; of Augustus 134, 138, 138–39; of Celsus (Library of Celsus) 299, 299; of Galerius 363, 363–64; of Hadrian 272, 272, 349

Maxentius, Western emperor 368–69; Basilica of 368, 368–69

Maximian, Western emperor 353, 353, 361, 368

Maximinus Thrax, emperor 318, 324, 325, 346, 346

McKim, Charles Follen 386

medieval art 385

Medusa protomes 334, 335

megalographic painting 87–88

Megarian bowls 345

Melfi: marble sarcophagus 313, 313

Meroë Head of Augustus 132, 132

Mesopotamia 304, 314, 331

Metellus, Aulus 47, 47

Metellus Macedonicus, Quintus 53

metroon at Olympia 219–20

INDEX 403

Michelangelo 281

middle-class art 208, 210, 313, 330, 332; see also *liberti*

Milvian Bridge, Battle of 369, 371, 373

Minerva 40, 45, 176, *176*, 196, *196*, 252; see also Athena

mirrors 40, *40*

Misenum 172–73

modernism 386

money see coinage

morality laws 137, 196

mosaics 79–81, 339, 340–41; Antioch *338*, 338–39, *339*; Baths of Caracalla 327; Baths of Neptune, Ostia *255*, 255–56; Hadrian's Villa *302*, 303; House of the Faun, Pompeii 78–79, *80*, *81*; House of the Masks, Delos 79, *80*; Isthmia *341*; Pella *340*; Praeneste 64, *65*; San Vitale, Ravenna *384*, 385; Santa Costanza 377, *377*; Square of Corporations, Ostia 256, *256*; Timgad 292, *292*

Mummius Achaicus, Lucius 59, 218

mummy portraits 322, *322*

murals see tomb painting; wall painting

Museo Nazionale Romano 359

museums (ancient) 53, 196, 380

Mussolini, Benito 140

mystery cults 309, 337, 376

N

Naulochus, Battle of 110, 113

Necropolis of Banditaccia 28

Nemausus see Nîmes

Neo-Attic sculpture 90–95

Neptune (Poseidon): baths of Neptune, Ostia *255*, 255; Munich reliefs *65*, 65; sanctuary of Poseidon, Isthmia *341*, 341

Nero, emperor 127, 151, 156, 158–59, 168, 200; baths of *198*, 198–99; Claudianum project 193; coinage *180*; Domitianic echoes of 169, 170, 196, 203; Jupiter Column, Mainz 250; portraiture *158*, 159, *159*; possible Ravenna Relief depiction 167; Sebasteion relief 226, *227*; see also Domus Aurea

nero antico marble 246

Neronia festival 198

Nerva, emperor 151, 177, 236, 237; Forum of 196, *196*; images of Domitian recut as *173*, 176, *177*, 237; portraiture 237, *237*

Nîmes (Nemausus) 274; amphitheater 230–31, *230–31*; Maison Carrée 214, *214*

Numerian, emperor 352

Nymphaeum of Herodes Atticus, Olympia 297, 297–99

O

obelisks 195, 246, 276; *Horologium Augusti* 139; of Theodosius (Constantinople) 381, *381*

Octavian see Augustus

Odeum of Herodes Atticus, Athens 288–89, 289

Odyssey (Homer) 27, 192

Olympia, Greece 219, 228, 298; imperial statuary *157*, 157–58, 219, 219–20, *220*; Nymphaeum of Herodes Atticus 297, 297–99; Phidian statue of Zeus 380; Philippeion 219; Temple of Augustus Soter (metroon) 219–20

Olympic Games 289

Oppian hill: baths of Titus 199; baths of Trajan 239–41; Domus Aurea 181–82, 239

Orange (Arausio), France: Arch "of Tiberius" *223*, 223–24, *224*; theater 229, *229–30*

Orator statue 47, *47*

Orestes and Electra sculpture 92, 93–94

Orientalism see eastern influences; Egypt: artistic influence; Hellenism

Ostia 241, *254*, 254–57; architecture *256*, 256–57; mosaics *255*, 255–56, *256*, 341; portrait of Hadrian 262–63, *263*; portrait of Trajan 238, *238*, 263

Otho, emperor 168

Otto I (the Great) 383, *384*

Otto III 383, *384*, 384–85

P

painting 15, 81, 345; ceramics 26, 27, 31, *31*, 33, 345; mummy portraits 322; perspective effects 86; Severan tondo 321, *323*; triumphal 63–65, 250, 332; see also tomb painting; wall painting

palaces 112, 181; of Augustus 112–14, *113*, 116, 116–17; of Diocletian (Split) 361–63, *362*; of Galerius (Thessaloniki) 363; Great Palace of Constantinople 379, 379–80, 381; see also Domus Aurea; Domus Flavia

Palatine 22, 113, *183*; House of the Griffins 84, 84–85; imperial palaces 181 (*see also* Domus Aurea; Domus Flavia); palace-forum access 180; Republican temples 115; residence of Augustus 112–14, *113*, 116, 116–17; Severan building projects 325–26

Palazzo della Cancelleria, Rome: relief friezes 176, *176–77*, *177*

Palazzo Torlonia, Rome: portrait of a patrician 72, *72*

Palazzo Valentini, Rome 244

Palestrina see Praeneste

Palladio, Andrea 198, *199*

Palmyra, Syria 296, *296*, 306–7, 348

Panathenaic Stadium, Athens 289, *289*

Panhellenium, Athens 293

Pantheon 122, 246, 266–71, *267*, *269*; Iseum obelisk 195

Paris-Munich reliefs 65, 65–67, 66–67, 112

Parthenon, Athens: Athena Parthenos statue 312; frieze 141

Parthian Arch (of Septimius Severus) 330, 330–32, *331*

Parthians, war with 274, 308, 310, 318, 330, 365

Pasiteles 54, 92–94, 107

Pausanias (general) 379–80

Pausanias (geographer) 290, 293, 294–95, 308, 309

pavonazzetto 245

Pax Augusta (Augustan peace) 134, 140, 141, 144, 160, 379

peace and prosperity 141, 144, 163, 290

Pella, Macedonia: floor mosaic *340*; House of the Wall Plasters 83, *83*

Pennsylvania Station, New York City 386, *386*

Pentheus painting, House of the Vettii (Pompeii) 188, *188*

peperino 113, 246

Pergamon, Turkey: Attalus I 53; cult of Augustus and Roma 164; Great Altar 68, 69, 120, 191, *191*, 307, 310, 336

peristyles 77, *77*, 78–79

Perseus of Macedonia 51, 67, 68, 76

perspective 64, 85, 86, *86*, 116, 207, 248; architectural exploitation 361

Pertinax, emperor 318, 319, *319*

Pescennius Niger 318, 330

Petronius: *Satyricon* 207

pharaonic portraits 221, *221*, 309, *309*

Pharsalus, Battle of 103, 107

Phidias 53, 54, 380

Philip II of Macedon 219

Philip the Arab, emperor 347

Philippi, Battle of 110

Philodemus of Gadara 99

Piazza della Repubblica, Rome 360, *360*

Piazza d'Oro, Hadrian's villa (Tivoli) 302; centaur sculptures *303*, 303–4

Piazza Navona, Rome 203, *203*, 228

Piazza Venezia, Rome 244, 273
Pietrera Tomb sculptures 36, *36*
Plancus, Lucius Munatius 118
Plataea, Battle of 379–80
Plautianus, Gaius Fulvius 329
Pliny the Elder 54, 172; *Natural History* 46, 54, 63, 80, 82, 90, 112, 124, 139, 161, 191, 195
Plotina (wife of Trajan) 171, 257
Plutarch 54; *Life of Marcellus* 51; *Life of Pompey* 104
Pollux 41, *41*; *see also* Dioscuri
Polybius 71
Polycleitus 54; *Doryphoros* 42, 133, *133*
Pompeii 76, 84, 186; amphitheater 203; House of the Vettii 186, *188*; Villa of the Mysteries 85, *85*, 88, *88*; *see also* House of the Faun
Pompey the Great (Gnaeus Pompeius Magnus) 12, 102–3, 104, *104*; theater complex 105, *105*, 300
Pons Aelius 272, *272*
Pontic amphorae 26, *26*
pontifex maximus 114, 118, 136, 139, 358; emperors depicted as 142, *142*, 329, *329*, 358
populares 102
porphyry 246, 354, 355, *355*
Porta Capena, Rome 326, 327
Porta Maggiore (Porta Praenestina), Rome 197, *197*, 209
porticoes 53, 77; arched 334, *335*; wall painting 84, *84*, 85, 86, *87*; *see also* colonnades
Porticus Metelli 55, 57, 112
Portonaccio sarcophagus 312, *313*, 350
Portonaccio Temple, Veii 46, 46–47, *47*
portraits: of Antinous 309, *309*; of Antonius 110, 110–11, *111*; of emperors (*see* imperial portraiture); identification 103, 136–37, 163, 165, 167, 354; of Julius Caesar 103, 103–4, 111, *111*; on mummy cases 322, *322*; of Octavian 110, *110*, 111, *111*; of Pompey the Great 104, *104*; Republican tradition 70–73; on sarcophagi 37–39, 349, 351; in tomb painting 34–36; in tomb sculpture 210, 211; verism 36, 72–73, 104, 137, 170, 211, 344; Villa of the Papyri collection 97; of women 136, 137, 170–71, 320–21
Poseidon *see* Neptune
postmodernism 386
pottery 345; Corinthian 25–26, 218; Etruscan 25, *25*–26, *26*, 27, *27*, 30, *30*; Villanovan 23, 23–24, *24*

pozzo burials 23, 23–24
Praeneste 40, 60; Ficoroni *Cista* 41, *41*; Sanctuary of Fortuna Primigeneia 60–61, 61, 64, 65
Praetorian Guard 126, 156, 168; emperors assassinated by 168, 318, 348
Praxiteles 53, 54, 380
priests 135–36, 162, 166; *see also pontifex maximus*
Prima Porta (Villa of Livia): statue of Augustus 132, 132–34, *133*, 281; wall paintings 148, 148–50
princeps, title 132, 184; *Optimus Princeps* 237
Probus, emperor 348, *348*, 351–52
Proconnesian marble 246
protomes 146, *146*, 334, *335*
provinces 19, 203, 213, 288, 290; Achaea 218; Africa Proconsularis 336, 345; Cisalpine Gaul 222; Galatia 216; Gallia Belgica 361; Gallia Lugdunensis 214, 215–16; Gallia Narbonensis 214; interrelationships 336; personifications 226, *226*, 284, *284*, 385; reconfiguration under Diocletian 352–53; Syria 308, 324, 325, 338 (*see also* Palmyra); *see also* Dacia; Egypt; Gaul
Pseudo-Athlete 72, *73*
Ptolemy 220
public building projects 55, 122, 193, 288, 289; aqueducts 197–98; Christian churches 375; and cultural assimilation 213; material and message 246; Severan 324–25
Punic Wars 19, 50–51, 115, 131, 219
Puteoli (Pozzuoli) 172
Pydna, Battle of 51, 67, 68, 76
pylon temples 221
Pylos Combat Agate 161
Pyrrhus of Epirus 18–19, 50, 97, *97*

Q

Quintilian 53, 54
Quirinal hill 183; baths of Constantine 370; Serapeum 324; Trajan's Markets 241, 241–42

R

Rabirius (architect) 185–86
Ravenna 382; Church of San Vitale mosaic 384, *385*
Ravenna Relief 167, *167*
realism: of *imagines* 71, *72*; in imperial portraiture 127, 158, 169–70; in wall painting 149; *see also* verism

red slip ware 345, *345*
Regilla (wife of Herodes Atticus) 297, 299
Regolini-Galassi tomb, Cerveteri 28, 28–29
relief sculpture 65, 165–67; Algiers Relief 145, *145*; Amiternum reliefs 206–8, *207*, *208*; *Anaglypha Hadriani* 257–59, *258*, *259*; Antonine period 276–79, 281–83, *284*, *284*, 310–13; Apollo Palatinus temple evidence 114, *114*, *115*; Ara Pacis 140, 140–44, *141*, *142*, *143*, *144*, 214; Ara Pietatis/Ara Gentis Iuliae reliefs 165, 165–66; Arch of the *Argentarii* 329, 329–30; Arch of Galerius (Thessaloniki) 364, 364–65, *365*; Arch of Septimius Severus, Rome 330, 330–32, *331*; Arch of Tiberius, Arausio 223–24; Arch of Titus 173, 173–76, *174*, *175*; Arch of Trajan, Beneventum 251, 251–53, *252*, *253*; Belvedere Altar 166, *167*; Column of Marcus Aurelius 281, 281–83, *282*, *283*; Conservatori reliefs 263–64, *264*, 278, 278–79, *279*, 281; Leptis Magna monuments 332–36; Neo-Attic decorative work 91, *91*; Palmyrene funerary reliefs 307, *307*; Paris-Munich reliefs 65, 65–67, 66–67, 112; protomes 146, *146*, 334, *335*; Ravenna Relief 167, *167*; Sebasteion 225–27, *226*, *227*; Temple of Dendur 221, *221*; Temple of Vespasian entablature 194, *194*; tetrarch group from Constantinople 354–55, *355*; tomb of Eurysaces 209, 209–10, *210*; tomb of the Haterii 211, 211–12, *212*; Trajan's column 233, 247, 247–50, *248*, *249*, 258–59; *Tropaeum Traiani*, Adamklissi 253, 253–54; *Vicomagistri* Altar 166, 166–67; *see also* Arch of Constantine; cameos; First Style wall painting; friezes (sculpted); sarcophagi
Renaissance 385; archaeological discoveries and attitudes 95, 140, 181, 182, 198, 325; artwork 43, 181, 198, 281; redevelopment of Rome 121, 138, 281
replicas and copies 89, 90–91, 98, 339
Republican forum, Rome (Forum Romanum) 45, 63, 109; cult of Vesta 22, 59, 114; Diocletian's renovations 358; and the Domus Aurea 181; early archaeology of 22; palace access projects 180; Parthian Arch 330, 330–32, *331*; Severan restorations 324; statuary 42, 280; Temple of Antoninus and Faustina 284–85, *285*; Temple of Augustus location 193; Temple of Julius Caesar (*Divus Iulius*) 117, 117–18, *118*, 130, 213; *see also Anaglypha Hadriani*; Arch of Titus; Basilica Aemilia; Basilica of Maxentius; *Decennalia* monument
Republican government 11, 18, 102; and the assassination of Caesar 109–10; *see also cursus honorum*
Res Gestae Divi Augusti 130, 138, 140, 142, 216

Rhamnous, Attica: Temple of Nemesis 222

Rhodes 76

Roma (goddess) 69, 69; Antoninus Pius column-base 276, 277; Arch of Titus 175, 175; cameo depictions 160, 160, 162, 163; Cancelleria Reliefs 176, 176, 177; on coinage 131; Gospel book of Otto III 384, 385; Roma and Augustus cult 162, 163, 164, 215, 216, 217; Temple of Venus and 270, 271, 271–72, 368

Roman empire 213; Augustan extent 12, 12, 213; division 353, 369, 381, 382; *limites* (frontiers) 304–5, 352; peak cultural success 290; Republican-era conquests 18–19, 50–51; seats of power 315, 353, 365, 370, 382; second-century extent 233, 237, 262, 274, 304, 304–5; third-century collapse 314, 352; Western fall 315, 382, 383

Roman red ware 345

romanitas 11, 73, 254, 291, 382–83

Rome, city of 11; American Academy 386; Augustan "re-foundation" 18, 115; Aurelianic fortifications 314; beginnings 22, 44–45; catacombs 378; under Constantine 370, 375; under Diocletian 358–60; festivals and theaters 105, 106; fires 169, 181, 194, 200, 267, 268, 358; Forum statuary 42, 280; modern archaeology 22, 273; under Otto III 383, 384–85; personified (*see* Roma); Renaissance and Baroque period 138, 181, 182, 198, 325; sack of (390 BCE) 18; sack of (410 CE) 382; as seat of Maxentius 368; Severan Marble Plan 105, 195–96, 325; stock exchange 283; temples (*see* temples (Rome)); *see also names of specific buildings and monuments*

Romulus 146, 193; and Remus 22, 43, 43, 115, 298–99

Romulus Augustulus, Western emperor 382, 383

Room of the Masks, House of Augustus 116, 116

rosso antico marble 246

S

Sabina (wife of Hadrian) 171, 264, 264

Sabratha, Libya: theater 300, 301

sacellum of the Augustales, Misenum 172

sacrifices 70, 140, 141, 165–66, 275, 333, 357, 358; *see also suovetaurilia*

Samian ware 345, 345

Samnite House, Herculaneum 83, 83–84

San Giorgio in Velabro, Rome 328

San Lorenzo in Miranda, Rome 284–85

San Nicola in Carcere, Rome 58, 58

San Vitale, Ravenna: Justinian mosaic 384, 385

Sanctuary of Fortuna, Praeneste 60–61, 61, 64, 65

Santa Costanza, Rome 370, 376, 377, 377

Santa Maria degli Angeli e dei Martiri, Rome 359–60, 360

Sant'Omobono temple site, Rome 45–46

sarcophagi 37–39, 47, 212, 310–13, 337–38, 349–51; of Balbinus 349, 349–50; Christian 374, 375, 377, 377; of Junius Bassus 374, 375; of Lars Pulena 39, 39; Ludovisi sarcophagus 350–51, 351; Portonaccio sarcophagus 312, 313, 350

Sardis, Turkey: bath-gymnasium 300, 300

sardonyx 161

scale of figures 166, 207–8, 248, 279; hierarchic 66, 70, 211, 252

Scaurus, Marcus Aemilius 106

sculptural practices and materials: bronze casting 42; drapery effects 165, 177, 279, 372; drillwork hair effects 171, 275–76; eye details 320, 346, 354; ornamental deep carving 194, 194; outline channels 224; reproduction industry 90–91, 92–93, 96–97; sarcophagus production 310; stone types 112, 246; terracotta 46; use of *spolia* 356–57; verism 72–73, 167; wax *imagines* 71, 72

sculpture *see* Arch of Constantine; bronze statuary; cameos; friezes (sculpted); imperial portraiture; portraits; relief sculpture; sarcophagi; statuary; on tombs 206–12

Scylla group sculpture, Sperlonga 192, 192

sealstones 161

Seasons 337; Capitoline sarcophagus 337, 337–38

Sebasteion, Aphrodisias 224–26, 225, 226, 227, 297

Second Sophistic 54, 273, 289, 293

Second Style wall painting 84–89, 116–17, 147–50, 187

Second Triumvirate 109–10, 130

Sejanus, Lucius Aelius 154–55, 192

Seleucids 50, 51, 293, 338

senate 11, 55, 207; and accession of Nerva 236; and accession of Tiberius 154; and the Ara Pacis 142; and assassination of Caesar 109; empowerment of Octavian 112, 130; *genius* of 176, 176, 264, 358; relations with Hadrian 283; role in imperial era 126; and Severans 319, 323

senate house, Rome: Curia Iulia 107–8, 108, 273, 279, 358; Curia Pompeia 105

Seneca (the Younger) 158, 240

Septimius Severus, Gaius, governor of Africa 336

Septimius Severus, Lucius, emperor 171, 196, 318, 324; Arch of 330, 330–32, 331; depictions of 319, 319–20, 320, 321, 321, 329, 329; and Domus Flavia 325–26; and Leptis Magna 332–36; and marble plan of Rome 325; Parthian campaigns 330, 331

Septizodium 325, 326, 326

Serapis 194–95, 301, 319, 319; allusion to in portraiture 171, 319; Serapeum, Rome 304, 324

serpent column, Constantinople 379, 379–80

Severan dynasty 314, 318; *see also* Alexander Severus; Caracalla; Elagabalus; Geta; Septimius Severus, Lucius

Severan Marble Plan (*Forma Urbis Romae*) 105, 195–96, 325

Severus *see* Alexander Severus; Septimius Severus

Shapur I, Persian king 314

shipwrecks 93

Sicily: Battle of Naulochus 110; Greek colonies 24, 44; mosaics 341; Pyrrhic invasion 50; Roman control of 19, 213

Sidus Iulium 111, 145, 167, 167

single-point perspective 86, 116

skenographia 86

skiagraphia 86

slaves 77, 207; freed (*see liberti*)

social and economic measures 251–52, 257, 325, 352; morality laws 137, 196

soldier emperors 314, 318, 344, 346–47, 348; *see also* Caracalla

Sorrento: monument base relief 114, 114

Sosibios Amphora 91, 91

Sosius, Gaius 122–23

Sosus of Pergamon 80

Sperlonga 192

Split (Spalatum), Croatia 361–63

spolia 356–57, 373

Square of Corporations, Ostia 256, 256

St. Mark's Basilica, Venice 354

St. Peter's Basilica, Rome 375, 375

stadia 203, 203, 228, 228

Statius 186

statuary 188, 189–93; in baths 13, 327–28, 359; bronze (*see* bronze statuary); at Constantinople 380; in Forum of Augustus 146, 147; at Olympia Nymphaeum 297–98; in Republican forum 42, 280; Stephanos Youth type 92, 93–94; in theater at Orange 230; at Tivoli 303–4, 306; at Villa of the Papyri 95–98, 99, 189; *see also* imperial portraiture; portraits

Stephanos Youth 92, 93–94

style and chronology 14–15, 54, 193, 373–74; Arch of Constantine 372–73; in architecture 215; date of "Brutus" 43; in mosaics 339; persistence of Classicism 350; of sarcophagi 310; wall painting 82

styles of art: Antonine portraiture 275–76; Asiatic 227; Flavian 171, 176, 177, 194; Italic 209–10, 222–23, 284, 285; Neo-Attic 90–95; patrician and plebeian 206, 278; Severan 320, 328, 329–30, 331, 333, 337, 339; under Trajan 239, 248, 251; variety in same work 127, 206, 210, 303, 351; *see also* abstraction; Classicism; Hellenism; idealized portraiture; late antique style; realism; verism

succession, imperial 134–35, 156, 168, 233; and adoption 156, 236; after Commodus 318; Antonine 274, 275, 308, 308; and deification of predecessor 134, 266; of Hadrian 257; soldier emperors 344; and the tetrarchy 353

Suetonius 103, 183, 237, 264; *Augustus* 112–13, 146, 181; *Caligula* 180; *Julius Caesar* 103; *Nero* 159, 180, 183; *Titus* 168

Sulla, Lucius Cornelius 60, 102, 109, 294

suovetaurilia 66, 66, 222–23, 223, 258, 258

supplicatio 142

symposia 32, 77

Syria 308, 324, 325, 338; *see also* Palmyra

T

Tacitus 126, 151, 183

Tarquin monarchy 11, 18, 22, 34, 44–45, 46

Tarquinia: and early clay sculpture 46; sarcophagus of Lars Pulena 39, 39; Tomb of Hunting and Fishing 32, 32–33; Tomb of the Bulls 30–31, 31; Tomb of the Leopards 33, 33

taverns 256, 256

Tazza Farnese cameo 161, 161

Teatro Marittimo, Hadrian's villa (Tivoli) 302, 302

Tellus relief, Ara Pacis 143–44, 144

tempera 82, 321, 322

temples (general) 44–47, 213, 375–76; *see also* architectural orders; capitolia; *tholoi*

temples (outside Rome): of Apollo, Didyma 269; of Ares (previously Apollo), Athens 222; of Augustus Soter (metroon), Olympia 219–20; of Bel, Palmyra 306, 306–7, 307; of Dendur, Egypt 220–21, 221; of Hecate, Lagina 68, 68–69, 69; of Livia (previously Nemesis), Rhamnous 222; Maison Carrée, Nîmes 214, 214, 215; of Olympian Zeus, Athens 293, 293–94; Portonaccio Temple, Veii 46, 46–47, 47; of Roma and Augustus, Ankara 216, 216–17; of Roma and Augustus, Athens 217, 217; of Roma and Augustus, Vienne 214–15, 215; of Vesta, Tivoli 60, 60; of Zeus, Olympia 266; *see also* Sanctuary of Fortuna, Praeneste

temples (Rome) 57–59, 115; of Antoninus and Faustina 284–85, 285; of Apollo Palatinus 113, 113, 114, 114, 130; of Apollo Sosianus 122, 122–24, 123, 124, 125; of Augustus 193, 193; of Castor 118, 155, 180, 356; of Claudius (Claudianum) 181; of Concordia 118; of Hadrian (*Divus Hadrianus*) 283, 283–84, 284; of Hercules Victor 59, 59; of Isis and Serapis (Iseum) 194–95, 324, 325; of Janus 111; of Julius Caesar (*Divus Iulius*) 117, 117–18, 118, 130, 213; of Juno Regina and Jupiter Stator 53; of Jupiter Optimus Maximus (Capitolium) 44–46, 45, 109, 193, 272; of Mars Ultor 141, 142, 142, 144, 146, 165, 165, 214; of Portunus 58, 58, 141; of Salus 63; at Sant'Omobono 45, 45–46; of Saturn 118; of Sol Invictus 344; of Sol Invictus Elagabalus (later Jupiter) 325; of Trajan (*Divus Traianus*) 144, 244, 266; of Venus and Roma 271, 271–72, 368; of Venus Genetrix 107, 108, 108, 109; of Vespasian 193–94, 194; of Vesta 22, 59, 114; *see also* Divorum; Largo di Torre Argentina; Porticus Metelli; Templum Pacis; theaters: Theater of Pompey

Templum Pacis, Rome (Forum of Vespasian) 195, 195–96, 243, 244, 295, 325

Terme Boxer sculpture 359, 359

terracotta 46; Archaic temple sculptures 44, 45, 45–47; Cerveteri sarcophagus 37, 37; via San Gregorio pediment 69–70, 70

Tertullian 105

tetrarchy 315, 352, 353, 368; group sculpture from Constantinople 354–55, 355

theater temples 60–61

theaters 105, 106, 227, 300; Epidaurus 106; Orange 229, 229–30, 297; Ostia 256–57; Sabratha 300, 301; Theater of Marcellus 121, 121, 202; Theater of Pompey 105, 105, 121, 300; Timgad 291, 291

Theodoric, Ostrogoth king 382

Theodosius I, emperor 381, 381

Theophanu (wife of Otto II) 384–85

thermae see baths

Thessaloniki, Greece: Arch of Galerius 364, 364–65, 365

Third Style wall painting 150–51

tholoi 59, 217, 219

Tiberius, emperor 118, 135, 154–55, 156, 236, 336; depictions of 154, 155, 160, 164; Domus Tiberiana 181; and Roma and Augustus cult 162, 164, 215; and Sperlonga 192; *see also* Arch "of Tiberius"

Timgad, Algeria 290–92

Titus, emperor 168–69, 169, 172, 172, 174, 183, 191, 193; baths of 199, 199; and Flavian Amphitheater 199, 200; *see also* Arch of Titus

Tivoli 60; Hadrian's villa 301–4, 306; portrait of a general 72, 73, 112

Todi: "Mars" 42, 42

Togatus Barberini 16, 16

tomb painting 30–36, 63, 84; catacombs 378, 378; *see also* mummy portraits

tomb-building relief 212, 212

tombs 28–30, 206, 208–9; François Tomb (Vulci) 33, 33–36, 34, 35, 63; Great Tomb at Lefkadia 84, 87, 87; Pietrera Tomb (Vetulonia) 36; Regolini-Galassi tomb (Cerveteri) 28, 28–29; Tomb of Eurysaces (Rome) 209, 209–10, 210; Tomb of Hunting and Fishing (Tarquinia) 32, 32–33; Tomb of Lyson and Kallikles (Lefkadia) 84, 84; Tomb of the Bulls (Tarquinia) 30–31, 31; Tomb of the Haterii (Rome) 210–12, 211, 212; Tomb of the Leopards (Tarquinia) 33, 33; of Trajan 244, 247; *see also* catacombs; mausolea; sarcophagi

Trajan, emperor 107, 151, 182, 232, 233, 236–37, 308, 330; baths of 239, 239–41; Dacian wars of 237; depictions of 171, 238, 238, 248, 252, 252–53, 253, 258, 259; Forum of 241, 241, 242–45 (*see also* Trajan's column; Trajan's Markets); foundation of Timgad 291; later evocation of image 370; and the Pantheon 268; social and economic policy 251–52; tomb of 244, 247

Trajan Decius, emperor *see* Decius

Trajan's column 233, 247, 247–50, 248, 249, 258–59

Trajan's Markets 241, 241–42

travertine 210, 246

Trier, Germany 353, 360–61, 361

triumphal monuments 173; Ara Pacis as 140; *see also* arches; columns

triumphal paintings 63, 64–65

triumphs 51–52, 222; of Bacchus 337, 337; depicted 123, 123, 174–75, 175, 278, 278–79, 279; imperial restrictions 146–47; of Marcus Aurelius 274, 278, 278, 279, 280; of Pompey 102; route of 55–59, 370; shipping of looted art for 93; of Tiberius 160

Trojan War 31, 34, 187, 191

Tropaeum Traiani, Adamklissi 253, 253–54

tuff 112, 246

Tuscan order 17, 17, 44, 44, 215

U

United States Capitol building *385*, 385–86

urbanization 16, 18, 213, 232, 290; *see also* cities

V

Valerian, emperor 314, 347

vase painting 26, 27, 345; and tomb painting 31, 33

Vatican 200, 302; basilica of St. Peter *375*, 375

vaults 62; Aula Traiana 242, *242*; Basilica of Maxentius 369; Domus Aurea *186*; in theater construction 106

Veii 46; Portonaccio Temple 46, 46–47, *47*

Velian hill 182, 271, *271*

Velleius Paterculus 59

Venturi, Robert: House in New Castle County, Delaware 386–87, *387*

Venus 22, 107, 144; Balbinus' wife as 349, *349*; Livia as 167, *167*; mosaic with hippocamps 292, *292*; temples to (*see under* temples); Venus Genetrix 107, *107*, 145, *145*, 225; Venus Victrix *103*; *see also* Aphrodite

verism 36, 72–73, 104, 137, 170, 211, 344; in *liberti* portraits 210

Vespasian, emperor 127, 168, 193, 196, 283, 352; *adventus* scene (Cancelleria Relief B) 176, *177*; and the Claudianum 193, 283; and Flavian Amphitheater 199, 200; Forum of (Templum Pacis) 195, 195–96, 243, 244, 324, 325; portraiture 169, 169–70, 172, *172*; residence 183; temple to 193–94, *194*, 283

Vesta, cult of 22, 59, 114, 217; Severan buildings 324; Tivoli temple 60, *60*; Vestal Virgins 22, 114, 140, *141*, 177

Vesuvius, eruption of 54, 76

Vetulonia: Pietrera Tomb 36

via Appia 251, 326, *327*

via Flaminia 140

via Ostiensis 326

via Sacra 173, 181, 212,

via Traiana 251

vicomagistri 166, 207

Vicomagistri Altar 166, 166–67

Victoria 115; on commemorative monuments 174, *175*, 175, 223, 248, 249, 250, 332–33, *333*, 355, 356, *356*; cuirass of Hadrian, Olympia 298–99; Gemma Augustea 160, *160*; sarcophagus of Balbinus 349; Villa Albani relief 114, *115*

Vienne (Vienna), France: temple 214–15, *215*

Villa Albani, Rome: Neo-Attic sculpture 93, 114, *115*

Villa Farnesina, Rome: wall paintings 147, 147–48, *148*

Villa Medici, Rome: altar reliefs 165, 165–66; Arcus Novus fragments 356, *357*

Villa of the Papyri, Herculaneum 96–98, *98*, 99, 189

Villanovans 23–25

Virgil: *Aeneid* 18, 143, 191, 192

virtues: female 137; imperial 130, 137, 279; Republican 43, 72, 171

Vitellius, emperor 168

Vitruvius 17, 44, 82, 87, 149, 215

Vulca (sculptor) 46

Vulci: François Tomb 33, 33–36, *34*, *35*; sarcophagi 38, *38*, *39*

W

wall painting: First Style 82–84, 246; Second Style 84–89, 116–17, 147–50, 187; Third Style 149, 150–51; Fourth Style 186–88; *see also* tomb painting

warfare 50–51; campaign practicalities 247–48; cultural attitudes to 282–83; High Empire 233, 274, 304; as means to peace 134, 281, 290; third century 314; and wealth 16; *see also* battle scenes; civil wars; *Pax Augusta*; Punic Wars; triumphs

Weber, Karl 99

Winckelmann, Johann Joachim 14, 232

women, depictions of 136–37, 170–71, 264–65, 320–21; non-noble 210, *210*, 211; Palmyra funerary reliefs 307

Y

Year of Four Emperors (69 CE) 168, 352

Z

Zeus 298; Artemision statue 93; Claudius as 157, 157–58; dedication on sculpted bull 297; Nymphaeum of Herodes and Regilla statuary 298, *298*; Phidian statue 54, 380; Zeus Ammon 146, *146*; *see also* Jupiter